OUTSIDER

Also by John Rockwell

All American Music: Composition in the Late Twentieth Century
Sinatra: An American Classic
The Idiots (monograph on the film by Lars von Trier)

OUTSIDER

JOHN ROCKWELL ON THE ARTS, 1967–2006

Published in 2006 by Limelight Editions
512 Newark Pompton Turnpike
Pompton Plains, New Jersey 07444

Printed in the United States of America

Book design by Mark Lerner

Library of Congress Cataloging-in-Publication Data is available upon request.
ISBN 0-87910-333-7

www.limelighteditions.com

CREDITS

To Linda and Sasha, who make me feel like an insider

CONTENTS

1980–1991

1992–2004

2005-2006

ACKNOWLEDGMENTS

I would like to thank Robert Levine, John Cerullo, Carol Flannery, Barbara Norton, and Caroline Howell at Limelight Editions; Tim Page for serving as the initial contact between Limelight and me; Robert Cornfield for advice; Greil and Jenny Marcus for title consultation; Sierra Neal for technical wizardry; and my many friends and colleagues, past and present, at *The New York Times*.

INTRODUCTION

It's slightly creepy spending months on a selection of one's journalistic criticism over nearly forty years. My friend Dave Marsh's contribution to a desert-island-discs compilation called *Stranded* was "Onan's Greatest Hits." He meant sexy rock records for a lonely guy. Had I used that title, it would have been a testament to unhealthy self-absorption.

Outsider might seem an odd choice for someone who seems from the outside like the consummate insider. But it means something to me, both on a personal level—always feeling slightly detached from my surroundings—and professionally.

For a long while, in my twenties, I was unable to figure out a profession where I could feel at home. When I found one, journalism, and more particularly criticism, I entered a series of jobs in which I initially felt out of place, an outsider blundering in. Into classical music, where musicians seem like a closed guild, and where my fascination with "downtown" experimentation, let alone pop music, put me at odds with most of my fellow critics. Into pop, in which I started at the top with no prior experience. In Paris, where I was an American abroad. At Lincoln Center, where I ran a multimillion-dollar summer festival with no prior administrative experience. Back at *The New York Times*, I had never been an editor (except in high school) before I took over the Sunday Arts and Leisure section. And even though I had been a dance critic in California, few remembered that when I was named chief dance critic of the *Times*.

But there is more to *Outsider* than my own self-reflections. Criticism can be practiced from the inside or the outside. Eduard Hanslick, Wagner's arch-foe, played chamber music with Brahms. Joseph Horowitz

argues with his characteristic ferocity that outsider critics have cut themselves off from the real life of art, and he adduces his own (and mine, curiously) experience as an arts administrator as a corrective.

My two bosses as a young critic, Martin Bernheimer and Harold C. Schonberg, both preached the independence of the critic from social entanglements. I sympathized with the ideal of the critic as being as informed about the arts and the circumstances of their making as possible, but still detached, still his own person, still able to comment from a vantage point separate from the inevitably self-serving perspective of artists themselves. When I was covering both classical and pop music in the '70s, I took a perverse pleasure in wearing jeans to Carnegie Hall (common today; times change) or dashing down for a late show at CBGB in a suit and tie.

This selection from my nearly four decades of arts journalism—including my eight-year hiatus as festival director and editor, and even then I kept on writing—consists almost entirely of criticism. I was a good reporter and feature writer. I enjoyed tracking down stories and evoking a scene or a person, and there are a few examples of that kind of writing here. The lines can blur between the subjectivity of criticism and the supposed objectivity of reporting. But for me, the excitement of arts journalism comes in voicing my own opinion, trying to shape the aesthetic experience into something communicable to others. When I wasn't a critic, when I couldn't set down my reaction to a performance in writing, the experience seemed oddly incomplete.

This, then, is a collection of critical writing. It is presented as it first appeared, although overt errors and glaring stylistic infelicities have been tweaked, and there are a few cuts of material of no interest beyond the moment. My criterion was mostly the quality of the writing, although the significance of the event or artist sometimes played a role. There is nothing from the three books that have appeared under my name, but everything else was fair game, including collections of essays to which I contributed.

In selecting what to include, I first divided my writing into categories: classical music, pop music, dance, and other, meaning theater, film, books, art, and all manner of indefinable cross-genre performance. This was helpful as an organizing methodology in providing a standard of comparison: which pop pieces stood up better than others, and so on. But for the reader, and ultimately for myself, I have arranged all this into chapters, chronologically ordered, with all the various arts I have written

about mixed together. This makes for a truer picture of my critical evolution, and a better snapshot, year by year, of my varied interests. There are more pieces from the later years that the earlier years. This reflects some polishing of my prose, perhaps, but also the wider scope I had, the greater opportunities for extended commentary in the *Times* and elsewhere.

My headlines for each article in this book are blandly descriptive, no more: I have made no effort to grab the reader's attention. Most people don't realize that at newspapers the authors do not write the headlines. Over the years, some of mine were clever, some perfectly fine, some egregious. These just tell you what the article's about.

This may be a book of journalistic criticism, but of course the entire value of criticism can be questioned. When I had books of my own reviewed, I was angered or hurt by negative responses, but also annoyed by what I called trivial praise—opaque responses that never engaged with what I had done, even if the writers professed to like it. It gave me some insight into what performing artists must feel. (Of course, praise is preferable to disparagement, and I have certainly been guilty of lazy triviality in my own dispensing of judgments.) When I was at Lincoln Center, I was bemused by the odd combination of scorn and fear critics aroused in arts administrators. Forget high-toned analysis or poetic evocation; critics' only value, it seemed, was their ability to sell tickets. And then there are essayists and academicians who look down on newspaper critics as a lesser breed.

For me, newspaper criticism is a higher calling than all that. I have always believed, self-servingly, that even short notices written on deadline can be well written and insightful, and that journalism offers larger perspectives, beyond its place as the first stage of the historical record.

Covering a particular field, a beat—be it classical or pop or dance— forces one into a close-up knowledge of an artistic community. While I much admire the best specialist critics, I have always enjoyed breadth, openness, and diversity in my artistic appetites, even within a particular field: prizing rock and pre-rock standards and disco, for instance, or ballet and postmodern choreographic experimentation and social dancing. This book attests to my hunger for seeking parallels among the arts, insights from one to another.

There are dangers here. One can be accused of failing to plumb the depths. Or of a shallow impatience with routine, an unwillingness to brood and rebrood over recognized masterpieces, and of a fatal fascina-

tion with novelty, eccentricity, and sensation. Those who still disparage the early-music movement think its partisans just want something different. Similarly, there are those who saw nothing in Sergiu Celidibache or Matthew Bourne or Talking Heads but perverse, self-serving egomania. I have responded to extremes because they enlarge the field of the possible.

That makes me a romantic, however much I shrink from self-categorization. I love balance and proportion and perhaps allow myself the luxury of artistic extremism because I ultimately feel that it will be contained within larger societal and aesthetic limits. But intensity of feeling, passion, and expression have always attracted me, whether from Richard Wagner, Lars von Trier, Patti Smith, Arturo Toscanini, Ornette Coleman, René Jacobs, Ariane Mnouchkine, Leonard Bernstein, Sylvie Guillem, the Who, Valery Gergiev, Martha Graham, Hélène Grimaud, Robert Wilson, or the Grand Union. These are hardly the only artists I have admired, or the only types of artists. But they suggest a sensibility.

I will leave to others the further analysis of me; enough with the onanism. But there are larger concerns in the arts and arts criticism. One is the ever more oppressive weight of popular culture in our society, and the other is the threatened demise of print journalism and hence of newspaper criticism as a viable profession.

When I became a rock critic in the early 1970s, there were many in the world of classical music who thought I was betraying the cause of high art. But there is a difference between then and now. Back then—quite apart from the fact that I really loved a lot of popular culture, and still do—I thought I was fighting the good fight against an entrenched high-art establishment, struggling to bring a little balance and veracity to our perceptions of what American culture really was. Now pop culture seems so dominant that classical artists and their champions have good reason to feel threatened.

In the '70s we could still dream our post-'60s dreams, however naive, that pop culture spoke to people in a way that high art could or would not, that the best pop culture had a vitality that could serve as a corrective to convention—a romantic jolt to ossification. We didn't write about popular culture because we thought it a good barometer of society (though there was some of that). We wrote because we thought it was thrilling, and true.

There is plenty of exciting popular culture today, maybe more than ever, and plenty of feisty independent filmmakers and dance companies

and record labels helping artists make themselves seen and heard. But corporate control of the upper reaches of popular culture, always dangerous, has reached new levels of monopoly and oppression.

The solution, as I have tried to preach and practice all my life, is to blur the divisions. Music is music; dance is dance; the arts are the arts. Someone like Meredith Monk is not content to be a dancer or a composer or a singer or a filmmaker. Nor is Björk. Nor is Julie Taymor or Twyla Tharp or anyone unselfconsciously comfortable ignoring the high-low divide. They are artists, and most audiences are interested in the arts, not some narrow corner of one particular art as conventionally defined. You can argue—I have argued—that even at each extreme there is something of the other: even the snootiest elitist must communicate, and even the grubbiest commercial panderer needs some art to succeed.

As for newspapers and their decline in the face of the Internet and the supposedly callous indifference of youth, so what, say I. Newsprint is a delivery system, not a fetish object. With all due respect to the idealized freedom of the Web, as soon as someone figures out how to make real money from Web-based publications there will be jobs for critics to write about the arts. The whole wide world of blogs and Web sites has certainly opened up the dialogue, about the arts and everything else, in a salutary fashion. And there will always be readers, even youthful Web readers, who will devour and contest their opinions.

What you hold in your hand, however, is a printed book of reprints of print on paper. Maybe it represents a farewell, illuminated manuscripts on the eve of the printing press. Or maybe, looking optimistically forward instead of pessimistically backward, as I have been inclined to do all my long life, it's a hello.

New York
January 2006

1967-1972

I got my start in journalism in radio, at WHRB at Harvard and KPFA in Berkeley, doing mostly opera programs and, at Berkeley, a late-night live hippie-ish free-for-all. All this time I was working on my doctoral dissertation on opera reform in Berlin in the 1920s, and, for two years, dancing and co-writing manifestos for Ann (now Anna) Halprin. I began writing program notes for the San Francisco Opera, and in 1968 became the San Francisco correspondent for Opera News. *In 1969 I spent six months as interim classical music and dance critic of* The Oakland Tribune, *after which, from 1970 to 1972, I was assistant classical music and dance critic of the* Los Angeles Times.

DON RODRIGO

The San Francisco Examiner, December 9, 1967

Los Angeles—Modern opera, it is said, is dead. New works appear, often in fine, conscientious productions, and they are dutifully absorbed and gratefully forgotten. The range of their reception seems to be between outright failure and hopeful resignation.

So would you believe Alberto Ginastera's *Don Rodrigo*, his first opera, premiered in Buenos Aires in 1964, produced in New York in 1966, lauded by critics, and so popular that extra performances had to be added and the work repeated this year?

Would you believe that it opened the New York City Opera's Los Angeles season and was such a critical *and* popular success that the management decided to drop a performance of *Madama Butterfly* so it could be played again? And to a second full house and enthusiastic acclaim?

Well, it happened.

Whether Ginastera is the operatic messiah of the '60s will have to be answered by posterity. But he has indeed written a serious opera of integrity and broad appeal. A few Los Angelenos, primed for *Butterfly* despite all the cancellation announcements, were disoriented enough to leave, and talking was persistent during the opera's orchestral interludes. But on the whole the audience liked it, and so did I.

Don Rodrigo has a wonderful libretto, by the late Argentinean poet Alejandro Casona. It is a blend of almost archetypal operatic situations—coronation, seduction, battle, redemption—and of modern psy-

chology, symbolism, and dramatic structure, clothed in rich and vibrant Spanish.

Ginastera's music is based upon the serial technique, and each of the nine scenes, as in *Wozzeck*, has its own specifically musical form. Yet, as in *Wozzeck*, the music is operatically conceived. The vocal writing shifts along the spectrum from speech through declaimed recitative to actual song. And over the whole Ginastera has set a smorgasbord of coloristic effects, using a huge (eight horns!) and varied orchestra.

Sometimes the effects seem too numerous and indiscriminate—if all the colors on the palette are mixed the result is a dirty, dull brown. Occasionally the sterility of post-Viennese international style serialism can be heard lurking beneath the glittering surface. But often enough the music works, and the third act especially is convincing throughout.

The New York City Opera's production, supervised by the composer, is an effective one. But like San Francisco's 1966 *Boris Godunov*, it tries to be a budget spectacle. *Rodrigo* calls for as much display as *Boris* or *Aida*, and the NYCO, for all its many virtues, is not the Bolshoi.

Stage director Tito Capobianco is an erratic, mercurial man of the theater. When his ideas work, as they often did in *Rodrigo*, they are exciting. But there were sloppy, poorly conceived moments as well, and the production could use some tightening and polishing—chorus people stand slackly, some of the dance sequences are lackadaisically executed.

Mexican tenor Plácido Domingo's Don Rodrigo was a triumph—a big, handsome voice, good stage presence, and intelligent musicianship and acting. Julius Rudel held the whole together soundly, and managed to compensate for the Music Center's lively pit acoustics.

Although the San Francisco Opera would gain nothing in prestige but a local premiere by staging *Rodrigo*, Kurt Herbert Adler should seriously consider it. Certainly the response in New York and Los Angeles has been favorable, and it would be nice to see an opulent production of this opulent opera.

MERCE CUNNINGHAM
San Francisco Express-Times, November 20, 1968

Note: An attack on Merce from the perspective of Ann Halprin.

Merce Cunningham has been "avant-garde" for more than fifteen years. His collaborators have included some of the furthest-out musicians and artists on the New York scene — men now in their forties and fifties; and he is regarded by the world at large as the last word in dance daring. In response to this reputation and to the art-combining aspect of dance, his performances at Berkeley November 9 and 10 attracted two sold-out houses of people from every kind of scene in the Bay Area. The ability to attract talented people in other fields is a good criterion of how alive an art is, and by this standard Cunningham is certainly alive.

Cunningham's dance style is a formalization of his own personal and mildly eccentric movement ideas. His movements, and those he trains his dancers to imitate, are full of disjointed angularity. Many sequences are as if an originally fluid motion were electrically altered, so that some limbs, but not all, would go in slightly perverse directions. The body, normally a natural grouping of forces of which we are more or less aware, becomes a seemingly chance meeting-place for a myriad independently inspired movements. And then these strange sequences are periodically and abruptly halted, in the manner of film stills, so that we, as audience, may contemplate the curious new formations which have emerged. Sometimes this all seems almost purely abstract; sometimes it gives hint of a winsomely emotional communicativeness. Unfortunately the amount of variety, from dance to dance, is small. And Cunningham seems stronger in individual choreography than in the patterning of groups: often with more than three onstage (the company numbers nine) the movements lose coherence or fall into rather tired formal clichés. But certainly his dances are conceived, rehearsed, and performed with extraordinary virtuosity, especially by Cunningham himself.

Beyond his gifts as a choreographer, Cunningham is famed for his reconsideration of the relation of the arts within the theater. In dance as in opera the audience is assaulted by a combination of arts. It has always been assumed that some conscious authority would oversee this fusion, organizing things in a *harmonious* manner. Cunningham and his collab-

orators work almost totally independently of one another, and their performances thus represent a continuously new coming together of their elements.

The results are odd. Certainly Cunningham is, within his limits, a diverting mover; David Tudor, La Monte Young, Gordon Mumma, and John Cage are intriguing musical manipulators, and the latter a droll and theatrical storyteller; and Lord knows Robert Rauschenberg and especially Andy Warhol are visually gifted. And certainly it is fascinating to see the kind of random interaction such a disjunctive encounter brings.

The trouble is, Cunningham is creating in a different world than the others. Cunningham is an old-time dancer with a capital D. His "avant-gardism" consists, like that of many, many others, in abandoning ballet clichés—and even establishment modern dance clichés—and admitting into dance, some fifteen years ago, a new vocabulary of gesture and movement formerly considered "beyond" art. But everything is still very tightly controlled. Cunningham and all of his dancers owe a great deal to ballet and to ballet training. It is really disconcerting, especially with a Warhol "set" or a Cage "score," to watch Cunningham and his dancers: will they *make a mistake*? Cunningham's dancers are an extension of Cunningham's personality. They express their own selves as performers have always done: through others' ideas and movements.

Cunningham is in a different world because he has quite deliberately chosen to hold back from the new freedom, to maintain structures. At a Cunningham concert the dancers' improvisation is nonexistent, as is any attempt to involve the audience in any but the traditional ways. Thus in the most recent work shown, *Walkaround Time*, with its elaborate middle section of supposedly postperformance informality, with the dancers throwing on sweaters and ambling conversationally around the stage, my main reaction was one of pained annoyance: how odd to see a bunch of uptight New York dancers *pretending* to relax!

It is, for better or for worse, a different world. Maybe Cunningham is right, maybe discipline and initial repression of individuality free one from the lazy confines of the natural into the artificially artful. Maybe those who believe—like, consciously or unconsciously, his own collaborators—in a freer, more open kind of life are misguided dilettantes who in their attempts to naturalize art and to confer on life the quality of art are simply diluting the precious drops of art into the dreary and threatening sea of life. Maybe. Maybe not.

RAVI SHANKAR

The Oakland Tribune, February 17, 1969

Before a half-full house of flower children, amidst clouds of incense and the vast ugly spaces of the Berkeley Community Theater, with seraphic Western ladies in saris distributing announcements for a meditation session of the International Society for Krishna Consciousness, with bull-necked gentlemen hawking dollar programs, Ravi Shankar, sitar, and Alla Rakha, tabla, with Kamala Chakravarty, tamboura, appeared Saturday night in recital.

Pandit Ravi Shankar has something of a reputation as a charlatan, or at best a popularizer. I have heard him called "the Lawrence Welk of Indian music." Certainly his "show" was weighed down with annoyances: aimless packs of people were seated noisily and late, the hall was far too large, the amplification was faulty, and the dollar programs were made up for an entirely different tour last summer.

In other words, the smell of the big hype was pervasive.

Through it all, Ravi Shankar remains one of the supremely great musicians of our time. Of course he has written movie scores—good ones—but when he plays in the classical style he is both faithful and creative. Those who put him down simply don't know what they are talking about.

Indian music is a genre of great internal variety and ancient tradition, and of course repays the most devoted and exact study. But it is music which a Westerner either loves or hates, immediately and intuitively. Of course if you don't like it at first you may one day change your mind. But the change will probably be a sudden one. All it takes is the realization that here is music of supreme and unequaled beauty, of a sensuous strength and subtlety to be found in no other culture.

Ravi Shankar is, quite simply, the most extraordinary virtuoso that I know. He combines, within the music's largely improvisatory context, musicality and bravura in a way which seems far more difficult in our music. For us, "virtuosity" is often an end in itself. To an Indian, music is still sufficiently a part of an all-inclusive attitude toward life that virtuosity remains a means.

Saturday night's program followed the now familiar Shankar format: two opening ragas, intermission, tabla solo, sitar solo, and concluding dhun in a more popular style. All of this is interspersed with explanatory comments.

Although the uncomprehending fad for Indian music seems to have abated, Shankar still earnestly explains his art to the neophytes. But during the music itself art quickly transcends pedagogy. Even a silent movie of Shankar playing, with the ecstatic, blissful expressions and the yearning glances from musician to musician, would be a work of art.

Saturday the fine tabla player Alla Rakha was a little off form: he seemed to have a cold. He still came forth with the usual syncopated, dazzling rhythmic flourishes, especially in his solo, but more often he was content to slap out the basic tala in the background.

Partially for this reason, but only partially, the finest performance of the night came in the thirty-eight-minute sitar solo, in traditional sixteenth-century style, to the classic raga Darbari Kanada. All Indian music is arguably a refinement of the extraordinary microtonal variety of the subcontinent's vocal styles, and nowhere in the concert was this kinship more lucidly revealed.

The greatness and scope of today's Indian music can be heard, to some small extent at least, on innumerable LPs—particularly the imported Indian Odeon label. It is certainly to be hoped that an ever greater number of these musicians can visit America, preferably in smaller halls. The master shehnai player Bismillah Khan's recital in San Francisco a couple of years ago was disappointing, for a number of reasons. But hopefully we can hear some of the great singers—perhaps Bhimsen Joshi and the Dagar Brothers, to start at the top.

But Ravi Shankar was the first, and he is still the best. His generous, three-hour concert Saturday was one of the great musical events of the year.

THE LIVING THEATER
The Oakland Tribune, February 22, 1969

The Living Theater presented its best-known attraction, *Paradise Now*, Thursday night in Berkeley, and will repeat it in early March in San Francisco.

Paradise Now is a three-to-four-hour, loosely structured interaction

ritual of audience and performer. To call it "theater" is no more or less accurate than to call it "art," "dance," or "music." It is a confrontation, a stylized encounter.

Thursday night the atmosphere in the Berkeley Community Theater was extraordinary at the outset. The day's street fighting had presumably primed the predominantly young and hippie audience for true revolutionary theater: they *wanted* that promised glimpse of the paradise to come. Almost every radical theater group in the Bay Area was there, in force: the Mime Troupe, Berkeley AgitProp, Steppenwolf Magic Theater, Floating Lotus Opera, Ann Halprin.

I have never been in a situation more congenial to the kind of spontaneous interaction of a true hippie group celebration. Before the "performance" began, all sorts of audience-generated theater events had already rippled through the crowd, evoking enthusiastic audience response: groups of people linking arms, chanting, sheets of plastic unfurled from the balcony.

By the end of the evening only about a hundred devotees were left on the vast stage—which had early on become the locus of the action. Director Julian Beck has been quoted as saying that if they win over only two or three people each night they consider themselves successful. By that criterion they were thirty to forty times more successful than usual.

But I thought they were an unfortunate failure, for two separate reasons.

Paradise Now is cast in the form of a spontaneous event. In reality it is constructed around the most rigid and clumsy kind of structure. The evening consisted of the spontaneous carryings-on of a gradually dwindling audience, methodically punctuated every fifteen minutes or so by a Living Theater "bit," which usually killed off anything developing in the audience.

Many of these bits involved direct verbal confrontation with the audience, and here the second reason for their failure emerged.

The Living Theater is seemingly unaware of its audience. To complain about not being allowed, presumably by Society, to smoke marijuana or take off your clothes, and to accuse your audience of wasting their minds on TV, seems silly when several people who haven't seen TV in years are standing next to you naked, or are offering you joints. To call messianically and just a bit pompously for "free theater" seems naive when you charge from three to five dollars a head admission.

The Living Theater's ideology is based on the by-now almost nostal-

gic belief in the possibility of nonviolent change, which was widespread among radical American youth at the beginning of the group's exile, a few years ago.

The form of *Paradise Now* was set and hardened in Europe. It is, really, an exhortation to the straight world by men and women who have presumably (despite a surprisingly large amount of hostility) accomplished the nonviolent, internal revolution. This kind of thing invariably goes over fantastically in Europe, where everyone seems starved for the "natural freedom" of America.

When, however, they are confronted by an audience which is both personally free and committed, more or less consciously, to violent revolution, they lack the flexibility and the theatrical skill to adapt their performance.

At one point Thursday night they got into a denunciation of Berkeley street fighting, and here, momentarily, they did make a real and direct contact with a real audience.

But mostly they remained frozen within their old patterns and within themselves. Their dialogues were monologues, delivered clumsily to people who had passed them by.

YVONNE RAINER

The Oakland Tribune, April 28, 1969

Yvonne Rainer gave a dance performance at Mills College Friday night. I loved it, and her.

Performance Fractions for the West Coast No. 3 was just what the name implied. Miss Rainer created a kind of retrospective collage of her own choreography, and included in it the current problems with which she works.

The performers, besides herself, were some thirty young people whom she had assembled in the East Bay, and with whom she had had six rehearsals. They were not trained dancers, and Miss Rainer did not give them trained movements to do. Instead there was a continual flow of patterned motion, meaningless and meaningful. And there was a

heady variety of speech (live and recorded), sound, music, films, and slides—all of it presented in a refreshingly coordinated and professional manner.

The fifty-five-minute piece was suffused with Miss Rainer's personality. She is a great artist, in that both her own dancing and choreography are expressions of a unique personal style: highly serious; wonderfully warm and funny; sexy; purely, privately happy; magical; glowing with energy.

Miss Rainer is, one assumes, a complex person: her beauty lies in her complexity. Friday night's performance, too, was a collage of contradictions, and the tensions sparked the art.

Even when a particular part didn't work—as in the on-the-spot rehearsal sequence to the accompaniment of taped comments by Miss Rainer on the ambivalence of her role as a manipulative choreographer—it fitted necessarily into the whole. Every part of the whole meant nothing, or the opposite, or everything.

Toward the end Miss Rainer danced alone. She is a fantastic performer: the material, like her choreography, is a continuous, flowing exercise in the juxtaposition of small gestures, a one-woman movement collage.

When in the final section some of the performers joined her in a quasi-rehearsed imitation, the circle of contradictions was completed. Her own role as Yvonne Super-Star, set against a literal background of her "performing material" struggling in their labored emulations, was posed with wit and understanding, but deliberately not resolved.

They danced to the Chambers Brothers' overwhelming version of "To the Midnight Hour," a final look back to the beginning, a reverberation of her own love-hate feelings for music, a parody so soft in its focus that it took in everything, with love.

FLOATING LOTUS MAGIC OPERA COMPANY
The Oakland Tribune, July 4, 1969

The Floating Lotus Magic Opera Company is both an extraordinary experience in itself and a superb challenge to "establishment" notions of what musical theater is all about.

The troupe has been in existence for some two years now, and has been performing its latest creation, *Bliss Apocalypse*, since early May. Most performances—such as the one I saw last Sunday night—take place in the John Hinkel Park Amphitheater in Berkeley, and many weekends this summer will see the company there. But the Lotus also tours, to hippie communities all over the state. The performances are, of course, free.

The central figure of the company, its founder and its most charismatic performer, is poet and musician Daniel Moore. He wrote the original version of *Bliss Apocalypse*, but the members of the company are also creators, not only because of the improvisational elements in the performance, but in the actual working out of the script.

Bliss Apocalypse is not self-consciously "avant-garde" in that it attempts to be new, or different. There is no tension between it and the mores and ideals of its audience. The Floating Lotus is communal art in the most ancient and traditional sense, deeply rooted in the new community from which it has emerged.

The company is content to remain, until the very end, within the traditional relationship of performer and audience, with a rehearsed and prearranged ritual enacted before an audience which does not physically participate.

The opera is a parable of magic enlightenment. Moore's poetry flows in waves of apocalyptic imagery. There is no plot, in the linear, narrative sense, but instead a series of scenes depicting the possible poles of human experience (horror, bliss, hatred, love), all leading to the mystical transfiguration of the human community into a new consciousness.

The vocal lines alternate between ritualized speech and quasi-melodic chanting. The orchestral accompaniment is provided by an ensemble of drums, chimes, bells, horns, bass, conch shells, and other exotica. There is no attempt at tonality or obviously structured melodic improvisation; instead, the orchestra emits textures and blocs of colored sound.

The influence of non-Western theater is clearly apparent in *Bliss Apocalypse*. Tibetan musical sounds predominate, but Balinese, Chinese, Japanese, South Indian, and American Indian influences are visible in the colorful sets, costumes, and props and in the dancing movements of the cast.

My only reservation about the performance Sunday concerned the unrelieved seriousness of tone. In many of the highest forms of commu-

nal, religious art that I know of, the comic has played a vital role. It would be wonderful to see the Floating Lotus introduce humor into their performances, perhaps even gentle—or raucous—self-parody. Gods (Oriental gods especially) have been known to laugh.

At the end of the performance, after a bacchanalian "danse generale," the tribally costumed, feathered, painted, semi-nude performers move upward through the audience, exhorting each person individually to free the bliss within him.

Then the audience joins the Lotus in widening circles around a central ground for a sharing of home-cooked, pungently sweet bread. The bread, and the Floating Lotus Magic Opera Company, taste just fine.

BAYREUTH FESTIVAL MASTER CLASS
Opera News, January 10, 1970

The other day I got a letter from my friend Ray Donnell:

> We decided yesterday that Amneris is fifty-five, and the insane daughter of the king. Radames is twelve, has pimples, and wears glasses—also has buck teeth. Radames carries a big teddy bear with an alligator head. Friedelind is going to come in on an elephant.

Ray is not crazy; it's just that the experience we shared four years ago remains so strong it keeps coming back, like a remembered hallucination. Let me explain.

Giuseppe Verdi's pleasure in the success of *Aida* was soured by persistent critical contentions that he had become a Wagnerian. In the summer of 1965 Verdi got his posthumous revenge: it was then that Friedelind Wagner's Bayreuth Master Class tackled *Aida*.

The Master Classes are now apparently a thing of the past, victims of Friedelind's lifelong battle with the now dominant conservative wing of her family. But until a couple of festivals ago they were the occasion for some twenty young people of all operatic kinds—embryonic singers, conductors, designers, directors, scholars, critics, and general enthusi-

asts—to gather together. In a sense, the brochure Friedelind got out each preceding winter was the best part of the program. In practice her organizational talents did not always equal her theoretical empire-building; she is not Richard's granddaughter for nothing.

Still, the Master Classes were both fun and helpful. First of all, of course, were the three months at Bayreuth itself, with access to rehearsals and performances. The actual working festival personnel often seemed rather dubious about the value of us members of the *Meisterklasse* (or *Kleistermasse*—"mess of glue"—as Wolfgang Wagner, with his delicate sense of humor, liked to call us). But we had our own staff: Edward Downes (of Texaco's Opera Quiz) was there in 1965, as was the pianist Bruce Hungerford (an amateur Egyptologist), two assistants of Komische Oper director Walter Felsenstein (who himself had come in previous years), two acting coaches for the singers and several guest lecturers. The group took occasional trips to opera performances, theaters, and towns in both East and West Germany. In the case of the performers, Friedelind's personal influence in securing further coaching, auditions, and jobs often proved extremely helpful.

But we had problems, too. Artists are a neurotic lot, and the 1965 Master Class contained a fair assortment. Friedelind's ideal of a great communal sharing of specialized talents, a kind of *Gesamtkunstwerk* in the process of becoming, was continually compromised by gaping holes in the knowledge, skills, and curiosity of the participants, and by their petulant refusal to cross-pollinate in quite the fructifying manner Friedelind had in mind. When it came right down to it, in those circumstances at least, nobody seemed really willing or able to become a *Gesamtkünstler*.

The center of our summer's study experience, the thing that was supposed to pull it all together for us, was *Aida*. Day after day we would assemble in some kind of slow-motion, Germano-manic parody of the Felsenstein "method." The idea was for us all to discuss the opera, to strip away the encrusted layers of meaningless tradition and spurious performance practice, to rip and tear until we had exposed the true, essential, raw Verdi, the ultimate *Aida* Idea. Then we were to carry out our agreed production plan, the designers designing sets for different scenes, the singers coaching their parts, the directors working out their dramatic interpretation with the singers, and so forth.

We never got much beyond the discussion stage. In a sense, we had a cross-cultural problem. The vast majority of us were American;

Felsenstein's assistants, who led the sessions, consisted of one East German set designer (Reinhart Zimmermann) and one highly Germanified American *Regie-Assistent* (Siegfried Schoenbohm). These two had, it gradually developed, cheated on us by doing their homework; they had worked out an *Aida* interpretation before they even came on the scene. We Americans, on the other hand, despite some warning from Friedelind, had done next to nothing in the way of preparation—reading the score carefully, reading Verdi's letters, reading Mariette Bey's original scenario, checking the original Italian stage directions. Instead we all sat around, unprepared, lazy, and "democratically" anarchic, and threw about dilettantish suggestions as to how we were to go about this thing. We thought we were really starting with a directorial tabula rasa.

The leaders, on the other hand, expected more in the way of humble docility when confronting us with their divine word. *Aida*, they told us, was essentially a political drama, based on a vicious power struggle between an insecure pharaoh and an aggressively ambitious priestly caste. The love triangle of Aida, Radames, and Amneris was decadently peripheral, of interest only to the petite bourgeoisie.

Now, I am by no means such a purist that I can't appreciate an occasional ingenious if unusual interpretation. Felsenstein's productions at the Komische Oper have been miraculous fusions of scholarly conscientiousness and brilliant theatrical originality. In this country we tend to remain a little (deliberately?) naive when it comes to opera staging, doggedly sticking to what we assume to be "tradition." Sometimes this means that we wind up being more faithful to the composer's intentions than your average power-mad German director, but usually we fall back on cliché, such as the tenor leaning atop a convenient table in a crowd scene. With Zimmermann and Schoenbohm, however, the *Meisterklasse* balked at what it considered a classic case of compulsive overanalysis and a kind of holier-than-thou attitude that continually cut through our little democratic charades.

In a crucially important sense, I'm sure, art is a dictatorial process; if so, it is foolish and misleading to pretend otherwise. For instance, I remember the working out of the first scene of act 2, when Amneris tricks Aida into revealing her love for Radames. Schoenbohm and Zimmermann had decided that Amneris's zealous interest in the progress of Egyptian proto-capitalistic imperialism—and in the chief executant of that policy, Radames—meant that her "apartments" were a temporary camp up the Nile near the battleground of the two armies.

So we all sat there, trying to imagine the tiny stage of Bayreuth's community theater as the princess's lavish tent in the Sahara. Nervously pacing about was an excessively intense American girl director, vague of ideas but aggressive in the imposition of them on "her" players. The two singers (a lack of males in the 1965 class limited our own capacity to mount *Aida*), who were trying to perform, came across as plain Midwestern girls, nice people and talented vocalists but at this stage of their careers totally devoid of the slightest histrionic skill. They plodded hopefully about the stage listening to the directress rant, to Schoenbohm and Zimmermann consult one another in increasing perplexity, and to us cynical "students" lurking in the gloom of the auditorium and dismembering everything with our hopefully mordant wit.

We all took an increasingly negative attitude: anytime anybody came up with any idea, good, bad, or simply amusing, we threw out a counter-idea to nullify it. This was dialectic in its most childishly abortive form. We were a convocation of baby opera critics, plagued by absurdities and ennui, adrift from the real world.

I wonder what Verdi, that curious mixture of theatrical cunning and gruff integrity, would have thought of all this neo-Wagnerian ruminating, in the middle of Bayreuth, over *Aida*. We in the Bayreuth Master Class were operating in a kind of limbo, in which everything was exaggerated to baroque extremes. But I have begun to realize that our project did produce all sorts of insights into the artistic and directional processes, even into *Aida* itself. Friedelind, in her wild Valkyrie way, wasn't so crazy after all.

JOHN CAGE

Los Angeles Times, January 27, 1970

Any appearance by John Cage is an event suffused by John Cage's personality. Sunday night, to open the "Encounters 1970" series at the Pasadena Art Museum Auditorium, Cage played part of a tape a recent work, read from his diary, performed on the piano, and left a lingering afterglow of gentle anarchy.

A section of the computer-programmed harpsichord piece made in conjunction with Lejaren Hiller served as a kind of entrance music for the audience, before the announced starting time. It is a rather intriguing study in multiple overlays of altered and unaltered harpsichord notes, arranged in scientifically premeditated random patterns.

The concert ended with *Cheap Imitation*, a half-hour *I Ching*– and computer-generated transformation for solo piano of Satie's *Socrate*. The effect was boring, if one chooses to think in such oppositional categories as "interesting" and "boring." A steady, restful flow of single notes, sometimes in parallel octaves, the piece recalled devotional chanting.

In between Cage read two as yet unpublished sections from his ongoing diary, entitled *How to Improve the World (You Will Only Make Matters Worse)*. Read in Cage's wonderfully resonant, professorially articulate manner, the new parts ranged from the accustomed amusing little stories, aphoristic pronunciamentos, personal asides, and gentle political reproofs to, Sunday, a hint of sadness at the way things are working out on this planet.

The fragmented but anecdotal form of the diary is likely to mollify a person uncomfortable with the abstraction of Cage's music. Conversely the true, long-standing aficionado sometimes seems to resent the diary's simple lucidity.

But Cage's prose is neither a more nor less an integral part of his artistry than his music. Whatever reaction he may produce in his audiences, Cage is "together," a man who, in words from the diary, is as "serious and frivolous as chaos."

LADY WHITE SNAKE

Los Angeles Times, March 19, 1970

If you have ever nourished a private desire to watch a "great snake, beautiful woman and faithful wife . . . summon her shrimp soldiers, crab generals (and) turtle commanders . . . to fight her eternal enemy . . . who requests help from the Heavenly Forces of outer space to defeat the aquatic invaders," then Chinese opera is for you.

The Foo Hsing Opera Troupe of Taiwan is currently appearing at the Sing Lee Theater in Chinatown, through Sunday evening. Each program is different in content, though similar in style. Tuesday night's offering was three hours' worth of *Lady White Snake*, from whose program synopsis the above was excerpted. The complete opera lasts some seven hours, spread over two nights.

Foo Hsing's productions are obviously aimed at the local Chinese community. Of the some five hundred persons in the nearly sold-out theater Tuesday only about ten were non-Chinese. 'Subtitles" are projected by slides—but only in Chinese, which the predominantly Cantonese American Chinese can read even if they miss most of the Mandarin dialect in which the operas are traditionally presented. But Foo Hsing's performances should still appeal to nearly everybody, at least in the proper spirit of adventure or state of consciousness.

The standard Peking form of Chinese opera is broadly popular, a true theater of and by a community, and as such universally appealing. The music, to Western ears, may sound monotonous and clangorous, with vocal techniques which seemingly hold up adenoidal whines and yawing vibrati as a model of Oriental bel canto.

Yet the costumes and makeup are dazzling, the acrobatics exhilarating, the acting convincing, the girls cute, and the sheer wash of exoticism superbly refreshing.

LES BALLETS AFRICAINS
Los Angeles Times, August 12, 1970

Toward the end of Les Ballets Africains' opening performance at the Greek Theater, a dancer began to spin around and around, maniacally, his whole body flailing in all directions at once. A woman behind me shifted in her seat in amazement. "That man," she said out loud to no one in particular, "has got to be high on *something*."

Maybe so. But if he was, then half the company was, too. For the most extraordinary impression left by this national dance troupe of Guinea is of almost animalistic self-possession and demonic energy.

The company of forty-four, which opened its fourth American tour here Monday evening, is drawn from ninety-six regional dance groups sponsored by the Guinean government. The program—billed predictably enough as "all new"—seems similar in many details to those of previous tours. There are the same legendary allegories of emerging African independence, evocations of tribal life and ceremonies, and shorter vignettes.

Despite its title, this is no ballet. It is not even strictly dance, but rather a theater focused around movement, with dialog, song, inchoate cries, pantomime, dazzling costumes, exotic musical instruments, and drumming.

The choreography is hardly sophisticated, or even artful. Broader structures build purposefully to climaxes and are then dissipated by shorter numbers, inevitably anticlimactic for all their innate charm. Fascinating individual steps and movements are mixed indiscriminately with flatly familiar forms of athleticism, like cartwheels and back flips.

The sequence of events and the dramatic interactions of characters have been planned and rehearsed to the last detail. Les Ballets Africains is, for all its spontaneity, a smoothly running production, with an attractive basic set, crisp lighting, and an unbroken pace.

Yet what ultimately sticks in the memory is beauty and energy. These people have beautiful faces and bodies—bodies which, in the case of many of the girls, remain properly topless. If anyone wants to see what pride looks like—not black pride, necessarily, just pride itself—they should go to the Greek this week.

Even more remarkable, though, is the sense of brinkmanship. Any good show gives the impression that the performers are putting out. But these dancers from Guinea suggest the illusion—if it is an illusion—of an energy charged past normal human limits by a kind of special frenzy. It is exhilarating, a little frightening, and most definitely worth seeing.

MARTHA GRAHAM

Los Angeles Times, December 1, 1970

The two appearances Sunday by the Martha Graham Dance Company at UCLA left inevitably mixed feelings.

First of all, there was sadness. Miss Graham is no longer performing. The lady may have been old during her last seasons on the stage, but her dramatic fervor never left her.

She never much liked to revive her dances, especially with other artists in her own parts. She had redone two works in this year's tour repertory (*El Penitente* and *Cave of the Heart*) in the '60s, but this season's reliance on classics from twenty to thirty years ago marks a break from past practice.

Revivals run the risk of looking dated, and certainly much of the Graham theatrical language—the determinedly personal symbolism, the whole movement vocabulary, the dutiful neo-Hindemithian music, the jock-strap/evening-gown costumes, the sweaty sexuality—must now seem a little peculiar, decades later and robbed of much of their inner conviction.

Now, everything has to be imitation. The current season was put together from ancient rehearsal films and individual dancers' memories, all under the direction of Patricia Birch. Miss Graham still appears periodically, but it's obviously not the same.

Sometimes the resultant imitations are good, sometimes not so good. The imitations are not of Miss Graham alone, although those who take on her parts have the most difficult job. The company has contained some of the great dancer-choreographers in American modern dance; the present group sometimes seems a little pale by comparison.

But—the company seems to be dancing better than when I saw it in New York two months ago. Perhaps it is simply repeated practice. Perhaps it is being away from the pressures of the Big Time. Or perhaps it is the occasional rehearsals in which Miss Graham has reportedly led the company during the tour.

And the company, comparisons with the past aside, contains many strengths. Some of the younger dancers look a bit unfocused. But there is a nice range from experience (Bertram Ross; Helen McGehee in New York and the early part of the tour) to youth (Takako Asakawa, Phyllis

Gutelius, and several others). And there are Matt Turney and Mary Hinkson.

Miss Turney has a long-limbed individuality of expression and movement which seizes the attention whenever she is onstage. Miss Hinkson, in *Cave of the Heart* and especially *Deaths and Entrances*, gave evidence of both a sovereign technical mastery and a developing dramatic power of great distinction.

And there is some hope for the future: Ross's *Oases*, premiered this year, is a convincingly abstract cross between Merce Cunningham and Gerald Arpino's *Solarwind*.

Ultimately, one can be thankful as well as sad. The 1970 tour repertory (which also included *Phaedra* and *Every Soul Is a Circus*, plus *Diversion of Angels*, given Saturday night at El Camino College) contains some of the great Graham masterpieces—and hence, by definition, some of the great masterpieces of modern dance. Their revivals may have been flawed, but they gave us a glimpse.

DANIEL BARENBOIM AND JACQUELINE DU PRÉ

Los Angeles Times, May 26, 1971

Conductor Daniel Barenboim, cellist Jacqueline du Pré, and the Philadelphia Orchestra combined for a fascinating concert Monday night at UC Irvine's Crawford Hall.

The fascination—apart from the simple brilliance of the orchestra's playing—lay in the insight the concert afforded into the Barenboims' continuing search for a viable style.

Barenboim (as both conductor and, on other occasions, pianist) and his wife seem intent on the recreation of an unashamed romanticism in the performance of romantic music—certainly a justifiable and even admirable aim.

Thus Barenboim's conducting Monday was given to extremes of tempo and dynamics, blunt and forceful ritards, and overt eccentricities of phrasing. Similarly Miss du Pré attacked her cello solos with appar-

ently unbridled passion, pulling the line and forcing the tone, willing to sacrifice cool technical perfection in her pursuit of emotional fervor. In both cases visual impressions mirrored the aural: Barenboim, disjointed and distractingly spasmodic; Miss du Pré, proudly equine, hair flying and head tossing.

Barenboim is not always successful in imposing his conceptions on even so responsive an instrument as the Philadelphians. The opening Euryanthe Overture of Weber and the Dvořák Cello Concerto seemed proficient and even sporadically insightful, yet both lacked personality, with outer mannerisms imposed on (superbly accomplished) run-throughs.

In Schumann's Fourth Symphony the orchestra sounded more minutely reflective of the conductor's wishes. But for all the spectacularly effective moments the overall impression remained artificial and constrained. Wilhelm Furtwängler—whom Barenboim has adduced as a model—was able to make his idiosyncrasies sound like the inevitable manifestations of interpretive conviction; Barenboim has not (yet) learned that craft.

Miss du Pré's impetuosity is less easily open to a similar charge of self-consciousness. Instead she seems at first—particularly with naturally elegant, understated mastery of ensemble and concertante work behind her Monday at every turn—more in need of refinement. It is an extraordinary talent, of course, as great as her husband's. Yet on second thought it too seems self-indulgent and—for the moment, at least—devoid of the true romantic's innocence.

Still, that said, one wonders how such self-consciousness and excess are part of an unromantic age's perceptions. Perhaps our difficulty in accepting the Barenboims' neo-romanticism lies in part with our own embarrassment at the profession of overt feeling. If so, then their work serves as needed pedagogy.

Perhaps by the time they have ripened into a mature, natural style, we will have advanced to a more empathetic appreciation of it.

JESUS CHRIST SUPERSTAR

Los Angeles Times, September 25, 1971

Like medieval Christendom, the legal body of the opera *Jesus Christ Superstar* is torn by warring armies. Schismatic popes (the various "authorized" companies, one of which is holding forth at Hollywood Bowl this weekend) and antipopes crisscross the realm, sowing confusion amongst the believers—those millions who bought the original Decca album.

At the moment a rather appealing little heresy is holding forth at the Aquarius in Hollywood—its official opening was Thursday, with a scheduled run of two weeks and an option for a year. It will be curious to see if the avenging attorneys of the true *Jesus* can wipe this latest scourge from the land.

The show is being put on by a twenty-seven-member group which calls itself the Canadian Rock Theater. From its home in Toronto it has battled its way through increasingly thorny legal thickets by way of Las Vegas (forced to close after two performances) to the sunny Southland.

On September 8, the day before the originally scheduled opening at the Aquarius, a U.S. District Court judge issued a temporary restraining order, under the complex provisions of which the CRT was allowed to perform extended excerpts from *Jesus* but not the whole show. At that point, however, the opening was postponed for regrouping and rehearsals. Then a new legal setback—ASCAP's loss of the right to authorize performances of even the songs—slowed things up another week. The next decisive legal step will apparently come in mid-October. But in the meantime, for how long nobody knows, the Aquarius opened its doors at last.

The whole thrust of the September court order, as I dimly understand it, was to limit any nonauthorized group to concert performances of songs from *Jesus* rather than a staged version of the whole drama. The CRT's version may not be the exact Lloyd Webber–Rice original, as on the records. But it is most definitely a cohesive entity on its own terms, and it boasts some rather tentative semi-staging as well.

What CRT has done is take the original *Jesus*, cut a few numbers, scramble the order in the middle, add three dramatically congenial and musically effective numbers from the musical *Godspell* plus three original efforts, and reorchestrate the whole.

The focus of the CRT version has shifted from the tortured, enigmatic Judas of the original to Jesus himself. The first of Mary Magdalene's two songs is missing, as is Judas's death scene. The end, however, has been much improved by cutting things off after the hit single, "Superstar," and avoiding the pretension which follows on the album.

The skillful CRT orchestrations lean heavily on the brass—three trumpets and two trombones—and sound rather unvariegated when all the stops are out, which is often. The effect is a touch elephantine, instrumentally a monstrous multiple of Blood, Sweat and Tears. Sometimes the twenty-seven manage to get it on engagingly enough; sometimes they sound merely ponderous. Co-arranger and conductor Peter Mann contributes some nice, gospel-inflected piano playing.

One obvious reason for the focus on the title figure is that Victor Garber, who portrays Jesus, is far and away the most charismatic and vocally endowed performer onstage. But none of the singers is really bad, and the whole show is enlivened by a kind of determined infectiousness.

It is easy to be cynical about *Jesus*. No doubt current battles behind the scenes on both sides of this particular schism the money changers are lurking: the ferocity of the current legal battles is no doubt motivated more by all-American greed than by art or religion.

Whether the CRT kids, with their index-finger Jesus signs and their earnest enthusiasm, can be called "sincere" or not is really beside the point—a critic should concern himself with things artistic, not psychoanalytic or theologic.

What counts is that they give a pretty good show, full of energy and effort. Anyone who likes the album will probably enjoy himself at the Aquarius. But he had better hurry: the knights of *Jesus* are at the castle walls, preparing for the charge.

PAUL TAYLOR

Los Angeles Times, October 22, 1971

A good indication of the quasi-moribund state of dance in this town is that a major American company like Paul Taylor's is giving only one per-

formance here this season—its first since 1966—and did so Wednesday in a college gymnasium totally unsuited to dance located nearly fifty miles from downtown Los Angeles.

For the smallish, predominantly student audience which showed up in UC Irvine's Crawford Hall, Taylor and his accomplished company put on a typically amusing, perplexing performance.

True, the only example of his recent work, *Book of Beasts* (1971), slipped a little too far into the self-consciously cute—whimsy calcified into coyness. True, the superb Bettie de Jong, Taylor's principal female dancer, didn't have much chance to display her talents.

Still, Wednesday's program did contain two landmarks of Taylor's notable career. *Insects and Heroes* (1961) may border on the too literarily enigmatic—at times it comes on like some sort of Jungian Roadrunner cartoon. But this curious interaction between a half-menacing, half-paternal insect-totem and five determinedly playful dancers does establish a striking tension between the humorous and ominous.

The opening *Aureole* (1962) remains one of Taylor's most engaging creations. An overtly lighthearted frolic to varied instrumental music of Handel, it makes its friendly bows to ballet and then easily transcends the archness of many such balletic divertissements. It is a piece which demonstrates triumphantly (if such demonstration still is needed) that modern dance can approximate classical style as easily as can ballet.

Taylor manages here simultaneously to suggest neo-classical mythology (nymphs and satyrs) and a spirit of erotic play sensitively evocative of the baroque. He does it with a choreographically and musically delicious counterpoint of suddenly languorous dance phrases against Handel's insistent jollity.

Book of Beasts, to harpsichord arrangements of pieces of music conceived in sometimes bizarrely different idioms—e.g., a bit of *Nutcracker* juxtaposes seven black-clad helpers with Taylor bedecked in an array of wildly extravagant costumes.

As a neatly satirical ego-trip for the Star Performer, as casual entertainment, and as a loosely eclectic assemblage of choreographic and theatrical borrowings, it makes a gently genial impression. But one hopes and assumes it is only a minor example of what Taylor is up to these days.

MAURICE BÉJART

Los Angeles Times, **November 16, 1971**

Sunday's performance by the Ballet of the Twentieth Century at Royce Hall did not contain anything to rile Maurice Béjart's critical enemies unduly.

There were no massed choreographic routines. No aggressively mod appeals to the now. No hours-long mixed-media onslaughts. There was, instead, a generally refreshing afternoon of dance.

True, the opening *Les fleurs du mal* did toy a bit coyly with *Dolce Vita* decadence, with its varied erotic posturings, op/psychedelic settings, and chi-chi costumes. Yet it was largely redeemed by some superb dancing from the seven protagonists, and especially from Dyane Gray-Cullert as the principal manipulator.

In fact, it was an afternoon of fine individual achievement. Even his most unrelenting critics cannot deny Béjart the remarkable collection he commands. Any program which can boast not only Miss Gray-Cullert, but also Jorge Donn and Suzanne Farrell in *Symphonie pour un homme seul* and Paolo Bortoluzzi and Orie Ohara in *Bhakti*, is a program worth watching,

Symphonie was Béjart's first important ballet, created in 1955 and antedating his present company. Set to an early, intriguing example of *musique concrète* by Pierre Schaeffer and Pierre Henry, it pits a tortured, lone male against ten ominous, anonymous male tormentors. And an archetypal castrator-female.

Bhakti is built around three different incarnations of Vishnu and three lovers. The piece offers a lovely, unintellectualized blend of Western and Eastern dance. But it suffers from a muddled frame of priests and "adorers," and an imbalance occasioned by the overwhelming excellence of Ohara and Bortoluzzi in the first of the three duets.

Throughout, Béjart's choreography demonstrated a steady consistency. Certainly, like all choreographers, he has his stylistic trademarks (viz, mannerisms): angularly serpentine poses, geometric quasi-acrobatics, basic classroom positions blending fluently into modern and ethnic borrowings.

But what impressed me, at least, was the surprising focus of his choreographic language. Instead of a disparate jumble of half-digested

sources, Béjart's ballets seemed all of a piece—diverse, yet bound together by an elemental, exhilarating theatrical extroversion.

DANCE CRITICISM

Los Angeles Times, November 19, 1971

American dance makes a wonderful story, and two recent books fit together rather neatly to try to tell that story. Unfortunately, though, they tell us as much about the limitations of American dance criticism as they do about the greatness of the dance itself.

The 1971 edition of Walter Terry's *The Dance in America* (Harper and Row; $8.95) is a radical revision of his 1956 original. The book's virtues are tangible ones: a bright, chatty, richly illustrated overview of the whole panorama of America dance from the colonial beginnings to now, with praiseworthy attention paid not only to the pre-Isadora scene but to such heretofore neglected areas as black dance, regional ballet, and dance notation. Anybody who hasn't yet heard the story of American dance and wants a knowledgeable, readable introduction need look no further.

And he will find more than just the facts. Terry, currently dance critic for the *Saturday Review*, has an overflowing, sometimes almost pushy love for his subject. He calls to mind a backslapping enthusiast at a party who pushes his enthusiasm enthusiastically down your throat. Still and all, over-enthusiasm is better than jaded mordancy.

What Terry really is, is a booster, the kind of critic beloved of artists and, especially, of impresarios, the kind who can he counted on almost invariably for a good, quotable word. A veteran of American dance criticism, he writes as if negativism of any sort might kill the tender plant at its roots.

In the end this seems a superficial book, and a slightly giddy one, as well ("The headlines literally yelped: 'Boston Gasps as Ruth St. Denis Dances'"). Only in six longer-than-normal chapters on some of the giants of modern dance (Duncan and Fuller, St. Denis, Shawn, Graham, Humphrey and Weidman, Holm and Tamaris) does Terry give us

something more than breathless surfaces. And here, ironically enough, his genuine insights seem out of balance with the rest of the book: Graham is certainly a seminal figure, after all, but does she really rate seventeen pages to Merce Cunningham's one-plus and Paul Taylor's one-minus?

It is just here, at Terry's hasty sketch of the contemporary dance avant-garde, that Don McDonagh's *The Rise and Fall and Rise of Modern Dance* (Outerbridge and Dienstfrey; $6.95) comes along to fill out the picture. (The nice title refers to McDonagh's persuasive argument that today's avant-garde represents a renewed vitality after the lull which followed the original generation of American modern-dance innovators.)

The modern-dance specialist for *The New York Times*, McDonagh has with this book produced a genuinely pioneering effort, the first attempt at a comprehensive look at American (i.e., New York) avant-garde dance of the post-Cunningham era.

Here, for spot reference or sequential reading, one can find separate chapters on such fascinating figures as Cunningham himself, Tharp, Paxton, Hay, Rainer, Monk, Nikolais, Taylor, Waring, and many, many more, plus shorter descriptions of the work of numerous others.

But for a book which by default will exert an enormous influence on our way of thinking about dance, it is a great pity that McDonagh has not made a better job of it.

The book is, first of all, rather erratically organized, long on short-sighted enumeration of concrete detail and short on long-range, contextualizing analysis. (Terry is similarly choppy, if for slightly different reasons.) McDonagh far too often loses himself in description of a particular work without either evoking its physical feel or convincing us of its representative quality.

Even more dubious is the selection process operative as the book was being planned. McDonagh may in fact be right in choosing the particular people he has focused on, and in allotting varying amounts of space to them. Anyone who lives outside New York is, after all, in an almost helpless position when it comes to making detailed judgments about experimental American dance. The provincial must take McDonagh on faith when he singles out dancers like Gus Solomons, Elisabeth Keen, or Art Bauman for special treatment. But it is sometimes hard to muster up that faith.

McDonagh makes no real pretense at encompassing anything

beyond New York. But a more rigorous and overt admission in the preface of his geographical bias (east of the Hudson, west of the East River, and south of Central Park) might have made some of the omissions more understandable. A West Coast dancer like Bella Lewitzky goes unmentioned; her mentor, Lester Horton, is skipped over in a phrase; and—most astoundingly—San Francisco avant-gardist Ann Halprin gets only passing nods, referred to as a key influence on several New York dancers, but never discussed.

Certainly, though, this book will be useful for reference, especially with the chronologies McDonagh has appended of the major works of the dancers he chooses to concentrate on. The reference value remains even after one recognizes the less than total commitment to pedantic accuracy: such minor errors as the notion that José Limón came to America in the late '30s (actually it was in 1915, when he was seven) are only symptomatic of more serious distortions which New York insiders claim are spotted throughout the book.

What is ultimately most disappointing about both Terry's and McDonagh's efforts is not what they are but what they are not. American dance—arguably this country's most impressive and unique contribution to the world's high art—may be still at such a level of primordial, incoherent vitality that it has not provoked a comparably distinguished critical response.

Perhaps when that day comes, American dance will have already lost its present-day animal vigor. Critical and academic parasites will fasten their suckers on the pulsating body of the art, and drain away its lifeblood.

Perhaps, but perhaps not. One likes to hope that any art and its criticism can and should work together, fruitfully. There have in fact been great dance critics in America already, and there are some now. People like Edwin Denby and Arlene Croce have, in their different ways, managed to combine passion, perception, and poetry into a criticism both physically evocative and analytically insightful, a literature worthy of the art which inspires it.

NORMAN TREIGLE

Los Angeles Times, November 24, 1971

Norman Treigle prefaced his recital Sunday night at El Camino College with a few well-chosen words. This was, he said nervously, only his second such program in ten years. He was neither a song recitalist nor an opera singer, just an actor and a man. He hoped his audience would understand his program not as an odd and unconventional recital, but as the essence of what Norman Treigle the man had to offer.

As it turned out, his remarks seemed somewhat like Abe Lincoln's self-deprecations before launching into a particularly awesome oration. Treigle's recital, or whatever you choose to call it, was one of the most impressive, moving musical events in memory.

Treigle deals with the normally restrained conventions of the recital format by ignoring them, grandiosely. His version of "Ella giammai m'amo" from *Don Carlo*, for instance, found him at first slumped hopelessly behind the grand piano, his face buried in his hands, singing through his palms. As the sentiments grew more impassioned, he stalked about the stage, sometimes turning his back on his audience for bars on end, sometimes slamming his fists down on the piano lid in impotent rage. He sang, whispered, croaked, and gasped.

What Treigle commands more than almost any other practicing operatic artist today is a kind of possessed theatricality. He does things naturally and triumphantly which would only look stagy if imitated.

He is right about being first of all an actor. But he is a specifically musical and vocal actor. His generously rich bass-baritone is securely and evenly produced. Yet he is not afraid to sacrifice the simply beautiful in pursuit of a dramatic effect, and his higher musicality attains its ends sometimes by means other than pure vocal technique narrowly defined.

Sunday's program ranged from Verdi ("Il lacerato spirito" as well as "Ella giammai m'amo") to Handel (delivered in stately disregard of stylistic good sense but wonderful nonetheless) to Ravel's *Don Quichotte à Dulcinée* (worthy of Chaliapin, for whom it was composed) to three of the five songs in Carlisle Floyd's *Pilgrimage* cycle (in which the performances overshadowed the music) to a rather special group at the end.

Throughout his apologetic if increasingly relaxed remarks, Treigle

was at pains to stress his bedrock, Louisiana-born heritage. To end his program he chose songs of a type which could well have seen heard at a Chautauqua program forty years ago: "None but the Lonely Heart," "When I Have Sung My Songs," "Deep River," "Sometimes I Feel Like a Motherless Child," "Shadrack," "Without a Song" (in affectionate tribute to his boyhood idol Frank Sinatra), and "Old Man River."

Had such a selection been offered by some urbane sophisticate, one might have suspected—and even welcomed—a self-conscious revival of nostalgic Americana. From Treigle, it was simply real.

Judith Somogyi was the warm and sympathetic accompanist.

RITUAL ACROBATS

***Los Angeles Times*, November 29, 1971**

Zour Khaneh, the so-called Ritual Acrobats of Persia, might be better named the Ritual Musclemen of Persia. How one responds, after all, to the sight of sixteen bare-chested men in patterned purple pantaloons doing straddle-legged pushups on a bare stage for thirteen minutes must be a matter of individual taste.

But for those who could begin to empathize with this company's exotic blend of athletics, art and religion, effort and mystical service, Friday evening's performance at the County Museum of Art became an increasingly absorbing experience.

In addition to the muscular sixteen—swarthy young men in their twenties and thirties, except for two magnetic oldsters who looked like gurus—the performers consisted Friday of two tunicked specialists (for juggling and fancy footwork) and two superb musicians (one of whom chanted poetry and rang a peremptory bell, and both of whom kept up an infectious rhythmic accompaniment on what looked and sounded like two large, vertically held tablas).

Zour Khaneh means House of Strength. This touring company is reportedly one of twenty-four such clubs which flourish in present-day Iran, and the one the shah selects for special state occasions,

All the clubs practice a tradition which dates back to the sixth century

B.C. Its mixture of muscular and mental culture was meant to hone young Persians into worthy warriors and polished gentlemen.

What was most fascinating about the uninterrupted, one-hour-and-twenty-minute sequence of exercises Friday—aside from the near-compulsive doggedness of it all—was the ancient mysticism which pervaded every purely physical effort.

The whole was continually referred to as "the work"; a push-up was not a simple test of biceps and pectorals but an occasion for a poetic thought of God ("man is dust and must always humble himself before his creator"). Particularly challenging maneuvers were prefaced by kneeling obeisances; entrances and exits were executed single-file in a sinuously prancing swagger which made Latinate machismo look positively epicene.

Friday's performance was accompanied by a well-meaning American narrator who translated the chanting only occasionally, was continually drowned out by the drummers, and at the end got one whole exercise ahead of actuality in his descriptions.

TWYLA THARP

Los Angeles Times, April 11, 1972

There are lots of things one could say about the local debut of Twyla Tharp and Dancers Sunday night at East Los Angeles College, and most of them aren't going to get said in the short space of this review.

One must say this, though: anybody interested in dance who misses the company's performances Friday and Saturday nights at Inner City Theater is a fool.

Tharp is an avant-gardist, but hardly the kind of self-indulgent elitist who gives the breed a bad name. She has often worked without music, in non-proscenium spaces, in casual dress, sometimes with hordes of amateurs. Her dances have been abstract, rigorous, "objective." But what she really is an original, and one with an extraordinary ability to project that originality in focused, theatrically effective terms.

Her choreography stretches her individual dancers to their considerable limits, and builds itself upon those dancers' individualities. She val-

ues proscenium spaces, now that she is famous enough to command them.

She may blend herself communally among her dancers in performance—there is no obvious way of telling which of the seven (the eighth is a boy) she is. But her company has a shape to it which could only be the work of one dominant personality.

The overriding impression is of energy, sometimes wild, even momentarily manic, but always controlled with daredevil virtuosity. Given the supercharged, aggressive ambience, the range of expression is enormous, from abstraction (whatever that may mean in emotional terms) to every sort of dramatic mood, usually fleetingly but always forcefully conveyed. Not least among her gifts is humor—sometimes raucous, backslapping humor, but the kind which has resonance in something deeper.

Sunday's program began with *Torelli*, a counterpoint of hyperkinetic grotesquerie and structured musical jollity. It moved on to *Eight Jelly Rolls*, an astounding masterpiece which pays tribute to jazz dance and a whole era and stratum of American life without ever slipping away from Tharp's own style. And it ended with *Fugue*, a strictly shaped choreographic and aural statement lent an aura of tense, expressionistic sexuality by the sharpness of the gestures and the fetishistically stylish costumes.

Twyla Tharp spent some ten years in the Los Angeles area before going east to college and a career. She has returned one of the finest dancers of our time.

THE ONE HUNDREDS

Los Angeles Times, April 17, 1972

Twyla Tharp's *The One Hundreds*, seen Saturday night at Inner City Theater, is a piece which manages to make of a rather rigid formal idea to say something witty.

First Tharp and Rose Marie Wright danced one hundred short movements in silence, broken by matter-of-fact returns to their starting points.

Then five other company members came on and did twenty of the

movements each, unbroken by pauses. Then one hundred (actually rather less, but who had time to count or care?) local volunteers appeared suddenly from the wings. Each had been taught one of the movements, they all did them simultaneously in a total elapsed time of about eleven seconds, then disappeared offstage.

The first section was full of Tharp's characteristically floppy, twisting movements and her deadpan don't-tie-me-to-the-tracks-I'm-too-young-to-die looks. But its length only made real sense retroactively, when one understood it as part of the dance's formal structure.

1972-1980

I arrived at The New York Times *in late 1972, courtesy of Harold Schonberg, who hired me as a freelance classical music critic. Since there was a fully established dance department at the* Times, *I only wrote dance features and Sunday essays. But pop criticism was not yet established, and I soon volunteered to do that on the side. By 1974 I had become chief pop critic, and joined the staff in June of that year. This selection is tilted toward my criticism of pop and experimental composition, which I was the first to cover regularly for the* Times. *Harold was a little bemused by my involvement in rock and downtown weirdness. The straight classical reviews are relatively sparse here because as the most junior classical critic, I got a lot of tiny reviews and debut recitals. But I began to freelance more and more, sometimes under the* Times *radar.*

URIAH HEEP

The New York Times, December 18, 1972

Note: The last two sentences of this review were intended, tongue in cheek, as a statement that my Times _rock criticism would be a little different than the norm._

There was a lot of magic, or at least magical hype, in the air at the Academy of Music's rock show Saturday night. Uriah Heep, the headliner, has recently put out two records called _Demons and Wizards_ and _Magician's Birthday_. Publicity for Elf, the group that opened the proceedings, deliberately evokes fairy tales and speaks fondly of its "magical music." But the only real magic onstage Saturday was provided by the middle act, Manfred Mann's Earth Band.

Mr. Mann has been around for awhile, in various manifestations. He was first known as a jazz and blues specialist, then as a bright new figure in British rock. The next phase was a jazz-rock fusion, and he has now returned to rock, enriched.

The Earth Band consists of Mr. Mann on electric keyboards and synthesizer; Mick Rogers singing and playing lead guitar; Colin Pattenden, bass guitar; and Chris Slade, drums. It is not an unusual combination, but the group's musicianship and invention are unusual, in terms of simple quality and in the originality of the arrangements, characterized above all by Mr. Mann's eruptive keyboard interjections and an ingenious and discreet use of taped sound-collage. It is a band with visceral class.

Elf can be distinguished primarily by the diminutive stature of its

members. They make a basic, brutally functional sound. To call Uriah Heep one of the better British-American neo-simplistic heavy-blues hard-rock outfits is perhaps not saying much. Some genres with imputed magical properties—warts, for instance—preclude by their very nature much interest in a hierarchical ranking of their components.

JUDY COLLINS

The New York Times, December 24, 1972

The persistence of Judy Collins, with her gentle, folk-flavored innocence, should be enough to give our more apocalyptic pop prophets just a little cause for hesitation. For there she was, before a rapt, sold-out Carnegie Hall audience Friday night, providing pleasure to a Nixon generation that we are sometimes told is traumatized past hope on downers and hard metal rock.

Miss Collins's material, hers or by others, remains firmly circumscribed within her own, peculiarly cleansed folk style. She sings either absolutely alone, accompanying herself on acoustic guitar or piano, or backed by an adroit instrumental quartet that at its most rambunctious never transcends the energy level of a kind of Carole King soft rock.

Her girlish soprano is near-perfect within its own deliberately limited terms. She rarely sings above mezzo-piano, hardly ever allows a womanly fullness to flesh out the amplified breathy, near-whispered croon she congenitally employs.

Her repertory and especially her performing style remain similarly chaste, with the same demure pastels applied for songs of love, longing, or protest. Whereas many indigenous folk idioms contain progressively complex vocal ornamentation within a given song, Miss Collins keeps things statically clean, repeating each successive verse to the same tune over and over again, with loving doggedness.

The results deeply please those who love her. She is the eternal pretty, romantic, idealistic, lonely young girl, full of soft, yearning dreams. Those who can respond wholeheartedly to such poetic notions as silver stars and sunlight on birds' wings can fall happily under her

spell. For others, her sweetness and sincerity and undoubtedly inadvertent slickness cause those little glands, the ones just below the ears at the jaw hinges, to ache ever so slightly.

MEREDITH MONK, MUSICIAN

The New York Times, January 13, 1973

Past scores for dance—*Swan Lake*, for instance—have emerged to stand on their own, and Thursday night at Town Hall Meredith Monk, herself a dancer, offered her music for William Dunas's *Our Lady of Late* in concert. The result was an extraordinarily consoling, meditative experience.

The formal structure seemed chaste simplicity itself. The concert began and ended with some brief offstage ritualistic tappings on glass by Collin Walcott. Miss Monk came on, dressed in an austere, vaguely Chinese costume. She sat in a chair, straddling a stool on which sat a thin-stemmed glass of water, with one microphone aimed at the glass and one picking up her voice. Holding the base of the glass with her left hand, she rubbed the index finger of her right hand around the rim, eliciting an eerie drone.

And then she sang, or more accurately vocalized, in brief sections, each devoted to a different kind of wail or broken squeak or choked whisper or near-lullaby, consisting of ostinato reiterations of short, breath-length phrases. Miss Monk may not sing in the conventional sense, but her work is a highly individual fusion of a variety of ethnic and new-music styles, and she is an incontestable virtuoso at what she does, capable of a wide range of vocal color and ornamentation and always shaping her sounds with natural artfulness.

Above all, however, it is the emotional range of this music that seems most impressive. To this listener, the evening sounded like a compendium of womanly experience, from birth to girlhood to motherhood to shamanistic ecstasy to grief to old age to death. But whatever associations one chose, the sounds themselves reached deep, beyond intellectualization.

BATTEAUX

The New York Times, April 21, 1973

Note: I think of myself as a constructive critic, but one of the Batteau brothers wrote me after this review appeared claiming that I had cost them their record contract and ruined their lives. I find it hard to believe that Columbia Records would have let one review dissuade them from believing in Batteaux; they must have had doubts already.

Terry Reid and Batteaux, who opened at the Bitter End Wednesday night and continue through Monday, make an oddly complementary pair. Reid is a British singer with a warmly frayed tenor and a comfortably appealing musicality. Backed by a bass guitarist and drummer and accompanying himself on his own guitar, he moves easily from soft ballads to jazz singing to rock.

It may not be the most original art in the world, but it sounds like honesty incarnate after Batteaux, a four-man group from Cambridge, Massachusetts, built around Robin and David Batteau, brothers. They are fascinated with nakedness, dolphins, and other bits and pieces of poetic postadolescence. The imagery is set into a musical context that strives for slickness without attaining it. Ultimately, opinions about their merit must be a matter of taste: If you have any, you will find them insupportable.

RAHSAAN ROLAND KIRK

The New York Times, July 7, 1973

Note: John S. Wilson was the mainstream jazz critic of the Times, *but I got my chances to write about jazz, innovative jazz especially, when the Newport Jazz Festival demanded that we be in more places at the same time than Wilson could manage.*

Rahsaan Roland Kirk has a touch of madness to him, although to what extent he deliberately cultivates his eccentricity would be hard to say. At the end of the Thursday night Newport Jazz Festival show at the Apollo Theater, Mr. Kirk had abandoned his saxophone, manzello, stritch, and nose flute and was industriously bashing a strongly built chair to splinters.

Just before he did this, his percussionist had distributed all his instruments to the crowd (except for the most expensive ones—ecstatic abandonment has its practical limits) and was busily fighting off Apollo officials who were trying to close the curtain. And just before that, Mr. Kirk had delivered himself of a high-pressure, rambling diatribe against unnamed enemies (Newport officials? Apollo officials? American society? the world in general?) who were trying to quash "black classical music" and, more particularly, to cut short his set.

It was, everything considered, a notable Apollo debut for Mr. Kirk and his accomplished accompanying quartet—not least because in between the extramusical excitement they played some magnificent jazz, highlighted as usual by Mr. Kirk's own quite spectacular virtuosity and musicality.

The rest of the show wasn't bad, either, with the exception of the Roy Haynes Hip Ensemble's rather mindless jazz athleticism. Louis Jordan and his Tympany Five charmed with their blend of old-fashioned humor, jazz, and rhythm and blues; Carmen McRae succeeded more than one might have thought likely in appealing to an Apollo audience with her cabaret style; and John (240) Palmer, a comic, did a nice job of bridging the gaps between acts.

The oddity of the evening was a group called the Jazz Opera Ensemble, an offshoot of the Afro-American Singing Theater, which is in turn an offshoot of the Harlem Opera Society. Its juxtaposition of three sopranos and a baritone singing jazzily improvisational vocal lines with a jazz group led by Sam Rivers had its naive moments, but at its best sounded ingenious and original.

YOKO ONO

The New York Times, October 26, 1973

Let us start with the premise that Yoko Ono, who opened a stay Tuesday night at Kenny's Castaways, is a simply terrible pop music performer. She can't sing, her tunes are tuneless, and her lyrics are clumsy. (Her Plastic Ono Super Band does have its virtues, especially when it is on its own.)

Yet it can't be that simple. Miss Ono is certainly not dumb. Surely she must realize that by any normal criterion she is terrible; in fact, she deliberately emphasizes the abrasive aspects of her singing. So what is she up to? Perhaps she is simply working out her neuroses in public. But perhaps she is fascinated with the tension between herself and her audiences. After years as a leading avant-gardist, with the bland acceptance common at avant-garde events, perhaps she relishes any kind of electricity in the air, positive or negative.

Her whole performance Tuesday seemed designed to provoke an awareness of contradictions—particularly the oddity of her persistent concern with women's integrity coupled with a costume that included hot pants and black plastic boots up to her knees. But at the moment the means by which she confronts her audience are so grating that few will be willing to put up with her for long.

BOB DYLAN

The New York Times, January 31, 1974

Note: Arthur Gelb made me chief rock critic and then put me on staff largely on the basis of several Dylan reviews at this time.

You could sense it even before the concert began. The audience was expectant, even exultant. And when Bob Dylan and the Band trotted onstage last night at Madison Square Garden for their first Manhattan concert, they were clearly exultant, too.

Hardly anything was different in matters of format and repertory from the concert Monday night at the Nassau Coliseum, and none of the rumored celebrities appeared to perform. But the adrenaline was flowing, and everything was different, after all. It was one of the great rock-and-roll concerts.

Yes, the voice of Mr. Dylan and the Band's singers still sounded a little husky from the rigors of their month on the road. Mr. Dylan was singing with a care and an intensity extraordinary even for him. Suddenly—as it had in the Philadelphia concerts early this month—it all came together: the rough-edged, growling baritone, the emphatic delivery, the mocking, the laughing distortions of the ends of phrases combined with the Band's superb backings to present Mr. Dylan's songs in a totally convincing light. It wasn't the same as the records. But Mr. Dylan has always been an artist who grows and changes, and he is growing still.

Things began with "Most Likely You Go Your Way (and I'll Go Mine)" and continued with "Lay Lady Lay," "Just Like Tom Thumb Blues," "Rainy Day Women," "It Ain't Me, Babe," and "Ballad of a Thin Man." After six of the Band's own standards (including Mr. Dylan's "I Shall Be Released"), the first half ended with "All Along the Watchtower," "Ballad of Hollis Brown," and "Knockin' on Heaven's Door." These are some of Mr. Dylan's best songs, but what was fascinating was the way in which the inspiration of his singing made them all sound equally good, even some of the later ones that had seemed a bit sentimental on records.

In Mr. Dylan's solo acoustic set after the intermission—"The Times They Are A-Changin'," "Don't Think Twice, It's All Right," "Gates of Eden," "Just Like a Woman," and "It's Alright, Ma (I'm Only Bleeding)"—the same determination to alter the tunes radically and to recast these most familiar of numbers into something new was present. But where, in earlier concerts, Mr. Dylan's alterations had seemed mostly willful, last night they made their own kind of sense. One might still have preferred how they sounded ten years ago. But the conviction was hard to deny.

After four more of the Band's best songs, performed again with the tightness and gut-level energy one expects from them, Mr. Dylan came back with two songs from his and the Band's new album, *Planet Waves*—"Forever Young" and "Something There Is About You." Mr. Dylan produced such an astonishing succession of great songs in the mid-1960s that such signs of decline as have appeared are all the more

alarming. But the death pronouncements may be a little premature. The new songs, on continued rehearing, sound more and more persuasive. Mr. Dylan may not be turning out great songs with quite the precocious frequency of yore. But he is still capable of greatness as a writer as well as a performer.

The evening ended, as all of these concerts have done, with "Like a Rolling Stone," followed by a reprise of "Most Likely You Go Your Way (and I'll Go Mine)," and (unusual on this tour) a second encore, "Blowin' in the Wind."

"Like a Rolling Stone," sung with the house lights up and the audience standing and clapping to the music, has really become the anthem of Mr. Dylan and his generation, and last night it sounded like a holy battle cry. Mr. Dylan's music may be the first and finest artifact in the newborn nostalgia for the '60s. But it may be hoped, both for him and his audience, that it looks forward as well.

ANIMALS

High Fidelity, **March 1974**

Note: I wrote a lot of classical-record reviews for High Fidelity, *but this is the one I like most. It does involve William Bolcom.*

Animals of Africa: Sounds of the Jungle, Plain and Bush. **Live recordings from East Africa of the leopard, vervet, monkey, hyrax, rhinoceros, zebra, wildebeest, lion, hyena, wild dog, silver-back jackal, elephant, and hippopotamus. Nonesuch H 72056. $2.98.**

What we have here is exactly what the jacket advertises, nothing more and nothing less. The record is short (28 minutes, 38 seconds), but there is more variety on it than in your average five-disc set. If the rhinoceros (eroticism incarnate), hyena, elephant, and hippo were my own special favorites, all of these nicely varied and crisply recorded grunts and growls will give pleasure.

But the question is, to whom and for what purpose? Naturalists should like this disc, and people in search of a party record, and Hugh

Hefner types who want to add a bit of spice to their grapplings before the roaring fireplace. The jacket annotator, composer-pianist William Bolcom, argues that "at least some of these animals' speech is as articulate as ours," but that strikes me as pushing the insecurity of the relativistic white liberal a bit far. I mean, these are *animals*, after all. I can believe that the ants are getting ready to take over, but it will take a while before I'm threatened by a vervet monkey.

ROBERT WILSON

Musical America, April 1974

Note: In 1973 and 1974 I wrote a monthly column for Musical America *called "What's New?"*

Robert Wilson is a hard man to talk about. What he does is put on multimedia theater works—which he calls "operas"—of a complexity and lavishness unprecedented in avant-garde annals. *The Life and Times of Joseph Stalin*, which was performed in the Opera House of the Brooklyn Academy of Music in mid-December, lasted twelve hours, from 7:00 P.M. to 7:00 A.M. (actually, it wandered on until about 9:00 in the morning the first night, ended at 7:00 on the nose the second, and came in a little early both times in its two subsequent performances).

The difficulties for the critic are simple enough to understand, even if the work itself is not. First of all, this really is something new. Certainly, one can evoke the obvious precedents in Surrealist and Dada theater, the debts to the hypnotic *longueurs* of Wagner, the parallels in such present-day groups as the recently disbanded Open Theater and Meredith Monk's House productions. But to peg Wilson neatly as "contemporary epic ritualism" or some such category doesn't begin to give a reader an idea of the impact and density of the theatrical events at a Wilson performance. Quite apart from the problem that if the critic fails to sit out the whole twelve hours, he hasn't done his job, but if he has, the logistical problem of knowing what to describe becomes all the more unmanageable.

The tempo of Wilson's pieces is slow, as it would almost have to be to extend over a twelve-hour span. Anyone used to the linear, outwardly logical continuity of the conventional spoken theater would be disconcerted with the zombielike solemnity and "meaninglessness" of a Wilson performance. But in fact Wilson is a lot less minimal than many of those currently active in avant-garde theater and dance: his work is full of a continual flow of incident. It's just that it's focused differently from the norm. And when Wilson unleashes one of his frequent, overt *coups de théâtre*, the effect is all the more overwhelming for having emerged from the understated backdrop that precedes it.

The fourth act (of seven), for instance, is called "The Forest." For most of its two hours an extraordinary but still steady-state continuum unfolds: There is a dining table on the left, at the head of which squats a frog-man, who periodically drinks and plays guitar and passes notes to a formal, nineteenth-century couple sitting to his left. Behind the couple are mysterious servant figures. There are also a low-comedy waiter and waitress who emerge occasionally with a flourish. There is a false-theatrical house behind them, toward the center, from the window of which a foreign lady emotes in a foreign language. It eventually burns down and collapses. There are continual processionals, such as a line of ladies dressed in black, steadily clicking the reels of the fishing rods they carry. And that's just a tiny portion of the downstage activity.

Behind that is a wall of slim trees, and behind that is a space, through which processionals pass and sylphlike temple dancers weave mysteriously. Behind that is a dark blue sky and a pyramid, illuminated by a glowing yellow moon. Suspended high over the stage two children sit on boxlike swings. It is very beautiful.

But then, the top of the pyramid detaches and floats away, and an eye appears in the sky (cf. the back of a dollar bill). Gradually the stage is emptied of props and people. (I am leaving out key incidents and an infinitude of detail, but let it pass.) The stage is suffused with a strong blue light. The space behind the trees and in front of the pyramid fills with billowing white smoke, and indistinct figures emerge from it, wending their way through the trees downstage. They are apes, about eight of them, of all sizes, ages, and sexes, gibbering to one another and shuffling about. They look down and spy eight red-orange apples on the ground. Each ape picks up an apple, and they all stumble into a rough line downstage on the right, picking at one another and looking confusedly at their apples.

Suddenly the pervasive blue is illuminated by a flickering yellow-

orange light from offstage left, and immediately thereafter two figures appear from that direction. They are a perfectly matched couple dressed in formal late-eighteenth-century court attire. Except that all the attire is white with silver trim, and their faces are silver, too. The woman is carrying a white parasol, and it is on fire — the source of the light, which naturally has become all the brighter now that they are onstage. At the same time, the apples have turned out to be attached to quite visible wires, and as the apes look up in amazement, the apples ascend smoothly into the flies as the curtain falls.

The Life and Times of Joseph Stalin was full of scenes like that, and it might be easy to dismiss (or at least categorize) Wilson's work as the ultimate so far in the hippie mind-blowing school of theatrical sensation for its own sake. Except that your ever eager reporter went back and saw extended parts of the piece again the second weekend, and came away with a rather different impression. There can be no question that Wilson does appeal to the irrational side of the romantic spirit, and that as such he should quite rightly be an object of intense suspicion on the part of the commonsense rationalists who dominate our culture and critical writing today.

But Wilson is hardly unintelligent, and my second visit began to reveal all sorts of more or less explicit formal ideas running through the work. Even on a first visit, the sight of a long-distance runner dressed in rust red plodding matter-of-factly back and forth across the stage at odd intervals not only provoked amused recognition from the audience, but served obviously as a unifying motif. The work is permeated with such motifs, in a quite specifically Wagnerian manner, even though Wilson draws his motifs from all the media, with music not really paramount among them, and applies them perhaps (but who knows, really) less systematically than Wagner did.

There are verbal motifs (lines like Wilson's aviary, cawing "What?," or a boy's disquisition on "Emily watches the TV; Emily likes the TV"); dance movements (wonderful, wonderful ones that evolve from simple exercises into a whole, hieratic ballet by the fifth act); scenic links (Wilson loves animals, real and impersonated, and ostriches, sheep, camels, turtles, and the like wander all over the work); musical recurrences (Pachelbel's Canon, the Fauré Requiem, original music by the two house composers); and the simple reappearance of the same characters, sometimes played by different people (among others, Sigmund Freud, Queen Victoria, Ivan the Terrible, Dave Clark, and above all, Joseph Stalin).

And there are intellectual juxtapositions going on, too: the fifth act,

the most overwhelming of the seven, includes a lecture by Stalin on the nature of dialectical materialism, read in a flat voice through a dehumanizing loudspeaker by Stalin in a glass isolation booth, set in the sunlit interior of a pyramid, with the dancers swirling and prancing all around him. The lecture discusses dialectical materialism in a quite unintentionally mystical manner. Suddenly the processes of the dialectic don't sound all that removed from the all-embracing beliefs that transparently inform Wilson's work, and the structural notions in Stalin's thought begin to sound like Wilson's methodology in putting his theater piece together. The universal horde of characters in the work can separate into innumerable groupings, but among them are a three-class division suggestive of Communist thought—aristocracy, bourgeoisie, workers—set against other categories (animals, priests, madmen) that amplify Marx and Engels's view of the world.

I don't really think it would be too fruitful to analyze Wilson structurally in the best English 1 manner. What I am suggesting is that intellectual notions play their part in giving the piece its shape, and that Wilson is hardly a naïf as he goes about putting his works together. First of all, and most obviously, there is the sheer weight of numbers of people involved—well over a hundred—testifying to an organizational ability that transcends the normal. Second is the lavishness of the sets, props, and costumes, indicating that Wilson has been able to enlist some formidable patrons (principally the Gulbenkian Foundation). Third, there is the history of this work, which actually consists of a retrospective of what he and his company have been doing since 1969: it all fits together in a manner that suggests that Wilson is a man with very clear ideas of what he is about. And fourth, there are the differences between the first weekend and the second: all sorts of excesses had been trimmed and tightened in the intervening week, showing not only that Wilson has a sharp critical idea about his own efforts, far removed from the self-indulgence endemic in the world of the avant-garde, but that he has the needed combination of the charisma to attract large numbers of obviously talented people to work with him and the discipline to bend them to his will without alienating them.

It would be silly to imply that Wilson represents *the* future of dance, theater, or opera. There are some specific problems with his work: not all the parts work as well as others; some of the individual "bits" are more effective than others; and the music varies widely, from the very moving indeed to the slightly stale, and could in any case be exploited far more pervasively than it is now. But more generally, this is a classic

instance of a theater not for everybody. Wilson has attracted an audience, in New York and in the European cities where he has appeared. His influence has been profound on those it has affected (e.g., Jerome Robbins in his ballet *Watermill*). But this is not a theater for the matinee crowd. It is a painfully personal, exquisitely fashioned exploration of new theatrical ideas, and it will attract an audience as new as itself.

AL GREEN

The New York Times, June 23, 1974

For the last three years, Al Green has been the most successful soul and rhythm-and-blues singer in the business, with a steady stream of million-selling singles, albums that do nearly as well, and a torrent of adulation from the black and white press. But his most recent couple of singles have shown a slight falling off in sales, and his performance at the early show Friday night at the Apollo Theater—where he will be playing through Thursday—was a long way from an unqualified success.

Certainly, there were the expected signs of adoration: intermittent cheers, clusters of women fans with hands outstretched toward the star, eager to receive the roses he dispensed by the bundle.

But the galleries were having none of it. The twenty-seven-year-old Mr. Green's style doesn't preclude the hard-driving excitement that Apollo audiences want (and got, by and large, from Laura Lee, who preceded Mr. Green). But his trademark is soft, confidential singing, an almost conversational intimacy. It can be wonderfully effective on records, and perhaps it could have been—or even was—on Friday.

But you could hardly hear from the balcony. People would call out "Just sing, Al," or "Hey, Al, you singing to yourself?" Toward the end, the steady gabble of derisory conversation and rude remarks had abated somewhat, since a good third of the mezzanine had walked out. Those who stayed, however, were full of comments like "He must be drunk," or "Naw, he's *high*," or "Don't go blame it on that cheap wine."

Through it all, Mr. Green gave every outward appearance of basking in untroubled adulation. But his performance was erratic, full of aimless wanderings around the stage and a determined predilection to stifle his

excellent band's enthusiasm just as it was settling into some excitement. It was all like some odd combination of James Taylor, Stevie Wonder, and Joe Cocker.

Perhaps underneath all that noise his art was spinning out effectively as ever. Perhaps the Apollo is no longer Mr. Green's audience. What can be said for sure is that he failed to reach large parts of it on Friday.

THE BEATLES MUSICOLOGIZED

The New York Times, July 4, 1974

Twilight of the Gods: The Music of the Beatles. **By Wilfrid Mellers. 215 pages. Illustrated. A Richard Seaver Book/Viking. $7.95.**

When it comes to writing about rock and roll, Wilfrid Mellers is not exactly your basic boogier. His prose runs more like this: "The second strain of Paul McCartney's 'Things We Said Today' hints at the possibility of loss, with a weeping chromatic descent in triplet rhythm, and with rapid but dreamy tonal movement flowing from B flat by way of a rich dominant ninth to E flat: the subdominant triad of which then serves as a kind of Neapolitan cadence drooping back (without the linking dominant) to the grave pentatonic G minor."

This is—one feels it necessary to insist, hastily—not a joke. Mr. Mellers, a professor of music at the University of York, England, has written intelligently about music of many kinds, including one of the very best (although slightly dated now) histories of American serious and popular music, *Music in a New Found Land*. He even has a sense of ironic humor, and he knows that lots of people will make fun of his Beatles book—including, no doubt, the four Beatles (or ex-Beatles) themselves.

Why does he write this way? Well, first of all, he doesn't, always. As the title might imply, Mr. Mellers sets the Beatles into a deliberately legendary, mythical context, one part McLuhan to one part Jung and Wagner (the title is more suggestive than accurate, actually, since Mr. Mellers thinks of his subjects as eternal innocents rather than as worldweary exemplars of a declining order, as in Wagner's music drama to which he refers).

Mr. Mellers hears Beatle music as reborn tribal primitivism—not necessarily inferior to Western art music (although he is a bit ambivalent on that), and answering to the needs of a new generation of global villagers (to use his nonmusical terminology). But the core of his book is an album-by-album, song-by-song analysis of the Beatle oeuvre (including post-breakup solo efforts), keyed to the notion of "a tie-up between the widening range of the Beatles' experience and the expansion of their technical resources."

The premise behind it all is that "descriptive accounts of music cannot be valid unless they are based on what happens in musical terms." And the unstated premise behind that is that the musical terms are essentially those of the tonal period of Western art music.

But that leads to two problems. First, nobody but musical technocrats can really hope to understand what he is talking about. Mr. Mellers says hopefully that "any reader who is prepared to devote a little time to the glossary should be able to read the book," but he is kidding himself. Every once in a while he will tie his evaluative, interpretive notions of a song specifically to his technical analysis, and then, just maybe, the sympathetic non-musician can get some idea of what he is talking about, and how all these arcane bits of terminology relate to human emotion. But all too often Mr. Mellers counts unconsciously on a technical tag to evoke the same set of emotional memories in the general reader that it evokes in him, and in so doing he seriously limits the wider appeal of his book.

So he has confined his book to classically trained musicians who happen to be sympathetic to popular musical culture. Even then, is his approach the best one possible to this sort of music, or even valid? Can one sensibly discuss music written outside a given tradition in terms designed to apply to that tradition? Can one discuss the music of the Beatles—which, for all its debts and similarities to tonal music, stands as much outside the long line of "serious" Western musical development as in it—as if it were some latter-day Schubert lieder collection? Often, one gets the feeling that while Mr. Mellers's laborious descriptions aren't exactly wrong, they aren't very right, either.

What makes the music what it is has a lot to do with rhythmic and microtonal subtleties and coloristic contrasts that are more avant-garde or ethnic than traditional, and a technical vocabulary of a complexity comparable to that for conventional harmonic movement simply hasn't yet been refined for those aspects of music. Mr. Mellers's continual, perhaps inevitably vague references to vocal "ululations," "electronic gib-

bering," and the like don't go very far toward refining such a new termi-nological precision.

Still, old-fashioned analysis can hardly hurt these songs. It may not answer the more mystical question of just *why* this was great music—but then again, the same kind of analysis of a late Beethoven string quartet stops similarly short. It may exist in a world miles removed from the intensity generated between the Beatles and their true, adoring audi-ences. But Mr. Mellers has raised some questions well worth consider-ing, and on its own very idiosyncratic terms, he has written a book well worth reading. If you can.

GENEVIEVE WAITE

The New York Times, July 19, 1974

One might think that the most important thing about pop music was the music, but it isn't necessarily so. Rock has always been significant as a battle cry for teenage protest or as background for amorous couplings. And for many people, especially those at the center or on the periphery of the music business itself, the most important thing has been glamour.

Linda Ronstadt, who has the image of an organic little sexpot but who drops quite remarkable quotes into her conversation, once referred to glamour as "the power to sexually intimidate someone." Certainly glamour has a lot to do with sex, or at least its image. It is inextricably associated with sexual charisma, with a power emanating from certain people that makes them transcend ordinary norms.

The trouble with all of this, especially in our media-conscious age, is that glamour seen close up can look pretty tacky. Certainly it did Tues-day night at Le Club.

The invitations began, "Mr. Elliott Gould requests the pleasure," and the occasion was the "christening of Miss Genevieve Waite 'The Glam-our Queen of Rock.'" Miss Waite is married to John Phillips, one of the Papas in the late Mama and Papas, and Mr. Phillips has written a clutch of songs for her that she has recorded and put out on Paramour Records.

As a singer, Miss Waite left a little to be desired. She mewed out her

songs in a childishly nasal whine, booping along with the beat with loose-limbed twitches. Mr. Phillips accompanied on the guitar with a look of fixedly amused adoration on his face.

Music is not the point of Miss Waite's latest career venture, however. A film actress (*Joanna*), she now hobnobs with the jet-set beau monde, the back of her record jacket informs us, and they all love her. Certainly they—Mick Jagger, Andy Warhol, Michelle and Mackenzie Phillips (Mr. Phillips's previous wife and their daughter, who was in *American Graffiti*), Cat Stevens, Lorna Luft, and a gaggle of the socially prominent—did on Tuesday, raucously so.

The point presumably is sex of, one hopes, an affectionately parodistic kind. The songs Mr. Phillips has given Miss Waite to sing are all of the single-entendre sort ("Love is on the rise"), and her record cover is a pretty successful re-creation of 1940s pin-up styles.

Maybe it is all wonderfully titillating around a Beverly Glen swimming pool or a Mulholland Drive terrace, with Mick and John and Michelle and a few intimates. Maybe some people will even like the record as a novelty. At Le Club, with the photographers and columnists and miscellaneous freeloaders jostling one another and griping about the crowds, and Miss Waite aimlessly giving glamour a bad name, it was just kind of dumb.

THE ROLLING STONES

The New York Times, July 27, 1974

Mick Jagger: Everybody's Lucifer. By Tony Scaduto. 375 pages. Illustrated. David McKay Co., Inc. $8.95.
S.T.P.: A Journey through America with the Rolling Stones. By Robert Greenfield. 337 pages. Illustrated. Saturday Review Press/E. P. Dutton & Co. Inc. $8.95 (hardback), $3.95 (paperback).

Some people like to savor and celebrate legends, others like to probe behind them. The Rolling Stones have been around for more than ten years, and if their legend isn't quite the same as it once was, it is clearly a logical extension of their early image. When the Stones first appeared,

they quite consciously took the role of the scruffy, snotty antithesis to the cherubic innocence of the Beatles (as defined especially by Paul McCartney's personal image).

Since then the image has matured as the Stones have matured (or aged). Punks were transformed into superstars, and teenage rebellion became adult satanism. The subtitle of Tony Scaduto's Jagger biography is *Everybody's Lucifer*, and that—particularly after the killing at Altamont, widely ballyhooed by the press as the demonic answer to the angelic Woodstock—is how the world looks at the Stones. It's not that their fans think of them as just folks and their enemies see them as devils: *everybody* thinks them diabolical, and opinions vary as to whether deviltry is evil, amusing, or enticing.

All music is in some sense inseparable from the life around it. Music can be perceived in the abstract, but at some point it is performed in a social setting, and one has to realize that a real person wrote it and that it has taken on meanings that transcend its purely aural properties. With rock music, born as it was as generational protest and still the anthem of the young, the extramusical meanings take on an even larger share in the art's overall impact. You cannot separate the Stones image from the Stones music.

Yet in the end, it all comes back to the music. For all of Mick Jagger's ugly-sensuous beauty and charisma, he got where he is today (wherever that is, given the impermanence of latter-day café society) through his music. If you love the Stones' records then you know most of what you really need to know about them. And, in fact, the image you have of them evoked through their music may be appreciably more "real" than the "real" story behind the image.

Certainly it will be more real than the clumsy, unfocused mishmash offered by Mr. Scaduto. This book is so bad that one might well consider not reviewing it at all, except for the fact that fascination with the Stones is so great that millions will lap up *any* promised glimpse into Mr. Jagger's supposedly lurid life, and for the fact that Mr. Scaduto did write another, rather better "intimate biography" of Bob Dylan.

The Dylan book was awkwardly written, too, and whenever Mr. Scaduto took it upon himself to "explain" Mr. Dylan's songs, one wanted to hide one's face from the shared embarrassment of all musical journalists. But at least Mr. Scaduto had taken a previously inscrutable subject, done a lot of good, hard work in the way of interviews with all sorts of folk who knew him back when and had actually

gotten to Mr. Dylan himself. The result was genuinely interesting, for all its flaws.

In the Jagger book, Mr. Scaduto turns up precious little we didn't know already. The Stones' world—despite Mr. Scaduto's attempts to portray Mr. Jagger as a double-dealing betrayer of friends and associates—is clearly a tight, loyal one, and a significant number of insiders simply wouldn't talk to him—not least, Mr. Jagger himself. Besides, Mr. Scaduto's gracelessness as a writer is even more obvious than before, his organization is chaotic, his moral stance alternately unfocused and absurd. It is all—to use a phrase coined by Geoffrey Stokes to describe another piece in another place—"unswervingly dumb."

Robert Greenfield's *S.T.P.* (which stands for "Stones Touring Party" and other, less printable things, and which appeared in part in *Rolling Stone* magazine) attempts less cosmic revelations and winds up offering a good deal more. This is a detailed, evocative, brightly written journalistic account of the 1972 Stones American tour. Through it all, Mr. Jagger and the rest of the Stones hover over the battle: they are there, and their actions and performances are described, but Mr. Greenfield makes no pretense of knowing Mr. Jagger's thoughts and secret sexual practices.

Instead, he concentrates on all the levels of hustling and hysteria that made up the tour, from road managers to producers to groupies to film makers to dope dealers. It is a sordid story, and unsparing in its picture of the calculation and the cynical decadence behind the tour. And yet Mr. Greenfield loves rock and he loves the Stones, so that nothing ever seems like a philistine cheap shot.

Mr. Greenfield's book is, in short, worth reading; Mr. Scaduto's is worth avoiding. Neither invalidates earlier efforts such as J. Marks's *Mick Jagger* or, especially, David Dalton's *Rolling Stones*. Best of all, go listen to the records again; they are where the real action is.

MIKHAIL BARYSHNIKOV

The New York Times, **August 4, 1974**

New York is a town accustomed to the best. But the event at Lincoln Center's New York State Theater last Saturday night was something special, even by local standards. For this was the American debut of Mikhail Baryshnikov, formerly of Leningrad's Kirov Ballet, and his first performance anywhere since he had defected from the Soviet Union a month before while on tour in Canada with a group of Bolshoi Ballet dancers.

The excitement was artistic, not political. When word leaked out on July 11 of Baryshnikov's three performances with American Ballet Theater—he will appear with Natalia Makarova in one pas de deux tomorrow night and another on Friday—the State Theater lobby filled with a snakelike line of incipient Baryshnikovians. An hour before the performance last Saturday there was another line in the same lobby, this time of resigned yet hopeful fans, waiting on the slim chance that there would be a returned ticket. Scalping—up to $50 and beyond—was reportedly common.

Inside the theater, the atmosphere was marked by the sort of charged tension that can make a performance great. Yet this wasn't another routine New York premiere, with a host of name performers promising surface glamour and stale ideas. This was going to be something special, something in which genuine artistry, excitement, and ballet history were all to blend harmoniously. People greeted one another in the foyer with a pleased sense of conspiracy: Ah *ha*, they seemed to say, *you* got in, too. The audience was stocked with dancers, known and not so known. The Hamptons, for once on a late July weekend, must have been nearly empty—at least of ballet fans.

Baryshnikov's credentials and advance reputation were the source of all this excitement, of course; only a handful who had trekked up to Canada or had been to London in 1970 or to the Soviet Union itself had actual firsthand knowledge of what the legend could do.

Baryshnikov is only twenty-six, the last great pupil of Alexander Pushkin, the Leningrad teacher who had previously molded Yuri Soloviev and Rudolf Nureyev. Baryshnikov's previous appearances outside of the Soviet Union had provoked extremes of praise from both the perennial gushers and the determined hardliners among Western critics.

Baryshnikov was, we had read, either the greatest male classical dancer of his day or, maybe, the greatest dancer, period. It wasn't a bad advance buildup.

"Greatest" is one of those absolutes that doesn't really have a place in the arts. Certainly Baryshnikov is a great dancer, and equally certainly the full range of his gifts won't be seen until he has appeared in a wide variety of roles. Let us be conservative, instead. Let's just say that his work last Saturday was overwhelming.

There was some grumbling before and after the debut about the choice of his first part here. *Giselle* is thought of as a vehicle for the ballerina, and the opportunities for virtuosic display accorded the principal male dancer are relatively restricted: Warren Conover, who danced in the peasant pas de deux in the first act, had perhaps more to do in terms of athletic endeavor than did Baryshnikov, as Count Albrecht. The performance began shortly after 8 P.M., but it wasn't until 10 P.M. precisely that the audience—which had been cheering nearly everything in this admittedly excellent performance—had a chance to let loose a concerted roar for Baryshnikov, after the first of his relatively extensive solos in the second act. The *Bayadère* and *Don Quixote* pas de deux, coming up this week, will show us more in the way of display, and, needless to say, his forthcoming appearances in new ballets by Western choreographers—his principal reason for defecting, he says—will show us still more.

Actually, however, *Giselle* was a fitting selection. It is a cornerstone work of the traditional ballet repertory with which Baryshnikov has heretofore been identified, and a summation of what romantic ballet is all about. It was, incidentally, Makarova's debut role with Ballet Theater after *her* defection in 1970. More to the point, Albrecht is a part that allows the male dancer a chance to show how he can transcend mere feats of technical display.

Not that even the brief glimpses in the second act didn't tell a lot about Baryshnikov's technical mastery. He is not a tall man, nor does he project the instantly compelling, mad-Tartar machismo of Nureyev (who, quite coincidentally, was dancing that night across the Lincoln Center plaza at the Metropolitan Opera with the National Ballet of Canada). His face is soft and pleasantly distant, his body compact and rounded.

And yet the man is clearly capable of the most astonishing leaps and twists. Like those of many great dancers, his *élévation* and *ballon*—the

ability to jump grandly into the air and then hang there, suspended in time—look extraordinary, but his appear somehow more extraordinary than most. He is able to execute the most difficult steps and even to ornament them in a personal manner—a seemingly casual chain of smoothly running jumps with an ornamental double beat, executed on a diagonal from upstage left to downstage right, brought gasps from the crowd. And all of this is integrated with the most perfect musicality and in a manner that never seems to impose its brilliance in an inartistic way.

What is perhaps most impressive about Baryshnikov as a technician is his purity of line, both at rest and in motion. Every aspect of ballet form has its archetype of perfect balance and extension, a classical picture of poised weightlessness. But the exigencies of muscular effort—the physical reality from which ballet is the metaphorical escape—usually distort that purity. Dancers visibly set themselves, thrust into a movement, distort it as the body or a limb sags from strain, and then have to recoup as they complete the movement just barely off balance. Classical training struggles to overcome such imperfections, and Baryshnikov manages to do so better than almost anyone within memory. His form is maintained throughout each movement, in a way that makes it look like no effort at all, and to a degree that palpably suggests that ideal perfection has indeed been achieved.

It is, in short, a virtuosity that contributes to and heightens artistry, rather than distracting from it. Sheer technical flash can be thrilling, of course, but what makes Baryshnikov so valuable and so special, even after only a first viewing, is the way he subsumes his skills into the larger task of artistic communication.

The part of Albrecht was so fitting as a debut role because it enabled Baryshnikov to prove to us that he wasn't a mere mechanical dynamo, however awesome. This is a part requiring extensive mime, a part in which the dancer's acting ability is really more important than his virtuosity—as Erik Bruhn proved over and over again in the latter days of his career as a *danseur noble*. Certain of Baryshnikov's details of acting—the emotive fervor of his grief at the end of act 1 and the stylized agony of his cradling of the lilies at the beginning of act 2—were clearly derived from the Kirov tradition, and suggested a Russian demonstrativeness that might have struck some Americans as excessive. But it was all done with such conviction and restraint that it wound up marvelously compelling. And in certain small moments, as when Giselle's spirit slipped across

the stage in act 2 in and out of Albrecht's arms and off into the mist, leaving him with a look of confused pain and longing, Baryshnikov's mimetic gifts seemed almost as expressive as his purely dance skills. What was ultimately so moving, of course, was how the two sides of his talent fused into one: this is a great dancer, pure and classically simple, as long as "dancer" is understood to embrace all aspects of the nonverbal performer's art.

The performance would have been a superior one, even without Baryshnikov: Makarova's Giselle was as classically perfect as ever, and inspired by Baryshnikov's presence; Cynthia Gregory's Myrta was both technically and temperamentally distinctive; and the soloists and corps looked at their best.

But the evening was clearly Baryshnikov's, as it had to be. And even at the end, during more than 15 minutes of standing cheers, dozens of bouquets, rhythmic clapping, and chanting shouts of "Misha, Misha, Misha," Baryshnikov stayed in character. He avoided the exuberantly lavish curtain-call flourishes that some male dancers affect, preferring instead to stand simply and smile modestly. In so doing he seemed simultaneously to acknowledge the audience's enthusiasm and its sense of occasion, and yet to hold back from it, aristocratically. He is an artist who would seem to know quite clearly what he wants to do, and we can only be thankful that we will be allowed to watch him do it.

CHARLIE MORROW

The New York Times, August 10, 1974

One might have thought that Charlie Morrow picked a rather odd site for an avant-garde concert yesterday morning—on a boat in the middle of Little Neck Bay in Queens—and that the timing was rather odd, too: a weekday morning just before a new president was to be inaugurated.

But Mr. Morrow wasn't concerned. His concert was meant primarily for fish.

Mr. Morrow has long been involved with chanting and with the music of primitive peoples. Primitive man anthropomorphized animals

and attempted to communicate with them. Thus Mr. Morrow's interests have lately expanded to include musical animism, and his immediate target is fish.

Yesterday's concert took place on a forty-eight-foot powerboat called the *Unicorn*, owned by John Doswell, a multimedia artist. Mr. Morrow and two other members of the New Wilderness Preservation Band, Carole Weber and G. Richardson Cook, made mostly lugubrious, moaning improvisational music with voices, woodwinds, Moog synthesizer, and percussion and played tape recordings of actual fish sounds from the rear deck. Their work was amplified through both an underwater loudspeaker and another perched on the deck. Audience members listened from the *Unicorn*, from another boat some forty yards off called the *Jan Song*, or from the fishing pier a hundred yards distant.

One might have complained that Mr. Morrow hadn't taken his project seriously enough to insure a fair deal for the fish, since a swimmer reported that not much was emerging from the underwater speaker and since Mr. Morrow admitted after the concert that it was probably underpowered. One might have further complained that the smallish audience—which would certainly have been larger with a more convenient time and place—consisted mostly of Mr. Morrow's friends, the press, and miscellaneous fishermen, and that when the music was audible from the pier it couldn't be heard from the *Jan Song*, and vice versa.

But all that would amount to a rather churlish underestimation of the event's charm. Concerts like this require a neat balance of media-oriented hustle and meditative calm, and Mr. Morrow seems to have struck that balance. This event, like other forms of contemporary performance art, will owe its larger impact not so much to immediate reactions as to its dissemination through photographs and reportage.

So let it be reported that from an above-ground perspective, the trio's music sounded slowly sensuous and refreshingly consoling in the muggy morning air. The fish will have to speak for themselves.

JOE COCKER

The New York Times, September 23, 1974

All sorts of events are being taken these days to signify the death of the 1960s, and Joe Cocker's concert Saturday night at the Academy of Music works as well as any.

Mr. Cocker is a British blues-rock singer who first appeared in this country in 1967. But his greatest fame here came a couple of years later, with his appearances at Woodstock and on the Mad Dogs and Englishmen tour—and in the films that documented those events.

Musically, Mr. Cocker offered a wonderfully gravelly, hoarsely evocative whisky baritone allied with an intuitively apt improvisatory feel for his material. But as with many rock stars, it proved impossible to separate his music making from the overall impression he made onstage. Mr. Cocker gave his audiences the illusion of a man living purely in the present, tapping sources of energy and intensity that weren't naturally of this world.

Well, it turned out not to be an illusion. Mr. Cocker's private agonies became common knowledge, and for the last four years he has been mostly out of the public eye. There was a disappointing tour in 1972, and a disastrous one-night stand in Los Angeles early this summer.

But recently Mr. Cocker came out with a surprisingly effective album, more muted than before but still successful. Then he put together a band and went on the road, and it was this short tour that brought him to the Academy of Music on Saturday night.

The result was agonizing. Yes, the band was good, and Mr. Cocker made it through the night, in the sense of standing up at the microphone and emitting most of his lines when called upon. But the words were slurred and the dynamism lost almost entirely. And his face and body registered such continual confusion and pain that one wanted to cry for him.

In the late '60s, one could respond to the romanticism of intensity driven to its limits. Five years later, one sees the results, and it is impossible not to reflect and wonder about the irresponsibility that applauded such excess in the first place. But however one looks at the past, the present is grotesque, and anybody who stands to make money from this tour should feel ashamed.

CLEO LAINE

The New York Times, October 4, 1974

Cleo Laine has clearly captured a certain segment of the New York audience completely. Wednesday night's Carnegie Hall appearance was yet another triumph for the British pop-jazz singer, who made her New York debut two years ago, and who was once again appearing with a small combo led by her husband, John Dankworth. The house was sold out and the audience was rapturously enthusiastic, hurling flowers onto the stage.

Wednesday's program contained a few of her old favorites and a medley of some of her special hits. But Miss Laine is such a wide-ranging singer that the songs were largely new, and her fans didn't seem to mind much at all.

The reasons for all the fuss are easy enough to see and hear. Miss Laine has a voice that ascends from a husky contralto all the way up to glass-cracking howls in alt and above. She has a frighteningly accurate ear and a teasingly infallible sense of rhythm. She has a repertory that answers every nostalgic need. And she has a persona, mockingly casual, that many find irresistible.

But for this listener, admiration stops a good deal short of affection. Miss Laine strikes me as a calculating singer, one whose highly perfected artifice continually blocks communicative feeling. To me, she has all the personality of a carp. But then, obviously, I'm just a cold fish.

MYSTERY TRAIN

The New York Times, June 14, 1975

Mystery Train: Images of America in Rock 'n' Roll Music. **By Greil Marcus. 275 pages. E. P. Dutton & Co. Inc. $8.95.**

Greil Marcus has written a book that takes rock and roll seriously. Maybe too seriously. But the sheer intelligence with which he

approaches recent American popular music is so evident and so unusual, and the sheer passion that motivates his love of this music so transparent, that his book can be most heartily recommended to almost anybody.

The book begins with two short essays on men Mr. Marcus calls "ancestors"—Harmonica Frank, an eccentric white man whom few have heard of but whom Mr. Marcus considers a direct precursor of rock, at least in spirit, and Robert Johnson, a black bluesman from the 1930s who has influenced every rock musician.

The core of the book is divided into four chapters: on the Band, Sly Stone, Randy Newman, and Elvis Presley. Although each of these chapters has a focus, none is limited to its ostensible subject. Mr. Marcus broadens the discussion to include not only other musicians (the Sly chapter, for instance, pretty much covers the whole recent history of American black popular music), but more crucially broader themes in a consideration of American culture.

The Band chapter is thus really about "groups [as] images of community" and about the questionable solution that rural retreat suggests for contemporary America. The Sly chapter is about black sensibility and politics as reflected in black music. With Randy Newman—the least commercially successful of his central foursome—Mr. Marcus concerns himself with the tension between popularity and artistic value, and affirms his own populist's belief that, in a democracy, an artist denies his deepest nature by ignoring the country as a whole.

With Mr. Presley—whose chapter is almost as long as the other three together—Mr. Marcus sums up his search with the man beside whom "the other heroes of this book seem a little small-time." For him, Elvis is the ultimate American myth made real—the little man who made himself big on his own terms and changed the country's consciousness as he did so. Even Mr. Presley's decline into schlock (with periodic bursts of the old vitality) strikes Mr. Marcus as symptomatic of America, and somehow he manages to maintain an underlying optimism even as he chronicles that decline.

The book ends with a long section of notes and discographies, which is as valuable a part as any other. Here Mr. Marcus reserves the hard-core devotee's fascination with records and performances that he has largely pruned from the rest of the book. The four principal chapters deal with the music, of course, and most perceptively. But the argument isn't overburdened with a fan's enthusiasms about the various discs of his idols.

Mr. Marcus is a fan, however—he couldn't have written with such pros-elytizing ebullience if he weren't—and at the end he shares his knowl-edge with his readers.

The size of the discography indicates, though, that this is really a book that will attract two sorts of readers, and that what appeals to one may alienate the other. Mr. Marcus isn't only a rock writer of distinction: he also spent time working toward a doctorate in political theory at the University of California at Berkeley and teaching there.

Thus this book is by no means meant only for rock fans. It is meant, perhaps most of all, for people concerned with what this country and its culture are all about. And as the continual references to American liter-ature and to such academics as Leslie Fielder make clear, that kind of reader will—given the generation gulf that still divides the pop-music audience in this country from adult culture—most likely not know much about the music under discussion here. In fact, Mr. Marcus runs not only the risk that his subject matter will be too arcane, but also that many potential readers will have an active prejudice against it. The kind of castles-in-the-air speculation that he indulges in is common practice among academic literary historians, but less common (unprecedented?) in writing about recent popular music. Mr. Marcus's book is likely to be scorned in some quarters for telling us far more about him than about its ostensible subjects, which "everybody" knows are really beneath "seri-ous" consideration.

From the other side, the rock fan who just wants to boogie, aurally or intellectually, may be put off by Mr. Marcus's cultural-historical preten-sions. Following his arguments step by step can be fascinating. But sometimes one pulls up and begins to wonder just how far afield he has led us: Is Robert Johnson's work really Puritan? Was Sly's album *There's a Riot Goin' On* really such an influential, significant turning point, or was it maybe just a not so hot pop record?

At his worst, Mr. Marcus comes across as a self-satisfied academic rhetorician, spinning out indulgent theories that owe more to them-selves than to a perception checked continuously against reality. Or he's like a minister who has to preach every Sunday, even if he doesn't always have anything special to say.

But that's only at his worst, which isn't very often. At his far more fre-quent best, he is a writer of rare perception and a genuinely innovative thinker. Cultural history deals in the relation of culture to the wider forces of history, and usually it slights one or the other. Mr. Marcus

remains sensitive to both, and his blend of love and expertise should be read by anybody who cares about America or its music.

METAL MACHINE MUSIC

The New York Times, June 20, 1975

Lou Reed has an onstage image of off-the-wall instability, and it has served him well. His rock songs have always played with notions of treading a line—the line between sanity and insanity, the line between the sexes, the line between love and hate.

But one imagines that his latest record, a double album called *Metal Machine Music*, will convince many of his admirers that he has finally tripped over the line between outrageousness and sheer self-destructive indulgence. This is over an hour of screaming, steady-state electronic noise. Mr. Reed makes some reference in his mostly elliptical liner notes to heavy-metal rock, of which this is presumably some sort of abstraction. But the abstraction is so absolute that it will leave most rock fans gasping for air. Next to this, Kraftwerk sounds like Chuck Berry.

Actually, though, Mr. Reed's latest musical experimentation is hardly unprecedented in the world of the classical avant-garde. Mr. Reed makes specific reference in his notes to La Monte Young (even if he does misspell the name), and John Cale and others in the original Velvet Underground were close to Mr. Young, who has been turning out vaguely similar electronic music for years.

European composers like Iannis Xenakis have also produced analogous work (cf. Xenakis's *Bohor* on Nonesuch Records), all of it seemingly constant in its sonic onslaught, but actually consisting of a myriad tiny overlapping layers of sound. The initial impact of Mr. Reed's piece, not unsurprisingly, is of unrelieved anger. But just beneath the surface is a wealth of listenable detail. All this sort of music is dismissed by some as a head trip, properly produced and appreciated only by members of a drug culture. Certainly *Metal Machine Music* won't hurt the image Mr. Reed projects as a drug cultist.

It will be fascinating to see how this record is received. Clearly it

won't sell wildly; it's too forbidding even for the sort of pop fan who is starting to buy the German space-rock records. But what will it do to Mr. Reed's sales the next time he puts out a "real" rock record? He himself is clearly full of hostility about the whole problem of balancing his rock-star career with his need to experiment; his opaque liner notes, whatever else they tell us, certainly convey that tension.

One would like to see rock stars take the risk to stretch their art in ways that might jeopardize the affection of their fans. But one can't help fearing that in this instance, Mr. Reed may have gone farther than his audience will willingly follow.

SMOKEY ROBINSON

The New York Times, June 28, 1975

Smokey Robinson was the lead singer of the Miracles, one of the most popular of all soul groups, from 1958 through 1972. His appearance Thursday night in Carnegie Hall—his first here since he resumed his performing career as a solo artist earlier this year—proved that he had lost none of his magic.

Mr. Robinson was the composer of some of the best soul songs of the 1960s. And his singing style—a subtle blend of high tenor crooning and ethereal falsetto—became a model for a whole flotilla of imitative groups, among them the Stylistics and Blue Magic. It is a sound that has appealed more to black audiences than to white, but Mr. Robinson and the Miracles always enjoyed significant white sales, too. Thursday's crowd was mixed, but blacks were in the majority and seemed to provide the bulk of the responsive enthusiasm.

That enthusiasm came mostly from the women, and it recalled the communal fervor of black churches or the Apollo Theater. One fan kept moaning in the loudest possible voice, "Oh, my *God*, oh, my *God*."

But the most extraordinary response came when Mr. Robinson swung into a greatest-hits sequence with a song called "The Tracks of My Tears." Without even being prompted, the women began to sing along, chorus and verse, and Mr. Robinson found himself joining antiphonally

with what sounded like a trained female chorus numbering in the hundreds.

Mr. Robinson sings both up-tempo songs and ballads, but it is in the slower, more sensual material that he makes his true mark. His isn't so much a style for biting rhythmic impact as it is for caressing and embroidering a phrase in an intensely erotic way—the kind of music where time disappears and the singer plays with his listeners' expectations.

Mr. Robinson has lowered the keys of most of his repertory, and the specific kinds of harmonies the Miracles used to provide him are no longer there. But his two women back-up singers and his seven-piece band—headed by Marv Tarpin, a guitarist and the collaborator on many of his best songs—provide him admirably flexible, understated support. One hopes that Mr. Robinson will return here soon; his kind of artistry is worth hearing far more often than every three years.

TOP POP SINGLES

The New York Times, **July 18, 1975**

Periodically, samples are taken of what passes for water off our beaches to decide where bathers can swim uncontaminated. On the same theory, this column proposes to sample the top 10 pop singles periodically, in order to ascertain if there's anything out there on the airwaves worth listening to. The water has reportedly improved; maybe the music has, as well.

Actually, of course, the association with pollution may be unfair to pop artists, who are, after all, turning out a music of undeniable vitality and occasional real merit. Perhaps some sort of gold-panning metaphor might be more polite.

Some general comments: First, dancing is back. Whenever pop gets too arty, its roots in rhythm seem naturally to reassert themselves.

Second, electronic instruments have become a working part of pop instrumentation. The special favorites are synthesizers and other electric keyboards (see "Love Will Keep Us Together," a whole overdubbed symphony of such instruments, ebulliently played by "Captain" Daryl Dragon) and electric guitars colored by various kinds of filters.

Third, *Record World*, one of the trade magazines, thinks rock is reasserting its hold on the pop charts. Maybe so, but it isn't obviously apparent from the current top 10.

Fourth, Latin music hasn't really affected the top of the charts yet, except in the syncopations of disco rhythms. The influence there is considerable, however, and is likely to grow.

Fifth, singles are sloppily pressed. Of the ten discs purchased for this column, two were pressed off-center (Paul McCartney's and Olivia Newton-John's) and one was warped (Melissa Manchester's).

So here's the top 10, collated from the sales charts in the three music-industry trade magazines, with capsule comments:

1. "Listen to What the Man Said," Paul McCartney and Wings (Capitol): This mostly indifferent record proves that pop still sells. It also proves the lasting appeal of the Beatles in general and of Mr. McCartney in particular. In fact, stars dominate the top of the charts: Mr. McCartney and the holders of the third, fifth, and eighth spots have all had other top-10 singles this year, and two other artists (Elton John and Linda Ronstadt) have already had two hit singles, each this year, even if they're out of the top 10 at the moment.

2. "The Hustle," Van McCoy and the Soul City Symphony (Avco): A classic mindless dance record, with a catchy beat and water-torture chorus. Cute.

3. "One of These Nights," the Eagles (Asylum): The Eagles sound plodding and pretentious here, and their vaguely American Indian effects seem little more than annoying.

4. "Love Will Keep Us Together," the Captain and Tennille (A & M): The surprise hit of the year. Buoyant and fresh, and pungent in its use of all those keyboards.

5. "Please, Mister Please," Olivia Newton-John (MCA): Miss Newton-John strikes a simpering pose guaranteed to drive feminists crazy, and her mewing, phony-country work in the verses makes one wish that Emmylou Harris would hurry up and supplant her in this repertory. But then the chorus comes along, and it's so undeniably catchy that you realize Miss Newton-John has a place in bubble-gum country after all.

6. "Magic," Pilot (Capitol): A really engaging teen-rock hit, slick but vital. The opening, with that triumphant adolescent tenor whine reminiscent of Mr. McCartney's best days with the Beatles, is like a cock crowing.

7. "I'm Not in Love," 10 cc (Phonogram): The most interesting sin-

gle on the top 10, and certainly the most progressive. The ethereal choral chorus (synthesized?) is really more important than the vocal up front.

8. "Swearin' to God," Frankie Valli (Private Stock): Tin Pan Alley lives, just barely. Junk, even if it is proficiently done.

9. "Rockin' Chair," Gwen McCrae (TK): Clever disco music, and proof that insinuating sexual innuendo survives on the airwaves to this day.

10. "Midnight Blue," Melissa Manchester (Arista): Like Barry Manilow, another product of the Bette Midler stable, Miss Manchester has achieved success by stripping Miss Midler's theatricalized nostalgia of its irony. Good of its type, though.

ELVIS PRESLEY

The New York Times, July 21, 1975

Elvis Presley played Madison Square Garden in 1972 for the first and last time. Since then, he has stuck to the suburbs, like most middle-of-the-roaders. Except that, when he wants to, Mr. Presley can still rock, and he felt like rocking a refreshing lot of the time Saturday at the Nassau Coliseum.

When this observer last saw Mr. Presley, it was also at the Nassau Coliseum, two summers ago. Then he was fat, lazy, and ineffectual. On Saturday he was still fat—fatter than ever, a blown-up cartoon of his spare 1950s toughness. But he wasn't lazy, and he most certainly wasn't ineffectual.

Fat or thin, overpowering or futile, he still inspires and accepts the adoration of his fans with the good-humored grace of a king. Mr. Presley's fans may not number all the country these days: His records are no longer guaranteed the top spot on the charts.

But his concerts still sell out sports arenas months in advance, and his Coliseum audience consisted evenly of people from small children to grandmothers. They were polite and neatly dressed; decorum prevailed before the star's appearance and well-mannered ecstasy when he was

onstage. His following probably includes a broader sweep of white Americans than that of any other pop performer.

The ritual at any Presley concert has grown ornate with age. Like many other pop stars these days, he announces his imminent arrival with the Richard Strauss fanfare used in 2001; for him, it seems more cosmically fitting than for some.

When he finally emerged, he was greeted by a tidal wash of squeals and flash cubes. Mr. Presley's roots lie in country music, and country crowds are particularly addicted to taking flash pictures of their favorites. But the rippling explosions of light whenever he turns in a new direction are really unique.

Saturday afternoon's costume had been laboriously conceived to disguise and distract attention from his size, and its most striking aspect was its sheer lavishness: basically black, bellbottom pants and a vest over a puffy, doublet-sleeve shirt, but extravagantly overlaid with "jewels" (presumably rhinestones) arranged in baroque exaggeration of American Indian designs. It looked wonderful.

Mr. Presley's onstage manner is full of bits of business to the audience and to members of the band. There was even more joking than usual Saturday afternoon; he seemed to be in a particularly affable mood. And there are always the teasing glances and winks and the half-crouched self-parodies of the "Elvis the Pelvis" swivels of yore.

When Mr. Presley cares about a song, he cuts out most of the vaudeville. But when he finds himself mired in material he has long since ceased to care about, the scarves-and-kisses rite begins.

Trailed by a dutiful "gofer" who loops scarves around the Presley neck whenever they are needed, Elvis approaches the crowd, picks a hand from the stalks of stretching arms, and pollinates it with a scarf. Each scarf has graced the neck at least momentarily; one was further blessed by having been brushed under his arms.

Sometimes Mr. Presley will kneel among the upraised arms, and lean over and kiss. Saturday afternoon he kissed little children and women of all ages; no men. The kissees wander dazedly away, sanctified. The aura of revival is intensified by the fact that all Mr. Presley's backup vocalists are white and black gospel singers.

When Mr. Presley first struck the American consciousness twenty-one years ago, he epitomized tough, young rebellion. Outrageously sexual, his songs were charged with a rhythmic energy that swept the simperings of Tin Pan Alley aside and gave birth to rock and roll.

But then he went into the Army and emerged into a drab sequence of schlock movies. Through most of the '60s, he functioned as a purveyor of soupiness, his dancing energy and his sexuality overlaid with a ponderous maturity.

His much-ballyhooed comeback to live concertizing in 1968 signaled a brief spurt of renewed energy. But then he settled back into a curiously unpredictable pattern of alternating quiescence and conviction.

On Saturday afternoon, there were a few nods in the direction of bathos, and the few rock oldies were mostly mumbled and thrown away, although he did do his early "Mystery Train," and "Heartbreak Hotel" did begin with some spunk.

But the bulk of the show was moderately up-tempo material or overt rock, much of it relatively unfamiliar to a crowd that would squeal at the first recognition of a favorite. It was as if Mr. Presley had decided to recast his repertory in imitation of the livelier sides of Charlie Rich and Tom Jones.

But really, Mr. Presley imitates nobody. The youthful sexuality has long since gone; it couldn't be otherwise. But in its place there is a wonderfully relaxed, ironic affection that can be almost as nice.

His baritone is still as solid as ever, with its humorously cavernous bottom and its nasal vibrato on top. When he is putting out as he did Saturday afternoon, reaching for the top notes and shaping phrases with the same easy individuality that has always marked his best work, he is still the king.

EARTH, WIND AND FIRE

The New York Times, July 27, 1975

Earth, Wind and Fire (what happened to water?) is a nine-man black band that can be called flashy in both the figurative and literal senses of that much overused adjective.

The group, which comes out of Chicago and which played for a sold-out Madison Square Garden crowd Friday night, is full of fire and spunk in its disco jamming, with a full panoply of partying dance steps, flash-

ing spotlights and strobes, smoke bombs, dry ice, and gymnastic props, including a harness that lifted the electric bass player and allowed him to somersault in midair as he played and a platform for the drummer that hoisted him off the floor and then twirled him around, again as he played indomitably on.

It has become a cliché that when you either don't like the music or don't know what to say about it, you discuss it in sociological terms. But in Earth, Wind and Fire's case, it is hard to avoid a description of the crowd, so closely does the band echo the audience's expectations and so seamlessly does the crowd extend the band's aesthetic.

Musically, this may not be strikingly original, although it must be admitted that the group pounds out its mélange of soul and disco styles with a rare flair and conviction, and that conviction, to any music, is half the battle.

But this is really an art that can be appreciated only with an audience like Friday's. This observer has been to innumerable concerts in which a band implores the crowd to say "Yeah!" and gets a tepid response. But the "Yeah!" that greeted the request preceding the encore on Friday was the loudest, most exultant "Yeah!" he has ever heard.

The whole concert was like that, the crowd blowing whistles, dancing, and singing along, and Madison Square Garden rattling with tambourines and jumping with the little green plastic phosphorescent light-makers that are all the rage this summer. This is the kind of band that a deaf man would know was OK, just by looking.

THE HUSTLE

The New York Times, September 5, 1975

This observer spent his summer vacation learning to hustle—the dance, that is.

It was not an easy experience. The basic step seems simple enough, performed independently of the music. But what one knew all along cerebrally—that overtly popular music has grown a lot more complex since the slugged-out duple meter of earlier rock and roll—becomes a

whole new matter when one's body gets into the act. The music's syncopations and cross-currents pose dramatic problems for wayward feet, which persist in lagging behind the beat.

But all that can be mastered neatly enough. Where it gets tricky is trying to coordinate with one's partner. The hustle, in all its many variants, consists basically of a step out and back with the left foot, ditto with the right foot, and a lot of jiggling about before you repeat the left-right process again. The jiggling about is theoretically counted as three steps, and that's what's complicated in conjunction with the rest.

The central problem boils down to making the left-foot and right-foot thrusts at the same time as one's partner. The key rule would really seem to be that one can do anything in the jiggling part, or "verse," as long as both partners get together on the "chorus." Above all, whatever the steps, everything must be executed with confidence and style. It doesn't so much matter what one does as long as one is doing pretty much the same thing as one's partner and one gives the impression of absolute mastery.

All of which—when one has retreated to the sidelines to gather breath and count bruises before hurtling back onto the dance floor—is of great interest to veterans of the free-form, individualized rock dancing of the 1960s.

Agnes de Mille, the noted choreographer, has been waging a campaign for years to bring partnering back to pop dance; she must be gratified now. Certainly the experience of working with a partner is not only fun (once you get past the stepped-on-toes stage) but also instructive and symbolic of larger human relations.

But free-form dancing wasn't the atomized, dehumanized nightmare that Miss de Mille seems to think it was. It was fun and it could be creative. And it eased the hierarchy of skill that inhibits so many self-conscious potential dancers. In the '60s, everybody could dance, and nobody had to worry about getting it "right." The hustle is fun, and one hopes stylish partnered dancing is back for good. But one also hopes free-form dancing holds its place in our discos, if only to leave us oafs our illusions of grace.

PATTI SMITH'S *HORSES*

The New York Times, November 7, 1975

Note: The whole 1970s New York punk/new wave/art rock scene was remarkable, but of them all, Patti Smith moved me the most.

Patti Smith's first album, *Horses*, should be in the stores about now. It's an extraordinary disc, and every minute of it is worth repeated hearings, but you can learn about all you need to know of the essential Patti Smith by listening to the first eighty seconds of a "song" on the second side called "Land."

"Land" begins with unadorned words, declaimed rhythmically with Miss Smith's intensely personal urgency. The words are about typical events—a boy, a school hallway, lockers, another boy. As she describes the other boy, her own voice, overdubbed, creeps up toward her first voice, locking into phase with it.

Miss Smith's visions arise out of normalcy but then transcend it almost instantly. Very soon the boy in the hallway is being assaulted, homosexually or murderously or both, by the other boy. Miss Smith never stops at violence and sex, either, and within another few seconds she has shifted into cosmic apocalypse, with other planes of reality breaking through into ours.

The boy finds himself surrounded by horses, proud and circling, their noses in flame. And then the music, which has been rising in tension and volume all this time behind her, releases into basic infectious rock and roll, and Miss Smith is into a chanted litany of pop dances, starting with "Do You Know How to Pony?"

Patti Smith comes from New Jersey, like Bruce Springsteen, but the two aren't very much alike. Miss Smith, now twenty-eight years old, arrived in Manhattan some years ago and made her first impact as a visionary poet. But her readings quickly evolved into ritualistic chants— a predilection she shared with several other poets (Allen Ginsberg), composers (Charlie Morrow), and even dancers (Meredith Monk), but which she pushed further and deeper than any of them.

Chanting alone turned out not to be enough, however, especially considering her longtime fascination with rock, and by a couple of years ago she had begun to put together the nucleus of a Velvet Under-ground–ish rock band. Late last summer she finally added a drummer

(the missing link) and won a record contract, of which *Horses* is the first result. Touring, promotion, press parties, and all the superstardom that poets from New Jersey turned rock and rollers from Mars can expect will soon be hers.

It's hard to imagine Patti Smith as anything more than a cult hero on the order of, say, Randy Newman, though. Any AM, top-40s success she might win would surely be of the novelty sort, or at best no more lasting than that of David Bowie. She's just too weird. But she's a lot more than just weird, so that maybe enough people will respond to the shamanistic compulsion of her art to make her a commercial success.

All song strikes a balance between words and music. Sometimes the music supports the words; or, commonly, the words become a more (in a typical opera aria) or less (in rock) audible excuse for the music. Does anybody really care what Bernie Taupin and Elton John are trying to tell us in "Island Girl"? What we care about is that silly hook of an upward-sliding guitar chord and Mr. John's bouncy music.

But with *Horses* you simply have to listen to the words, carefully. As a record, *Horses* plays it absolutely straight: There is no attempt here to capture Miss Smith's quirky between-songs comments or the actual atmosphere of a concert. These are simply eight "songs," sung as musically as Miss Smith can manage. But the words are really the thing, for all the indispensable support the music so aptly provides—the words and Miss Smith's way of shaping them into incantatory visions.

All of which will repay endless hearings and may sound a bit peculiar on the car radio after "Island Girl."

Devotees of Miss Smith will want to know how honestly and accurately this record captures the feeling of her club performances, and the answer is—with the obvious exception noted above—marvelously. The balance between voice and band is perfect, and the big basic sound is the tacky, ricky-tick rock that her quartet produces live.

But John Cale, the producer, has made his presence felt, and in a way that reaffirms the inspiration behind his selection. Mr. Cale shares many of Miss Smith's antecedents, after all (he was one of the founders of the Velvet Underground), and has his own rather wonderful solo albums as credentials. The songs are infused with discreet, subtle touches that enhance them, and the vocal overdubbing in "Land" (reportedly Miss Smith's idea) is handled brilliantly.

Horses may be an eccentricity, but in a way that anything strikingly new is eccentric. It will annoy some people and be dismissed by others.

But if you are responsive to its mystical energy, it will shake you and move you as little else can do.

THE WHO

The New York Times, **December 17, 1975**

Philadelphia, December 16—Thwarting the order of nature and the clammy strictures of time, the Who returned for a full-scale, three-part American tour November 20 in Houston. The band may make it to New York sometime during the second part—in about ten weeks. But in the meantime, last night's concert at the Spectrum here, which ended the first leg of the tour, is the closest the group is getting to Manhattan.

For those who haven't heard, the Who is a British rock quartet that came together in its current configuration—Roger Daltrey, singer; Pete Townshend, guitar; John Entwistle, bass; and Keith Moon, drums—in 1964. As such, it is the oldest rock band in the world—of those that have stayed together continually with the same members.

The Who isn't only old; it is obsessed with age—or at least Mr. Townshend, its chief songwriter and guru, is so obsessed. Ten years ago, Mr. Townshend was writing defiant anthems of youth—"Hope I die before I get old" was perhaps its most succinct formulation, in a song called "My Generation." And in the band's latest album, he broods gloomily about life and youth passing him by.

The age problem is compounded because the Who has always been a young people's band. Unlike the Rolling Stones, the Who has never really caught on with the Establishment press and high society. Widely recognized as the best of the pure rock bands, the Who has remained an underground phenomenon even as it sells out outdoor sport arenas.

But age isn't the band's only trouble. Most of the members seem to dislike one another—an antipathy possibly fostered as part of the group's brawling, hostile image but apparently nonetheless true. And given Mr. Townshend's moodiness and perfectionism, long stretches pass with no group activity. As a result, all four have wandered off to do solo albums and other ventures—Mr. Daltrey, for example, to star in two Ken Rus-

sell films (the first being *Tommy*, the Who's rock opera, that involved the band as an entity only peripherally).

Things didn't look too hopeful for Who fans, who are a tense and loyal bunch, and they looked even worse after the band's scrappily rehearsed, indifferently executed run of four performances in June 1974 at Madison Square Garden. Reports from Houston didn't sound too promising, with even Who diehards complaining of a long, unfocused set.

But on the basis of last night's show, Who loyalists can take heart. Even with erratic sound, this was as fervent, tight, and thrilling a Who performance as this observer has ever seen. When these men are on form, there is nobody to surpass them in rock and roll.

The show opened with a lively, engaging, and grumpily received half-hour set from Toots and the Maytals. The Who played for an hour and forty minutes (considerably less than in Houston), beginning with "I Can't Explain," their first single, and running through a variety of favorites old and new (two from the latest album) for forty-five minutes, ending with "Magic Bus." Then came half an hour of *Tommy* (there was nothing from *Quadrophenia*, Mr. Townshend's other rock opera), capped with a flashy laser display and full wattage from the lavish lighting frame. The show ended with twenty-five minutes of "Summertime Blues," "My Generation," "Join Together" (a 1972 single), and "Won't Get Fooled Again."

The Who has several secrets for its success. First, there is the creative tension between Mr. Townshend's subtlety and artistic ambitions and the rude power of the rock that the band as a whole sticks to. Second is the contrasting stage personalities of the four. And third, there is their demonstrable musical talent—Mr. Daltrey's strong, raspy voice and screams; Mr. Entwistle's rock-solid bass playing; Mr. Townshend's fascinating blend of lead and rhythm guitar styles (mostly the latter, with rhythmically precise, full-bodied chordal attacks), plus his nervously stuttering synthesizer work on tape; and perhaps above all Mr. Moon's drum playing. Mr. Moon has his off nights; last night he was triumphantly on, punctuating everything with perfectly judged syncopations and feisty flurries of ornamentation.

What it all amounts to is the quintessence of rock's energy and passion. Both energy and passion are generally thought of as youthful attributes, and there have been times recently that everyone—both the members of the Who and their followers—must have thought time had

passed them by. But it all came together last night, however illusorily and temporarily, and it was a wonderful thing to behold.

PATTI SMITH IN CONCERT

The New York Times, December 28, 1975

Patti Smith fought what may have been the most crucial battle of her life Friday night. And in fighting it in front of an audience at the Bottom Line and lifting the combat into the realm of art, she made it seem about as epochal as anything this observer has seen.

The occasion was the late show of her opening night at the club, where she is playing seven hopelessly sold-out performances through tonight. This is her big New York showcase. So far she has played only on the underground scene here, for all practical purposes. She's already performed at the Roxy in Los Angeles, and she embarks on a full-scale national tour after New Year's Day. But New York is her town; this is where the national and international press is; and this weekend at the Bottom Line is where—she must quite legitimately feel and fear—people think she has to put up or shut up.

She had some cause for worry. Ever since she emerged from South New Jersey in the late 1960s, she has been both a leader and oddity in whatever circle she chose to move. First an artist's mistress, then an artist, then a rock-and-roll scene maker and poet, then a chanting poet, and finally a poet turned rock and roller, she has always walked the line between genius and eccentricity, between the compelling and the merely odd, between art and insanity.

The word "insanity" may seem a little strong; this listener hasn't been inside Miss Smith's head. But she acts crazy sometimes, and if it's an act, it's an act that she plays so intensely that it's became its own kind of reality. And she says she has been crazy: "I was hallucinogenic all my life— not on drugs," was the way she put it the other day. "Robert [Mapplethorpe, an artist and her first New York boyfriend] taught me to siphon insanity into art. He helped me exorcise my demons into a form."

When she first started performing regularly at the Mercer Arts Center in 1972, she had to learn to deal with hecklers and hostility. But more recently she has been playing to a growing cult, at clubs like Max's Kansas City, CBGB's, and the Other End, and at her own "Rock 'n' Rimbaud" performances.

"I work well when people believe in me," she says, and all her life there have been people to give her confidence—first her family and especially her sister Linda (Patti is twenty-eight, and Linda, who lives now in California, is twenty-seven; there are two younger siblings), then her manager of four years, Jane Friedman, then her band, and, most recently, her audiences.

Patti Smith's problem now is that her album has come out and she has to start living out the fantasy of being a rock star that she has nurtured for so many years. She has to face audiences that don't know what to make of her, and she has to do it night after night, in city after city. The mystical, mad prophetess has to find some way to keep her art compelling but to make it an art—to formalize its energies into something shaped and repeatable. If she fails, she will either lose her uniqueness or she may wind up the way of some of her closest heroes, whose spirits she continually evokes—Jim Morrison, Janis Joplin, and Jimi Hendrix.

Those of us who have followed her career were nervous. Her first appearance uptown, as part of an Arista Records showcase at the City Center in September, had gone poorly: she was scared and the sound system obliterated the words that are so crucial to any Patti Smith performance. And last month, at a downtown dance studio, the sound system had been equally blurred, and she herself had slurred her speech and mumbled through her spoken remarks disconnectedly.

The first show Friday at the Bottom Line reportedly went well. She was nervous, but she gave a good performance. But the second show was a different matter.

Miss Smith is her own opening act this weekend. The idea is to come on, chat with the crowd, and read her poetry, some of it accompanied by Lenny Kaye and his guitar—just as it was when she began her readings at St. Mark's Church in 1971.

Only Friday it wasn't working. She was scared or stoned, and the phrases were jerky and fragmentary. She couldn't focus on her own book, and the monologue wavered off into girlish ramblings, punctuated by giggles and pockmarked by memory lapses.

When she came back with the band, it was as if a different person had

inhabited her body. Instead of flighty confusion there was grim, purposeful power—abetted, one thankfully noted, by a solid sound system that let the words be heard without undermining the impact of the band.

Her opening song was called "We're Gonna Have a Real Good Time Together," and on Friday the mood of her rendition of it was even more of a threat than usual. Miss Smith, in her search for support, had earlier appealed to the audience for its energy. She looked when she came back as if she felt betrayed—cast up there onstage by a hostile crowd and condemned to collapse before her judges. Except that now she was fighting back, desperately, struggling to master her own energies and hurl them back at her tormenters.

It was a "performance" terrifying in its intensity, like some cosmic, moral struggle between demons and angels. At one point during one of her new songs she slumped to the floor and started banging her head against the organ. It was reminiscent of Iggy Pop's self-mutilations or the excesses of SoHo performance artists, except that it had the fervor of reality.

The climax came with versions of the two long songs on her album, "Birdland" and "Land." "Birdland" was arguably the best single performance this listener has heard her give—slow, thick-tongued, rapt, fanatic, possessed. And "Land" reached its climax in a self-purgatory section in which she screamed out to the crowd to allow her the right "to fear to fail in front of you" and to help her avoid letting herself "fall into a formula." It was her own drama transformed into art but hardly disguised in the process, and all the more real for that.

She came back for encores of the Rolling Stones' "Time Is on My Side" and the Who's "My Generation," the last with John Cale on bass and Miss Smith on guitar, working up a quite fearful amount of raw noise. The battle won and the demons overcome, she could go back to her old, appealingly arrogant self again, cocky and cool. It was as if she realized that all along the enemy hadn't been the audience, but herself.

JON VICKERS

The New York Times, February 8, 1976

Jon Vickers's admirers didn't quite fill Carnegie Hall on Friday night for the Canadian tenor's recital, his only New York appearance of the season. But they filled the hall with their enthusiasm, all the way through the third encore, the "Winterstürme" aria from Wagner's *Die Walküre*. There was admittedly much to admire, but there was also good cause for dissatisfaction.

Mr. Vickers has one of the finest, most characterful voices before the public today. A manly, full, reasonably bright heroic tenor with a solid baritonal bottom, it can be modulated with apparent ease down to the subtlest blends of falsetto and head tone. Heroic tenors often push and bellow, and lose nearly all flexibility and grace in the process. Mr. Vickers's vocal method isn't exactly Italianate, but on its own terms—heroic bel canto—it is a fine example of natural talent and mature technical development.

In addition, Mr. Vickers escapes another tenorial stereotype: he is demonstrably intelligent. Throughout his career he has given evidence that he cares for more than stentorian top notes, and his program Friday approached the eccentric in its determination to avoid the typical. There were arias by Handel, from *Semele* and *Samson*, songs by Purcell as arranged by Britten and Alessandro Scarlatti. There were Beethoven's "An die ferne Geliebte," a song and an aria by Ralph Vaughan Williams, and five Gypsy Songs of Dvořák. And, as encores, two light ballads and—finally, for those waiting for familiar operatic repertory—the Wagner.

But if Mr. Vickers is smart, he is often far too smart. His singing Friday was afflicted with all manner of mannerisms, and nearly all of them weren't so much a result of painstaking interpretive care as of simple self-indulgence. Mr. Vickers weaved back and forth between full voice and crooning. He wobbled and yawed rhythmically. He swelled and faded long-held syllables and distorted vowel sounds with little regard for musical phrase or declamatory integrity. And, extramusically, he paced and bobbed distractingly about the stage.

There was much to admire, nonetheless, particularly the Purcell-Britten songs, "Total Eclipse" from *Samson*, the "Song of the Road" from Vaughan Williams's *Hugh the Drover*, and the Wagner. But one's

annoyance at the rest was heightened by an awareness of what a great singer Mr. Vickers could really be if he would just relax and sing, honestly and unaffectedly.

Richard Woitach accompanied with a nice blend of supportiveness and musical integrity.

THE COMPLEAT MEREDITH MONK

The New York Times, March 28, 1976

Meredith Monk, whose new music-dance-theater event, *Quarry*, begins Friday at the La Mama Annex, has called her works operas, opera-epics, theater cantatas, live movies, composite theater, nonverbal opera, visual poetry, image dance, and mosaic theater. Miss Monk started her professional life as a dancer, however, and most of the time she has been reviewed by dance critics.

Her work has been both extravagantly praised and disparaged. In 1967, for example, Anna Kisselgoff called her "spectacularly original" and Clive Barnes dismissed her as "mildly tedious." Two years later Mr. Barnes denounced her as "a disgrace to the name of dancing," but recently Robb Baker of the *SoHo Weekly News* rhapsodized that she "is the most significant intermedia artist of our time."

I can remember reading about her *Vessel* four years ago and feeling that I just had to get out of Los Angeles, where I was living, and go to New York, where such amazing things were happening.

What got to me more than anything was Deborah Jowitt's description in the *Times* of "the final hair-raising moment when Monk, identified as Joan of Arc . . . begins an odd skittering little dance that carries her into the depths of a parking lot, where she disappears into the flame and sparks of a [welding] torch."

Miss Monk's most recent evening-long piece, *Education of the Girl-child*, is representative of her approach and concerns. Presented first in a downtown space in the summer of 1973, then repeated in an expanded version both downtown and in the shadowy recesses of the Cathedral of Saint John the Divine, it was theatrical, but hardly conventional Broad-

way. There were theatrical tableaus with six women, Miss Monk among them, in various sorts of white costumes and a seventh in festive Peruvian peasant attire. In the first part, they went through a series of rites and visions, some verbalized but mostly danced and mimed. At one point there was a medieval morality play, with the figure of death appearing in two different, ornate guises and a grotesque, Boschian dance of death. There was a lurching procession, the kind that sometimes appears on the hour in European city-hall clocks, with each woman bearing on her head some symbolic, totemlike prop—a globe, a miniature house, a lizard, a bunch of roots. At the end of the first part, Miss Monk was costumed as an ancient crone and left to sit alone, immobile throughout the intermission, on a cloth-shrouded throne from which stretched a crumpled white river of cloth. In the second part, she proceeded to execute a forty-five-minute solo, passing through all the stages of a woman's life in reverse, back to childhood. Finally, she stepped off the cloth and was held, dazed, as her five woman companions, dressed in velvet gowns, revolved slowly in place.

But that description, which may suggest the surrealist dream pictures of Robert Wilson, can't begin to capture the complexity of the piece. In all her work, there is a tangled undergrowth of private imagery—sometimes so much of it that Miss Monk can be justly accused of overloading her audiences with incomprehensible symbolism. In addition, there are her extraordinary settings, costumes and, especially, props. And, of course, powerful dance elements, too. Miss Monk's sense of movement and her choreographing of group movements remain among the most acute of the dance experimentalists—full of quick stylizations of natural motion; funny, oddly flowing, puppetlike jerkiness; and sudden ritual poses. And then there is her music, which so far has included childlike keyboard pieces vaguely reminiscent of Eric Satie and Miss Monk's own yelping, chantlike singing.

After *Girlchild*, in 1974 and 1975, came a still-to-be-completed series of smaller works, most co-created with Ping Chong, a multimedia artist and longtime collaborator. But much of Miss Monk's time over the past two years has been spent in preparing *Quarry*, which will run at La Mama through April 18. Miss Monk is loath to dwell on the specifics of the new work, but it is clear that in broad terms it represents an extension of her past concerns. This time, in addition to ten central characters from her performing group, the House, there will be a chorus of thirty, who both sing and dance, and three instrumentalists. Miss Monk,

who worries about sounding pretentious, explains the title as "a digging up of memory, of racial unconsciousness. I don't want to say it's a prophecy, but I am very interested in archetypes. The one I'm coming to more and more is the oracle or the sibyl. I'm not so pretentious to think I am one. But when I sing I feel the energy taking me over. The voice of the gods or something. It's like a healing, something coming through me."

In *Quarry*, which Miss Monk calls "a memorial piece for a world at war—a myth, a documentary, and a requiem"—her problem has been "how to balance between specificity and abstraction. *Vessel* and *Juice* [another large-scale piece, presented at the Guggenheim Museum, a theater, and a loft in 1969] were gigantic landscapes. *Girlchild* grew out of the characters in it. In *Quarry* I've melded the character thing and the landscape thing together—if it works."

The music for *Quarry* would seem to be Miss Monk's most ambitious yet, to judge from the unison chants and choral polyphony heard at a recent rehearsal. Music was part of her life very early: "I sang before I talked, and read music before I read words—at three." But despite piano lessons throughout her childhood and voice studies at Sarah Lawrence, she had decided to concentrate on dance by the time she graduated in 1964. "I had this union of the voice and the body in mind then, but I guess I wasn't physically strong enough." In the course of the works she began presenting in New York after 1964, she "realized that the voice could be as flexible as a foot or a spine, that it could be waves of energy."

From the beginning she experimented with more than just dance. "I was never really interested in pure movement, in pure physicality. My work was always trying to break through the boundaries."

Since 1979 she has given several solo concerts of her keyboard and vocal music; the next is scheduled for Town Hall on May 12. She has also made two records—one on an obscure West Coast label, Increase, and the other on a private label of her own—and is preparing a third.

Miss Monk's chaste and evocative instrumental music is so simple that it seems simpleminded to some. She confesses a fascination not only with Perotin, Satie, and Bartók, but with "children's pieces of all the composers. To get it down to that form, you really have to know what you're doing." In 1974 and 1975 she gave a concert in which she sang music by Schütz, Purcell, Ravel, Satie, and Bach. To judge from a videotape, if she wanted to Miss Monk could have a respectable career in conventional classical music. But she has already perfected her own

technique to emit amazing varieties of sounds rarely heard from a Western throat, full of wordless cries and moans, a lexicon of vocal coloration, glottal attacks and microtonal waverings that lie at the base of all musical cultures.

Miss Monk resists the obvious comparison to Robert Wilson's work. "His background is painting and architecture," she argues. "His work is visually based; mine comes from dance and music." But she does admit a kinship with not only Mr. Wilson but other lower Manhattan experimentalists who are reaching out beyond traditional borders—people such as Charlie Morrow, Charlemagne Palestine, Allen Ginsberg and the other performing poets, and Patti Smith, the rock singer. "I don't think I'm alone," she says. "It's all part of a rejection of the West, a spiritual thing of trying to get back to a whole. You can't be a jack of all trades but master of none, though. You have to work in your own personal way, developing your own iconography. In a way, I've been focusing down over the years. I think of what I'm doing as a tapestry or a weaving—if it's good, the weaving has to hold."

A DREAM

The New York Times, April 26, 1976

Ever gone to a concert you had really looked forward to and then fallen asleep? Perhaps you'd had a good dinner and some wine, or perhaps you'd had too little sleep the previous night or a strenuous day.

Whatever the cause, there you sit, surrounded by a uniformly alert, eager audience, battling against yourself as your weighted eyelids close inexorably and your chin falls forward on your chest.

If that's your problem, it would have been solved late Friday night at an event by a young composer named Richard Hayman called *Dreamsound*. The music might not necessarily have been to your taste, but the rest of the circumstances would have actively encouraged you in your secret sin. For this was, in the words of the advance publicity, an "event for sleeping audience—music, information, relaxation . . . with gentle sounds for collective dreaming."

Curiously enough, all of these bedroom activities took place in the kitchen—more accurately at the Kitchen, the avant-garde video-art and music space at Wooster and Broome Streets in SoHo, so named because formerly, as part of the Mercer Arts Center, it was in the old kitchen of the Broadway Hotel.

The audience numbered about fifty and consisted mostly of young, arts-oriented types of the sort that normally frequent the Kitchen.

Mr. Hayman and his assistant, Vivian LaMoth, had scattered the place with foam rubber mattresses. ("I hope we have enough foam," he said worriedly around midnight; "we scrounged every gallery in the neighborhood to get it.") Candles and television sets flickered here and there, and films of crackling fires danced on the walls.

After a while Miss LaMoth came around with a tray of chamomile tea and cinnamon-spiced warm milk and little brochures entitled "Pillow Notes," full of aphoristic remarks from sages through the ages about sleep.

Later still Mr. Hayman gave a brief talk about what he was up to— something to the effect that researchers have explored the sorts of sounds that reinforce dreams, and that collective dreaming has a history dating back thousands of years.

Then, after a few ghost stories, people settled down for sleep. There were some ocean noises, some breathing and some ticking, some lovely chime sounds, a passing piano reverie from Mr. Hayman, and the ever thundering trucks bouncing along Broome Street, and then this observer—except for periodic waking moments—can no longer say precisely what happened.

Saturday morning there were orange juice, coffee, and breakfast rolls in an adjacent room, and things seemed to be breaking up when this observer, bleary but mildly content, left around 9:00.

Any such event takes a curious combination of artistic seriousness, humor, and organizational ability. Mr. Hayman, a jolly-looking, red-haired, and red-mustached man of twenty-four who lives on nearby Spring Street, doesn't seem to have it all together quite yet.

Part of the problem was the sheer time Mr. Hayman took getting things under way. When he finally began his talk it was 12:30 and at least one person had left, impatient. Then he had an unfortunate predilection to overdo the cuteness and lame little jokes.

And there wasn't really enough sound. Mr. Hayman conceded that the sounds after the first hour or so were "intermittent," and maybe

more might have kept people awake. But there wasn't really anything for long stretches on end. Different sorts of undulating shifting sounds might have given his event more substance—continuous so as not to jostle one's sleep but varied enough to nudge dreams in unexpected directions.

In fact, as he staggered home clutching his sleeping bag, this observer was prepared to give Mr. Hayman all due credit for the piquancy of his basic idea but to fault him grumpily for his failings of execution.

Then something crept into his mind. It seemed to be some sort of wonderfully beautiful, never-before-heard music, cool and crystalline in sound, chaste and flowing in construction. The memory of that music awoke a pang of recollection, as if the music had been heard and had then slipped away again, leaving only a dim and fading afterimage of an extraordinarily consoling emotional experience.

Whether Mr. Hayman had actually played music like that, or whether it had been a dream, or whether it had been an idea during a period of wakefulness about what should have been happening, this dreamer can't say for sure. And in that very confusion lies the ultimate success of Mr. Hayman's event.

MELANIE

The New York Times, November 6, 1976

Melanie is now twenty-nine years old, and she's been around since before Woodstock. She has her fans, but she is hardly a big star; for most rock enthusiasts especially, she is tacitly taken as a symbol of gosh-oh-gee sentimental excess, and tales of her devotees bearing candles to her concerts as if to Lourdes hardly helped her image. She's been putting out records fairly steadily, but people with closed ears didn't listen, and even if they did, they would have found much misconceived production and uneven material.

But to this observer's complete surprise—he had always managed to miss Melanie's concerts—her late show Thursday at the Bottom Line

was a complete delight. She's there through tomorrow, with no opening act, and she's most definitely worth catching.

Melanie (her maiden name was Safka and she's married now to a man named Peter Schekeryk, but both last names are vestigial) has always had two incontestable virtues: her voice and her onstage personality. Both were intact at the Bottom Line. The voice is a quick-quivering mezzo, akin to, but less tortured and exaggerated than, that of Buffy Ste. Marie. It's strong and driving for up-tempo numbers and its slightly frayed qualities suggest vulnerability in ballads. And her personality exudes so much warmth that she could probably read computer printouts and still win our hearts.

But what surprised this observer was the sheer musicality of her phrasing and the quality of her songs. All fine singers have a way with the musical line that transcends the ordinary, and Melanie's instincts for the weight and flow of a phrase are simply superb. In addition, her new songs—she sang most of her new album, *Photograph*, at the late show—reveal her as one of the most fascinating songwriters before the public today.

Some of the too naive innocence peers through, still. But this album makes overt the links between 1960s folkies and 1970s cabaret stylists as persuasively as anyone—Paul Simon, Janis Ian—has yet achieved. Her best new songs grow and build organically, shifting musical moods in response to the poetic imagery. The imagery, in turn, is expressed with a fresh directness, and the music blends styles in a way that never seems diffuse. These are adult songs for adult audiences, and the audiences would be well advised to listen.

EINSTEIN ON THE BEACH

The Village Voice, November 22, 1976

Note: This article appeared under the byline David Sargent, a pen name I used for articles either written for money against The New York Times *policy (like a music column for* Vogue *magazine) or when I was unable to get an article I wanted to write accepted for publication by the* Times. *The*

Times Magazine *rejected an article about Wilson, Glass, and* Einstein, *so I turned to* The Village Voice. *The* Magazine *finally ran a long feature by me about Wilson in* 1992.

> Everything that emanated from his supremely great mind was as clear and beautiful as a good work of art.
>
> —Albert Einstein, shortly before his death,
> on the physicist Hendrik A. Lorentz

> Everything is determined, the beginning as well as the end, by forces over which we have no control. It is determined for the insect as well as for the star. Human beings, vegetables, or cosmic dust, we all dance to a mysterious tune, intoned in the distance by an invisible piper.
>
> —Einstein, 1929

> A great adventure in thought had at last come safe to shore.
>
> —Alfred North Whitehead, on the confirmation
> of Einstein's general theory of relativity

The greatest scene is the simplest. The music begins with a stately, almost Arabic electric organ solo: single notes on a modal theme, with shimmering roulades of improvised ornamentation. On the stage, broadside to the audience, is an oversized bed; nothing else. Its cover is turned back, as if ready to receive a dreamer. Two wires, dim but visible, are attached to the corners at the foot of the bed. The side nearest the audience glows strongly and evenly: fluorescent light. Slowly and steadily, pulled by the wires, the bed begins to rise, angling upward to the vertical. As it reaches an upright position, pivoting on its end, it is off center. Awkwardly it inches to mid-stage, directly under the spot where the wires and their pulley are positioned. As the lift continues, the end finally swings free of the floor. The music changes to an eerie, wordless solo for soprano voice, over simple organ accompaniment. The bed, now hanging vertically after the swaying stops, glides slowly, upward, the brilliance obliterating any murky detail in the darkness behind it. The vertical band of light shortens steadily, until finally it is cut off by the top of the proscenium arch, leaving only a ghostly glow.

For the rest of my life I want to reflect on what light is.
— Einstein, after the publication of the
general theory of relativity in 1916

Einstein on the Beach is a continuous, nearly five-hour "theater piece with music" by Robert Wilson and Philip Glass. Wilson was primarily responsible for direction and decor; Glass wrote the music; both men worked together on the overall conception. *Einstein* was first performed in July at the Avignon Festival, and toured Europe in September and October. It will receive its American premiere with the same troupe at the Metropolitan Opera this Sunday night at 6:30, with a repeat performance the following Sunday. Although there has been talk of further performances in Brooklyn and a possible American tour, it looks now as if these will be the final *Einstein* performances anywhere; the piece is expensive, money is hard to raise, and the 35 thirty-five people who have been working on it for nearly a year are tired. There is some hope of video or film documentation, but it will hardly be the same.

Like Wilson's earlier works, Einstein is a dream-play, only this time with music. There is no coherent narrative: there are some words, but even the apparently linear stories are so disoriented by the context that they become dreams themselves. More often the texts are disjointed, stream of consciousness. Instead of dialogue, the characters dance or chant numbers or solfège syllables (*do-re-mi*). They pose and gesture, purposefully acting out roles whose purpose seems, at first, impossibly private. They do this against elaborate painted drops, bathed in lighting so exactly composed that the effect is of a grand, glacially kinetic painting.

The work is divided into nine scenes, none longer than half an hour, with five "knee-plays" (so named for their function as joints) flanking and separating them. The nine principal scenes can be grouped into three trios. There are three train scenes: the first scene has a train in the background; the fourth is at night with a train moving off into the distance; the seventh finds the shape of the disappearing train transformed into a building in which Einstein can be seen scribbling his equations. There are three trial scenes: the second, a complex courtroom sequence with a large bed in the foreground; the fifth, initially the same trial, but split in the middle, with the stage-left half becoming a prison; and the eighth, with the bed alone, which rises as already described. Finally, there are three space-machine scenes: in the third and the sixth, the two

formally choreographed dances, the machine is suspended over the otherwise bare stage in the form of a clock; in the ninth and most lavish scene of all, we move inside the machine, full of flashing light panels, for a vision of nuclear explosion and science gone mad.

The knee-plays all involve two women, Lucinda Childs and Sheryl Sutton. Their interchanges constitute a gloss on the main action, from abstracted counting and clerklike absorption, through intimations of flight, mystical technocracy, and torture, to a postapocalyptic rebirth.

On the page all of that must seem impossibly schematic. In performance, *Einstein* is full of teeming life. Each moment is a subtly layered network of detail, with one's attention absorbed simultaneously and sequentially by the sound of music, Wilson's extraordinary eye for colors (mostly grays, with sharp accents of red and the recurrent fluorescent light), the intricate detail of each actor's gestures, their positioning on the stage, the rightness of the props, and the veiled intimations of philosophical issues.

> The cosmic religious experience is the strongest and noblest driving force behind scientific research.
> —Einstein, 1930

> Before we settled on Einstein, I was thinking of making pieces about Hitler and Charlie Chaplin.
> —Wilson, at an Avignon press conference, 1976

> I could say something, but I'd hate myself for saying it. Somehow it seems appropriate, but I don't know exactly why.
> —Wilson, at the same press conference

Questions about "meaning" are agony for Wilson. And Glass, for all his relatively greater verbal fluency, doesn't do much better. Wilson works on an inspirational basis very close to free association, and then judiciously winnows those associations down to art. Take the recurrent images of a trial and a bed. Wilson says he can't recall whether the pairing came about when he found an old engraving of a 1776 Versailles *lit de justice* (which appears as a drop in the midst of the first trial scene), or whether the discovery of that peculiar, suggestive phrase confirmed an

association he had already dreamed of. But it fit into what he knew about Einstein; both he and Glass read Ronald W. Clark's biography and other works by and about the scientist. "I thought of Einstein as a dreamer and a sailor," Wilson says (Einstein was a lifelong recreational sailor). "The light falling on the bed in the trial scene looks like a sailboat to me. Maybe the bed in the courtroom means that's what's on trial." In other words, dreaming. The most immediate "meaning" of the first trial scene is that the accused is science itself: One of the characters actually says so, and there are enough symbols of science on hand to remind one of Galileo and drive the point home. But it's more than that. Wilson has built his major works around famous figures of the past— Freud, Stalin, Philip II, Queen Victoria. Like those earlier pieces, *Einstein* takes the scientist as the starting point for a metaphorical examination of the age. Hitler and Chaplin, the demonic and the comic, have been subsumed into Einstein, and since Wilson works above all in painterly visions, their physical resemblance serves to deepen our view of the scientist. *Einstein* is certainly about the uses and misuses of science. But science is a product of the imagination, like art and like dreaming. *Einstein* is about human beings dehumanized, about justice and Patty Hearst, about the apocalypse (Nevil Shute's *On the Beach*), and, in the final knee-play, about the flowering of simple human love. And at all times, it's about higher forces that illumine our lives. If that sounds too bold, so be it; both Wilson and Glass owe their artistry in large part to their ability to translate simplicity into sophistication without dimming the purity of their naiveté.

Einstein worked on his own, an outsider of outsiders.
—Clark, *Einstein: The Life and Times*

Bob Wilson's spectacles aren't at all surrealistic, but they are that which we, who gave birth to surrealism, dreamed would surge after us, beyond us.
—Louis Aragon, in an open letter to André Breton, 1971

When we first got together, I said I wanted to do a science-fiction opera, because machines go well with my music.
—Philip Glass, at the Avignon press conference

One of the things I never liked in the theater of the 1960s, when I first came to New York, was that there was never any time to think. Everything was so speeded up. You had to see what the playwright and the actors wanted you to see. It seemed important to me for the audience to have a more interesting experience than that.

—Wilson, quoted by Calvin Tomkins
in *The New Yorker*, 1975

Do less with the movement. It's too interesting.

—Wilson, at an Avignon rehearsal

When one first heard, in 1974, that Wilson and Glass were considering collaboration, it seemed just a little odd. Wilson was an all-encompassing neo-surrealist dreamer; Glass was a tightly contained structuralist. But their work together has reemphasized our awareness of the structure of Wilson's dreams and the dreamlike aura Glass attains through structure.

Wilson hardly set about to make a reborn surrealist theater; the one book he's always admitted reading is John Cage's *Silence*, and he came to New York and the theater after careers in Texas as a therapist with brain-damaged children and a painter. His mature works date back to the late '60s and reached a culmination in December of 1973 with a twelve-hour retrospective called *The Life and Times of Josef Stalin*. The next year he offered the shorter *A Letter for Queen Victoria* on Broadway and *The $ Value of Man* in Brooklyn, but since then his time has been spent on *Einstein*.

His work has always moved slowly, and that includes his therapeutic techniques. His principal effort was to get patients involved in the immediacy of sensation around them—the ticking of clocks, the smells in the room. Once he organized a "dance" for iron-lung patients, in which they moved themselves and affected the lighting through a construction of strings hanging from the ceiling. In his early workshops, he would concentrate on getting people to execute ordinary tasks, like getting up from a chair, in tiny, nearly imperceptible increments of movement. One of his most influential experiences was his encounter with some films made by a psychiatrist, Dan Stern. Dr. Stern caught, in protracted slow motion, the body language between mothers and their babies—the little lunges of attraction and repulsion that we never see in

ordinary life. Wilson's theater is the minutiae of life slowed down and expanded so we can see everything.

The slow tapestry of shifting images is occasionally punctuated by a sudden *coup de théâtre*, as when a "spaceman" swings into view, suspended by a rope, during the penultimate scene of *Einstein*. Even within the prevailing slow sequences the speeds vary; part of the richness of texture in a Wilson piece is the overlapping rates at which different kinds of images are transformed. Binding it all together, one realizes soon enough, is an intricate series of recurrent leitmotifs: not only the large ones, like the trains and the trial and the bed, but smaller visual devices (the clocks, the periodic eclipses), gestures, and, of course, sounds.

Glass enjoyed a conventional training for an American composer, including stints at the Peabody Conservatory in his native Baltimore, the Juilliard School, and even with Nadia Boulanger in Paris. It was in Paris, a decade ago, that he went off the deep end, traditionally speaking. He got involved with Conrad Rooks in his *Chappaqua* film project and was asked to notate some of Ravi Shankar's Indian improvisations so they could be played by Western musicians. In so doing, he says now, he misunderstood the formal basis of north Indian music. That music seemed to him to be built on additive principles—small modules of notes or rhythmic units that could be combined and recombined linearly. This may have been a brutal simplification of the subtle realities of a several-thousand-year-old tradition. But it was clearly akin to the ideas of his closest associates in those days, especially after he moved back to New York—minimalist and structuralist painters and sculptors. And it was similarly akin to the composers with whom he was most frequently compared at the outset of his mature career, Terry Riley and Steve Reich.

Since the late '60s, Glass has steadily evolved his vocabulary. Without sacrificing the minimalist rigor that gives his music backbone, he has enriched the textures and deepened the hypnotic emotional appeal that was always latent in his way of working. He's done this by combining lines polyphonically, by admitting abrupt shifts into the previously static harmonies, by complicating the rhythmic procedures, and by adding sonorous elements independent of the main lines. The basis of his style remains the busily interacting strings of telegraphic eighth notes from his ensemble of electric keyboards and winds. But now, in addition to the mournful sustained wind lines and the soprano voice he's had previously, there is a prominent part for solo violin (played with enormous

poignancy by Robert Brown, who's made up to look like the aged Einstein) and the chantlike choral music.

> You see, my son, time changes here to space.
> —Wagner, *Parsifal*, 1882

Wilson has always called his works "operas," even if the music was only very occasional. They were silent operas, in the sense of the Italian usage, as a blend of the arts. Now, with Glass's music, *Einstein* is more an opera than any previous Wilson work. But it's hardly an opera in the way that regular Metropolitan Opera subscribers—many of whom have reportedly bought tickets for November 21—are used to the term, since there are no staged roles for conventionally trained solo singers. The Met is coproducing the two performances, partly out of a genuine belief in its value, no doubt, but also partly to fill the house on the dark Sunday nights and partly to enliven its staid image. One suspects that at least some people in the audience Sunday night will be extremely disconcerted. It will probably do them good.

Opera as a living, ongoing art form is dead: New operas that are both intellectually respectable and decently popular simply are not forthcoming. Yet the idea of "opera" remains our principal repository for a suprarational theater of style and symbol. Both Wilson and Glass work in a manner that can easily be called Wagnerian. Wagner, of course, was the most visionary reformer in the whole, four-hundred-year history of opera. He, too, developed a network of leitmotifs to reinforce the dramatic and musical unities of his works, and he too created vast, hypnotic theatrical landscapes. Wilson's interlocking images can easily be conceived of leitmotivically. And Glass is quite capable of sitting down and sketching out the underlying formal ideas in his *Einstein* music; unlike the formal notions of so many twentieth-century composers, they are ideas that actually contribute to a unifying listening experience. There are germinal themes that recur in simple or metamorphosed form, linking rhythmic ideas and an overall pattern. It's nowhere near so complex as Wagner, obviously, nor so intimately related to the minutiae of dramatic development. But out of temperamental conviction, both Wilson and Glass deal in simpler, more meditative ideas and emotions.

> We're all so different—you, Andy, and me.
> —Wilson to Glass, during a New York *Einstein* rehearsal

The dance unfolded gradually, the spare, rituallike gestures of the beginning eventually becoming manic and restless. She skittered and limped and bounced while making complicated darting hand signals. Her facial expression maintained that consuming determination, but character feeling changed with the speed of hallucinations intercepting one another.

> —Wendy Perron, on Lucinda Childs at a New York
> *Einstein* run-through this spring,
> in the *SoHo Weekly News*

It's not worth my time to do incidental music.

> —Glass, last week

Einstein on the Beach is a collaboration, and, as with any cooperative venture, there is always a difficulty in figuring out who did what. This might not seem important—the work is the work—but it is intensely important to the participants, and the problem for all of them but one is that Wilson's reputation and contribution are so huge that he overshadows the others, including Glass. This is partly because it has been his preexisting organization, the Byrd Hoffman Foundation, that has organized the massive physical production and done the bulk of the fund-raising. But even on a purely artistic level, his work is so compelling that even Glass is openly miffed at the way attention in Europe tended to focus on Wilson. Wilson himself is continually solicitous of Glass's feelings and those of the others. But it doesn't always help.

The piece grew out of joint discussions between Wilson and Glass. But both men have always needed others to realize their ideas. In Glass's case, it's relatively straightforward: his musicians play his music. There is some room for performer choice, but generally this is notated music with the performance led strictly by Glass. Musicians associate themselves for a greater or lesser period of time with Glass's ensemble, and though they may chafe at the time it takes from their own work if they are themselves composers, it is at least interesting, remunerative work, and they need labor under few delusions that they are "co-creating" the music.

With Wilson, it's a little more complicated, since he has always allowed his collaborators a good deal of creative freedom. Wilson picks people who will bring much of their own to the process. During

rehearsal, he will roughly sketch the situation, sit back as the performers fill in the details, and then gently reject what he doesn't want. The results always look recognizably like Wilson's work, and hence bear his subtle, but crucial, imprint. Yet they "belong" to the performers, and the question of credits in the program can be a tricky one.

The main collaborator, aside from the two principals, is the "Andy" above: Andrew DeGroat, Wilson's longtime choreographer. In his solo dancing, DeGroat is the master of rapid, virtuosic spinning, but the two formal sequences he provides in *Einstein* (the first two "space-machine" scenes) are full of patterned, crisscrossing lines and sudden, contained leaps that not only echo the structure of Glass's music, but suggest a metaphor for molecular movement. DeGroat is hardly the only dancer in *Einstein*, however. Lucinda Childs has a solo career that goes back to the Judson Church days, and if any of the performers is the "star" of the twenty-six-member cast, it is she. The multiple demands of acting, singing, and dancing in *Einstein* have reinforced an already apparent tendency in Wilson's work after *Stalin* to cut down from the seething communal confusions of his past (*Stalin*'s cast approached 150) and to work with smaller, more economically manageable groups of professionals. Many old Byrds were weeded out during the *Einstein* auditions, but that hardly means the *Einstein* cast lacks personality or even eccentricity, from the seventy-seven-year-old black actor, Samuel M. Johnson, whose moving final lines about the power of human love puts the seal on the five-hour experience, to the ten-year-old Paul Mann, to a typically Wilsonian assortment of tall and short, round and skinny actors.

> Bob wants something impossible. We propose something he doesn't like. What I haven't figured out yet is how to find the third way that will be feasible and still fulfill his vision.
>
> —Beverly Emmons, lighting designer,
> during rehearsals at Avignon

Wilson owes much of his artistic strength to his unabashed naiveté, but that naiveté is not always obviously intentional or effective. Sometimes in conversation he will hint at a Brechtian aesthetic. For instance, the ascending bed was lifted at Avignon by wires and pulleys, the pulley attached to an ancient crank turned with sweating effort by two French stagehands. The bed *pulsed* upward rather than rising with mechanical smoothness, and its awkward inching toward center stage before it

began its vertical rise broke the illusion of mystical levitation. Wilson said in Avignon that he wouldn't use a hydraulic lift if he had one; he will have one at the Met, and it will be interesting to see whether he uses it. The Avignon performances were full of moments that could have been accomplished more smoothly and efficiently, and Wilson went out of his way to include some of the stagehands in two scenes, undercutting the magic of his illusions with the intrusion of the mechanisms necessary to create them. Yet the blend doesn't seem entirely fluent. Wilson never quite convinces us that his technical naiveté is deliberate. Yet the intrusions do prevent one from falling into pure escapism. Perhaps the real question is whether escapism itself is progressive or reactionary.

> Camp represents the homosexual sensibility defying a heterosexual world by flinging enormous exaggeration into the faces of the smug straights. . . . Wilson's work is for escapees from thought, feeling, and confrontations with reality. . . . I see nothing more in *The Life and Times of Josef Stalin* than its tune-in-turn-on-and-drop-out value. And for that, marijuana is both easier to come by and less expensive to produce. . . . Pot, moreover, is unpretentious.
> —John Simon, *The New Leader*, 1974

> The illusions which exalt us are dearer than a thousand sober truths.
> —Chekhov, pinned on the wall of the *Einstein*
> company's office in Avignon

Whatever their dope experiences may be, and whatever their religious beliefs (both Glass and Wilson participated in last week's benefit for Tibetan Buddhism at Town Hall, but Wilson did so only out of his friendship for students of that religion, like Glass), it is clear that *Einstein* is both mystical and prone to a heightened appreciation by those who have had experience with meditative drugs. That hardly means you have to be high to enjoy it. But something has happened to the American psyche, or resurfaced in a new form, that makes more and more of us open to such experiences, whether induced by drugs or not. People want less immersion in an onslaught of sensation. They prefer to dwell on a few things more deeply, turning them over and over in their hands like a well-worn stone. Beleaguered defenders of the rationalist bulwarks, like Simon, resist Wilson in the same way that academic classicists

have always fought against romantic art. But what is curious about the mystical romanticism of both Wilson and Glass is the lucid, balanced form in which it expresses itself—so cool that it strikes some as lacking in incident. As one of Einstein's last assistants put it, "Beauty for him was essentially simplicity."

Wilson is somewhat reminiscent of Einstein in his politics, too. Not that he throws himself passionately, if naively, into crusades, as Einstein did with pacifism and Zionism and a myriad other causes. But for both men, politics is an arena for transcendent concerns, and both thus leave themselves open to attack on the grounds of inconsistency and simple-mindedness. Which in both cases is hardly very telling criticism since, of course, their true work lies elsewhere. Wilson has aroused resentment for the huge size of his budgets, and both he and Glass have been casti-gated for their belated and grudging withdrawal from the Shiraz Festival in Iran. For them, the shah was no worse a tyrant than anyone else, and an Iranian engagement would have filled a gap in the *Einstein* touring schedule in August. It was only after several important backers grew nervous, and after the Merce Cunningham company pulled out, leaving them isolated, that the Iran dates were abandoned.

Which in turn might make the enthusiasm of the European Left for Einstein seem surprising—perhaps a typical instance of the giddy trendiness of the French intelligentsia or a further affirmation of the muddled state of Marxist aesthetics. But again it's not so simple. *Libéra-tion* and *Humanité* loved *Einstein*, not out of some failure to recognize its roots in bourgeois escapism, but because it points the way to a new sensibility. Marx himself left the nature of his classless society open and was similarly vague and inconsistent in his writings about the role of art in the revolution. Marxist intellectuals have generally espoused avant-gardism as a model for the future; workers have preferred more directly comprehensible, overtly moralistic exhortations to arms. In our own day, Herbert Marcuse has tried to develop the notion of unfettered play in Schiller and other German romantics into a paradigm for the art and the society of the future. Perhaps the French Left senses something of that freedom in *Einstein on the Beach*. They know that not all revolution-ary art need be a blueprint for political insurrection.

It's not to be done alone. It's done for the public. You're trying to relate and you're trying to relate in a positive way.
—Wilson, at the Avignon press conference

The *Einstein* audience so far has consisted of European sensation seekers, students, devoted avant-gardists, a few rich patrons, and a few political radicals. It's easy to be dismissive about the trendiness of that following. But it's also refreshing to see a vanguard artwork that generates excitement outside a tiny coterie. Wagner was trendy in his day, too.

Still, in this country especially, Wilson and Glass have clearly not reached their potential audience. One wonders—quite apart from the sheer size of the stage and the house—whether the Met is the best place for the American performances. It will certainly add some snazz to the Met's image. But the true Einstein audience is likely to be found among people for whom the Met, and indeed the whole notion of opera, are anachronistic. So far American foundations, government agencies, and private patrons have not responded in sufficient numbers to enable widespread performances in this country. But that's partly because Wilson and Glass haven't reached enough young, inquisitive people to generate the excitement that would stimulate what available patronage there is.

Glass has an arrangement with Virgin Records in England to distribute his music in Europe. The trouble is that Virgin, which is active in British progressive rock, hasn't chosen to promote him very actively, and so far, no major American label has been willing to distribute the music here. Glass talks from time to time about giving concerts for progressive-rock or jazz audiences, but he is clearly nervous about the prospect of artistic misunderstanding or compromise.

Wilson conceives of broadening his audience in terms of storming the traditional bastions of theatrical and operatic culture—Broadway and the Met. Yet he's embittered about it, too. "Theater in New York is very corrupt," he complains. "Theater like we do isn't possible here."

What *Einstein* needs is an impresario of imagination and energy who believes in it and will spread it to its potential audience. Wagner's works were disseminated through Europe late in the nineteenth century by a passionate, flamboyant impresario named Angelo Neumann, and Wilson and Glass need a Neumann now. There is a demonstrable hunger for a spectacular musical theater of a sort heretofore unimagined by most theatergoers. The enthusiastic response accorded the almost invariably lame "theatrical" displays at rock concerts hints at that need. If people go wild for a few laser effects and the odd smoke bomb, some of them would surely seek out *Einstein* if they only knew it existed. It's like two strangers reaching out in the dark, neither quite knowing the other is there.

BLACK SABBATH

The New York Times, December 8, 1976

You can tell it's a Black Sabbath concert from the shards of broken glass and the smell of alcohol as you enter Madison Square Garden. Packs of young people cluster, *Clockwork Orange* fashion, plotting ways to break through the police barricades. Upstairs there are what look at first like Arcadian picnic scenes in the hallways—groups of people, their possessions spread about them, nodding together—except that when you look closer it's friends tending a companion who's fallen down or passed out.

Inside the hall the balconies are festooned with banners, just as at a championship game, with band favorites exhorted ("Go Geezer") or the words "Black Sabbath" written with the "S" in Nazi SS calligraphy.

All of which may sound especially depressing, a mid-1970s teenage downer bacchanalia. But what is really most depressing is that the majority of the audience are still just passive kids, who sit there looking a little bored, throwing beach balls or Frisbees about between acts, wondering where the release is. The real problem with a Black Sabbath concert is not that it represents the nadir of human behavior but that it points that way and winds up just sort of lame.

Black Sabbath is in many ways the archetypical 1970s heavy-metal rock-and-roll band. Its first record came out only six years ago, right at the beginning of the decade, and since then the English quartet has varied its successful formula hardly at all.

That formula consists mainly of a simple, inexorably repetitive ostinato with the electric bass (Geezer Butler) and guitar (Tony Iommi) an octave apart, the bass providing the thudding bottom and the guitar investing it with an ominous, grinding buzz.

Sometimes Mr. Iommi will enliven this procedure with double-time rhythmic strumming, and at other times he breaks free for some standard, higher-flying linear playing. Bill Ward contributes the steady, unimaginative drumming, and the incongruously chubby Ozzy Osbourne whines out silly vocals that play gingerly with images both violent and demonic.

The whole thing is probably heard better live, since a concert sound system has an impact records can't match and because a whole arena full of white teenagers similarly stoned offers the illusion of a communitar-

ian experience. But it would speak more favorably for the temper of society today if such populist pleasures were being obtained from better artists.

JOHN CALE

The New York Times, December 21, 1976

Well, that was easy enough. All John Cale had to do was put together a band and automatically he becomes one of the leading figures on the whole New York art-punk-rock scene. His debut performances with his new group Sunday night at CBGB were triumphant, and he will be back at the Bowery club Thursday through Saturday, as well as part of the Patti Smith and Television bill at the Palladium on New Year's Eve.

One could have predicted his success, because Mr. Cale certainly has the credentials. Classically trained in his native Britain, he was one of the founding members of the Velvet Underground, which started the entire phenomenon of New York art rock. He produced both Jonathan Richman and Miss Smith. He had a whole slew of records, which moved from a dreamy surrealism to a tougher, tighter, more angry kind of mid-1970s rock.

What he doesn't have, yet, is a viable American solo career, and this new band is clearly designed to rectify that lack. Put together from four unknown New York musicians—Richie Fliegler, guitarist; Bruce Brody, keyboard player; Mike Visceglia, bassist; and Joe Stefko, drummer—it provides Mr. Cale with a tight, driving accompaniment. Mr. Cale, in turn, plays rhythm guitar and piano—and viola, his original instrument, although he didn't do so at the first show Sunday. He also composes and sings. The songs are strange, blunt, and ominous, and if the singing seemed sometimes just a bit calculated on Sunday, it still was of a piece with the whole.

The club itself was packed to a point that a normal human-type person would have found difficult to believe. It was uncomfortable, but it did generate the excitement of a real event, and Mr. Cale didn't disappoint. One hopes he's through with the erratic wanderings of his

post–Velvet Underground days. He's a big talent, and rock music could use him.

SIRIUS TRIXON AND THE MOTOR CITY BAD BOYS

The New York Times, January 10, 1977

Punk rock, the kind inspired by the Velvet Underground and Iggy and the Stooges, is hardly limited to New York, London, and Los Angeles. This past Friday and Saturday, two bands from Detroit and Cleveland played in a double bill at Max's Kansas City.

Sirius Trixon and the Motor City Bad Boys were billed as "legendary," and one has to admit that anyone who can come up with a name like that deserves some sort of place in rock-and-roll annals. Mr. Trixon himself is a rather dour-looking man, with his hair blasted into the approved Keith Richard scraggly artichoke coiffure.

His band is very good, punching out tight, exciting rock. It's really quite amazing how rock retains its appeal if well executed: the predictable formulas seem always to be reinvested with life if energetically and passionately presented.

The trouble is that Mr. Trixon can't sing very well; the voice lacks its own characteristic color and Mr. Trixon doesn't compensate with unusual phrasing or convincing stage antics. The result has its moments, instrumentally speaking, but ultimately fails to live up to even the most guarded of legendary expectations.

Stiv Bator, the lead singer of Cleveland's Dead Boys, can't sing very distinctively either. But at least he hurls himself about the stage in the best Iggy manner, his jeans carefully rent in the rear and his remarks full of aggressive and obscene patois. The difficulty here is that his instrumentalists are decidedly run-of-the-mill.

The group might be able to compensate with a greater degree of sheer outrageousness, and reportedly in some shows they have done just that. But it's hard always trying to top both the past and yourself in terms of outright disgusting excess.

There are limits, after all, and everybody knows them. To suggest those limits without crossing over them is where art rears its ugly head, and at this stage of their careers, art is what both the Dead Boys and the Bad Boys lack.

BLONDIE

The New York Times, January 24, 1977

Blondie graduated into full membership in the upper reaches of the New York underground/punk rock circuit this weekend at Max's Kansas City.

The band had always attracted a certain amount of attention because of the image of Deborah Harry, who lent the group her nickname. Miss Harry is a quite remarkable-looking woman, and she isn't shy about capitalizing on her attributes. She has a trim, sexy figure, two-toned peroxided hair (white-blond in front and dark toward the back) and a fine-lined, pouty, heart-shaped face.

Given her predilection for appearing in tiger-striped miniskirts, décolletage, and swaggering, female variants of punk attire, sound seemed almost irrelevant.

Last spring it appeared that Blondie was more of a nice idea than a successful band, however. Miss Harry seemed unsure in the projection of her image, and the band wasn't striking enough to make up for that disappointment. But a few weeks ago the group put out its first album, on which Miss Harry sang amusing, original songs very prettily indeed, and the band backed her with a driving yet clever blend of punk-rock, progressive keyboard textures and 1960s nostalgia. It was time to check out how Miss Harry was handling her image.

The answer is, delightfully. She was hardly all tough strutting Saturday at Max's, but this time her shyness and humor enriched, rather than confused, the image. Even when she's singing a song like "Rip Her to Shreds," the childlike sweetness shines through.

And Miss Harry is now an exact visual counterpart of her band's eclecticism, happily echoing all the images from films and television

we've come to expect from punks' girlfriends, high-school bad girls, and pop "girl groups." Since the band's instrumentals are fully up to the record in terms of polish and excitement, one imagines that Blondie won't remain an underground phenomenon very much longer.

KISS

The New York Times, February 20, 1977

Stumbling in the darkness into a Kiss concert, as this well-meaning observer did Friday at Madison Square Garden, might lead one directly to dire meditations on the decline of Western civilization. How else, after all, are we to interpret an entertainment that highlights a bass player spitting "blood" atop a tower, surrounded by swirls of smoke and bathed in bilious green light, all the while dressed in a black-leather and silver costume that makes him look like a diabolical armadillo? And the sight of this apparition evoking a dull, throaty roar of appreciation from the sold-out house, the cries of the multitude overlaid with the treble piping of a large prepubescent minority?

It was difficult to dismiss Kiss as altogether outrageous, however, having just come from the Metropolitan Opera, where Leonie Rysanek as Salome had most convincingly mimed the act of kissing the lips and caressing the severed head of a saint she had ordered killed out of necrophiliac lust. This confection of Oscar Wilde and Richard Strauss not only dates back seventy-two years, but is appreciably creepier than anything Kiss managed. *Salome* is also a good deal more decadent, in the sense that a vastly more sophisticated technique is bent to the service of lurid exploitation.

So, with Kiss's menace defused—and their musical impact muted by a thin and distorted sound system—it was possible to look upon the Kiss phenomenon in rather more benign and distant fashion than the four band members or their "Kiss army" of fans might like.

What Kiss is is a big, blowzy, amiable cartoon, a sort of animated version of comic-book superheroes. Even with their smoke, flames, spat blood, explosive charges, and levitating drum stands, they are still tied to

the stiff format of the arena rock show, and as such their theatricality looks limited and lame.

But they apparently fulfill a need, which is to present to the American heartland a safely sanitized image of the sort of glittery outrageousness that was so popular among more vanguard bands three and four years ago.

Kiss is a "New York band," in that its members come from this area. But it's no surprise that the group won its initial popularity in the Middle West. Friday's concert and the one tomorrow night at the Nassau Coliseum are in a sense big-time homecomings, certifications of having "made it."

Nothing is so transitory as the early mid-teen idol, and with their confining format and musical limitations, Kiss looks particularly vulnerable to being swept aside by next year's Alice Cooper. That's not to say they can't conceivably evolve both their theatrics and their music; in both areas they have shown an undeniable flair and even hints of a capacity for growth. But at the moment this is a pretty shallow show, and surely their fans will catch on to that shallowness soon.

GRACE JONES

The New York Times, March 26, 1977

One has to be careful criticizing cult objects when one isn't part of the cult. Grace Jones, who made a return appearance at Les Mouches, the discotheque and restaurant at 260 West Eleventh Street early Saturday morning, is the current darling of Manhattan's homosexual-disco crowd. To this observer, she was pretty terrible. But perhaps that's because one needs the rose-colored glasses that cult membership provides.

Certainly one can sense what Miss Jones must be trying to do. She is a commanding black woman, a fashion model and film actress as well as a disco star, much given to miming tableaus of dominance. She surrounds herself with scantily clad males in the manner of Mae West— although instead of muscle men she uses lithe sorts who can appeal more directly to her audience, and she clearly represents some sort of sexual paradigm for that audience.

The act itself began with Miss Jones making a smoothly managed

entrance on a motorcycle, doing a slow strip down to a gold top that kept flopping open, panties, and baggy black stockings. She sang her disco songs through a cordless microphone with recorded accompaniment, stalking about the stage as she did so. The stage was a round one, with her packed audience seated on the disco dance floor on all sides.

Her between-songs patter dealt mostly with bawdy remarks about her own proclivity to perspiration, and she leavened her brassiness with one number in which she pretended, not very affectingly, to be crying because love had done her wrong. After a costume change she returned in bridal attire to sing her disco hit, "I Need a Man," accompanied by four seminude men from whom she removed various artifacts of ritual attire—studded belts, etc.

Now, all of this represents a genuine entertainment phenomenon in late-1970s New York. There are more than a hundred homosexual discos in town, of which Les Mouches is surely one of the largest, fanciest, and flashiest. These clubs constitute a circuit with its own idols, and those idols and the fashion and musical styles they epitomize have a way of rippling out into the mainstream sooner than one might think—reference Bette Midler and Barry Manilow. Perhaps Miss Jones will be at the Westchester Premier Theater by 1978.

But that said, one wishes her act were a little better—a little more stylish and a little less sophomorically vulgar. Even within the context of disappointing live performances by studio-crafted disco stars, Miss Jones's singing was amateurish and awkward. And although she is certainly a handsome woman, she moves unsurely. Fine to be a sensation, but better still to be sensational, and that Miss Jones definitely is not.

ANTIGONE

The New York Times, July 31, 1977

Munich—For most American music lovers, Carl Orff is known as the composer of *Carmina Burana*, that jolly neo-medieval suite that has appeared on the programs of symphony orchestras and opera and ballet companies.

But Orff, who was born in Munich and who celebrated his eighty-sec-

ond birthday on July 10, is far more diverse a composer than that. Before *Carmina Burana*, there were a fascinating series of reworkings of early baroque scores and experimental pieces of one sort or another, and since the late 1930s there have been comic operas, a vast body of influential music for children, and a trilogy of extraordinary "music dramas."

One uses that specifically Wagnerian term quite deliberately. Like Gluck, Wagner, and, indeed, the founders of opera itself four hundred years ago, Orff is consumed with a desire to create a musical theater akin to the now-lost music dramas of the ancient Greeks. His trilogy began at Salzburg in 1949 with *Antigone*, and all three works take Greek dramas—Antigone sets word-for-word the wonderfully romantic translation of the Sophocles by Hölderlin—and underscores them with chant over a primarily percussive orchestra. The chant ranges from insistently repeated single notes to highly ornate melisma, and is broken by sometimes lavish choral interludes. But the vocal lines never flower into music for its own sake; the music always strictly supports the declamation. The result is extremely austere unless you are caught up in the unfolding of the drama—this is clearly work that must be performed in the language of the audience. But that is, of course, the point.

Opera has seen a continual oscillation between the poles of drama and music. Orff's music dramas push that oscillation toward the extreme verbal end of the scale. Ideally, one is absorbed by the drama and forgets the exact musical means by which it is being presented. But that hardly implies that the music makes no effect; it is simply focused to a hypnotic intensity through the Sophocles-Hölderlin drama, and intensifies that drama in turn.

The orchestra, which fills the entire pit of the National Theater here to beguiling visual effect, consists of a raft of timpani, gongs, and percussion, including six pianos and a host of trogxylophones (akin to a marimbaphone), plus winds, muted trumpets, double basses, and harps used in a percussive or otherwise strictly contained sense.

Generally this assortment marks out the meter with precise regularity, in unison or minimal counterpoint, and next to no melody or harmonic development. But Orff's sense of color and timeliness is so exact that when he allows for wilder outbursts, the effect can be overwhelming. Especially in Antigone's farewell oration at the end of the third act, before she goes off to her death, the throbbing inexorability of the orchestra, building from steady, funereal strokes into huge, crashing outbursts of sound, makes a profound impression.

The Bavarian State Opera has prided itself in recent decades on its championing of Orff's music. The annual Munich Summer Festival of Opera, which is now in progress, is supposedly ruled by a "trinity" of Mozart, Wagner, and Richard Strauss, but in recent years the company's service to Orff has suggested the addition of his name to the other three. This Munich production of *Antigone* was new two years ago, but was preceded by earlier incarnations of the work that were equally distinguished.

The 1975 production was by Günther Rennert, with sets and costumes by Rudolf Heinrich, and was staged this year by Holger Schulz. Its classical austerity reinforces Orff's conception to excellent effect—a symmetrical setting with a round skylight and a thrust stage partially over the pit, the male chorus assuming balanced positions and the principal characters making precisely delineated entrances and exits. This arrangement shifts one's attention to the central scenes and monologues of soloists, and by and large the soloists in Munich proved worthy of such close attention.

The title part was taken by Colette Lorand with a stentorian soprano and generally creditable intensity (one would think Anja Silja would be unforgettable in the role). Her antagonist, Creon, was less successfully portrayed by William Murray, whose main failing was a weak and dry baritone. The rest—Ortrun Wenkel, Hildegard Hillebrecht, Thomas Lehrberger, Horst Hoffmann, Keith Engen, and Hans Günter Nocker—all handled themselves with security. But there was one performance that made one realize the real potential of Orff's re-creation of tragedy. Helmut Melchert, a veteran character tenor, doesn't have much voice left these days. But his portrayal of the aging, blind Tiresias, provoked by Creon's stubbornness into shamanistic fury, was the most moving contribution of the night.

Wolfgang Sawallisch, the music director of the Bavarian State Opera, conducted idiomatically, if without always the ideal rhythmic firmness, and the chorus under Wolfgang Baumgart's direction sang with winning authority and solidity of tone.

THE SEX PISTOLS

The New York Times, January 7, 1978

Atlanta, January 6—After weeks of confusion, capped by a visa controversy that was resolved only a few days ago, the Sex Pistols finally made their American debut last night at the Great South East Music Hall and Emporium, a 525-seat half theater, half club in a shopping center here.

The publicity that swirls around this most controversial of British punk-rock bands has been so intense that a simple report on its performance becomes almost impossible. The Western world's fascination with bizarre sensations can be measured in no better way than in the fact that a band that hasn't even cracked the top 100 in album sales in this country, and hasn't even released a single here, nevertheless attracted forty reporters for its United States debut, including several television crews and at least three journalists who had flown over from England.

Such an agglomeration creates its own, self-generated excitement, but there was a fair degree of anticipation among the Atlantans on hand last night, too. There were a few self-consciously festooned punk archetypes—avidly filmed by the television crews—complete with safety pins in their flesh, although the Atlanta variety doesn't seem to have made too clear a distinction between glitter and punk.

The bulk of the crowd, however, seemed surprisingly aware of the Pistols and their album. They may not have been fans—there were a few aggressive skeptics and a lot of innocent curiosity seekers. But the audience looked older and more sophisticated than a typical teen rock crowd, and was clearly interested in what the Pistols would do.

They had been primed in their interest not only by the local FM stations, but by the more established radio and television stations and newspapers, most of which seemed to take an openly derisory stance about punk before the event. Such determined hostility will probably be the band's biggest problem here at first: audiences will come expecting to be insulted, spat upon, and punched, and if the band doesn't oblige, the crowd is likely to provide its own excitement.

Certainly the Pistols weren't the ones indulging in overt violence last night. It was the crowd that was screaming insults, making obscene gestures, and throwing things at the band—including, the drummer Paul Cook said afterward, a pig's ear.

But most of this seemed essentially good-natured, and the audience

gave every indication of enjoying itself thoroughly. After an extended opening set by a local band, Cruis-o-matic, during which people remained resolutely seated, the Pistols straggled onstage, unannounced, at 10:25. The crowd rose to its collective feet and stayed there throughout the forty-five-minute set, which began with "God Save the Queen," ended with "Anarchy in the U.K.," and consisted entirely of previously recorded songs. People cheered and shouted, jumping up and down in random imitation of the London punks' "pogo" dance.

They had reason to be enthusiastic. It seems silly at this point to complain about what the Pistols are not, or to try nervously to rank them with other concert experiences. They don't play in tune; they are certainly sloppy; they don't purvey tender emotions or fat melodies. This observer has been more thrilled at other rock-and-roll shows.

But, still, the Sex Pistols are a fine band on the basis of last night's appearance—and this was a fairly typical performance; some wondered if the group had toned down its act because of the presence of Atlanta and Memphis vice squad officers, but the proceedings were essentially similar to the performance this reporter saw in Sweden last summer.

Anti-punks will, of course, be put off by the technical crudeness of the band. But, for this observer, the angry energy of its arrangements and playing more than compensates. The most obviously proficient of the instrumentalists is Mr. Cook, whose drumming is sharp and solid. Sid Vicious, who replaced the original bass player about a year ago, seems decent enough. And Steve Jones, the guitarist, unleashes a tightly controlled series of rock-guitarist riffs and poses. The other two instrumentalists fill visual roles, too: Mr. Cook cute and boyish; Mr. Vicious scrawny and scowling, but in a somehow sweet and alluring way.

But it is Johnny Rotten, the singer, who seizes nearly all one's attention. Mr. Rotten sings with a limited, snarling baritone, and he does what he sets out to do very well. But it is his looks and his manner that make the Sex Pistols special. Mr. Rotten has one of the great faces in rock and roll, all spiky hair, darting eyes, and childlike, sly little smile. And he is a performer, in that he's hardly shy about "working" an audience, teasing and toying with it, strutting back and forth across the stage like a crouching, frenzied Pierrot.

It doesn't look now as if the band will be able to make up the concerts missed because of the delayed visas, and, in any event, New York was not on the original itinerary, which was designed to hit mostly heartland cities, avoiding the centers of the music business and holding ticket

prices to a $4 top. But they will surely be here soon enough, and—quite apart from the provocative hysteria that surrounds the Sex Pistols—they are very much worth seeing.

ROBERT ASHLEY

The New York Times, January 8, 1978

For well over a decade Robert Ashley, the experimental composer, has been involved in amalgams of music, sound, words, and theater. The elements shift from year to year, with one or another sometimes fading away almost altogether. But with *Private Parts*, an hourlong work in progress that he presented Friday night at the Kitchen, Mr. Ashley has all of them in balance. The result is a work of rare elegance and emotional energy, although perhaps the word "energy" is a bit too overbearing for something so quietly mystical and intensely personal.

The piece in these performances consists of three "songs," as Mr. Ashley calls them, entitled "The Park," "The Supermarket," and "The Backyard." The centerpiece of each was Mr. Ashley, dressed in a grayish jacket, tie, and slacks, with dark glasses, and bathed in ghostly light from a video monitor, on which were projected the words of his text.

He read in a soft incantation, sometimes pitching the syllables and sometimes fading into incomprehensibility. The words were a series of shifting ideas, scenes, and images—the stream of consciousness of a man with a particularly interesting consciousness.

To his far left and right were a California composer who calls himself (Blue) Gene Tyranny, at the piano, and another musician, Peter Gordon, at an electronic keyboard called a PolyMoog. Between the keyboard players and Mr. Ashley were four video monitors, two on each side of the composer, carrying images of Mr. Tyranny's jeweled hands at the piano.

Jill Kroesen was responsible for the video, and joined Mr. Tyranny for a vocal chorus in the second part. Marc Grafe handled the electronic coordination. The result of all their efforts was that Mr. Ashley's readings were supported by a trancelike tapestry of sight and sound—lovely rippling piano filigree from Mr. Tyranny, sustained or pulsing chords from

Mr. Gordon, and a blend of drone notes and electronic chirpings on tape (some of this exists independently as *Settings for Piano and Orchestra* by Mr. Tyranny).

Mr. Ashley has written mystically of this work, saying that "certain images are called up in the sounds, and some people can actually *see* them," although he adds that he wishes "to avoid the feeling of a séance." This observer "saw" nothing, but he was moved nonetheless.

The closest parallel to past work would be some of Mr. Ashley's earlier "operas" and choral pieces and the supermarket monologue of Lucinda Childs to Philip Glass's music in *Einstein on the Beach*.

But Mr. Ashley is very much his own man, and his work has a most powerful sense of personality to it. The person who emerges is funny and deeply romantic, full of wonder and a sense of gentle absurdity, angry but in a muted way that seems almost to have been turned by force of will into something consoling.

The last words of the night, spoken with the same semi-singsong sense of puzzlement and hurried awe as everything else, were "Dear George, what's going on? I'm not the same person any more." Those who let themselves open to Mr. Ashley's art can feel similarly transformed.

DISCO

The New York Times, January 21, 1979

There has been grumbling in the rock ranks for some time now. Especially at the Palladium, on Fourteenth Street, that bastion of white mainstream rock and roll, the signs and slogans protesting the dominance of disco have become increasingly common in the past couple of years. Just recently this writer received a fervent plea in the mail, calling upon him to become a standard-bearer in the fight against disco.

The argument goes like this: Rock is not only the true voice of the people, but our principal medium for personal expression in the realm of popular music. Disco represents a dehumanizing conformity, the imposition of a rigid, expressionless format. It has been imposed on the

masses by a diabolical conspiracy consisting of people who always hated rock and who in disco see their best chance yet of reducing us once again to the musical pabulum that prevailed before the advent of rock.

Quite apart from the issue of what these anti-disco activists want us to do—firebomb discos? write character assassinations of disco artists? mount protest marches?—there is a certain wonderful irony about their whole position, and a certain wonderful silliness, to boot.

Rock, after all, was born as a revolutionary popular upsurge, and was hated for just that reason. People who thought popular music was best served by the likes of Rosemary Clooney were convinced that rock represented a bludgeoning of all that was musically good and true. Just as disco is now called format ridden, simplistic, and crude, so was rock just twenty-five years ago—and the protests were a lot more virulent and widespread.

Rock was likewise regarded as a plot by a few record executives, and the anti-rockers could point to the payola scandal of 1959 as "proof" that people, left unmanipulated, would really prefer Bobby Vinton. And, until the advent of the Beatles in 1964, they did.

The idea of disco as dehumanized is silly, too. Disco is dance music, and dance music has a strong, steady beat. So does rock, or at least it did before it started getting all fancy. It might seem odd for rockers to complain about disco being dehumanized just at a time when so much rock is playing happily with notions of mass-man and androids—Devo, Talking Heads, and many more now, and the British science-fantasy progressive bands before that.

There's a darker side to all this as well. Even with the embrace of disco by the white masses, symbolized by John Travolta and the Bee Gees, disco is still regarded by rock loyalists as a black and homosexual phenomenon. It's not always clear when whites profess a dislike of disco as to whether they dislike the music or whether they dislike those who like it. If the whites are well-to-do, their prejudice could be snobbery; if they're disadvantaged themselves, their animosity suggests that they're threatened. Sitting in the Palladium, listening to a hall-full of white rock fans chanting their anti-disco slogans over and over, is just a bit too reminiscent for comfort of Lumpenproletariat proto-Fascism.

As it happens, there's a lot of interesting disco being made these days, and a lot of variety within a form that is often considered monolithic in its lack of individuality—just as rock was by non-rockers, way back

when. All you have to do is listen to WKTU-FM for a couple of hours to hear that variety.

Besides, rock is hardly being obliterated by disco—far from it. People complain about how bland rock is, and indeed there *is* a lot of overly bland rock (and bland disco, too, certainly). But we happen to be in the midst of a revival of hard-rock energies that's lasted several years now.

And, of course, the formerly rigid distinctions between "rock" and "disco" have long since begun to erode. Established rockers (Mick Jagger, Rod Stewart, even the Bee Gees) have turned to disco, and instead of that being a sickening sellout, as the anti-disco fanatics maintain, it's just an inevitable realism. The hypnotic repetitions of the Munich disco producers have an obvious parallel in the trance- and techno-rockers, and even as a leading new-wave band like Talking Heads can be danced to in a disco, so does the captivating version of Donna Summer's "I Feel Love" by Blondie and Robert Fripp a few months back at CBGB stand as the best symbol yet of the coming together of disco, punk rock, and old-fashioned "progressive" rock.

The reality today is a continuum stretching between all kinds of music. Disco is a tendency, not a form, and happens to be the preferred kind of music for people who like to dance together in groups, or to be reminded of that experience when they aren't actually doing it. The success of one kind of music doesn't necessarily hurt another, unless that music is flagging in its artistic vitality, anyway.

The relationship of jazz to rock is a case in point. Jazz fans used to be in the forefront of those who denounced rock in the same terms that rock fans use for disco today. But the fact remains that there's a marketplace for music, and that marketplace, far from being just a crass, brutal world in which artistic sensibilities are crushed, is a functional mechanism by which people register their preferences. Jazz fans used to argue—some still do—that if jazz only had the promotion that rock enjoys, it would sell just as well. That's simply nonsense. If jazz had the potential to sell, you can be sure that some ambitious record-company executive would be out there, selling it. In fact, some jazz does sell, but it sells in its electrified and/or mellow forms, and jazz purists reject those kinds of jazz as a sellout.

"Real" jazz has become a specialized form of art music, and perhaps it's all the purer for assuming that status. In its own way, uncompromising rock and roll is becoming an art music, too, in the sense

that it appeals to a specialized group of aficionados and has no pretensions to reaching a mass market that prefers the Eagles. Some fine, defiantly noncommercial rock has already been made that way. But it's futile for the fans of such rock to talk as if their favorite music was really the music of the people, and was being suppressed by a disco conspiracy.

It's a big country, and there's room for most everybody, musically speaking. Given the realities of mass communication and mass taste, it's almost an accident when music of real quality tops the charts. When it does, populists can rejoice, since such a moment represents a popular confirmation of elitist taste. And, maybe, the very finest popular music is just that, a music that both aficionados and the millions can simultaneously enjoy.

But in the meantime, there remain fans and markets for a vast variety of music, and the cause of music in general is poorly served by backbiting among the sub-genres. Disco can reign and so can rock and roll, and maybe even mingle and merge.

So, sorry, guys, but this writer is not about to join the anti-disco crusade, let alone help lead it. He loves rock and roll as much as the next man; indeed, he loves more rock than disco. But he fails to see a profound ideological gulf separating the two. This is simply a case of one group of fans' tastes hardening with age, and of their being unwilling to accept something new. As such, the anti-disco campaign is actually more contrary to the accepting spirit of true rock and roll than disco could ever be.

QUOG MUSIC THEATER
The New York Times, February 6, 1979

Note: I admired Eric Salzman as a critic but could never respond to his music-theater collaborations with Michael Sahl. I always felt a little embarrassed coming down on their work so hard, but I really hated it, it seemed worth reviewing, and no one else at the Times was interested. I kept hoping.

The Quog Music Theater was founded nine years ago by Michael Sahl and Eric Salzman. But their *Passion of Simple Simon*, a new "theater opera," is their first coproduction with the Hunter College Center for Lifelong Learning. After a run of previews, the opening was Sunday, with repeat performances scheduled for tonight through Sunday at the Theater for the New City.

The story concerns a punk sniper who kills joggers in Central Park (or its fictionalized equivalent), is taken up as a liberal cause and subsequently acquitted, becomes a punk-rock star, and is ultimately killed by the former lover of the female television newscaster who has given up her career for the killer rocker.

None of this is in the slightest way plausible on a realistic level, and metaphorically it is manipulative and confused. The music, a sort of noodling, eclectic stew, is facile, although some of the choral textures betray a certain cleverness. But it is never exciting or moving—Gian Carlo Menotti's slickness combined with Leonard Bernstein's vulgarity without either of their talents. And almost needless to say, the evocation of punk rock is ludicrous.

Most of the performances are in the earnestly amateurish category. But they could hardly be otherwise, given the banality of the two composers' conception and direction (Ben Schonzeit's photo-realistic backdrop of the Central Park skyline is handsome, though).

In the end, this reviewer is at a loss as to what to say about *Simon*, as indeed he has been about all of the Quog productions he has encountered. Mr. Sahl and Mr. Salzman have shown distinction in other fields. But this work so mangles and trivializes those issues it attempts to address that the result can only be called meretricious.

RECORDED ANTHOLOGY OF AMERICAN MUSIC
The Musical Quarterly, April 1979

On December 12, 1978, there was a reception at the Lincoln Center Library in New York to celebrate the completion of the "first phase" of

the New World Records *Recorded Anthology of American Music* project. Self-congratulation flowed freely, and in this case was deserved. New World Records still has more work to do. But it has achieved its initial goal, which was to issue one hundred discs of American music of every conceivable sort, "tracing the history of America through its music" (in the words of a press release) "in all its richness and diversity" (in the words of a brochure). Or, as Howard Klein of the Rockefeller Foundation said on that occasion, to capture in sound "what it's like to be an American."

The Rockefeller Foundation was represented because without its support of $3.9 million, there would be no New World Records. Conceived as part of the Bicentennial celebration, the company released its one hundred discs between 1976 and 1978, making use of recorded materials previously released on commercial labels or recording its own productions. Complete sets (700,000 discs) were distributed free to educational and cultural institutions worldwide, and other such institutions could purchase the set for $195. In addition, those recordings that did not contain material upon which commercial companies had placed restrictions could be offered for public sale at normal prices (fifty-three of the one hundred discs are now available in that way); altogether some 200,000 records have been sold in one manner or another.

The anthology is not just a collection of great American music. According to the company's figures, more than sixteen hundred American musicians are represented on these records. For music before this century the performances are naturally contemporary ones, but for the past seventy-five years the phonograph has been used as an archival tool, and thus a wide body of historically important performances has been preserved along with the music performed.

Confronting such a mass of material from a critical standpoint poses certain problems—not least of which is the sheer bulk of time required to *listen* to one hundred records. And ultimately one's notion of how well New World Records has done the job it set out to do depends on how one defines the nature of that job. The search for such a definition is complicated by a slight ambivalence either in New World Records' own self-image or between that image and the image that has been conveyed to a wider public.

Perhaps falsely, one assumes these one hundred records to be a sort of ultimate "greatest hits" collection—*the* cream of the American crop, the one hundred finest and most representative records of American

music of every sort that could be assembled. Sometimes the company's propaganda hints that that was the intention. But to be fair, its president, Herman Krawitz, and others speak more frequently of "filling the gaps." Thus instead of a set which one could passively absorb and feel one had digested the best of American music, we have a more complicated task. This is a collection of great American music *not otherwise represented on disc.* The potential listener is asked to muster a considerable degree of sophistication and selectivity, and to avail himself of the extensive notes, bibliographies, and discographies to fill out the complete picture. Just to give one of many examples, the only Charles Ives composition available here is on the first side of NW300 and consists of nine songs. No one felt the need to duplicate any of the symphonies, which are readily available on many other labels.

Beyond that issue, there are other criteria for trying to come to terms with New World Records' achievement. American music can be looked at as the product of several related dialectical polarities—European versus indigenous American, classical versus vernacular, white versus ethnic, urban versus rural, the political Left versus the political Right. As a general observation it can be said that the "establishment's" view of what constitutes American music has gradually loosened up and shifted left over the past few decades, with an ever-greater weight being placed on the second half of all the above polarities.

New World Records, which is nothing if not a product of America's musical establishment, has moved an honorable distance away from the Northeastern conservatism that might have informed a similar selection if it had been made only a few years ago. If one still adheres to a conservative position on such matters, of course, the fact that sixty-one of the one hundred discs are "nonclassical" (there are some borderline records, but that gives a fair idea of the proportions involved) could be construed as a lamentable erosion of standards. For others of us, the balance seems about right, in broad terms. The classical records in this series are full of fascinations, even those made before the turn of the century. But by and large they reinforce the view that in American art music (and by that I mean to include jazz and artfully composed popular music) the bulk of what is really interesting has been created in the last seventy-five years, and that the roots of our serious music lie more in folk styles than in the industriously imitative classical music of the eighteenth and nineteenth centuries.

So more power to the New World establishmentarians for includ-

ing—to take a particularly obvious example—Alan Lomax as producer of several of these discs, when Lomax is affiliated with the Department of Anthropology at Columbia University, not Music. But at the same time, there are still various establishment biases that distort the picture of American music presented in this series. The distortion increases the closer we get to the present, and there are two reasons for that. One is that prejudices and subjective passions burn brightest during one's own lifetime, and only fade under the consensus of historical opinion. Another is more practical: for recent material (especially recent commercial material) it became increasingly difficult to obtain clearances from the major record companies.

Still, that does not really excuse, for instance, a strong bias for Broadway over Hollywood. Or the virtual exclusion of electronic music, or the post-Cageian experimental avant-gardists. In a collection of ethnic folk music, scant attention is paid to American Jews.

Contemporary jazz is seriously underrepresented, although there is a fine Cecil Taylor record (NW201). Modern country music at least has one strong anthology (NW207). Rock and roll has only a single disc for the 1950s (NW249), and that was produced by Gary Giddins, a jazz critic not very interested in rock music. (There is, admittedly, a fine disc of the rhythm and blues antecedents of rock on NW201.) The fact remains that an enormous amount of American musical creativity over the past twenty-five years has been invested in the popular field, and that there is a large, knowledgeable and growing group of academic and journalistic experts who could have been called upon to document that creativity. New World Records' failure to make that effort is just lame.

In the classical selections, stopping short of the present does have one interesting side effect. It focuses attention on the generation of composers who just precede the present. This music—by such as Aaron Copland, Roy Harris, Virgil Thomson, Vincent Persichetti, David Diamond, William Schuman, Samuel Barber, and others—has rather fallen out of fashion in recent years, as the tide of serialism and chromaticism produced by students of emigré composers took hold. But there are now signs that this music is returning to favor, and it is nice to be reminded how worthy much of it is. (Another advantage of a decreased attention to the present is that we are spared a too liberal helping of the sort of fare served up at most ISCM concerts these days, although we still get more of that than we do of most other kinds of contemporary music, classical or popular.)

Although one applauds the attention paid to vernacular music, there is still a tendency here, I think, to regard folk and popular music as "resources" for an eventual reworking into "serious" art music. Perhaps that is a defensive bias of my own, or an unfair projection onto the New World Records editorial committee. But except in the admittedly significant area of jazz, when the program notes show that this music is taken with a real seriousness, there is a hint that popular songs were either sociological or anthropological effusions or grist for classical composers' mills, that Broadway was raw material for the as yet unborn Great American Opera, etc. If the series had had the boldness to include present-day popular music in all its diversity, we might better see that, largely unheralded, a whole, viable, new tradition of American art music in a commercial context has arisen, and that "fusions" between that tradition, older forms, and modern-day "classical" experimentation are proceeding in a far less self-conscious way than the third-stream efforts and Broadway-operetta hybrids of a couple of decades ago.

The records in the New World series fall into two types. One is a record devoted to a single piece, artist, folk singer, church choir, or whatever. The other is a more obviously *produced* disc, in which the producer has had a determining say in the artistic impact of the record. Such records can range from fairly straightforward historical surveys (*Hills and Home: Thirty Years of Bluegrass*, NW225; *The Music Goes Round and Round: The Golden Years of Tin Pan Alley, 1930–39*, NW248; *When I Have Sung My Songs: The American Art Song, 1900–1940*, NW247, etc.) to far more ambitiously produced "concept albums." Here the producer strives to make a point by juxtaposing music in a way that reinforces a thesis; some of the most intellectually stimulating, purely enjoyable records in the series are a result of this process, particularly when the notes surpass the prevailing high standard of informativeness and lively literacy. *Let's Get Loose: Folk and Popular Blues Styles from the Beginnings to the Early 1940s*, NW290, offers a wonderfully pointed dramatization of the musical relations between blacks and whites. *The Birth of Liberty: Music of the American Revolution*, NW276, gives a real panorama of our variegated musical life two hundred years ago. And *Where the Home Is: Life in Nineteenth-Century Cincinnati*, NW251, is so graphic you almost feel you have intruded upon your great-grandparents in their living room.

The variety of production approaches gives us some indication of another characteristic of the series. The company's distinguished edito-

rial committee and key staff members coordinated the overall production plans, laying out a large grid pattern and gradually refining the details. But individual records were turned over to individual producers, and the amount of leeway such producers were able to exercise naturally varied depending on the stature of the producer and his clout with the editorial committee. This had an obvious advantage: it freed independent-minded producers from excessive editorial supervision and constraint. But it also led to certain imbalances and self-indulgences. Lomax, for instance, is such a well-respected figure in the field recording of American folk music that he was allowed to devote entire records to material that might better (given the hundred-record limit, the grid pattern, etc.) have been confined to excerpts—the disc of Georgia Island Sea Songs (NW278), for instance, or the disc devoted to white spirituals from the *Sacred Harp* (NW205), although that record is so stirring and exciting that one can hardly complain.

Similarly, a record of American psalmody with the Oregon State University Choir (NW255), produced by Elizabeth Ostrow. director of research for New World Records, sounds a bit slick and excessive. Two discs of "forgotten" material—jazz (NW275) and pop (NW240)—make one wonder, in a highly selective series, why one should bother with this material, unless it is so outstanding as to be remembered fervently by a strong consensus of aficionados. Presumably these two discs reflect the private enthusiasms of Gunther Schuller and the jazz contingent on the editorial committee on the one hand, and of Milton Babbitt, who produced the pop disc, on the other. Most glaring of all is an entire disc devoted to *The Jazz Sound of Ricky Ford* (NW204). Ford is a graduate of the New England Conservatory and played with the late Charles Mingus and his record is actually quite pleasing. But with so little devoted to contemporary jazz, to give a decidedly marginal figure fully 1 percent of the whole series suggests (no doubt inadvertent) cronyism.

But in spite of all this, one still has to recognize the magnitude of this achievement, and to consider the ways in which it can be used. The most obvious derives from the manner in which the whole program was set up. With seven thousand sets now presumably ensconced in libraries around the world, instructors (especially in smaller institutions) have a significantly increased pool of resources upon which to draw for educational purposes. The ways in which these discs can be used in the classroom are nearly infinite, and their usefulness will be in direct proportion to the sophistication of the instructor. Given the "filling the gaps" real-

ity of this project, a blind assignment of the whole series to gullible ears as an ostensible representation of the totality of American musical culture would be a distortion. For most of the great creative works of American music are on other labels—all duly noted in the New World Records discographies. And before 1900 much of "serious" American musical culture consisted of European imports, which by definition New World Records does not include. But used selectively, these discs can prove an invaluable resource to students.

Another way to come to terms with this set is on one's own, either simply listening for pleasure or private instruction to such records as catch one's fancy, or arranging them in sequences that seem amusing and productive. I listened first to such folk musics as might be considered to flow into jazz, then to jazz itself, then to other sorts of folk music and miscellaneous religious and secular musics, then pop, and finally "classical" from the eighteenth century to the present. But that was an almost arbitrary choice. Fascinating comparisons could be made on a strictly chronological ordering, or according to instrumental groupings, or any other pattern one can dream up.

Listening to the records individually makes sense, too, in part because so much of the really strong, sturdy, and lasting American art music was made by rugged individualists—eccentrics, even—who fought free of traditions (especially European) and built a music that was as long on substance as it was short on immediate, overt influence on subsequent composers. This was as true for William Billings or Anthony Heinrich as it was for Charles Ives, Carl Ruggles, Henry Cowell, John Cage, Henry Partch, Conlon Nancarrow, or Lou Harrison.

In some ways the most painstaking records here are those on which a producer had to ransack private collections and record-company vaults to come up with just the archival material he needed to document his case or prove his point. Of those discs, the most dramatic, possibly the most important, and certainly one of the most enjoyable, is the disc devoted to a semi-reconstruction of Eubie Blake's black musical, *Shuffle Along*, of 1921 (NW260). There were no "cast albums" in those days, but a documentation has been assembled from period recordings by the composers and cast members. The result not only dramatizes the key role this musical played in allowing black culture to enter the white mainstream, but suggests that *Shuffle Along* forced as radical a realignment of American popular sensibilities as did rock and roll in the mid-1950s.

Naturally, the recordings that attract the most attention are those in which New World Records itself has gone out and recorded heretofore neglected major American works. The most widely publicized example is Virgil Thomson's *The Mother of Us All* (NW288/289), which some of us consider the finest American opera, and its neglect by our major opera companies to be a national scandal. (It appears that New World Records will be the first to record a complete version of Thomson's *Four Saints in Three Acts*, too.) Unfortunately the *Mother of Us All* album, recorded in Santa Fe and using that company's cast, is marred by the eccentric decision to cast a mezzo-soprano in the soprano title role; this transforms the score's many shining high notes into occasions for strain. But the music is still there, available to be heard.

There are other important recording projects that New World Records itself undertook. There are some fine efforts by the Federal Music Society, offering such morsels as John Bray's *The Indian Princess* or *La belle sauvage* and Raynor Taylor's *The Ethiop* (NW232) and a selection of *Music from the Federal Era* (NW299). There is an unusual pairing of Heinrich's *The Ornithological Combat of Kings* and Louis Gottschalk's *Night in the Tropics* on NW208; a fascinating (if rather bland, in terms of actual musical pleasure) section of George F. Root's pastoral cantata, *The Haymakers*, on NW234; a fine recording under Schuller's baton of John Knowles Paine's powerful Brahmsian Mass in D (NW262/263); the ingenious recording of Cowell's remarkable *Quartet Romantic* on NW285; a lovely Griffes disc (NW273); and Roger Sessions's *When Lilacs Last in the Dooryard Bloom'd* on NW296.

Beyond these expensive recording projects, there is a host of worthy individual records, and it would serve little purpose to chatter on, gushing over my favorites. But aside from the records already cited, enthusiasm will not let me avoid mentioning a disc of Puerto Rican and Cuban music by New York immigrants (NW244); a lovely ragtime collection on NW235; a fine disc called *The Roots of the Blues* on NW252; a snappy collection of "club jazz" on NW250 with affectionate, informative notes by Nat Hentoff; a disc of small jazz groups on NW242; a stimulating juxtaposition of black and white religiosity on NW224; two collections of country music from the 1920s, 1930s, and 1940s that prove how slick most Nashville modern-day country music really (NW236 and NW287); a charming collection of children's songs (and one of the several of the field recordings that really do make a *musical* impact) on NW291; a lilting assortment of popular dance music from the eighteenth century to

the 1920s on NW293; a kitschy but amusing garland of sentimental pop
piano stylings (NW298); Ivan Davis's *The Wind Demon* collection of
nineteenth-century piano music (NW257); the Arthur Foote violin
sonata on NW268; the Harris-Cowell-Shepherd disc on NW218; the
Copland solo piano record (NW277); the Cowell-Cage-Nancarrow-
Johnston disc on NW203; and Salvatore Martirano's moving a cappella
Mass on NW210.

Needless to say, among the unmentioned records are many that pro-
vide great pleasure. And equally obvious, there are others that may
sound a little austere or even grim, but still serve a needed documentary
function. To my taste the worst is attained by the late-nineteenth-century
material, both classical and, especially, popular: Victorian/Wilhelmian
culture tended to wallow in the bathetic and the (innocently?) racist,
but nowhere did it wallow more happily than in America. It is to the
great credit of New World Records that contemporary pieties are not
allowed to launder the racism or purge the sentimentality, yet some of
this stuff is still quite offensive treacle. No wonder America was ready for
the Jazz Age.

But it is part of the charm of listening to these discs in bulk that, even
on records that otherwise are perhaps only mildly interesting, the most
remarkable gems crop up. For instance I enjoyed the delighted cackles
and remarks like "Boy, oh, boy, that's good" that punctuate an otherwise
rather dogged record of Indian chants on NW297; or "Starvation Blues"
on NW256, or "Passion Flower" with Johnny Hodges and his Orchestra
on NW274; or the Jaki Byard piano solos on one of the discs of
"neglected" jazz, NW275; or the highly political Charles Mingus cut on
NW242; the Lennie Tristano and Stan Kenton (especially "Mirage")
selections on NW216; Meliton Roybal's Spanish-Indian violin playing
on NW292; John White and Roy Smeck doing "Whoopee-Ti-Yi-Yo" on
NW245; "Fox on the Run" and "Body and Soul" on NW225 (the blue-
grass collection); Grant Rogers on an otherwise uneven disc of New
England folk songs (NW239); "Bobby Halsey" on a collection of chil-
dren's songs (NW291); the silly but endearing *mélodrame* of "Beaure-
gard's Retreat from Shiloh" on a Civil War collection, NW202; an
extraordinary duet for Italian bagpipes recorded in New York around
1916 on NW264; the spirituals sung by Roland Hayes, Marian Anderson,
and Paul Robeson on NW247 (which, nicely enough, is devoted to *The
American Art Song*); the John Alden Carpenter and John Powell pieces
on NW228; Randall Thompson's *Americana* on NW219; Lou Harrison's

Suite for Cello and Harp on NW281; and the Paul Chihara and Chou Wen-Chung works on NW237.

From a technical standpoint, this is a generally admirable achievement. Occasionally some oddity intrudes, like sour pitch on my copy of NW208, or an inner page of notes sticking to the jacket and obliterating some text when it is torn loose, or occasional skipping. But by and large the new recordings are engineered in a manner competitive to [the] major labels, and the remastering of the older material is handled with admirable care. The notes and other textual matter are done with scrupulousness and style, although some are less good than others (e.g., the too breezy notes for the Irving Berlin record, NW238).

Now that the initial Rockefeller grant has been exhausted and the first one hundred records have appeared, the New World Records organization has trimmed its staff, but it has no intention of disappearing. The Rockefeller Foundation has come up with a new $80,000 matching grant, and New World Records has launched a fund-raising drive to continue its operations on a more circumspect level, with contributions already received from fourteen sources. The company promises several new releases that should be out when this essay appears in print: a second Cecil Taylor record, a field recording of an Indian "turtle dance," a collection of twentieth-century piano music, and performance tapes in the Library of Congress. There is talk of the complete Charles Griffes, more nineteenth-century symphonies, more theater music. The policy of enlisting top-rank American artists and institutions, already so much in evidence in the first one hundred records (e.g., Sherrill Milnes, the Boston Symphony), will continue with projects involving Zubin Mehta and the New York Philharmonic, John Nelson and the Indianapolis Symphony, etc.

As in any such endeavor, the totality is both more and less than the sum of the parts. On the one hand, whatever reservations one might muster about the exact delegation of individual assignments or the balance of ingredients in the overall stew or even any particular record, there are still surely a large number of discs in this collection that will give anyone pleasure. Even with the inevitable reservations, it is hard not to feel grateful and congratulatory about the New World Records project. Here, finally, is an instance of an idealistic, difficult undertaking that enough intelligent people cared enough about to pursue to a happy conclusion. Scholars, students, and music lovers will be in their debt for years to come.

THE ROCHES

***The New York Times*, April 1, 1979**

The Roches, which will be released on the Warner Brothers label later this week, is the best pop record of 1979 thus far. In fact, it's so superior that it will be remarkable if another disc comes along to supplant it as best album of the year.

The Roches, pronounced as in the bug, consist of three sisters named Maggie, Terre, and Suzzy. They're in their mid-twenties, come from New Jersey, and live in New York. Maggie and Terre have sung together publicly for over a decade, and even made a record under Paul Simon's auspices on the Columbia label in 1975 (Mr. Simon discovered them and served as overall producer). Called *Seductive Reasoning*, the record went out of print only last year, and even though it's not at the level of The Roches, it's still very much worth hearing.

Just as *Seductive Reasoning* was released, however, Maggie and Terre opted out. Maybe they were nervous or neurotic, and maybe they had reason to feel that Columbia was tolerating them just because of Mr. Simon's interest. In any event, they disappeared; the record won some warm reviews but no sales, and that was that.

Then, a couple of years ago, they started appearing again in public in Greenwich Village after their younger sister, Suzzy, joined them to make a trio. Their following grew steadily over the course of 1978, and now a new record contract and this album are the result.

The Roches is eminently accessible, yet it is disturbing and thought-provoking, too. Its tunes are so catchy that everyone who hears it seems to wander around humming odd fragments of Roches songs for days. The lyrics are generally expansions of small, everyday events into epic vignettes. As such, there's a curious parallel to another New Jersey artist, Bruce Springsteen, although musically the two are worlds apart. In a song called "Mr. Sellack," for instance, Terre is ostensibly trying to get her old job back as a waitress, and every detail of her plea to the restaurant owner rings autobiographically true. But soon we realize that the song is also a metaphor for broken dreams and a vehicle for wonderfully loony humor ("Give me a broom and I'll sweep my way to heaven"). By the time the song is over, the Roches have transformed it into both poetry and a full-scale vaudeville number.

Humor is always present in the Roches' music, and occasionally their

songs can sound just a bit coy (that coyness finds its equivalent in musical terms in their recurrent mannerism of resolving cadences upward with a giddy swoop). But underlying the wit is a seriousness and an even dangerous intensity. "We went so far out there, everybody got scared," they sing in a song called "Runs in the Family." What they mean is they are the kind of people who take risks—artistic, psychological, emotional—and that sort of risk taking can be frightening for a relative, a friend, or for someone just listening to this music.

Musically, the Roches can be called "folk," in that they do without drums and most of the common appurtenances of the rock or folk-rock idiom (*Seductive Reasoning* has those appurtenances, and is far less original for them). But they could also be called "Renaissance," in that the closeness and complexity of the Roches' three-part harmonies and the intricacy of their song structures recall late Renaissance madrigals as much as simply strumming folk banalities.

All of this comes to a climax in the last two and finest songs on the album, "Quitting Time" and "Pretty and High." "Quitting Time" is about the end of a love affair, but its imagery evokes industrial America and its religious underpinnings with fearless ambition. "Pretty and High" is a self-portrait of three women who went "way out there" and didn't come back. The song (and the record) reach their peak with Terre's repeated cry of "pretty and high and only partly alive," the last wrenched out with such agony that all notions of ladylike gentility are left far behind.

The credits for *The Roches* include the line "produced in audio verité by Robert Fripp." Mr. Fripp is the legendary British progressive-rock guitarist who has lived in New York for the past couple of years and who's been involved in new-wave rock, his own projects, and production. His work here is crucial to the disc's success, but not in any obvious way.

Seductive Reasoning falls short because Maggie, Terre, Mr. Simon, and the other producers didn't trust the Roches' music on its own terms. Mr. Fripp reportedly fought hard to keep drums and other commonplaces off *The Roches*, and the term "audio verité" suggests that what we hear is the sisters as they sound in a live performance.

But it's not as simple as that. Mr. Fripp has actually done something far more difficult and creative—he's made a recorded equivalent of their live performance by building up artifice and making it sound "natural." *The Roches* is full of little Frippisms—a bass line here, a snippet of tape-

looped electric guitar there, a sustained synthesizer chord. All of it works perfectly, as reinforcement rather than distortion or distraction.

More subtle still is his technique of playing with the perceived direction of the three women's voices, and his vocal overdubbing, so that three become six or more ("Quitting Time" sounds in spots like a small church chorus, yet it's never heavy or excessive, and it never blurs the individuality of the three voices). One's only worry is that Mr. Fripp didn't persuade them to include a couple of their delightful arrangements of nonoriginal songs—their charming account of the "The Naughty Lady of Shady Lane," for instance. Not only are these high points of the group's live shows, but their inclusion would have saved some of the Roches' best original songs for future albums and relieved them of the obligation to come forth with ten new songs for every album.

If this is the best record of 1979 so far, that hardly means, of course, that it will be the most commercially successful disc of the year. No way, although it is so attractive that maybe the Roches and Warner Brothers will get lucky.

Part of the problem is the sisters' own attitude toward pop-music success, which remains defiantly ambivalent. In this regard, as in many others, they recall another Warner Brothers sister act, Anna and Kate McGarrigle, and the parallel becomes even more striking when one realizes that after Loudon Wainwright III (the singer-songwriter) and Kate McGarrigle separated, Mr. Wainwright lived with Suzzy Roche. Both the McGarrigles and the Roches are folk-based sister acts of enormous originality and fragility, and both aren't really quite sure they want to tour or devote the bulk of their time to their careers. Maybe, from their point of view, that's wise and mature. But artists have an obligation to art, not just to themselves. It would be a great shame if the Roches wandered away again, as they did after *Seductive Reasoning* was released.

The word "artists" was not used capriciously. The ultimate commercial success of *The Roches* is almost unimportant (except maybe to Warner Brothers). "Popular music" is such an amorphous panoply of styles and levels of commercial aspiration these days that many of the old presumptions are simply inapplicable. Some "pop" records are art now, and it's just silly to pretend otherwise. That doesn't mean they can't conceivably be successful commercially, or that all that does sell isn't art. But it does mean that the principal purpose of this disc is to express the musical and poetic achievements of three enormously talented women.

LINDA RONSTADT

Stranded: Rock and Roll for a Desert Island, 1979

Note: This the first half of a long essay I wrote on Ronstadt for a desert-island-discs compilation edited by Greil Marcus. No doubt totally coincidentally, Marcus followed my effusion with Dave Marsh's "Onan's Greatest Hits," referred to in the first paragraph of the introduction to this book. This half is a self-standing study of her as an artist and a person. The second half, omitted here, was a structurally awkward appendage in which I discussed the songs on her album Living in the U.S.A. *track by track; the first half reads better without the second half.*

Ronstadt was the biggest exception to my generally detached attitude about those I reviewed. I loved her music and eventually I became close with her, too, though not as close as some people assumed. We're still friends. With Linda, I was not an outsider, and I felt increasingly squeamish being a critic and a friend. When The New York Times went on strike for three months in the fall of 1978, I had my chance to write a huge piece about her, an effort to practice "insider" criticism, a disquisition about the standards and prejudices of rock criticism, a fairly technical exploration of her voice, and a mediation about the psychology of obsessive admiration, all in the context of American history and musical history. It went way beyond anything I could have attempted in a daily newspaper, even the Times. After this, I stopped reviewing her work, which is more than you can say, for better or worse, about Hanslick and Brahms.

What I'm going to write here is a piece of passionate advocacy, and one doesn't normally introduce advocacy defensively. My defensiveness, such as it is, derives from the nature of my intended audience. Linda Ronstadt hardly needs defenders in the world at large. She is the most popular woman singer of the 1970s, and perhaps ever, as measured by record sales; in 1977 she had the most commercially successful album by any solo artist, with *Simple Dreams.*

But with popular music the relationship between popularity and critical approbation is an especially complex one. Rock critics are by definition populists, yet simultaneously they must trust their own instincts with the same elitist ferocity as any high-art connoisseur. In rock criticism, commercial success doesn't so much attest to quality as corroborate it; if you like something the millions like, their general

enthusiasm adds resonance to your private enthusiasm, certifying its universality.

In Ronstadt's case, her reputation among rock critics is not very grand. In Britain especially, she is widely regarded as a mindless puppet in the hands of her producer, Peter Asher—which must be an odd irony for Asher, who was a British pop star once. A typical passing crack about Ronstadt in the British rock press comes from a recent *Melody Maker*, in which Michael Oldfield grumbles that "it's ridiculous that the most successful female rock singer is Linda Ronstadt, whose voice is nothing special, but who has made it through ruining other people's songs." And the British attitude, or at least something approaching it, is shared by many of the best-known American rock critics; Ronstadt didn't even make the *index* of *The Rolling Stone History of Rock & Roll*, which was a compendium by exactly the writers I'm talking about—many of the same people who have contributed to this book.

The problem is further complicated by the fact that several of those writers are my friends, and so is Linda. My love for her music long antedated my friendship with her, and that friendship has remained the exception rather than the rule in my dealings with the people I write about. But knowing her both adds to my knowledge of her music and reinforces my desire to champion her work with my peers. As you will see below, I am by no means blandly uncritical about Ronstadt's accomplishments. But ultimately I love both the accomplishments and the accomplisher, and it frustrates me that more people whose sensibilities I respect don't get as much pleasure as I do from this wonderfully pleasurable music. My friend Dave Marsh thinks I'm the ringleader of a media plot to win Ronstadt some critical respect, and he's right.

Before I launch into my advocacy, I should say something about why I've chosen her latest album, *Living in the U.S.A.*, as my ostensible subject. I was originally going to write about *Heart Like a Wheel*, which came out in late 1974 and by early 1975 had made her a superstar after nearly a decade of cult success. This was her first album produced entirely by Asher, and it inaugurated a string of discs that have defined both her commercial dominance and her mature artistry; even the weakest of her Asher-produced albums, *Prisoner in Disguise* of 1975, is superior to any LP she'd done without him. *Heart Like a Wheel* is also the album least disliked (most liked?) by critics who generally find Ronstadt uninteresting, although at this writing *Living in the U.S.A.* has just been released, so its critical reception has yet to be determined.

Heart Like a Wheel remains a fine album. I can remember putting it on my turntable for the first time and being instantly thrilled by the new authority and assertiveness of the singing on the first track, "You're No Good," which eventually became the first of the album's two number 1 singles. For all the diversity of its personnel, the album boasts a convincing focus and a solid consistency; there are no obviously weak or misguided selections here, even if "It Doesn't Matter Any More" and "You Can Close Your Eyes" don't seem really memorable. But there are both specific and theoretical reasons for picking *Living in the U.S.A.* One, quite simply, is that although I haven't lived with it as long as the others, it's the one I'm fired up about right now. That means I am still in the process of thinking it through, which may lend the whole enterprise of writing once again about Ronstadt a certain spontaneity. Another is that after ten or fifteen listenings it seems about as strong an album as she's done. And as her most recent, it is more characteristic of her evolution in the past five years than *Heart Like a Wheel*, whose arrangements sound more pop and less rock than her recent work. Quite apart from her growing intelligence and range as an interpreter, there's been a steady shift since 1974 from innocence and vulnerability to sophistication and aggression, and that's a shift worth considering.

In any case, I planned all along to devote as much space to Linda and her work in general as to whichever specific album I finally chose. Partly that's because any selection of a "best" or a "favorite" is a distortion. All of Ronstadt's records have things on them I'd want on a desert island, and nearly all of them have what I consider "mistakes"—songs that she might better not have sung. Beyond that, for all my love for Linda, I would not seriously suggest that she was the most important single artist in the history of rock music. But she *is* the one I've been the biggest fan of, the one whose music has meant the most to me over the longest time. Pop music has always been about emotional release, about passionate responses to artists who might not rank at the very top of our rational hierarchies. There are those of us who like to think about why that happens, and this book offers us at last the chance to explore our compulsions in depth. What follows is for those who could be moved by Ronstadt, by one who has been.

Any consideration of Linda Ronstadt has to start with her voice. Objectivity may be a myth in art, but it's hard to avoid the flat statement that Ronstadt has the strongest, most clearly focused, flexible, and simply beautiful voice in popular music. As a physical instrument, it is capa-

ble of authoritative usage in almost any kind of pop music, and with a bit of technical work, could encompass most any classical style, as well. Many of the great voices of the past have been "natural"; subsequent technical work has served only to refine an already extant gift. Most pop voices are defined by a certain huskiness, which is generally the result of a vestigially developed voice or one that has been driven to a near-hoarseness by strain. At its best, such huskiness can serve as a metaphor for passion or warmth; one need only think of Rod Stewart. But at its worst the huskiness leads to nodes or nodules on the vocal cords that can so reduce a singer to whispery silence that an operation becomes necessary, and sometimes that operation can radically alter a voice (occasionally for the better, as in the case of Bonnie Tyler) or end a career. With Linda the only huskiness is that which she consciously applies to specific syllables as coloration. Her voice has a strength, size, and basic technical security that enable her to sing with force, yet without the sort of strain that leads to its rapid degeneration. And it has a focus or "edge" that helps lend it that ultimately undefinable character that constitutes her essential sound. Throughout her career that sound has been there, and apart from the natural shifts of aural color and the slight lowering of basic range that come with age, it will probably serve her well for decades to come.

Ronstadt is a soprano, although she never worked to develop the ringing upper extension that constitutes the climactic top octave or more for an operatic soprano. She can in fact sing in an overtly "operatic" way, plummy and full of a marked vibrato, and by so doing can reach higher notes than she normally attains. But that method of vocal production doesn't sound stylistically appropriate to her for the music she sings. By choosing not to deploy that register of her voice, she has constricted her range from what it could be. What's left is not really wide in operatic terms, as anyone who heard her bull her way through "The Star-Spangled Banner" during the 1977 World Series can attest. Her effective range is from around G below middle C to the C above it, with a few notes beyond that in falsetto.

Compared to the average pop singer, however, that range is relatively wide. Singers with multioctave voices, operatic or otherwise, attain their breadth through the more or less smooth knitting together of several distinct registers, from a booming chest voice through the middle and up to various head-voice or falsetto top extensions; operatic training consists largely of the cultivation of those registers and of evening them out—of

engineering transitions between them that don't sound too inadvertently disjunct. For all practical purposes Ronstadt's great natural instrument, her wide-ranging and near-perfectly focused middle register, has never been subjected to any vocal training (which is different, of course, from a steady improvement in her musicianship and her command of various musical styles). She lacks a chest register, at least in the sense of an operatic contralto. *She* thinks of the lower notes of her range as her "chest voice," and feels them resonate in a different, deeper part of her body than her top notes. But at the very bottom of her voice, the sound could hardly be heard at all in concert without amplification. It is defined mostly by its characteristic vibrato—the rapid pulsations that nearly all singers have and most modern instrumentalists affect to excess. Too much vibrato can sound mawkish and, at its extreme, can be a sign of near-terminal vocal strain. Too little vibrato sounds plain and churchy, and makes the attainment of proper pitch needlessly difficult.

As she moves up the scale into her middle and upper middle range, which she calls her "pharyngeal voice," the body of her soprano fills out. This is the typical Ronstadt sound, loud or soft, and most of her singing is done here. As she ascends in pitch, toward the C above middle C, her limitations at the top become apparent: the vibrato thins out and the voice can sound like a hard, nasal yell. That can have its expressive virtues, especially in hard rock (cf. the end of her live version of "Tumbling Dice," in the *FM* soundtrack album). But at the very top it's neither a very grateful nor a very controlled sound, and when she's not singing at her best in concert, the voice can crack at that altitude; eventually, one suspects, it will become increasingly difficult for her to hit such notes consistently, and she may have to pitch some of her standards down a half or a whole step. Even now on records, in material that courts operatic comparisons like Sigmund Romberg's "When I Grow Too Old to Dream" from 1935 (unless otherwise specified, all Ronstadt songs mentioned henceforth are on *Living in the U.S.A.*), it's possible to wish for just a bit more operatic control, tone color, and flexibility; on the other hand, there's a folkish naturalness to Ronstadt's sound that an operatic fullness and upper extension would preclude.

Above the "natural" top of her middle register comes her falsetto, which she has been employing more and more in recent years. This is really a delicate version, thin and tenuously supported, of the operatic head voice she *could* develop if she so chose. She uses it partly for expressive purposes, and sometimes it works very nicely, as at the end of

"Alison" or throughout "Ooh Baby Baby." In that song she makes the shifts between mid-volume full voice and falsetto smoothly, but on the whole her falsetto remains undeveloped in comparison to the confident power of her full middle voice, and too often (e.g., at the very end of "Blue Bayou" on *Simple Dreams*) it sounds simply as if she had no other way to reach a high note.

Now, this is all semitechnical description, and it quite completely avoids the issue of one's gut response to the sound. There is nothing inherently superior, aesthetically, to a well-produced voice ("produced" in vocal terminology, that is, rather than in the recording-studio sense). But the actual sound of a voice is indeed an aesthetic consideration, perhaps the prime one for a singer. And a voice with a solid technique (natural and/or acquired) not only secures the vocal quality over time, but ensures a wider and more varied use of that quality. In Ronstadt's case the sheer joy and physicality of her singing has always been instantly communicable to me, and the specific coloration has seemed intensely moving. To take just one example—and we're still speaking here of sound alone, not the interpretive uses to which it is put—consider Linda's version of "Just One Look." Doris Troy, who had a hit with the song in 1963 (her version is on volume 6 of Atlantic's *History of Rhythm & Blues* series), sang it with a good deal of gusto, and the Ronstadt arrangement and phrasing emulate her record in every respect but one. Troy essentially fades out on the phrase "just one look" after the last chorus; I say "essentially" because she raises the note values slightly on the last two repetitions. Ronstadt constructs an entire coda that's not in Troy's version at all, full of exhilarating "come on baby"s and other shouting manifestations of lust. She can do this because her voice has all the authority and strength of Troy's in the lower middle range, but can extend upward to climactic upper middle notes in a way that Troy's simply cannot. For a direct comparison, listen to both women's treatment of the word "wrong" in the second line of the bridge; next to Ronstadt's joyous vocal authority, Troy sounds hard and pressed. Of course it's ultimately impossible to separate technical and interpretive issues entirely. The sort of buoyant strength Ronstadt flaunts in her "Just One Look" makes an aesthetic and emotional statement all by itself; when she sings the line "Without you, I'm nothing," you don't believe her for a minute.

People who can't respond to the sheer power of Ronstadt's voice sometimes complain about her "belting" style: they don't find the sort of vocal musculature that epitomizes her sound at its loudest either very

attractive or very appropriate to much of the music she sings. Partly this is a question of the husky sound color that characterizes most popular-music voices, forming the model against which many pop critics compare Ronstadt. In my own case, after an early fascination with pre-rock pop and mid-'50s rock and roll, I became immersed in classical music, and only came back to pop in the 1960s after my tastes in vocal music had been crucially influenced by opera. Today I can love all sorts of vocal sound, but my longtime attraction to Ronstadt's voice, dating back to the late 1960s, was clearly reinforced by my instant appreciation of its operatic qualities.

The most provocative theorist of classical and popular vocal singing has been Henry Pleasants, in his book *The Great American Popular Singers*. To compress his argument brutally, Pleasants suggests that the original Italian notion of bel canto some four hundred years ago was an intimate, highly flexible vocalism, built around declamation. Over the course of centuries, under the pressure of man's innate tendencies toward virtuosic and rhetorical display and the growing size of opera houses (itself a result of the democratization and popularization of opera), opera evolved (or devolved) into a more brilliant, less expressive excuse for clarion vocal athleticism. The introduction of the microphone and electronic amplification after 1925 has meant that singers like Bing Crosby and Frank Sinatra could be freed from the need to sacrifice expressivity on the altar of volume and could revert to the traditional virtues of bel canto. Thus, one could conclude with a straight face, Frank Sinatra was a better bel canto singer than Jussi Bjoerling.

Pleasants himself has never paid much attention to rock; generationally it's beyond him. He tends to regard rock singers as brutes who bellow into the microphone even when they don't have to. Quite apart from the blues-rock shouters, there is indeed a whole school of semioperatic rock emoters, epitomized by Bruce Springsteen. But of course a great deal of contemporary popular culture corresponds exactly to the models Pleasants himself has posited for pre-rock pop, particularly the folk style that underlies both modern-day country music and the folk-rocking singer-songwriters. Next to them, Ronstadt can sound like an anachronistic reversion to the semioperatic emoting of Al Jolson and back to the days of the American vaudeville stage. For me, though, that aspect of her vocal style can be very appealing, since it both echoes the operatic singing I love and evokes a whole image of nineteenth-century America. It's not just a matter of vocal style, either; Linda's way of pro-

nouncing the English language is very much of this country. In fact, of contemporary women popular singers, only Bonnie Koloc, with her wonderfully direct mid-American declamation, surpasses Ronstadt for the sheer Americanness of her singing—in that respect, the otherwise somewhat spurious "American" theme of *Living in the U.S.A.* makes perfect sense. Anyhow, "belting" isn't all Ronstadt can do; her soft singing combines the purity of an operatic voice with the simple plaintiveness of folk singing, and her clarity of focus and security of pitch make her harmony singing a special joy.

When one says "American," one means white America. Until the advent of jazz, blues and soul singing in this century, white culture was American culture; blacks made their influence felt on the mainstream, but usually in such white translations as Stephen Foster. No doubt John David Souther meant something deeper and broader by the phrase "white rhythm and blues" in his song on *Living in the U.S.A.*, but it seems to me that it suggests something important about Ronstadt's singing style. Even when singing black songs she remains an inescapably white singer. This could be—and has been—taken as a condemnation, a proof that she has no business assaying such songs. Her critics complain that some of her cover versions of black hits have sounded uncomfortably close to the bland reductions that Pat Boone used to inflict on Little Richard (e.g., her version of "Heat Wave" on *Prisoner in Disguise*). But at her best, it seems to me, she has developed a most convincing solution to her black material, with a style that simultaneously evokes the original interpreters yet remains honorably white.

But terms like "black" and "white" are both vague and possibly racist, and in any case we should realize that by this point we have moved into a discussion of Ronstadt's interpretive abilities, as opposed to her voice. Blacks have represented the principal symbols and agents of passion, spontaneity, and rebellion in recent white American culture, and most of the best white rock singers have not only built their music on black foundations, but assumed similar attitudes. Linda's singing has been criticized interpretively on a number of grounds, but all of those grounds have a common theme. As the most popular woman singer of the 1970s and a quintessential Southern Californian, she epitomizes for her critics all that is soft, safe, and retrogressive about this decade. Her singing has been called stiff and hopelessly uptight, with that uptightness carried over into her stage shows, which rarely approach the mass celebratory rapture of great rock events. Her records, and in particular Peter

Asher's production, have been branded as too coldly, clinically "perfect," a studied formalization of songs meant to be sung with loose, improvisatory fervor. Her song selection has been dismissed as formulaic (mechanically trying to recreate the pattern that made *Heart Like a Wheel* such a hit) and misguided, in her frequent selection not only of black songs but of material by such as Randy Newman and Warren Zevon that supposedly suggests subtle, ironic, or abstract connotations that she's too dumb either to understand or to project. And her overall image of love and sexuality has been called both manipulative and reactionary.

There is a bit of truth to every one of these charges, especially in years past, although I would argue that some of the criticism of Ronstadt on feminist grounds is itself just a bit sexist: it's unconsciously suspected that someone who is small and pretty and who admits openly to emotional vulnerability can't simultaneously contribute creatively to her own music and image, and that to the extent that she does so, she is a manipulator.

Before we consider the charges point by point, however, three other issues need to be raised. Linda Ronstadt is an interpretive singer, even if she collaborated on two songs from her 1976 album, *Hasten Down the Wind,* and may one day compose more (according to her collaborators, she played the determinant role in both songs). Composers as executants of their own music have by no means always been the rule, in either classical or popular music. In the Tin Pan Alley days—think of Crosby or Sinatra—singers generally sang others' songs. But with the advent of rock, the two functions have tended to merge. This has led to an unparalleled intensity of personal expression in the music, even if the composers weren't always particularly fluent singers. But critics used to the singer-songwriter (or his rock equivalent, stripped of that term's folkish connotations) generally prefer the composer's original, no matter how roughly executed, to another's interpretation; it's somehow assumed that a "mere" interpreter will lack the insight of the creator. Furthermore, the very roughness of a singer-songwriter's voice somehow symbolizes an honesty that a more polished interpretation supposedly must lack.

Now in my own hierarchy of musical values, a composer may indeed rank higher than an interpreter; clearly Bob Dylan and Neil Young are more important to the history of rock music than Linda Ronstadt. Yet such a bias need hardly consign all interpreters to the slag heap. And

insofar as interpretive singers can project a focused, interesting image through the music of others, welding disparate materials into a new unity, they can make their own cohesive artistic statement. Besides, not all composers are great singers, even within the terms of a singer-song-writer aesthetic; it's no accident that Linda has enjoyed some of her greatest successes with the work of Zevon, Souther, and Eric Kaz. And not having to come up with an ever-better collection of ten tunes every year enables interpretive singers to develop more steadily and surely than many composers; if Karla Bonoff, for example, fails to match the quality of songs of her previous album, it won't make much difference how well she sings.

There's another basic bias to consider before we go on. It isn't just that contemporary rock critics prefer husky, untrained voices over more polished varieties, or that they sometimes unthinkingly doubt that any interpretation can conceivably equal the composer's original. There is a widespread prejudice against beauty per se in present-day popular music. People are so appalled by our culture's tendencies toward slickness and surface packaging that they seize hold of almost any rougher alternative. Pretty voices, pretty faces, pretty songs all become suspect to such a sensibility. Yet surely we have to allow for that part of life if the rebellious alternatives are to have meaning.

Or at least we do if we tend toward an attitude that in some crucial sense accepts things as they are. For better or for worse, I have always been a person who tries to keep things in balance. I may be drawn to extremes in art and behavior, but I find them most desirable when contained within the sum total of human experience. And with my longtime fascination for German art and thought, I ultimately conceive of extremes in terms of the dialectical tension between them.

This runs counter to the extremist positions about art, politics, and life that shaped the ideology of today's active rock critics, people who grew up in the1960s. I spent most of that decade in Berkeley, and in my parents' eyes I was a hopeless hippie. But I never really rejected them or their values, however much I may want to see changes effected in the way society works. Most serious rock critics think in more radical terms, whatever their day-to-day lives may be. For them the greatest rock serves as an explicit or implicit call to battle. For me it can well do that, but it can also echo the softer sides of life. They think of the polarities between rock's extremes—or between the extremes and the middle ground—as combatants in which only one side can be victorious. For me, there may

be slow movement of the whole societal and artistic organism in a progressive or retrogressive direction, but all positions along the scale from radicalism to conservatism have at least some potential for validity.

Those three speculative considerations aside, however, a rational defense of Ronstadt's interpretive style and public image has to begin with the admission that she has been and still can be a constrained performer. She herself has often worried in interviews (especially in years past) about being considered a "lame" singer, particularly by the circle of musicians and songwriters who are her closest collaborators. And even during the making of *Living in the U.S.A.*, one song was ultimately left off the album because, as Linda put it, "I sang it like a librarian." Related to that constraint is her stiffness in public performance. Ronstadt has never been one to whip up her audiences to rock frenzy; if your standard of comparison is Bruce Springsteen, then she is certainly a failure.

But of course Springsteen can't be the standard, since what he is doing and what she is doing are so different. Admittedly, Ronstadt's stiffness could be relaxed to her own advantage, and it has been over the past few years, especially in the matter of her singing. But as I've already indicated, that stiffness can have its own validity and charm, as an echo of a particular kind of white, churchish gentility. Her performing manner can be effective on its own terms, too. Often the simple sight of her standing there with her blend of beauty and shyness can be intensely touching, and serve as a fine foil for her sassier rock numbers. And when she's singing well, the sheer *sound* of that voice absolutely aceing a song can be just as thrilling as the most frenzied rock celebration.

There's also some validity to the charge of the "cold perfection" of Peter Asher's production, even if some of those qualities derive from Linda's own fears and perfectionism. In any case, one man's clinical coldness can be another's jewellike beauty. Much of the best rock has striven for spontaneous passion above all else, with technical correctness far down on the scale of virtues: Bob Dylan's deliberately helter-skelter recording technique is the epitome of this tendency. Asher is trying for something different, something approaching the formal clarity and abstraction of classical music, that holds up under repeated listenings in a manner akin to precisely structured Western art music. At its best—and perhaps especially for those of us with a strong background in classical music—the sheer taste and *rightness* of his work has a real conviction of its own.

But to what extent it's *his* work and to what extent it's that of Ronstadt and her other collaborators is an extremely difficult matter to judge, even for them. Which in turn makes the assumption by some critics that Ronstadt is a mindless puppet a misapprehension. The one thing Asher does indisputably in both the recording studio and on the road is organize details like a computer. But the arrangements are a joint matter between Linda, the band, and Asher, with Linda's role far more crucial than her detractors might think. And a simple consideration of her last few albums indicates that her closest collaborators in the band have had an influence that rivals Asher's, and that shifts in personnel become a key way to vitalize and extend her sound. In particular, the change from Andrew Gold to Waddy Wachtel as unofficial bandleader was a significant one. Gold has a sensibility that is very close to the McCartneyesque British-pop cleverness that underlies Asher's style, and the two of them together pushed Ronstadt's work a bit too close to the ornate and brittle. That phase reached its peak on the last Gold album, *Hasten Down the Wind*, in 1976; the arrangements are often supportive and always ingenious, but Linda herself had grown uncomfortable with the distance that the sound had traveled from the harder and/or more folkish roots of the music she loved best. Thus the next album had a tougher, sparer sound that reflected not only her own inclinations but the more rock-oriented spirit of Wachtel; its title, *Simple Dreams*, referred in part to the arrangements.

As an interpretive singer, Ronstadt needs collaborators even more than singer-songwriters, and thus her interaction with her musical co-workers is a complex and delicate one. She has to cultivate songwriters and performing musicians both, and she has to develop relationships with them that work to her advantage yet aren't either domineering (which would be self-defeating) or unduly submissive. Her success in this regard (for all her periodic insecurities) is a quite remarkable one. Linda stands at the center of a number of overlapping musical worlds. She is the queen of the so-called L.A. school of rock—a "school" that these days seems stylistically ever more the anachronistic invention of some rock critics, given the distance some of its members have traveled from the old country-rock clichés. But it remains a viable grouping in a social sense, as a network of friends who share songs, appear on one another's records, and support one another in various ways. Ronstadt is also the leader of the burgeoning crop of women singers that has helped define one crucial aspect of 1970s rock. She is not only the best-known

and most commercial of the lot, but she has gone out of her way in numerous specific cases (Karla Bonoff, Nicolette Larson, the Roche sisters, Annie McLoone, etc., etc.) to help younger singers get recognition and record contracts. In that sense, the long-brooded-over trio album with Emmylou Harris and Dolly Parton would be not only a joy to hear, but a fitting symbol of the cooperative, loving spirit of this musical community in general and its women in particular.

In light of all this, the charge of supposedly "formulaic" song selection and sequencing on Ronstadt's albums since 1974 seems silly. As an interpretive singer and a leading member of a musical community, she naturally works with the best songwriters she can find. And since many of those songwriters are her friends and since good songwriters generally write more than one good song, she often goes back to the same people. There has perhaps been a tendency to choose well-known hits of the past over more obscure songs that would free her from invidious comparison, and a slightly recurrent pattern in her selection of oldies composers. But there's been greater variety than repetition; each album finds new names entering the lists, with new themes—or fresh variants on the old themes—underlying the song-by-song selection. Thus whereas earlier albums produced by Asher relied on people like the Eagles, Lowell George, and James Taylor, she later moved through close identification with the music of Kaz, Bonoff, Zevon, and Mick Jagger; Souther remained a constant throughout. In no case has she broken with any of these songwriters, but as circumstances shift (e.g., Bonoff needing all her new material for her own albums) the search for songs and songwriters moves on. And songs don't of course always come directly from songwriters. Linda relates as intensely to people as she does to music itself, and hence her wide network of friends has been a continual source of suggestions for oldies and promising contemporary songs.

Some of these relationships are romantic; others are friendships. It would be absurd, in the light of her own past interviews, to deny that Linda has been romantically involved with many of her collaborators. For her, consciously or unconsciously, sex is a way of getting what she wants. I don't mean it is just a device for her, that she is a cold manipulator; vivacity, warmth, and honesty define her nature. But she is an overtly sexual person, and she likes to relate to men on that level (or, with her many women friends, on a nonsexual but deeply emotional level) and is often ready to fall back on flirtation when she feels insecure about dealing with men in an intellectual or musical way.

Many of the troubles that some rock critics have with Ronstadt as a performer and a public image have to do with this sexuality, and because of it, I think, judgments about her recorded work sometimes become tangled unwittingly with preconceptions about her person. The first thing that needs to be said on this subject is that whatever one may think of Ronstadt as a sex bomb, it is by no means a false representation of the "real" person—all that public iconography, right down to the airbrushed album covers, is part of the same process whereby she attempts to make herself as alluring as she can.

Now, this flies in the face of many feminists' convictions; for all sorts of good reasons they are deeply suspicious of women who prettify themselves in conventional ways that serve to reinforce male expectations. In my own case, although ideologically and emotionally sympathetic to feminism, I've always enjoyed people of either sex who try to look sexually desirable—how they try to do that can vary widely, but the effort itself bespeaks a commitment to style and social generosity that I can respond to. In the case of Linda, what appealed to me about her image back in the late 1960s was the overt blend of good-girl gentility, hippie rebellion, and Los Angeles tough-tramp sexuality. I had moved to Los Angeles from Berkeley at the very beginning of 1970. By then I had grown heartily sick of girls in army jackets, and was ready for a little flash.

What makes Ronstadt fascinating in terms of image is not that she is a stubborn holdout for Total Womanhood in an age of guerrilla feminism. It's the tension of the opposites she incorporates. Any fantasy object (which is what she is for her fans) and any love object (what she is for her lovers and close friends) have within them the ability to suggest all possibilities: we see our own contradictions mirrored in the other. But Linda embraces more strongly articulated alternatives than most people I know. She is at once sensual and clever, sweet and irrational, vulnerable and strong. Perhaps all of us contain these opposites; it's just that she denies very little of herself, and thus nearly all the facets of her character coexist in a state of high intensity.

It is the strength of these differing aspects of humanity, and their incorporation into one person of uncommon charm, that not only make her unusual as a person but help explain the really quite extraordinary diversity of musical styles that she can successfully encompass. Most interpretive singers (and certainly most singer-songwriters) are identifiable in terms of a specific style or focused concentration of styles. With

Ronstadt, the range is far broader. She is often thought of as a country singer, and of course her best work in that idiom (I think of Hank Williams's "I Can't Help It If I'm Still in Love with You" from *Heart Like a Wheel*, with Emmylou Harris's angelic harmony singing) has made her about the most popular woman country singer of the day—even when she's been downright stingy about including real country songs on her recent albums. She herself regards both the pop songs of her teen years (i.e., the late 1950s and early1960s, the period of nearly all her oldies covers) and the Mexican *ranchera* style as her principal formative influences. This last, which she learned from records, the radio, and her father, is epitomized by the work of Lola Beltrán, and probably contributes as much to Ronstadt's "belting" style as do opera and the semioperatic vocalism of nineteenth-century America. In her own recorded work, the most obvious manifestation of *ranchera* singing is her Spanish-language version of "Blue Bayou," released as a single only under the title "Lago Azul."

Aside from country music, Linda is justly praised for her way with soaring ballads in the folk-rock idiom—"Long, Long Time" from *Silk Purse* and the title track of *Heart Like a Wheel*, to name the two best known, plus all the Souther songs she has sung. This style—and country music, of course—is related to the acoustical folkish material she's recorded, often singing in harmony with Harris or Parton. There was "The Sweetest Gift" from *Prisoner in Disguise*, "I Never Will Marry" and "Old Paint" from *Simple Dreams*, and, maybe, "Love Me Tender" from *Living in the U.S.A.* More recently her ballads have evolved into more sophisticated torch songs that suggest the genre of Broadway and cabaret—her own "Try Me Again" and Willie Nelson's "Crazy" from *Hasten Down the Wind*, Kaz's "Sorrow Lives Here" from *Simple Dreams*, and several more. And there are the grander, anthemlike extensions of this style, full of gospel passion, in Tracy Nelson's "Down So Low" and Bonoff's "Someone to Lay Down Beside Me," which end *Hasten Down the Wind* in that order.

If her ballads are most valued by those who collect her albums, it is the covers of early rock and black songs by which listeners to AM radio and purchasers of *Linda Ronstadt's Greatest Hits* know her best. Here her work has been more erratic. "You're No Good" and "When Will I Be Loved" from 1974's *Heart Like a Wheel* may have been brilliant successes. But interpretations of better-known songs like "Tracks of My Tears," "Heat Wave," and "Many Rivers to Cross" (all from *Prisoner in*

Disguise) and "That'll Be the Day" (from Hasten Down the Wind) were not so good. For me, they still retain an undeniable charm, but her detractors condemn them out of hand. She's been somewhat more consistent recently, suggesting a real growth. To this taste both "Blue Bayou" from Simple Dreams and "Back in the U.S.A." from the new album seem only moderately convincing. But "It's So Easy," "Poor, Poor Pitiful Me," and "Tumbling Dice" from Simple Dreams are all fine uptempo covers—with "Pitiful Me" a nice bit of self-parody and "Dice" her best-ever hard-rock song—and "Just One Look," "All That You Dream," and "Ooh Baby Baby" uphold that standard on the new album. Except for hard-core disco, it's hard to think of any style she hasn't tried at least once.

Ronstadt has not only become a persuasive interpreter of most every idiom she has assayed, she's also not diffused her image in the process. Singers who try to sing everything generally fragment themselves. With Linda, the end effect is not a grab bag, but an overarching personal style. Part of her secret is simply an instinctive musicality and a willingness to work hard on phrasing. But in a larger sense it is the very multifaceted cohesiveness of her image that binds the diverse styles together, helping to make them all believable. And at the base of both the music and the image, I think, is the nature of her involvement with people. She may well relate better to individuals than she does to crowds. But audiences clearly can identify with the intensity of her private passions.

Linda has sometimes compared the voice with the kiss; both for her are infallible indices of a personality. In other words, she thinks it's possible to perceive pretty much all you need to know about a person from how his or her voice sounds or how he or she kisses you. I can't speak about her kisses, nor judge her theory about voices in general. But it does seem to me that the key to her own voice's remarkable appeal—quite apart from its sheer strength and quality in the abstract—is the way it mirrors her. People feel they can see into her heart when she sings, and they're right. The range of vocal colors in her singing, from childlike intimacy to punkish yell to commanding assertion to shaky vulnerability, reflects the facets of her private person with infallible candor, and makes her recent public discretion about her private life no real defense at all.

Ronstadt has spoken of herself as a "real '70s person," by which she means that she admits to and identifies with the notion of her music as personal statement rather than political or ideological manifesto. But

especially from a musical standpoint, I think she's better thought of as a blend of the '60s and '70s, and perhaps of earlier decades as well. Her singing combines the rhetorical strength of an earlier America, the folk-ish honesty of the '60s and the frank willingness of this decade to concentrate on personal sentiment.

Ultimately what I wish those who are hostile or indifferent to Ronstadt's music would do is try to open their ears—to perceive what she does well without damning it by standards that simply don't apply. Of course, rock can be rebellious and angry, and new-wave rock has reaffirmed that part of the music. But it can be softer, too, as can people. At her "shining best," as she once put it, Ronstadt can suggest those extremes better than any singer of our time.

THE GRATEFUL DEAD

The New York Times, September 6, 1979

The Grateful Dead, for some reason or other, has become the New York area's biggest cult-rock band, as attested to—in this time of supposed music-industry recession—by its arrival Tuesday night at Madison Square Garden for the first of three sold-out concerts.

A Grateful Dead concert is a mostly well-mannered affair, redolent of the 1960s, with lots of pushing and shoving but little violence on the part of the generally white, middle-class audience. The ushers had given up the battle even before the concert began, and the aisles were clogged with people.

Even more than most arena rock concerts, a Dead concert appeals to its audience for extramusical reasons; two young men in front of this writer spent all of forty-five minutes trying to light their marijuana pipe.

Musically, however, the rewards are slim. The band is now a sextet, with the departure of Keith and Donna Godchaux and the addition of a new keyboard player in Brent Mydland. But the result is pretty much the same: loose, often sloppy country-blues-rock jamming and raw, off-pitch vocals.

Every once in a while the music will suddenly cohere, the players set-

tling into a really engaging groove. And to its credit, the crowd almost invariably responds to those moments with a flurry of mass excitement. But the grooves were far apart, and what came in between seemed pretty perfunctory. Unless, perhaps, you succeeded in lighting your pipe.

THE WALL

The New York Times, March 2, 1980

It seems now as if Pink Floyd's *Wall* production is history, after only twelve performances—although there is talk of a few European shows in the spring and summer. The most spectacular, lavish stage show in the history of rock was simply too expensive to tour in the conventional manner, so after seven performances in Los Angeles and five last week at the Nassau Coliseum, it's gone. But hardly forgotten.

What will stick in the memory are the special effects, created with a care and on a scale literally unprecedented in rock-concert annals. Above all, there was the gigantic wall itself, constructed "brick" by "brick" during the first hour of the show and eventually extending across the entire stage end of the coliseum, some 90 feet high at the center and 130 feet long at the top. Christo, the Bulgarian conceptual artist who likes to build his own walls, would have been envious—or proud.

The wall was destroyed at the end, in a satisfying heap of falling bricks, dry ice, and electronic rumbling. The collapse of the temple at the end of *Samson et Dalila* at the Metropolitan Opera should look this good. But before the wall collapsed, there was much else to wonder at: gigantic, balloonlike puppets that embodied the animations of Gerald Searle that could otherwise be seen in brilliant slides and films; little vignettes that took place in front of the wall or on top of it, or in one instance on a ministage that appeared when a panel opened up in the wall; and two wonderful effects from previous Pink Floyd tours—a large model airplane that traversed the full length of the auditorium (on a wire) before smashing into one end of the wall, and a huge pig (at least thirty feet long) that lumbered out over the crowd on a track, its eyes glowing evilly.

But now that the shows have gone, one must try to gather oneself together and attempt to assess the meaning of it all, if any. Was this just the latest and most extreme extension of acid rock, that genre of mind-blowing music from which Pink Floyd emerged in Britain in 1966? The answer seems to be both yes and no. Clearly the *Wall* stage show in some sense was a sort of ultimate light show, designed to do little more than awe and impress. But it was also a serious attempt at a mass theatrical spectacle by Roger Waters, the member of Pink Floyd who composed nearly all this album's music, wrote most of its words, and conceived the show.

Rock stage shows have often had their spectacular elements, but they have hardly ever heretofore lived up to the potential of a modern day mass spectacle. The reason, pure and simple, is greed (or, more charitably put, "economics"). As rock grew more popular in the '60s, the possibility of playing concerts in huge places become a reality. At the first such shows—e.g., the Beatles in their stadium concerts in the mid-'60s—the spectacle itself was the thing, and the sheer thrill in being in the same general space as one's idols.

Soon, however, rock stars began to experiment with the possibilities for theatrically conceived spectacle: David Bowie, Alice Cooper, and Kiss are some of the best-known purveyors of such theater, quite apart from Pink Floyd's own past tours. In so doing they were merely the latest in a long line of democratically inspired and/or megalomaniacal theater people who had similarly attempted to expand theatrical spectacle beyond the confines of an enclosed theater and out into a city's arenas and public spaces. The very ideal of the Greek tragedy, as a theatrical image of a community for that community, lies at the root of this dream. Later, Roman spectacles in the Coliseum and baroque operas attained degrees of lavishness still not matched.

Since then such diverse phenomena as performances of Handel's *Messiah* in Victorian England and America with up to 20,000 choristers, the expansion of the Barnum and Bailey Circus into what it is today, Nazi party rallies, halftime football displays, sports demonstrations and flash-card events in Communist China, and the theatrical visions of Max Reinhardt ("Everyman" at Salzburg) and Robert Wilson have carried on the tradition.

But until recently, they all lacked what the rock concert boasts to excess: the power of electronic amplification to fill large spaces with sound as well as sights. With rock amplification and a music that makes

use of that potential—cause and effect become cloudy in situations like this—the creator of mass theatrical spectacles has at last the possibility of creating a truly multimedia event that can appeal to the thousands or even the hundreds of thousands.

The recent rush of enthusiasm for video is a small-scaled manifestation of this same impulse toward the dramatic visualization of rock. But video denies the communal and celebratory implications of the large-scale rock concert. Yet it remains tempting, since for all its costs, those costs are paltry next to what Pink Floyd must have spent on a show like *The Wall*. Figures varied and seemed sometimes contradictory, but one source put the cost of the show at $1.8 million, which included a full month spent at the Los Angeles Sports Arena before the February 7 premiere setting things up. Most bands' inclinations toward theater stop well short of that sort of self-sacrifice.

Quite apart from costs, there are other ways in which Pink Floyd needn't necessarily serve as a model for other rock bands. *The Wall* has its muddled moments, conceptually; it doesn't flow along all that coherently in more basic dramatic terms, and it suffers from an ending (after the wall's destruction) that seems all too pat: if one wants a rebirth of childlike innocence after the apocalypse, Robert Wilson and Philip Glass did it far, far better in *Einstein on the Beach*.

The *Wall* show remains a milestone in rock history, though, and there's no point in denying it. Never again will one be able to accept the technical clumsiness, distorted sound, and meager visuals of most arena rock shows as inevitable. If Mr. Waters or the rest of the band feel like it, perhaps they can reach down within themselves and come up with something of an artistic merit to match their imagination and technical skills in the area of special effects. Until then, however, the *Wall* show will still be the touchstone against which all future rock spectacles must be measured.

MIRELLA FRENI

The New York Times, March 23, 1980

The whole institution of the recital by a beloved prima donna is worth a sociopsychological study, so rigid are its traditions. The artist coiffed to the nines, the doting public that cheers long before any music has profaned the proceedings, the snippets of music that gracelessly interrupt the applause, and finally the endless encores—it all varies little from donna to donna.

Still, Mirella Freni's recital Friday night at Avery Fisher Hall was special. She is a much-admired Italian soprano who has not sung as frequently or as prominently as she might at the Metropolitan Opera recently. Furthermore, this was her first recital proper in New York, meaning a mixture of arias and songs; her closest approximation was an all-aria concert thirteen years ago at Hunter College.

The program Miss Freni chose—accompanied rather rigidly and unsubtly by John Wustman—moved from a baroque Italian song by Giuseppe Giordani to Mozart's "Dove sono" from *Le nozze di Figaro* to pairs of songs by Rossini and Verdi to Verdi's "Tu che le vanità" from *Don Carlo* to song pairs by Duparc and Fauré to a final trilogy of songs by Rachmaninoff, sung in Russian.

This was a selection reasonably representative of Miss Freni's art. She has moved forthrightly in her career past the Italian lyric roles into which she might have placidly settled to Mozart, French, and Russian repertory, and heavier Italian parts (she's even sung Aida).

Not that she's done all these with equal skill. The heavier roles are not ideally suitable for her—though given the paucity of the viable competition, one can understand why she's tempted. Her command of languages is not all that secure, and in any event, clarity of diction seems not her uppermost concern.

That is partly because of the priorities she's chosen in her technique. Miss Freni has an interesting voice, besides it being an inherently attractive one. It sounds simultaneously liquid and rich, yet also bright. In addition, her production is pleasantly even from top to bottom, avoiding both awkward register breaks and, more difficult, allowing the coloration of her chest register to match the sound higher up.

This evenness was most notable in her account of the wide-ranging *Don Carlo* aria. Her technical faults, never quite overcome, include a

tendency toward brittleness and hardness, no doubt exacerbated by Fisher Hall's acoustics. There was also the very artificiality of the prima-donna recital, which tends to inflate any tendencies toward precious-ness. But that said, Miss Freni is a fine singer and an honorable artist, one who phrases with musicality and personality, and much of her work gave genuine pleasure.

1980–1991

In mid-1980 I retired as chief rock critic—pressure was growing to devote all my time to it, and I didn't want to limit myself—and, after a flirtation with New York *magazine, became the number 2 classical music critic and de facto classical music editor (de facto because, again, I didn't want to pigeonhole myself). Hence the* Times *articles in this section are predominantly classical.*

WHICH WORKS OF THE '70S WERE SIGNIFICANT

The New York Times, July 27, 1980

It is often said that we live in a sterile musical age, at least as far as the composition of serious art music is concerned. Most classical-music lovers wallow happily in the past, their need for novelty slaked by the occasional obscure revival. New music is dismissed as ugly or hermetic or a tired repetition of gimmicky ideas that weren't very interesting when they were new.

It isn't only conservatives who discount the notion of modern-day musical masterpieces. There is a line of thought, propagated by such experimental composers as John Cage, that the very idea of a masterpiece is outdated. This argument prefers to emphasize the process of composition over its mere results; the interaction between composer, environment, and audience, and the awakened creativity of perception.

But there is a counterargument, which will be made here, and that is that the last twenty or even ten years have seen the creation of a number of genuinely important, enjoyable compositions, and that a list can be made of such compositions. The list makes no pretenses to timeless objectivity. But it should at least offer ammunition for those who wish to defend the music of our day.

What is a "masterpiece"? By one very good criterion, it is a work tested by time, and hence the very notion of a masterpiece composed within the past decade becomes suspect. It must be reaffirmed right away that the list below makes no claim of being complete. For one thing, there is simply too much potentially fine music that isn't yet

known. One thinks especially of European music; for all the complaints of American composers that their works are not played here often enough, at least as great a scandal is the failure of American musical organizations to keep us abreast of contemporary European music.

But the case can be made that not only are there important works being composed every year, but also that composers are still—despite the theories of the Cageians—doing their best to produce works that might one day claim the status of "masterpiece."

I ultimately decided to confine the list to the 1970s in order to dramatize the issue of contemporaneity. But at a time when the idea of "modern music" can still encompass *Pierrot lunaire* and *Le sacre du printemps*, the '60s most definitely count as "contemporary." And so it can only reinforce the notion that our musical era is a vital one to mention the following fifteen pieces composed between 1960 and 1969, in alphabetical order by composer: Benjamin Britten's *A Midsummer Night's Dream*, Luciano Berio's *Sinfonia*, Pierre Boulez's *Pli selon pli*, György Ligeti's *Atmospheres*, Olivier Messiaen's *Et exspecto resurrectionem mortuorem*, Pauline Oliveros's *Bye Bye Butterfly*, Carl Orff's *Prometheus*, Krzysztof Penderecki's *Threnody to the Victims of Hiroshima*, Steve Reich's *Come Out and Show Them*, Terry Riley's *In C*, Karlheinz Stockhausen's *Hymnen*, Toru Takemitsu's *November Steps*, Stefan Wolpe's String Quartet, Iannis Xenakis's *Bohor* II, and Bernd Alois Zimmermann's *Die Soldaten*.

The selection of both '60s and '70s masterpieces is an unashamedly subjective one, and it leaves out some composers who are better known than others who are included—George Crumb, Hans Werner Henze, Sir Michael Tippett, etc. Works chosen were ones that have excited or moved me deeply, and that seemed to have a strong chance of appealing to some sort of real audience over a long period of time. Naturally some of these choices will fade away, unnoticed by posterity. Other, better works will be seen to be superior, and some of the selections will be judged as having greater surface appeal than inner content. But the works chosen have at least a reasonable likelihood of being enjoyed by open-minded music lovers.

This presupposes a bias in favor of music that means to appeal to an audience in the first place. There are compositions by Milton Babbitt, for instance, that really do make a deep impression on some of us. But Mr. Babbitt, who is just a particularly overt example of a widespread tendency, has chosen to move in a musical milieu that places ingrown com-

plexity above communication. Perhaps some of his work will last and be widely and internationally prized. More likely it will remain the province of a few lonely champions, in the manner of some obscure late-Renaissance madrigalist. Which is no cause for regret: Mr. Babbitt has made his choice, and is presumably content with it.

Most ultimately successful vanguard music has appealed from the start to fellow artists—poets, painters, dancers. This list proves that there are still composers writing for a larger, educated public—not "the masses," to be sure, but not just other, like-minded composers, either. Most of these pieces have not found a mass public, and probably never will. But they have a potential to be admired in the broader world of generally cultivated people.

There are no pieces here from the worlds of jazz, rock, and other forms of ostensibly popular music. The reason was partly to keep things manageable: there are quite enough fine "classical" pieces to make up a list of ten. But also, the point here is to reaffirm the vitality of the classical music tradition down to the present day. Should one choose to recognize Ornette Coleman or Miles Davis or George Lewis, or Neil Young or David Byrne, in some future, expanded list, that would only strengthen the idea that we live in a time full of musical vitality and variety.

Even with the elimination of jazz and pop, there will be those who will grow truculent at the inclusion of some or all of this music. "How can this trivia be considered really important?" they will ask. How can it be compared to, say, a late Beethoven string quartet?

The answer is that it cannot be and needn't be. On some level nothing can be judged or compared to anything with that assured degree of firmness. How can *Parsifal* be stacked up against *Falstaff*? Or *Eine kleine Nachtmusik* be compared to Bruckner's Eighth Symphony? Any conferral of status is a matter of consensus among educated men and women, and there will always be dissenters. All my list means to do is suggest that the formation of that consensus is still going on, and that the production of significant musical work is by no means at an end.

Here, then, is a list of ten significant musical compositions of the 1970s. Like the '60s pieces, all of these works have been recorded, on the theory that nothing can convince a reader better than the music itself, no further away than the nearest record store.

The list is presented in the rough order of greater to lesser accessibility, real or imagined. In other words, number 1 should pose no problems

for a lover of traditional symphonic or operatic music; number 6 is actually a lot more accessible than number 3, but number 3 is a more familiar name working in a more familiar idiom; number 10 is likely to prove difficult indeed—not because its idiom is complex so much as because it is defiantly new.

1. Dmitri Shostakovich, *Suite on Verses by Michelangelo*, available on Columbia-Melodiya M2-34594 (two discs). For all his struggles with the Soviet cultural bureaucracy, Shostakovich remained a great composer to the end. This moving, embittered song cycle, composed in the last year of his life, is an undisguised attack on the regime, and recalls the great monologues of *Boris Godunov* by Mussorgsky.

2. Witold Lutosławski, Cello Concerto, Angel S-37146, with Mstislav Rostropovich. Along with Mr. Penderecki the leader of the postwar Polish school, Mr. Lutosławski started in a nationalist romantic idiom, moved into coloristic experiments in the '60s, and has consolidated his traditionalism with his experimentation in his more recent works. This concerto answers every need for a virtuosic, heartfelt vehicle for a star cellist, yet does so in a way that makes artistic sense, bending the experiments of the '60s to genuinely expressive usage.

3. Elliott Carter, String Quartet No. 3, Columbia M-32738. Mr. Carter's music is the finest example of the intensely cerebral style evolved by northeastern American composers over the past twenty years. Overall, this music is far too often academic and dry in the worst way, and Mr. Carter's String Quartet No. 3 is particularly knotty in terms of its construction, as well as devilishly difficult to play. But there is a perceptible passion that informs it throughout, and a listener willing to abandon himself, free from technical jargon and elitist pronunciamentos, can be touched on a first hearing.

4. Peter Maxwell Davies, *Ave Maris Stella*, which has just been recorded, according to the composer's publisher, and will soon be available on the British Unicorn label. This extended work for chamber instrumental ensemble combines Mr. Maxwell Davies's medieval mysticism, his skill at writing for the new virtuosos among us, and his intense musicality into one supremely successful work. The writing for the marimba alone is cause for inclusion in this list.

5. Morton Feldman, *Rothko Chapel*, Odyssey Y-34138. If John Cage is the most influential theoretician for experimental music, Mr. Feldman has been his most musically persuasive disciple, surpassing even his master on musical grounds alone. *Rothko Chapel* is for chorus, viola,

and percussion, and attempts with considerable success to capture in music the quiet impact of Mark Rothko's brooding, mystical paintings.

6. David Behrman, *On the Other Ocean*, Lovely Music, Ltd. LML 1041. Mr. Behrman creates electronic music that is gentle and accessible, far removed from the fearsome sound effects of the early electronic composers. This music is made with computers and synthesizers, but it sounds gently Arcadian.

7. Charles Dodge, *Earth's Magnetic Field*, Nonesuch 71250. An ambitious piece of computer music, and one linked literally and metaphorically with cosmic forces. Yet the musical results are what count, and like all of Mr. Dodge's music, the actual sounds are by turns beguiling and intriguing.

8. Steve Reich, *Music for Eighteen Musicians*, ECM 1129. Mr. Reich started his mature musical life as a minimalist, but has steadily evolved throughout the '70s into a composer of dense, lush orchestral tapestries. This was a significant step along that road. The shifting, dappled textures of this music, its hypnotic pulse, and its blend of simplicity and complexity make for one of the most sheerly enjoyable pieces on this list.

9. Philip Glass, *Einstein on the Beach*, Tomato 4-2901 (four discs). Along with Mr. Reich, Mr. Glass counts as the other leading "minimalist" or "trance music" composer. *Einstein* was a massive theater piece created along with Robert Wilson, the playwright-director-designer. It remains one of the great achievements of 1970s avant-gardism. A recording may not capture the full impact of the stage spectacle; it hardly could. But it succeeds profoundly on its own terms.

10. Robert Ashley, *Private Parts*, Lovely Music, Ltd. LML 1001. This is something of a ringer on the list, in that it is not even complete, and will count as a work of the '80s when it is finally finished. The record is only of parts 1 and 7 of a seven-part work, and those parts have been altered since the release of the recording.

Still, the disc gives a palpable foretaste of what promises to be a major American musical-theater piece—an "opera," if you will, but projected through the medium of video. Mr. Ashley blends hushed, repressed declamation with music that is alternately lulling and eruptive, partaking—especially in the still unrecorded parts—of the energy of underground New York rock and roll without really sounding anything like rock. It is listed last here because it is furthest from the conventions of classical music. But as it embraces aspects of popular music, it also sums

up a generation of classical experimentation, and points clearly toward the future.

THE PARADOX OF THE FROMM WEEK
The New York Times, August 28, 1980

Note: Around this time I wrote a series of reviews and articles criticizing the narrowness of the high-modernist programming at Tanglewood's annual Festival of Contemporary Music. These were regarded by Gunther Schuller, the composer and director of the Berkshire Music Center, and his allies as not only wrongheaded, but an abuse of journalistic power, since Paul Fromm, the patron, withdrew his support, and Mr. Schuller eventually stepped down. I thought I was just doing my job. The festival's programming has since opened up admirably.

The Tanglewood estate, which is the summer home of the Boston Symphony Orchestra, is an idyll—an immaculate setting in the Berkshires, complete with sparkling lawns, a view down to Lake Mahkeenac in the distance, all surrounding the Music Shed. That shed may be a little ramshackle-looking, compared to all the glossy summer arts centers around the country. But it is the prototype for them all.

The visual beauties of the place become a metaphor for what any true festival should be, as defined by Hugo von Hofmannsthal in the original manifesto for the Salzburg Festival: something special, poetically removed from the bustle of the prosaic everyday.

And Tanglewood's annual Festival of Contemporary Music, otherwise known as the Fromm week, is an idyll within this idyll. Tanglewood has two main activities that go on the whole course of the summer: the concerts of the Boston Symphony on the weekends, and the educational functions of the Berkshire Music Center. The center is a sort of multipurpose master class for bright young performers and composers, and some of the brightest in both categories (including Seiji Ozawa, the Boston Symphony's music director) have matriculated there.

And then, for one week in August, the center turns its primary atten-

tion to contemporary music, with the participation of the Boston Symphony and with the generous aid of the Fromm Music Foundation. Paul Fromm has been about the most active patron for contemporary music in this country over the last couple of decades, and his largesse deserves special mention.

But idylls can either be restorative or escapist. In their remarks opening the Fromm week, both Mr. Fromm and Gunther Schuller, the composer and director of the Berkshire Music Center, addressed the paradox of the Fromm week. The contemporary music festival's ostensible purpose, as Mr. Schuller put it in the festival's program, is to reinforce a view of new music "not as something cut off from the literature of the past and segregated from ordinary professional life, but as part of the ongoing continuum of musical history and as an integral part of a musician's commitment to his art and his profession."

Why, then, one might ask, should the Fromm week be cut off from the regular offerings of the Boston Symphony? Apart, that is, from the world premiere of George Perle's *A Short Symphony*, which came on the final night of the festival as part of a shed program that also included music by Rachmaninoff and Janáček (an all-twentieth-century concert, it is true, but not exactly tooth-rattling in its modernity).

The other Fromm week concerts were given in the much smaller Theater–Concert Hall at the other end of the lawn, and were erratically attended even there. The programs were all "contemporary," even if they did mix classics and semiclassics of modernism with brand-new scores. In other words, it might seem, they were indeed "segregated" from the ordinary business of the festival, which in turn is "cut off" from regular concert life in the first place.

There is no real solution to this paradox, really, at least not right away. New music is not very much loved, not even by "music lovers," let alone the general public. The various arts seem to have their bursts of creative energy—periods in which giants arise and speak to cultured people everywhere. By common consensus, we are not in such a period for music just now. So perhaps the wise course for those interested in new music is to retreat into idyllic isolation, helping performers come to terms with the idioms of the day, bringing scores to life for the cloistered elite that wishes to hear them, and hoping that somehow this incubation will lead to the birth of a revitalized creativity in generations to come.

There is, however, another way of looking at all this, one not quite so sympathetic to Mr. Schuller and those who determine the festival's pro-

grams. Both Mr. Schuller and Mr. Fromm stressed repeatedly in their opening remarks how diverse and eclectic the festival's offerings had been ever since the festival was initiated in 1963. (Tanglewood had a distinguished tradition of fostering the new way before that, of course, largely through the concern of Serge Koussevitzky.)

And indeed a perusal of Tanglewood's new-music offerings since 1958 indicates a genuine effort to look beyond the parochialisms of the northeastern establishment. There is a continual and no doubt fertile tension between the sturdy Americanists of the Copland-Schuman-Piston-Harris-Thompson variety as opposed to the more cerebral, international Schoenbergians of more recent years. But there has also been a laudable attempt to introduce important works of European composers, including even the occasional iconoclastic sensation. This year it was the Austrian composer Heinz Karl Gruber's *Frankenstein!!*

But, in fact, the Fromm week organizers are still determinedly blinkered in their view of what is really happening in new music today. The radical view—and one that Mr. Schuller, the chief theoretician of "third stream" music and a lover of jazz, might be expected to propagate more actively—would directly and systematically juxtapose traditional classical art music with vital examples of jazz and even popular music.

But without going that far, the Fromm week might at this late date be expected to include the vast and burgeoning kinds of experimental music that are flourishing in Europe and America today. Where was electronic music? Performance art? Modern-day conceptual pieces? The very fact that Steve Reich was included in festival programs for the first time only this summer, and then by a piece composed seven years ago and uncharacteristic of his current work, is indicative of how removed the Fromm week is from too many significant trends in creative music today.

One reason for the festival's conservatism, no doubt, is the very fact that the music is played by the student fellows of the Berkshire Music Center. There is something about a laboriously accrued technique that seems to tip some people toward conservatism—to deaden their receptivity to anything that challenges the way they learned to do things, let alone that hints that all those labors were in vain. Performers throughout musical history have often resisted innovation, and Mr. Fromm and the others are trying to inject some life into the young center fellows every year with their festival.

But if exposure to the technical rigors of the complex new composers

is supposed to broaden a young musician's outlook, one might think a further exposure to the full range of new music being composed today would prove similarly beneficial—even if some of that music circumvented the traditional performer or made use of him in surprising new ways.

The Fromm week tries simultaneously to be of service to composers, performers, and audiences. But too often this year it seemed as if the programs were really being selected to comfort the performers and to reinforce the tired prejudices of composers whose time has passed.

CHARLES ROSEN

***The New York Times*, October 28, 1980**

The first of Charles Rosen's Beethoven recitals Sunday afternoon at Carnegie Hall was a definite event, if not a purely musical one. Mr. Rosen's immense and deserved reputation as a scholar of the music of the classical era has awakened an interest in his performing of that music that might not have existed without his critical accomplishments. Still, whatever the strictly musical virtues of the concert, it had the advantage of directing a large audience's attention to Beethoven's music in a way that other, less anticipated recitals do not.

Mr. Rosen's program was monumental in scope and concentration, if not in length. He offered four Beethoven sonatas, the "Waldstein" and the final three, Opp. 109, 110, and 111. (Next week, he returns with the "Diabelli" Variations and the "Hammerklavier" Sonata.)

In *The Classical Style*, Mr. Rosen devotes most of his attention to Haydn and Mozart and then offers a final chapter on Beethoven that serves almost as an epilogue. Although he shies away from simplistic adjudications of Beethoven as either a classicist or a romantic, he clearly opts for the former designation.

For Mr. Rosen, Beethoven's achievement was an extension of classical principles but never a violation of them. The romantics, on the other hand, launched off onto harmonic adventures that owed little to Beethoven or his classical predecessors. Indeed, in his final years—the period Mr. Rosen is playing in these recitals—Beethoven had in a sense

returned to classical stylistic tenets and had gone decidedly out of fashion in Vienna.

All of which is stimulating to think about, but more problematic when translated into Sunday's recital. Mr. Rosen is faced with the apparent necessity of playing in large, romantic halls, and to do so he has to use a modern concert grand (a Steinway, in this case). Yet his playing had a shallowness of tone that may have been a personal preference, a characteristic of the piano or an attempt to evoke the colors of the pianos of Beethoven's day.

Coupled with the tonal pallidness was a curious lack of legato and rhythmic steadiness. Mr. Rosen conforms neither to the romanticized breadth of the German performance tradition nor to the tense linearity of modern American artists. Were his rhythmic unsteadiness perceivable as an idiosyncratic rethinking of the pulse of this music, it might well be welcome. As it was, it sounded merely unsettling.

This is hardly to say that his playing failed to offer any rewards. Particularly in bright, motoric passages, a slightly ragged quality humanized the music, and one was always conscious of a thoughtful musical mind at work, guiding the fingers. But, on the basis of Sunday's efforts, Mr. Rosen cannot match his writing about music with his playing of it.

PINCHAS ZUKERMAN

The New York Times, November 14, 1980

Like many instrumentalists of the younger generation, Pinchas Zukerman has taken up conducting. He may be good at it one day; he's getting better already. But he should never give up the violin.

Last night he addressed himself to Brahms's Violin Concerto with Zubin Mehta and the New York Philharmonic at Avery Fisher Hall. He didn't have to look nervously over his shoulder or exaggeratedly cue the orchestra with his body or turn around distractedly between solos and wave his bow like a baton. Instead, he had a longtime friend and collaborator to take care of those tasks for him, and could concentrate single-mindedly on his violin playing. The result was dazzling.

Like any really fine performance, this one had a character that precluded certain aspects of the score. Mr. Zukerman offered a young man's interpretation, full of fire. He seized ahold of the music with a fierce bravado, and tore into the choppy gypsy refrain in the rondo like Rudolph Valentino might have done it, had Valentino played the violin. The way he attacked unprepared high notes was alone thrilling: he did it as if there were no risk involved at all, as a dare, and he hit them dead on nearly every time.

All of which might have struck some as just a little vulgar. Mr. Zukerman was not shy about the odd bit of portamento here and there. And his playing was a long way from the cool, contained poetry of a Nathan Milstein or a Leonid Kogan.

But on its own terms, this was a complete vision of the score. Mr. Zukerman approached the slow movement with a tenderness that seemed the soft counterpart of his passion. The top notes had an eerie whistling tone to them, which was in part a testimony to the commanding virtuosity displayed throughout, but made a telling interpretive statement, too. And the expressivity with which he phrased such passages as the final, ascending run of sixteenth notes at the end of the slow movement demonstrated ample poetic insight on his own, virile terms.

In all of this he was closely complemented by Mr. Mehta and the orchestra. It is true that the brash acoustics of the hall sometimes made the accompaniment seem raucous. But by and large Mr. Mehta had the orchestra playing in fine form, in a loose-buttoned, casually rambunctious way. And he matched Mr. Zukerman for hellfire abandon and crunching accents, bar by bar.

It cannot be said, however, that this program is a particularly well balanced one. Before the intermission, Mr. Mehta turned his attention to William Schuman's Symphony No. 9, as part of that composer's seventieth-birthday celebrations.

Mr. Schuman's Ninth Symphony was finished in 1968, lasts twenty-five minutes, and bears the subtitle "Le Fosse Ardeatine." Unlike most of his essentially abstract symphonic scores, the Ninth has a programmatic tale to tell. The story is that of a Nazi massacre of 335 Italians in Rome's Ardeatine Caves in 1944. The outer movements suggest the reverential scene of the memorial to the victims that has been built in the caves; the quicker middle movement "stems from the fantasies I had of the variety, promise, and aborted lives of the martyrs," in the composer's words.

This translates sometimes into sudden moments of apparent pictori-

alism: children's tunes and games in the middle movement, snare drums as gunfire toward the end. But the overall impression is more generalized: quiet, elegiac music with a preponderance of sustained string chords in the outer movements, and a rather choppy, disjointedly lively second section, all in Mr. Schuman's basically conservative, accessible idiom.

The trouble with the piece—which unlike some of Mr. Mehta's efforts with new music seemed to have received a conscientious performance—is that it lacks a strong compositional character. Mr. Schuman was never a self-conscious American symphonist like Roy Harris, his teacher, or Aaron Copland. Yet in his earlier work there are a breadth and an energy that sound very American.

In the Ninth Symphony that personality has dissipated. There is considerable craft and there are moments of sudden feeling. But the final impression is emotionally diffuse, as if the great machinery of the modern orchestra had been set in motion with too little overt expressive purpose.

BRUCE SPRINGSTEEN

The New York Times, November 29, 1980

Note: I wrote a lot about Bruce Springsteen when he "broke" nationally in 1976. But this seems to me to be better written. Curiously, half of the pop articles I chose for this collection postdate 1980. One reason is that after that, when I did write about pop and jazz, I had more expansive forums in which to do so.

Almost any Bruce Springsteen concert is triumphant, in the sense that his music celebrates ecstatic release more than that of any other rock musician alive, and his performances are so consistently affirmative that audiences become part of that ecstasy. But his Madison Square Garden appearance Thanksgiving night was special. It was the first of four there, all long since sold out, and it came at a time when, for the first time, an album of his, *The River*, had reached number 1 on the sales charts.

While Springsteen aficionados could recall other shows, especially years back in clubs, that were just as exciting, Thursday's 245-minute performance (counting one 35-minute intermission) marked a new maturity. With no loss of energy, Mr. Springsteen has integrated his theatrics and lighting into the music better than ever before, and, in his new songs, has purged some of his more lurid textual excesses. He was also singing better than ever, and had the E Street Band playing at a new level of excellence.

There are many things that make Mr. Springsteen the finest performer in rock music. Perhaps above all is the positive nature of what he conveys to his fans. Mr. Springsteen is no Paul McCartney, all sunnily simplistic. But he is a far finer role model for teenagers than the petulant, bored, and nasty rock stars who customarily fill the Garden. Mr. Springsteen's themes may arise from the despair of working-class lives. Yet his ultimate message is affirmative, a vision of the promised land right there just beyond his grasp. And the way he proposes to reach that land is through the joyous energy of rock and roll.

Rock started out as a slightly naughty kind of dance music, but it soon became a catalyst for the transformation of American popular culture. As soon as people realized its power, they began to elevate it into art. Yet too much "art rock" is either pretentious or not really rock at all, whatever its other virtues may be. Mr. Springsteen has not entirely escaped charges of pretension and self-consciousness. But the toughening of his lyrics is a sign that he is balancing himself ever more securely between the joy of innocent rock and its usage as art.

That art is at one with the whole range of contemporary films (Martin Scorsese), prose (Studs Terkel), and the visual arts (Duane Hanson) that treat the lives of working people in this country as a fit subject for artistic exploration. Mr. Springsteen does that, and he does it in an idiom—rock music—that is by now inextricably a part of people's lives. The extent of his success serves to validate the very notion of popular art, in the face of the trash continually propagated in its name.

Years ago, Jon Landau spoke passionately if ungrammatically about Mr. Springsteen as "rock-and-roll future," and subsequently worked to realize his vision by becoming Mr. Springsteen's manager and producer. While some might assume that Thursday's triumph constituted the attainment of that goal, others have seen Mr. Springsteen as a figure from the past—at worst a maker of rock pastiche, at best the last of a long and dying line of rock avatars.

But it is still possible to hope that Mr. Springsteen represents a future, not just of rock, but of the wider reaches of American culture. He has now reached number 1, but his work is still widely regarded as kids' stuff by people who might happily go to see *Raging Bull* or read Mr. Terkel's *American Dreams*. Seeing Mr. Springsteen's effect on Thursday's audience, it was hard not to believe that he someday soon will make that next jump, staying true to rock's spirit, but bringing its message out beyond its current limits of class, age, and race—and in so doing help inspire the country as a whole in the ways already suggested in his music.

SPAS WENKOFF AND WOLFGANG WINDGASSEN

The New York Times, February 16, 1981

At the first night of the Metropolitan Opera's revival of Wagner's *Tristan und Isolde* a few weeks ago, the Bulgarian tenor Spas Wenkoff was rightly praised in his debut as Tristan. This is a murderously difficult part: the first Tristan, Ludwig Schnorr von Carolsfeld, died a few weeks after the premiere in 1865, and Wagner's enemies were quick to suggest that the part had done him in.

Mr. Wenkoff is a Tristan in the manner of Ludwig Suthaus or Ramon Vinay. He sounds like a converted baritone, with a solid lower register, an overall soft graininess of timbre, a secure but not very bright top, and a need to set himself carefully for the high notes. When combined with a care for declamation and a sensitivity to the drama—as it was in all three men—the result can be a mightily effective representation, one that emphasizes Tristan's introspection and makes its finest impact during the legato of the act 2 love duet and Tristan's final dream vision of Isolde's arrival just before his death.

However, for some of us, especially during the delirious monologue for Tristan that takes up most of act 3 and forms the climax of the work, it was impossible not to recall Wolfgang Windgassen in the part. For those unfamiliar with Windgassen as Tristan, his performance at the

1966 Bayreuth Festival is available on a Deutsche Grammophon live recording with Birgit Nilsson and Karl Böhm—which on balance is the best *Tristan* ever recorded.

Windgassen had a short American career, at the Met in the 1950s and then, at the very end of his career, in San Francisco in 1970. The reason was that Americans, their tastes shaped by Lauritz Melchior, found Windgassen's tenor disappointingly small. With their big opera houses and their predilection for gigantism, Americans wanted to be over-whelmed by Wagnerian voices. When one came along that placed a greater premium on subtlety and nuances of expression in a language that most Americans didn't understand, he was undervalued.

Yet in Europe's smaller opera houses and on records, Windgassen's vocal size receded in importance, and he enjoyed an unequaled career there as the most important Wagnerian tenor of the postwar era. Unlike Suthaus, Vinay, Melchior, and Mr. Wenkoff, Windgassen had a real tenor, in the sense that it was light and bright in timbre. This meant that he could do what tenors are supposed to do: suggest the alacrity of youth and the quick excitement of passion.

But in part because of the clarity of his means of vocal production—the way he placed verbal articulation forward in the mouth—he was able to shape Wagner's words like a lieder singer. In such passages as Tristan's quiet, sorrowful rebuke to King Mark at the end of act 2, Windgassen was unparalleled—by Melchior or anyone else—for poetic understanding.

Even more overwhelming was his traversal of the great act 3 mono-logue. This is a mounting sequence of fevered fantasies, at first delusory and with the approach to reality conditioned by Tristan's acceptance of his responsibility for his actions. Windgassen was sometimes accused of husbanding his resources earlier on, to save himself for this monologue. That could be disputed. But certainly by the third act, more than any tenor I have heard in the part, he gave the impression of an absolute commitment of all of his resources—physical, emotional, intellectual.

Wagner once said that a great performance of *Tristan* would drive the audience mad. On the Böhm recording, Windgassen sounds obsessed in a way that has left common, daytime rationality far behind. Mr. Wenkoff was an honorable, respectable Tristan. At his finest moments, trans-formed by the drama, Windgassen *was* Tristan.

COULD SHOSTAKOVICH BECOME THE MAHLER OF THE '80S?

The New York Times, February 22, 1981

Note: I was not always prescient; I doubted hip-hop would last, for instance. But on this one I was right.

It was announced recently that the Fitzwilliam String Quartet of Great Britain will present the complete cycle of the fifteen Shostakovich quartets at Alice Tully Hall in March of 1982. Unless someone else beats them to it, this will be a New York first. It will not, one can confidently assume, be a last. Predicting the future of musical taste may be even riskier than most prognostications: forecasting with wet tea leaves or the entrails of birds is probably more scientific. Still, it seems likely that Shostakovich's performances will proliferate in coming years. The man threatens to become the Mahler of the '80s.

Consider the parallels. Like Mahler, Shostakovich created a body of work by extending traditional forms: mostly symphonies and orchestrally accompanied songs for Mahler; mostly operas, symphonies, and quartets for Shostakovich. They both worked in idioms that seemed conservative compared to contemporary vanguard composers, and they were slighted by the musical intelligentsia for that reason. Yet they had and have their fervent champions among performers, and their appeal to audiences soon became obvious. There are even quasi-mythical, extramusical reasons for heightening their appeal. Eventually, critical opinion swung around behind Mahler, and that appears to be happening now for Shostakovich, as well.

It sometimes seems as if a generation or two must pass before a composer's work is accepted into the repertory; Hindemith, for example, appears to be suffering through his purgatory right now. Shostakovich died only in 1975. But for a variety of reasons, he may be allowed to bypass the generational holding pattern and win acceptance right away.

The first—and ultimate—reason for his rapidly growing popularity is the sheer quality of his work. Westerners really only now know a few, more popular of these pieces, above all the Symphony No. 5, but also the occasional ballet suite.

But as more and more of the later and more obscure works creep into performance, it becomes clear that there is a plethora of major scores yet

to be discovered. Especially the fascinating later symphonies and quartets—John Nelson did the fifteenth and final symphony with the New York Philharmonic just last month—show that the stereotype of Shostakovich as the purveyor of brassy, motoric formulas is in serious need of revision. Even the Russians are getting into the act: the Bolshoi Theater recently presented the opera *Katerina Ismailova*, which even in this revised version had long been discouraged for political reasons.

Shostakovich's simplicity of idiom is not entirely a fiction, however, and it should contribute to his acceptance into the standard repertory. We seem to be living through a period in which the dogmatic complexity of recent decades of contemporary music is being replaced by a simpler, more open, more traditionally communicative style. If that is true—and composers as disparate as George Rochberg, David Del Tredici, and Philip Glass suggest that it is—then Shostakovich could soon be looked upon as progressive, not retrogressive.

We realize now that to retain a tonal harmonic base and recognizable form does not mean automatically that a composer is incapable of originality. Music is no longer seen as a single track leading inexorably forward, with all deviations banished as heretical. Many ways are now considered possible, and Shostakovich's seems one of the more fruitful.

There is a considerable irony about some of Shostakovich's simplicity, to be sure. His music is largely diatonic, with simply repetitive rhythms and easily comprehensible structures. Just how he might have evolved stylistically without his continual rebukes from the Soviet cultural bureaucracy is something we can never know. For personal and patriotic reasons, Shostakovich chose to remain in Russia. During his lifetime, his work seemed almost cyclical—surging forward with innovations, brutally chastised back to populism, then venturing out once again into innovation.

There is a parallel here with Carl Orff, another simple composer whose work—though he was never a Nazi or even a Nazi sympathizer—was in some crucial sense shaped by another totalitarian regime eager to enforce a bright and bland optimism upon its artists. Orff, whose eighty-fifth birthday year passed last season with barely a ripple of acknowledgement in this country, is another undervalued composer whose time will come, if not so soon or so surely as Shostakovich.

Yet even if both men's work was conditioned by totalitarianism, it is hard not to think that the essence of their composing remained untouched. Virgil Thomson—another simple composer whose music

will soon be recognized more than it is today—had no similar governmental restrictions. Neither did Benjamin Britten. Not that the music of all four composers sounds alike, no more so than that of Mr. Rochberg, Mr. Del Tredici, and Mr. Glass. What they share is that they are composers of "ear music" rather than "eye music"—music whose secrets can be heard by the reasonably acute ear, and not deciphered only after inspection of the written score. They all use intervals generally recognized as consonant, rather than dissonant, and they lean toward fewer notes rather than more.

What really seems to have happened is that quite independently of political circumstance, a generation of composers all over the world leaned instinctively to the simple and interpreted it in different, personal ways. And of those composers, Shostakovich may well have been the greatest.

Both Mahler and Shostakovich had their fervent champions—conductors and performers who espoused their music even when it was not always the most popular or the most critically fashionable thing to do. Needless to say, the very existence of a champion does not ensure eventual popularity: witness Max Reger and the indefatigable Rudolf Serkin. But just as Mahler had conductors such as Bruno Walter, Otto Klemperer, Jascha Horenstein, and Leonard Bernstein, Shostakovich has Mstislav Rostropovich, Mr. Bernstein, and the Fitzwilliam Quartet, among many others.

There are extramusical considerations in the case of both composers, as well. Mahler was a Jewish composer fought for by Jewish conductors at a time of apocalyptic anti-Semitism. Shostakovich, in turn, has become a potent symbol of the plight of Russian artists and intellectuals—both Jewish and non-Jewish—under the Soviets. And we seem now on the verge of a period of cold-war conservatism that will surely have its effect upon the arts and the shaping of artistic reputations.

Myth enters here. We will probably never ascertain the real accuracy of the "autobiography" of Shostakovich presented in the West by Solomon Volkov, the emigrant Russian musicologist and critic. But in a curious way, the vision of Shostakovich that Mr. Volkov presents, as an embittered opponent of the Soviets, should add to his status in the West yet not harm him in Russia. It adds to the drama of his reputation in the same way that Mahler's fervent love life, tortured perfectionism, and consciousness of impending death add to his romantic image.

But in the end, of course, it will be Shostakovich's music and not the ephemera that surround it that will ensure his reputation. And that

music, to judge from the recordings and ever-increasing performances we encounter today, should handily accomplish the task of entering him into the pantheon.

VIRGIL THOMSON

A Virgil Thomson Reader, 1981

Note: I edited A Virgil Thomson Reader *with Virgil; it was tons of fun. But owing to my weird scruples about a perceived conflict of interest, I chose not to identify myself as coeditor. I did openly write this introduction, though.*

Many notable composers have written notable criticism. But in the vast majority of cases, the criticism was either a self-justifying forum or an enforced way to earn money, grudgingly attempted and rapidly abandoned as soon as composition itself started to pay off. Virgil Thomson's criticism was sustained over nearly a lifetime, reached far beyond narrow self-advertisement, and not only equaled his best music in quality, but mirrored its attributes.

Any critic-composer reveals as much about his own music as he does about his ostensible subject. In Thomson's case, this synchronicity is particularly exact, given the coequal nature of his gifts as a composer and a prose stylist. Indeed, Thomson himself stresses this kinship with his reiterated argument that composers make the best critics.

Noncomposing critics have a vested interest in disputing this view, just as Thomson had his own self-justifications as grounds for advancing it. In fact, it would seem, criticism is a calling in itself, and critics both good and bad have emerged from every possible background. Still, the argument that composers know better than anyone else how music is actually made is a persuasive one. And being a composer may well have contributed to Thomson's refreshing cynicism about star performers and the self-satisfied conservatism of performing-arts institutions. The insights a composer with a trenchant prose style can bring to music criticism are considerable, and Thomson stands as exalted proof of that.

Chief among those insights was the most basic one: a commitment to

the music of his time, meaning a solid knowledge and a willingness to approach new music not with bland "objectivity" but with unabashed passion. This might seem a point hardly worth making, except that such a commitment remains the exception among practicing music critics. Most pay lip service to the idea of championing new composers, or at least "responsible" ones. But their hearts lie in the past, with the music that first kindled their love for the art. As such they are no worse than most "music lovers." But they have abdicated their highest role.

With Thomson everything, new and old, was seen with a fresh, contemporary spirit, and one not limited to music. He didn't accept all that was new. But he was open to every stylistic persuasion, even if he did have a happily admitted bias for things French and American. He also concerned himself with music that most music critics didn't consider serious music at all—jazz, folk, gospel—and with the sociological ramifications of a supposedly "pure" art form. Thomson confronted the crisis of serious contemporary music in our century by refusing to wallow unduly in the notion of crisis in the first place. He wrote with enthusiasm and perception about the new music he liked, sweeping his readers along with him. By so doing, he built bridges—long dilapidated or never constructed—between music, the other arts, and the American intellectual community.

Those bridges benefited both music and the community at large. Any art form runs the risk of growing moribund if it becomes too self-involved. Good new music of the past may not have appealed at first to the conservative concertgoing public. But it attracted the poets, painters, and dancers, as too much twentieth-century music has failed to do. In Paris in the '20s and '30s, however, music was central to avant-garde culture, and when Thomson returned to New York in 1940, he stayed alive to such kinships. In fostering them in his writings and his music, he fostered the art of music itself, by reaffirming the inevitable sterility of isolation.

Bridges have two ends, and Thomson's literary gifts helped enliven the intellectual community beyond inspiring a few writers and painters to listen to music. Intellectuals understandably concentrate on the written word, and American intellectuals have long turned their eyes toward Europe, to the detriment of a truly American culture. Thomson's European connections were impeccable, yet he maintained a graceful balance between his American instincts and his European culture. He was thus able to establish a style authentically and unmistakably American

in both his prose and his music, and to have it accepted by American intellectuals because of its meticulously crafted polish.

Thomson's criticism stands in relation to the evolution of American music criticism in precisely the manner that his music relates to the overall evolution of American music. The greatest American composers, of this century and before, have been outsiders, men who accepted the historical rootlessness of American life and turned instead to its folk traditions and within themselves to create something new. Establishment American musical culture up until the First World War, on the other hand, was intensely Germanic. Just as the Germans provided the model for our educational and scientific establishments, so did they for our musicians. Many American composers (John Knowles Paine, Edward MacDowell, Charles Tomlinson Griffes) were actually trained in Germany. So, too, the leading American critics around the time of Thomson's birth were steeped in German culture—men like William James Henderson and Richard Aldrich and, later, Olin Downes. They were also opposed to what they regarded as the more extreme trends in modern music, and largely oblivious to the validity or even the existence of a cultural life apart from the educated classes.

Thomson, with his Franco-American wit, Parisian elegance, and Missouri frankness, stood as an antidote to such weighty sobriety. And he fulfilled the same function with the latter-day Germanic school of American composers and intellectual critics, who sought with serialism to resurrect the German hegemony. It is hard now, in this age of deliberate simplicity and repetition among so much of the musical avant-garde, to realize how radical Thomson's childlike tonalities and tunes and his innocently straightforward prose could seem. By hewing to Baptist hymns and Erik Satie, he ran the risk of being dismissed by soberer sorts as something fluffy and trivial.

But Thomson was no cheerfully marginal gadfly, full of fun but not worth taking too seriously. There are such critics, wise guys without substance, although Thomson can hardly be held responsible for what is really another, less honorable American tradition. With Thomson, the jabs were always backed by strength and style—at once "sassy and classy," as he put it. Just as a remarkable depth of emotion lurks beneath the lulling tunefulness and folkish abstraction of his two Gertrude Stein operas, so, too, in his criticism, a clarity of vision and a profundity of refined feeling are never far from the simply elegant surface.

Thomson managed a synthesis of European and American culture

that can help resolve the long-standing blurring of this country's self-image. He makes the point in the conversation with Diana Trilling included in this volume that he and the other American artists in Paris between the wars didn't think of themselves as "expatriates"; they were simply Americans living abroad. In terms of position, power, and recognition, Thomson became an archetypal American Establishmentarian. But as a Missourian who attended Harvard, an American in Paris, a musician among critics, and a critic among musicians, he has really always been a little bit of an outsider. His music and his prose may have been artfully simple, but he avoided the primitivism of some American outsiders, and he used his outsider perspective to see more truly than most of us can. Above all, he never turned his back on any of his homelands. Indeed, in his music and his prose, he has given us as profound a vision of American culture as anyone has yet achieved.

FRANCO ZEFFIRELLI'S *LA BOHÈME*
The New York Times, December 15, 1981

Note: Overnight reviews on tight deadlines are fun: they get the adrenaline pumping. Whether the result loses in reflective depth, I cannot say, since I write pretty much all my reviews at the same tempo.

Last night's new production of *La Bohème* at the Metropolitan Opera was a gift for the old guard—for Met conservatives disgruntled by the carefully modernist line taken by the new Met in its repertory and production style. This Franco Zeffirelli *Bohème*—he both directed and designed it—is a production for people who come wanting to applaud the scenery. And applaud it they did, throwing in bravos to boot.

One calls the production new, and in a technical sense it is. But if the Met ever went out to get guaranteed goods with a minimal risk, they were doing so here. Mr. Zeffirelli has been staging "his" *Bohème* for some twenty years now. It has graced most of the world's major opera stages and it has been filmed. He was reportedly persuaded to assay the opera once again because he had come up with some new twists.

The second act is still a split-level stage connected by wide steps, with passers-by above and the Café Momus down below. But now the actual interior of the café is revealed when pushcarts are rolled away. The crowds—280 people are on stage at the climax—continue to pursue their assigned tasks throughout, occasionally freezing when Renata Scotto has a big moment, and the bustle would be distracting.

The first- and fourth-act set is a cutaway garret, complete with lower-lying roofs on which the bohemians stage their mock battle in the fourth act. Act 3 is softened by a scrim with the inn below the road and a snowy incline separating them. All of this is accomplished in Mr. Zeffirelli's familiar superrealistic manner, and the sheer lavishness of detail—and demonstrable expense required to realize it—brought appreciative, nostalgic comments from the opening-night audience.

To this taste, however, the decor lacked an enlivening sense of style. The idea of a realistic *Bohème* is hardly out of date; indeed, it is probably the only intelligent way to do the opera. But Mr. Zeffirelli's imagery seemed grandiose and even pretentious. And it did not appear to have been executed or lit with a real sensualist's feeling for visual elegance.

The stage direction was conventional. This again is not a complaint; *La Bohème* is such a familiar opera that eccentric new bits of business only stand out. But occasionally Mr. Zeffirelli or his singers indulged in isolated, vulgar exaggerations of their essentially realistic portrayals. Musetta is a flamboyant character, but did Miss Scotto really need to pull her dress up above her head, repeatedly, when a flash of ankle would have done the trick?

Teresa Stratas, who created far and away the most interesting portrayal, was similarly given to obtrusive, melodramatic moments: her stagy faint in the first act, for example, or her health-club trick on her deathbed—stretching out her arms and half levitating her torso toward Rodolfo near the end. For the most part, however, she played Mimi as a nervous wraith out of Edward Gorey, and compelling it was, with Peter J. Hall's costume design contributing to the effect.

The other singers relied on the standard *Bohème* characters and gimmicks. These worked functionally, but it takes a greater flair from both director and actors to make the bohemians' cavortings look fresher than mere superannuated horseplay.

The slack, larger-than-life qualities of the decor and direction were mirrored in James Levine's conducting. This was not one of Mr. Levine's better nights. The playing was loud, crudely colored, and slow.

It lacked the pulse and tension necessary in the love music—although the third act was better than the first, and the all-around best, musically, of the night. The more boisterous scenes needed more snap and wit.

This kind of production used to be peopled by the best singers the Met could muster, and maybe it still was. But none of the four principals matched memories of even the near past. The best was Miss Stratas, occasionally a bit edgy but a full and appealing lyric soprano, and a nice change of pace from her Jenny and Lulu.

The most disappointing was José Carreras, the Rodolfo. Mr. Carreras's tenor has grown so dark and baritonal that it sounds even lower than it is: he took "Che gelida manina" down a half tone, which is not uncommon, but it sounded lower than that. Worse, his voice has lost its brightness and alacrity; what should have been youthful ardor emerged as beefy effort. When he could pour forth unstintingly, without concern for intimacies, however, as in the third act, he was more convincing.

Miss Scotto's Musetta further chronicled what seems to be her vocal decline. She was moving in the fourth act, but in her second-act pyrotechnics she barely compensated for her frayed and strident top with extra dollops of personality. Richard Stilwell and James Morris, the Marcello and Colline, were straightforward and adequate; nothing more or less. The best baritone on stage, as he usually is, was Allan Monk as Schaunard: why he doesn't get bigger parts only he, his manager, and the Met know for sure. Italo Tajo, the veteran Italian comprimario, doubled wittily as Benoit and Alcindoro.

Singers will come and go for years in this production, and Mr. Zeffirelli's direction will soon erode. But the decor will remain and it should prove durable: the Met wanted a *Bohème* that would last, transcending fashion, and it got one.

Perhaps *La Bohème*, Puccini's finest and most innocent opera, works best in a far more intimate house than the Met. Perhaps it is best encountered on a journey, with young, unknown singers playing out its tale of passion and despair in a way that can really be believed. Mr. Zeffirelli's *Bohème* is grand and traditional, but it lost its innocence long ago.

LOS ANGELES ROCK

The New York Times, April 4, 1982

Note: I was something of a devotee of Los Angeles folk rock in the 1970s. This is my effort to come to terms with what followed.

Los Angeles is still enjoying its latest underground rock explosion, which began around 1978 and which is still largely misunderstood. The city plays a crucial role in our popular culture, as the center of films, television, and pop music. But that centricity provokes its own virulent reactions within Los Angeles and helps explain why the city is perceived in such distorted fashion by the rest of the country, and even by its own pop moguls. What actually happens there is considerably more complex and interesting than simple stereotypes suggest. And a few key records from the younger rock scene can help clarify that complexity.

In the '60s, the image of Los Angeles pop music was of surfers and bikinied blondes; in the '70s, it was of mellow folk rockers. The image of underground Los Angeles rock today is still defined by its earliest and most extreme practitioners. Los Angeles punks looked like silly and dated imitators of the Sex Pistols, down to the roughhouse dancing, the spitting, and the safety pins in unlikely places. And since most people assumed that the surfers and the folk rockers epitomized Los Angeles rock, it was easy to dismiss the L.A. punks as behind-the-times trendies, shallow copycats, and deracinated eccentrics.

But an overview reveals a wide range of rock being made by younger musicians in Los Angeles today, as well as firm links between all these different styles and earlier aspects of the city's pop music. To start with, it should be remembered that many of the leading artists in '70s L.A. rock were carpetbaggers—people who came from places like Michigan, Texas, Arizona, and even England. To be fair, such artists as Linda Ronstadt, the Eagles, and Fleetwood Mac defined one part of the Los Angeles sensibility honestly and honorably. And some of the finest artists of this style did have deep roots there: Jackson Browne is a fourth-generation Los Angeleno.

The first reaction to the sleepy, earnest pretensions of the '70s folk rockers came with "power pop," which mild-mannered folks hoped would quickly supplant the ruder insistence of the New York and London punkers. Although the Knack has faded from the scene, that spirit lives on

with the Go-Gos, who unashamedly court commercial success (and have attained it). Their *Beauty and the Beat* album (I.R.S. SP 70021) is not really very original. But it is pleasing enough, and the Go-Gos score their own points for progressiveness by being an all-woman band.

The Blasters, whose eponymous first album is on Slash SR-109, represent an equally commercial, unthreatening side to L.A. rock, the rockabilly revival. As such they conform neatly to another aspect of the Los Angeles pop tradition, a fascination with older forms of American blues and early rock: Gram Parsons and Ry Cooder live on.

Another commercial chart topper recently has been Joan Jett, with *I Love Rock n' Roll* (Boardwalk NB1-33243). Although she is identified with recent Los Angeles punk, she makes a heavy-metal rock not all that far removed from Van Halen. She was also a former member of the all-woman Runaways, which was one of the prime pre-punk projects of Kim Fowley, the flamboyant hustler-king of Los Angeles rock in the mid-'70s in the same way that Malcolm McLaren fulfilled that role in London just a little later.

Moving another step down the trail toward so-called hardcore punk, we come to X, which was recently signed by a major label, Elektra-Asylum (criteria for a flourishing underground rock scene include an active club life and new rock magazines and independent record labels, both of which were fulfilled in Los Angeles by Slash magazine and then Slash Records). X's most recent LP, *Wild Gift* (Slash SR-107), made most critics' top-10 lists for 1981. The band seemed more punk a couple of years ago than it does now. *Wild Gift* is a polished LP, and demonstrates considerable musical variety. The band's lead singer, Exene, recalls the rawness of New York "no wave" art rock, to the point that she is co-writing a book of poetry with Lydia Lunch, the "no wave" queen. But there is also a more diverse sensibility in John Doe, and even an old-fashioned rock-star guitarist in Billy Zoom.

The true hardcore punkers are the most difficult part of the L.A. underground to deal with. There is an undeniable sociopathic, racist, quasi-fascistic streak to this scene, a violence that never really surfaced in New York and could be rationalized in London as a manifestation of leftist-anarchic politics. In Los Angeles, the violence is sometimes diffused by parody, welcomed as cathartic, or explained away as outside agitation (i.e., visitors to Hollywood clubs from beach towns that most people think are part of L.A. in the first place). But at other times, the violence simply seems to define the hardcore scene.

Once again, however, things are more complex than that, and such violence is hardly a new phenomenon in Los Angeles rock history. Surf rock, which came from those same "beach towns," had its violent and eccentric side (Brian Wilson of the Beach Boys was not exactly normal, after all), and there were lively riots on the Sunset Strip in the '60s. The line of pre-punk misanthropic loners in Los Angeles rock includes Frank Zappa, Captain Beefheart, Randy Newman, and Tom Waits. Above all, there were Jim Morrison and the Doors, who defined a gloomy obsession with darkness and death that reflects Los Angeles just as accurately as cheery cries of "fun, fun, fun" and mellow strumming guitars. Ray Manzarak, the Doors' organist, produced X's *Wild Gift*.

History aside, the Los Angeles hardcore bands are simply more interesting than mere brute noise. The Germs are no longer with us, their lyricist and lead singer, Darby Crash, having overdosed after his starring role in Penelope Spheeris's fascinating film documentary of the scene, *The Decline of Western Civilization*. But his lyrics, while concerned with lurid denunciations of American culture like so many of these bands, are couched in curiously literate, even collegiate terms. And their discs—*Germs (GI)*, produced by Miss Jett (Slash SR-103) and the twelve-inch, 45-rpm *What We Do Is Secret* (Slash SREP-108)—have an energy that does credit to their English punk inspirations.

More recent records from this school are Black Flag's *Damaged* (Unicorn/SST 9502) and Fear's *The Record* (Slash SR-111). They, too, owe their debts to Johnny Rotten and Mr. McLaren. But there are a passion and a furious intensity here that are far more vital than mere uncontrolled, garage-band imitations could ever be. And the buzzing planes of guitar textures echo the similar instrumental experiments of current New York art rockers.

All these records, from the cheery fluff of the Go-Gos to the screaming denunciations of Lee Ving of Fear, are worth exploring. But another way to appreciate the diversity of the Los Angeles underground scene is through compilations. The soundtrack album to Miss Spheeris's film (Slash SR-105) contains some less distinctive groups but offers Black Flag, the Germs, Fear, and the earlier, punkier X. A collection called *The Future Looks Bright* (Posh Boy PBS-120, also available in a longer cassette version) has seven bands, including Black Flag and the quite wonderfully funny Descendents, who are given to mini–"speed rock" masterpieces about barbarians dining at Der Wienerschnitzel and other vignettes from Southern California suburbia.

Finally, there are two *Rodney on the Roq* compilations (Posh Boy PBS 106 and 123), the first introduced chirpily by Brooke Shields. These were assembled by Rodney Bingenheimer, who demonstrates the links that bind Los Angeles rock's past and present as well as anybody: a perennial scenemaker who achieved the transition to punk without shifting gears once. What is most instructive about Mr. Bingenheimer's collections is their range—everything from hardcore punk to artsiness to the most eagerly commercial idioms. These records suggest not that Los Angeles has betrayed its past, but that the city has simply escaped the stereotyping of the mid-'70s to reveal the full, bizarre diversity of musics that have proliferated there all along.

MARIA JERITZA

The New York Times, July 11, 1982

Note: There aren't many obituaries included in this collection, but here's one. For all the raw information that needs to be laid out, and for all one's scruples about trashing the recently dead, they can still offer a nice forum for a reflective essay about someone one admires.

Maria Jeritza, the internationally renowned soprano who has been called the golden girl of opera's "golden age," died yesterday at St. Mary's Hospital in Orange, New Jersey, after a long illness. She was ninety-four years old and lived in Newark.

She was, said one admiring Metropolitan Opera veteran, a "genuine twenty-four-carat prima donna of the old school." When Maria Jeritza swept onstage—a tall, imperious, yet irresistibly feminine woman with a ravishing figure, exquisite face, and shimmering blond hair—audiences knew they were in the presence of a star. And one of the things that made Miss Jeritza a prima donna was that she knew it, too.

Miss Jeritza was one of the great artists of opera's "golden age," or at least the latter part of it, from 1910 to 1930. It was a time in which opera singers were accorded the sort of mass adulation they hardly receive today; the only contemporary parallel would be the hysteria that greets rock singers, but that is from presumably susceptible teenagers.

In the two cities in which Miss Jeritza based her career, Vienna and New York, she was a household word, the object of envy and avalanches of gushing newsprint.

Opinions vary as to her greatest role, but there can be no question that the title role in *Tosca* was the part by which the general public knew her best. Floria Tosca is herself an opera singer, and Miss Jeritza's portrayal epitomized everything opera audiences loved about her.

It was grandly and broadly sung, with a hefty lyric-spinto soprano. It was passionately acted, in so convincing a manner that singers to this day copy her in many details—above all, the business of singing "Vissi d'arte," her great second-act aria, prostrate on the floor before the diabolical Scarpia. And it radiated a love of life so voracious that Miss Jeritza was idolized in just the way Tosca was meant to have been idolized in Puccini's opera.

Miss Jeritza enjoyed adulation from every quarter. Olin Downes of *The New York Times* called her first Metropolitan Opera Tosca in 1921 a "sweeping triumph." It was, he said, "gloriously sung," "distinguished and original," blessed with "physical beauty of the highest type."

"Those whose privilege it was to behold her performance will have memories," he concluded. "When great artists arise in future years, they will say: 'But I heard Maria Jeritza in *Tosca*.'"

Marcel Prawy, the historian of the Vienna Opera, was more succinct. He simply called Miss Jeritza "the prima donna of the century." Critics were hardly alone in their admiration. Miss Jeritza's third husband, Irving P. Seery, a New Jersey businessman and lawyer, was said to have fallen in love with her in 1910 when he saw her on the stage and remained a bachelor for thirty-eight years until he could finally marry her.

Aside from her husbands, she was reported to have had close relationships with some of the most famous composers of her day. Hardly a year went by in the 1920s when Miss Jeritza was not in the Austrian courts, suing to suppress some scandalous novel that purported to reveal new facets of her love life.

Musing over her collection of jewels several years ago, she sniffed scornfully about today's prima donnas: "Flowers! If they had tried to give me only flowers, I would have spit in their faces."

Her fans, in Vienna and New York, were as tenacious as they were loyal. Giulio Gatti-Casazza, director of the Metropolitan Opera from 1908 to 1935, said her ovation after "Vissi d'arte" was the greatest he had ever heard. And when she returned to the scenes of her former triumphs in the early 1950s, applause stopped the shows for minutes on end.

Miss Jeritza had a good head for publicity, and her lavishly publicized imbroglios with the leading sopranos and tenors of her time only added to popular fascination with her.

Her best-known tenor antagonists were Alfred Piccaver, the English American who was a leading tenor in Vienna, and Beniamino Gigli, who was said to have kicked her in the shins over who should get priority during a curtain call. He thus caused Miss Jeritza to appear alone before the Met footlights, weeping and crying that "Mr. Gigli is not nice to me."

Lotte Lehmann, the first to sing the role of Composer in Richard Strauss's *Ariadne auf Naxos* (Miss Jeritza was the first Ariadne) and the first Dyer's Wife in his *Die Frau ohne Schatten* (Miss Jeritza was the first Empress), was amusingly sharp-tongued about her rival in her autobiographical study of Strauss's operas. And the grand and venerable Lilli Lehmann is said to have observed, apropos Miss Jeritza's Tosca, that "a real artist shouldn't have to lie on her face to sing a big aria."

The most celebrated Jeritza feud involved Maria Olszewska, a noted mezzo-soprano of the period between the World Wars. At a 1925 performance of *Die Walküre* in Vienna, Miss Olszewska became upset over what she believed to be some giggling and whispering from the wings on the part of Miss Jeritza and another artist.

After several increasingly emphatic comments of "Cut it out," "Silly gooses," and "Pigs" failed to quiet the disturbance, Miss Olszewska marched determinedly toward the wings and spat at Miss Jeritza, hitting the other giggler. She was dismissed from the company, and then sued for reinstatement on the ground that Miss Jeritza was, illegitimately, the de facto head of the company. Miss Olszewska was eventually rehired.

Miss Jeritza was born in Brno, Czechoslovakia—then Brunn, Austria—on October 6, 1887, according to most current reference books (when she was at the Met in the 1920s, newspaper interviews gave her year of birth as 1891). Her original name was Mitzi Jedlicka, but she changed it to Jeritza (pronounced HAIR-itza) in her early twenties.

Although her family was poor—her father was a concierge—she received early dramatic and vocal training, and made her debut as a member of the Olmutz Opera company in 1910 as Elsa in Wagner's *Lohengrin*. Five months later won a position at the Vienna Volksoper, with Elisabeth in Wagner's *Tannhäuser* as her debut role. With that forum and subsequent appearances in a lavish production of Offenbach's *La belle Hélène* in Munich and as Strauss's first Ariadne in Stuttgart, the young singer gained an increasingly favorable reputation.

But it was not until Emperor Franz Joseph heard her as Rosalinda in *Die Fledermaus* at Bad Ischl, a summer spa, that she was invited to join the Vienna Opera itself. "Why isn't this ravishing creature singing at the court opera?" the monarch asked. "Must I always listen to fat, elderly women?"

Miss Jeritza made her debut in 1912 in the title role of a long-forgotten opera called *Aphrodite*, dressed in a costume that then seemed the next thing to nakedness. Her success was complete. By the time she left for the United States, she had nearly sixty roles in her repertory.

Miss Jeritza's career at the Metropolitan Opera lasted from 1921 to 1932, although she returned to Vienna each year and sang in many of the important houses of the world.

At the Met, Miss Jeritza sang twenty roles, counting a single Rosalinda she learned in English for a benefit in 1951. Her most famous and frequent Met parts were Tosca, Santuzza, Sieglinde, Elsa, Elisabeth, Octavian, Turandot, and Minnie. But she also essayed Carmen (one of her few failures, despite such novelties as a "Seguidilla" sung flat on her back), appeared in the ill-fated American premieres of Korngold's *Die tote Stadt* (her debut role) and Strauss's *Die ägyptische Helena* and the historically more significant American premiere of Janáček's *Jenůfa*.

As her repertory and her recordings suggest, Miss Jeritza had a big, bright, gleaming soprano—toward the end of her prime, she took on the *Walküre* Brünnhilde, although she never went further into the heavy Wagnerian parts. Early in her career, the critics were nearly unanimous in their praise of her singing. In her last years at the Met, there were complaints about stridency, "scooping" up to notes, and singing under pitch.

Her acting style was highly realistic (real tears were, it is said, not uncommon) and marked by an innate theatricality. The habit of singing "Vissi d'arte" on her stomach apparently came about after an accident during a dress rehearsal. Puccini rushed up to her after the act and insisted that she always do it that way, that her insight was "from God." In her later years, though, what had seemed at first like inspired theatricality came sometimes to look like calculated mannerism.

Still, her acting, or perhaps the simple magnetism of her stage presence, obviously overwhelmed most of her audience. She was an artist in the Callas mold. Miss Jeritza was never afraid to sacrifice bel canto beauty of tone for dramatic effect.

After she left the Met in 1932, Miss Jeritza continued to sing, in

Europe and all over the United States. She also made several movies, most notably of a Léhar operetta for the German UFA company. But she gradually devoted more and more of her time to retirement.

In 1934 she divorced her first husband, Baron Leopold von Popper, an Austrian businessman, and the next year she married Winfield Sheehan, a Hollywood film executive. The marriage brought her a lavish estate in Beverly Hills, with a dining room that seated 182.

Mr. Sheehan died in 1945, and in 1948 Miss Jeritza married Mr. Seery, who died in 1966. After that, she continued to live in her Newark home, accompanied by her private secretary of many decades. She had no children.

She was active well into her eighties, serving as hostess for functions at the residence of the late Cardinal Spellman and for visiting Austrian officials, and maintaining a regular box and block of seats for the Saturday matinee performances at the Met.

She is survived by several nephews and nieces. A funeral service will be held at 9:30 A.M. Wednesday at the Spatola Funeral Home, 240 Mount Prospect Avenue, in Newark. A mass will follow, offered by Terence Cardinal Cooke at 11 A.M. at St. Patrick's Cathedral in Manhattan.

WHEN FAMILIAR WORKS TAKE ON RENEWED VIGOR

The New York Times, January 9, 1983

Critics may be jaded, as members of the public sometimes complain. But they have their reasons: the very nature of their job puts them in constant confrontation with the egregious—which can be amusing, in a grim sort of way—or, more commonly, with the merely mediocre. Thus no one is more happy than the critic who stumbles upon a performance that breathes fresh life into even the most weary of warhorses.

Of course, there is no mystical dividing line between revelatory experiences and unutterable boredom. A too frequently programmed standard played decently and honorably can still give pleasure, even to a jaded critic. But the revelations remain special, in part for the immedi-

ate experience they offer but also for their function as standard setters for more conventional concert encounters.

So far this season, there have been four performances that I recall with a special intensity—interpretations that took works of a seemingly hopeless familiarity and made them sound pristine: There was Bernard Haitink's performance with the Concertgebouw of Amsterdam of Berlioz's *Symphonie fantastique* at Carnegie Hall; Carlo Maria Giulini's account of the Dvořák Eighth Symphony with the Los Angeles Philharmonic at home in the Dorothy Chandler Pavilion; the clarinetist Roger Salander in Brahms's Sonata in E-flat (Op. 120, No. 2); and the Jean-Pierre Ponnelle production of Leoncavallo's *Pagliacci* at the Houston Grand Opera.

What did these performances share, other than their excellence? To start with, scrupulous attention to the score—both its letter and its spirit. A judicious blend of fidelity and interpretive individuality. And finally that intangible X factor, "musicality," the fuzziest of all positive words in any critic's vocabulary.

Mr. Haitink's interpretation went against type, "type" being the American tradition in recent decades of treating the *Fantastique* as a showpiece for a powerhouse virtuoso orchestra. The Concertgebouw is certainly one of the great ensembles of the world, but its greatness lies in its contained sobriety, its homogeneity and sensitivity of tone, its organic impact.

The performance did offer one textual variant to jog a jaded ear: the cornet part (in this case, doubled) in the "Ball" movement, which lends that music a wonderful carousel flavor. But mostly Mr. Haitink made his points by playing it straight: by attending to the phrasing and dynamic markings in the score, and by keeping the balances in chaste proportion, thus letting us hear something of how Berlioz's audiences, still attuned to classical sonorities, perceived this strange and radical new work.

This approach hardly vitiated the excitement. By allowing the music to build to the climax Berlioz intended, without inserting false hysteria earlier on, Mr. Haitink managed to make the final movement more thrilling than I had ever heard it before.

Mr. Giulini's Dvořák Eighth was far more idiosyncratic, but no less persuasive. This was an interpretation in which lyricism superseded everything else. All of Dvořák's music sings in one sense or another, but here every note and chord was linked into a seamless legato line. Yet the effect was never mannered, but wonderfully heartfelt.

This is a Brahms year, and we have already heard a good deal of his chamber music along with his more expansive scores, with more to come. The two Opus 120 sonatas, for clarinet or viola, are typical of Brahms's chamber music in that they can sound curiously thick tongued, with the composer's penchant for Germanic earnestness approaching the pedantic.

Mr. Salander, an American based in Vienna, invested the E-flat sonata with a rare fluency and liquidity of tone and line. His performance was fully idiomatic, as his residence might seem to assure. But it had a resilience that was individual and convincing, too, and like all great performances, it made the music sound better than one had previously believed it to be.

Finally, Mr. Ponnelle's Houston *Pagliacci*. That very wording triggers dark suspicion from those who feel that modern stage directors, Mr. Ponnelle at the forefront, have usurped creative dominance of opera in our time. But this *Pagliacci* was truly a team effort, and it did justice to the composer's intentions.

Opening night marked the first time Mr. Ponnelle had worked with Jon Vickers, the Canadian tenor who sang Canio—and very much acted the part, as well. It included a fine supporting cast and an excellent young conductor in Hal France. Above all, it showed Mr. Ponnelle at his best as both designer and director: sensitive to the score and capable of creative innovation within legitimate limits prescribed by the libretto. This hard, tough, sunbaked, raw, and impassioned opera wasn't "Mr. Ponnelle's *Pagliacci*" at all, really, but Leoncavallo's, scrubbed and fresh.

In our contemporary musical culture, so centered as it is on the standard repertory of the past, it might seem worthwhile to wave these four performances like some hortatory banner, urging musicians ever onward and upward toward self-improvement.

But that might also seem vague and presumptuous, and in any case things aren't quite so simple. Unless you believe, sweetly and innocently, that objective standards exist and any decently trained musician can pick out the best performances as they come along—which on one level, of course, is quite true—you are forced into a more relativistic position. Relative, but realistic, too. Great performances look great in part because of the very context against which they are perceived, and that context is the daily routine which becomes such an obvious target for protest.

On most quantifiable levels, the general level of performances has improved in the course of this century—which might make great performances more difficult to notice because the backdrop is now brighter. There are more highly qualified, technically adept players, ensemble is more proficient in a larger number of orchestras, individual musicians can master more complex scores than they could a century ago, and so forth. Reading any trustworthy critic from years past leads one rapidly to the conclusion that there was plenty of dross in any "golden age" you care to feel nostalgic about—along with a good deal of indisputable excellence.

Conversely, one hears frequent complaints that all this expertise has been purchased at the price of music's spirituality: that the cool efficiency of modern performances denies the music the life it needs to communicate beyond the printed page.

The four performances I heard this fall do not resolve this age-old argument between those who think that things—in any field, at any time—are better than ever, and those who are convinced that we are in a period of vertiginous decline. But they do prove that it is still possible to make great music, and that sometimes, even in unexpected circumstances, a critic's smooth routine can be disrupted and elevated.

GLENN BRANCA

The New York Times, January 14, 1983

Like some musical beast heaving itself up out of the primordial sonic sludge, Glenn Branca is back, this time with his Symphony No. 3 ("Gloria"), subtitled "Music for the First 127 Intervals of the Harmonic Series." Mr. Branca's effort—and an effort it is, for all concerned—received its world premiere last night at the Brooklyn Academy of Music's Helen Owen Carey Playhouse, as part of the academy's Next Wave series. The performance will be repeated tonight and tomorrow night at 8 and Sunday at 2.

Mr. Branca first called attention to himself as an art rocker, and his Symphony No. 1 ("Tonal Plexus") of 1981 made use of what amounted

to a massive rock band, all slashing electric guitars and pounding drums. The sheer, visceral onslaught was exhilarating.

But that turned out to mark not the beginning but the end of one phase of Mr. Branca's career. Starting with the Symphony No. 2 ("The Peak of the Sacred") in May of last year, Mr. Branca turned to home-made instruments—in particular, "mallet guitars," which consisted of multiple sets of electric-guitar strings mounted on racks and hammered with mallets. The Third Symphony uses them, plus some newly designed amplified keyboards that sound like monster dulcimers. Both symphonies also employed a rock rhythm section, the drums pounded gleefully by the irrepressible Stephan Wischerth.

To this taste, the Symphony No. 3 was considerably more effective than its predecessor. Last year's extravaganza was diffuse and shapeless, and disfigured by the antics of a bare-chested percussionist named Zev. It was as if Mr. Branca had spent so much time conceiving and con-structing his mallet guitars that he forgot to compose any music for them.

In any case, composition in the traditional sense, meaning the well-crafted exposition of musical ideas, is not Mr. Branca's strong suit. Like all musical primitives, he seems to have difficulty extending his initial—and, in his case, exciting—ideas beyond their first flash. This poses a special problem for him in a careerist sense. Even a cult hero's fans may grow restive at the repetition of the same throbbing sustained chords, the same ponderous crescendos, the same thumping drum crashes.

Since he apparently finds it easier to invent new sonorities than to find fresh uses for the sonorities he already has, Mr. Branca has turned to instrument design and, in this symphony, harmonic mysticism. The subtitle alludes to the pure, untempered tuning that has fascinated many twentieth-century composers. The trouble with such fine grada-tions, however, is that the limits of human hearing and the imprecision of actual tunings turn the sound into dull, brutal murk.

Thus for much of this symphony's seventy-minute length, the impres-sion is more deafeningly glutinous than anything else. Chord changes by the twelve-member band proceed with elephantine solemnity, punctu-ated and occasionally enlivened by Mr. Wischerth.

One problem is the sheer volume Mr. Branca favors: The hypnotic aura Robert Wilson achieves through protracted stasis, Mr. Branca apparently hopes to equal by sonic overload. But the losses—of subtlety, beauty, and even actual hearing—outweigh the gains.

In addition, Mr. Branca lost something vital when he gave up electric guitars. With the Symphony No. 1 and the shorter pieces that preceded it, it wasn't just Mr. Wischerth who provided kinetic impetus, but the whole band, blasting in together. Besides, the ever-theatrical Mr. Branca himself looked better as a bohemian Presley than in his present rag-doll conductorial frenzies.

What does it all mean? Neither the advent of the musical millennium nor the effusions of a charlatan. Mr. Branca's Symphony No. 3 will be of interest to those who wish to chart his progress, and it has its powerful and even moving moments, as in the serene ending. But he still seems to be caught in an exploratory limbo between the simpler impact of his old voice and his newer, more complex aspirations.

HANS-JÜRGEN SYBERBERG'S *PARSIFAL*
The New York Times, January 23, 1983

Hans-Jürgen Syberberg's film version of Richard Wagner's music drama, *Parsifal*, should enthrall both film lovers and Wagner fans. Mr. Syberberg's work represents not only the summation of his career thus far, but is as gripping, strange, and, in the end, devotionally faithful a staging as any Wagner opera has received in our time.

The film will be shown in its American premiere in a special screening at Alice Tully Hall tonight under Francis Ford Coppola's aegis, and then opens for at least a five-week run February 11 at the Guild Theater.

Mr. Syberberg is a West German film avant-gardist of aristocratic Prussian ancestry with an idiosyncratic but deeply conservative love for, not to say obsession with, Germany's past. He is best known here for his three-hour *Ludwig: Requiem for a Virgin King* and his eight-hour *Our Hitler: A Film from Germany*. In both one finds a most curious blend of hothouse interior settings, Victorian kitsch, puppets, glowing backlit projections, and disjointed monologues, all of which manage to suggest the essence not just of his ostensible subjects, but of Germany, its myths, and its confusions.

Lurking behind both Ludwig, the Bavarian monarch who was Wag-

ner's patron, and Hitler, who thought of Wagner as his spiritual father, is the brooding, bizarre, compelling master of Bayreuth himself. *Parsifal* was Wagner's last work, a mythic tale of the knights of the Holy Grail and of their salvation by a Christlike "pure fool." It is Wagner's ultimate statement of his operatic theories and his mystical notions of redemption, innocence, race, and dreams. The story provides Mr. Syberberg's characteristic mélange of associative imagery with a coherence it has heretofore lacked, yet in no way robs his visions of their elusive power. *Parsifal* seems a subject for which Mr. Syberberg must have felt himself destined.

The first step in making this film was to record a new version of the score, which is due out shortly on RCA Records. Originally, the plan had been to make use of a taped performance from Bayreuth, but Wolfgang Wagner, who runs the festival, refused in the wake of Mr. Syberberg's documentary about Winifred Wagner, the composer's English-born daughter-in-law, friend of Hitler, and mother of Wolfgang.

The performance recorded for the film enlists the rather unlikely forces of the Monte Carlo Philharmonic Orchestra and the Prague Philharmonic Choir under the baton of the none-too-well-known Armin Jordan. The chorus is not all that wonderful, and some of the special effects (the temple chimes, for instance) are clumsily done. But Mr. Jordan conducts an entirely persuasive account of the score, and the orchestra plays very well for him.

Better still is the singing: This is as strong and evenly cast a *Parsifal* as we have had. Reiner Goldberg, who made his American debut as Guntram at Carnegie Hall last week and who will be the Siegfried in Georg Solti's new Bayreuth *Ring* this summer, makes a vigorous title figure; Yvonne Minton sings as well as she has ever sung as Kundry, and is probably the most convincing singer of the part on records; and Robert Lloyd is a fine, moving Gurnemanz. The other roles are confidently sung, as well. All in all, this is superior to anything the producers could have gotten from the past few years at Bayreuth.

Enter Mr. Syberberg. He sets his *Parsifal* in another of his odd, closed-in, cloistered environments, which gradually reveals itself to be nooks, crannies, and surfaces of a giant reproduction of Wagner's death mask. The "Good Friday Spell" takes place before a giant double cave that turns out to be the composer's nostrils. All the imagery is suffused with overstuffed, late-nineteenth-century plush, with the backdrops— often of earlier stagings of Wagner operas or of related artworks, Bosch

especially—arrayed like illuminated turn-of-the-century painted post-cards.

For his onscreen cast, Mr. Syberberg sometimes uses the actual singers—Mr. Lloyd most prominently, surprisingly young and virile for Gurnemanz, but sensitive and convincing. Most of the time, however, Mr. Syberberg casts actors who lip-synch to the singing extremely well. The oddity is that the conductor, Mr. Jordan, appears as a suitably afflicted Amfortas. And without exposing the film's greatest surprise—if the word "surprise" can be used for such a stately, sensuous film—it can be said that Mr. Syberberg provides a unique and beautiful solution to the androgynous duality of Parsifal's nature.

But the greatest casting coup comes with the use of Edith Clever, well known from other German films, as Kundry. Miss Clever—who is for Mr. Syberberg the film's center, to judge from the book on the film that has already appeared in German and French—is the finest Kundry this longtime Wagnerian has seen. Her scenes with Parsifal are wonderfully subtle and believable, whether as mother, penitent, or seductress.

Just why Mr. Syberberg's scenic innovations don't seem as disturbing as other modern directorial innovations—Patrice Chéreau's Bayreuth *Ring*, for instance—is hard to explain. Partly, it is because of their absolute consistency and eccentric but entrancing character. In part it is because Mr. Syberberg's command of the film medium is so sure that subtleties emerge that could never be perceived in an opera house. Above all, Mr. Syberberg has the secret of providing a plethora of allusions in the best modern manner—the final tableau of the "Good Friday Spell" is positively dizzying in its textual density. But instead of their shocking us away from the romantic spell of the music, they reinforce that spell. It's as if Wagner's hypnotic allure and Brecht's intellectualized alienation have been somehow mystically united.

This film will not be to every taste: it is too ponderous and Germanic and, perhaps, weird for that. But it should have an audience, and deserves to become as potent a cult film as the West German cinema has produced. Wagner created his testament in his opera, and Mr. Syberberg—while too young, one hopes, to have made his own testament—has revitalized Wagner or our time without any serious distortion at all.

PAUL DRESHER

The New York Times, April 7, 1983

Beauty and its little sister, prettiness, were once considered essential to great art: if a painting or a piece of music didn't please on its sensual surface, it was rejected out of hand. But in recent times, beauty has become suspect. In our art today we value sincerity, strength, energy, and formal rigor, and surface charm and grace can seem almost antithetical to these rougher virtues.

Such thoughts came to mind Tuesday night at the Dance Theater Workshop, where the Californian Paul Dresher presented an evening of his music. Mr. Dresher shares with many other San Francisco–area composers a penchant for music that sets out to seduce the ear in an almost sinfully sweet way. As such, it seems a direct reaction against the grimness of modernism.

The four pieces offered by Mr. Dresher Tuesday consisted of two for electric guitar (played by the composer) and tape processing—a system of tape delays controlled by foot pedals—plus another for synthesizer (again by Mr. Dresher) and similar processing, and a fourth for two pianos. The admirable performers for the piano piece were Nurit Tilles and Edmund Nieman.

Mr. Dresher's music is in part a simplified extension of the repetitive structuralism pioneered by Terry Riley, Steve Reich, and Philip Glass. A typical Dresher piece sets up an innocently consonant repeating pattern and then lets it evolve. Characteristically, the evolution leads to oceanic sounds created by tape looping and its overlapping of textures. More unusually, as in the two-piano piece, it comes from increasingly rapid arpeggiated figures in the right hand.

Once a texture has been established, Mr. Dresher punctuates it with portentous new bass figurations, or overlays it with a lush tune, or—less effectively in the final piece—breaks it up with a subtractive process using his electronics (the frenetic clicking of the foot pedals here was especially jarring). The overall result is a music that in many ways seems closer to the rock reductions of the minimalist-structuralist style than a "serious" evolution of that style.

And yet, one must not be too ready to dismiss. There is indeed a tendency on the San Francisco scene toward sincere simplemindedness; to this taste, Mr. Dresher's second evening-long music-theater piece with

the performance artist George Coates, *are are*, which will be presented in Europe this summer and staged with its predecessor next fall at the Brooklyn Academy of Music, falls into this simplistic category.

But over the course of his whole program Tuesday, Mr. Dresher made some genuinely gorgeous sounds—so gorgeous that they almost swept aside any curmudgeonly prejudices. Perhaps he will grow as a composer, deepening and toughening his style. Or perhaps we in the East will relax our protestations against the pretty. Because for better or for worse, this music is most assuredly pretty in a way that most new music very rarely allows itself to be.

ORQUESTA ARAGÓN

The New York Times, July 17, 1983

The first of two shows Friday night at the Beacon Theater by the Orquesta Aragón was, at its core, a musical event—a performance by one of Cuba's grandest, longest established bands, with two promising supporting acts. They sang, they played, they (and the audience) danced—a quintessential Latin concert, one might think, if a rather more distinguished one than most.

But this was an event fraught with politics. As one entered, a crowd of anti-Castro demonstrators, hemmed in by barricades and a considerable number of police, yelled at concertgoers and waved denunciatory signs. Inside the hall, security was tight, down to the frisking of every patron and the searching of all bags and umbrellas. In the lobby people were selling not just Orquesta Aragón records, but Cuban revolutionary booklets. And the music was framed and punctuated by fervent speechifying in both Spanish and English, hailing what the Castro government marks as the thirtieth anniversary of the beginning of its revolution, on July 26.

The odd thing about this rhetoric, however sincerely intended, was that it had absolutely no connection with the music on stage, which seemed entirely devoted to traditions that long antedated the Communists and which evoked little more than an innocently apolitical response from the crowd.

The Orquesta Aragón is a *charanga*, meaning a flute-and-violin-fla-vored variant of the typical Latin band. The group dates back to 1939, and began recording (for RCA) in 1953. By the time the revolution had succeeded in 1959, it was an established Cuban musical institution, and it remains one to this day.

The group came to the United States in 1978, but this writer first encountered it at a Havana concert in 1979 as part of a Cuban and American music festival there. Since then, however—just last year—the longtime leader, Rafael Lay, died in an automobile accident. His place has been taken by the flutist Richard Egues, and it is a pleasure to report that the Orquesta Aragón carries on—with a number of talented younger players attesting to its ability to renew itself.

Friday night the group consisted of twelve players—a front line of two singers (who doubled on percussion), a violinist (who also sang), and Mr. Egues, plus two more violinists (who joined in on the vocal choruses), an electric organist, an electric bassist, a cellist (who also danced up a storm, as did the lead singer), and three percussionists.

The music that resulted from all this had the expected Cuban rhyth-mic liveliness and subtlety—Cuba had and has what is probably the richest, most purely African rhythmic tradition of any Caribbean coun-try—as well as a beguiling sweetness from the flute and strings.

But this music is not all bland sweetness, by any means. What makes the Orquesta Aragón so fine is the sophistication of its arrangements. A familiar song like "Guantanamera," for instance, was subjected to all manner of chromatic twists and instrumental niceties, yet such clever-ness never got in the way of the original's fervent intensity.

Not that the show was perfect. There was a raucous sound system, an all-purpose pop-folk singer named Caridad Cuervo, who was a little nightclubbish for this taste, and a veteran percussion quartet from San-tiago de Cuba called Los Bravos.

Los Bravos made a stirring entrance from the side of the hall, thump-ing its way down the aisles, and led the exit offstage after the grand finale with Miss Cuervo and the Orquesta's percussionists. But neither they nor Miss Cuervo, for that matter, were allotted enough time to make much of an impression, and Los Bravos seemed too willing to settle for flashy stunts instead of extending itself into more interesting rhythmic explorations.

No matter though: the Orquesta Aragón is still a treat, and it would be nice to hear it some day freed not just from show business pressures but from political pressures, as well.

PETER MAXWELL DAVIES'S
THE LIGHTHOUSE

The New York Times, **November 6, 1983**

Boston — The English composer Peter Maxwell Davies has only written three operas, but they have been much admired. And this season, Boston will see two of them. In May, Sarah Caldwell will stage *Taverner*. She will have to go a long way to surpass the impact of the Boston Shakespeare Company's production of *The Lighthouse*, which received its American premiere with a beaming Mr. Davies in attendance on Wednesday, and which will run in repertory until December 4.

The company has been taken over this year by Peter Sellars, the young director responsible for such innovative, controversial recent stagings as Handel's *Orlando* at the American Repertory Theater in Cambridge, Massachusetts, the original version of Broadway's *My One and Only* (before he was replaced), and *The Mikado* in Chicago. *The Lighthouse* is Mr. Sellars's first opera with his new company and his second production, following Shakespeare's *Pericles*.

Although Mr. Sellars's *Orlando* seemed cute and cheap, his staging of *The Lighthouse* is brilliant—faithful to the spirit and, where it counts, the letter of Mr. Davies's libretto and music, superbly realized musically, and thrilling as theater. Perhaps the moral is that Mr. Sellars should concentrate on creation or co-creation, which he is clearly good at, and stay clear of re-creation, which so often puts him at odds with the original creators.

The Lighthouse, first performed in 1980, is a chamber opera, but it builds to a shattering conclusion worthy of opera at its grandest. The story is based on a true incident in which three lighthouse inspectors reported in 1900 the discovery of an abandoned lighthouse off the coast of Scotland, its furnishings in good order but with no sign of the three lighthouse keepers. The mystery of the keepers' disappearance was never solved.

From this, Mr. Davies, who himself lives in the Orkney Islands off northern Scotland, has fashioned a fascinating libretto, positing an explanation of the mystery.

The opera begins with the three singers portraying the team reporting the mystery. Then (after what was originally an intermission but is so no longer, at the composer's request) comes a depiction of the three

keepers and their demise, followed at the end by a brief return of the inspectors and a fleeting vignette of the replacement keepers. The entire cast consists of only three singers, and the opera lasts only seventy minutes.

What happened, Mr. Davies tells us, is that the keepers went mad, transfixed by a vision of a "beast" that had to be extirpated. The shining eyes of the beast are in fact the lights of the inspectors' ship, and the inspectors are forced to kill the crazed keepers and then cover up their deed. The replacement keepers, in turn, begin the cycle of madness all over again.

Mr. Davies's musical idiom is dramatically responsive and harmonically tart, with a pervasive, mild dissonance, interspersed with songs and effects culled from disparate earlier styles, including Victorian ballads and hymns. The three singers—tenor, baritone, and bass—are accompanied by a twelve-member chamber ensemble that manages to work up a fierce impact by the end. The three fine singer-actors in the Boston production are Michael Brown, Sanford Sylvan, and Kenneth Bell, and the conductor is David Hoose.

Mr. Sellars's production—with video segments by Michael Nishball, costumes by Ellen McCartney, and lighting by James F. Ingalls—places the instrumentalists on the stage, with the court of inquiry played in and on three formal chairs (set, eccentrically, in pools of water) between orchestra and audience and the lighthouse scenes on a scaffolding at the center rear of the performing area. There are also three television monitors and light towers for the flashing, piercing eyes of the beast.

From the outset, Mr. Sellars establishes a mood of horror and bizarreness that presages the gruesome climax. The climax itself is wonderfully handled, with an evocation of monstrosity out of the simplest means, unprecedented in this writer's experience since the Living Theater's version of *Frankenstein*.

One hopes Mr. Sellars can bring this production to New York. Until then, those interested in contemporary music theater or theater in general are advised to make the trip to Boston between now and December 4.

SERGIU CELIBIDACHE

The New York Times, **February 28, 1984**

It is not often that a seventy-two-year-old unknown makes his American debut leading a student orchestra at Carnegie Hall and attracts what looked like most of musical New York. Sergiu Celibidache did just that last night, conducting the Symphony Orchestra of the Curtis Institute of Music in a semi-pops program. The result was about as revelatory an experience, both thrilling and thought-provoking, as this writer has encountered in twenty-five years of regular concertgoing.

Mr. Celibidache is, of course, not *quite* unknown. Romanian born and German trained, he was chosen as a young man to lead the Berlin Philharmonic in the interregnum between 1945 and 1948, when Wilhelm Furtwängler was de-Nazified. Since then he has conducted here and there, but his increasingly imperious rehearsal demands, combined with his distaste for recordings, have turned him into a reclusive legend, especially on this continent.

Thus when the Curtis Institute convinced him to come to Philadelphia for an extended period of rehearsal and to make his debut here, at a "gala 60th anniversary benefit concert" for the institute, it was an event in advance. But what *kind* of event? Last night, we found out.

First of all, Mr. Celibidache really makes use of all that rehearsal. He stands on the podium, stolid and blunt, conducting from memory and chopping out the beat with both arms. But for vivid, almost shocking detail, this concert was unprecedented in my experience. Especially in overtly coloristic works like Debussy's *Iberia* and Prokofiev's *Scythian Suite*, which ended the evening (its second movement was encored), the sheer intensity of aural color was dazzling.

And this was a student orchestra; here and there its inexperience peeped out, as in some sour wind intonation in Wagner's *Tristan und Isolde* "Love Death," but only against the crystalline backdrop of its playing the rest of the time. It is a cliché to report that musicians in any great orchestral concert played like soloists united in spirit, but it really did sound that way last night.

Detail was only the beginning. Mr. Celibidache opened with Rossini's *Gazza ladra* Overture, and immediately pronounced the strength of his musical personality. Tempos were not unusual, a little on the slow side, perhaps, but the dynamic range was astonishing. Most of

the time, the music sounded preternaturally quiet, down to the tiny ping of the triangle. But the crescendos built inexorably, and the whole performance was suffused with a striking sense of legato, whole pages rising and falling like waves. Idiosyncratic, perhaps, but this was riveting music making, and superbly individual.

At times, one wondered if all Mr. Celibidache's concentration on fine points—the consistent subtlety of the voicings, the elegance of even the smallest inner minutiae of phrasing—might vitiate old-fashioned animal energy. Yet the climaxes rang out as excitingly as one might wish, and the concluding Prokofiev positively roared with barbaric splendor. Even here, however, the playing was never needlessly, sloppily vulgar; there was always that wonderfully scrupulous coloration suffusing and shaping the loudest passages.

If, so far, Mr. Celibidache sounds like a songful sensualist, he revealed a different facet in the *Tristan* music. Here all the coloristic exactitude remained—never has the altered emotional world between the prelude and the onset of the "Love Death" sounded so dramatically telling. And yet the arching long line of the music, the fluctuating melodic impulse that lies at the heart of Wagner, propelled the performance forward.

That, then, was the thrilling part. The thought-provoking aspect has to do with the nature of Mr. Celibidache's career, past and future. His kind of loving, fanatical care represents the next logical step beyond such orchestral virtuosos as Mahler, Klemperer, and Toscanini. But Mr. Celibidache has pushed their perfectionism into the realm of the impractical; the famous conductors of today, those he says he discounts, are willing to make sacrifices for practicality. Of course, their performances nearly always *sound* as if they made those sacrifices. But the kind of close approach to the ideal that Mr. Celibidache strives for simply will not fit into the businesslike routine of today's musical world.

Or will it? The audience was full of America's musical movers and shakers, and if they chose to do some shaking for Mr. Celibidache, perhaps he could appear here with a professional orchestra—his own Munich Philharmonic or an American ensemble under special circumstances. It all depends, not on musical idealism, but on Mr. Celibidache's market and prestige value as an aging celebrity cult object. But let's not get as picky about motivations as he is about music. It would be tragic if last night's American debut were also his American farewell.

TWO OPERAS BY PHILIP GLASS

The New York Times, **March 26, 1984**

Stuttgart—The very notion of a critically applauded, popularly success-ful composer of new operas might seem to exist only in the nostalgic past. But Philip Glass is enjoying a career right now that seems unparal-leled since the glory days of Puccini, seventy-five years ago. This past weekend saw not one but two premieres of full-length Glass operas com-missioned and performed by major European opera houses, both created in conjunction with visionary director-designers. And both are meant to appear in the United States and New York later this year.

Mr. Glass's two collaborators are Robert Wilson, whose work—how-ever infrequently he is allowed to present his full-scale creations in the United States—is fairly well known. That of Achim Freyer is less so out-side of Germany. But Mr. Freyer is as extraordinarily gifted as Mr. Wil-son—the most original, exciting German opera director-designer since the death of Wieland Wagner nearly twenty years ago.

The first of the operas to be performed was supposed to be the fifth act, with prologue, of Mr. Wilson's massive, multisectioned *Civil Wars: A Tree Is Best Measured When It Is Down*, at the Teatro dell'Opera in Rome. Of the twelve hours in six self-contained sections being created in different theaters around the world, only this fifth act is fully operatic, with two hours of music by Mr. Glass.

The Rome *Civil Wars* fell victim to a dizzying onslaught of Italian comic-opera confusions. The labor unions at Italian opera houses like to stage their slowdowns and work stoppages before premieres, to gain leverage on management. In Rome, there are apparent political and personal problems within the theater, as well, and the result was a drum-fire of disruptions the entire week before the scheduled premiere—orig-inally set for last Thursday, then Friday. In the end, the Friday performance was a dress rehearsal with some invited observers, with occasional halts and incomplete lighting. The formal premiere was scheduled for this evening, but there was a good chance this morning that an electricians' strike would postpone the actual premiere until Tuesday.

The world premiere of Mr. Glass's *Akhnaten* Saturday night at the Württemberg State Theater was relatively trouble free. The perform-ance took place on schedule, with seemingly dazzling efficiency. But

even here, there had been rumors that the premiere might have to be postponed because of technical difficulties.

The Rome *Civil Wars* was incomplete mostly from Mr. Wilson's point of view. His stage pictures depend more on the precision and subtlety of the lighting than on any other factor, and the lighting was incomplete or incompletely realized on Friday. There were still some riveting images, including a final slow procession of trees from every part of the world, gorgeously painted on two proscenium-sized rolls of transparent fabric that slid smoothly across the stage at the front and rear. These images will be more riveting still when the lighting is right, but this fifth act clearly brings to a stirring conclusion Mr. Wilson's grand fresco of world myth and human fratricide.

Just how effective the Italian portion will be must await not only the formal premiere in Rome, but the full combination of the various elements that make up *The Civil Wars*. Right now, the likelihood of even the truncated, eight-hour, two-thirds-length version planned for Los Angeles in June in conjunction with the Summer Olympic Games looks dubious. That city and its Olympics Committee seem unable or unwilling to raise the necessary funds, and Mr. Wilson quite rightly resists the idea of a further abridgement of his vision. The Metropolitan Opera House may see the portions composed by Mr. Glass (Rome and Cologne) and David Byrne (Minneapolis) in July, however. And there is talk now of Cologne or some other German city assembling the entire twelve-hour package.

For his part, Mr. Glass called his music "reviewable" on Friday. His score consists of orchestral, solo, and choral parts reminiscent of his previous opera, *Satyagraha*—a prevailing consonance, with slow and fast arpeggiated figures for the strings and simple sustained chords and punctuation from the brasses and winds. The effect is consoling and occasionally arresting. But too often it sounds like a recycling of ideas Mr. Glass has used before. Having reached the level of success where he is constantly asked for new music, he allows himself to fall back on formula. His formulas are very pretty, but it is only when he exerts himself that he really makes memorable music.

In *Akhnaten*, he has very audibly exerted himself. Occasionally, especially in loud, blustering passages, the old Glass tricks reassert themselves. But most of this score is simply wondrous in its refinement and imagination. The arpeggios are usually not simple triads, but strange, spiky chords that sound extremely difficult to play in the rapid, purling patterns Mr. Glass demands.

The prevailing orchestral color is dark; there are no violins. But the writing for winds and quiet brass is of a special pungency. And there are unusual percussion interludes and effects, including one driving section for tom-toms. The orchestra has had to be reduced to fit into the Stuttgart theater's small pit—the city's main opera house is being remodeled—but the players handled their parts competently under Dennis Russell Davies's sure hand.

Akhnaten has a libretto by the composer in collaboration with Shalom Goldman (who supplied the various ancient texts), Robert Israel and Richard Riddel (who will design and light the American production scheduled for Houston in October and the New York City Opera in November), and Jerome Robbins. The opera consists of a series of meditations, linked by a narrator who speaks in the language of the audience, on the pharaoh who is sometimes called the first monotheist.

The work is framed by death: the burial of Akhnaten's father and his passage to the underworld at the beginning, the spirits of Akhnaten and his family haunting the present-day ruins of his city at the end. In between comes the story of his childhood coronation, upbringing, marriage to Nefertiti, family life, and downfall at the hands of a military cabal led by his mother. Of his possible sexual liaison with his mother, there is nothing; instead, emphasis is placed on his human and saintly qualities in the iconic sense of the treatment of Gandhi in *Satyagraha*.

Although the librettists are credited in the back of the Stuttgart program book, the actual cast list omits all mention of their names, in favor of "scenario by Achim and Illona Freyer," Mrs. Freyer having codesigned the sets and costumes. However rude and unethical this credit omission may be, it does reflect Mr. Freyer's dominant role in the Stuttgart production. The American may well be very fine. But Mr. Freyer's version makes a breathtaking statement on its own terms.

One could complain that he seemed to run out of ideas toward the end—and, perhaps, that Mr. Glass's music sounded a little more ordinary in the final scenes, as well. But most of the time, Mr. Freyer's stage pictures were simply on another level of achievement from the conventional operatic experience, in Europe or America. Mr. Freyer began as a painter—an exhibition of his paintings hangs in the Stuttgart lobby—but his true medium is light and space. However much he may have been influenced by Brecht, puppet plays, circuses, video, and electronic wizardry, his painterly stage pictures work most profoundly in the service of imagistic magic. His radicalism captivates many, but would surely

appall and offend most American operagoers—indeed, it offended some in Stuttgart on Saturday. But it is theater of genius.

The singing on both nights was excellent, but the Stuttgart cast, given more rewarding material to work with, shone brighter. In Rome, Seta Del Grande and Ruby Hinds handsomely assumed the parts meant for Hildegard Behrens and Jessye Norman in the completed version, with stalwart additional contributions from Luigi Pieroni, Franco Sioli, and Luigi Roni. Marcello Panni conducted, and Jim Self provided the dull, awkwardly executed choreography.

The Stuttgart cast was headed by the superb English countertenor Paul Esswood in the title part—Mr. Glass's intertwining countertenor and soprano vocal lines were especially lovely—plus Milagro Vargas, Maria Husmann, Wolfgang Probst, Hildegard Wensch as the narrator, and Ralf Harster as an unusually expressive dancer.

OTTO KLEMPERER

The New York Times, April 24, 1984

Note: Peter Heyworth was a gentleman and a fine critic, and he wrote a wonderful biography here (part 2 is very good, as well). I was especially proud because his excellent chapter on the Kroll Opera drew heavily on my unpublished doctoral dissertation (since compacted by me and included in a collection called Late Thoughts, *edited by Karen Painter and Thomas Crow and published in 2006 by the Getty Research Institute). Which probably should have rendered me unsuitable to write this review, but so be it.*

Otto Klemperer: His Life and Times; Volume 1, 1885–1933. By Peter Heyworth. Illustrated. 492 pages. Cambridge University Press. $34.50.

Peter Heyworth, the music critic of *The Observer* of London, has given us a richly detailed, historically acute, aesthetically insightful biography of the conductor Otto Klemperer. It is so rich, in fact, that at nearly five hundred pages, Mr. Heyworth has only got through half the story; the second part will not be coming for many years.

Such sober attention is normally lavished on composers, not mere re-creators. But Mr. Heyworth justifies every page. He certifies Klemperer's own importance as the quintessential practitioner of "objective," postro-mantic conducting, and he provides a lucid history of music and musi-cal politics in this century.

One might fear that the really lively material would await the second volume. It was only after 1933, when Klemperer had fled Nazi Germany, that the drama of his life insofar as most of his latter-day admirers know it really began. It was then that he became conductor of the Los Ange-les Philharmonic, in the heart of the Southern California German cul-tural community in exile; that he had surgery for a brain tumor and was forced to prove his sanity by fleeing a mental institution and promoting his own concerts; that he slipped further and further into obscurity, con-ducting in East Berlin and Budapest; and that, finally, he was welcomed into the pantheon of the master conductors by the British musical com-munity in the 1950s and 1960s. Klemperer died in 1972.

Mr. Heyworth's young Klemperer seems a far cry from the stern, grim, rock-silent guardian of German musical tradition that he later became. Klemperer was a disciple of Mahler, a champion of the avant-garde, a leftist, and a sometimes manic philanderer. Mr. Heyworth details, in all its melodramatic complexity, one comic-opera, nearly tragic affair with the recently married soprano Elisabeth Schumann in 1912.

But Klemperer was no dashing, happily amoral Don Giovanni. He was a brooding, tortured, painfully earnest young German Jewish provincial struggling to make his way in the Central European cultural and political world. His romantic and sexual outbursts, which occurred simultaneously with his intermittent spasms of composing, are explained by Mr. Heyworth as the products of an increasingly severe manic-depressive syndrome that plagued him all his life.

The explanation is a convincing one, although it sometimes too patly excuses the conductor's moral lapses. Having swept Elisabeth Schu-mann away from her husband, for instance, he quickly cooled toward her. And in 1933, in a pitiful effort to retain his already compromised position in Germany, he wrote prose poems in praise of the New Order and even suggested the formation of a Jewish Palatine guard to protect Hitler.

What makes Mr. Heyworth's treatment of these failings so admirable is his scrupulous fairness, as well as the firmness with which he places

Klemperer within the larger cultural and social context of the late nineteenth and twentieth centuries. Mr. Heyworth is brilliant in sketching the complex world of pre-Weimar Germany: the clashes between musical progressives like Mahler and conservatives like Hans Pfitzner, the ethnic confrontations between French and Czechoslovak majorities and the ruling German minorities in Strasbourg and Prague, and the texture and substance of small-town German operatic life.

This book is fine, too, in tracing strictly musical questions: the growing isolation of composers in our century, the evolution of conducting style from romanticism to a less sentimental sternness, and the particulars of specific Klemperer interpretations over the years. Mr. Heyworth seems to have read every review and memoir, explored every archive, talked to every survivor with even a wisp of memory of the way things were fifty and more years ago.

His study is at its very best, however, in the description of the Kroll Opera in Berlin, which Klemperer helped found and which he led over its entire existence, from 1927 to 1931. Mr. Heyworth offers the most comprehensive account yet of this seminal opera company, which served as the primary inspiration for Walter Felsenstein, Wieland Wagner, and nearly all modernist operatic innovation in the half century since. And what makes the Heyworth portrayal so valuable is his refusal to whitewash or sentimentalize the Kroll's many artistic failures and conceptual confusions.

The Kroll was the keystone in Socialist attempts to reform German operatic life. House policy was a forced marriage of the avant-garde in composition and production with the working class. Klemperer and Alexander von Zemlinsky and Fritz Zweig conducted; there were premieres by Stravinsky, Schoenberg, Hindemith, and Janáček; the designers included Oskar Schlemmer and László Moholy-Nagy; and the subscription audience was drawn from the Socialist-linked Volksbühne organization.

Unfortunately and almost inevitably, while the Kroll became the darling of leftist intellectuals, it had no success at all convincing workers that what they really wanted was not *La Bohème* with stars but twelvetone music and Cubist *Fidelios*. At the end, the company had lost nearly all the political allies who might have been able to save it.

This book could have been better copyedited and proofread; there are insignificant errors and inelegancies here and there. But the overall prose style is as deft and direct as the scholarship is reliable and imaginative. On to volume 2—but even if for some reason it never gets writ-

ten, this volume alone will stand as one of the most informative, readable musical biographies ever written.

A MINIMALIST EXPANDS HIS SCALE

The New York Times, **April 7, 1985**

Note: I didn't know Feldman well, but I admired him as a man and an artist, and I proved my admiration by staging a minifestival of his music at the first Lincoln Center Festival in 1996. The paragraph beginning "My whole generation was hung up" is probably the most widely disseminated quotation from my writing, simply because the music publisher Boosey and Hawkes chose to put it in their Feldman catalog.

America is famous for ignoring its own. In particular, American composers have often found little resonance at home but resounding applause abroad. One might think, though, that in our enlightened time such reverse chauvinism would be a thing of the past. No such luck, as Morton Feldman can testify.

Mr. Feldman is, by all reasonable criteria, one of the finest of present-day American composers, with the New York premiere of a fascinating new work set for next Sunday evening at the Alternative Museum. Yet as an old-fashioned post-Cageian avant-gardist, he finds himself ignored and isolated at home—not a member of the still institutionally dominant northeastern academic-modernist school, nor of the trendier California group or the young "downtown" experimentalists, nor one of those trance minimalists who have won a new audience from the world of progressive pop.

Born in Brooklyn in 1926, he came of age in Manhattan but lives and teaches in Buffalo, which in itself is a fair symbol of isolation. He makes music that in its quiet simplicity is truly minimalist—though with characteristic obstinacy, he renounces the term. And now, with seeming perverseness, he has taken to composing pieces that are not only pure and abstract, but go on for hours on end, uninterrupted, and thus are simply impossible to perform at normal concerts under normal circumstances.

The most extreme example of this new trend toward minimal gigan-

tism is his most recent string quartet, mostly murmuring and meditative, which lasts six hours without a break.

It was first performed in shortened form last year in Toronto by the indefatigable Kronos Quartet, having been commissioned by the Canadian Broadcasting Corporation. It was repeated at this past summer's Darmstadt new-music festival in Germany, where Mr. Feldman reports it received a twenty-five-minute ovation.

Three Voices, which the singer-composer Joan La Barbara will perform next Sunday, was composed in 1982; this writer heard it with her at the California Institute of the Arts new-music festival two years ago. It is not quite so long as the quartet—a mere ninety minutes. But it's just as challenging, and just as rewarding for those with the slightest taste for crystalline musical intelligence at play. Described cursorily, it might seem dull and schematic. A setting of only a few brief lines from a Frank O'Hara poem written for Mr. Feldman—the most prominent is "Who'd have thought that snow falls"—the work consists of a trio between Miss La Barbara's simple, folkish soprano and two vocal lines she prerecorded.

The first half hour is wordless, then the text begin to emerge out of the flux, like the outlines of something perceived through swirling snow. Musically, the piece is a series of shifting chords, ever-changing like snow crystals. And it's not mere sensuous sound, either: there are three self-devised "systems" of chord structures at work in the course of the piece, and at its harmonically densest, the juxtapositions of the three lines become highly chromatic.

As usual with Mr. Feldman's music, *Three Voices* can be appreciated on several levels. There is the sheer beauty of the sounds, and their magically evolving tone colors. There is the relationship between the music and the poetic text. And there is an added, theatrical dimension, associations Mr. Feldman brought to the score's conception and to the performance layout he has envisaged.

"One of my closest friends, the painter Philip Guston, had just died; Frank O'Hara had died several years before," Mr. Feldman recalled the other day in his music-department office at the State University of New York at Buffalo. "I saw the piece with Joan in the front and these two loudspeakers behind her. There's something kind of tombstoney about the look of loudspeakers. I thought of the piece as an exchange of the live voice with the dead ones—a mixture of the living and the dead."

The term "minimalism" in music—today associated with the nerv-

ously motoric music of Steve Reich and Philip Glass—derived from the structurally precise, limpidly clear minimalist painters of the 1960s. Mr. Feldman's artistic coming of age was in the 1950s, and central to his circle of friends were the abstract expressionists of the New York School of that time.

To this day, Mr. Feldman's ebullient, playfully provocative personality, with his obvious lust for life, seems more akin to the bohemians of the '50s than to the cooler minimalists of the late '60s and '70s—or to his music, for that matter. Yet Mr. Feldman sees no contradiction between his passionate pursuit of artistic purity and a passionate lifestyle. And his true mentor, closer to him even than his poet and painter friends, was that avatar of coolness, John Cage.

As with most of the composers Mr. Cage has influenced, Mr. Feldman does not write music that sounds like Mr. Cage. The influence was more philosophical and, in Mr. Feldman's case, personal.

"The main influence from Cage was a green light," says Mr. Feldman, who had studied earlier with Wallingford Riegger and that mentor to a generation of American serialists, Stefan Wolpe. "It was *permission*, the freedom to do what I wanted."

Throughout the '50s, Mr. Feldman was part of the closest Cage circle, which also included Earle Brown, Christian Wolff, and David Tudor. But Mr. Cage also played a key role in triggering Mr. Feldman's development in the early '70s into the macro- pieces he now composes.

"He was actually upset with a work I had written; it wasn't all that long, but he didn't like my direction at all," Mr. Feldman remembers. "He came up to me after the performance in Berlin and said, 'Morty, you are a poetic extremist.' I *liked* the idea of extremism in poetry. He *defined* me."

As a seeming rebellion against the pitch consciousness of the serialists, Mr. Feldman has always insisted on an instinctual basis in his selection of pitches; for him, in his composition and his teaching, the greater interest lies in the other parameters of music—rhythm, shape, dynamics, timbre, and mood.

Up to the early '70s, he had first composed works that used graphic notation, then had experimented with other ways of loosening the composer's direct control over the outcome of the piece. His decision to push ahead to epic works and the full realization of his inner instincts, abandoning any hope of ready acceptance on the concert stage, involved a reassertion of compositional control.

"My whole generation was hung up on the twenty-to-twenty-five-minute piece," he says. "It was our clock. We all got to know it, and how to handle it. As soon as you leave the twenty- to twenty-five-minute piece behind, in a one-movement work, different problems arise. Up to one hour, you think about form, but after an hour and a half, it's scale. Form is easy—just the division of things into parts. But scale is another matter. You have to have control of the piece—it requires a heightened kind of concentration. Before, my pieces were like objects; now, they're like evolving things."

As his poetic ideas about *Three Voices* suggest, Mr. Feldman thinks of his longer pieces in theatrical terms, and seems eager to involve himself once more with overt musical theater. He tried once, with a seventy-minute opera called *Neither*, to a text written for him by Samuel Beckett, commissioned and performed by the Rome Opera in 1977.

"I think about theater all the time," he concedes. "I think my music hugs the stage very well. In the theater, time becomes dramatized for everybody. Everything that's done is interpreted as part of the theatrical experience. Everything becomes heightened."

All this might seem very much in tune with the times, given the larger-than-life stage creations of Robert Wilson and the mega-filmmakers of Germany, with their fifteen-hour marathons. In the meantime, however, Mr. Feldman—like Mr. Wilson—remains largely ignored at home. A classic avant-gardist of yore, he puts his faith in audiences that haven't yet manifested themselves. And like the experimentalists of the '50s, '60s, and '70s, he still counts on the art world to provide him a patronage that conventional musical institutions withhold. Later this month, for instance, he is giving a private concert in a painter friend's lower Manhattan studio.

"There used to be an audience once, without any media hype," he recalls wistfully. "I was walking along Eighth Street in the late '60s, and one of those flower girls came over and said, 'You are our Schubert.'

"There was something going on then, but that sense of time and place is lost now. My own students think I'm a cross between Wittgenstein and Zero Mostel—they can't handle it. But there's a whole new intellectual audience in New York now that just doesn't go to concerts.

"Europeans like the *spacey* quality they hear in my music; they find it very American, like Ives and Copland. That new audience in New York is full of Europeans—Italians and Germans. Maybe they will change things."

HANS WERNER HENZE'S *THE ENGLISH CAT*

The New York Times, July 29, 1985

Santa Fe—The German composer Hans Werner Henze has devoted much of his life to opera, but it's doubtful he's created a more charming work, or that any opera has received a more charming production, than *The English Cat* seen here in Santa Fe.

First performed by the Stuttgart Opera in 1983 and then last year by the Paris Opéra Comique, the score is receiving its first American performances—and its first performances anywhere in the language, English, in which the libretto was written—by the Santa Fe Opera this season. Charles Ludlam's absolutely delightful staging, seen Friday night, is scheduled for three more performances, Saturday and August 6 and 16. Anyone within hailing distance of the Southwest should make the effort to see it.

The superb libretto by Mr. Henze's now three-time collaborator, the English playwright Edward Bond, is based on Balzac and might best be described as a thinking man's *Cats*. Cats (and dogs and birds and a fox and a mouse) dressed in Victorian finery act out a sweet little morality play about man's hypocrisy and pretensions. With its worldly cynicism and its English setting, not to speak of its crisply neoclassical score—*The English Cat* strongly recalls *The Rake's Progress*. And with its striking animal makeup, there are also hints of *Renard*, *The Cunning Little Vixen*, and *The Planet of the Apes*. But *The English Cat* has more than enough character to stand proudly on its own.

As with any successful operatic performance, this one owed its appeal to three factors: the score itself, its staging, and its musical realization. On all three counts, *The English Cat* scored very high indeed.

Mr. Henze has long been recognized as perhaps the most brilliant craftsman among contemporary composers: No one knows better how to shape a score or achieve an orchestral effect. But his sometimes portentous politicizing and an aura of cold calculation have undercut much of his work. Recently, however, with scores like *Tristan* for piano and orchestra and this *English Cat*, he suggests that he may be maturing into greatness.

The English Cat has a whiff of chilly disdain. But there is so much real lyricism, precisely pointed color, and even innocence about it that one hardly minds. Mr. Henze's music manages to sound accessible and

buoyant even when, at times, there is considerable dissonance. (There is also considerable outright consonance.) This may not be a "progressive" score in the modernist sense; Mr. Henze has clearly set about to appeal to a present-day audience. But he has not altered his basic harmonic idiom, and the score is so cleverly done that it can hardly be called retrogressive. In fact, he manages to convey his political messages far more subtly and effectively with means like these than with some of his more strident proclamations.

Mr. Henze came to Santa Fe to oversee this production and even wrote a new orchestral interlude to cover a scene change. But one suspects he found little to worry about, given the quality of the forces the Santa Fe Opera had assembled.

Mr. Ludlam, founder of New York's Ridiculous Theatrical Company, has a triumph in his first opera staging, happily abetted by Steven Rubin's magical sets, costumes, and makeup. The invention and wit are nonstop, yet Mr. Ludlam never tilts over into campy excess. For those of us who found the Frank Corsaro–Maurice Sendak *Cunning Little Vixen* at the New York City Opera disappointingly flat, this is a vision of animals as people that couldn't be more winning.

The musical performance is conducted with the utmost technical finish and rhythmic élan by George Manahan, and the cast is strong throughout. Chief among the singer-actors is Inga Nielsen, a Danish soprano who also sang the leading part of Minette in the Stuttgart and Paris productions. Miss Nielsen handles the English idiomatically, looks fetching, and has one of those pure, sweetly covered Benita Valente–style voices.

Other leading singers include the baritone Scott Reeve as Tom, Minette's ill-fated true love; Michael Myers, a tenor, as her aging husband; the bass Kurt Link as the villainous nephew Arnold; the soubrette Kathryn Gamberoni as a sweet mouse who rises up righteously at the end and James Ramlet, a very funny comic bass who plays two roles with equal panache.

JOHN ADAMS'S *HARMONIELEHRE*

The New York Times, **August 7, 1985**

Lenox, Mass.—As in the Brecht-Weill parable, when "God Came to Mahagonny," minimalism came to Tanglewood tonight, incarnated as John Adams's *Harmonielehre* (1985). The score received a standing, cheering ovation from a big audience in the Theater–Concert Hall.

The Tanglewood Festival of Contemporary Music has been close to paranoid about minimalism. Gunther Schuller, who led the festival through last summer, seemed to regard an avoidance of this music as central to his grim effort to preserve "standards." Never mind that many other kinds of new music were also slighted; it was to the dreaded minimalists that talk continually returned.

Mr. Adams comes from Massachusetts and was a student at Harvard of Leon Kirchner, who is running this summer's festival. But he rose to prominence as a San Franciscan, and it was a Bay Area conductor, Kent Nagano, who seems to have brought him into the Tanglewood fold and who led the absolutely first-class performance of his score tonight.

Mr. Adams began his mature compositional career (he is now thirty-eight) as an overt disciple of Steve Reich, and the shimmering textures and plinking pulse of Mr. Reich's music could be clearly heard tonight, framing the piece. But from the first, Mr. Adams was determined to find ways not just to expand minimalism, but to forge links between with older forms of musical expressiveness.

Harmonielehre, which is either devoutly or puckishly named after Arnold Schoenberg's book, lasts forty minutes. The first, unsubtitled movement moves from a Reichian beginning into broader, more sweeping tunes reminiscent of both Sibelius and Tchaikovsky. The second movement, "The Anfortas Wound" (Mr. Adams says his spelling is closer to the mythic originals than Wagner's) is an austere meditation on his own creative crisis in composing this score. The last movement, "Meister Eckhardt and Quackie," depicts celestial play somewhere between Holst's *Planets* and the angelic song of Mahler's Fourth Symphony, Quackie being Mr. Adams's fourteen-month-old daughter: "Quackie, who is still too young to walk, rides upon Meister Eckhardt's shoulders as they glide among the heavenly bodies," writes Mr. Adams. "Quackie whispers the secret of grace in Meister Eckhardt's ear."

Mr. Adams's efforts to escape Minimalist mannerism have mostly

involved lush late-romantic gestures. In *Grand Pianola Music*, this was done comically. In the first movement of *Harmonielehre*, he sounds dead serious, but his neoromanticisms seem at their worst (which usually means at their loudest) obvious and vulgar. The second and third movements are much better, however, and Mr. Adams gives every sign of developing an idiom of real individuality and appeal.

Tonight's concert was hardly all Adams. Mr. Nagano began with a decent performance of Pierre Boulez's clever, elegant, ten-minute *Messagesquisse* (1976) for seven cellos, with Joel Krosnick as soloist.

The program continued with another message, a work commissioned by Mr. Boulez and his Ensemble InterContemporain. *Messages of the Late Miss R. V. Troussova* (1978), by the Romanian-born (in 1926) Hungarian György Kurtág, is a setting of twenty-one Russian poems by Rimma Dalos for soprano and chamber ensemble. It was full of piquant instrumental combinations and coloristic effects, but less successful as poetry settings—partly because it was hard to keep track of which text was being sung in the long, fragmentary final section. Mr. Nagano's performance seemed committed, and the vocal part, divided among three young sopranos—Darnelle Scarbrough, Judy Schubert, and Sharon Baker—was handled well.

BRUCE AND HYPE

The New York Times, August 29, 1985

Note: A footnote to the whole Springsteen hype controversy, which erupted back in 1976. Excerpted from a longer article.

Some afterthoughts on the Bruce Springsteen phenomenon: Suddenly, a man who has been with us for years (remember those simultaneous *Time* and *Newsweek* covers a decade ago?) is the biggest star in the land. It certainly comes as a source of amused satisfaction for those of us who were accused of conspiratorial manipulativeness—of "hype"—in his first rush to stardom in the mid-'70s.

But just how big a star is Bruce Springsteen? In Santa Fe, I came

across a newspaper column by a syndicated religion writer named Lynne Bundesen.

"For some time now," Miss Bundesen wrote, "there have been people around the world announcing the return of the Christ. They say he will be a normal person, someone we all know and then one day he will get on television and communicate to everyone on the planet that they must change their ways and the Kingdom is returning to earth.

"Is it Bruce? . . . It all sounds like a 'possible.'"

Now *that's* hype.

CITY OPERA: *MADAMA BUTTERFLY*

The New York Times, October 27, 1985

The 1985 installment of the New York City Opera's Frank Corsaro production of *Madama Butterfly*, seen Friday evening, offers little that seems exemplary, though next to nothing that is deplorable, either. And yet this honorably ordinary performance made a powerful impression not just on the audience, but on this curmudgeon of a critic, too.

Mr. Corsaro's staging, now directed by Christian Smith, has been around forever, yet remains thoughtfully conceived and executed with reasonable freshness. The cast now on view is solid, but no more: Catherine Lamy's conscientious, vocally secure, but not very subtle Butterfly; Robert Grayson's stentorian Pinkerton; Robert McFarland's sympathetic Sharpless (but then, everyone is sympathetic as Sharpless); and a hardworking cast of supporting players headed by Cynthia Rose as a graceful Suzuki. Imre Palló's conducting is fluid but properly lyrical.

And yet, the seemingly full house positively murmured with pleasure during the intermissions; applause was generous, and, indeed, Puccini's melodrama worked itself up to a stirring climax.

The reasons for this success are three. Puccini really was a clever composer for the musical theater, as if we needed more reminding of that fact than what we get, week in and week out. Jaded critics may find it daunting to contemplate yet another evening of his old, familiar manipulations. And yet the City Opera deliberately and successfully

courts an audience that does not consist entirely of the New York voice buffs, but rather of real people who are chancing the rather daring notion that viable theater might be found in an opera house. And compared to the shallow contrivances that too often pass for Broadway music theater, they certainly get better value (aesthetic value and financial value) with the City Opera.

Second, an honorably ordinary performance is not to be scorned, in this age of rampant variability of opera casts, performances, and productions. While there may have been little on Friday to make a connoisseur perk up his ears in awe, there was also little to horrify him. And the City Opera, so often maligned for trotting these warhorses out on stage with little care or concern, should be recognized for doing a good—good but not great, but given Puccini's surefire formulas, good is good enough—job.

Third and perhaps most important, there are the supertitles. These have been disparaged in some quarters as letting the audience off the hook too easily, and encouraging the singers to slight the dramatic articulation of the text. Nonsense: Opera is art, and therefore perhaps morally salutary. But it is entertainment, too, and it seems severe to expect an audience at a *Volksoper* like the City Opera to spend hours in earnest preparation—or to strain to discern English words in a huge theater.

And far from discouraging the artists from giving their dramatic utmost, supertitles seem to work the other way: how satisfying it must be for a singer, after years of struggling with textual niceties that are then blithely missed by 90 percent of the audience, to feel that his or her dramatic intensity is being understood and appreciated. Friday's audience loved those supertitles; it was as if that once-moribund theatrical form, opera, had come to new and unexpected life for them. Any opera performance, and any opera company, that can make that visceral an impression is surely doing something right.

THOMAS HAMPSON

The New York Times, **April 17, 1986**

The question about most debut recitalists is whether they're any good. The question about the American baritone Thomas Hampson, who made his debut at Town Hall Monday night, is just how good he is. Chances are, he will rank among the leading lyric baritones of the late century.

Not every debutant arrives on the scene already represented by Columbia Artists Management and already scheduled to make his Metropolitan Opera debut next season, as the Count in *Le nozze di Figaro*. Mr. Hampson has already won extensive praise for his operatic and concert appearances elsewhere in the United States and in Europe.

Aside from good looks, a commanding stage presence, and, even within the confines of the recital format, an apparently vivid theatricality, Mr. Hampson has a rare voice. What makes it so distinctive is in part that he has had the good sense not to shout it away. Unlike too many promising young baritones, he hasn't pushed it for volume so that its initial freshness has been bludgeoned into hoarse mediocrity.

In fact, Mr. Hampson spent much of his time Monday playing with sustained mezza-voce effects, which he delivered with a striking beauty of tone. When he opened up for volume and richness, he revealed some limitations at the bottom of his range—this is still a real lyric baritone. But on the whole he managed the louder music admirably, too.

His program, nicely accompanied by Armen Guzelimian, ranged from Hugo Wolf through Debussy and Samuel Barber to six love songs of Richard Strauss. Mr. Hampson handled the French and American well enough, with a slight but not really damaging predilection toward overinterpretation. But with the German language and German lieder, he demonstrated a special affinity that will bode well if he is able to translate that insight into his operatic roles.

ELLA FITZGERALD

The New York Times, June 15, 1986

Chicago—Last month, Ella Fitzgerald, the serene classicist of American song, was awarded an honorary doctorate of music by Yale University. "Not bad," she said with her typically modest good humor a few days later in a Chicago hotel room, "for someone who only studied music to get that half credit in high school."

Yale's doctorate was something like her seventh, joining others on her wall from Dartmouth, Washington University in St. Louis, the University of Maryland, and several more. This is a woman who's collaborated with the best, from Duke Ellington and Count Basie, to Nelson Riddle, to Frank Sinatra, Sarah Vaughan, and Louis Armstrong. She's won every award she might have aspired to, from endless listener's polls as favorite jazz and pop singer to Grammies to a Kennedy Center Award. "I never knew how good our songs were," Ira Gershwin once said to George T. Simon, "until I heard Ella Fitzgerald sing them."

Yet Yale was special, and not just because it's Yale. In 1935 a painfully shy teenager entered a talent contest at the Apollo Theater in Harlem. She had meant to dance, but stage fright diverted her into imitating her idol, the woman whom today she still refers to with a big smile as "Miss Connee Boswell."

Miss Fitzgerald won the contest, but more importantly she attracted the interest of the bandleader Chick Webb, who eventually became her legal guardian. Webb took her up to a college date at Yale, and told her if she pleased the college audience, he'd hire her. She did, and he did, and the now fifty-one-year-old legend of Ella, America's incontestably greatest woman jazz-pop singer, was born.

The latest installment in that legend is scheduled for Friday, the opening night of the JVC (formerly Kool, formerly Newport) Jazz Festival, when Miss Fitzgerald is to sing at Avery Fisher Hall. George Wein's festivals often seem overweighted in the direction of nostalgia. But in this case, her accomplishments are so immense and long-standing, and the love felt for her by jazz fans, pop fans, and the general public so enormous, that no one would dare object.

Ella Fitzgerald owes her eminence in American music to a constellation of talents. There are her musical gifts, but what may come first of all is the way her genuinely lovable personality shines through her singing.

Seated on a couch in her Chicago hotel suite—she was in the city to sing for an advertising convention—she looked frail at first. Miss Fitzgerald used to be a big woman; now she seems almost drawn, with prim attire, thick glasses, and a worried look.

But first impressions aren't always accurate. She began talking almost formally, polite but shy. As her apprehensions eased into smiles, she spoke alertly and frankly, without ever denigrating a soul (her most frequent interjection, whenever she spoke of a deceased collaborator, was "God bless the dead").

An example of her lack of pretense came with a no doubt embarrassing question about what it felt like to be a legend, and just when she noticed a change in people's response to her, from affection to veneration. She didn't duck the question, or hide behind fluttery platitudes.

"I don't think I noticed it at first," she answered. "But when Norman Granz and I began recording the 'songbook' series in the mid-'50s, it just seemed that more people began to like my singing. The awards I started winning didn't make me feel important, but they made me realize people loved me. And then when kids started calling me 'Ella'—half of them never even mentioned 'Ella Fitzgerald'—just 'Ella.'"

Behind her personality lurk a multitude of specifically musical gifts. First but not necessarily foremost, there's her voice itself. She has a silvery, almost girlish instrument that manages to achieve the key technical goal of opera singers—the smooth passage from the mid-register up into the vibrant upper soprano register—without taking on the fruity roundness of tone non–opera fans object to with opera singing. Miss Fitzgerald's upper register might best be called a falsetto, rather than a true soprano extension. Yet she avoids the pale fragility of a really undeveloped falsetto, and she keeps her mid-range light and flexible to balance with the rest of her voice.

A voice—any voice—means little unless it's linked with musicality and style. Miss Fitzgerald has a sense of pitch and rhythm, and most crucially a sense of harmony, that make her the envy of skilled jazz instrumentalists. She can not only hit whatever note she wishes, bending it and coloring it at will, but she knows just the right note to select from the dizzying possibilities flying past her in the heat of a jazz improvisation. The way she can shade a pitch, or slither up or down a chromatic scale, or pick out the most piquantly expressive note in a chord, reveals a consummate musician, however informal her training.

But voice and musicianship are still lost without style. From her note-

to-note inflections and embellishments to her overall sure sense of herself as a singer, Miss Fitzgerald makes a complete and telling statement as a vocal artist, managing to project that charm and charity into vocal performances that are always balanced and generous. She has a remarkable stylistic range, from bop and scat to pop balladry, from classic American songwriters to innocently trashy Tin Pan Alley types of the 1940s, to such selected contemporary songwriters as Paul Williams and Stevie Wonder, to improvisations with the great names of modern jazz. Yet she ties all those threads together into a statement about herself and about American popular music that few have come close to matching.

Her diversity has led some who care about such matters to worry about whether she should be called a jazz singer or a pop singer. The truth is, she's both, and we are the better for it. She emerged in the late 1930s with Webb's dance band, which may have been considered a jazz outfit at the time but which purveyed the kind of innocent popsy tunes that aspired to the charts in those years. Her first hit (and Webb's, too) came in 1938 with a ditty co-composed by her called "A-Tisket, A-Tasket."

For a while, she seemed locked into attempts to repeat that novelty success, but fate and her own instincts dictated otherwise. Webb died in 1939, and after a brief effort to lead his band herself (she was only twenty-one years old when he died), she went out on her own as a solo singer.

Although her record company, Decca, continued to stress pop ballads and novelties, she found herself working more and more with jazz musicians. Indeed, her scatting with Dizzy Gillespie is said to have coalesced the very notion of "bop." By 1946, she had hooked up with Mr. Granz's Jazz at the Philharmonic tours. He became her manager and, in 1955, brought her over to his record company, Verve, thereby revitalizing her recording career.

What Mr. Granz did was effect a fusion at a higher level of accomplishment of her pop and jazz instincts. Under his auspices she embarked on a series of "songbook" albums, with separate disks devoted to the classic American composers and lyricists—Ellington, the Gershwins, Berlin, Kern, Rodgers, and more—and bringing her together with classic arrangers (Nelson Riddle above all) and jazz musicians. Mr. Granz also opened up for her the whole field of symphonic dates, engagements in which Miss Fitzgerald could sing American popular songs and even jazz with the backing of full symphony orchestras. "It was like a whole new beginning for me," she recalled.

The lines between jazz and pop have been polemically blurred. Pop

at its worst is banal, simplistic, and calculatedly commercial. But jazz, too, can devolve into mere facile virtuosity or formless displays of ego. At its best, pop represents a clean-lined, modernist formalism, while jazz introduces wit, subtlety, and expressive ornament. Miss Fitzgerald is the easy master of the improvisatory aspects of jazz. Yet unlike so many jazz singers, she has clung to the natural, conversational directness of 1930s crooning. For a younger generation, jazz singing could sound mannered and flashy. Like Frank Sinatra, Miss Fitzgerald attained a remarkable level of artful simplicity, letting her jazz enrich pop's simplicity without subverting it.

She herself sees her pop and jazz repertories as providing needed respite from potential routine. "You can get bored doing the same thing every night," she said. "I try to do a little of each. I love lyrics. I love ballads. But if I was to sing all ballads, I'd get bored. I'd feel I wasn't learning anything. When I do the improvisations, they teach my ear. I learned when someone like Tommy Flanagan would throw those chords under me. That was my lesson in music." But there's more to it than that. Miss Fitzgerald doesn't so much alternate between pop and jazz as combine the two, and she's done so from the very beginning: listen to the sly inflections in her phrasing of "A-Tisket, A-Tasket" from nearly fifty years ago for proof of that. With her blending of styles, she brings together the major influences that have shaped American popular music in this century. Her style is not just a combination of pop and jazz, but of white and black, girl and woman, voice and instrument.

She herself doesn't feel comfortable talking in terms of race. But from the first, she sang with both black and white musicians, and appealed to audiences of all races. It's no accident that her idol (and one of her mother's favorites, too) was Connee Boswell, a white singer who could swing pop tunes. Miss Fitzgerald has never been a true blues singer; her vocal inflections and ingenue manners have always kept her close to the white mainstream, just as American music itself is a complex but amazingly fertile cross-pollination of Jewish songwriting, black blues and improvisation, Appalachian folk music, country twanging, Italian vocalism, and indeed every ethnic impulse in our polyglot national personality.

It is Miss Fitzgerald's lack of affinity with the blues, and that whole vein of oppressed passion that black music epitomizes—especially to some white intellectuals—that may have led a few critics to complain about her lack of depth. She has her limits, areas into which she will not

venture. But in her case it seems more accurate to perceive her limits as the clear, precisely focused definition of her artistic personality. For her to push still farther, into areas of confessional romanticism in which she felt uneasy, would be to shatter her image without substituting anything valuable in its place.

For what she may lack in womanly passion, she more than makes up in ebullient charm—what the jazz critic Martin Williams has called "the stuff of joy." And if she refuses to plumb her own darkest depths, that hardly means she's skirting the truth when she says, "I sing what I feel." She's a determined, self-made optimist, a person who can even make emotional repression sound like an affirmation.

"I used to be very self-conscious," she remarked. "I used to wish I was pretty. My cousin Georgia always taught me that if you smile, people will like you. Sometimes people will say something you don't like, and you get angry a bit, but you just smile. You let it go by, even if you really would like to choke 'em. By smiling, I think I've made more friends than if I was the other way."

Ella Fitzgerald has been before the public for more than a half century, but in recent years she's had her troubles with health. In the early 1970s it was cataracts. She built her schedule back up to some forty-two weeks of performing a year. But last summer she collapsed and had to be hospitalized, and on the advice of her doctors and Mr. Granz she's cut back her touring again. In addition, her less sure breath control these days has led her to collaborate more in concert with instrumentalists, thus sparing her energies, and to emphasize her scat singing, which lessens the need for the long-held notes of ballads.

Miss Fitzgerald has a big, sustaining family, and enjoys her home in Los Angeles, where she's lived for many years. She is thrilled, too, by her first grandchild, born nine months ago. "She was my Easter bunny, when she came to visit this spring from Alaska," she said happily.

But if retirement comes, it won't be voluntary. "They say, even iron wears out," Miss Fitzgerald said in her Chicago hotel room, her lake view shaded by drawn curtains. "I think if I ever just had to sit down, I'd say to myself, 'What am I going to do now?' If I ever get to the place where people don't want to hear me, or if I ever just can't do it. . . . But I hope that doesn't happen. I love to sing."

LEONARD BERNSTEIN

The New York Times Magazine, August 31, 1986

In a wash of weepy emotion, Leonard Bernstein stepped down as music director of the New York Philharmonic in 1969, assuming the title "laureate conductor." Laureates sometimes carry with them an air of doddering grandeur. But at the age of fifty, Bernstein was still full of fire, mostly fueled by ambitions to fulfill his interrupted promise as a composer.

Instead, the 1970s turned into Leonard Bernstein's personal diaspora. Early on in his retirement, he was publicly mocked for his supposedly "radical chic" socializing at his home with the Black Panthers. His compositions came haltingly and were generally derided. He seemed caught up in a manic round of guest conducting, mostly in Europe. His personal life was marked by the death in 1978 of his wife, the Chilean actress Felicia Montealegre. They had separated just before she was diagnosed as having cancer, and though they reconciled, Bernstein wondered aloud whether their troubles had somehow precipitated her illness. After her death, there was a period of depression, then giddy flamboyance. From being the central figure in American musical life, Bernstein seemed dangerously close to grotesque self-parody.

But any dismissal of Bernstein was premature. He seems now, at long last, the magisterial presence his grandiose Philharmonic title implied seventeen years ago. His conducting has attained a new level of recognition—many critics, this one included, would be hard-pressed to think of another conductor they would rather hear in the mainstream orchestral repertory. Earlier this month, Bernstein led the New York Philharmonic before 200,000 cheering admirers in Central Park, earning the sort of adulation only true musical icons receive, and then took the orchestra on a nationwide tour. This Friday and Saturday he is to share a Philharmonic program at Avery Fisher Hall with three young conductor protégés, and he returns there on September 13 to lead the Israel Philharmonic as part of its fiftieth anniversary celebrations—complete with the world premiere of a new Bernstein composition for the occasion, *Jubilee Games*.

While his composing must still be judged as uneven, his old pieces sound better than ever: the New York City Opera's production and recording of *Candide* met with high praise, and his recent album of *West Side Story* topped the classical records sales charts. His work as a

whole can now, in the climate of the "new romantic" movement, be appreciated from a more sympathetic perspective. Ambitious Bernstein festivals were held this year in London and Paris, with two more to come in October, in Milwaukee and Bridgeport, Connecticut. He is showing signs of achieving, at sixty-eight, a new balance in his personal life, as well—despite inevitable, sometimes embarrassing, sometimes wonderful lapses into emotionality.

It is that quite remarkable personality, for better and for worse, that defines every aspect of his near-manic existence. There are those who still find him inherently annoying—when he shoots off what he likes to call his "big Jewish mouth," when he prances and gyrates on the podium, when he seems to squander his compositional gifts in flashy trivia or overwrought excess. By his own admission an "embracing type," Bernstein hugs and kisses on all occasions, and his response to any hint of resistance from a huggee is to hug all the harder. Yet he seems so convinced of the value of such contact ("Some people have gender problems and sexual problems; some of them never even touched their parents; we talk about it later and they change and I'm rewarded") that the easiest recourse is to hug him right back.

The one thing he cannot be accused of is insincerity. If anything, Bernstein has a surfeit of sincerity—he feels so extravagantly, and so wants us to feel with equal intensity, that he goes overboard. But in going up to and past the limit, he takes risks and achieves goals most others can't even imagine.

Like many artists, Bernstein is prone to deep depressions and wild upswings. This summer, his mood has been euphoric. One recent evening, at the Fairfield, Connecticut, country home he has had for twenty-five years, he was typically juggling several balls at once. He was finishing *Jubilee Games*, and his oldest friend, Sid Ramin, whom he has known since he was twelve and who has orchestrated several of his Broadway scores, was helping him with the second movement. Bernstein was boning up on Sibelius's Second Symphony, prior to conducting it with the young Tanglewood Music Center Orchestra and, this fall, recording it with the Vienna Philharmonic. And two of his three children were in for the weekend—twenty-four-year-old Nina and thirty-one-year-old Alexander, both actors. The eldest, Jamie, a thirty-three-year-old rock composer and performer, was due to arrive the next day, and Bernstein, having just learned that she is to make him a grandfather for the first time, was thrilled.

Years ago, Bernstein spoke admiringly of the image of the old Picasso in the south of France, near-naked in his bikini and unfettered by bourgeois conventions. But despite his campy excesses, Bernstein remains very much the family man; the bonds between father and children are deep. When Nina arrived in her father's crowded dressing room after a Tanglewood concert a few days later, Bernstein looked up at her affectionately and said, "Hello, critter." "Hello, creature," she answered. It was a moment—a quiet place, if you will—of such simplicity that it validated his most extreme emotionality.

Although it was Bernstein's wife who was known as the hostess, his social life has remained active since her death. He gives parties, both formal and informal, at his homes in the Dakota, the well-known apartment building on Manhattan's Upper West Side, and in Connecticut. His social circles include many young people—student musicians, his children, and their friends. But there are also contemporaries from the worlds of classical composition and performance, the theater, literature, and politics.

For a true insight into Bernstein's public side, Tanglewood provides an ideal setting. It was at Tanglewood, in 1940, that Bernstein, fresh from Harvard, found one of his key mentors, the Boston Symphony conductor Serge Koussevitzky. In recent years, he has gone there every summer for ten days to conduct the annual Serge and Olga Koussevitzky Memorial Concert with the Boston Symphony, to lead the Tanglewood Music Center Orchestra, and to teach.

At Tanglewood, Bernstein runs himself happily ragged. "It doesn't stop," he sighed one day, changing his soaked sweatshirt for yet another fresh one. But he would be desolate if it ever did stop. He glides through the Tanglewood grounds in his beige Mercedes convertible with his assistant, Craig Urquhart, waving royally to crowds of earnest music students snapping their Instamatics, asking for autographs, and hoping for a word or two.

He once described his conversations, television programs, and even conducting as teaching. "I'm a closet rabbi," he has said. Seated on his rehearsal stool, peering out from the podium over his half glasses, he indeed looks rabbinical—like his father, Samuel, a Boston beauty-supply merchant and Talmudic scholar from Russia.

The most interesting of Bernstein's orchestral rehearsals this summer came with the Tanglewood Music Center Orchestra, a group young enough to profit from his broader cultural asides, yet sophisticated

enough to respond to technical fine tuning. Bernstein walked on to fervent applause from the players. He was wearing a baby-blue sweater, jeans, cowboy boots, and a red handkerchief tucked into a rear pocket, a big grin creasing his tanned and still classically handsome face. His favorite verbal punctuation consisted of hortatory adjectives like "glorious," "perfect," "terrific," "beautiful," and "sensational," often delivered while he scrutinized the score for some item he intended to make even more sensational. "Great!" he cried to the basses. "Use the whole bow and you'll be even greater—twice as great!"

Bernstein's podium manner in private rehearsal is just as "choreographed" as in public performance; his contortions may be distracting, but they are neither premeditated nor false. In the performance of the Sibelius, just before a violent brass entrance, he jumped straight into the air, his legs tucked up under his body as though he were taking a cannonball dive (he said later he had no memory of it). At the students' party afterward—he stayed until 5 A.M., talking and dancing—one could gaze out onto the crowded dance floor and see bodies occasionally springing up above the throng. The students had incorporated "Lenny's Leap" into their dance routines.

Bernstein's customary blend of analytical rigor, emotional fervor, and psychological cunning showed up in every rehearsal. His comment, "It's always thematic; you never have the sense you're playing unimportant stuff—that's Sibelius's glory as a symphonist," simultaneously reveals something very true about the composer's genius and serves to inspire performers who might otherwise lapse into boredom.

"Rule number 1 in orchestral playing is: it's all chamber music," Bernstein said, whipping his glasses off and on again to conduct and examine the score. It was a remark he must have made thousands of times, but it remains vital. "Think dark, even when you're playing high," he cried, trying to elicit a Nordic feeling. "You can make a diminuendo on an upbeat—you don't think you can do it, but I tell you you can do it. . . . Thank you for that fortepiano; Sibelius thanks you. . . . Doesn't he say tenuto or something? Well, I say it; he told me to say it; we talk." To the first oboe: "This tiny entrance is like fifty trumpets." Then: "A great orchestra is a flexible orchestra: 'Lenny and his flexible cats.' . . . Pelvic pulse; excuse the expression, but that's what it is. Passion. . . . Now it's really throbbing; the whole orchestra is alive with this throb. . . . You gotta cry and suffer and that upbeat is part of it. . . . I love you; what can I say? You're just terrific."

When Bernstein first came to the Philharmonic, observers regularly complained about his exaggerations and superficiality, his application of a Broadway sensibility to the classics. Some of that may have been mere snobbery. But Bernstein himself concedes he used to "overconduct," punching home seductive details at the expense of an overall conception, and that his repertory and interpretations were too imitative of his teachers. These days, the details remain just as transparent, with more sensuous niceties than ever, but now they are nearly always subordinated to a vision of the entire piece.

Bernstein attributes some of his recent success to the orchestras with which he regularly works—the New York Philharmonic, the Boston Symphony, the Israel Philharmonic, the Bavarian Radio Symphony in Munich, and the Vienna Philharmonic. The linkage of this last ensemble to its "local" repertory of Haydn, Mozart, Beethoven, Schubert, Brahms, and Bruckner has lent a new weight to his realizations of the core repertory: the Viennese players steady him, he enlivens them. But part of it, too, is his own maturation. "You either get better or you die," he says. "To stick in a groove is an illness. I hope I've gotten better. What's the point of all the agony and the bliss and the study and the chameleonlike changing into Beethoven or Brahms or Schubert, otherwise?"

Orchestras today are routinely overworked and turn in routine performances as a result. Bernstein's status entitles him to extra rehearsals: for most Boston Symphony Tanglewood concerts, conductors get two rehearsals totaling five hours. For the Koussevitzky concert, with only two pieces on the program, Bernstein got three rehearsals and more than an hour of overtime, for a total of nearly nine hours. One could hear the difference—even wizened veterans respond to his care and passionate conviction.

In years past, his reputation as a conductor suffered because he didn't fit neatly into any of the then-prevalent categories. He was neither a brooding Germanic mystic like Wilhelm Furtwängler nor a brisk, intense literalist like Arturo Toscanini. Bernstein's initial inspirations were the subjective emotionalism of Koussevitzky, with his commitment to unfashionable modern music, and the erratic but, at its best, incandescent blend of emotion and intellect of Dimitri Mitropoulos, who first implanted in the "genius boy" (as Mitropoulos called him) the notion that he could conduct. Bernstein honors his past, almost to the point of fetishism. When he conducts, he wears Koussevitzky's cuff links

(he got married at Tanglewood wearing Koussevitzky's white suit) and a Picasso dove of peace that Mitropoulos wore around his neck (this last is linked to a gold-plated shekel from 66 A.D. from Bernstein's wife).

Another secret to his success—and here his decision to give up the Philharmonic comes into its own—is that he is no longer a full-time conductor. He accepts those projects that attract him through his own organization, Amberson Productions, the name being a play on the English word for Bernstein, amber. Amberson is run by Harry Kraut, who is his "manager," if any person can be said to manage such a self-managed person; Kraut took over from Schuyler Chapin when Chapin went on to run the Metropolitan Opera. One of the things Bernstein and Kraut pay most attention to is blocking out time for composing. Bernstein took 1964–65 as a sabbatical from the Philharmonic, and 1980 was entirely devoted to composition. Usually, however, the stolen time comes in two-to-four-month chunks, meaning he isn't mired in the day-to-day routines of conductors who only conduct.

Most of history's great conductors have been composers, bringing a special insight from their own time to their interpretations of music from other times.

This tradition has deteriorated in recent decades as avant-garde composers have either given up the orchestra altogether or have composed in idioms too abstruse for audiences to understand and too complex for orchestras to play. Bernstein comes from a tonal American symphonic tradition, one to which most audiences can still relate, and conducts the classics with a present-day rhythmic alacrity and a sense of color and drama that most other conductors, aping one past conducting style or another, grievously lack.

But if his composing freshens his conducting, Bernstein is not so sure the reverse is true. During his eleven-year Philharmonic tenure, he was able to complete only two major works—the "Kaddish" Symphony of 1963 and the *Chichester Psalms* of 1965. In the 1970s, he began with *Mass*, his closest approach to rock and a work dismissed by many critics. He then took time to prepare the Charles Eliot Norton Lectures at Harvard for 1973—a sometimes too breezily argued yet impassioned defense of tonality and eclecticism. After that came *The Dybbuk* in 1974, an ambitious but problematic ballet with Jerome Robbins, and *1600 Pennsylvania Avenue*, a disastrous Bicentennial musical about the White House. In 1977, there was the rather more successful *Songfest*, a compendium of poems and musical styles designed to honor the outsiders of

American culture. Throughout this period, there was also a host of abandoned projects and occasional pieces and, finally, the opera *A Quiet Place* in 1983. This attempt at a sequel to his brief domestic drama of 1952, *Trouble in Tahiti*, was widely attacked as maudlin and melodramatic. Yet in its revised 1984 version, with the older opera imbedded in the new material as flashbacks, one can imagine a successful production in a properly intimate theater.

Bernstein himself clearly feels a deep sense of disappointment as a composer. When Stephen Wadsworth, his *Quiet Place* librettist, said he didn't have time to undertake the libretto for their next operatic project, a five-language vision of the Holocaust, Bernstein was devastated. One problem is an increasingly rigorous sense of self-criticism—or, one suspects, self-doubt. "I've always thrown stuff away," he says, "but I throw a lot more now. I've thrown it away for the same reason—it's dishonest, it's not me, it's there for some specious reason that I may not even know myself."

Another difficulty is freeing himself of his involvement with the music of others. The first part of any composing period, he complains, is spent purging the composers he has been conducting, and the last part in reentering other composers' psyches as he studies their scores for forthcoming performances. "When I really study a score, I recompose it along with the composer," he says. "It takes so much time and so much psychic energy, it's almost schizoid. It takes two weeks to get those other guys out of my head—Ives and Haydn and Copland and Brahms. Then maybe I can go about finding my own notes. At first, even if you find what you think are your notes, you don't trust them. It's painful."

There are those who feel he has never escaped those other voices—that his music is at its core derivative. Back in 1949, his old mentor and friend Aaron Copland, of all people, wrote that "at its worst, Bernstein's music is conductors' music—eclectic in style and facile in inspiration." Add to that a tendency toward soul-searching affirmations of verities that veer dangerously close to clichés—pious conventionalities masquerading as archetypes.

Set against such doubts—his own and others'—are his music's palpable virtues. He has a moving melodic gift, something especially rare in our time. Tunes such as "Somewhere" from *West Side Story* or the big theme from *Trouble in Tahiti* rank him very high indeed. His vernacularly inspired rhythmic dash and syncopated swagger, and the theatrical directness and accessibility of even his most ostensibly "serious"

scores, make him a composer of undeniable gifts and popular appeal. But Bernstein's deeply conservative adherence to the tonal tradition—the precise opposite of his reputation for trendiness—put him at odds with vanguard composers during the 1950s and '60s, including Stravinsky and Copland. Now, in a climate of "new romanticism," Bernstein begins to look like a prophet. That's why he's so proud of his Harvard lectures, with their affirmation of tonality as based on universal law. "I don't feel vindicated as a composer," he says. "But I do as a lecturer, as a teacher."

Yet there is more to Bernstein's music than a mere dogged adherence to tonality. He brings an irresistible flavor of popular music and jazz to his symphonic scores, and that still gets him into trouble with conservative critics who might otherwise applaud his harmonic traditionalism. He would surely have enjoyed a more straightforward success if he had stuck to Broadway after the triumph of *West Side Story* in 1957. Then, all the plaudits that have accrued to Stephen Sondheim, his onetime librettist and avowed disciple, might have fallen to him. Instead, Bernstein took on the Philharmonic and continued his perhaps futile, yet still noble attempt to inject the spirit of the vernacular into the classical tradition. In this sense, his most extreme and interesting work has been *Mass*, and its rejection caused him much bitterness. Compared with eighteenth- and nineteenth-century masses, Bernstein's work sounds bizarre. In its proper context, as a fusion of classical music, Broadway, and the nascent rock musical, it is remarkable.

All his life, Bernstein has championed the idea that it is imperative for an American composer, caught up in our welter of cultural influences, to be an eclectic. "Why is that word pejorative?" he wonders. It is just this blending of popular and "serious" styles, and his willingness to leap wildly from style to style within a given score, that incurs the greatest critical antagonism. But it should be remembered that Mahler—"the most original mind of his time," says Bernstein—was rejected for decades because of his seemingly incongruous mishmash of styles and excess of emotion. Bernstein may not be Mahler. But one suspects his time will come, too, and for much the same reasons—people will accept the emotionality and cherish the diversity.

One reason tonal, accessible music is back in fashion is the conservative cultural and political climate of the Western world. Ironically, the vilification of Bernstein for "radical chic" was a harbinger of that reac-

tion, with protests that he is sure were organized by the FBI to discredit his liberalism and to drive a wedge between the Jewish and black communities. If Bernstein has been wandering in a lonely diaspora since the 1970s, part of the reason has been his sense of alienation from the conservative mainstream. Bernstein remains an unregenerate liberal, a fighter for minority rights and for peace. A friend of Democratic presidents, he was last in the White House—"my favorite house in the whole world"—in the waning days of the Carter presidency, when he managed to "sneak" twenty-one members of his entourage and family into Lincoln's bedroom to recite Jewish prayers. He has not been there since, and says he won't go while Reagan remains in office.

Such commitment to principle and to his Jewish faith might seem to pose him an enormous problem. He loves the Vienna Philharmonic, but many American Jewish leaders are advocating some sort of boycott of Austria now that Kurt Waldheim, accused by some of covering up his Nazi past, is that country's president. What is Leonard Bernstein, a powerful symbol of American Jewish achievement, to do? He plans to march back to Vienna in October to show the colors.

"I think *not* to go back is to retreat," he argues. "I *am* going to go back, because the musicians are my brothers, my Brüderlein—I love them. Not to go would be abandoning them. It would be like *rejecting* them, because of this ghastly Waldheim thing. It doesn't matter if he was a criminal—that's water under the bridge. But that he spent as much effort forging an autobiography, and then on top of all that totally lying—he has the nerve, the chutzpah, to run for the presidency of his country, knowing full well his main support would come from ex-Nazis, or not even *ex*-Nazis."

Eventually, Bernstein would like to write his autobiography, utterly candid and for publication only after his death. But having given up trying to type it into a computer, he is looking for a collaborator—perhaps Stephen Wadsworth and a video crew, he muses. Additional motivation for telling his side of his story comes from the forthcoming tell-all biography by Joan Peyser, which he "dreads."

But in the end, for this most instinctive and gregarious of collaborators, everything returns to the solitary, lonely act of composition. Bernstein works in the studio his wife fashioned for him from an old barn in back of the Fairfield house. Most of his memorabilia are in a Manhattan studio presided over by Helen Coates, his former piano teacher (when he was fourteen years old) and longtime secretary, now eighty-seven and

in poor health. Along with his mother, now eighty-eight, Helen Coates represents the last link with the previous generation.

But there is plenty of memorabilia in Connecticut, too—pictures of a wife he still describes with sudden, passionate intensity as "the greatest person I ever met in my life," of his mentors and idols. There are Grammy awards, a grand piano, a sit-down desk, and a stand-up shelf where he does his actual composing—unless you count the couch; he swears the real work comes at night, when he's prone.

Although he seems in ruddy good health, Bernstein has reason to worry. Always asthmatic and prone to emphysema, he remains a mercilessly heavy smoker. "The great thing about conducting," he says, "is you don't smoke and you breathe in great gobs of oxygen. When I sit around for months and compose, I get bronchitis." At times, he is afflicted with a racking cough that makes his friends wince, and he constantly has to clear his throat. At Alan Jay Lerner's memorial service, people outside held up a sign saying, "We love you—stop smoking."

Beyond all that, more and more friends are dying from those natural causes that begin to touch everyone at his age. And an entire younger set of friends is falling to acquired immune deficiency syndrome. Bernstein says he spent an agonizing time on a European tour recently trying to make telephone contact with a young conducting student who was dying of AIDS and whose family was profoundly embarrassed by any of his friends' attempting to contact him. "It was terrible—he was absolutely pure, this boy. When I was finally put through to him, he said everything was wonderful: he felt better, he was gaining weight. Right after that, he died."

In less than two years—on August 25, 1988—Bernstein will be seventy years old, the biblical life span beyond which all time is borrowed from God. "My father was seventy in 1962, and there was a huge party for him in Boston," he recalls. "The whole family was there, the mayor and other politicians—it was the high point of his life. But already he was worried. After that he declined steadily, and finally died in 1969." The implication is clear: Bernstein feels driven to accomplish whatever he hopes to accomplish, soon.

But all that might seem too downbeat for a man who still has the seductive charm and youthful vitality of an ageless boy wonder. After a couple of weeks with him, watching him in action and thinking about his life, one finds oneself wishing that he can knit it all together, that he can achieve his lifelong goal of combining the classical and popular, tra-

ditional and daring, creative and re-creative, intellectual and emotional, social and solitary. He has given us a lot; here's hoping there will be more for years to come.

JOHN ZORN AND ENNIO MORRICONE
The New York Times, **November 2, 1986**

The East Village improvisational scene reached some sort of apotheosis at the Brooklyn Academy of Music Friday night (and presumably last night, as well, when a repeat was scheduled). John Zorn and a twenty-five-member "big band" consisting of nearly every well-known name on that scene who happened to be in town addressed themselves to the film music of Ennio Morricone as arranged, insofar as an arranger can be said to arrange improvisation, by Mr. Zorn. The event, rather too cutely entitled "Once Upon a Time in the East Village," was part of the Next Wave Festival.

Some explanations for those to whom all this sounds like alien gibberish. The term "improvisational scene" lumps together all manner of musicians—American, English, and otherwise; male and female; white and black; classical, jazz, and rock—who share an interest in improvisation. The common stylistic traits are a blend of raucous anarchy with idiosyncratically devised structures, amplification and the piercing, percussive racket of the electric guitar, and animallike yelps and howls.

Mr. Morricone has scored more than two hundred films, nearly all of them Italian. His best-known work has been with the director Sergio Leone, in the series of "spaghetti Westerns" that includes *The Good, the Bad and the Ugly* and *Once Upon a Time in the West*, hence the title of this particular program.

His music at first might seem far removed from the crazed eruptions of these noise improvisers. He writes big, fat, romantic tunes, and can fill a soundtrack with a wash of weeping strings as well as any elevator composer alive.

But there is a lot more to Mr. Morricone than bathetic neoromanticism. He's a minimalist, with the haunting use of a few deftly placed

shards of sound. He's an electronic composer, fascinated with echo and timbral alteration. He has played with an improvisational group back home in Italy. And he's something of a psychedelic-style acid rocker, too, or acid sound tracker: the smell of marijuana in the men's room Friday night recalled a Grateful Dead concert.

What Mr. Zorn has done is evoke Mr. Morricone's spirit in the wittiest, and at times most haunting, of ways. Generally his strategy (he has a couple of albums out called *A Classic Guide to Strategy*) is to have his band (he stood before the ensemble during most numbers in a saggy T-shirt giving minimal cues) state the theme in a fairly straightforward way, either sung or on an electric guitar or with a saxophone or woodwinds. Or he establishes a powerful ostinato riff with the keyboards and percussion. And then all hell breaks loose, a crazed bestiary of sound effects all somehow channeled and shaped in a persuasive way.

Well, nearly always persuasive. Sometimes things sounded a little cut and dried on Friday, as if the musicians and maybe Mr. Zorn, too, would have preferred to let loose for a real rave-up. But most of the time, the blend of power, ingenuity, wit, and charm was just about perfect.

His treatment of the score to *Giu la testa* was typical: a lovely combination of shamisen (Ushio Torikai) and delicate percussion to start; then a sweet, sentimental, but moving theme, beautifully intoned on the English horn by Vickie Bodner; and finally a more generously extroverted passage with the singer Shelly Hirsch and insistent percussion. Some of the arrangements were smaller-scaled, pithy and directly reminiscent of East Village improvisation. Others—like the treatment of *The Battle of Algiers* and *The Big Gundown*—were far more ambitious, drawing on the entire ensemble and clearly controlled and rehearsed.

In a huge cast of characters, only a few can be mentioned: Ms. Hirsch, somewhere between Cathy Berberian, Ella Fitzgerald, and Nancy Sinatra; the guitarists Bill Frisell, Robert Quine, and Fred Frith; the guitarist and singer-yelper Arto Lindsay; Mr. Zorn himself on saxophone, in a whooping duo with Mr. Lindsay; the percussionists Anton Fier and Robert Previte; and the Batucada Ensemble of Brazilian carnival percussionists. Other Morricone scores explored included *The City of Violence*; *Once Upon a Time in the West*; *The Good, the Bad and the Ugly*; and *Erotico*, this last a real showcase for Ms. Hirsch.

All in all, it was quite an occasion, amusing and fun but also proof that, right under our ears, avant-gardists are still busily inventing ways to communicate musically. Those interested in a recorded version are

directed warmly to the brand new Zorn-Morricone album on Nonesuch Records entitled *The Big Gundown*.

JOSEPH HOROWITZ AND ARTURO TOSCANINI

The New York Times, **February 16, 1987**

Understanding Toscanini. **By Joseph Horowitz. 492 pages. Illustrated. Alfred A. Knopf. $30.00.**

Joseph Horowitz, a former music writer for *The New York Times* who is now the program annotator for the Ninety-Second Street Y, has written a laudably serious book about the most famous of all conductors, Arturo Toscanini. During his lifetime (1867–1957), no musician was more venerated than Toscanini, but now his star has dimmed. Younger musicians and music fans profess a greater interest in his rival and antipode, the mystical German Wilhelm Furtwängler, and RCA Victor has done a poor job of keeping Toscanini's finest performances in print and in the best possible LP and CD transfers.

Mr. Horowitz tries very hard to take Toscanini seriously as an artist, although he undervalues the sheer visceral impact of the conductor's performances. But this book is not really so much about Toscanini as about Americans' response to him. The subtitle tells it all, about Mr. Horowitz's intentions and also his quirky idiosyncrasies: *How He Became an American Culture-God and Helped Create a New Audience for Old Music.*

According to this book, Toscanini's fame during his tenure with the Metropolitan Opera (1908–15), the New York Philharmonic (1926–36), and especially, from 1937 to 1954, the NBC Symphony, was extended and distorted by merciless midcult hype. The result, Mr. Horowitz argues, was the ossification of symphonic repertory (that of Toscanini and of those who followed him), the reduction of classical music to a canon of dead "masterpieces," the isolation of new music, the spawning of hundreds of literalist epigones, and the certification of present-day

celebrity adulation epitomized by yet another Italian superstar, Luciano Pavarotti.

This honorable book's faults are, I think, two. First, it is far too long: the polemical points could be focused into an article or a slim volume; they hardly require 492 pages. The organization is clumsy and repetitive, and much of the book is taken up with plodding regurgitations of critical responses to Toscanini over the years (they make for lively reading, though, and provide a nice insight into earlier decades of American criticism).

The second flaw is that this whole matter of the corruption of American musical taste is both questionable and better approached thematically than personally. One of Mr. Horowitz's chief influences, the gloomy Theodor Adorno, set the tone with his *Sociology of Music* and *Philosophy of Modern Music*. All by himself, Toscanini can't quite bear the weight of responsibility Mr. Horowitz lays upon him.

As Mr. Horowitz himself points out, brightly and informatively, there were ample antecedents in the annals of American cultural hype, and American tendencies in this direction since run far wider and deeper than any one man's popularity and promotion. Classical music all over the world has been slipping steadily into the past since the mid-nineteenth century, yet "music" (unconstricted as to genre) has never been more vitally important to more people than it is today.

Mr. Horowitz shares the endemic pessimism of so many present-day Western intellectuals and lovers of classical music. For them, the democratization of culture amounts to its adulteration. But while the vulgar promotion of truly great artists is subject to enormous abuse, it is still one very effective way to spread the news about art—not to debase elitist culture, but to make it available to more people who may come to care deeply about it.

Complaints aside, this is a genuinely high-minded book, one that should (despite its price) have a wide readership among lovers of classical music. Mr. Horowitz has contributed something of real value to the ongoing discussion about musical values in this country.

ARTIST AND LISTENER

The New York Times, **August 9, 1987**

A couple of weeks ago, I found myself at a Mostly Mozart Festival Orchestra concert that ended with Gerard Schwarz conducting Beethoven's "Pastoral" Symphony. Mr. Schwarz is an enormously talented conductor who has been growing steadily as an interpreter in the years since he switched from the trumpet to the baton. On the other hand, the Mostly Mozart Festival Orchestra is an overworked, underrehearsed ensemble, for all the skills of its players.

There was thus no particular reason to assume this performance of one of the most hoary scores in the standard repertory would surpass the great recorded performances of the past (Bruno Walter, Otto Klemperer, Arturo Toscanini) or the finest modern-day, full-orchestra versions (Leonard Bernstein with the Vienna Philharmonic or Christoph von Dohnányi with the Cleveland Orchestra) or the fresh insights offered by the early-music movement, in particular the excerpts from the "Pastoral" played by Roger Norrington at his Beethoven weekend last February in London.

And, in truth, Mr. Schwarz's performance didn't surpass those memories; it didn't turn out, improbably but thrillingly, to be the "greatest" Beethoven Sixth Symphony of a lifetime. But music making is not a competition, despite all the musical competitions underfoot these days. This "Pastoral" was an entirely convincing, coherent, sensitively played account of a masterpiece, and one that needed no undue evocation of other performances to validate it.

What fascinated me as the score unfolded was the way a listener can be drawn into persuasive music making, and gradually form a compact with the performers. Mr. Schwarz has had a tendency in the past, now gradually being overcome, to play music too quickly and rigidly. The first movement of his "Pastoral" seemed to be falling into that trap, and I settled into my chair, waiting for yet another brisk, efficient, soulless performance to end.

But things picked up considerably in the second movement, the "Scene by the Brook." Mr. Schwarz seemed to care about this music, all of a sudden. The tempo was still fleet (so are Beethoven's metronome markings, it might be remembered). But Mr. Schwarz was getting chamber music–style interplay from his woodwind principals, and the

strings were caressing the notes with loving feeling. "Terrific," I wrote in my program. "Clarinet!"

The success of that movement made me sit straighter in my seat. Not that I, like all critics, don't concentrate fully on every movement of every performance laid before me, good, indifferent, or horrific. But the prospect of further pleasure aroused my powers of attention. Suddenly, I was on the performance's side, rooting for further revelations.

And they were forthcoming. The "Merry Gathering of Country Folk" was delightful, with more piping winds and rollicking brass and double basses. The "Thunderstorm" may have lacked the weight of a one-hun-dred-player-plus modern symphony, but it gained in intensity from the focus of Mr. Schwarz's interpretation and the lean strength of forty musicians working tightly together. And the final "Shepherd's Song: Happy and Thankful Feelings after the Storm" sang with buoyant momentum.

A good performer is like a storyteller, drawing in his listeners and compelling them to pay attention. More, he makes a listener hang on his every sound, caught up in a timeless mental state that psychologists tell us is very close to the meditation practiced by gurus or the creative concentration that makes anyone seized fully by a task (repairing a car, composing a string quartet) oblivious to all else.

A West German scientist has even objectively measured such states, wiring up a bunch of fanatic Wagnerians at a Bayreuth Festival *Meistersinger* and measuring their pulse rates, blood pressure, and so forth. He found that they all reacted pretty much the same when Wagner's good bits (the entrance of the assembled Mastersingers in the second scene of the third act, for instance) came along. Which in turn suggests that there really is such a thing as a like-minded, like-feeling community of music lovers caught up together in a great performance.

The "Pastoral" is like an opera, in that it has a "program," a narrative line hinted at in the movement titles and in more specific indications (identifications of particular birdcalls) within each movement. Beethoven's music can therefore be heard as the illustration of an actual narrative tale—or that tale can be altered and elaborated, as Walt Disney did in *Fantasia*.

But the true drama of a good musical performance lies on a musical level, not a verbal or narrative one. It is the sensuous beauty of flutes counterpointed with oboes and clarinets, the gathering energy of a vigorous Allegro, the climactic power of terpsichorean repetition that thrills the music lover, not some vision of carousing peasants.

John Cage, our avant-garde father figure now about to celebrate his seventy-fifth birthday, has long urged listeners to take a more active role in the musical experience. For Mr. Cage, the ultimate "performance" requires no performers at all, just a listener totally attuned to the benevolently anarchic sounds of nature.

Yet for all the Oriental wisdom of that notion, and all the value of encouraging us to a greater meditative concentration, there is something onanistic about Mr. Cage's image of the solitary soul attuned to the cosmos. A more human vision is of a partnership, a dialogue between performer and listener. Just as it's Mr. Schwarz's job to perform the best "Pastoral" within his powers, it's my job to pay as close and loving attention as I can. And if everything is working as it should, his performance will heighten my concentration, and my concentration will make— within my own being—for a better performance. That night in Avery Fisher Hall, Mr. Schwarz did his job, and I like to think I did mine.

GROUPIES

The New York Times, August 16, 1987

Groupie memoirs and interviews, of which there has been a recent onslaught, might seem only peripherally related to actual music. But at their best they shed light not just on the world of rock, but on music itself.

If ethnomusicologists are to be believed, all music stems from primitive rituals, reflecting mankind's most basic physical and psychological needs. Cave music was also an attempt to propitiate angry gods, and temple priestesses sometimes worshiped those gods by worshiping their priests.

In the nineteenth century, as a secular sensibility spread over the Western world, it was common to discuss romantic artists as having usurped the role of religion. Virtuosos like Liszt commonly inspired the most extravagant, swooning flights of passion from their female admirers, highly born, courtesans, and otherwise.

In our own time, while classical music became more severe and

abstract, these functions of the charismatic mass performer were assumed by popular musicians. Frank Sinatra had his bobby soxers, whose more candid reminiscences take on an overtly sexual tone. But it was rock that really unleashed groupie passions—usually (but not always) female passions for usually (but not always) male stars.

As social mores grew more liberal in the late '50s and '60s, rock became the anthem of youthful sexuality (its very name is black slang for copulation). Male rock stars—many of whom frankly admit that they first thought of becoming musicians to attract girls—performed like peacocks, strutting and crowing of their prowess. Their songs are single-mindedly about love, not to say sex (George Michael's current hit single "I Want Your Sex" being only the most recent graphic example). They dress to stress their flamboyance and sometimes even their male attributes (Ian Anderson of Jethro Tull always wore a codpiece). And their videos are frequently soft-core fantasies of males wafting through gauzy roomfuls of languorously draped models.

Thus while there is certainly a sordid side to some groupie cavortings, the notion of an ecstatic, romantic, even sexual response to a powerful performer has deep roots in human behavior and musical history. And when one combined that with the sunny, peace-and-love ethos of California in the '60s, groupies blossomed.

That's why of the current outpouring of groupie literature the brightest, sexiest, funniest of the lot is Pamela Des Barres's new *I'm with the Band: Confessions of a Groupie*. Other books relating to this subject include Stephen Davis's *Hammer of the Gods: The Led Zeppelin Saga*, a sometimes lurid history of that archetypally strutting British blues-rock band, and Victoria Balfour's *Rock Wives*, just issued in paperback, which describes in words and present-day pictures the often thoughtful reminiscences of seventeen present or former rock wives, girlfriends, and groupies. All three of these tomes, by the way, are published by William Morrow or its Beech Tree Books subsidiary; somebody over there has a mission.

Pamela Ann Miller, or "Miss Pamela" (courtesy of Tiny Tim, who called all women Miss, his wife, Miss Vicky, included), was the queen of Los Angeles groupies in the late '60s and early '70s. Her fame derived in part from the number of "notches on the handle of my love gun," as she puts it with her characteristic blend of innocent vulgarity and knowing kitsch, and in part from the sincere affection, maybe even love, so many of her famous admirers felt for her.

Miss Pamela was a West Coast Edie Sedgwick—Andy Warhol's brightest "superstar"—who survived. Born in Hollywood and raised in the San Fernando Valley, she was thus a proto–Valley Girl, and in fact the kinship is direct. Frank Zappa made her a protégé, the leading member of his experimental groupie band Girls Together Outrageously, or the GTOs, whose one album of 1969, *Permanent Damage*, can be said to have prefigured the female amateur bands of the punk era (it was terrible, but it remains a sweet time capsule of an era).

Miss Pamela babysat for Frank and Gail Zappa's two older children, Moon Unit and Dweezil (Mrs. Zappa is one of Ms. Balfour's subjects). And it was Moon Zappa who—in another of daddy's bits of masterminding—wrote, sang, and starred in the "Valley Girl" novelty single of 1982 that popularized Valley Girldom as the archetype of southern California suburban culture.

Blonde, angelically pretty, and blessed with a big, endearing grin and dimple, Miss Pamela, who always seemed to enjoy the love and support of her parents, had her first rock-star crush with a classic case of Beatlemania, Paulmania to be precise. Her vividly written description—no ghostwriter for her—of hysteria for the Fab Four matches any bobby soxer memoir yet penned.

The closest she got to her goal, however, was John Lennon's face staring at her through a limousine window, "full of sorrow and contempt." Soon her self-confidence returned; at Lenny Bruce's eulogy, of all places, she was suddenly suffused with "stand-up-straight pride about being a blonde American girl, so ripe, I was about to pop off the tree." Having duly graduated from high school in 1966, she sustained her full-throttle groupie career about six years, from the age of nineteen to twenty-five, ending up with sometime rock star Michael Des Barres, to whom she has now been married for thirteen years; they have one son.

The standard negative responses to her tale are: (a) this is a horrible, immoral, pitiful, wasted life; (b) it's a betrayal of feminine integrity in a search for self-assertion through men; (c) it's a classic case of teenage fantasies carried to their logical extreme but frozen emotionally at the sixteen-year-old level.

But wait: No doubt Miss Pamela had and has her neuroses; who hasn't? No doubt she upset some people, and perhaps she doesn't deserve the Nobel Peace Prize just yet. Perhaps there are other, deeper ways to respond to rock music than as lust made aural.

Yet to deny the raw emotional power of rock is to repress a positive part

of it and all music. Miss Pamela represented something honorable and loving about southern California and the '6os, about hippies and innocent hedonism, and even about the sexual honesty of modern women, that modern-day moralists ignore at their own peril.

Or, as she herself put it in her lyrics to the GTOs song "I'm in Love with the Ooo-Ooo Man": "Remember girls, please don't stop hoping / Never say your love is wasted / Love is only for giving / And something that cannot be taken."

SINGERS AT THE METROPOLITAN OPERA
The New York Times, January 3, 1988

Ever since the Rudolf Bing era ended and the Metropolitan Opera was gradually taken over by its board of directors, company administrators have offered a flurry of excuses about their inability to cast as many superstar singers as veteran Met audiences were used to.

Perhaps it's just that there are fewer of them now than in any of opera's several golden ages. But we are also reminded that there are more opera houses now, both in the country and in the world. Singers prefer to stay in Europe, close to their homes and within easy reach of other quick, money-making engagements. European fees are way up, too, from the era in which singers were expected to be humble ensemble members and stick dutifully to their home base.

There is no doubt some validity in all of this, and we might add another factor that the Met chooses to deemphasize—that its own casting personnel and administrative leadership may not be as efficient or flattering or ego soothing or persuasive as they could be.

But there is a big irony to all this Met hand-wringing: what do the Met's current managers think accounted for the plethora of superstars at the old "yellow brick brewery" at Broadway and Thirty-Ninth Street from the Met's founding in 1883 to 1966? The answer, down at the bottom of the pile, is money: singers came to the Met because the Met paid them enough to make it worth their while.

To be sure, intangibles may have entered into the picture after that.

Once notable artists had begun to gather at the Met, and once the house had established a reputation as a singer's haven, others may have wanted to come there, too, either to share in the artistic excitement or, just as important, to share in the glory. But the Met, founded by a rump group of newly rich patrons who were denied boxes at the snootier Academy of Music, got its first singers by paying them buckets of money. And so beneath all the rationalizations, it's tempting to speculate that the simplest explanation for the company's current singer crisis is that it doesn't or can't or won't pay top singers enough.

Art always marches alongside economics. The social history of opera is as much a story of high-society self-display, of opera as a trapping of worldly success, as it is of purely abstract artistic idealism. America in the late nineteenth century, the Civil War behind it and a bright economic and political future ahead, was a land of millionaires at a time when having a million was rather more impressive than it is today. European singers may have complained about traveling to the barbarous New World, and were far more isolated from home and close-by European theaters than now. But they came, and they came because they were handsomely paid. Obviously, with Europe at war or in economic crisis, the discrepancy between what they could earn at home and what the rich Americans were offering grew even greater. But even in times of European peace and prosperity, America in general and the Met in particular simply marched out boldly and bought its superstar talent by the boatload.

Today, with such singers as Renato Bruson and Giorgio Zancanaro breaking their Met contracts apparently because they can get more money in Italy, times have definitely changed—not just for the Met but for this country, as the dollar declines and the trade deficit widens.

Bruce Crawford, the Met's general manager, says the Met's current top fee is $9,000 per performance. Some Italian companies are paying star singers up to and beyond $20,000 a night. Should Renato Bruson be presumed to operate on different, higher moral standards than athletes who hold out until they are traded or their contracts are renegotiated? One may talk about artistic conscience or fan loyalty or all manner of mitigating factors. But what would you do, with a limited career span and a family (or an ego) to feed?

So, the logic continues, if the Met really wants lots of star singers back on its stage, night after night, all it has to do is raise fees and beat the competition. Yes, the budget is high, but it's all a matter of priorities

and sheer, raw disposable wealth. What would happen to the company's coffers if an internal decision were made to raise the top singer fee to $20,000 or $25,000 or $30,000? How much would be added to what is already in the $80-million-a-year range of expenses?

Let's say it would add $5 million or $10 million to the budget. Surely there could be found enough hard-line Met "canary fanciers" to come up with the needed money. If not, then perhaps the options of darkening the house one night more per week, or cutting short the season a bit, or giving more concerts or ballets or renting the house out more often could be considered. One could also cut back on new productions or their lavishness. I would not advocate either of the latter two options; the Met is remiss enough as it is in matters of stagecraft, and it could hardly be more conservative than it already is in repertory.

One might argue that better artistic results could be obtained by more imagination and taste in the casting of mid-level singers. Undoubtedly true, but if the Met had the ability to exercise that option, it would have done so already.

Other opera-house managers, in the clubby world of opera administrators, might complain that the Met was starting a price war. But the crude truth of the matter is, that's what got the Met its reputation in the first place. Do you think the moguls of Thirty-Ninth Street worried squeamishly whether the English or the French could match their fees?

That's the way the Met always used to operate: hurl money at singers, and let questions of artistry and etiquette fall into place after that. I am not saying that the Met should simply revert to its old status as opera's fanciest aviary. There's still room for taste and style and imagination, if the company knew where to look and what it was looking for. But mere singers? Easy. Buy 'em.

CECIL TAYLOR

The New York Times, May 22, 1988

Cecil Taylor has been before the public—some sort of public; he has never commanded anything approaching a mass audience, despite all

his critical acclaim—for more than thirty years. Yet those who admire his music, from critics to musicians to plain fans, still grope for ways to describe it.

That conundrum won't be resolved by his latest releases, both on the limited edition English import Leo label, available through the New Music Distribution Service: a two-disc set with Mr. Taylor and his latest group, or Unit, as he calls his bands, *Live at Bologna* (LR 404/405; LPs only), and a single solo disc of spoken poetry with percussion and over-dubbing, *Chinampas* (153; LP only). Another two-disc set, *Live in Vienna* (LR 408/409), is promised for September.

There are two basic critical strategies for dealing with the Taylor dilemma. One is to fall back on metaphorical evocation, describing the torrents of energy unleashed by Mr. Taylor's virtuosic piano playing, his hours-long, feverish flights up and down the keyboard with all manner of percussive effects, clusters, and general explosions of physicality thrown into the mix. In this case, his other musicians are judged by their seeming ability to answer or at least support his pyrotechnics.

The other approach is generic, to attempt to pinpoint him in terms of influences or equivalents. By this strategy, much stress is laid on his childhood piano lessons, his training at the New England Conservatory of Music, and then (the argument goes) his deliberate, lifelong struggle to throw off the burden or the stigma of an academic musical education and to replace it with jazz (Ellington, Powell) and a rawer, more instinctual attestation to his black African identity. By this argument, his musicians are appraised on how well they uphold or contradict the critic's biases for or against modernism or funk or ethnic exploration.

Mr. Taylor himself, who by all accounts is an extremely defensive, angrily scornful man, has mocked both approaches. The trouble with the impressionist tack is that it fails to distinguish him from any of his peers and followers, from 1960s free-jazz erupters to 1980s "free-improvisation" avant-gardists. The trouble with the generic approach is that it can lose Mr. Taylor's uniqueness in a welter of contradictory influences.

Clearly, there is something to all sorts of attempts to come to terms with this music. It can indeed seem like a rush of roiling energy, and one can indeed hear or at least adduce parallels between his fractured syntax and the modernist line from Stravinsky and Bartók to Milton Babbitt and Elliott Carter. Not to speak of such overt followers as—in their very different ways; we wouldn't want to disparage anybody's individuality here—Anthony Braxton, Anthony Davis, and John Zorn.

Composers, even the most original of composers, partake of a zeit-geist. Clearly there are some connections, even if hotly denied by those being so connected, between the Art Ensemble of Chicago's ritualized Africanisms and fervent eclecticism and Ornette Coleman's driving energy and Mr. Taylor's improvisation, a kind of compacted, instantaneous composition. All speak with the energy of modern urban life, all harken back to distant (in time or space or both) roots, and all balance the demands of freedom and form that have occupied the attentions of so many mid-century composers, jazz and otherwise. To recognize such links, or to adduce further similarities between these musics and the energy and vitality of a wide range of modernist and postmodernist "classical" composers, is hardly to deny Mr. Taylor his well-won originality.

Live at Bologna captures a single set played last November in that Italian city by what seems basically to be the pianist's latest Unit: William Parker, bass; Carlos Ward, reeds; Leroy Jenkins, violin (Leo Smith, trumpet, replaced him in club dates here a few months ago); and Thurman Barker, marimba, drums, and percussion. The music is continuous over three and one-half sides, with an encore at the end.

Even those who respect Mr. Taylor's feisty independence and remarkable technical facility have complained about what seems like an excessively unrelieved assault of aggressive energy: it's involving, even thrilling, but it cries out for moments of relaxation to set the energy into relief.

Those moments come here. The members of the quintet seem especially responsive to Mr. Taylor and to one another, and there are long passages of really lovely quiet music to be enjoyed for themselves and to prepare for the patented steady-state climaxes. Particularly on the second side, when Mr. Barker's marimba is partnered by soft flute and airy piano, along with what sounds like the happy chanting and chatting of an African ethnomusicological recording, an almost gentle Taylor begins to emerge.

Not that he's lost his bite. Gradually his piano transforms this material into something edgy and uneasy, and soon enough we're back to manic angst. Yet all in all, the range of moods and styles and textures on this set is wide indeed, and welcome in its reach.

Still evident, especially in a group as attuned to itself as this one seems to be, is the delicate, fascinating, only dimly graspable way in which composition and improvisation interact; much of the interest of the music, in fact, lies in the very effort one is willing to make to perceive that mystery.

All jazz, perhaps, consists of a balance of these tendencies, of some sort of notated or mutually understood basis for improvisation alternated with free flights by each player. But with Mr. Taylor, the shared material is not a familiar tune and the flights of improvisation don't come in a predictable round of solos. The interchanges take place in microbursts, high-intensity tradings of fragments and ideas back and forth, all at telegraphic speed.

If Mr. Taylor's music reminds me of any one classical composer, it is Mr. Carter, who himself had an early interest in jazz. Both men place a premium on hair-trigger responsiveness among the lines and parts and actual players. The difference is Mr. Taylor's own virtuosity, his concern for black cultural identity, and the greater latitude allowed each of his players.

The poetry disc will be a harder nut to crack, even for those who already know Mr. Taylor's music. The poems are true 1960s artifacts, whenever they may have been written—mystical rambles with intellectualized erotic overtones, verbal sound effects, percussive underpinning, and occasional dual tracking. For Taylor admirers, however, they recall the diversity of his interests, offer further insight into his music (in a well-known quotation he compared his piano playing to the leaps of a dancer; this disc suggests a link to the flights of a scatting poet), and seem themselves to breathe the energies of his piano playing.

Now fifty-five years old, Mr. Taylor will almost surely never command a mass audience, or reap the financial rewards such a command (and, no doubt, compromises) would bring. He remains the artist, proud and alone in the best high-art tradition, with the further resentment of working in a supposedly vernacular tradition that denies him the respect and rewards that similar artists (like, say, Mr. Carter) expect from the high-art academic establishment.

Yet cruel as it might sound—critical respect and a token will get you on the subway—isolation is something Mr. Taylor has in part courted through the determined purity of his music, and something that in turn serves to protect that purity. Caught between the jazz mainstream and the sober respect accorded establishment classical artists, Mr. Taylor travels his own path. But more and more, it's a path that others, maybe too far back along the road to do him any immediate good, but on the road nonetheless, have begun to follow.

JEROME SIRLIN AND *1000 AIRPLANES ON THE ROOF*

The New York Times, December 16, 1988

Note: After his burst of fame, Jerome Sirlin disappeared, at least insofar as prominent productions were concerned. A great pity.

There are two main collaborators behind 1000 *Airplanes on the Roof*, an avant-garde, mixed-media piece of crossover musical theater that opened Wednesday night at the Beacon Theater for a run through Tuesday. But the third partner neatly steals the show.

The project belongs primarily to Philip Glass, for whose ensemble of electronic keyboards, amplified winds, and wordless soprano this is a touring vehicle. Mr. Glass, who is also the stage director, provides a nearly continuous ninety-minute score to accompany a dramatic monologue by David Henry Hwang. Mr. Hwang wrote the play M. *Butterfly* for Broadway and will provide the libretto for Mr. Glass's opera *The Voyage*, due at the Metropolitan Opera in 1992.

Mr. Glass's music is, well, Glassian: rock-band loud, full of rippling arpeggios and repetitive syncopations, with some appealing variants on his familiar style but an all-too-dogged reliance on that style. At least it doesn't aggressively disturb one in its sameness, instead receding deferentially as underscoring to Mr. Hwang's text.

That text is a tale of a man who has probably been abducted by aliens and then returned, altered and alienated, although he may be just nuts. He rants and he raves, unable to connect with anyone (including the audience), fearful of his past, just wanting to forget the teeming images in his brain but unable to quell them.

Mr. Hwang has some fine ideas: the evocation of a beehive to suggest alien swarming, a striking panorama of human faces mutating into the past and the future. But at least in Patrick O'Connell's recitation, halfway between actorish overemoting and stand-up comedy, the character never strikes home emotionally. Mr. Glass seems to have exercised precious little shaping of Mr. O'Connell's performance. Mr. Hwang and Mr. O'Connell court cheap laughs and get unintended ones in places that subvert their presumed intent. And the intellectual complexities of the text never cohere into emotional veracity.

That leaves the look of the show, which is dazzling. Jerome Sirlin's

credits include Wagner's *Ring* at Artpark near Niagara Falls and Madonna's 1987 world tour. He specializes in projections on cleverly designed backdrops through which actors can enter and exit. The images are ingenious, beautiful, and powerful, and the technical expertise they show is astonishing. Mr. O'Connell seems to leap across New York City buildings, or stand before an ordinary apartment, or disappear within the alien swarm. And the final picture of him fading out among heavenly stars was more moving than anything in the text or the music.

One hopes, as one has hoped before, that Mr. Glass—whose best music remains some of the most impressive of our time—will gather himself together and stretch for a new level in *The Voyage*, if not sooner. One hopes, too, that Mr. Hwang can tame his teeming cleverness long enough to make his often wonderful ideas serve deeper human needs.

For Mr. Sirlin, one hopes only that he gets continued opportunities to dazzle and enlighten us. To see his work in a specially rebuilt theater, with projection screens on more than one side of the audience, could be remarkable.

For now, *1000 Airplanes* isn't long, and it passes the time beguilingly enough. But it is for its visual pleasures above all else that this show is worth attending.

HERBERT VON KARAJAN AND BRUCKNER

The New York Times, February 28, 1989

Herbert von Karajan and the Vienna Philharmonic are presenting two programs in their three-concert visit to Carnegie Hall. Saturday's—to be repeated tonight—was an almost pops affair devoted to Schubert's "Unfinished" Symphony and various confections of the Strauss waltz dynasty. But Sunday night, Mr. Karajan got serious, with Bruckner's Symphony No. 8 in C Minor, all eighty-nine minutes of it in his statement of the Haas edition.

Bruckner's Eighth might itself seem almost a warhorse by now. It's one of Zubin Mehta's favorites, and guest conductors program it frequently.

Klaus Tennstedt played it with the Philadelphia Orchestra just last month, and others who have led it here in this decade include Giuseppe Sinopoli, Günther Herbig, Daniel Barenboim, and Eugen Jochum.

But Mr. Karajan owns this score; his interpretations of it stand on another level altogether, both in relation to other conductors and to his own work in other music. Whether in concert or on his several studio recordings with the Vienna Philharmonic or the Berlin Philharmonic, this is surely the way this symphony was meant to be heard.

Pale and frail as he is, Mr. Karajan seems to have lost nothing of his ability to control an orchestra and to encourage it to realize his intentions. This was the type of concert to tell your grandchildren about, and was greeted with deserved, fervent ovations.

To say that any conductor "owns" a score is of course hyperbole: it is possible to imagine others shaping it in different, perhaps even equally persuasive ways. In particular, Mr. Karajan's image of the Scherzo has grown downright sleepy and sly over the years, underplaying the bucolic vigor and substituting a deft subtlety.

But unlike so many scores in which decades of reworking have drained the lifeblood from his interpretations, the Bruckner Eighth remains vital and soulful under his ministrations. Indeed, one can almost hear it as self-affirmation, the credo of an Austrian musician who responds to the craggy grandeur of his beloved Alps yet anticipates with grandiose, mystical fervor the heavenly raptures he fully expects will be his.

Even with an occasional blooper in massed brass chords, the Vienna orchestra's playing was magisterial—and with great playing, the "new" Carnegie Hall acoustics sound pretty fine, except for a slightly pinched quality in fortissimo chords. On page after page of the score, remarkable felicities caressed the ear. Some of these were Mr. Karajan's, as in the chamber-music delicacy of passages most other conductors hasten through on their way to the next climax. Others were the birthright of this ensemble, especially the creamy strings and mellow horns.

Gorgeous sound has long been a Karajan trademark. What distinguishes his Bruckner Eighth is the way he translates those sounds into profound musical meaning. Mr. Karajan is rightly considered one of the great conductors of this century, and that act of translation is what great conductors are supposed to do. He hasn't always accomplished it in other repertory, especially in the last twenty years. But with this towering symphony, he proved he hasn't entirely lost his touch.

A MUSICAL FREE SPIRIT WARMS UP FOR CARNEGIE

The New York Times, April 20, 1989

Note: *There aren't many straight interviews in this collection, but I love Celibidache's quotes. As Bruce Springsteen said, all we street poets have to do is stand back and let it all be.*

From a careerist standpoint—an implication from which Sergiu Celibidache would recoil with disdain—the appearances of this seventy-six-year-old cult conductor tomorrow and Saturday night at Carnegie Hall have been brilliantly orchestrated.

Mr. Celibidache is a Romanian-born, West German–based maestro whom few classical-music lovers have heard. Before this current tour with his orchestra, the Munich Philharmonic, he had conducted only once in this country, a single Carnegie concert in 1985 with the student orchestra of the Curtis Institute of Philadelphia. He has made no recordings, because he regards them as distortions, although pirate Celibidache discs of erratic quality exist. He has performed most of his life with obscure orchestras.

Nonetheless, tales have proliferated of his fierce refusals to compromise, his thirty to forty hours of rehearsal for every program (compared with the average five to nine hours), his incorrigible insulting of his colleagues. His every performance provokes at least some critics to awed rapture.

But no genius, or even would-be genius, can exist without controversy, and controversy has dogged this three-week North American tour. There are those who seem to regard Mr. Celibidache as little more than a charlatan.

Criticism seems merely to reinforce Mr. Celibidache's messianic self-righteousness. "The fact that I have been attacked—that I have been called a fool—gives me enormous encouragement," the conductor said the other day in his Manhattan hotel suite. "A fool cannot create the conditions to bring everybody to a transcendence."

In conversation, the conductor exudes the theatricality of the true maestro, mixing grandiose Germanic turns of phrase with flamboyant Mediterranean gestures and expressions.

Mr. Celibidache was born in Romania in 1912 and completed his

musical education in Berlin. When World War II ended, he won a conducting competition and, since he had no "political past," as he put it, he was permitted to assume the temporary directorship of the Berlin Philharmonic. Since 1952, he has wandered Europe, seeking tolerable working conditions; Munich has been his base since 1979.

Mr. Celibidache regards his music making as part of a larger spiritual mission, teaching courses in what he calls "musical phenomenology." Just what, his visitor asked, is that?

"Until you and I speak the same language, I could not possibly explain such a complicated matter within two hours," Mr. Celibidache announced.

Is it influenced by Zen Buddhism, of which he has been a longtime student?

"You are a Buddhist," Mr. Celibidache answered. "You just don't know yourself. The end of any spiritual discipline is Zen. You cannot do anything if your ego intervenes. You must be empty. We all can transcend this world of the senses, but we must not want to."

Does this mean he admires John Cage, who has done so much to apply Zen ideas to composition?

"He talks about things of which he has no idea." Mr. Celibidache replied. "The question is, what is behind thinking? The answer is reality. But thinking has no access to reality. My work as a conductor is to give you a chance to pull down the veil. You must be spontaneously open to anything that happens: Free of style, free of will, free of culture.

"If you do this, you will say not that this is the most beautiful music or the greatest orchestra but 'It is so.' You will have reduced all the complexity of perception to one, and this one is yourself. And that is the divine origin of man."

In his years of wandering after 1952, Mr. Celibidache worked largely with radio orchestras. This might seem odd, given his aversion to electronic documentation, but they were the only ones who would accede to his extreme rehearsal demands. Those demands also help explain his failure to appear in this country.

Endless rehearsal could reduce music to mannerism and musicians to robots. But Mr. Celibidache says his purpose is to attain a level of intense, participatory spontaneity.

"My greatest enemy is routine," he said. "If we play the Bruckner Fourth"—which comprises Saturday's entire program—"four times, I

will take the score before the fifth concert and look at it like a child. That way, Bruckner happens, Bruckner takes place. This is my work."

Mr. Celibidache's ten-year relationship with the Munich Philharmonic has been stormy, with the conductor chafing at the budgetary limitations of a municipal ensemble considered the second in Munich, after the Bavarian Radio Symphony.

Mr. Celibidache has had to make compromises to sustain his personnel. Those compromises also include offering conventional programs, constant repetitions ("We played Strauss's *Heldenleben* eleven times — imagine!") and even soon-to-be-released video discs, which he justifies as "documentation, not music at all."

Why compromises now, after a career based on their avoidance? "I am a very poor man, and I will die poor," he replied. "There is no way I can make the money to have an orchestra with perfect independence."

But even in this world of illusion, Mr. Celibidache keeps his eye on a higher reality, and music is a key to it.

"I am a very religious man," he said, "but I only became ripe to the revelation, to the transcendence, at a very late age, at forty-two, during a concert in Venice. Then I understood that the beginning was in the end, and all my doubts disappeared.

"If you are at bar 14, bar 14 did not come out of nowhere. It came from bar 13, bar 10, bar 1. I must be there in order to transcend bar 14. But being there I am at the beginning also, I am at the end also. I am there because I am not there. This is the end of logic.

"Tempo is a spiritual condition; it has no physical relation to speed. You can perceive music as one effect after another, but this is not a musical perception. The musical perception is the eternal one.

"Music has nothing to do with sound. Sound is the vessel, the glass, the vehicle. So is rhythm, so is harmony, so is everything. The purpose of music is not to be beautiful. Music is not beautiful. Music is truth. Music is reality."

In addition to his teaching and conducting, Mr. Celibidache is also a lifelong composer, but his music has gone largely unplayed: "I would need another life to fight for it," he explained.

And what does the music of this musical spiritualist actually sound like?

Mr. Celibidache replied with a mystifying smile, "It is exactly what you would write if you were a free human being."

ASTOR PIAZZOLLA

The New York Times, April 27, 1989

To an innocent outsider, it might seem no big deal that Astor Piazzolla, the master of the tango, had changed his ensemble from a quintet to a sextet. To tango lovers, it is a very big deal indeed, Mr. Piazzolla's first new band in twenty-seven years, and Alice Tully Hall was full Monday night to witness the "world debut" of his new ensemble.

Mr. Piazzolla had announced the new group in Buenos Aires just last week, but it had clearly been in preparation for a lot longer than that. Much of the material was new, specifically written for the new configuration, and the older titles had been rearranged. Furthermore, the level of execution was so accomplished that much rehearsal lay behind the performances.

He counts as the tango master partly because of his veteran status (he is sixty-eight years old) and longtime popularity, and partly through his venturesome efforts to expand the tango genre beyond its slightly sleazy origins. In Argentina, the form has long been the repository of an entire range of cultural feelings, dreams, and aspirations.

Mr. Piazzolla, who had considerable classical training (including a year in Paris with Nadia Boulanger, the mentor of so many American composers), has pushed the tango still further, into opera, theatrical ventures (*Tango Apasionado* and the reworked *Tango Orfeo*), and musical modernism. Monday's concert was presented by the prestigious Composers' Showcase organization.

The new sextet—six Argentines of Italian descent, as Mr. Piazzolla proudly pointed out, dressed all in black—differs from the old quintet not merely in numbers. Remaining are Mr. Piazzolla himself as leader and principal player of the bandoneón, the Argentine accordion, along with Horacio Esteban Malvincio on guitar and Hector Lopez Console on bass. But there is a new pianist, the sovereign Gerardo Jorge Gandini. And instead of a violinist, there is a cellist, José Bragato, and a second bandoneónist, Julio Oscar Pane.

This instrumentation lends the entire texture a darkness that goes beyond the black attire. The two bandoneóns can sound airy and light, like an expanded Michel Legrand ensemble. But they can also evoke organs and mournful pedal points. And with Mr. Console's densely layered pianism, the modest contributions of the guitar (either deliberate or

the result of a poor sound mix, about which Mr. Piazzolla and the others were constantly grumbling), and above all the presence of the two low string instruments, the effects were often downright somber.

The music in each half began with shorter tangos conceived in modernist terms or colored by modernist effects—dissonant harmonies, abrupt interjections, fracturing of the expected rhythms. The sets then proceeded to longer, suitelike structures, some lasting up to fifteen minutes, with a sequence of sections and movements.

To this taste, not steeped in the tango as a national heritage, the effect was still a little like trying to make an entire meal out of fancy candies: no matter how Mr. Piazzolla struggled and twisted, he was still gussying up a form of music rooted in popular dance. But both in the abstract and especially within the evolutionary context of the tango subculture, his achievement was certainly very striking, and wildly applauded by his adoring audience.

HERBERT VON KARAJAN AND MORTON FELDMAN IN HEAVEN

The New York Times, July 30, 1989

Note: Pardon the self-congratulation, but this is one my favorite pieces. Maybe my favorite.

Two weeks ago today, Herbert von Karajan died. Probably the best-known conductor of the post–World War II era, he epitomized worldly success, with his adulatory audiences, hopelessly sold-out concerts, record sales in the millions, and lavish life style.

But as I wrote his obituary, another name kept creeping into my mind, and for a while I couldn't figure out quite why. That name was Morton Feldman, a largely unknown—to the general concertgoing public, that is—minimalist composer who died at Buffalo General Hospital a little less than two years ago. I wrote his obituary, as well, and couldn't help musing on the disparities of their lives.

Karajan was a renowned Wagnerian, and he might have appreciated

a Wagnerian comparison between himself and Feldman. The conductor was not a tall man, but he towered like Wotan above the musical world, especially that part of it triangulated by Salzburg, Vienna, and West Berlin. And down below, scrabbling among the rocks and lusting after stray Rhine Maidens, was the Alberich of this particular piece, Morty Feldman.

This vision goes astray, however, in that Karajan and Feldman played different dramas. While Karajan strode the peaks of earthly success, Feldman operated across the ocean, in the byways of American avant-gardism and academia. One doubts if Karajan ever heard of Feldman, or if Feldman cared any more about Karajan than he might have cared, say, about Mercedes-Benz annual production figures.

But there is still a contrast to be made between these two very different musical lives — between the material success that is the reward of the famous performer and the tenuous hope for posterity's favor that is the lot of the vanguard composer.

Decades or centuries from now, what will history's judgment be of these two men? The romantic notion would be that Karajan will occupy an honorable footnote in the history of conducting, nowhere near so important as Bülow or Nikisch or Toscanini or Furtwängler or Klemperer, but noteworthy, nonetheless. And Feldman will be a famous figure, his music played constantly and his historical position assured as John Cage's most important, musically gifted follower and the precursor of an entire tradition of meditative masterpieces.

But there are other scenarios. Perhaps both men will be forgotten, or both will be famous. Or, unromantically, Karajan's reputation will swell to Furtwänglerian proportions, and Feldman will be utterly forgotten as soon as those who knew him during his lifetime have themselves passed away.

My own hope is for a modified version of the first prognosis. Karajan doesn't deserve to be consigned to the footnotes. He was an important symbol of the twentieth-century music business, of the commercial world of classical music and its need for marketable idols.

He was also a conductor of undoubted gifts, especially in the 1950s and '60s. And his talent for orchestral sonorities, along with his ability to elicit magisterial performances of the music of a few beloved composers — above all, Bruckner — remained undiminished until the end. His truly wonderful performance of Bruckner's Eighth Symphony with the Vienna Philharmonic at Carnegie Hall in February was proof enough of that.

But Feldman was a wonderful composer, and composers count higher than performers in the celestial musical hierarchy. In some genres of music, composers and performers are inseparable, and perhaps that's ultimately the healthiest situation. But at least in the way responsibilities have been divided in modern classical music, composers create and performers recreate, and creation is the ultimate gift.

One might argue that it is capricious and arbitrary to choose Feldman as a spiritual contrast to Karajan's worldly glory. Wouldn't any obscure avant-gardist do—Andrzej Panufnik or Luigi Dallapiccola or even Elliott Carter, none of whom have enjoyed anything like the wealth and fame and applause accorded our mightiest maestros?

Feldman kept coming to mind not just because of his curious polarity of image and background with the elegant Austrian—an American who proudly retained his New York ethnicity to the end.

The curious thing was that had these two very different career tangents actually intersected, composer and conductor might have made fruitful contact. Anyone who loves Bruckner can't have found Feldman's slowly unfolding sonic tapestries all that alien. And Feldman, for all his feisty eccentricities, was hardly immune to the lure of powerful, persuasive performers to propagate his work.

Feldman was proud of Cage's description of him as a "poetic extremist," and had a mystical notion of the extended breadth of works like his six-hour String Quartet No. 2.

"Form is easy," he once said "just the division of things into parts. But scale is another matter. You have to have control of the piece; it requires a heightened kind of concentration."

Karajan had that concentration. A forty-year student of yoga and Zen Buddhism, he transcended the slickness and overrefinement that eroded his interpretive gifts in his last decades when he could address music that favored such meditative control—like Bruckner's.

So maybe, in heaven, these two radically dissimilar men are still occupying separate clouds, unaware of their respective angelic existences. But maybe Karajan is even now encouraging Feldman to compose a Brucknerian symphony, and maybe its performance will fill the celestial concert hall with sounds of truly heavenly length.

And maybe, just maybe, Karajan has humbly accepted a modest place in the musical pantheon, deferentially below Feldman's. That image may not be very poetic. But it would be just.

AMANDA ROOCROFT

The New York Times, September 4, 1989

Careful readers of the English magazine *Opera*, those who bother to devour all the fine print down to the "fringe" and school performances section of local British esoterica in the back, may have perked up a bit on page 623 of a recent issue.

There Michael Kennedy, who otherwise plies his critical trade at *The Sunday Telegraph*, in reviewing a performance of Handel's *Alcina* at the Royal Northern College of Music in Manchester, described the "thrillingly beautiful singing" of a young English soprano named Amanda Roocroft. "In forty years of listening to young singers," he wrote, "I have never before heard, at this stage in development, a phenomenon to surpass Miss Roocroft."

An appetite whetter if there ever was one. Although Mr. Kennedy went on to caution that she not be exploited "for the sake of a quick buck," he offered the sort of notice that will surely propel a career.

Shortly thereafter, at a performance of *Le nozze di Figaro* at the Glyndebourne Festival Opera, I found myself seated next to Mr. Kennedy. He confirmed his enthusiasm, which I found refreshing in this era of hedged judgments, and ticked off coming prestigious engagements for his discovery. And he whetted my appetite all the more.

Two days later, early for dinner in Aix-en-Provence, I wandered by the town square in which the local summer music festival does business. There, outside the little church courtyard in which recitals are given, the name of the scheduled singer had been crossed out and in its place was the name Amanda Roocroft, whose recital was to begin in five minutes. Culinary appetite momentarily displaced by aesthetic appetite, I slipped inside and took a seat.

Out came an attractive young woman in one of those puffy-sleeved gowns that recitalists unaccountably favor. She began to sing a song by Thomas Arne. It sounded pleasant enough, but the words were so mushy that the language (English) was not immediately identifiable. She continued in this vein for half an hour until, midway through her program, I had to leave for my dinner engagement. Afterward, a prominent critic long resident in England—and unaware of *Opera's* enthusiasm—dismissed Miss Roocroft's performance as "everything I detest about English singing."

So it would seem that her unstoppable ascension to international stardom may not be so assured after all. This critic finds himself somewhere in between adulation and condemnation. Mr. Kennedy made innocent reference to another "distinguished colleague" who had voiced reservations about Miss Roocroft's diction, although Mr. Kennedy "did not perceive this as a fault."

What we have here, for better and for worse in a still-young singer, is an archetypally English kind of "covered" vocal production, way back in the throat. The benefits of this method of singing are that register breaks are easily hidden, facilitating a smooth transition from mezzo-soprano low notes to ringing soprano high notes. A modern, non-English example is Carol Vaness. But this is an especially popular method of singing in England, and Mr. Kennedy himself compared Miss Roocroft to the young Janet Baker. As such, it is beloved in Britain, hated by a curmudgeonly minority elsewhere, and regarded case by case by the rest of us.

To this taste, Miss Roocroft at her best—an impassioned delivery of Mahler's "Um Mitternacht"—is a soprano of real promise. But there are some whom, the more she excels in her current method of singing, the more she will offend. It will be interesting to hear how she develops—whether she can modify her technique to overcome Anglophobic reservations yet still retain the fervid loyalty of early devotees like Mr. Kennedy.

HOW IS A MIGHTY INSTRUMENT FALLEN

The New York Times, December 3, 1989

There is no music, it sometimes seems, only musics—subdivisions of the universal art of aesthetically ordered sound that appeal to narrow constituencies, most of whom actively disdain the others. But in two decades of wandering through this musical minefield as a critic, I have come across one embattled community that seems to be scorned by the rest of the musical universe. Perhaps scorned is too strong. Dismissed and disdained will do.

That community is comprised of organists, but the real source of the

disdain is often their favored instrument, the organ. Otherwise tolerant, musically catholic concertgoers will aggressively volunteer their lack of enthusiasm for the organ and its literature and its concert rituals, as if such negativism were proof of their seriousness of taste.

The disdain seems particularly virulent in New York, which, apart from the underused organ at Alice Tully Hall, lacks a proper pipe organ in any of its other major halls, most lamentably Carnegie and Avery Fisher. That shortcoming robs all kinds of music of its specified instrumentation: little portable organs and electronic imitations are no substitute for a rumbling, trumpeting romantic pipe organ in full cry in scores like Saint-Saëns's "Organ" Symphony or Richard Strauss's *Also sprach Zarathustra*.

Particularly galling for the organ lover is the fact that both these halls once had pipe organs, which were removed during reconstructions. At Carnegie Hall, Isaac Stern defends his unwillingness to consider installing a new organ on acoustical grounds ("It would ruin Carnegie's sound, and that will only happen over my dead body," he once told me). This seems downright odd, since most of the world's great concert halls contain pipe organs.

The only really plausible explanation for this neglect, this denial by so many music lovers of palpable musical pleasure, is simple prejudice. Much of it must have to do with religious associations. The majority of organs are situated in churches, and most organists double as choirmasters, consecrating their careers to the church and eschewing the professional world of secular music making.

Secular musicians who grow up in such an atmosphere often come to resent it; certainly Mozart, to pick one random example from the past, loathed the Archbishop of Salzburg and couldn't wait to establish an independent secular career. He didn't write much organ music, either.

More recently, the organ was linked with a particularly sappy, sentimental kind of music purveyed in the home and in movie palaces, before the advent of talkies.

As someone who remains blissfully unburdened by such associations, I can only find the organ's neglect deplorable. My enthusiasm may have been reinforced by a couple of positive associations of my own. As a boy, I was taken on a visit to a distant relative who had installed a big organ in her mansion on the North Shore of Long Island. In her massive living room, itself two stories high, the organ stretched to the very ceiling

and its deepest pipes plunged into the sub-basement where, Nibelheim-like, the bellows and support mechanisms dwelled. I can still remember being awed by the sight and sound of that private toy.

In graduate school, a friend took it upon himself to purchase an old, broken-down church pipe organ (the minister wanted to replace it with a modern electronic device) with the intention of installing it in his attic. I was enlisted to help him break down the organ and then reassemble it, lever by pulley by key, in its new home. The trouble (and the fun) was that we took the job of breaking it down a little too literally, more or less reducing the thing to a gigantic stack of kindling. From which we had to reconstruct a working pipe organ. Somewhere in contraption heaven, Rube Goldberg was smiling.

Pipe organs are the closest any one musician can come to capturing the tangible sound of a full symphony orchestra. That is why romantic French composers like Widor and Vierne wrote gigantic "organ symphonies." Of course, organ design has varied along with the successive periods and styles and fashions of music, from modest, austere instruments in the Renaissance to boldly proclamatory, flamboyantly decorated organs in the baroque to the thundering, elephantine romantic organs of a century ago. Organs have also varied in fascinating ways from country to country, the nasal braying of Iberian organs being a particularly pungent regional example.

Sometimes, organ design even seems to anticipate fashions in the secular world—as in the fad for restored or newly constructed baroque-style organs in the 1950s and '60s preceding the broader original-instruments movement of today.

Electronic organs, in which sound is emitted from loudspeakers rather than actual pipes, have threatened the pipe organ for decades. Today, the synthesizer offers a keyboard player a far wider range of sounds than even the most dazzling and diverse pipe organ.

Yet as Carnegie and Avery Fisher Halls have proved, no loudspeaker can match the sheer brawny authority of a genuine pipe organ. And with the new historical awareness of today, the new appreciation of the actual sounds composers composed for, pipe-organ playing and building might seem to have a reasonably healthy future.

The indifference that greets too many organ concerts and organ recordings among the wider concert public remains a cause for regret, however. And there are laments in organists' own publications that the number of young performers interested in the field is declining. But as

long as one has faith that great music and these great, mighty instruments will beguile great performing talents, there should be nothing to fear.

MARIANNE FAITHFULL AND KURT WEILL

The New York Times, December 13, 1989

Periodically, in the world of popular music, some aspirant gets saddled with the title "the new Bob Dylan." In the semiclassical, semipopular world of Kurt Weill, there has been a parallel succession of "new Lotte Lenyas." From Gisela May to Ute Lemper, from Julia Migenes to Teresa Stratas, they keep on coming. Now we've another claimant, perhaps the best one yet, in Marianne Faithfull.

Ms. Faithfull has had quite a history, from angelic teenage rock star in the mid-'60s to consort of Mick Jagger to actress to drug addict and alcoholic, all punctuated by occasional critically acclaimed comebacks. Reportedly free from her addictive demons, she is now in the midst of another rock comeback. But she has also developed a side specialty in Weill, with a harrowing contribution to a rock Weill tribute album, *Lost in the Stars*, leading to her latest venture.

That was two performances of the principal vocal role in the thirty-five-minute Weill-Brecht "ballet with song" *The Seven Deadly Sins*, Saturday night and Sunday afternoon as part of the imaginative Arts at St. Ann's series at the Church of St. Ann and the Holy Trinity in Brooklyn Heights. The Weill was preceded by deft performances under Fred Sherry's direction of Bach's Cantata No. 183 and Stravinsky's *Danses concertantes*.

Brooklyn and Weill seem to go together these days, what with Peter Sellars's clever Bach-Weill pairing in the spring at the Brooklyn Academy of Music and Miss Stratas planning to undertake *The Seven Deadly Sins* and other Weill songs herself next spring, again at the academy. But Miss Stratas will have to work hard to surpass the St. Ann's performance. Ms. Faithfull looked nervous on Sunday, and extremely relieved when her work was over. But both her contribution and those of her collaborators sounded absolutely first class.

One says sounded because except for a few props and lighting effects, this was a concert performance. There was no dancing Anna as mirror to the singing Anna, who narrates this rather heavy-handed Brechtian parable of capitalist exploitation involving a young woman wandering through America, falling into the traps of vice.

The performance was sung with amplification for all the singers and in a deft translation by W. H. Auden and Chester Kallman. The alert, personable male quartet consisted of Mark Bleeke, Hugo Munday, John Trout, and Wilbur Pauley, and Jason Osborn, an English Weill expert, drew an elegant, idiomatic instrumental performance from the Orchestra of St. Luke's.

But this was Ms. Faithfull's show, and she handled her part with a fine blend of dramatic world-weariness, quivering timbral allure, conviction of phrasing, and bitterness of declamation (her repeated "gnashing their teeth, gnashing their teeth" at the end, with the pounding stress on "gnash," was chilling).

There is an irony in all this success, however. The Lotte Lenya model we all associate with Weill's music is the later Lenya, the grizzled trouper who spits out Weill's songs in a ragged alto. To sing his music this way requires all manner of downward transpositions. When Lenya was young, in the late '20s to the mid-'30s, from *The Threepenny Opera* to *The Seven Deadly Sins*, she was still a fragile little cabaret soprano, projecting ingenue innocence with an artless simplicity.

In that respect, for all Ms. Faithfull's success, her performance is just as much a distortion of Weill's intentions as the later Lenya's was. If Miss Stratas sings this music in the soprano keys, perhaps she will be able to combine cynicism with ethereality in an even more persuasive way.

In the meantime, on her own terms, which were also Lenya's terms, Ms. Faithfull's performance would be hard to surpass. One hopes it is being recorded.

WHEN PRACTICE REFUSES TO MAKE PERFECT

The New York Times, **December 17, 1989**

The news arrived by fax, as news so often does these days, but it echoed nostalgically from a past seemingly long gone. The Philadelphia Orchestra regretfully announced that *Transfigured Notes* by Milton Babbitt had been dropped from a subscription program beginning December 7 and would be replaced by another Babbitt score, *Composition for Twelve Instruments.*

This might seem a rather trivial change, shuffling one Babbitt piece for another, except that *Transfigured Notes* was a new work commissioned by the orchestra and *Composition for Twelve Instruments* is for chamber ensemble and was composed forty-one years ago.

One read on, with growing amusement, yet sadness, too: *Transfigured Notes* was completed three years ago. It was to have received its premiere under Erich Leinsdorf, but that venerable maestro backed off when he saw the score. Then Dennis Russell Davies, a new-music specialist, was to conduct it. He withdrew after a single rehearsal—which led to a controversy that precipitated his resignation as music adviser to the orchestra's Saratoga summer season.

The third (and, one presumes, last) attempt by the Philadelphia Orchestra to tackle this work—which lasts eighteen or nineteen minutes and is scored for strings alone—was more carefully prepared.

Richard Wernick and Bernard Rands, composers affiliated with the orchestra who are also friendly with Mr. Babbitt, assured him and the orchestra that the piece could indeed be performed. Hans Vonk, another specialist in modern music, received the score months in advance and studied it thoroughly; Mr. Babbitt says he's its absolute master. The players got their parts in advance, too. Everyone rehearsed for "many hours," including sectional rehearsals for components of the overall texture.

The decision to give up disappointed all sides. "I can only conclude that the piece is unplayable at the standard of excellence audiences are entitled to demand of a professional ensemble," said Mr. Vonk.

No one was willing to let any brooding anger boil up to the surface. Mr. Babbitt said he felt "no bitterness." Yet resentments peeked through the carefully chosen words. Mr. Babbitt suggested that there was some-

thing about the hurly-burly of a symphony orchestra devoted to weekly subscription programs that made the mastery of difficult new music nearly impossible, and that modern orchestra players, especially older ones, trained to play music of the past, were underprepared to tackle new work like his.

Mr. Vonk, conversely, argued that "it is impractical for an experienced composer to believe that an orchestra like this could devote the rehearsal time necessary to perform this work to our level of expectation." Which makes one wonder why the conductor wasted so much time on it.

Mr. Wernick made what might seem the funniest statement. "Conductors and composers are privileged in that our training has given us the capacity to hear a piece of music as we see it on the written page. But, unfortunately, there is an intermediary between the music and the public."

It's the "unfortunately" that's funny: so much for those who cling to the apparently outdated notion that performers have a role to play in the musical experience. Maybe Mr. Wernick was trying to be ironic.

The reason all this seems nostalgic is that tough-guy music, the kind of densely dissonant, diabolically complex scores that some composers (above all Mr. Babbitt) favored in the 1950s and '60s, had seemed swept aside by new romanticism, minimalism, serious vernacularism, and other such isms. Composers were now writing pieces that musicians liked to play and audiences liked to hear.

Mr. Babbitt will go to his grave famous for, among other things, a piece of prose whose published title—"Who Cares if You Listen?"—he insists was appended by an unfeeling editor. Yet the title accurately echoes the essay's ideas: modern music is pure sonic research, he argued in 1958. Composers should be supported by society free from any demands or expectations by a public that can't be expected to comprehend their experiments, let alone like them.

This might seem as silly as Mr. Wernick's suggestion that performers represent an "unfortunate" intermediary between music and the public. But there will always be some people with an avid taste for complicated music, including players who relish the chance to tackle works that challenge their skills and imagination. The curious thing about Mr. Babbitt's music is that underneath its bristling theoretical armor, there often beats an expressive heart. It looks thorny, but sounds (if those unfortunate intermediaries do their job) beautiful.

The history of music is full of scores now recognized as masterpieces that musicians once deemed unplayable or worse: insulting, evil, "non-music." Beethoven's late string quartets, Wagner's operas, even Aaron Copland's "Short" Symphony all fall into that category.

One of these days, probably soon, someone with sufficient will and skill and rehearsal time (a student orchestra? a European radio orchestra? maybe even just some regular old American orchestra?) will perform *Transfigured Notes*, and those of us who like to hear our music as well as see it can begin to judge for ourselves whether all that work was worth the effort.

In making that initial judgment, we will be the shock troops of the accumulative process of consensus known as posterity. Whether Mr. Babbitt pushed compositional virtuosity to impossible lengths or the Philadelphia strings lacked the requisite chops, only posterity will be able to judge.

CONAN IN COMICS? SURE. BUT WOTAN?

***The New York Times*, April 5, 1990**

"GRONNK" cries Alberich the toad as Wotan steps on him. "AROOOOOOOOO" echoes Hunding's horn as he pursues Siegmund and Sieglinde with murderous intent. "HARRARG" howls Fafner the dragon during his fight with Siegfried. "KTHOMP" goes his mighty claw as it slams into the ground.

One will not find such language at a staged performance of Richard Wagner's *Ring des Nibelungen*, even one with supertitles. One certainly won't find it at the Metropolitan Opera's traditional *Ring*, now playing at Lincoln Center.

But that is exactly what readers encounter in DC Comics' account of *The Ring*. And this surprisingly faithful fantasy-superhero version of the operas by Roy Thomas and Gil Kane turns out to be merely the most recent of the flourishing subculture of opera comic books. There are several other titles already available, and a competing comics *Ring* is due in a couple of years.

For those who still think of comics as childish or, worse, funny, a trip to a comics emporium like Forbidden Planet, on Broadway near Twelfth Street, will set one straight. Comics now attract not only children but also adults with a special interest in the superhero, fantasy, and sword-and-sorcery aspects of the genre.

DC Comics and Marvel Comics, both based in New York, are the largest American comics companies. Mr. Kane is one of the world's best-known comics artists, the man who almost defined the shinily high-tech, extravagantly fanciful, heavily muscled superhero look. He is also an enthusiast for the whole range of Norse legends and Nibelungen sagas, which served as Wagner's own inspiration.

He brought Mr. Thomas in as the writer for his Nibelungen idea, and it was Mr. Thomas who focused their efforts on Wagner. Mr. Thomas is another heavyweight in the comics world, the former editor in chief at Marvel.

Mr. Thomas and Mr. Kane begin their version earlier in the legends than Wagner did, with an illustrated recounting of Norse genesis legends. But starting with Wagner's own beginning of the tale, at the *Rhinegold* Prelude, this comics version treats his operatic texts with faithfulness and intelligent care. Naturally, long Wagnerian narrations are compressed in favor of more pictorially engaging scenes, although they aren't excised altogether. As Andrew Helfer, the senior editor at DC Comics, points out, recapitulation is also a part of comic-book methodology.

Sometimes things get a little salacious or violent—"suggested for mature readers" is the warning on the covers—what with taunting, naked Rhine Maidens and blood streaming from wounds. But all that sex and bloodshed is explicit in Wagner's libretto. And this comics version, with its flying horses and sudden transformations, is more faithful to the composer's vision than a genteel, gravity-bound stage production could ever be.

The competing comic-book *Ring* will be the next project of the comics artist who has most actively involved himself with opera, P. Craig Russell. This Cleveland artist concentrates on serious, even esoteric operas and publishes his work—to which he appends opus numbers—through Eclipse Books (formerly Eclipse Comics) in Forestville, California, north of San Francisco. Among other items, Eclipse has issued a comic-book history of the Central Intelligence Agency and a series of trading cards on such themes as "The Kennedy Assassination," "Friendly Dictators," and "The Iran-Contra Scandal."

Mr. Russell got involved in opera comics after he included two songs of Gustav Mahler in a fantasy comic called *Night Music* in 1984. His versions of "Das Trinklied vom Jammer der Erde" and "Ich bin der Welt abhanden gekommen" are more airy and fantastical than the blunter Gil Kane style of the DC *Ring*.

Since then, Mr. Russell has produced comics versions of two Maurice Maeterlinck librettos, Debussy's *Pelléas et Mélisande* and Dukás's *Ariane et Barbe-bleu*, along with the Oscar Wilde–Richard Strauss *Salome*, part of Wagner's *Parsifal*, and a soon-to-be-issued, 134-page, three-volume version of Mozart's *Magic Flute*.

Catherine (Cat) Yronwode, editor in chief of Eclipse, says these are called "graphic novels," rather than mere comics. Eclipse has published them in special, clothbound, signed collectors' editions as well as in conventional softcover form, and plans to reissue all of them in a single volume called *Operas*.

The fourth and last installment of the DC *Ring*, *The Twilight of the Gods*, is due in a few weeks. For now, the comics, which cost $4.95 each, are available only in specialty stores; the gift shop at the Metropolitan Opera had never heard of them. Mr. Helfer says the entire Thomas-Kane *Ring* will probably be reissued in a single volume and made more widely available.

While he could provide no sales figures for the *Ring* comics, Mr. Helfer said they are selling "very well for DC." He added that the intended readers were neither children nor students, as in the venerable Classics Illustrated forty-eight-page versions of well-known novels, which are rumored to be sometimes read by students in lieu of the novels themselves.

Instead, citing Wagner as "the granddaddy of fantasy," Mr. Helfer said the composer's works appealed to comics artists as fertile opportunities for rich illustrations and gripping fantasy narratives.

Although the DC *Ring* is not intended to lure readers into opera, no one objects to that progression. "That was not our motivation," Mr. Helfer said. "We saw the potential of taking a classic source and making it exciting in a contemporary sense."

A MAN INSPIRED BY CHANCE

The New York Times, May 13, 1990

I–VI: Method Structure Intention Discipline Notation Indeterminacy Inter-penetration Imitation Devotion Circumstances Variable Structure Nonunderstanding Contingency Inconsistency Performance. By John Cage. Illustrated. Two cassette recordings. 452 pp. Cambridge, Mass.: Harvard University Press. $34.95.

Methodology plays a role in all artistic creation. Some artists become obsessed with it, elevating the how above the what. Others internalize their technical training and then operate from instinct during the process of creation, perhaps reverting to craft during the final stages of execution. In all cases, however, creation is a dialogue between intention and nonintention, craft and art, intellect and instinct.

But no matter how the dialogue is conducted, for the perceiver of the art it's the creation itself that counts, not how it came to be. That's true even if an understanding of an artist's methodology aids in the apprecia-tion of the art, or if the methodology itself has become art.

No artist has been more methodologically inclined than John Cage; in that, he shares much with the rigid total serialist composers who might seem his polar opposites. Indeed, some have argued that Mr. Cage's mature philosophizing about his art is more interesting than the art itself.

I am one who has espoused that view, but I'm beginning to have sec-ond (or third or fourth; Mr. Cage makes you think) thoughts. Partly that is because in *I–VI* Mr. Cage has overcome this disjunction between his anarchic art and his elegantly didactic texts, bending his words into a mirror of his music by fracturing conventional expectations and trans-forming didactic prose into elusive poetry.

But it is also because I am slowly coming to a new appreciation of the beauties of his art itself. Once, I liked his early prepared-piano pieces but found the later music of no more than passing interest, gentle or amusing but no more—less, maybe—conducive to my own medita-tional musings than the sounds of nature. Now I am coming to under-stand and value his delicate balance between total freedom and total control.

If it came down to a choice, which it never will, I would still prefer

more deliberate discourse from a composer, no matter how much perception and creativity I as listener bring to the aesthetic experience. But a couple of years ago, in an otherwise typical new-music concert in midtown Manhattan, full of busily crafted scores in all the fashionable idioms of the day, a work by Mr. Cage, limpid and calm, came as an oasis, or better, as a leafy green park in a bustling city.

With all that in mind, we have Mr. Cage's latest artwork, a lavishly produced book of his six Charles Eliot Norton Lectures given at Harvard University during the 1988–89 academic year. It is a complex affair, in several layers. Central are the six actual "lectures," which Mr. Cage arranged as "mesostics," meaning vertical lines of capital letters (spelling out the various words of this book's subtitle) with horizontal lines of varying lengths extending in both directions from each letter and incorporating the letters into new words.

The horizontal lines are drawn from various "source texts," broken down by chance procedures (computer-aided *I Ching*) and then further refined by Mr. Cage. In addition, the book offers an introduction by Mr. Cage in conventional prose, explaining his methods; the source texts themselves as an appendix, again in ordinary prose, ranging from his own writings to those of Wittgenstein, Joyce, Thoreau, Emerson, Buckminster Fuller, [and] Marshall McLuhan, to passages about international affairs from newspapers.

Running along the bottom of each page are transcriptions of question-and-answer sessions with his Cambridge public. There are page-sized photographs of a Cage score. And there are two cassette recordings of Mr. Cage reading the fourth lecture and responding to his sometimes deferential, sometimes puzzled, sometimes testy questioners (these are clumsily packaged, between the book and its plastic shrink-wrap, leaving nowhere to put them once the wrap has been broken).

Although Mr. Cage has spent a lifetime attempting to break down preconceptions, most people still approach his work with their minds made up. Some think of him as a guru, a beatific holdover from the 1960s who dispenses Oriental wisdom to the Western unwashed. Others see him as an old-fashioned charlatan or, however benign his intentions, as a termite nibbling away at Western cultural values.

One thing that needs understanding, however, is that Mr. Cage is by no means an absolute anarchist. For him, everything only goes within limits set by him. It is he who determined the form of these lectures, chose the source texts, decided to use the *I Ching* in the way he uses it,

edited its raw results, inserted pauses, and arranged the text upon the page, and, above all, who presented his work to the public, as a performer. In other words, Mr. Cage uses chance the way other artists have used alcohol or opium or inspirational walks in the woods. Chance frees his mind and loosens his creative flow. But it is still John Cage who is creating, not the *I Ching* and not the computer.

This book will prove frustrating for all those who know for a fact that anarchistic blather is bunk, and it may be taken as insulting when they recall Mr. Cage's distinguished predecessors in the Norton series (Stravinsky, Copland, Roger Sessions, even Leonard Bernstein among composers alone). But its multilayered structure makes it his most interesting textual creation since his first collection of essays, *Silence*, in 1961.

His aesthetic, philosophical message has not changed: we must abandon ourselves to the experience of life, create our own art through the sensations that surround us, participate in the unfolding of the universe gently and lovingly. But the mesostics provide the missing link between all his chance-derived music of the last thirty years and his texts, which have taken longer to catch up to the promises made by his music.

Especially when he reads them, in his frail but steadfast baritone, shaping the phrases and illuminating hidden meanings and poetic undercurrents in word jumbles that seem at first—and may still be, on the less important level of explication—meaningless, Mr. Cage attains a perfect synthesis of all that he is: soft-spoken backwoods storyteller, vanguard modernist, Zen master, kindly village preacher. Yet this is not mere accident: Mr. Cage is making art. And by any generous definition of what art is and can be, he is making beautiful music as well.

DEBORAH VOIGT

The New York Times, January 23, 1991

Note: All careers develop incrementally. This was perhaps Deborah Voigt's first big review in a New York newspaper, but others wrote about her before and still others since. But I am touched that she continues to give me public credit for "discovering" her. It's not true, but I like it.

Boston—The Boston Lyric Opera production of Richard Strauss's *Ariadne auf Naxos* on Friday night at the Emerson Majestic Theater, repeated Sunday afternoon, showed heartening growth for a company until recently mired in amiable provincialism. It was not perfect and betrayed some signs of budgetary modesty. But it served the opera well, and it introduced one truly remarkable singer in Deborah Voigt.

Miss Voigt, who is thirty years old, was trained in New York City and San Francisco. In 1989 she won the Busseto Verdi Competition in Italy, and last summer she picked up a gold medal at the Tchaikovsky Competition in Moscow. After a rapturously received series of Amelias in Verdi's *Ballo in maschera* last fall in San Francisco, she will sing the same role this summer with the Metropolitan Opera in New York–area parks.

Friday's performance, her first of Ariadne, revealed one of the most important American singers to come along in years. It is wise to counsel caution, but foolish to stifle enthusiasm. Miss Voigt's voice seems huge. It was hard to tell just how huge in the roughly twelve-hundred-seat Majestic Theater—but it rang effortlessly in the ears.

More to the point, it sounded warm and solid and musically shaped. The obvious comparison, among earlier American dramatic sopranos, is Eileen Farrell. If Miss Voigt does not soon become an important Wagnerian soprano, she will have taken a wrong career turn.

The other excellent singer in the cast was Erie Mills, who offered a surely sung, wisely acted Zerbinetta. David Rampy, the Bacchus, has had a late development as a professional singer and hence remains inexperienced. His heroic tenor is large but effortful, and he lost voice and confidence toward the end of the long final duet on Friday. Others in the cast included Kristine Jepson, Michael Krueger, Mary Ann McCormick, Mary Margaret Sapp, Kenn Woodward, and John Drabik.

Bruce Donnell's production, sung in English and German with a functional setting by John Michael Deegan and Sarah G. Conly, was conventionally conceived, but deftly so, including witty forays into the aisles and audience and a clever comic performance from Miss Voigt. Joseph Rescigno's conducting and the orchestra's playing sounded thin and pale, but that may have been due partly to the theater's acoustics.

RADU LUPU

The New York Times, January 29, 1991

Radu Lupu is not the most charismatically compelling of performers. He trudges onstage, sits down at the piano like a court stenographer at a tedious trial, and proceeds dispassionately to do his job. It's just that the execution of his particular job results in beautiful music.

What he lacks in flair, both personally and musically, Mr. Lupu makes up in poetic seriousness rendered by what might be called self-effacing technique. He doesn't dazzle with pointillistic runs and cosmic banging. But his playing sounds timbrally warm and solid, and it's gradually becoming apparent that it is good artists who sound good at the new Carnegie Hall. Lesser competitors, for all their other virtues, fail to find, through instinct or diligence, the keys to turning the hall's acoustical quirks to their advantage.

Mr. Lupu's program on Thursday night was soberly Germanic, with Brahms's Piano Pieces (Op. 118), Mozart's Fantasia in C Minor (K. 475) and Sonata in C Minor (K. 457), played as one piece, and, after the break, Schubert's Sonata in A (D. 959). His playing was properly German in its sobriety and formal rigor, but leavened with a poetic grace that, if you subscribe to national stereotypes, perhaps derives from his romance heritage. (He is Romanian born.)

Although the entire program was first-rate, the Schubert was special. This grand, late essay (composed in 1828, the year of his death) is now, after decades of neglect, one of the composer's most beloved works. Mr. Lupu played it in a way that highlighted its beauties, but also its profound strangeness, its uneasy strategies of subversion. Without vulgarly overemphasizing its chromatic turns, harmonic shifts, and disturbing disruptions of mood, Mr. Lupu made his audience feel the blend of grace and dread that emanated from one of the most enigmatic personages among our great composers.

The final Rondo: Allegretto epitomized Mr. Lupu's (and Schubert's) art. After as songfully embracing a statement of the opening theme as could be imagined, Mr. Lupu followed Schubert unerringly into deeper, darker waters. It was the kind of performance that quite properly made the final consonant flourish sound like a desperate effort to patch over the abyss.

ANNIE SPRINKLE AND AIDS

The New York Times, February 9, 1991

The opening event of the annual benefit series presented by Performance Space 122 last week was like a crash course in the performance art of the 1980s. But the very forces that have rendered much of those '80s antics almost offensively irrelevant may also be toughening the avantgarde for the '90s, lending it a resonance and a seriousness it has so grievously lacked. In short, tragedy may make for better art than rampant greed and trivial hedonism.

Some background on the benefit: P.S. 122 is one of five avant-garde institutions housed in the former Public School 122 on First Avenue at Ninth Street. Like Franklin Furnace, it has become one of the premier forums for the performance art that proliferated in the East Village in Manhattan over the last decade. Much of that art tested normal boundaries of propriety, and as a result became a prime target for the religious Right in its fulminations against the National Endowment for the Arts.

P.S. 122 still lists the endowment as a supporter, but it deliberately — heroically, even — courts confrontation with the agency's new "decency" guidelines. Last week's benefit opener offered Annie Sprinkle as host. Ms. Sprinkle is the porn actress turned performance artist whose past appearances have included inviting the audience to examine her vagina through a gynecological instrument.

But there was a good deal more than just Ms. Sprinkle and her privates. There was Diamanda Galas, stripped to the waist and covered with a convincing likeness of blood, howling and screaming in agony, as is her wont. Bebe Miller and three of her fine dancers contributed an athletic excerpt from a larger work in progress. John Kelly did a fey falsetto imitation of Byronic poetic lassitude, too lightly flavored with camp, in an aria from Bellini's *Sonnambula*. Pat Oleszko cavorted in one of her remarkably elaborate costumes. Eric Bogosian told stories, and Julee Cruise repeated her kewpie-doll chanteuse act, singing or lip-synching to her album, which is mostly soundtrack music from *Twin Peaks* with words by David Lynch and music by Angelo Badalamenti, both uncredited.

For one who never fully accepted the East Village bar-scene, fun-and-games performance-art aesthetic, in which young people tarted themselves up in unattractive ways and acted out sexually provocative

charades, the P.S. 122 benefit was like a farewell to a not-very-appealing era. If the '80s were defined by manic acquisitiveness and self-gratification uptown, the decade's downtown mirror was this performance art scene, formalized at publicly supported spaces like P.S. 122. Its denizens may have thought they were making trenchant comment upon Donald Trump and Michael R. Milken, but in a disturbing way they were acting out those same vulgar, exhibitionistic fantasies on an underground level.

As the '80s advanced, however, AIDS turned the party into a nightmare. AIDS is a tragedy that transcends America and its artists. But in the East Village Bohemia of the '80s, where sexual experimentation and heroin both played a larger role than in most sectors of society, the disease hit with a terrifying vengeance.

Now the Persian Gulf War has come along, with an as yet undetermined effect on our traditionally left-leaning artistic vanguard. So far, that effect has been fragmented, with the Left confused by contradictory impulses. But artists voice concerns before the rest of society, and horror at war and death already looms large among those who took part in the P.S. 122 benefit.

All of this cast the evening into a rather different light than one might have expected from what was, after all, a celebratory gala. One need not subscribe to the implied conspiracy theories of Mr. Bogosian—"What does the Gulf War have in common with AIDS? Everything"—to sense the impassioned concern that has transformed the East Village community.

The shift in vanguard sensibilities could be observed most clearly in the case of Ms. Sprinkle.

Not that she has been fully tamed, or turned into some politically prim and proper propagandist. While she didn't invite us to peer at her genitalia, she did allude to all manner of questionably attractive people doing mildly gross things, and she did perform her "bosom ballet," in which she jiggles and manipulates her breasts in time to bouncy ballet music.

But this time, at least, there was more to Ms. Sprinkle than a rather ordinary, overweight woman flaunting her wares. It was her principal monologue that defined the new agenda facing artists today. After a parade of slides of her lovers, in all shapes and races and sizes and sexual inclinations, the mood darkened. Lover after lover, it turned out, had died of AIDS; descriptions of their attributes and endowments

shifted to the past tense. What had been happily hedonistic became a funeral procession of martyrs to the cause, the cause being a community's search, through sexual liberation and artistic license, for anarchic bliss.

One could argue that her success, her ability to move her audience and make it feel her pain, was inadvertent, provided not by her art but by the somber foil of our time. But wittingly or unwittingly, her transformation of sexual celebration into a litany of death provided a focus for what could have been an otherwise disparate benefit evening, a focus that turned all the artists involved into voices for their generation.

THE GRAMMYS

The New York Times, February 23, 1991

Let's see: a Playskool Tiny Tim, three pens, four buttons, *The Big Apple Guide*, one can of caffeine-free Diet Pepsi, a bottle of lemon-flavored Perrier, a small bottle of Glenfiddich Scotch whisky, a cassette sampler, a New York restaurant guide, not one but two copies of *Entertainment Weekly* magazine, a sample of Elizabeth Taylor's Passion for Men cologne, a Warner Brothers cap, a *Life* magazine 1991 calendar, a Trump Plaza key chain, a CD/book package of *The Lives of Quincy Jones*. Anything else? Oh, yes, the most important: earplugs.

Those were the contents of a shopping bag full of plunder handed out to anyone who asked for one at the National Academy of Recording Arts and Sciences post-Grammy party at the Hilton Hotel. Of course, those famous people who were there were probably too cool to accept such trivia. And most of the really famous folk were at one of the record-company parties in other hotels, clubs, and restaurants around town. But the Hilton bag still served as some sort of symbol of Grammy acquisitiveness.

This year, I found myself clutching an actual Grammy ticket, which cost $200, and thus was privileged to move among the actual demigods who make up today's record business. The experience was intermittently amusing, instructive, appalling, exciting, and pulverizingly dull.

The Grammys on Wednesday, held in New York for the first time since 1988, make an easy target for the varied constituency that laments the commercialization of music, from Frankfurt School Marxists to neoconservatives to rock critics to Sinéad O'Connor to religious moralists who puritanically oppose all manifestations of Mammon.

Mammonophobes would have had a field day on Wednesday evening. Wretched excess was everywhere; if we live in a recession or if pop music is under siege from tape pirates or if we are tastefully espousing austerity in wartime, the record business hasn't heard the news. From the lavish ice sculptures at the Hilton to Warner Brothers' re-creation of *tout* New York at Roseland, the record companies flaunted everything they could flaunt.

Which included female bodies: décolletage is definitely in, or out, as the case may be, although my companion noted somewhat acerbically that such exposure has never gone out of showbiz style. The snazzy clothes were mostly on the stars of both sexes and the male executives' trophy wives and girlfriends. But since the record business caters to youth and young bodies are usually cuter and sexier than older ones, the cutest clothes were on the small army of young women in bouncy miniskirts and young men in neat little ponytails and earrings who were directed by field generals with walkie-talkies to fill up even momentarily empty seats in the first twenty rows at Radio City Music Hall.

If you have any sort of taste for mainstream pop music, the production numbers were mostly pretty sophisticated, at least compared with Hollywood glitz of the past, with M. C. Hammer's flashy energy burst an early highlight. Along with a touching John Lennon montage and Kitty Wells's achievement award, the oldsters' high point was Bob Dylan's craftily mumbled, slyly enigmatic acceptance speech. It was only later that most people (myself included) realized that his nearly unrecognizable song was one of his most trenchant pacifist denunciations, "Masters of War."

There are seemingly hundreds of Grammys, far too many to make a meaningful viewing experience. While one can understand the two-tiered class system that banishes many awards to before the telecast, the treatment of some of the pre-telecast artists is pretty shabby. Too bad television viewers missed Alannah Myles's leather-and-tights outfit in her victory as best female rock singer, while Eric Clapton's award as best male rock singer was beamed out to a waiting world. And by the time the pre-telecast awards got around to classical music, all mention of the

nominees had been dropped and winners were hustled on and off the stage like cattle, without time for acceptance speeches. All to make more time for Garry Shandling's jokes.

In the end, however, I found myself feeling less censorious about the whole brouhaha than I had thought I might. Of course it's excessive, with a cast of characters straight out of a Weimar Berlin gallery of capitalist sharks. But it's also an all-American party. Of course pop music is commercial. But while the nominations celebrate commercial success even more than the Oscars, the voting seems as often to reflect clubby feelings for paying your dues as sheer numbers of records sold. Thus the awards to veterans like Bonnie Raitt last year and the slighting this year of such hot-selling parvenus as Wilson Phillips and Vanilla Ice.

Still, most aspiring popsters, even the critically respected ones, want to "make it," by which they most often mean not winning a critics' poll but selling records by the truckload. Unlike other art forms, music has been bifurcated into noncommercial art and commercial, youth-oriented entertainment. If you want art, you can get it at Carnegie Hall or the Knitting Factory. If you want flash and sexy style and exultation in success and, sometimes, pretty vibrant music, you got it at the Grammys.

Vernon Reid, the guitarist of the critically beloved band Living Colour, dedicated the award for best hard-rock performance to "all the bar bands, all the acts who are struggling to make it." He was wearing a Sinéad O'Connor T-shirt, but his words suggested a willingness to participate in just the commercial process Ms. O'Connor professes to abhor.

LUCIANO PAVAROTTI AND PLÁCIDO DOMINGO

The New York Times, June 2, 1991

Anytime a critic ventures to write about the human voice, his timid little breaststrokes into this murky sea are swamped by mighty waves of letters and telephone calls. Sometimes the impassioned respondents agree

with what has been written and wish merely to add their own gloss to the commentary. More often, they take violent exception, calling into question not just the qualities of the singers described but the mental, musical, and moral essence of the describer. Only rock-and-roll fans exhibit a comparable degree of blind (selectively deaf?) intensity, but opera buffs boast bigger vocabularies and write longer letters.

Two recent experiences reminded me of this volatile blend of subjectivity and passion. One was listening to learned musicologists, critics, and performers disagree about the basic attributes of voices they had just heard via recordings at the concurrent Lincoln Center Mozart symposium and annual meeting of the Music Critics Association. The other was a column I wrote a couple of weeks ago about Luciano Pavarotti and Plácido Domingo and their forays into heavier repertory, respectively Otello and Parsifal.

The Pavarotti-Domingo column provoked outrage from those who found it inconceivable that the work of these pygmies (as the complainants saw it) could be compared to the giants of the past. This ire was odd, for while it is incontrovertibly true that Mr. Pavarotti and Mr. Domingo dominate contemporary Italian tenorism, that was about the strongest claim I made for them, apart from some admiring words about Mr. Domingo's taste and Mr. Pavarotti's stentorian style and crisp diction. Not only did some people seem actually to hate Mr. Pavarotti and Mr. Domingo, but they also assumed, unclouded by the slightest doubt, that any kind words wafted toward those singers could come only from someone utterly ignorant of a century of recorded vocalism.

Such overwrought behavior is commonly explained by the fact that the human voice is the least mediated expression of human emotion in music, which makes opera the most emotional, not to say luridly melodramatic, musical form. Then there are stereotypes about the especially impassioned nature of Italian opera and its fans, with raucous audience antics in places like Parma adduced to buttress the argument.

But there's more to it than that. American opera audiences, especially those in conservative Manhattan, are more likely to fixate on singers than to appreciate the total musical-theatrical package that opera can and should be. For some of them, operatic acting and set design and even the music itself are bothersome distractions from the true order of business, which is individual emotional outpouring through song. In this vast country, even with the recent proliferation of regional companies, it is the purely aural experience of opera, more

often on radio or compact disc than in live performance, that defines the operatic event.

If your very idea of opera is recorded sound alone, there is little reason to confine yourself to the present. For technical reasons (primitive recording technology suited the frequency range of the human voice better than instruments), the recorded history of singing stretches back further than that of other musical forms, providing a wider range for appreciation. Or obsession.

People do obsess about their recordings, which is a perhaps unkind way of saying they love them. If you have grown up, operatically speaking, listening to Tamagno or Zenatello or Melchior trumpet Otello's proclamations, Mr. Pavarotti may sound like a tawdry pretender.

But if Mr. Pavarotti had lived seventy-five years ago, his flaws would have been selectively forgotten and his virtues nostalgically inflated. Generations of opera lovers would have grown up doting on a few treasured Pavarotti aria recordings, and some latter-day Martinelli, say, would be castigated scornfully by comparison.

Recordings enrich our perception of the past but blinker our appreciation of the present. Most opera lovers, especially lovers of gracefully shaped Italian cantilena, despise angular dissonant modernism. Even if one sets aside for the moment the heretical notion that actual vocal pleasure can be derived from such music, there are vast expanses of accessible styles today, and thousands of singers for whom the idiomatic exposition of such music is a birthright. They may or may not stand up to older singers in older repertory. But they are busily defining new standards in new music, and carrying fresh insights born of those styles back to the older music—just as performance tradition has always redefined itself.

Most opera buffs, hunkered down in their listening-room bunkers and scorning all manifestations of a corrupt present, remain proudly ignorant of or unthinkingly indifferent to that music. Thomas Hampson, for example, may or may not bear comparison with great Mozart baritones of the past. But he can sing Cole Porter and, no doubt, William Bolcom with sovereign ease, and that ease may offer valuable insights into Mozart.

The point is hardly to moderate passion in favor of mealy-mouthed, cotton-eared ecumenicalism. You don't have to forget the beloved singers of the past to arrive at a more generous appreciation of the vocal and stylistic contributions of the present. Love needn't be narrow and hedged, defined by what it vituperatively rejects.

TEMPO AND *LE SACRE DU PRINTEMPS*

The New York Times, **August 4, 1991**

As a cranky autodidact, William Malloch resembles the late Sol Babitz, who graduated from playing the violin in the Los Angeles Philharmonic to hectoring the American Musicological Society in the 1950s about "sewing-machine Bach." Mr. Malloch is an academically unaffiliated musicologist based in Los Angeles, who has sometimes eccentric (not necessarily wrong, but eccentric) ideas about how music should be played. Much of his theorizing is based on evidence left by various mechanical means of indicating tempos, from pendulums and metronomes to musical clocks and piano rolls.

Babitz was a herald of postmodernist flexibility and ornamentation, and so is Mr. Malloch. But Mr. Malloch has had a hand in better, more convincing performances than Babitz ever did.

His most winning recent enterprise is a disc he inspired that combines Stravinsky's piano-roll version of *Le sacre du printemps* with an orchestral performance of the same score by Benjamin Zander and the Boston Philharmonic (IMP Masters MCD 25; CD). In the early 1920s, the composer sat down with technicians from the Pleyel pianola company to punch piano rolls for most of his major works. These were not meant to sound like a single pianist; they were ideal representations capturing full orchestral complexity.

What's especially exciting here is the furious speed of the final "Sacrificial Dance." Pierre Monteux attempted to play this music at the indicated tempo at the 1913 premiere, contributing to the riotous, nearly complete breakdown by both orchestra and dancers that has entered into artistic lore. In his 1929 recording he tried again to realize the fast tempo, with ragged results. Since then, conductors (including Stravinsky and Monteux) have played it much slower, which makes it sound anticlimactic after the cataclysmic "Dance of the Earth" that ends part 1.

This new recording finds Mr. Zander's orchestra playing *Le sacre* with exhilarating authority at the piano-roll tempos. The finale is positively harrowing: cross-rhythms explode against one another with brilliant virtuosity. That the performance was taped live makes it doubly impressive.

The recorded balance slights the strings, which robs the music of some of its biting gravity (all those grunting cellos). Otherwise, the

sound is superb, the interpretation likewise. The piano-roll version, played on a Bösendorfer Imperial concert grand and engineered by Rex Lawson, is if anything even more thrilling.

1992-2004

*This section covers my diaspora, if you will, during which
time I was not officially a critic of anything. From 1992 to
1994 we lived in Paris, where I was European cultural
correspondent for the* Times, *as well as classical records
reviewer. From 1994 to 1998 I was the founding director of
the Lincoln Center Festival, a job I gave up in 1998 to come
back to the* Times *as editor of the Sunday Arts and Leisure
section. While I was a correspondent and editor, I continued
to write intermittently—program notes, freelance articles,
and, from 1998 to 2002, periodic articles again for the*
Times. *Between 2002 and 2004 I was a* Times *cultural critic
without portfolio, which meant freedom to roam, but neither
the* Times *nor I could quite figure out what to do with me. I
did enjoy writing a weekly arts column called Reveberations
from the fall of 2003 to the fall of 2004. After agreeing to
become chief dance critic when Anna Kisselgoff stepped
down in January 2005, I spent the last four months of 2004
beginning to assemble this book.*

LA TOYA JACKSON AT THE MOULIN ROUGE

The New York Times, **March 7, 1992**

Paris—La Toya Jackson's opening performance at the Bal du Moulin Rouge on Thursday, the first of a contracted year of twice-nightly appearances by this lesser member of the Jackson family as star of the famed dinner theater's current revue, *Formidable*, was of perhaps less than epochal consequence, considered all by itself.

But her presence here seems part of a larger Parisian nostalgia for *la belle époque*, in which the city's artists and institutions look back longingly to a time when Paris was truly a home for glamorous popular entertainers and vibrant artistic creativity. Such nostalgia, even when tempered by an earnest scholarly apparatus, as in the comprehensive Toulouse-Lautrec exhibition at the Grand Palais, or by seemingly dispassionate cinematic realism, as in Maurice Pialat's film *Van Gogh*, suggests an almost touching insecurity about the city's cultural role today.

The one-thousand-seat Moulin Rouge theater was full of the usual tourists on Thursday, disgorged from herds of buses as part of their "Paris par Nuit" excursions. There was a sprinkling of Americans, but most seemed Japanese and French. Although everyone at one table insisted that the French came from the provinces, they themselves were all Parisians.

For two long hours, topless dancers promenaded, jugglers juggled, singers crooned in "I ♥ Paris" T-shirts, a comedian humiliated befuddled volunteers from the audience, a man dove into a tank full of crocodiles, and Ms. Jackson teetered carefully front and center, gamely singing clichéd French chansons (Edith Piaf's "La vie en rose") to elec-

tronically glossy accompaniments in her thin, plain little soprano. For most of her numbers, she would venture a verse or two and then disappear happily into the chorus, which sounded prerecorded. In all, until near the end, she sang solo for a total of perhaps seven minutes.

Finally, however, she threw off any pretenses of being the next Mistinguett and belted out a couple of American pop songs, including "Locomotion." Here at last she seemed slightly at ease, vocally, and she also managed to throw herself with some spirit into dance routines studiously reminiscent of siblings Michael and Janet.

Otherwise, the main excitement of the night (except for one of the jugglers) came when her husband and manager, Jack Gordon, doggedly working the room, urged journalists to pronounce her "the new Josephine Baker." *L'Express*, a French weekly, did just that, albeit in a preview blurb. Mr. Gordon also said that Michael Jackson might show up for his sister's big night and that "a table at the back has been held for him." He didn't show.

Ms. Jackson's engagement—for which Mr. Gordon said she is being paid more than $5 million—might seem a blatant attempt to capitalize on the Jackson family name, part of the Moulin Rouge's continuing competition with the Folies-Bergère, the Lido, and Crazy Horse. The show, *Formidable*, dates back more than two years, to the centenary celebrations of the Moulin Rouge.

La Toya Jackson has hardly enjoyed the sales success of her siblings, and recently signed with a less than grandiose record label called Dino, based in Winnipeg. Her biggest reputation derives from two interviews in *Playboy* magazine, full of harsh words about her family, with accompanying photo spreads. Yet the audience on Thursday seemed happy enough; it had come, after all, for the furs and feathers and bosoms, and they were in ample supply (though at no point was Ms. Jackson herself topless).

But Ms. Jackson's appearance at the Moulin Rouge, and the incessant references in the *Formidable* revue to Paris past and present as a world source of romance and excitement, are part of something larger than mere commercial calculation.

Paris, perhaps fretting about its supposed loss of influence in the new Europe, is currently awash in nostalgia for *la belle époque*. Even in campy and debased form, Ms. Jackson's engagement, recalling those of past foreign cabaret stars like May Belfort and May Milton of the Toulouse-Lautrec era and, yes, Josephine Baker, reinforces that nostalgia. Mistinguett and Maurice Chevalier are evoked like a litany during the current Moulin Rouge revue.

Henri de Toulouse-Lautrec, of course, glorified the Moulin Rouge and Montmartre night life of the 1890s in his paintings and posters. His Grand Palais exhibition (seen in London last fall and running here to June 1), accompanied by ancillary exhibitions all over town, devotes much attention to the Moulin Rouge and such earlier stars as La Goulue, Jane Avril, and Yvette Guilbert. The show is drawing enormous crowds and attention in the popular French press.

Mr. Pialat's *Van Gogh*, which has not yet opened in the United States, was the French nominee for the Oscar for the best foreign film. Its rejection by the Academy of Arts and Sciences provoked an outburst against Hollywood machinations by Daniel Toscan du Plantier, a prominent French film producer and head of Unifrance, which tries to sell French films abroad.

Van Gogh has been a big critical and popular hit in France, and Jacques Dutronc, who plays the title role and who is himself a former chanteur, won the César, the French Oscar, for best actor. The film contains lovingly realistic recreations of riverbank picnics of artists and models and balls at the Moulin Rouge. Toulouse-Lautrec makes a fleeting appearance in the film, in which Mr. Pialat manages to capture some of the spirit and charm of the casual mixture of artists, prostitutes, and people simply out for a good time that apparently characterized such balls in their heyday. The film's extended Montmartre sequence even ends with a remarkably unclichéd can-can, an adjective that can hardly be applied to the painfully stilted version at Thursday's Moulin Rouge revue, with obligatory kicks and obligatory squeals stripped of even the pretense of spontaneity.

Toulouse-Lautrec fixed forever our image of fin-de-siècle revelry in clubs like this, places that, in the words of the *belle époque* magazine *Figaro Illustré*, attracted "le Tout-Paris, joyeux." Toulouse-Lautrec posters are still plastered outside the Moulin Rouge today, and the biggest production number of the *Formidable* revue plays before those same posters, enlarged. A figure of the painter wanders among the bosoms; no dwarf, the hunched-over dancer looks less like an inbred French aristocrat than the Wandering Jew. Whether or not the Grand Palais exhibition succeeds in validating Toulouse-Lautrec as a prime precursor of twentieth-century art, it has powerfully reinforced his image as a chronicler of the stars and demimonde of Montmartre a century ago.

Things have long since changed at the Moulin Rouge. The club has been remodeled several times and it lost its famous outdoor garden

(complete with a giant model elephant inherited from the Paris Universal Exposition of 1889) in 1902. A period photograph at the Grand Palais shows that admission to a Moulin Rouge ball in 1891 cost 50 centimes. Today, the show alone (dinner is extra) costs 465 francs, about $85 per person. Public dancing has been reduced to a few fox-trotting couples before the revue begins.

Though cynics suggest that as early as the 1890s Montmartre club owners were capitalizing on the raffish Bohemian image of artists to attract a middle-class public, true artists today would seem in short supply at the Moulin Rouge. Were he alive in Paris in 1992, Toulouse-Lautrec would probably document African nightclubs or fashionable restaurants or movie stars. And he'd probably do it with a camera.

THEATER IN PARIS AND BERLIN
The New York Times, June 25, 1992

Note: I cut the last item of this column; what remains is more coherent. Orlando did appear in an English-language version, with Miranda Richardson; Jutta Lampe remained the best of the three actresses in the three languages, with Ms. Richardson number 2 and Isabelle Huppert (too femme) number 3.

Paris—Music and dance and art have no problems transcending linguistic frontiers. Movies and television can be subtitled or overdubbed. Literature can be translated.

But theater remains stubbornly isolated, the last bastion of national culture—short of supertitles that can't hope to capture much of a fast-moving spoken text, or annoying insectlike earphone whispers that blot out the words actually being spoken. In every country there are actors of enormous talent and popularity who are almost completely unknown outside their native cultures. Unless, of course, they also happen to work in the quasi-international language of English or make movies.

Theater directors have it better, since they can branch out to opera or film or even to plays in languages other than their own. Patrice Chéreau

is known to Western opera lovers for his Bayreuth *Ring* from the late 1970s, preserved on laser discs. His recent Berg *Wozzeck* in Paris, which is to travel to Chicago and Berlin, will further spread his reputation for scrupulously detailed, sensitively thought-out direction of singers and actors, even if the results sometimes look superficially modish because of Richard Peduzzi's sleek set designs. But Mr. Chéreau's far more extensive work in theater—the bulk of his career—remains largely confined to France and French-speaking Switzerland.

Giorgio Strehler could take his Italian-language Shakespeare *Tempest* to the Pepsico Summerfare north of New York City a few years back because Americans presumably know that play. The only appearance of the Paris director Ariane Mnouchkine in the United States, at the Olympic Arts Festival in Los Angeles in 1984, also consisted of Shakespeare. The repertory for her New York debut this fall, courtesy of the Brooklyn Academy of Music, will be her version of the *Oresteia* cycle, which again can count on the audience knowing the basic story.

Miss Mnouchkine is a painstaking rehearser who cancels performances if a leading actor cannot appear. It took her so long to prepare the final play in the cycle, *The Furies*, that it made it onto the stage of her Théâtre du Soleil in the Bois de Vincennes east of Paris for only two performances in late May before a long-scheduled tour.

The Paris press was asked not to write about a work still considered in progress, but suffice it to say that her vision of the Furies, fifteen ferocious creatures that seem to be crossbred baboons, boars, lions, and dogs, is enough to inspire the scariest nightmares. The beasts solve the communication problem by not speaking any known human language, just growls and roars.

Berlin, newly renamed the capital of Germany, may think it is heading for a new cultural golden age. But the people in Munich and Cologne and Frankfurt and Dresden don't seem too worried. The Cologne Theater, for instance, just offered the premiere of *Die Soldaten* by J. M. R. Lenz, the prescient, protomodernist German playwright of two hundred years ago whose text became the libretto for Bernd Alois Zimmermann's twelve-tone opera of the same name. The play was presented in an excoriating, operatically extroverted style by Werner Schroeter, the director and stage designer.

Mr. Schroeter also directs films, but here the formula that film equals international fame breaks down; his films are far too arty and weird for

that. The latest, starring Isabelle Huppert, was called *Malina* and hasn't made it to New York. But his direction for opera and the theater speaks to a broader audience, and he is steadily building a major career in central Europe.

It is frustrating for someone who regularly attends the theater in central Europe to realize that most of the superb productions and performers there will never be seen in English-speaking countries.

A Berlin Schaubühne staging of *Amphitryon* by Heinrich von Kleist—a Napoleonic-era Prussian playwright central to the German theater and rarely heard elsewhere—just closed, for instance, and to the final night people were crowding the lobby for last-minute tickets. Directed by Klaus Michael Grüber, another acclaimed German veteran, it deliciously mixed slapstick and a more refined comic manner; to hear Jutta Lampe intone the single German word "ach" at the very end, hinting at self-knowledge, sexuality, humor, and grief, was worth a trip to Berlin.

Along with many productions in the 1970s and '80s by Peter Stein at the Schaubühne, Miss Lampe starred in a monologue version of Virginia Woolf's *Orlando* directed by Robert Wilson. Now Mr. Wilson is going to restage the piece in French with Miss Huppert, who will attract more attention because she has had a film career. Harvey Lichtenstein of the Brooklyn Academy of Music has spoken of trying to produce an English-language version with some famous English or American actress. That won't help Miss Lampe attain an international reputation. But she hardly lacks honors and acclaim: she recently became the first actress awarded a prestigious German prize for her contributions to that country's theater.

Amphitryon didn't dominate the busy Berlin stage this season. The city's annual Theater Congress, in which productions from all over the German-speaking world vie for attention, has just ended. Miss Lampe and Otto Sander, the stars of *Amphitryon*, could be seen in a clever Luc Bondy production of *Schlusschor*, or *Final Chorus*, by Botho Strauss, whose examinations of Germanness are popular in Germany. This one, which ends with Miss Lampe as a down-and-out Prussian aristocrat making both war and love with a giant Prussian eagle, has packed in audiences at the Schaubühne.

There is also a splashy revue at the Theater des Westens based on the *Blue Angel* film and book (Heinrich Mann's 1905 novel, *Professor Unrat*). It opened in late May and was greeted by scathing reviews. The

director, Peter Zadek, whose résumé includes a Wedekind *Lulu* in Hamburg in which the leading actress appeared mostly in the nude, perhaps sensed disaster. He withdrew ten days before the premiere, complaining of heart irregularities. Ute Lemper, the star, has also withdrawn indefinitely, with a sore throat.

The Blue Angel, like a different musical of the same title directed by Trevor Nunn in London, may well have had international ambitions. *Hase Hase (Rabbit Rabbit)* at the Schiller Theater in Berlin has none, at least in its German incarnation. But this is the biggest critical and popular hit of the Berlin season.

It was written in French (*Lapin Lapin*) by the film actress Coline Serreau, who played a leading part in the original 1986 production in Paris. The director in both Paris and Berlin was Benno Besson, who as a Swiss comes from the country that can probably best bridge linguistic barriers.

Hase Hase is Mr. Besson's first Berlin production in fourteen years. He was the most popular and influential stage director in East Berlin in the 1960s and '70s, a Brecht disciple who broadened Brechtian orthodoxy into a kind of German magical realism. That gift is still in ample evidence in this current production.

His vision of this antic anarcho-feminist comedy caught its quirky spirit superbly, especially in the performance of the bucktoothed boy genius alien visitor of the title by the director's daughter, Katharina Thalbach. When Enzo Toffolutti's cramped domestic set blossoms at the end to reveal a vision of communal, woman-driven bliss, the whole audience cheers.

WELSH MALE CHOIRS

The New York Times, June 28, 1992

Even if one has driven often in Britain, getting behind the wheel of a tiny stick-shift car again, with all the gears and levers and directions backward, can still seem a shock. Add to that nighttime and street signs in an unfamiliar language, and you have a recipe for confusion.

That explains why I was late for my visit to a Thursday evening rehearsal of Cor Meibion Mynydd Mawr, one of Wales's renowned male choirs. I had set out boldly from Cardiff toward the tiny town of Tumble (it's called by its English name, but also known in Welsh as Y-Tymble), some sixty miles northwest of the Welsh capital. The first forty miles on the M4 motorway were easy enough, even with the gathering darkness and gigantic trucks hurtling by on the right and more confident and aggressive passenger cars determined to pass me on my blind side.

But the motorway ends at Pont Abraham. I had with me a complex series of instructions, from one rotary to another stoplight through a series of unpronounceable little towns, all in the dark with precious few signs or street lamps. I overshot the mark, getting off the A48 at Llandarog and doubling back along a road too small to have a number on my map, through Drefach and Cwm Mawr to Tumble. It would no doubt have been quite scenic had I been able to see a blessed thing. Tumble itself looked utterly abandoned, with no one on the sidewalks from whom to beg directions.

Everyone has a latent detective instinct. I was in search of a chorus rehearsal. Chorus singers come in cars. I drove about until I found a goodly number of cars parked along an otherwise empty road. I got out, cocked an ear, and heard distant manly sounds. I walked behind a dark and empty church, found a door with light peeping out through the cracks—the manly sounds were getting manlier by the minute—opened the door, and was confronted with a very cheery and welcoming sight indeed. Some fifty-five men sat in folding chairs in the Bethesda Chapel Vestry, the village's Congregational Church meeting hall. The older men, who were in the majority, were dressed mostly in tweed coats, long-sleeved shirts, ties, and sweaters, with the younger members trading the coats for zip-up jackets and dispensing with the ties and, usually, the sweaters.

They faced their conductor, Rhyddid Williams, and, accompanied at the piano by the sole woman in the room, forged their way through short snippets that ranged from Welsh hymns to a Schubert song ("Lorelei") in choral arrangement to operatic excerpts (the Anvil Chorus from Verdi's *Trovatore*, sung in Welsh) to a Maori tune in the original.

Visitors seem reasonably rare here, but are not unprecedented. The reputation of Welsh male choral singing has spread far beyond Wales, and Welsh communities in the United States have long staged festivals

to which Welsh choirs are invited. The seventy-odd active male choirs in southwestern Wales, the center of Welsh choral activity of this type, generally rehearse twice weekly in community or church meeting halls just like Tumble's.

The Welsh Tourist Board, eager to lure visitors to this ruggedly handsome but chronically depressed region, will provide potential tourists with precise rehearsal schedules as well as contact telephone numbers. The choruses can also be heard regularly in local concerts, in Cardiff, in London, and in regional or Welsh national eisteddfods, or competitive choral festivals.

The male choirs' repertory reflects popular taste, not the more elevated concerns of Western art music; that is left more to mixed groups that can address choral staples like the Handel oratorios and the Brahms and Verdi Requiems. The male choirs stick with popular favorites, and the bulk of the singers rehearse and perform from memory and learn new repertory using the old Welsh tonic sol-fa system of notation. This is a simplified way of writing music, without staffs, in which geometric shapes stand for different pitches, as in the Appalachian shape-note or Sacred Harp tradition in the United States. "Eighty percent of our singers use the sol-fa system," Mr. Williams said.

Rehearsals are conducted with a formal politeness that matches the attire, and are almost exclusively in Welsh: "Every member is a Welsh speaker but for one Englishman, and he's learning," Mr. Williams reported. There wasn't much in the way of musical admonitions from Mr. Williams; the singers were polishing up repertory for an approaching concert, and most of these chestnuts they had sung innumerable times before, anyhow. There was even plenty of time to stop and greet me, late though I was, and even for me to be asked to address a few words to them. In American.

Cor Meibion Mynydd Mawr translates as the Great Mountain Male Choir, and at full tilt they made a stirring sound. The voices reverberated through the hall, with its wooden floor and arched roof, but the singers did tend to be on the oldish side and their sound was a bit imbalanced: fervent, sonorous baritones and basses but tenors thin and unblended and just a little quavery. For although fifty-five singers make a bracing sight and sound, conventional wisdom has it that the tradition of Welsh male choral singing is threatened on several fronts.

"We lost six or eight in the last year," Mr. Williams reported later in his living room back in Drefach, on the other side of the Gwendraeth

Valley. Nearly all the singers live in the valley, within ten to fifteen miles of Tumble. "They passed away. There's been a lot of illness—heart complaints and such."

The choir was founded only in 1965, and after a peak membership of more than one hundred in the mid-'70s, it slumped to forty-five in the mid-'80s and has now grown again to a membership list of about sixty-five. "We've got lots of new members in the last six months," Mr. Williams said proudly. The choir has won several prizes at the Royal National Eisteddfods, made recordings, and toured to Cardiff, London, and Europe—although not, Mr. Williams regrets, to America.

Still, while Mr. Williams's choir has one nineteen-year-old and one twenty-year-old, it has been difficult for many of the choirs to attract younger members. Rugby stadiums can erupt in choral singing, but not like the spontaneous four-part harmonizing from ten thousand or fifteen thousand throats that Mr. Williams, who is sixty-five years old and who stands in the middle of five generations of Welsh choral singers and conductors, remembers from his youth.

Tenors are especially hard to come by, and the best are in such demand that they belong to three or four different groups. "Everybody is hungry for tenors," said Mr. Williams. The Royal National Eisteddfods used to limit entry to choirs with more than two hundred members, but one hundred is a big number now, and the rules have been relaxed.

Despite the deserved Welsh reputation for musicality, the male choral tradition dates back only one hundred years, and the Welsh-language repertory is largely a product of this century's revived interest in native Welsh culture. Male choral singing here is inextricably linked with the coal and steel industries of Wales, which arose with nineteenth-century industrial capitalism and which are now dying out, victims of foreign competition, alternative energy sources, and exhausted seams.

In recent years many mines have been closed, as a drive through the densely packed, scenically spectacular, but now slightly forlorn Rhondda Valley above Cardiff and below the Black Mountains will readily reveal. One passes north from Cardiff through still-busy industrial suburbs. Branching off onto the side roads reveals lovely green fields, towering hedges, and stern stone cliffs, the landscape captured by Bruce Chatwin in his eerie paean to this very countryside, *On the Black Hill*. From the top of the highest of the Black Mountains, reached by perilous switchbacks up a steep ascent (one had better be used to left-side driving by this point), there are sweeping vistas out over the north central Welsh

plains, neat farm fields miniaturized by distance and disappearing to the horizon.

But the landscape is pockmarked with abandoned coal mines and steel mills, too, great Victorian monster machines fallen into unnatural silence. Once past the Black Mountain crest and descending back down the Rhondda Valley toward Cardiff, there is an unbroken chain of tidy but dingy little towns, full of people who used to work the mines but can no longer do so. The Gwendraeth Valley, where Tumble lies, is farther to the west, but the sociology and economy are the same. The Great Mountain Coal Mine, as Tumble's was known in English, shut down five years ago.

"The choral tradition started with the miners north of Cardiff," said Mr. Williams, whose first name, Rhyddid, means freedom. "They worked close together and depended on one another. The communities were close-knit, isolated in their valleys. People from Rhondda would only go to Cardiff on a special trip."

It isn't just the loss of the region's economic base that has threatened the male choral tradition. "The younger people have so many other things now that interest them," Mr. Williams lamented—things like modern popular music and television and films. Today's pop music is a long way from the staples of earlier generations embalmed in the repertories of some of the less venturesome Welsh male choirs.

Still, all is not lost, and the choirs wax and wane in size depending on the appeal of their conductors and the liveliness of their programs. "I have no trouble attracting young singers," boasted Glynne Jones. He leads the one-hundred-strong Pendyrus Male Choir, which rehearses Sunday and Wednesday evenings at the Tylorstown School in the Rhondda Valley. Mr. Jones added that "the people who get in trouble are the people who aren't particularly adventurous in their repertoire."

Mr. Jones was almost aggressively optimistic about the tradition's continued good health, calling rumors of its decline a myth. But he insisted that its vitality was linked with the continued strength of Welsh male bonding, and he seemed less sure about that.

"I suggested a mixed choir once, and the boys were quite blunt in their reply," he recalled. "They said if the women come in, we go out. Boys like to play and men like to have a pint and get together and sing. It's a national tradition.

"But if the women take over, and insist on going everywhere with the men, then there will be a decline. As long as there is rugby and the

rugby clubs, as long as our men aren't like American men—poodles on chains—then things will be all right."

JOHNNY HALLYDAY (AND VANESSA PARADIS)

The New York Times, July 17, 1993

Paris—Johnny Hallyday, although never blessed with a hit single in those twin kingdoms of rock and roll, Britain and the United States, has managed to become a special target for Anglo-American scorn. How tacky, how derivative, how downright silly of the French to lavish on this nonentity the devotion worthy of an Elvis. He is a French idol, the eternal rocker beloved within the Francophonic world and reviled or ignored without. Yet he has built an entire career out of unashamed, unselfconscious translation of American pop culture into French. He is the pop-music equivalent of dubbed American films and television sit coms.

Had we cared, the recent fiftieth-birthday hoopla for Johnny in France would have only confirmed such prejudice. The actual date was June 15, but that was preceded by a barrage of media attention (including his fifty-first cover of *Paris Match*) and followed by the actual public celebrations. These were capped by three lavish concerts here at the outdoor Parc des Princes that accommodated nearly 200,000 worshipers. In composite form, they became the centerpiece of an hours-long Johnny documentary telecast, and retelecast, in prime time on TF1, the most widely watched national channel. The documentary not only gave us the whole concert, with backstage scenes to boot, but it also included film from every stage of the Hallyday career.

That film revealed the painstaking way Mr. Hallyday (who was born Jean-Philippe Smet) adapted every geological stratum of American pop since the '50s to his, and the French public's, uses. And his show, with its huge generic American suspension bridge (somewhere between Brooklyn and the Golden Gate) and big-finned American bulgemobiles and its Harley-Davidsons, was a visual homage to his influences.

And there, in the midst of adoring peers (most notably the French rocker Eddie Mitchell) and ex-wives and ex-lovers (most prominently the pop star Sylvie Vartan) and Madonna-esque armies of gyrating, posing extras, was Johnny himself. Taut now, after years of pumping iron in the best 1980s American rock-star manner, he growled away in his swallowed baritone, pawed at his guitar, and cranked out (French) hit after (French) hit.

It's probably best to resist the easy mockery of anything that lots of people love. Popular taste has hardly proven, over the decades, to be quite the infallible indicator of bedrock worth that 1960s idealists hoped it would be. Yet Johnny Hallyday has touched the French, and that surely means something. He allows them to partake of international rock style (which still means Anglo-American rock style) without feeling they have betrayed their own roots. And he's continuing to do it on a summer tour throughout the country.

To be fair to the French, at least some commentators managed to combine genuine affection for Johnny with witty deprecation. "So Johnny is fifty years old and still has most of his teeth," began Michel Braudeau's paean in *Le Monde*. Mr. Braudeau, while poking fun at Mr. Hallyday's derivativeness and faux pas, linguistic and otherwise, still praised his "energy and irresistible force."

The whole affair recalled the eightieth-birthday celebration at the Bastille Opera in May for Charles Trenet, that surviving torchbearer of the French chanteur tradition. It would be a stretch to argue that Mr. Hallyday has somehow fused French chansons with rock and roll, creating a genuine French cultural artifact with Anglo-American influences. Such fusions are taking place, in French rock and French Afropop and French rap, but Johnny Hallyday is just a neo-American: he copies, but he doesn't transcend the copying into originality. Yet still, for all his borrowings, he's as French in his way as Mr. Trenet, and justly beloved for that very reason.

If Johnny Hallyday is the éminence grise of French rock idols, the twenty-year-old Vanessa Paradis, who is currently crisscrossing France on a tour of her own, has been working hard for at least five years to become the rock idol of her generation.

Miss Paradis is another easy figure to mock, the archetypal French bimbette peddling her admittedly fabulous looks without benefit of much musical talent. Or so the feeling is among the hipper elements of the French pop-music public, those who dote on the Africans or the

Algerians or homegrown blends thereof. Or even on the Velvet Underground, which sold out the Olympia Theater in downtown Paris for three nights in mid-June on word of mouth alone, recording there a live album and a video document of their comeback tour.

Miss Paradis's own two-week engagement at the Olympia revealed a more plausible pop personage than her dismissive anti-image might suggest. Cheered on by her fans, who seemed to be mostly thirteen-year-old girls, she belted out her up-tempo tunes and croaked her ballads with all the fervor of a latter-day Trenet. She certainly has as many chops as all sorts of photogenic young performers who have had big international hits. All she needs is a dose of originality and a personal voice. And maybe she doesn't even need that, if she gets lucky.

By "international" hit, one means English-language. Miss Paradis has already put in time in New York, recording an album with Lenny Kravitz and singing away in pleasantly accented English. But so far, her international crossover efforts have not gone as smoothly as she might wish.

Even her side career as a model has been slightly stunted, apparently on the grounds of political correctness. A striking print and television advertising campaign for Coco, a perfume from Chanel, with Miss Paradis as a none too amply clothed bird-girl in a gilded cage, swinging back and forth on a little swing and whistling with a classic French moue, has been modified in the United States, at least in its print version, with Miss Paradis in a long black ball gown. The French argue that the puritanical Americans think the European version is sexist. Which it no doubt is, but still. . . .

Maybe, then, Miss Paradis in full plumage will remain a private obsession of the French, and evolve into yet another target of Anglo-American mockery. One can see it now: as Johnny Hallyday celebrates his 80th birthday (a mere five years after the death of Mr. Trenet at 105), Miss Paradis will be cranking out her (French) hits at the Parc des Princes, a fifty-year-old national treasure.

ARIANE MNOUCHKINE

The New York Times, September 27, 1992

Paris—As the dawn lightens, the first entrance of the Greek chorus shocks an audience into realizing just how astonishing Ariane Mnouchkine's Théâtre du Soleil really is. The double door at the distant rear swings open and in they surge—fifteen red-clad women (though some are really men), stamping and swaying with a gleeful joy that is very close to barbaric fury.

There is little scenery in the modern sense, but the look is still riveting: faces covered with chalk-white makeup, like masks; headpieces; and costumes with full skirts, vests, and glittering ornaments that are an ingenious hybrid of the ethnic cultures stretching from southern Italy through the Middle East to southern India.

Miss Mnouchkine's Théâtre du Soleil (Theater of the Sun), an institution in Europe for nearly thirty years, is quintessentially French and inherently cosmopolitan. A nearly lifelong Parisian, Miss Mnouchkine has created a unique style that blends world theatrical cultures in the service of Western classics and contemporary epics.

Outwardly similar to the work of another Paris-based theatrical internationalist, Peter Brook, Théâtre du Soleil's stylistic fusion is more diverse and organic, its enunciation of the French language more elegant and its dance and music closer to Pina Bausch and other European choreographers. Although Miss Mnouchkine has her detractors, she has won critical admiration and audience enthusiasm that is close to adulation.

Despite her fame abroad, her company has visited the United States only once, presenting Shakespeare in French at the 1984 Olympic Arts Festival in Los Angeles. Now, finally, the company will make its New York debut, with three cycles of its current four-part project, called *Les Atrides*, or *The House of Atreus*. The performances will take place over an eleven-day period starting Thursday at the specially refitted Park Slope Armory in Brooklyn, under the auspices of the Brooklyn Academy of Music.

Americans are hardly used to hearing theater in foreign languages; in Brooklyn, incomprehensibility will be alleviated by the familiarity of the plays and by translation through earphones. But more than language separates Théâtre du Soleil from conventional Anglo-American theater. In addition to its synthesis of theatrical traditions, the company is a com-

mune, a radical popular theater born of leftist idealism that speaks to theater lovers all across the political spectrum. When three of its four parts were staged in Paris last June, the conservative American monthly *New Criterion* called *Les Atrides* the "most exciting and innovative theatrical experience on earth."

Miss Mnouchkine is a cheerful woman with a handsome face, a winning grin, and Brillolike gray hair, given to baggy yet comfortably stylish clothes. She combines the images of fierce theatrical moralist, bubbling happy child, nurturing mother, and forbidding French intellectual. (It was she who branded Euro Disney a "cultural Chernobyl.")

Although she was born in Paris in 1939, the daughter of Russian immigrants, Miss Mnouchkine's first connection to theater was at Oxford. "I went there to study psychology," she said, during a break from tour performances in Montpellier, not far from Marseille. "But then I joined the Oxford University Drama Society, and one day I said, 'Of course, this is what I want to do.'"

In the early '60s, she embarked on a year's journey to Asia, then founded Théâtre du Soleil in 1964. From the first, it was a visionary enterprise, a band of leftist romantics convinced that they could change the world. And although the personnel has turned over completely, the vision remains consistent.

"Théâtre du Soleil is the dream of living, working, being happy and searching for beauty and for goodness," Miss Mnouchkine said. "It's trying to live for higher purposes, not for richness. It's very simple, really."

The theater got its name through a similarly openhearted idealism. "At the time theaters were named for their directors, but I could not imagine calling it Le Théâtre Ariane Mnouchkine," she said. "We were looking for life, light, heat, beauty, strength, fertility. . . ."

In 1970 the ensemble took possession of what has remained its home ever since—three airy warehouses in the Cartoucherie (or weapons depot, which is what it was up to the nineteenth century) in the Bois de Vincennes, just east of Paris. Today, the first of the warehouses is a huge lobby space, the second, a transitional area, and the third, the twelve-hundred-seat theater: sharply raked bleachers and a huge square performing area bereft of wings or flies or changeable scenery. It is this theater that Miss Mnouchkine insists be replicated whenever her company tours. But touring performances cannot duplicate the all-embracing mood in Paris, the sense of having entered, willingly, into another world.

The company spent the 1970s exploring France—"telling our history

in order to make it advance," as she once put it. In 1979 she shifted gears, with her own adaptation of Klaus Mann's novel *Mephisto*. Then, in the early '80s, came Shakespeare: *Richard II* (the company's first comprehensive employment of Asian masks and costumes), *Twelfth Night*, and *Henry IV, Part I*.

The success of the Shakespeare productions brought yet another change of direction: two nearly daylong epic pageants about contemporary Cambodia and India by the French feminist intellectual Hélène Cixous. The next project was to have been another Cixous blockbuster, this time on the controversial topic of the Vichy regime.

"Hélène Cixous was ready, but I was not," Miss Mnouchkine said. "It so difficult to imagine such a close period in time and space. Before, when we talked about France, it was a long time ago, and when we talked about now, it was far away. The Resistance images are still with us, from photographs and films. I felt my dreams were not free, not theatrical: they were still realistic."

Instead, Miss Mnouchkine plunged back into the classics. It was her idea, for *Les Atrides*, to preface Aeschylus's *Oresteia* trilogy with Euripides' *Iphigenia in Aulis*, written more than fifty years later and more sympathetic to Clytemnestra; her grief at the sacrifice of her daughter makes her murder of her husband more understandable. It's better theater and better feminism.

Beyond sheer spectacle, *Les Atrides* is striking for the power of its choruses, the omnipresence of the music, and the doubling and redoubling of the principal parts. The chorus changes from fiercely joyful women in *Iphigenia* to soldiers overcome by the horror of war in *Agamemnon* to black-clad, vulturelike harridans in *The Libation Bearers*. In *The Eumenides* they become terrifying mythic beasts, no longer dancing but growling and snarling, led by three harpies straight from a Brechtian proletarian netherworld and standing as eternal threats to human benevolence.

The ever-present background music is provided by Jean-Jacques Lemêtre, who has been with the troupe for fourteen years. When actors are speaking, he leaps among his battery of exotic instruments, a megalomaniacally inflated one-man band, although for the chorus dances he falls back on recorded ensemble music. He says his music is so intimately wedded to speech rhythms that having other musicians accompany him would be nearly impossible, and a live dance ensemble would be too expensive.

More unusual still is the casting of a few actors in most of the major

roles. The most dramatic case is that of Simon Abkarian, a French-born Armenian raised in Lebanon who spent many years in Southern California—as a cabaret dancer, he says. Mr. Abkarian plays Agamemnon, Achilles, a chorus leader, a messenger, Orestes, and, to cap this tour de force, Orestes' nurse.

The Brazilian Juliana Carneiro da Cunha, a dancer trained in the school of Maurice Béjart, does both Clytemnestra and Athena in *The Eumenides*; the Indian Nirupama Nityanandan is Cassandra, a chorus leader, and Iphigenia, a role in which her twenty years of training as a Bharata Natyam dancer in Madras can be seen to especially beguiling effect. Brontis Jodorowsky, born in Mexico of a Chilean father and a French mother, plays a host of secondary parts.

Artistic decisions are described as simple deductions from unassailable "evidence"; that doubling parts may make dramatic sense is dismissed as coincidence. "What I call theatrical evidence just emerges," Miss Mnouchkine said. "It's not discussed. We discuss when something goes wrong, when for two or three days we are stuck. When the work is going, we don't discuss, we work."

The actors concede, however, that Miss Mnouchkine makes the final decisions. Mr. Jodorowsky sees her as almost like a Zen master: "She directs not by adding things but by taking things away, down to the more and more simple, the more essential."

Dismissive of most acting today, with its uninflected imitation of life, Miss Mnouchkine prefers a broadly emotive style that recalls what we know of early Western theater and that still exists in the non-Western world. Not for her, despite her own academic background, the psychological identification of the typical modern Western actor. "We flee daily life," she said in an interview in *The Drama Review*. "We do not talk of psychology but rather of the characters' souls. The theater is not supposed to represent psychology but passions."

Miss Mnouchkine believes that masks (or masklike makeup) liberate acting from pale realism. In *Les Atrides*, the masks and makeup become simpler as the plays approach modernity. Yet, Miss Mnouchkine says, the mask is always there—"the mask of character."

She categorically rejects the idea that she has poached on exotic cultures. "What we do derives completely from the action of the characters," she said. "Iphigenia is not using the real steps and *mudras* of India, which would mean nothing to us. She's just showing her feelings. She's not using the codes; she's using what is inward."

"Imperialism is not my problem; it is your problem," she said, speaking of Americans. "Cultural imperialism is the opposite of what we do. It is the repressing of other cultures. It's what we suffer from in France, with the film and television products of the United States."

Economically, Théâtre du Soleil is still a commune, although its members live in their own apartments with whomever they please. It is legally organized to share income—at present, sixty people (including Miss Mnouchkine and the twenty-six actors as well as backstage personnel) receive 9,000 francs ($1,800) each per month. "It's a small salary," Miss Mnouchkine said, "but it's not worse than many other theaters."

The company is given $1.4 million annually by the French Ministry of Culture, the figure having been doubled in 1981 when the Socialists took power. The rest of its income (roughly twice the subsidy in an average year, according to Nathalie Pousset, a company administrator) derives from the box office and fees from tour hosts. Miss Mnouchkine rejects corporate sponsorship, but the New York debut was insured by French corporate support from Air France and Elf Aquitaine.

Right now, the troupe is a young one, with the veteran actors having only six or seven years of tenure. "When we started, we were there for all our lives," Miss Mnouchkine recalled wistfully. "But of course it's a mistake to think that."

Miss Mnouchkine holds annual workshops, usually ten days long, and although she says they are not auditions, she gets most of her actors from them. By all evidence this is a happy group, full of people who really like one another. Miss Carneiro da Cunha, for one, speaks lyrically of her new friendship with Miss Mnouchkine, how they left a late show in Toulouse and rode through the streets on their bicycles as the sun came up.

Still, there is the potential for estrangement between the director and her actors. "People who come here may be nervous at first," Miss Mnouchkine said. "They know Ariane as somebody very famous. But after a while they just see Ariane. And they're famous, too, collectively. What is difficult is the question of age. I've aged and they have not."

Although the company remains true to its Utopian ideals from the '6os, the Utopia seems now to be expressed in religious terms—the theater as a sacred space and art as an avenue to the divine.

"That is all very personal, very intimate," Miss Mnouchkine said. "We never go on stage thoughtlessly, without saluting it, some little sign,

just putting a hand on the stage. For some it's religious, for others super-stitious, for others just a habit. Our actors never step on the stage with-out realizing that it relates to spirit and the progress of the mind."

CULTURE IN THE NEW RUSSIA
The New York Times, November 9, 1992

Note: The first of three long articles, run on consecutive days, about cul-ture in the new Russia. It was the idea of Max Frankel, then the executive editor, to do this series. I thank him for it.

Moscow—The collapse of Communism and the Soviet empire awak-ened widespread hopes that the arts in Russia, so long repressed, might suddenly blossom into a new golden age. But that flowering has been blighted by the grim, uncertain realities of the country's economic and political life.

Although there are signs of stability in the provinces and of innova-tion throughout this vast land, the most immediate image of the coun-try's cultural life is of poverty and creative paralysis. A cultural establishment accustomed to virtually total state support and central-ized control was suddenly cut adrift, its subsidies reduced by fiat and inflation and its administrators forced to cope on their own. And it was the most prominent museums, theaters, and conservatories, the glories of the Soviet system, which had the greatest obstacles to overcome.

The lack of money, the dead hand of the past, and an almost hope-less capitulation to the worst of the West can now be seen everywhere: in routine performances before dated and shabby opera sets at the Bol-shoi Theater in Moscow, in crumbling hallways and decaying facades at the country's leading museums and conservatories, in cheap popular entertainments at its theaters, in third-rate American films on television and in movie theaters, in pornography sold at flea markets.

Most established artists and arts administrators believe that the artis-tic life of the country has suffered with the breakup of the Soviet Union. "The whole level of culture has been lowered," said Yevgeny Y. Sidorov,

the Russian Minister of Culture, who is an ally of President Boris N. Yeltsin with firm progressive credentials.

Anatoly F. Malkov, the administrative director of the Maryinsky Theater in St. Petersburg, the home of the Kirov Opera and Ballet, was optimistic about his own companies, but pessimistic about the country as a whole. "My general impression is that the situation is getting worse," he said. "And to a great extent, that is connected with the difficult economic situation of the country at large."

The most immediate sign of crisis has been an extraordinary diaspora of Russian arts and artists. Sometimes the flight to the West, of performing groups capitalizing on known artistic brand names, or cobbled together for the sole purpose of earning hard currency, becomes dizzying in its confusion.

"They're tripping over one another," said the promoter John Cripton of Satra Arts International, speaking of four competing Red Army Choruses that have crisscrossed North America this year.

Most museums still refuse to "deaccession"—to sell off their assets— but they happily diminish their collections by sending them on long tours with precious little in the way of exchange exhibitions from the West. Contemporary artists are likewise restless. Oleg Kulik, who runs the Regina Gallery in Moscow, grumbled: "No artist here loves his country. They all want to go to New York."

The drain began before the relaxation of Soviet rigor by Mikhail S. Gorbachev, with dissidents, star soloists, and rank-and-file dancers and orchestral musicians. Some emigrated to Israel. Many more are fleeing now to the West, or even to other former Communist countries, in search of hard currency and a better life. Every absence worsens the quality of artistic experiences available to Russian audiences now and Russian arts students for the future.

"This year we lost seven solo dancers, who went to Moscow and St. Petersburg to replace others who went to the West," said Igor M. Nepomnyashchy, the director of the Voronezh State Opera, Ballet, and Theater, three hundred miles south of Moscow. "It takes years to train a good dancer."

With the dissolution of the Soviet Union, one unlamented victim was the old Soviet Ministry of Culture, which with the Communist Party, the KGB, and the various artists' organizations sought to control the arts from on high. In its place, Russia and each of the former Soviet republics gained their own ministries of culture.

Yet the Russian ministry's role and budget were sharply reduced as part of President Yeltsin's decentralizing reforms. Mr. Sidorov, the Minister of Culture, said that under the Soviet system, culture received between 3 and 4 percent of the national budget but that now the share was below 1 percent.

The regional and municipal agencies that are supposed to fill the gap are undeveloped or crippled by the country's economic upheavals and rampant inflation. The old Soviet artists' unions or associations have lost most state subsidies, and artists are being forced to struggle for survival on their own.

Nor has there been much help from sponsors, or private and corporate philanthropists. Mr. Sidorov, along with arts leaders all over the country, laments the absence of a provision in the tax laws that would significantly reward arts support. The current law allows companies to donate 2 percent of earnings, but the definition of a nonprofit entity is vague (if a troupe sells tickets at the box office it may not qualify), and Mr. Sidorov would like the figure raised to 5 percent. So far, efforts to pass such a reform have been bottled up in the recalcitrant Russian parliament.

Even without its former Soviet satellite republics, the Russian cultural establishment is enormous. According to figures supplied by the Ministry of Culture, there are 402 state-supported season-long repertory theaters in Russia. These include 23 opera and ballet companies (the two are usually combined here) and 19 theaters for operetta and musical comedy. There are 80 full-scale symphony orchestras. There are more than 200 major arts museums (the figure is vague because some museums blend in history and natural history). There are nearly 4,000 state-supported music schools. In each case "state" can mean national, regional, or municipal, with many institutions now falling painfully into the cracks.

Some of the big performing institutions have managed to sustain performances and hold ticket prices within reach of their old audiences (at the Bolshoi, Russians can still pay as little as 3 rubles, or about 1 cent, while tourists are asked to pay up to $75 in hard currency). But others have watched their audiences slip away, unable to afford rising ticket prices, distracted by popular entertainment on television, or, in the words of Mikhail V. Bychkov of the Voronezh Theater for Youth, "spending time trying to find food, clothing, everything."

Some former showcases of Russian culture, like the Pushkin Drama

Theater in St. Petersburg, rent out their space several nights a week for popular revues or commercial exhibitions. "It's another lost fragment of our national culture," lamented Leonid N. Nadirov, the director of the Vaganova Ballet Academy in St. Petersburg and himself a former actor. "There are still people there who worked with the famous actors of the previous century."

Most arts institutions seem unsure about how to cope in a new international world in which their currency is practically worthless, and how to handle the new fund-raising and marketing needs thrust upon them by the withdrawal of state control and support. "Not everyone is inclined to appeal for help," said Vladislav A. Chernushenko plaintively. Mr. Chernushenko is the rector of the Rimsky-Korsakov State Conservatory in St. Petersburg, and his biggest problem is obtaining quality musical instruments from the West, for which he needs hard currency.

In the general economic confusion, long-term planning becomes nearly impossible as attention is focused on day-to-day survival. Backstage machinery and physical plants grow antiquated and dangerous. Even now, with the first snow of the season gracing the bare trees and crumbling facades ("Winter is not all bad; it covers the dirt," Muscovites like to say), the decay of the infrastructure cannot be escaped.

Mr. Bychkov in Voronezh needs 3 million rubles to fix a leaky roof, but has no prospect of getting it. Even when restorations are undertaken, they are often protracted into a years-long holding pattern in which nothing much seems to get done, as in the desultory construction at the Tretyakov Museum in Moscow. The new wings are handsome and up to date, but the main central building has been closed for eight years.

Most museums, like the Hermitage in St. Petersburg, have little immediate hope of installing modern air-conditioning or security systems, leading to fears in the West that their masterpieces may be damaged or stolen. And masterpieces they are: the Hermitage has one of the great collections of Western art, with especially extensive examples by nearly every major Italian, Flemish, and French artist from the Renaissance to early modernism.

On the horizon looms an even greater danger to the large museums. In the treaty establishing the Commonwealth of Independent States, it was agreed that cultural artifacts from the former Soviet republics would be returned to them. Although no formal claim has yet been filed, Ukraine has threatened to do so, and Russian officials are apprehensive.

"This is a very serious issue," said Dr. Vitaly A. Suslov, who retired this past summer as director of the Hermitage. "The agreement was not properly thought out. If we had to return objects, science at large would suffer. It would be as if all the Italian and Dutch paintings were taken from the Louvre."

Anatoly N. Konstantinov, of the Mayor's Cultural Committee in St. Petersburg, said, "If this decision were implemented, we would lose the Hermitage Museum completely."

Most of the big state institutions are still administered by holdovers from the Soviet regime, people who either were Communists or had made some sort of peace with the old regime. Many are simply unable at this stage of their lives to adapt to the straitened economic realities and the artistic challenges of today.

"Instead of trying to create a new kind of theater, they struggle to sustain the kind of theater they had before," complained Mr. Bychkov in Voronezh. "In the current situation, that's outdated." An official of the United States Embassy in Moscow, who spoke on condition of anonymity, said, "Younger people who work in these institutions are dying to do different things, but they are terrified."

Big companies like the Kirov Opera can at least count on sponsorship from well-established firms, Russian and Western, that hope to profit from an association with a widely recognized artistic brand name. The Kirov Opera's summer tour to New York included transportation provided by Baltia Air Lines, which said it "wanted to be linked with the best."

Smaller troupes, museums, and municipal arts programs, victims of cutbacks at the local level, must rely more heavily on private sponsors. But in Russia's chaotic economy, that is an almost impossibly unsure way to build a company over the long run.

Yevgeny Panfilov, a modern-dance choreographer in Perm, near the Urals in central Russia, dramatically shaved his flowing locks last spring to protest the reneging of a local sponsor. Mr. Panfilov later conceded, puckishly, that he also rather liked baldness as a fashion statement. The loss of the promised funds was no laughing matter, however: it meant Mr. Panfilov had to cancel a new production of his Experiment Modern Ballet Troupe, and his dancers went without pay for several months.

"A lot of people who are very wealthy now in this country are not very cultivated," said Viktoriya Pavlova of Ardani, a private arts management organization in Moscow. "They have no idea what modern dance or the

avant-garde is. They simply do not understand what it means to be a sponsor. They think we bring them rubles, and they somehow gain hard currency."

Writers, painters, and other individual artists are suffering from a collapse of the Soviet institutions that assured them privileges and access to the public. In every city, composers or writers' unions offered publication, performances, income, pensions, weekend homes, and a host of other benefits, along with repressive ideological control.

Though many such unions have been given their buildings by the regional authorities, they have little money to sustain their privileges. For artists accustomed to the old system, with or without political complicity on their part, adjustment to a free-market artistic climate, as in the West, can be painful.

"A hundred members of the Artists' Union used to work and live in Voronezh," said Yuri Pchelkin, the head of the Arts Department of the Regional Department of Culture in Voronezh and a proud former Communist. "Now, no one buys their paintings. What can the artists live on? They have no other skills or professions. It's not right."

Former dissidents who never, or only fitfully, enjoyed Soviet sinecures are often discouraged, as well. For them, the solidarity they experienced in common opposition to the state has been replaced by a queasy sense of uncertainty, a loss of center and purpose. For some, the depredations of capitalism are as painful as the repressions of totalitarianism.

"Today, you can do what you want and make a living out of it," said Garik Sukachev, the lead singer of Brigada S, a popular and respected Moscow rock band. "But the hard thing is that somehow it evolves into a profession, and it was never supposed to be that."

Curiously, given the widespread complaints in Russia about the triumph of commercialization in the arts, the popular arts are in similar crisis. Film production has almost ceased at the old Soviet studios, and private investment is erratic at best and shady at worst. At the last Berlin International Film Festival, a common thread in discussions of film financing in Eastern Europe was that underworld money, in need of laundering, was being plowed into any and all film projects.

In fact, few films are being made in Russia today. With a ramshackle distribution system and heavy competition from cheap or pirated Hollywood rejects, the chances for profit are slim. Especially since so many contemporary Russian films accent a bleakness that can hardly be

expected to entertain a large public. "The tone of Russian movies is too gloomy," said Sergei V. Koptilov of AIST, the private television station in Irkutsk. "They promote the black side of Russian reality."

The former state television networks limp on, plagued by inefficiencies, nepotism, and a capitulation to the sorts of soap operas and game shows that routinely clutter Western television. Leonid Orlov, a producer for the second, and supposedly innovative, national channel, complained that "a lot of the people who work there aren't even professionals." High culture on the state networks has declined. The most popular program in the country just now—work in offices and shops grinds to a halt when it comes on—is a Mexican soap opera called *The Rich Also Cry*.

Private television stations like AIST, which have sprung up around the country, have siphoned off many of the trained technicians who used to work at the state stations. But they are usually reduced, given Russia's economic woes and its refusal to sign the Bern copyright convention, to recycling Hollywood's worst.

"The distributors try to get the cheapest films possible," said Mr. Koptilov in Irkutsk. "Sometimes they ignore the copyright laws and show good American films, just to prove that American movies aren't always bad. If anyone complains about copyright questions, it's the distributor's problem, not ours; we just buy them."

Rock and jazz, though still popular among young people, have been undercut by commercial pop music far removed from the political and moral passions that inspired the dissident bands. "There is a distinction between rock and pop," argued Dmitri Groisman, the manager of Brigada S. "Rock music is what was before perestroika, and pop music is the result of perestroika."

In the Communist system, there was a coherent network of folk groups and community arts activities, often paid for by contributions, voluntary or expected, from factories and workers' groups. But in many Russian cities, former community centers stand empty as local amateur folk-dance groups, choruses, and theater ensembles have withered away.

Throughout the country, leaders in the arts seem overwhelmed by the despair and confusion of their everyday lives. Vladimir Martyanov, a composer of sacred music who teaches at the Zagorsk monastery near Moscow, worried that "as in the West, more freedom does not automatically mean a deeper or better culture."

Mr. Sidorov, the Minister of Culture, put it this way: "Now," he said, "we are free, proud, but poor."

ARTURO TOSCANINI ON RECORD

The New York Times, December 6, 1992

At long last RCA/BMG has repaid its debt to Arturo Toscanini, reissuing its stock of recordings of the maestro in seventy-one volumes comprising eighty-two CDs. The volumes are available individually and, in an edition of five thousand, in a "deluxe box set." A display case with a gold-embossed glass door is also available separately for those who acquire the CDs individually.

So your own personal ton of Toscaniniana can sit self-contained in your living room, right next to your big-horned phonograph and your quizzical dog, still loyally attending to his master's voice. One wonders what Toscanini would have thought of the hype. One knows what the curmudgeonly cultural critic Joseph Horowitz thinks, since he wrote a book about it.

What he was about was intensity and passion. Especially in his later years—in his seventies and eighties, when most of these recordings were made—he stripped his style down to its purest (or most exaggerated) form. Tempos were faster, rubatos more unbending, textures leaner. Bathetic wallowing in the German mold was ruthlessly purged in favor of unalloyed expressive directness.

This style naturally aroused resistance among those who admired the central European musicality and Germanic mysticism best espoused in Toscanini's late lifetime by Wilhelm Furtwängler. It also alienated all-Americans like Virgil Thomson, who came from a very different background, prizing the American folk tradition and French clarity.

On his own terms, Toscanini offered an exhilarating perspective on the great masterpieces of Western orchestral music. That perspective did not preclude other approaches. I speak from experience, since I came to know most of those masterpieces through these Toscanini recordings but was hardly precluded from loving Furtwängler's or Walter's or Klemperer's or Bernstein's versions.

Toscanini's brisk tempos, abrupt accents, and punchy brass had a clear influence on such early-music conductors as Roger Norrington and Roy Goodman. Of course, as Richard Taruskin never tires of telling us, early-music making is itself a modernist invention, so the influence of the primal modernist conductor should indeed be evident. In any

case, Toscanini's quick tempos for Beethoven, so foreign in the 1930s, '40s, and '50s, seem far more normal today.

Calling Toscanini a modernist may seem odd to lovers of modernist composition, who regularly excoriated the conductor for ignoring Stravinsky and Schoenberg. But Toscanini's latter-day image as one who enshrined a canon of dead composers seems unfair, given his youthful advocacy of such progressives as Wagner and Puccini. He died in 1957 at the age of eighty-nine, and in his later years played his share of Prokofiev, Shostakovich, Barber, and Gershwin, which to today's post-modernist tastes might seem almost hip.

Even in the most extreme formulations of his late style, Toscanini was never the rote automaton, the chugging machine that his detractors accused him of being and his imitators sometimes became. His passion for an Italianate, singing line always humanized his kinetic energy and softened his rhythmic muscularity.

As I looked back over the RCA collection and dipped into it to reex-perience favorites from the past, too many recordings stood out to men-tion here. Toscanini's Beethoven symphonies were justly famous: the powerhouse swagger of the first movement of his Second, the sweep of his "Eroica" and his Fifth, the unique force and coherence of his Ninth.

I have always had a special affection for his Brahms symphonies, with their leanness and Beethovenian clarity—not as the only way to play these works but as a corrective to the neo-Wagnerian wanderings of too many German maestros (or worse, the wishy-washy compromises of those who tried to reconcile Toscanini and Furtwängler).

Toscanini's Verdi was remarkable, of course, even in performances that can sound too fast and rigid, and even without the great singers of his years at La Scala before 1929. There are other Toscanini Verdi Requiems, perhaps better sung, but the 1951 Carnegie Hall version included here still astounds as an awesome intimation of the apoca-lypse.

Nor can one forget such bracing exercises in intensity as Toscanini's Tchaikovsky *Manfred* and his "Dance of the Furies" from Gluck's *Orfeo ed Euridice*. In "Siegfried's Rhine Journey" from Wagner's *Götterdäm-merung*, the sweep of heroic adventure is inimitably projected by an unstoppably youthful octogenarian.

Among the alternative items missing here are two rehearsal excerpts that I got as a teenager from someone whose cousin was an RCA engi-neer in the 1950s. A 78-rpm disc, it offers legendary Toscanini temper

tantrums in rehearsals of the "Dance of the Water Nymphs" from Catalani's opera *Loreley* and the opening measures of Tchaikovsky's *Manfred*. (The Catalani was available on a bloopers LP in the 1960s, the Tchaikovsky only on a pirate LP.)

Everything you ever imagined about Toscanini the self-involved autocrat, Toscanini the child, Toscanini the madman appears in these six or seven minutes. He screams and rants like King Lear on the heath, and he broods like Hamlet that he hates to conduct because he "shouts too much, too long." He thinks the players are staring at him; he wonders if they think he is crazy. He gets so overwrought in the Catalani that he smashes his watch (and, it seems, the podium) and storms off, cursing.

But in *Manfred*, he masters his rage and turns it back into the music, shaping Tchaikovsky's introduction of Byron's moody, impassioned hero into an indelible self-portrait. "What is this music?" he bellows hoarsely at his NBC Symphony musicians. "Passion, sorrow, and no sleep!" is his answer.

Toscanini's performances had all of that. RCA's collection should become part of a process by which his unmatched accomplishments can provoke and enthrall music lovers forever.

RICHARD SERRA

The New York Times, June 14, 1993

Paris—Richard Serra was in his element. Partly, that meant he was in Europe, which he believes has always supported his work more loyally and intelligently than the United States. Unfortunately, it also meant Reykjavik, Iceland, and a rain driven nearly horizontal to the grass-tufted volcanic rock and mixed with pinpricks of hail. "I love this light," he said, squinting up at the implacable, slate-gray sky. "And I love the look of the piece when it's wet."

He had a point. *Afangar*—the name was taken from an Icelandic epic and means something like "wandering about in a contemplative mood"—consists of nine pairs of hexagonal stone pillars, natural crystalline formations hacked from a quarry in the middle of Iceland and

transported to the site. The pairs outline the small island on which the piece stands, like Viking totems. When the weather is dry, the stones look light gray and are flecked with bird droppings. Wet, they're shiny and black, Nordic cousins of the Jupiterian sentinels in the film *2001*.

A couple of days later, on a lovely spring afternoon on the grounds of an elegant baroque chateau an hour's drive from Paris, Mr. Serra was in a very different element. "It's always like this," he chuckled, strolling across an expanse of manicured lawn after a sumptuous luncheon in the chateau dining room.

The occasion was the mocking up of a sculptural project commissioned by the chateau's owner, François Pinault. The grounds are dotted with giant sculptures by the likes of Picasso, Moore, and Mondrian. Assuming final contractual details are ironed out soon, Mr. Pinault by this fall will also possess a Richard Serra sculpture: ten rectangular pieces of Cor-ten steel deployed in asymmetrical formality in an allée defined by rows of ancient trees. Intense and a little nervous, Mr. Serra supervised the positioning of the wooden boxes, painted a deep red rust color, on the lawn. "The models are good," he muttered to himself. "Let's hope the piece is good."

These very different works give an idea of the contrasting reception Mr. Serra has received in his native United States and in Europe. In America, several of his public installations have provoked angry controversy, the most notorious incident occurring in 1989 when his *Tilted Arc* was removed from its site in lower Manhattan and "destroyed," as he still puts it bitterly. His sensuous curving abstractions, charged with industrial might, strike some as inherently hostile, as does the artist's confrontational, aggressively self-righteous style. Mr. Serra is convinced that Europeans simply have more taste than Americans. Be that as it may, a closer look suggests other reasons for his European success as well.

"In Europe," he said, "there is a long-standing commitment to art for its social function, not predicated on a secondary sale." Overall, he estimated, 75 percent of his work over the last twenty years has been commissioned and built in Europe.

Mr. Serra believes he has been stigmatized in the United States. "You're given a characterization that becomes an imprint in people's minds," he worried. "I would come back to America and there was such a level of rejection; for years I was glad to get back to Europe."

Certainly the Europeans have generally accorded him a reception worthy of a modern master. *Afangar* is on an island called Videy in the

Reykjavik harbor. To the south lies the capital itself, home to three-fifths of the country's 250,000 inhabitants. To the north are spectacular, snow-streaked mountains and the blue-black Atlantic Ocean. The island is sacred to the Icelanders as the site of the first Viking landing eleven hundred years ago.

The piece, a joint commission by the municipal and national governments, was installed three years ago, with an opening ceremony featuring recitations of epic poetry, a huge beach bonfire, trumpets from the surrounding rocks, and much champagne. Since then it has occasioned little or no public opposition. Partly that is because for most of the year its public consists of a couple of caretakers and a great many birds, several of which can be found perching on the pillars at any given time. But during the summer, when ferries bring visitors over from Reykjavik, it has proved a popular attraction, so much so that a stone path has been laid to link the pillars on the south side of the island. Mr. Serra himself revisits it every so often, just to see Iceland again and to sketch.

In Paris, a similar interest in Mr. Serra's work can be found, combined with a willingness to preserve it for posterity. Mr. Pinault seems ready to sign a contract that will insure the eventual donation of Mr. Serra's new piece and the land on which it will stand to the French state. The city of Paris already boasts four Serra sculptures.

Aside from his sometimes abrasive personality, part of Mr. Serra's problems in the United States come from his outspoken leftism, which didn't sit well in the Reagan-Bush years. His "he-man minimalism," as his art was once called, seemed incongruously moralistic amid the 1980s rage for pop and graffiti art. And the '90s climate of hypersensitivity and political correctness finds him again at odds with prevailing mores. Two accidents in the installation of his multiton steel sculptures—one worker lost his life in 1971, and another a leg in 1988—further fueled an image of callousness.

Even now, complaining that the public has been denied access to a walk-through sculpture in Paris, he can sound insensitive even if one understands what he means. "They closed off my piece because someone got raped in there," he groused. "People get raped in parking lots, and they don't close them."

In Europe, the accidents were long ago across an ocean. Europeans have prized American artists of the last fifty years as just the kind of quasi-primitive natural savages or "cowboys" that Mr. Serra so forcefully represents. More sophisticated about art and artists, European patrons

have a tradition of dealing with difficult individuals. "The Europeans could care less about my personality," Mr. Serra said.

There are specific, personal reasons for Mr. Serra's European success, too, however. In 1977 he established a relationship with a gallery owner in Bochum, Germany, named Alexander von Berswordt-Wallrabe, that has been of enormous importance to both sides. Mr. von Berswordt-Wallrabe had a young assistant, Clara Weyergraf. She moved to New York in 1979 and is now married to Mr. Serra. The three have remained close, cementing Mr. Serra's German connection.

Ms. Weyergraf handles practical aspects of Mr. Serra's life and career. Mr. von Berswordt-Wallrabe devotes 50 percent of his time to Mr. Serra's European projects, at every level. Aristocratic and cosmopolitan, he moves easily in the upper circles of European patrons, soliciting interest and arranging commissions and seeking private sponsorship to supplement public financing. He is also close to both the ownership and the workers of various Ruhr foundries and steel mills. Finally, Mr. von Berswordt-Wallrabe oversees a regular German crew of five or six men who install the pieces throughout Europe.

A good working relationship with those who forge and roll his pieces is of vital importance to the artist, who "uses mills and shipyards as extended studios." In America, he has to convince skeptical workers that an artist belongs among them. In Europe, with Mr. von Berswordt-Wallrabe's help, he has had fewer such problems.

For an American observer, though, there can be an element of authoritarian elitism to European arts patronage, an eagerness to elevate the masses by imposing art upon them.

"I have come to realize that democracy doesn't work all that well when it comes to integrating art and the public," Ms. Weyergraf said on the lawn of Mr. Pinault's chateau. "I don't think you can include a community in that kind of decision-making process. But a government can educate a community. That's almost nonexistent in America, but they have been very good at it in France."

Even so, the fate of Mr. Serra's public pieces in Europe has not been ideal. There have been political controversies about some of them, most notably in the late 1970s in Bochum, although none have been "destroyed." Mr. Serra has also overseen the moving of some of his "site-specific" works. A piece called *Clara-Clara*, on view in the Tuileries garden in Paris in 1983 and now removed to the working-class thirteenth arrondissement, serves as a sometime shelter for homeless people and is covered with flamboyant graffiti.

While Europe is likely to remain Mr. Serra's principal source of patronage, his prospects back home may now be picking up. Visibly buoyed by the critical and popular response to *Intersection II*, his recent installation in the Gagosian Gallery in SoHo in Manhattan, Mr. Serra wondered if American interest in his work might be building again.

"It was one of my biggest successes," he said, peering across the sea to the Icelandic mainland. "People really liked it. A woman in a store across the street from the gallery who's never given me the time of day said, 'Nice piece, Richard.' Do the Europeans like my work more than Americans? I felt that way until last week!"

BRITISH TELEVISION

The New York Times, August 9, 1993

London—After one short year, the BBC's dinosaurian soap opera *Eldorado* gasped its last this summer and fell into welcome extinction. Or at least Britain's rapacious television commentators seemed to feel its disappearance was welcome; they had mocked the poor beast unmercifully since it first lumbered to life.

A roundelay of romantic entanglements and low-life skullduggery set in an imaginary Spanish resort community, the series was everything that Anglophilic admirers of Masterpiece Theater think is foreign to British television: bloated, leaden, dull. Worst of all, it committed the sin of sins for a soap: the characters weren't sexy, weren't appealing, weren't in any way suitable for fantastical self-projection by couch potatoes. They weren't even ordinary enough to seem lifelike.

The set alone, built in southern Spain, cost more than $3 million; the budget was five times that, making the show the most expensive independent production ever commissioned by the BBC. The critics, especially in London's tabloid press, were merciless: "In its early days, 157 episodes ago, *Eldorado* was almost treasurably bad," *The Guardian* wrote just before the final show on July 9. "But then it began to improve. It became mediocre instead of dire." The audience watched elsewhere, with rarely more than a third of the projected 15 million people tuning in.

As it happens, *Eldorado* was meant, at least in part, to be a serious

soap, and its producer, Verity Lambert, has been quoted to the effect that it failed not because it was bad but because it was too experimental. Her credits, after all, include shows of just the sort that have given British television a good name in the United States: *Dr. Who, Rumpole of the Bailey, The Naked Civil Servant,* and the like. And the new head of drama for the BBC, Charles Denton, seems now to be aiming even lower, unashamedly courting the biggest possible audience. "We are in direct competition with ITV for the mainstream popular audience," he told *The Independent.* ITV stands for Independent Television.

For unrepentant *Eldorado* fans, however, the memories can live on, evergreen and forever: the BBC has released a ninety-minute video entitled *The Eldorado Story,* for those who wish to view and review their favorite characters for all eternity.

This has been a troubled season for British television and for the BBC in particular. John Birt, the new BBC controller, has been trying to reorganize the state television behemoth and reorient it toward competition with an increasingly feisty private industry. Survey figures indicate that BBC1, the corporation's flagship channel, has 28.9 percent of the audience compared with 41.4 percent for ITV's Channel 3.

Mr. Birt's efforts have provoked unrest in BBC ranks, capped by an employee's address at a recent Radio Academy Festival in Birmingham, a nationwide radio and television convocation, in which he denounced the new BBC management style as marked by fear and sycophancy, with Mr. Birt as Big Brother.

Nonetheless, clever television still gets made at the BBC, even ostensibly within the soap-opera format. The best if most eccentric example was a show called *The Vampyr,* cleverly timed to capture ambient vampire mania stoked by publicity for *Bram Stoker's "Dracula,"* which reached Europe this year.

This *Vampyr* was truly an only-in-Britain affair. It consisted of an updating of Heinrich Marschner's romantic opera *Der Vampyr* from the 1820s, set now in contemporary London as a soap opera complete with ample frontal nudity and lustily simulated sexual couplings. All of which were performed by opera singers without doubles, singing the score pretty much as Marschner composed it, albeit with updated lyrics by a sometime collaborator of Andrew Lloyd Webber, Charles Hart ("I'd invite you in for coffee," moans a Vampyr victim-to-be, "but all I have is gin"). The singers sang well and looked good, even in the buff and in the act, which should earn someone kudos in the casting department.

The Vampyr was a production of Janet Street-Porter, one of the flashier lights of British television. Miss Street-Porter has won enemies for her brashly self-promotional style and flamboyant looks and personal life, but as head of youth and entertainment features at the BBC, she has also pumped adrenaline into the corporation. Thus her being passed over for two top positions, controller of BBC1 and BBC2, has made some fear for the organization's continued venturesomeness. The person who eventually got the BBC1 job, Alan Yentob, was also the person who axed *Eldorado*.

It was Channel 4, not the BBC and not ITV, that produced the most charming, compelling quasi soap opera of the season. That was Dennis Potter's six-part, six-hour *Lipstick on Your Collar*, which will almost certainly be seen in the United States next season, once negotiations are completed.

Like many previous Potter extravaganzas (*Pennies from Heaven* and *The Singing Detective*), this takes a soap-opera or minidrama format and interleaves the story with outbursts of song, or song-and-dance routines in classic British music-hall style. The songs, enthusiastically lip-synched by the entire cast, are classics from the early years of rock and roll, which makes sense, since the story takes place in the London of the 1950s.

The basic setting is the War Office, where a wonderfully engaging assortment of old fogies, militaristic hysterics, and prim aging dandies led by Peter Joffrey confront the fading of the British Empire, symbolized by Gamal Abdel Nasser's seizure of the Suez Canal in 1956.

Three young assistants have their interwoven romantic entanglements as well. One befuddled young Welshman loves an unhappy movie usher who has to fend off the pervert who is the theater organist as well as the brutality of her husband, who is another of the War Room assistants. The Welshman's Cockney rock-and-rolling partner yearns for the nubile niece of the War Room's American adviser.

This was not to everyone's taste: in *The Times*, Benedict Nightingale wondered "if Potter's mix of fantasy, realism, song and period documentary might be too whimsically portentous." But even the doubters found things to enjoy, and for those swept up in Mr. Potter's delicate blend of elements and entranced by the generally sexy and compelling cast (a few of these actors in *Eldorado* might have saved that show), the end of the final episode left a lingering sweet regret that there wasn't more to come.

In case anyone wonders whether British television is all soapy sex, consider Sister Wendy Beckett, who has improbably become one of the BBC's star attractions. The sixty-three-year-old Sister Wendy is a real nun, a hermit and a consecrated virgin at a Carmelite convent in Norfolk. But she is also an Oxford graduate and a lover of fine art, and she has become Britain's most popular television guide to great painting and sculpture. Dressed in her habit, with her glasses and sensible shoes, she strides earnestly through gallery after gallery, pausing before her favorite pictures and explicating them in terms that anyone can understand.

Those terms tend to involve the anecdotal or the personal rather than the more rigorously art-historical. When some of her musings were gathered together in a book called *Art and the Sacred*, not everyone was convinced. "Her selection of twentieth-century art," wrote Martin Gayford in *The Sunday Telegraph*, "turns out to be a puzzling mélange of the great, the mediocre, and the utterly abysmal. All three, however, she treats with the same unflagging enthusiasm."

But it is that very enthusiasm that appeals to people. Even Mr. Gayford concedes that her words lose impact when "deprived of that engaging personality."

While Sister Wendy clearly prefers morality and even piety in her art, she is no prude. Defending her praise of a painter's depiction of his mistress's pubic hair, which she called "lovely and fluffy," she told *The Sunday Times*, "God made pubic hair, and to think of it as not quite nice is to criticize the work of the Creator."

GLORIA TNT

The New York Times, October 14, 1993

Regensburg, Germany—Two hundred years ago on October 16, Marie-Antoinette was guillotined in Paris. Before and after that anniversary, another German-speaking princess with even more lavish tastes is likely to make $20 million selling off her family trinkets. Sotheby's auction of *The Thurn und Taxis Princely Collection*, as the seven-volume boxed catalog is grandly titled, began today and will continue until October 21.

Marie-Antoinette's death is being remembered in Paris by all manner of nostalgic events, among them a newly composed Requiem Mass and a play in which the audience gets to vote on her fate. By and large, to the chagrin of the play's creators, they are choosing exile or death.

The closest her latter-day echo, Her Serene Highness the Princess Gloria of Thurn und Taxis, has come to that sad end is periodic embarrassment in the tabloids. Married in 1980 and now thirty-three years old, "Gloria TNT" (also known as "the punk princess") was famous for her jewels, her artist and rock-star friends, and her wildly lavish parties. At a particularly rambunctious affair in the family's four-hundred-room St. Emmeram Castle here in northeastern Bavaria, she once descended on a chandelier, dressed in full regalia as Marie-Antoinette.

The Thurn und Taxis fortune is estimated at more than $1.5 billion. But the family income has been dented by the worldwide recession, along with overextension in the family business empire, some outright corruption among the inner managing circle, and, not least, a hefty sum in estate taxes after the death in 1990 of the sixty-four-year-old Prince Johannes. The tax debt alone has been placed at between $40 million and $50 million.

What to do? Among other belt-tightening measures, one answer has been two auctions. The first, conducted by Sotheby's last November in Geneva, was of jewelry and silver and earned $13.7 million. The second and current auction consists of items estimated by Sotheby's at $8.7 million. But since that figure is the total of the low estimates for each lot, and since bidding the first day more than doubled the low estimates, the actual total could approach $20 million. The princess said that by the end of this auction, she should be able to resolve her tax obligations.

The high income might seem unusual, since by general consensus what Princess Gloria is holding here is a glorified yard sale. "Aristocratic cast-offs," "a flea market," "clutter," and a "motley collection" of "bits and pieces" were typical of preauction comment in the European press. The princess is keeping most of her finest items, much of the best of the rest was sold in Geneva, and the Bavarian state took $30 million in artworks in partial settlement of the estate taxes.

There was also opposition from members of the Thurn und Taxis family, who resented the princess—who is of noble blood herself but from the relatively impoverished gentry—for marrying into this vastly wealthy family and then selling off its assets. Between the death of

Johannes and the coming of age of the eleven-year-old Prince Albert, Gloria rules the familial roost.

The ninety-one-year-old Father Emmeram, an uncle on her husband's side and now a hermit, denounced her last year as "that slut, that beast." The princess calls the sale merely sound business practice. By all accounts, including her own, she is a woman transformed: from party animal to grieving widow, loving mother, and shrewd businesswoman. As *The Daily Telegraph* of London quoted her: "My fairy story is over. You can't be a fairy and meet a payroll."

The vast number of items being auctioned this week—more than 3,500 lots—are essentially the residue from the twenty-five castles that the Thurn und Taxis family lost or sold during this century. There are still six fully furnished castles in the Regensburg area. But many of Schloss St. Emmeram's rooms were reduced to storage space for items that were gobbling up insurance premiums. The princess would like to rent out rooms for conferences and social functions, and maybe even create a hotel, and all that bric-a-brac simply cluttered up her plans.

The thousand-odd bidders who registered for this auction were mostly German and mostly private, including a fair sprinkling of major and minor nobility. What they are being offered is primarily early- and late-nineteenth-century furniture and household objects of German and Austrian provenance. There are also 75,000 bottles of wine.

The Princess was prevailed upon by Sotheby's to include a few items reflecting her own frisky image, like two of her four Harley-Davidson motorcycles and the odd Keith Haring party invitation, complete with a recording of the princess warbling a song.

"That was a pure marketing thing," Princess Gloria conceded cheerfully. "We felt it was boring to sell only old things, so we included a few typically Gloria items."

Today's bidders in the Castle Carriage Museum (spilling over to a side wing and a tent) were dominated by just the kinds of eager amateurs that auction houses love. "They feel people will be taken in by the grand surroundings and the chance to buy a piece of the aristocracy," said one Paris-based dealer and collector who asked not to be named. "People like that tend to lose their heads when they start bidding."

Such giddy enthusiasm was reflected in the fact that it was the less expensive items that wildly exceeded their estimates, as with an Austrian walnut side table, circa 1815, estimated to bring between $1,320 and $1,500, that sold for $12,300. The top price for furniture today was nearly

$50,000 for a walnut cupboard. At this afternoon's art auction, a pair of bronze Venetian figurines, estimated at between $90,000 and $120,000, sold for $145,000.

Diana Brooks, head of Sotheby's auction sales worldwide, denied that her company had deliberately underestimated to make the sale look good. "The estimates were conservative," she conceded. "We didn't include the Thurn und Taxis factor."

This might seem odd, since several of the one hundred Sotheby's employees swarming about the castle bluntly conceded the importance of the Thurn und Taxis image in their marketing strategy. If an item wasn't already emblazoned with the Thurn und Taxis crest, Sotheby's stamped it somewhere.

"The family is very well known in Germany," said Count Christoph Douglas, head of Sotheby's German branch and the principal auctioneer. "A life style is being sold here."

By day's end, St. Emmeram's Platz in front of the castle was full of happy Germans squeezing their princely booty into the trunks of their Mercedeses and BMWs. The princess, too, had reason to be content. She will emerge from all this hoopla more famous than ever and amply reinforced to pursue whatever life style she chooses for the future. And the house of Thurn und Taxis, no matter what Father Emmeram may think, will be shored up for the future as well.

"My son is debt free," Princess Gloria stated proudly, a fact that should also apply to her two daughters, although they are not in the line of succession. Perhaps somewhere on high, though headless for two hundred years, Marie-Antoinette feels vindicated.

ROCK TEARS

The New York Times, November 17, 1993

Note: *The lead of a longer article about rock in Berlin.*

Berlin—As a symbol of change in the German capital, it could hardly be bettered. Before the fall of the Berlin wall in 1989, one of the most fear-

ful and depressing buildings in East Berlin squatted next to the Friedrichstrasse railroad station. The building was the screening area for anyone, from tourists with day visas to East Germans with exit permits, who wanted to leave that police state. Not infrequently, East Germans showed up with suitcases and nervous optimism and fell afoul of the People's Police. Scenes of sobbing and screaming, of desperate people being escorted away in custody, all in full sight of horrified Western visitors, were not uncommon.

Now this entire building, which was constructed in anonymous Soviet-modernist style, has been turned into a nightclub called the Palace of Tears. The club is festooned with the original grim signage of the building's previous incarnation ("Foreigners With Visas Enter Here"). You can buy Palace of Tears T-shirts at the coat check.

On Friday night, the headline band came from Yakutia, a Siberian state three times the size of India. The six members of Aj-Tal purveyed a kind of gothic art rock with growling, ululating vocal techniques familiar from Eskimos and other natives of the frozen north. They wore quasi-native costume, complete with tufted leather boots and various kinds of fringe, presumably obtained from reindeer or elk or other indigenous creatures.

Trendy Berliners quaffed their beers, trains slid by silently on the elevated tracks visible through the upper windows, psychedelic-ritualistic blobs glowed on a projection screen, the ghosts of the secret police hovered in the air, and the mind reeled with the contradictions.

LAPLAND

The New York Times, December 11, 1993

Rovaniemi, Finland—These days, the midnight sun is at the other end of the world. On and above the Arctic Circle, at the northern end of Europe, a pale sky lightens the low hills and glacial lakes of Lapland for just a few hours a day. The only living things visible for miles are white grouse and wandering herds of reindeer, pawing the snow for food.

But there are people here, too: the Samis, as the Lapps call them-

selves, who once herded reindeer and who are now adjusting, sometimes awkwardly, to modern life. This is the United Nations' International Year of Indigenous People, and Norway, Finland, Sweden, and Russia have been full of events celebrating Sami cultural achievement. These celebrations are turned as much inward, toward Sami self-awareness and cultural redefinition, as outward, which would lure even more of the tourists about whom the Samis are profoundly ambivalent.

From a traditional culture in which art in the Western sense once hardly existed, the Samis are now rapidly producing free-standing, professional artists. There are Sami writers (Nils Aslak Valkeapää, who is also a musician and artist, won the 1991 Nordic Council Literature Prize for his poetry), filmmakers (Nils Gaup's *Pathfinder* was nominated for the best-foreign-film Oscar in 1990), painters (Trygve Lund Guttormsen has a vivid exhibition of traditionally inspired abstractions now at the Sami art gallery in Karasjok, Norway), and, above all, popular musicians, like Mari Boine Persen of Norway and the Angeli Girls of Finland.

More than half of the sixty thousand Samis live in Norway. In Kautokeino (or Guovdageaidnu, as it is known in Sami), three days of cultural festivities just ended, pointing toward the Sami artistic contribution to the Winter Olympics in Lillehammer, Norway, in February. The town also contains two different Sami educational centers, a Sami museum, a Sami theater (state supported, with 150 performances annually), a new Sami archive, and the Sami Research Institute. In Karasjok, near the Finnish border, are Sami newspapers and a Sami radio station, a Sami crafts center, a Sami library, and the Sami art gallery.

Here in Rovaniemi, which bills itself as the gateway to Lapland, there is a particularly striking building called the Arktikum, a long shaft of a structure designed by Danish architects and embedded in the banks of the Ounasjoki River. At its north end, pointing toward the Arctic, it opens out grandly in a towering glass atrium. The Arktikum houses the Arctic Center, which sponsors research and offers an instructive display about Arctic life, and the Provincial Museum of Lapland, devoted largely to the Samis and their culture.

This week, the Arktikum presented the first annual Arctic Week, a series of lectures, discussions, exhibits, videos, films, and performances. Participants included scholars, artists, dancers, and musicians representing not only the Samis but also other reindeer-herding peoples like the Yakuts, the Nenets, the Dolgan, and the Nganasan of the Yamal and Tamir Peninsulas in Siberia.

Cultural self-awareness for the Samis has come as nationalist senti-ments have been rising around the world, and rapid change has dis-rupted traditional Sami life styles. As with all indigenous peoples, the economic, social, and religious basis of their lives directly affects their art.

The four-thousand-square-mile county around Kautokeino, the largest in Norway, is still home to 150,000 reindeer, along with more than three thousand humans, 85 percent of them Sami. Thirty percent of those people still herd reindeer and practice the nomadic seasonal migrations of their ancestors, albeit living in Western-style homes during the winter. But over all, said Reidar Erke of the Sami Research Institute, less than 5 percent of Samis now herd reindeer. Such economic change, along with the attempted suppression of shamanism by Lutheran Pietists and of the native language by secular governments, led to sharp breaks in Sami cultural development.

Now, the religion and its related artistic expression are permitted and the Sami language can be used in state-supported schools. But many Samis remain unsure whether they should return to the past or evolve toward an uncertain future.

Odd Keskitalo, the director of cultural affairs for the Kautokeino county, said some elements of the old religion and its attendant a cap-pella chanting, or yoiking, still existed. But Mr. Erke discounted most such religious expression as new-age nostalgia.

Pekka Aikio, a Finnish Sami who is the director of the Kautokeino Sami Research Institute and who was at the Arktikum conference, said the new emphasis on Sami culture has come after years of a forced infe-riority complex.

"There are so many historical reasons for us to feel defensive," he said. "Now, there has been a real revival of yoiking. Before, it had been declared a sin. It was not accepted. If you yoiked, you were being like the devil. You were not a decent person."

Many older Samis distrust the emancipation of a Western artistic sen-sibility among younger Sami artists. They prefer the old, organic links between art, work, family, and religion.

"A lot of people don't like it," Mr. Aikio said. "They think it's bad to yoik for the Finns or an international audience. They think it should be done only with your family or your reindeer. But the younger generation thinks in a different way."

It has been the evolution of yoiking into folk rock that has had the most direct impact on young Samis. Miss Persen is popular throughout

Lapland. And the younger Angeli Girls, who sang at the Arktikum in Rovaniemi on Saturday night, have been successful at home (the village of Angeli in the Inari district of Finland is forty miles from the nearest store), in Helsinki and on European and Far Eastern tours.

The Angeli Girls consist now of two sisters, Tuuni and Ursula Lansman, and a non-Sami Finnish guitarist, Alfred Hakkinen, who replaced their cousin, who dropped out after she had a child. Their repertory includes traditional yoiks, haunting solo or unison duets for the two women full of glottal stops, singsong repetition, and yelps both cheerful and sad.

But they have also broadened the idiom with instrumental accompaniments, harmonies, and even ambitiously constructed story-songs, with spoken interludes. And they are evolving still further, having recently recorded with a Helsinki hard-rock band called Waltari and even experimented with what Ursula Lansman, a twinkle in her eye, called "techno-yoik."

"There are some people who don't like it, but most Samis do, the young people especially," Miss Lansman said.

For progressives like Mr. Erke, such innovations are all to the good.

"We don't want to return to the past," he said. "It's gone. But we like to look at the past, and to learn from it. We want to create new codes of living. We have to make a new definition of what it means to be a Sami today."

CBGB

The New York Times, December 19, 1993

Scenes blossom and wither, stride forward and then stumble, and you never know for sure how real they are—great music objectively reported—or how much they are the product of scene members' subjective enthusiasms.

CBGB, which is celebrating its twentieth anniversary this month, was a true scene in the mid-1970s, with all the sweaty interaction that that long and narrow club compelled. Just going to the bathroom, down long

and dingy stairs behind the stage to the left, was an invitation to encounter every sort of downtown denizen and substance consumption known to man (and woman) at the time. Musicians mingled with groupies and fans and one another; writers schmoozed with each other and with musicians; fights broke out and friendships formed.

Rock-and-roll nostalgia can seem lame to younger folk, caught up in their own bands and scenes and testily impatient when some codger starts reminiscing about the good old days. One reason to celebrate CBGB (or, as we all used to call it for no good reason, CBGB's) is that its founder and owner, Hilly Kristal, has never allowed it to fall into a nostalgic rut.

He's always kept the doors of this seedy, sometimes sad, but always welcoming dive at the corner of the Bowery and Bleecker Street open to new bands. And while some of his side ventures (a theater, a record store) have gone off the rails, and not every band was great, the sense of youthful vitality has been pretty constant.

But the time that I was a regular visitor to CBGB (the initials, improbably, stand for "country, bluegrass, and blues") was near its beginnings, from 1975 through 1977, when its first great scene was flourishing and when I, then the chief rock critic of *The New York Times*, was there to write about it.

If all scenes have a whiff of subjectivity, a subtextual sense that they are the artificial product of communal hype, at the time we all felt that this one was real. And we have the records and CD remasterings to prove it.

I still think a lot of mainstream 1970s pop rock was not as dreadful as pop-crit cant would now have us believe. But downtown New York rockers of the mid-'70s, the spiritual grandchildren of the Velvet Underground and children of the New York Dolls, were convinced that they were fighting the good fight against commercial musical drivel. And in fighting that fight, they gave birth to English punk and all the forms of American alternative rock that thrive up to the present.

There was passion in the music the best of these bands made, but fierce intelligence, too, the kind the Velvets had. Naturally, that blend of brains and emotion captivated rock critics. Patti Smith, who actually got her start as a rocker with Lenny Kaye at St. Mark's Church poetry readings, had been a poet of distinction, but it took her reedy voice and Callaslike charisma to lift her words to their highest level. She was never better than at her beginnings, belting out her visions in CBGB's smoky

confines and culminating in her 1975 debut album, *Horses*. That record, as fine a document of those days as any, was produced by John Cale in a lovely attestation of kinship among British art rock, classical avant-gardism, the Velvet Underground, and New York's own high priestess of Bohemian rock and roll.

Ms. Smith was hardly the only proto-punk intellectual at CBGB. Tom Verlaine of Television was another poet, one who named himself after an even better poet, but it was his soaring but cerebral guitar duets with Richard Lloyd that created the band's nightly epiphanies. Chris Stein was the mastermind behind Blondie and the architect of its clever pop pastiches, although, of course, all attention was focused on the voluptuous Debbie Harry, a supposed cheesecake parody constantly toying on the edge of real cheesecake.

But for unabashed intellectuality, bordering for those who disliked it on artsy pretension, Talking Heads had no peers. In those days, just down from the Rhode Island School of Design, David Byrne, Tina Weymouth, and Chris Frantz made a minimalistically spare trio (I still have the live tapes to prove it). When Jerry Harrison came along and commercial success beckoned, the Heads' sound thickened but then quickly clarified into fresh experimentation. Still, it is that first encounter with Mr. Byrne's bug-eyed chicken-squawk singing and the trio's tense, tight, wispy, disturbing instrumentals that will stick in my mind.

Just as important to CBGB regulars were bands like the Ramones (for me, despite their distinguished critical champions, a one-joke act: one-two-three-four and then play as fast as you can), the Dictators (crudity without compromise, despite their self-image as parodists), Mink DeVille, Richard Hell and the Voidoids, Tuff Darts, and the Shirts. But as the stars got record contracts and moved on to larger theaters and arenas, the first era of CBGB faded away.

Younger regulars have entirely different times that they regard as the club's golden age. From the late 1970s on, there were punk and hardcore and all the varieties of alternative rock that now flourish. Although it had really ended three or four years before, for me the mid-'70s scene came to a close in 1982, at the memorial service/wake/rave-up for the writer and musician Lester Bangs, who had died in May of that year.

It was like a premature college reunion of everyone—musicians, writers, hangers-on, actual people—who had made the original scene what it was. There was music that night, but what I remember was community. Whether Lester, crusty and cranky and immune to nostalgic

wallowing, would have appreciated the emotion, I cannot say. But for a lot of us, that night was a validation of a time and a place that transcended mere nostalgia and elevated CBGB into rock-and-roll history.

THE BIG HAIRY GUY OF DANCE

***The New York Times*, January 23, 1994**

Mark Morris. By Joan Acocella. Illustrated. 306 pp. New York: Farrar, Straus & Giroux. $27.50.

Joan Acocella has written a distinguished piece of criticism. It will be seized on by those who think that Mark Morris is overrated as further proof that this young (thirty-seven years old) and flamboyant dancer and choreographer is a critics' darling. But the mere fact that Mr. Morris could inspire a book as good as this is credit to him, as well as to Ms. Acocella, whose analysis is keen and generally free of the technical jargon that dogs so much serious arts criticism.

Ms. Acocella was the chief dance critic of the short-lived New York magazine 7 *Days* and is now a dance writer for *The Daily News*, as well as an occasional contributor to many other magazines. She is a great reader of subtexts and parser of artistic intentions; indeed, her book will provoke charges that she reads meanings into Mr. Morris's dances that he never dreamed were there. She is also an exponent of aw-shucks plainness *à l'Americaine*: "There is a doggy side to love"; "things go pow."

In passing, she also offers a deft analysis of the rifts within the American dance-critic community, through which there has been no more jagged fault line than Mark Morris. His detractors see him as erratic, self-indulgent, campy, and overliteral in his treatment of music and narrative. Most of all, whatever his gifts, they see him as overpraised.

Ms. Acocella addresses these charges in her book but maintains that Mr. Morris is a great moralist and humanist, a heroic explorer of dialectical opposites who struggles to achieve a higher synthesis (not that she actually evokes Hegel or pays more than passing heed to Wagner, whose

motivic composition parallels her subject's approach). Above all, while less a creator of heretofore unimagined movement than an omnivorous recycler, Mr. Morris remains for her the boldest and most fecund choreographer of his generation.

Even more, though, *Mark Morris* is an effort, and a brilliantly persuasive one, to explain why this "big hairy guy" from Seattle, with his story-dances and his 1960s life style and his postmodernist stylistic clashes, appeals to the inherent cultural (and in some cases political) conservatism of some of the leading dance reviewers of this country. These critics are less a random collection of writers than a band of disciples that looks back to Edwin Denby and up to Arlene Croce, the dance critic of *The New Yorker* and their acknowledged leader. This group shares a classicist, formalist bias, and for Ms. Acocella and her allies Mr. Morris is himself a not-so-closet classicist, concerned with form, respectful of tradition, infused with music, and committed to universal values.

All of this is expounded with great thoughtfulness and a deft blend of biography, dance history, backstage detail, and critical analysis. Ms. Acocella's organization is very clever, setting the scene, laying out Mr. Morris's youth, switching to chapters on various themes and issues in his dances, then picking up the narrative for his evolving company's tumultuous three years (1988 to 1991) at the Théâtre Royal de la Monnaie in Brussels. At the end she brings us up to the present, with Mr. Morris living off his MacArthur Foundation fellowship and investing his fees and royalties in his company, which is now based in New York City.

What is especially impressive in Ms. Acocella's book is how everything in it supports everything else; there is no waste. Biographical information contributes to analytical insight. Particular dances are discussed in themselves, but also in relation to larger themes in Mark Morris's work and times: his spirituality and simultaneous celebration of the body; his preference for the love of community over heterosexual monogamy as idealized in the balletic pas de deux; his unusual involvement with text, narrative, and the inner workings of music; and his shifting balance between irony and sincerity.

The author maintains a tempered tone, a prevailing judicious adoration that only occasionally breaks into outright rapture. Her study, lavishly illustrated and with a detailed chronology of Mark Morris's work, is impressive on its own classicist terms and equally convincing for those who do not fully partake of this critical bias.

Of course, one could quibble. There is, for example, too little atten-

tion to the works Ms. Acocella concedes are failures, and too great an emphasis, in this age of dance notation and video, on the ephemerality of choreography. One could fault occasional slips in musical terminology (her use of the word "cadence" is correct as English but misleading in a musical context), or her passing use of dance jargon ("He created a work on them") and some vacuous pontification ("All art is concerned with the relations of things").

But one feels almost embarrassed mentioning such specks. *Mark Morris* is a book that clarifies dances you've seen and makes you want to see those you haven't. It's as warm and wise as Joan Acocella would like us to believe Mr. Morris is himself. And, thanks to her, we do.

DIE LUSTIGEN NIBELUNGEN
The New York Times, **March 19, 1994**

Note: *This was part of larger piece about European operetta theaters.*

Vienna—The freshest and funniest Viennese operetta revival of the season is not in an opera house but in repertory at the Kammerspiele of the Theater an der Josefstadt: *Die lustigen Nibelungen* (*The Jolly Nibelungs*) by Oscar Straus.

This is a *Ring* parody first seen in Vienna in 1904. More precisely, since it draws from the medieval *Nibelungenlied*, which was also one of Wagner's sources, it is a *Götterdämmerung* parody. For all its appeal to the Viennese and its German-language in-jokes, this is something that New Yorkers might especially enjoy.

The reason is that the operetta was directed by Otto Schenk, the stage director of the Metropolitan Opera's *Ring*, with sets and costumes by Rolf Langenfass, who did the Met's *Ring* costumes. The result, whether you regard the Met *Ring* as a solemn tribute to cultural conservatism or kitschy 1950s nostalgia, is a very funny bit of self-parody. The sets look eerily like the Met's, with lots of fur and horns and realistic painted backdrops. Yet the story is pure Offenbachian spoof, sometimes over the top but always sweetly and innocently so.

This is not just Mr. Schenk's parody of himself, or of the Met's demands on him. The staging is also full of operatic in-jokes. Heinz Zednik, for years a famous Mime, finally gets to play, and skewer, Siegfried. But he also looks as if he's been made up to resemble Siegfried Jerusalem, the world's current favorite singer of Siegfried, complete with an impossibly blond and refulgent wig.

To see Mr. Zednik prance onstage, in a scene just like Siegfried's arrival at the Gibichung Hall in the first act of Wagner's opera, firmly fix his monocle, give a little flip with his hand, and demurely coo "Hoi-ho" is to realize that comic operetta is by no means dead.

RICHARD STRAUSS IN FRANCE

The New York Times, April 21, 1994

Lyon—France's obsession with the music of Richard Strauss this season started out innocently enough in Paris, in series by the Théâtre du Châtelet and the Orchestre de Paris. But like some medieval dancing madness it spread, unstoppably, to other Paris musical institutions, like the Bastille Opera, and then to the Lyon Opera.

Now the French Strauss frenzy has peaked and, perhaps, spent itself with three operatic productions: *Salome* at the Bastille, the original version of *Ariadne auf Naxos* here in Lyon, and, most notably, *Die Frau ohne Schatten* at the Châtelet.

The Bastille's *Salome* came first (from February 5 to March 7) and can be passed over most quickly. This was an effort to recreate the synergy of the most successful production of the Bastille Opera's brief history, the collaboration between the conductor Myung-Whun Chung and the stage director André Engel in Shostakovich's *Lady Macbeth of Mtsensk*. But fire didn't strike twice.

"Ouf!" began Anne Rey in her friendly review in *Le Monde*. "No orgy, no blood, no nudity, no hysteria." But that was the problem. *Salome* can look pretty pointless unless it is rendered with all the lurid eroticism Oscar Wilde and Strauss invested in it. Maybe only a film could do the job in today's climate, though Ken Russell botched his ver-

sions on both screen and stage. *Salome* is about religious frenzy and sexual madness, and to pretend otherwise is to deny its essence.

Here, Mr. Engel chose that increasingly annoying cliché, to update the action to the fin de siècle, when both the play and the opera were created. But he also shrouded everything in a kind of staid monumentality. Mr. Chung conducted with polite efficiency, but the last thing one needs is a polite *Salome*. Karen Huffstodt sang stalwartly, but the last thing one needs is a stalwart teenage temptress.

The Lyon *Ariadne*, in a production by the German actor, director, and sometime singer Ernst Theo Richter, is also set in Art Nouveau opulence, but has more going for it. The production opened on Tuesday night and continues at the high-tech new Opera here until April 30.

This is not the *Ariadne* we are used to, the two-part second version from 1916, but—at least in the opera proper—the 1912 original. Strauss and his librettist, Hugo von Hofmannsthal, created the original version for Max Reinhardt's Berlin theater company, which couldn't cope with the extreme operatic demands, forcing the premiere's removal to Stuttgart. The problem was how to combine, aesthetically and logistically, an extensive adaptation by Hofmannsthal of Molière's play *Le bourgeois gentilhomme* with a seventy-five-minute opera.

The 1916 version replaced the play with the now familiar operatic prologue and slightly altered and simplified the opera itself. This was done by trimming some of the comedians' bits, the long final duet, and Zerbinetta's showpiece coloratura aria, as well as by lowering that aria a full tone. Hofmannsthal then further revised the play and Strauss added three numbers of incidental music to the eight he had already provided in 1912. This new version of the play appeared in 1918 (hardly a propitious year in central Europe for a satire on nouveau riche pretensions) and promptly disappeared. Strauss then salvaged the nine instrumental numbers of his incidental music in a *Bürger als Edelmann* Suite (Op. 60).

The Lyon *Ariadne* (and hence the recording to come) offers not only the 1912 opera but also all eleven numbers of incidental music from 1912 and 1918. For the stage production these were grafted onto a radically compressed adaptation (forty-five minutes total, including the music) of the Molière-Hofmannsthal by Mr. Richter. As drama, this proved negligible. It was also mostly in German, without supertitles, which must have mystified most of the Lyon audience, despite Mr. Richter's broadly comic presence as M. Jourdain.

The production, despite an attractive set by Karl Ernst Herrmann and Hartmut Schorghofer, seemed prosaic and poorly lighted, lacking either in atmospheric charm or cross-period insights. Kent Nagano conducted both the incidental music and the opera neatly, although some combination of his diffidence and the theater's dry acoustics robbed the music of rapturous breadth. The cast, headed by Margaret Price as Ariadne and Robert Schunk as Bacchus, was solid in more ways than one. Still, it was fascinating to hear the original version, with its witty deprecation by Zerbinetta and pals at the end, after the high-flown romantic sentiments, and especially Zerbinetta's fiendish aria.

Sumi Jo, "souffrante" (as French announcements of illness so charmingly put it), was replaced by a young German soprano named Carmen Fuggiss, who under the circumstances hardly deserved the persistent booing she got from one Sumi Jo fan. True, Miss Jo might have sailed through Strauss's insane pyrotechnics with more of the effortless bravura that the writing demands. But Miss Fuggiss looked charming (she should make a dazzling Lulu one day) and at least acted the part and hit the notes. Not bad for someone who had sung Offenbach's Olympia in Hanover on Saturday, the dress rehearsal here on Sunday, the second version of Zerbinetta in Munich on Monday, rehearsed in Lyon all Tuesday afternoon, and finally staggered onto the Lyon stage Tuesday night. Let the booer try that schedule.

But neither of these stagings came close to the Châtelet's *Frau ohne Schatten*, which ran throughout March and which was far and away the best production of this vast allegorical epic of an opera that this *Frau* veteran has ever seen.

The problem with most *Frau* productions has been the complexity of the scenario, the shifts between levels of existence and the specificity of Hofmannsthal's stage directions. Andreas Homoki, the director, and Wolfgang Gussman, his designer, solved these problems by simplifying much, by retaining a few key props (for example, the pan of frying fish), and by creating an entirely plausible, ravishingly beautiful parallel symbolic universe. This consisted of a stage covered with mysterious, vaguely pubic runic squibbles in black and white, gigantic phallic red arrows, yellow boxes and cloths for the Dyer's world, and rich purple cloaks as the Emperor and his once-shadowless wife took on the warmth of humanity at the end.

It may sound simplistic; in practice, it worked to near-perfection, with choice after dramatic and scenic choice solved in an utterly con-

vincing and visually seductive way ("this most stubborn of librettos became as clear as a fable of La Fontaine," wrote Ms. Rey). The young Mr. Homoki, whose first major production this was, is a talent to watch for, eagerly.

Luana DeVol and Thomas Moser (both far surer vocally and dramatically than in previous *Frau* productions in which I had encountered them) were the imperial couple; an excellent French baritone named Jean-Philippe Lafont and Sabine Hass sang the Dyer and his wife, and Anja Silja made a charismatically malevolent and hearteningly well-sung Nurse. Christoph von Dohnányi (Miss Silja's husband) led the Philharmonia Orchestra of London in a sumptuous account of Strauss's most orchestrally sumptuous operatic score.

This *Frau* started life in 1992 in Geneva, which bodes well for Paris, since Hugues Gall from Geneva takes over the Paris Opera next year. But it had been entirely recast by the Châtelet and rethought by Mr. Homoki in light of that new cast—especially with Miss Silja and her spidery handmaidens—which bodes just as well for the Paris Opera's municipally sponsored rival.

GHOULS, ZOMBIES, AND JUDITH WEIR
The New York Times, April 27, 1994

London—The earth may be on the far side of the sun from Halloween just now, but four days of attending operas and plays in London suggested that shape-shifting spirits, ghosts, fairies, medieval enchantresses, and singing headless knights have found new favor in the British capital. It must have something to do with Tory arts policies.

The dark festivities began on Wednesday night at the English National Opera with the world premiere of Judith Weir's latest opera, *Blond Eckbert*. The thirty-nine-year-old Miss Weir (pronounced weer) has attracted considerable attention since the success of her *Night at the Chinese Opera* in 1987, followed by *The Vanishing Bridegroom* in 1990 and a large amount of concert music. Both previous operas had American productions in Santa Fe, New Mexico, and St. Louis, respectively,

and *Blond Eckbert* has long since been scheduled for a production (by Francesca Zambello) at this summer's Santa Fe Opera.

Miss Weir makes her own librettos, and she adapted this one from a novella of the same name by Ludwig Tieck, written in 1796 and a hallmark of German romanticism. Although she discounts the influence, her father was a Jungian-trained psychiatrist, and it is hard not to believe that notions of mythic archetypes—be they from medieval epics, German romanticism, Wagner, or Jung himself—haven't encouraged her interest in fairy tales and indeed the entire British obsession with ghouls and goblins.

In the sparest of manners, her text tells the story of a reclusive couple, Eckbert and Berthe, whose lives unravel when they open themselves up to strangers. Berthe tells Eckbert's friend Walther of her youth, a magical tale of flight from uncaring parents, adoption by a crone, a bird who laid jewels for eggs, and her escape with bird and jewels. Walther reveals he knows more than he should; Berthe dies; Eckbert kills his friend and wanders the world distraught, finally stumbling onto the crone (who turns out to have been Walther and another friend, as well, at least in Eckbert's mind). She tells Eckbert that Berthe was his sister, and he dies, mad.

Miss Weir's music can be astringent or melodious, but its diversity of means does not suggest a lack of personality. Above all, it sounds as abrupt and concise, to the point of repressed understatement, as Tieck's prose. With its classical restraint and Haydn-sized orchestra, it never says more than necessary, and for some, not quite enough. Andrew Porter, in *The Observer*, admired "the confident workings of a mind closed by temperament and decision to 'development,'" but complained that "she has stripped so ruthlessly, shed so much resource, that she seems almost underequipped for the big journey she tackles."

Others had a warmer response, however, noting the parallels to Janáček's nervous orchestral bursts. That Miss Weir has an extraordinary ear for coloristic combinations, there can be no doubt. Nor can one dismiss the parallels to some of Britten's most pungent works, the church parables, with their comparable austerity and folkish-medieval rigor.

Few of the London critics had kind words for Tim Hopkins's flamboyant, ingenious, but fussily busy expressionist production, arguing that a simpler, more romantically evocative setting would serve the opera better. We shall see what Ms. Zambello and her designer, Alison Chitty, come up with in Santa Fe.

The London arts scene may not be exactly small, but it does seem healthily close-knit. This is not merely a question of critics promoting British art extravagantly. It also involves the constant recurrence of the same names in opera, theater, dance, fiction, film, and television.

Miss Chitty, for instance, Santa Fe's *Blond Eckbert* designer, also designed Harrison Birtwistle's *Gawain* (1991), which is being revived now by the Royal Opera. Mr. Birtwistle used to be music director of the National Theater. Miss Weir has composed extensive music for Caryl Churchill's ghoulish new play, *The Skriker*, in repertory now at the National. The choreographer of Miss Churchill's play collaborated with Miss Weir on another German-romantic piece in 1989, a ballet called *Heaven Ablaze in His Breast*.

Most of the London critics applauded *Gawain* at its premiere, and reiterated their praise even more fervently at this year's revival. Mr. Birtwistle has recomposed and shortened a masque at the end of act 1 and tightened a comparable spot in act 2, which a few diehards regretted and most of the opera's critical champions applauded.

Not that all in the opening-night audience for the revival were enthusiastic. An amply publicized coterie of young, neobaroque composers who called themselves the Hecklers took it upon themselves to boo ("Shame about the score" cried one before being drowned out by applause).

Their stated intention was to protest the inaccessibility of contemporary music. *Gawain* made an odd target, however; Mr. Birtwistle's *Mask of Orpheus* from 1986 was more inaccessible (though still powerfully compelling). *Gawain* is downright Wagnerian most of the time, its orchestra growling and heaving in the Nibelungen depths like some enraged sonic beast.

Yes, the vocal lines are often tuneless declamation, in approved modernist fashion. But David Harsent's libretto, adapted from the anonymous fourteenth-century manuscript *Sir Gawain and the Green Knight*, grips the viewer fast. This bardic allegory (given a misogynist twist by Mr. Harsent's emphasis on the malevolent role of the sorceress Morgan le Fay) depicts Gawain's problematic encounter with the terrifying Green Knight and his torment when he realizes his own fallibility.

The production by Di Trevis—a remarkable number of the most talented people in performing arts here are women—brilliantly catches the opera's measured ritual and Jungian passions. The scene in which the decapitated Green Knight, sung with booming authority by John

Tomlinson, Bayreuth's reigning Wotan, picks up his uncannily realistic head, which then keeps on singing, mouth moving and eyes rolling, is a stunner.

Nowhere are London's Jungian obsessions more evident than in Miss Churchill's *Skriker*, to which Miss Weir's dry, eerie music for electric keyboard and three clarinets lends a disturbing undercurrent. One of the most fascinating aspects of this fascinating work, which divided the critics but left a lot of them pondering its afterimages, is Miss Churchill's attempt to blend play, masque, opera, and dance into one modern-day Wagnerian *Gesamtkunstwerk*.

A skriker, here embodied with creepy conviction by the Linda Hunt–like Kathryn Hunter, is a shape-shifting bad fairy who, Dracula-fashion, needs to lure victims into her zombified world to sustain her own immortality. Miss Churchill (and her director, Les Waters) are very clever in deploying the detritus of big-city street life (punks, cripples, the mentally disturbed, all-purpose eccentrics) to create a world in which every other person just might be a spirit or a victim. Here the principal victims are two young women, one who murdered her child and the other pregnant. Their fate is dire.

But no more dire than the two young women in Anna Reynolds's latest play, *Red*. This production by the Clean Break Theater Company, all of whose members are female ex-convicts, was at the New End Theater in Hampstead until Sunday and is now touring British theaters and prisons until June 3.

The two women in the play, one black and poor, the other white and well-off, are in jail awaiting trial for murdering their husbands. They tell each other their stories and form a bond expressed in highly literary prose that coalesces by the end into myth.

Almost more interesting than her work—to her annoyance, no doubt—is the glamorous Miss Reynolds herself. Only twenty-five, she has already written an autobiography that was squelched by the British attorney general; several articles for leading British magazines; two earlier plays; a short film for Channel 4 in which she also performed, and a script for the BBC, with enthusiastic interest in more plays, a film screenplay, and a novel.

Not bad for a woman who, at the age of seventeen, bludgeoned her mother to death with a hammer. Miss Reynolds spent two years in jail and then was released on medical grounds, as hormonally disturbed after the birth of a son. (The autobiography, which the attorney general

found in contempt of court for its comments about a judge, was an attempt to explain to her son why he had been put out for adoption). In a season of fictional Halloween horror, no matter how telling, nothing quite matched Miss Reynolds's real-life drama.

CATALANS IN THE COLD

The New York Times, June 2, 1994

Manchester, England—Leaden skies hung overhead and a chill wind cut through this proud but bleak northern English city. But on the streets were the colorfully costumed members of Gog i Magog, a company from Barcelona, Spain, that calls itself a "medieval street theater troupe of the twentieth century."

Stalking about on stilts in the city's shopping center with their band blaring and thumping in the background, troupe members acted out an age-old tale of a dragon, a damsel in distress, and a none-too-competent knight on horseback. Finally, the knight managed to dispatch the dragon and the troupe sauntered off to its van, to prepare for another performance a mile away.

Gog i Magog's performance was part of a monthlong festival called Ona Catalana, or Catalan Wave, which has filled Manchester with lively vanguard theater and dance from the Barcelona area. The series, a part of Manchester's program as Britain's City of Drama 1994, seemed to provide passers-by and theatergoers with a good deal of bemused pleasure. But it also called attention to Barcelona's theater scene, one of the most energetic and distinctive in the world.

The best-known Catalan vanguard theater companies are La Fura dels Baus (Ferret in the Pocket) and Els Comediants. Two members of La Fura conceived and staged the spectacular mythological opening pageant at the 1992 Summer Olympic Games in Barcelona, and Els Comediants created the closing fire ceremony. To an outsider, their selection was as bold and eccentrically brilliant as, say, having Mark Morris put on a SuperBowl halftime show.

While an initial encounter with these groups suggests unbounded

vitality, some people fear that this remarkable twenty-year burst of creative activity may have peaked.

"We felt this was maybe the last time we could do such a festival," said Anne Tucker, one of the two English organizers of Ona Catalana. "Talking to lots of people, there's a definite feeling of tiredness. And it seems very, very hard for the younger artists to come up with new material."

Catalonia, the feistily independent northeastern corner of Spain, has long boasted a tradition of street theater, carnival celebrations, and collective creation. When the late-1960s era came along, with its rebelliousness, its provocation, and its colorful eccentricity, the spirit of place and the spirit of the times seemed ready to merge triumphantly.

And they would have, except for the brooding presence of Francisco Franco, who distrusted vanguard expression and Catalan independence in equal measure. When the Caudillo died in 1975, Catalan theatrical energies burst forth with long-repressed, ebullient vigor.

The period from the mid-'70s to the early '80s became a years-long festival, Miss Tucker recalled almost dreamily. "It was a bacchanalia," she said, "sex and drugs and rock and roll even if it wasn't always rock and roll. The Catalans wanted to celebrate that you get horny when it's hot. There's lots and lots of eroticism in everything they do."

That description certainly applies to Els Comediants, whose core members still live in the same house and who are devoted to a kind of priapic street theater, even if some of what they do now is performed indoors. Their latest piece, seen in Manchester, is called *Mediterrania* and offers a panoply of mythic images from around that ancient sea. Some of those images are almost defiantly erotic, like the three nearly naked Pans with erect prop penises who clambered through the slightly squeamish audience and with their enthusiasm transformed three shrouded old women onstage into semiclothed sexual predators.

Another Comediants specialty is a piece of street theater called *Demonis*, which was first performed at the Venice Carnival 1981 and done in Chicago in 1986. In it devils challenge and overcome white-robed defenders of some grand public edifice. "Basically, the devils win," Miss Tucker said. "In Britain, the devils would never win."

The devils seem to win most of the time in the spectacles of La Fura dels Baus, too, as in *Noun*, seen at the Expo '92 world's fair in Seville, or *M.T.M.*, which was first performed in March in Lisbon. La Fura's shows are like industrial heavy-metal rock writ theatrically large. As the band churns out deafening blasts of sound, actors who look like escapees from

a Mad Max Road Warrior movie flail one another and themselves as carts career through the sometimes terrified standing audience and explosions and flames echo through warehouse spaces.

Some Catalan theater, seen this week in Barcelona, is milder than that. Els Joglars has done boldly amusing work, like putting a yuppie in a cage at the zoo and inviting passers-by to study his habits. The group's latest piece, *El nacional,* is a more conventional sendup of state-supported theaters. *La cegada de amor,* translated as *Blinded by Love,* is the current La Cubana production, a wildly popular spoof of Latin soap operas and pretty much everything else. The gimmick here, brilliantly achieved, is film characters stepping out through the screen to confront the audience.

What all these groups share is a mixture of Spanish and Catalan along with a tendency to transcend language altogether, into image, music, and movement. This tendency is variously attributed to the powerful Catalan artistic and architectural tradition, to the linguistic dichotomy in Catalonia, and to the economic need to tour constantly. The companies also share a blend of anarchic spirit and meticulous control and, above all, a freewheeling eagerness to toy with theatrical conventions.

"Since there was no great Catalan dramatic tradition, our generation had to make theater itself," said Albert Boadella, who founded Els Joglars thirty-two years ago and hence counts as the pioneer of these groups. "With no Shakespeare, no Molière, no Calderón, we were free."

Still, a brooding apprehension dogs the scene. For Mr. Boadella, "All that we have done since the '70s is a reflection of that epoch, the neurological center of the creation. Since then, there have been no grand new movements."

One problem, said Jin-Hua Kuan, a half-Chinese, half-Italian Comediants veteran, is that social and economic realities have changed, discouraging younger theatrical anarchists. "We had no taxes, no bureaucracy, no rules," she said. "Many of the new companies have fewer people; there are more monologues or duos and trios."

Still, there is life left among both the older troupes and some of those pocket companies. The three-member Estaquirot Teatre presented a science-fiction fantasy called *Biotic* in Manchester that revealed a droll and ingenious ability to turn everyday objects into puppets.

Elena Posa, who runs the principal summer arts festival in Barcelona, said talented newcomers and "happy surprises" from the veterans had made people more optimistic.

Chief among those surprises were the flamboyant Olympics spectacles of La Fura and Els Comediants, which in turn were part of a deliberate effort by both groups to expand their range. Els Comediants has a working compound called La Vinya next to its home in Canet de Mar, a seaside town twenty-five miles northeast of Barcelona. La Fura has its Fundicio, or Foundry, which facilitates members' venturing out on their own. As Carlos Padrisa and Alex Ollé did for the Olympics opening ceremony.

"There is a danger of repetition," Mr. Padrisa said in the company's Barcelona office. "It's like an orange; when it's squeezed out, it's finished. We hope our members will come back from their outside projects with new ideas."

PETER GREENAWAY

The New York Times, June 21, 1994

Geneva—Peter Greenaway's films—strict, formal, erotic, and cruel—are often so bursting with ideas and props and fabrics and extras that they threaten to explode from the screen. Now they have, in a one-hundred-piece, one-hundred-day outdoor installation here called *The Stairs: Location*.

Mr. Greenaway's films have a true touch of the megalomaniacal. In his latest, *The Baby of Macon*, which ends with a ritualized rape to the death of a woman by an entire regiment and which has not yet found American distribution, he used four thousand extras. And this for a supposedly low-budget art film.

In 1986, after his relatively successful *Belly of an Architect*, he contemplated a three-screen, twenty-four-hour extravaganza called *The Stairs* that would have included the re-creation of a lost baroque ceiling dense with detail along with the recomposition of a lost Monteverdi opera. Clearly, something had to give.

What gave was his commitment to film alone, or at least to film as it is conventionally conceived. His feature films since have included *The Cook, the Thief, His Wife, and Her Lover* and *Prospero's Books*. But start-

ing in 1990, Mr. Greenaway has become increasingly devoted to art installations in museums and entire cities, as well as to CD-ROMs, IMAX films, and live opera.

And all this without giving up on films. Most of the nonfilm projects are filmed or videotaped. And Mr. Greenaway is now preparing to shoot another feature, *The Pillow Book*, in Hong Kong. Based on a medieval Japanese diary, it depicts shared erotic pleasure derived from writing on a woman's body. This combines, as Mr. Greenaway put it deadpan, "the pleasure of literature and the pleasure of the flesh."

Mr. Greenaway's forays into extended film technology await release, and his first opera production, a world premiere of Louis Andriessen's *Rosa* in Amsterdam in November, has yet to be seen. Projected as the first of ten new operas by ten different composers, it may also be his last. "I haven't been too encouraged so far," he grumbled over lunch here recently. "There is something about the stiffness of opera that is inimical to the way I work."

What are visible are his gargantuan art installations, of which *The Stairs: Location*, on view here until July 31, is his first outdoor project and his most prominent and impressive thus far. It turns out to be not so much a rejection of film as an homage to it.

The project, so big that it includes a cinematically ambitious museum exhibition as just one modest part of the whole, consists primarily of one hundred sentinellike white objects dotted about downtown. As one walks about the city, the view of yet another familiar shape, somewhere between a monument, a tombstone, a urinal, and a shmoo, awakens a sense of welcoming familiarity.

Each object has a set of stairs (with a little platform booster on top for children). From the top of each—Mr. Greenaway, as verbally ornate as he is visually ornate, calls them "modest positions of privilege"—the viewer can peer through a peephole onto a framed view of one tiny part of the cityscape.

This peephole is, of course, exactly like a filmmaker's viewfinder. Mr. Greenaway has scouted one hundred still-life film locations, and lets passers-by—or pilgrims clutching their *Stairs* guide maps—share his vision. But the light changes with weather and time of day; many of the sites are illuminated at night. There is a flow, a flexibility to the experience, which reminds Mr. Greenaway of his own pleasure in making films and his own discontent in watching them.

The indoor exhibition, in Geneva's Museum of Art and History, is

astonishing all by itself and carries the artist's themes still further. Dappled light plays upon giant stone staircases, transforming them into flowing water and flickering fire. One hundred metal helmets gleam in shifting light. Sculptured busts are framed by hanging wooden rectangles. Numbers are projected on the floors and walls, counted out in English and French. It is a magic fun house of cinematic theatricality, its myriad intellectual pretensions enlivened by sheer vivacity.

Mr. Greenaway was trained as a painter but soon fell eagerly into film, to which he has devoted himself for nearly thirty years. He returned to the art world in a big way in 1990, when he was invited to organize an exhibition using works from a collection in Rotterdam. These he mixed with live nudes in glass cases and presented in a kind of filmic sequence.

In 1991 came *One Hundred Objects to Represent the World*, an idiosyncratic assortment of items in Vienna meant as a highbrow parody of the *Voyager* spacecraft's pretensions to summarize the planet Earth's achievements in a single time capsule. In 1992 there was *Flying Out of This World* at the Louvre, which had actually been the first museum to ask him to organize a show; when he couldn't fit it into his schedule, Jacques Derrida was invited instead. In 1993 Mr. Greenaway had exhibitions in Cardiff and Swansea, Wales, and at the Venice Biennale, a wildly ambitions, palpably theatrical installation called *Watching Water*.

Now it's Geneva's turn, although starting today it was also supposed to be Rome's. Mr. Greenaway had prepared a sound-and-light spectacle at the Piazza del Popolo, with the obelisk transformed into a nighttime sundial. That project was canceled yesterday, apparently on political grounds, by the newly neo-Fascist Ministry of Cultural Artifacts.

The Stairs here in Geneva is not merely a single exhibition—Mr. Greenaway doesn't think that small—but the first of ten 100-day exhibitions in ten cities. Mr. Greenaway loves numbers, as in his film *Drowning by Numbers*, and especially multiples of ten. For him, numbers are an "organizing principle," although others might call them a formalist fetish. The entire sequence is to end in New York with *The Stairs: Illusion*, a project that is to involve, in his words, "huge light structures, with a tower as big as the Chrysler building."

In between are to come themes like "Audience," "The Frame," "Acting," "Properties," "Text," and "Time," in cities including Tokyo, Warsaw, Munich, and Barcelona. London is conspicuously not on the list; Mr. Greenaway, though born in Wales in 1942, says he feels utterly alienated

from the British capital. His warm reception on the European continent and cool response at home compare with those accorded Robert Wilson, the American theater director with similarly diverse ambitions. (He won the Golden Lion for sculpture at last year's Venice Biennale.) Mr. Wilson, too, has been taken less seriously in the United States and Britain than elsewhere.

The entire ten-exhibition series amounts to a deconstruction of film itself, an act inspired not just by his own restiveness within the medium but also by the one hundredth anniversary of film in 1995. For Mr. Greenaway, film, the essential art of the twentieth century, is the closest thing we've had to baroque multimedia extravagance. Hence his fascination with the seventeenth century in nearly everything he does. He thinks of himself as transforming cinema, breaking it into vastly enlarged components and then reassembling them, at least conceptually, into the "mega cinema," the "phenomenon of total spectacle," that he once dreamed his *Stairs* film might be.

DANCE IN FRANCE
The New York Times, July 27, 1994

Paris—In July it seems there are more tourists than Parisians in Paris, American tourists especially. So it was appropriate that the San Francisco Ballet was booked as the final dance attraction at the premier dance forum in town, the grand and storied Palais Garnier opera house. The San Franciscans finished their engagement on July 10, and on July 17 the Palais Garnier was closed for renovation and won't reopen until February 1996.

On the surface this is a typically eclectic American company, with a diversity of style reflected in its two programs here. Still, George Balanchine remains the father of classical dance in the United States, and the Balanchine connection in San Francisco is especially strong, with two longtime New York City Ballet dancers as artistic directors: Lew Christensen, who died in late 1984, and Helgi Tomasson.

The San Franciscans opened with Balanchine's *Bugaku* (1963), and

if the dancers seen on July 6, Katita Waldo and David Palmer, did not erase memories of the formal purity and sensual extravagance of Edward Villella and Allegra Kent, this was still a handsome testimonial to the staying power of Balanchine's erotic blend of classical symmetry and ethnic kitsch.

For Balanchine to "close in beauty" the Garnier's dance season, as *Le Figaro* put it, served to highlight the differences between French and American dance. American dance, ballet in particular, still seems wedded to formalism in ways the more overtly theatrical, expressionistic Europeans have long abandoned. And while the French developed an involvement in expressionism later than the north-central Europeans, they seem increasingly drawn to it.

Of course a Gallic form of classicism—pretty, precise, and newly confident—still prevails at the Paris Opera Ballet, which with its current generation of *étoiles* and its productive school is internationally admired. But where Paris has really made strides is in modern dance. And as is increasingly common throughout the world, choreographers here are busily erasing distinctions between ballet and modern dance.

While Rudolf Nureyev deserved credit for revitalizing the Opera Ballet's repertory, Patrick Dupond, his successor as dance director, has extended Nureyev's innovations. This season has seen at least three distinctive programs at the Garnier: a Nijinsky evening including a reconstruction of his last ballet, *Till Eulenspiegel*; a full-fledged return to the company by Roland Petit with a program of three new ballets; and the young French choreographer Angelin Preljocaj's first full-length ballet for the company, *Le parc*.

The Nijinsky evening offered two of the four ballets the great Russian dancer choreographed for Diaghilev, *Till Eulenspiegel* and *Le sacre du printemps*, along with *Petrushka*, the Fokine-Diaghilev ballet in which Nijinsky created the title role. The *Petrushka* and *Sacre* were both revivals of recent Paris re-creations, the former the Fokine original as transmitted through Bronislava Nijinska and restaged by Serge Golovine, with the original Alexandre Benois sets and costumes recreated; the latter a Paris restaging of the Millicent Hodson and Kenneth Archer re-creation first done for the Joffrey Ballet.

The *Till* was another Hodson-Archer production, with Miss Hodson doing her best to bring the only sketchily documented choreography to life and her husband, Mr. Archer, recreating the Robert Edmond Jones decor. This was a ballet, set to the Richard Strauss tone poem, that had

only been seen in the United States, where the Diaghilev troupe was on tour in 1916. It made for an amiable eighteen minutes, with Mr. Dupond winning warm notices for his dancing of the title character. But it would take a braver person than most of the critics on hand to judge how close it really came to Nijinsky's intentions.

Mr. Petit, whose relationship with the Paris ballet establishment has long been testy, has been honored in Paris this season, with an engagement by his Marseille company as well as the evening of Petit creations at the Garnier. The opening *Passacaille*, to music of Webern, had a kind of zippy formalist charm. But otherwise, Mr. Petit's idiom looks dated these days, with its jazz-dance flavorings and aspirations to existentialist angst (a ballet called *Camera Obscura* based on Nabokov and set to Schoenberg).

Mr. Preljocaj (of Albanian origin, his name is pronounced here as prel-zho-KAZH) is much talked about, but *Le parc* was overshadowed by a messy squabble in which he resigned the directorship of the Ballet du Nord in Lille before actually taking over, following strenuous protests from the dancers and local politicians. Residual tension between ballet traditionalists and modern-dance innovators is not dead yet.

Le parc was interesting in that it seemed two ballets in one, perhaps all by itself reflecting tensions within the French dance aesthetic. At the center was a sequence of pas de deux for two of the Opera Ballet's greatest stars, Laurent Hilaire and Isabelle Guérin. These were ingenious, compelling, and sexy. But they were set in a park populated by, among others, four strangely attired "gardeners" who looked like the rock band Devo and seemed to represent extraterrestrial forces or some such. The duets were wonderful; their theatrical context was pretentious and silly.

Outside of Paris, the most interesting of the municipal companies is the Lyon Opera Ballet, and that is largely because its director, Yorgos Loukos, has a terrific instinct for picking resident choreographers. The previous one, the Frenchwoman Maguy Marin, ended a two-year term on December 31, and her successor, the American Bill T. Jones, picked up where she left off. Both were active this season in Lyon and in Paris, to generally stimulating effect.

Miss Marin's best could be seen at the Théâtre de la Ville in Paris, where her wonderful version of *Coppélia*, first done in the spring of 1993 for the opening of the new Lyon opera house, enjoyed an enthusiastic reception. With her own company, Miss Marin presented an evening-long piece called *Waterzooi* at the performing-arts center in the working-

class Paris suburb of Créteil. This found Miss Marin exploring the overtly theatrical territory of the Belgians, Dutch, and Germans to less engaging effect: the speeches and skits got in the way of the dance, and vice versa.

Mr. Jones not only crisscrossed Europe with his own company, but presented "An American Evening" in Lyon, a program repeated in Créteil. It offered new dances for the Lyon company by Stephen Petronio, Susan Marshall, and Mr. Jones, who appeared as the central figure, isolated and fantasized about, in his own piece. For an American viewer, the program as a whole was a reaffirmation of movement: not necessarily solely for its own sake, since all three choreographers have stories to tell or messages to convey, but at least of inherent choreographic interest.

William Forsythe, the Frankfurt-based American who is beloved by the Parisian dance audience, has something of that quality, too, that ability to blend choreographic abstraction with theatricality. But to this taste he's been in Europe too long, simultaneously seduced by the European penchant for theater and shaping and extending that penchant himself.

The highlight of Mr. Forsythe's engagement at the Théâtre du Châtelet was the appearance of the redoubtable Sylvie Guillem, the long-fled *étoile* of the Paris Opera Ballet, in his *Herman Schmerman*. Miss Guillem dances the same ballet with the Royal Ballet in London, and her elastic, super-sinuous body and Mr. Forsythe's choreography seem destined for each other. But what made the casting touching here was her dancing the part created for Tracy-Kai Maier, Mr. Forsythe's wife, who died of cancer in February.

As if to reaffirm the dangers into which theatrically inclined choreographers can fall, there was the Théâtre de la Ville engagement of Karine Saporta. Miss Saporta is one of the most admired of the younger French choreographers. She has her own company, which appeared here, but she also does ballets and even operas (Lully's *Phaëton* for the Lyon Opera last year).

L'impur, her new work, consisted of the travails (deeply symbolic, to be sure) of a character danced by Nathalie Rousset, who ran through the piece, and at one point up an aisle, buck naked. Miss Rousset has a voluptuous figure, and the reason she was running was that she was being constantly imperiled by big, virile, ominous-looking (and fully clothed) SS officers. Concentration camp accouterments—barbed

wire, guard towers, searchlights—filled the stage, and Holocaust film clips flickered on the back wall.

The whole thing, with its none-too-subtle sadomasochistic sex, French modishness, and documentary horror, left a bad taste. Holocaust chic? It was a long way from Balanchine.

FESTIVALS

Lincoln Center Festival program book, July 1996

Note: I got into the festival business because Beverly Sills and Nathan Leventhal invited me to, but also because I really believe that festivals hold a special place in our cultural life.

Like mushrooms underfoot in a damp forest, or more colorfully like spring flowers dotting every field, or more prosaically like weeds, festivals seem to be springing up everywhere these days. There are so many of them, particularly in Europe, that one could easily grow cynical, suspecting festival organizers of a greater concern for siphoning off tourist dollars (or pounds or francs or marks) than for the noble cause of art.

Fie on the cynics. The Lincoln Center Festival is proud to take its place among the world's leading festivals, but from the onset we who put it together (initially Jane Moss, later myself, along with Nathan Leventhal and Beverly Sills and the Festival staff) sought to establish its unique identity. That proved a fascinating and challenging exercise, since the historical record and contemporary parallels and special circumstances offered by New York City and Lincoln Center itself in the midsummer months suggested a plethora of possible models.

Festivals have existed as long as humanity has kept historical records. From the first, they were meant to be separate from everyday routine, usually linked with some divine or ritual occasion. The Olympic Games in ancient Greece, as much about art and celebration as athletics and competition, are the best-known early instance. The Middle Ages offered folk and liturgical festivities, usually associated with the major Christian holidays. From the beginning, too, there have been festivals

intended to reinforce the political power of the moment—and ostensibly of God, too, when kings still asserted their divine right to rule.

In the nineteenth century, the romantics, with their cult of genius, pioneered festivals devoted to composers from Bach to Wagner (actually, Wagner did the job all by his lonesome, founding his own festival at Bayreuth in 1876 to celebrate himself). Some of these nineteenth-century festivals took the adjective festive to mean, simply, big. The Crystal Palace Handel blowouts in London grew increasingly elephantine; the final one, in 1926, drew four thousand performers. But that was nothing next to a Barnum-esque Boston impresario named Patrick S. Gilmore, whose World Peace Jubilee in 1872 offered twenty thousand performers.

Festivals in our own troubled century have sprung up on every conceivable agenda. Salzburg became an annual event in 1920 in an effort to reassert the universality and hegemony of Austrian culture in the wake of World War I. Other festivals celebrated cities (Munich, Berlin, Vienna, Edinburgh) or entire countries (Holland) or rural pleasures (Glyndebourne) or all sorts of niche repertories, chief among them opera in its varied forms. In the United States, festivals have tended to be built around orchestras, like the cultural life of most American cities. Hence Tanglewood, Ravinia, Blossom, Robin Hood Dell, and on into the summer nights.

The idea of a big, diverse international performing arts festival has caught on more slowly in this country. One reason is that such festivals are more difficult to promote than the niche festivals (the Boston Early Music Festival; Ojai or the Next Wave for contemporary arts; Mostly Mozart for, well, mostly Mozart). Another is the sheer cost of importing challenging transoceanic companies. The American branch of the Spoleto Festival in Charleston, South Carolina, has been an honorable, if mid-scaled, exception to a gloomy rule.

In the immediate area of New York City, there have of course been serious prior efforts to create an annual, concentrated, focused, yet diverse festival. William Schuman, the first president of Lincoln Center, with Schuyler G. Chapin as his chief programmer, actually offered Lincoln Center Festivals in the summers of 1967 and 1968, but they fell victim to bad luck and a fund-raising climate more cautious than today's. The Brooklyn Academy of Music's Next Wave is probably the best-known current New York festival, although it is really a series of postmodernist performances stretched out over the entire autumn. Martin E. Segal's New York International Festival of the Arts, citywide celebrations

that took place in 1988 and 1991, sought to accent with selected international offerings a panoply of events showcasing the artistic diversity of the entire metropolis. The longest-lasting honorable ancestor of our new Lincoln Center Festival was the Pepsico Summerfare in Purchase, New York, during the 1980s. Although not in New York City proper, it was sterling proof that arts lovers from all over the area will flock to venturesome repertory that is imaginatively selected and promoted.

Against this backdrop, we at Lincoln Center have tried to invent a festival afresh. Of course, there are practical considerations. At the height of summer, Lincoln Center's theaters are suddenly and briefly available, and an influx of tourists more than compensates for an egress of regular citizens. Arts are certainly a generator of income and prestige—not so much for Lincoln Center itself, which must naturally raise money to support a festival like this, but for the city at large.

But we wanted to do more than keep restless summertime arts mavens occupied and fill up empty theaters and sustain local merchants. New York is the cultural capital of the Western hemisphere and quite likely the world. It deserves a major festival as a self-assertion at a time of year when the regular season has fallen dormant and a time in our political cycle when public arts support has ebbed. Our festival epitomizes and expands the synergy of companies and art forms that has underlain Lincoln Center from the beginning. It also reflects New York's world centricity, its centuries-long role as a lure for and blender of cultures of every sort. This is a city of thrilling, sometimes clashing energies; a quintessentially New York festival should echo that energy, and amplify it.

Beyond all that, though, we have been mindful of the thousands-year-old history of festivals: to some extent, no matter how subtle, we do think that attending a festival means participating in a communal ritual, in honoring spirits that transcend the mundane, in celebrating the power and cosmopolitan ethos of New York and the United States at its present apex of influence.

PALESTRINA

Lincoln Center Festival program book, July 1997

I admire, even love, the Royal Ballet. Having reached a sufficient age that I can remember successive generations of dancers and choreographers, I can up to a point—the point afforded a viewer from the other side of the ocean—trace its artistic evolution and look forward to the novelties that the company will bring to Lincoln Center Festival 97.

That said, the catalyst for this entire, historic joint visit of the Royal Opera and the Royal Ballet, and for the joint presentation by Lincoln Center Festival 97 and the Metropolitan Opera Association, was my hearing from Nicholas Payne in his office at Covent Garden in the winter of 1996 that he was going to present *Palestrina* and that the production might be available for the summer of 1997 in New York.

Do I think that *Palestrina* is the greatest opera of the twentieth century? I do not. So why the enthusiasm? Partly it has to do with my past and how my past formed my tastes. I studied German cultural history and have had a lifelong fascination with why a country of such enormous culture could produce such enormous evil. That fascination was born during two years spent as a small boy in Berlin right after World War II, where my father was involved in the American occupation. It was heightened by my later love, developed as a teenager, for German music and, then, German culture. As a student in Munich after college, I heard a performance of *Palestrina* at the Prinzregententheater, where it received its world premiere in 1917, and later collected pirate tapes of Julius Patzak and Fritz Wunderlich singing the title role (the Wunderlich performance can now be purchased on CDs).

Pfitzner's *Palestrina* is of interest because the music is, in its lyrical, expansive, protracted way, a true extension of the idiom of *Parsifal*, mixed with a little *Meistersinger* boisterousness in act 2. But it is also a searching statement of artistic conservatism, and of German values during World War I. Thomas Mann, one of the many German artists who prized the opera, did so in part because he thought it upheld German ideals in the face of the soulless individuality of Western democracy (a position he modified during the Weimar Republic and abandoned as an exile in the United States, without loss of enthusiasm for *Palestrina*).

Pfitzner himself mirrored the dichotomy of modern-day Germany. Not long after the premiere of *Palestrina*, with Germany's defeat in war

and the loss of his beloved Strasbourg (or Strassburg) to the French, he had turned into an angry nationalist and—despite Jewish friends, despite Bruno Walter conducting the *Palestrina* premiere and remaining a lifelong champion—an anti-Semite. For Pfitzner, musical modernism was the enemy and Jews were the force behind modernism. It was a position that the Nazis found highly sympathetic, of course. But by the 1930s, Pfitzner had grown too grumpy even for them. He never joined the Nazi Party, he made vicious jokes about Hitler, and Goering even threatened to throw him into a concentration camp. He died in 1949, impoverished but protected from indignity by the likes of the Vienna Philharmonic and, from Beverly Hills, Bruno Walter.

It is a strange and disturbing saga, and *Palestrina*, while itself totally free of any hint of German nationalism or anti-Semitism, is a strange and utterly Teutonic opera, defined by its artistic idealism and mysticism. As such, it has attracted a tenacious cult of admirers. This opera may never enter the repertory outside a few German theaters. But it seemed and seems to me ideal festival fare—the kind of major reexamination that a festival like ours was invented to present. I hope you enjoy this perhaps once-in-a-lifetime opportunity to hear a work that has meant a great deal to a great many people. Beyond its artistic beauties, it encapsulates the glory and tragedy of the German spirit.

MUSIC CRITICISM
Opera News, July 1998

Anyone interested in classical music in the United States cannot have failed to notice the decline of classical-music criticism. By "decline" I do not mean so much the level of criticism as its simple presence. Yes, the major urban newspapers still cover concerts, and the level of criticism there seems comparable to what it was in the past, or at least the past covered by my adult lifetime. But arts coverage in the major magazines, always erratic in quality, has declined precipitously in quantity, shifting largely to popular culture or the most popular manifestations of the serious arts (a Picasso show, the Three Tenors). Robert Hughes at *Time*

magazine remains a curious exception, but does anyone seriously believe that his successor will enjoy as much space?

With newspapers in the heartland, increasingly dominated by publishing chains, the situation is bleaker. To its credit, USA Today does give David Patrick Stearns a broad mandate. But when it comes to the serious performing arts in the entire country, he is the paper's only staff critic. As one wanders about America, picking up newspapers (as we newspaper junkies invariably do), the mangy array of wire-copy personality profiles of movie and TV stars and country-music singers looks pretty familiar. Beyond perhaps a token review of the local symphony, serious music coverage has wasted away, with honorable exceptions proving the rule.

One way of looking at the problem of classical-music criticism today is to see it as an inevitable consequence of classical music as a whole. Even in our age of politically motivated attacks on the arts and on public arts support, this is hardly a question of numbers. On the right of the political spectrum, ideologically driven doomsayers would have you believe classical music is under siege from the swill of rock and roll and other forms of barbarous mass culture. But such critics seriously (and deliberately?) undervalue the continued vitality of grassroots cultural activity in this country. Millions of Americans continue to enjoy classical music, maybe more than ever (it depends on how you measure—per capita, absolute numbers, passive listeners vs. active amateur performers, piano vs. guitar vs. synthesizer, etc.).

Yet there is still a widespread feeling, even within the field itself, that something vital is missing. Contemporary classical composition, even in this age of accessibility and crossover, rarely seizes the imagination of fellow artists, let alone a broader public. Ours has been the century of film, television, and other mass media; popular music and world music have captivated serious audiences everywhere; dance has exploded into myriad variants of "modern dance"; art and architecture and the computer arts are proliferating; even literature has shown enormous sustaining power, worldwide. Still, classical music is seen by most people as the purview of gray-headed nostalgists. The seat rows at Tanglewood curve gently, and I remember not long ago looking sideways during an impassioned performance of something or other and seeing dozens of old folk dozing the night away. I recall that sweetly sad symbol of classical music, those happily unconscious connoisseurs of tradition, better than the music itself.

"Heritage is what classical music is all about," intoned Martin Gold-smith this spring at the annual Performance Today awards ceremony at Lincoln Center. Well, no. Classical music can and should be about heritage, just as art can and should be about art museums. But if, rightly or wrongly—and I myself believe this century has created an enormous body of thrilling music, from the most popular to the most esoteric—classical music is perceived to have lost its way, to be only about heritage, then it will wither and die, or at least rest moribund until the next unpredictable burst of creative energy comes along. And as it dozes, its space in the pages of our newspapers and magazines will be filled by something more awake.

Readers take pleasure in finding out about something they've just seen or heard, even if they disagree with what the critic is telling them. Hence there is a larger impact of this shrinkage of coverage on music, musicians, musical institutions, and audiences. The musical community in any given town or country is built around communication. Performers talk to one another; so do composers and musicologists and audience members, both fanatics and more casual listeners. Yet within a given locality, no one talks to everyone better than the critics. Critics are not just judges or monitors; they serve as the public focal point of a network of informed chat, the kind of chat that in our day has expanded beyond intermission lobbies to chat rooms on the Internet. The best relation between a critic and his readers is not so much didactic as conversational; the best readers are not those who acquiesce or haughtily reject a critic's opinion, but those who engage in active dialogue with it—whether or not that dialogue is carried as far as a letter to the editor or buttonholing the critic in a lobby ("I can't believe we were at the same concert!").

New York music critics at the turn of this century enjoyed a (to us) amazing amount of space to consider performances they attended from every conceivable angle. They brought enormous knowledge to their musings, even if by our lights today they were often "wrong," especially about the modernist music of their time. More recently, the best example of powerfully effective classical criticism has been in Britain. There, given the small size of the country and the national reach of the London papers, a well-placed, well-respected critic can affect an entire country's musical opinion. Despite their boosterism and provincialism, British critics have admirably championed new music and native performers, and the result has been a far larger impact of British music worldwide

than might otherwise have been the case. More crucially, the interest and encouragement shown by the Brits toward their own has actually fostered the musical community, not just its image, helping develop top-level composers and performers who in other countries, lacking similar support, might have become teachers or plumbers (Philip Glass actually *was* a plumber for many years).

In one city in which I lived, the critic on the dominant paper was an active champion of the local new-music scene, and it blossomed. When he retired, his successor was indifferent at best, hostile at worst. Composers soon started to move away (mostly to favorable academic environments), and the scene dissipated. Maybe those composers would have moved away anyhow; scenes have a life that comes naturally to an end. But I always felt that if the old critic had been replaced with a more sympathetic new one, the entire creative musical history of that city over the last generation would have been altered.

Of course, if the newspaper in question had sharply downplayed or eliminated classical coverage, the scene would have withered more radically. In this case, the paper has maintained its arts coverage. But other cities have not. And when they don't, the entire arts community suffers, not just the composers.

When I was at Lincoln Center, I was bemused by the weight my colleagues placed on whether they got an advance story in *The New York Times* for an upcoming attraction, and how much they cared about reviews, especially if the attraction was ongoing. They hardly cared if the critic or the advance writer was insightful, but they cared desperately about selling tickets, and they placed inordinate faith in the ability of the *Times* in particular, and the press in general, to do the work their programmers (meaning me, in the case of the Lincoln Center Festival) and marketers should have done. (Often as not, a glowing advance or review boosted sales not at all, or an unadvanced concert sold out handily.)

Still, newspaper coverage in all its forms (advance stories, profiles, reviews, even investigative reporting) is a vital part of any cultural community, and as it declines, so must the community. Newspapers not only provide a form of shared public communication, they also serve as a bridge between the professionals and the more fanatical connoisseurs of a given art form and the tentatively involved broader public. Whether a critic approaches his task with self-effacement or with an overt didactic mission, the tastes of the public can be nudged and encouraged (not formed or led; they must do that themselves), and the general level of

taste can be shifted from passive tolerance to active enthusiasm, from mild curiosity to devoted attachment—whether the object of devotion is a conductor, an institution, a singer, or a composer.

The decline in criticism is not attributable to any lack of interest or talent on the part of young aspirants to the field. The country is full of potentially brilliant critics, and one of the frustrations of being an editor is wishing there were easier ways to become informed about all the bright young things out there, toiling anonymously in the heartland. But there are probably fewer bright young things today, because the opportunities are fewer, and promising college students recognize the diminished career opportunities, consciously or unconsciously directing their aspirations elsewhere. Or they sense a greater energy in film or popular music and become critics in those fields.

Since I am now an editor, I find myself more directly concerned with seeking solutions to this problem. One might think that as an editor at *The New York Times*, I would be particularly well suited to solving the problem, but I'm not sure that is so. Speaking frankly, the arts coverage en masse at the *Times*—whatever one thinks of a particular writer—is so far superior to that of any other paper in the country that its role as a model may be curiously diminished. In other words, other papers may see the *Times* as so distant from the grim realities of their own situation that it can provide no realistic goal for aspiration. Still, it might be worth mentioning the two main reasons for the superiority of the *Times*'s cultural coverage (which was expanded before my recent rehiring, and for which I can take no credit whatsoever). First and foremost, there is a tradition of family control (the Ochs-Sulzbergers), and the family has placed a primacy on general excellence, including culture but hardly limited to it, over the short-term bottom line. Second, there is the paper's dominant position as the (upper-) middle-class newspaper in the cultural capital of the country.

Like Arthur Sulzberger, lots of newspaper publishers or their wives no doubt sit on cultural boards around the country. Yet I am generally dismayed at the low level of culture in our ruling classes. Sitting on boards is a social thing to do, like joining the country club. But American leaders, especially men, and very much including politicians—especially politicians—seem to pride themselves on being philistines. An interest in the arts must seem dangerously equatable with unmanliness. And that attitude translates right down the chain of command, if the manly man in question is a newspaper publisher or editor, to an indifference to,

or active disdain for, the arts. Lip service must be paid (at best; increasingly these days, it's not paid at all). But lip service is hardly passionate commitment or faith in art's importance. When considering arts coverage, an editor is likely to prefer the popular arts, which not only reflect his own tastes but attract a greater number of readers. And he is likely to prefer "bright" writing over substantive expertise, not that the two can't happily coexist.

Editorial indifference is only exacerbated by the proliferation of newspaper chains. Just as an industry, formerly local but now absorbed into a conglomerate, is less likely to support local arts philanthropically, so too a newspaper no longer locally owned has less reason to devote its valuable pages to local arts coverage. It's no wonder that the periodic efforts of the Music Critics Association to lobby meetings of editors and publishers fall on deaf ears.

Are there solutions? Sure, if you're an optimist, although the curiously dour tone of higher-level cultural commentary these days—attributable to a faction of neoconservatives or embittered ex-liberals who insist on cultural entropy even when their own eyes and ears might suggest otherwise—weighs heavily on any optimistic stirrings. One tactic might be for everyone—publishers, editors, writers, advertisers, and readers—to start thinking about newspapers and magazines less as money machines and more as aspects of our larger culture. As such, they must not be seen as aspiring on every page to a generalized bottom line, appealing to the lowest-common-denominator general reader (the abstract notion of a general reader, in my experience, is usually held up by editors to excuse their own ignorance). Instead, each section of the newspaper should be recognized as appealing to a narrower, more expert and impassioned constituency. Not everyone knows or cares about the intricacies of the bond market or baseball box scores. Music critics complain if editors strike out sophistication or technical terminology in their writings, when sports and business and even political writers use arcane terminology all the time. While everyone likes clear, pointed prose, the music critics are right to complain. In a democracy, we should not all be reduced to a totalitarian commonality; differences should flourish freely. Same thing with a newspaper.

Earlier on, I linked the decline in criticism with the state of music itself, referring to a time when "the next unpredictable burst of creative energy comes along." To reiterate: I believe our century has seen an enormous outburst of modernist masterpieces. I also believe critics can

have a positive role encouraging interest in new music. But at some point, one has to have faith that composers themselves will reconnect with a wider public than they now enjoy. I don't mean the dutiful acceptance of the latest commissioned premiere by a passive symphony or opera audience, but a passionate enthusiasm for a whole group of composers, similar to that enjoyed by—to pick almost utterly at random, and to confine the argument to Americans—Jonathan Demme in film, Mark Morris in dance, Richard Serra in art, Thomas Pynchon in literature, or Laurie Anderson in music.

But wait a minute: Laurie Anderson is a composer, albeit not one in the direct tradition of classical music. For classical music to rejoin the creative mainstream, which would lead to its rejoining the audience mainstream, it must merge into music as a whole. Categories can make sense; they reflect natural divisions of interest and training on the part of musicians and audiences. But categories ossify rapidly, falling out of synch with the realities of music as it is actually created, performed, and enjoyed. My own feeling, and faith, is that music criticism will regain a vital place in American newspapers and magazines precisely at the time when classical music is perceived again to be a vital, exciting part of our cultural life. And if you redefine "classical music" to reflect what is actually happening in American (and world) culture, maybe that rebirth is already under way.

THE PEONY PAVILION
Orientations, September 1998

Note: I wrote a ten-thousand-word chronicle of the rise and fall and rise of this Peony Pavilion production, my proudest accomplishment as director of the Lincoln Center Festival, for the spring 2000 edition of the Kaikodo Journal. This is an earlier, shorter account, more suitable for this collection.

The idea of staging The Peony Pavilion in its entirety came to me some years ago. I had heard it was a masterpiece—subsequently confirmed by

my reading of Cyril Birch's English translation—that it was long, and that it was rarely performed complete. At the time, I had no idea how long (some twenty hours) or how rarely (probably not for nearly four hundred years). As a lover of epic scale (Richard Wagner, Robert Wilson, all-night shadow-puppet plays), I figured simply that it would be fun some day to see it put on unabridged.

When, in 1994, I became founding director of the Lincoln Center Festival, *The Peony Pavilion* remained in my mind; through Laura Aswad, the associate producer on the festival staff, I came in contact with Chen Shi-Zheng, a Chinese opera performer from Changsha who had come to New York in 1987. Now an American citizen, he had since had a lively career as an actor, singer, choreographer, and director, at the same time maintaining active ties with China, principally in his staging of Euripides' *The Bacchae* at the China National Beijing Opera Company in Beijing.

Shi-Zheng agreed to plan a trip to China for us in March 1997 to visit five *kunqu* opera troupes, in Beijing, Suzhou, Hangzhou, Nanjing, and Shanghai. The trip confirmed how rarely *The Peony Pavilion* is ever performed in China beyond five or six conventional excerpts (out of fifty-five scenes in all), and that the Shanghai company was by far the most elaborate (an orchestra of eighteen!) and richly grounded in *kunqu* tradition and technique. I decided to go ahead with the project, engaging Shi-Zheng to direct it (and from the Chinese side, produce it), designating the Shanghai company as our Chinese partners, and beginning to arrange for Chinese support (including the Shanghai Bureau of Culture) and coproducers.

Why did I choose Shi-Zheng, and not a member of the Shanghai troupe itself? First, because I liked and respected him; second, because he was bilingual, with experience in the United States as well as in China; and third, because his very status as someone close to but not part of the current *kunqu* tradition appealed to me. Here, no doubt, is where our troubles began, even though the Shanghai troupe had previously employed a local director with no operatic experience at all. Shi-Zheng and I were at one in our perception of the steep decline in the *kunqu* performing tradition. Decimated by the Cultural Revolution and today starved financially by the Chinese authorities, the remaining *kunqu* companies struggle on, offering mostly assortments of excerpts to dwindling audiences of tourists and aging Chinese. My theory was that Shi-Zheng, as a native outsider, could look at the tradition sympatheti-

cally but objectively, and then help the Shanghai company rebuild it from within.

From the outset this was to have been a genuine East-West collaboration. What I brought to the table, aside from initiative and money, were two ideas from the Western early-music movement, which I thought might find particular resonance in a culture that has always venerated its past: textual completeness and "authentic" performance re-creation. We wanted to take Tang Xianzu seriously, to perform all fifty-five scenes with an unbowdlerized text and to do so in a style which, in gentle compromise with current *kunqu* practice, would seek to recreate the aura and atmosphere of performances during Tang's time. These ideas question the assumption that all officially sanctioned evolution is for the best and presume a faith in the work itself to speak to audiences worldwide, not only over vast distances, but over four hundred years.

We determined that the performance (with a little trimming of the literary references and recapitulations) would last around eighteen hours, divided into six segments. The production was to run in two formats: six consecutive evenings and a marathon of three days and nights. In contrast to the mostly bare stage that is used for *kunqu* nowadays, we planned a carved and joined wooden stage thrust over a pond with carp, ducks, and caged songbirds, modified Western-style lighting, some three hundred hand-sewn period silk costumes, food served in the aisles and lobbies, and occasional elements (puppetry, storytelling, a funeral procession with burned effigies) not now part of the codified *kunqu* tradition. I do not think Shi-Zheng and I approached our task naively. My mandate was for him to recreate the spirit of the time, to have faith in the text and the (reexamined) tradition, and then to trust his imagination—as long as his creative choices could be defended with scholarly responsibility.

Even after my resignation from the Lincoln Center in January this year, I was in regular contact with Shanghai by telephone and was constantly reassured by Shi-Zheng's reports of his research, his work with the company, and his growing closeness with the performers and the artistic director. I think it fair to say that the Shanghai dress rehearsals, which proceeded in early June in both formats, generated enormous enthusiasm—from a large and lively audience far younger than the current *kunqu* norm; from the official Chinese press, including a rave review in the *People's Daily* (and a complete taping with five cameras by Beijing television, not yet released); and from the Western visitors and

press. *Le Monde* called the experience "one of the great events in the performing arts in the late twentieth century."

But then Ma Bomin weighed in. Director of the Shanghai Bureau of Culture, she impounded the set, costumes, and props at the Shanghai airport, then released them but forbade the company to depart, instead sequestering it in a country villa (far from the junketing Bill Clinton) and forcing it to re-rehearse from the ground up to purge the production of "feudal, superstitious, and pornographic" elements, according to her press releases. Shi-Zheng offered compromise after compromise, but to no avail.

Why did she do it? Totalitarian political regimes and opera both breed rumors, and when the two combine, these grow positively lurid. Some speculated that Ma or members of her shadowy committee of *kunqu* experts wished to direct this prestigious production themselves. Certainly, the project's initiation in the West was resented, as was Shi-Zheng himself, branded both a Chinese "peasant" and a "long-haired American." Others adduced wild rumors of romantic liaisons and failed bribery expectations (the Chinese were careful to define this production as a "commercial venture").

From afar, I saw Ma's actions more as a perhaps all-too-predictable reflex action of the pedantic-oppressive bureaucracy that has a history in China long preceding 1949. The Chinese may venerate the past, but the past as reinterpreted and officially sanctioned by the present. Shi-Zheng's innovations offended academic purists (and many similarly pedantic *kunqu* devotees in the New York immigrant community, not that they had seen the production). While hardly "pornographic" in any Western sense, even a highly stylized dramatic realization of Tang Xianzu's often erotic and bawdy text undoubtedly did prove shocking to Communist puritans—some scenes offended Ming puritans, too. Worse, that Shi-Zheng did not properly kowtow to the officials was intolerable. But Shi-Zheng and I felt that detailed prior approval of every scene, line, and gesture would have scuttled many of his innovations from the start, and that since this was a Western-initiated and -funded project (with some Chinese assistance), we had the "right" (and the contract) to proceed judiciously.

Technically, hope remains for the other coproducers—Paris, Sydney, and Hong Kong—and, perhaps, for New York in 1999. But they would rightly reject any despoliation of Shi-Zheng's intentions, and Ma rests secure in her power and her righteousness. There seems little chance of

effective political intervention from Beijing, Washington, or Paris. The biggest irony in all of this is Tang Xianzu himself. A rebel who retreated from public life, his masterpiece satirizes the pettiness of bureaucratic power and pretension even as it offers as romantic and compelling a vision of young love and idealism as any world literature has produced. His lovers overcame every obstacle; maybe Shi-Zheng can, too.

PHILIP GLASS

The New Republic, April 10, 2000

Philip Glass's recent music not only seems tired; it *is* tired. His early innovations are largely unrecognized or forgotten, and premieres of his new works—and they keep on coming—are no longer anticipated with excitement, or even with hostility. They are ignored, except by the general public, which still sort of likes his music, and by professional beat critics, who routinely dismiss the new works as inherently simplistic or, less often, as tedious recyclings of earlier tricks. Some writers, denying their own early opposition to Glass, profess that he has fallen off from his more creative youth; others, more honestly, never saw much there to start with, apart from nagging arpeggios and mind-numbing repetition, which is all that they still see. But in truth it is Glass who has changed, not the critics. His music, outwardly similar to what came before, has declined in quality, and that decline can be described.

I, too, once found much to admire in Glass's music, and in his salutary position in a musical culture that still prized hermetic modernism. Twenty years ago, the polemics between the modernists and the postmodernists, between the uptowners and the downtowners, were at their height. Glass's music, inspired by John Cage's manifestos of liberation and by the spiritual exercises of Asian meditation, was a stirring circumvention of the dense dissonance of mainstream contemporary music, a blast of fresh air into a musty artistic temple. His music proclaimed that complexity was not the same thing as excellence, and that an ornate, virtuosic mastery of technical craft, in composition as well as in performance, would inevitably provoke a retort. Glass's success, far from a

sellout to commercialism, was a reconnection of the serious artist to the broader public that had recoiled from the further reaches of modernist abstruseness.

Yet memories of his past glories do little to explain his present failings. A recent run of performances of Glass's opera *Akhnaten* at the Boston Lyric Opera, in a coproduction with the Chicago Opera Theater, offered a welcome occasion for assessing Glass's development. A live confrontation with this work, in a vivid production from the Chicago director Mary Zimmermann, provided a tangible test of one's loss of pleasure in Glass's work. Is this declining interest in Glass's music the result of changes in his style? Or is it, rather, a listener's exhaustion with his trademark musical devices? Would even *Akhnaten*, an opera that was exciting and moving at its Stuttgart premiere sixteen years ago, now seem tepid and trite?

From the very first notes, a rapid arpeggiation of the tonic A minor chord, A–C–E–A, by a dark string ensemble (no violins) and with a pedal A intoned in the lower depths, I found myself drawn back into Glass's sound world, and into his contemplative vision of an eerily exotic, societally detached, theologically visionary monarch. Those opening notes, with their modal and polytonal implications and their brooding atmosphere, still mean more to me than all manner of more recent Glass scores that might on the surface be similarly analyzed. What, then, had changed since his nearly unbroken string of musical triumphs from the mid-'60s to the early '80s?

Glass is still considered the archetypal "minimalist," with all the baggage that poor little word has accrued. Never mind that he was preceded in this manner by painters and dancers and by John Cage and Morton Feldman and Alvin Lucier and LaMonte Young and Terry Riley and—maybe by a minute or two, but who but them is counting—by Steve Reich. And never mind that none of these composers was comfortable with the term. Glass likes to assert that if he ever was a minimalist, he stopped being one in 1974. But a minimalist he is and will always be, in the perception of the public and also in stylistic signature, no matter how grand and bloated his scores become.

Twenty years ago, Glass preferred to be called a composer of "music with repetitive structures." It was an accurate description, and it is, for better or worse, what he remains. His earliest music, for solo electric keyboard, sounded both repetitive and minimalist: to the pared-down minimalist aesthetic of offering the most rudimentary forms (of visual

elements, of dance gestures, of musical notes) and trusting in their power to carry the work, Glass (and Riley and Reich) added a motor energy that turned stark repetition into a formidable aesthetic idea and a high-energy ritual.

By the late '6os, Glass had evolved his ensemble instrumentation into two or three electric organs and pianos or, later, synthesizers; two or three winds; and a wordless soprano. Heavily amplified, like a rock band, the musicians could make a sound to match any orchestra for sheer volume, and hence could combine the impact of a large ensemble with the devoted executional accuracy of a small ensemble. The music composed for this ensemble, from the late '6os to the late '7os, was always evolving. Glass considers 1974 a significant date because in the conclusion of *Music in Twelve Parts*, and especially in the root-movement harmonic extensions of parts 11 and 12, he had consolidated the idiom that—with sometimes interesting, often cosmetic refinements—has served him to this day.

Each step seemed logical after the ones that had preceded it, yet none seemed like a compromise of aesthetic principle. And the aesthetic principle was, I think, essentially meditative. Glass is a Tibetan Buddhist, and his music sets up a mood that hypnotically seduces one into contemplation. The metaphor of seduction is not accidental, either in its blending of the sacred with the sexual or in its evocation of all those, from Plato to the post-Wagnerian Nietzsche to modern-day conservatives, who fear the seductive power of a nonrational art. And this idiom was strangely open-ended, emotionally flexible: it remained meditative whether the music was fast or slow.

Glass's two basic styles are fleet and burbling, with the electric keyboards of the ensemble shimmering with a silvery energy as the arpeggiated figures and pungent polytonalities fly by; and slow and stately, which is maybe best understood as the isolation of the mournful pedal tones in the winds and brass that sound beneath the mad burbling. The fast style resonates especially in the early work, in *Two Pages*, *Contrary Motion*, *Music in Fifths*, and *Music in Similar Motion*, music from 1968 to 1974, the earliest now available in recorded form.

But surely the definitive articulation of Glass's manner appeared in the music that he composed in 1976 for *Einstein on the Beach*, his first collaboration with Robert Wilson, a work so central to the Glass oeuvre that he recorded it twice. (The later version, the only one now in print, on Nonesuch, is more complete and more confidently executed, the

historical charms of the first version notwithstanding.) Both aspects of his early music are amply displayed in *Einstein*. The fast style predominates in the frantic, driving dances and the frenzied violin solos. The slow style (which for Glass connoisseurs remains the mystic center of his music) can be heard in the opening A–G–C descending chord on the organ; in the gravely dignified, dreamy Trial scenes; in the eerie Bed scene (in which for fifteen minutes "nothing" happens except that a bed, which is really a fluorescent-lit horizontal band of light, is raised to a vertical position and then drawn very, very slowly up into the fly-space of the theater); and in the flowing, elegiac final "Knee-Play," which is what Wilson calls his interludes.

People who hated this stuff all along still hear in it only an irreducibly simplistic reiteration of arpeggios, the separated-out notes of the basic chords in the Western harmonic vocabulary. Donal Henahan, a former chief music critic of *The New York Times*, could never write about Glass without mentioning Czerny. But those drawn to the music hear the rapture of ecstatic repetition varied by subtle shifts of note values and rhythmic emphases in the fast sections, and the profundity of the elemental in the slow sections. Floating over all of Glass's music is a veil of sadness, of regret at being bound to this earth, of yearning for the ineffable. For all its obsession with regularity in its structure, this music is brazenly romantic. It appeals to a joy that transcends rational codification (despite the learned technical analysis with which Glass can explain his methods). It is, indeed, a great musical monument to the prerational or the postrational, and hence it is anathema to the impatient rationalists and the avatars of common sense who figure prominently among the makers of our intellectual and critical discourse.

The spiritual underpinnings of Glass's music are reinforced by his reliance on old church modes, meaning variations of the basic major and minor scales by white-note-only octave sequences built up from each of the white notes on the piano, thus altering the pattern of whole tones and half tones, which can then be transposed, in the equal-tempered system, to other root notes. Two of my favorite moments in what might be called late early Glass, just before his music began to sink, are the conclusions of his first "real" opera (meaning a stage work composed for operatic voices and an orchestra), *Satyagraha*, from 1979, and of his score to Godfrey Reggio's film *Koyaanisqatsi*, from 1981. Both are in variants of the Phrygian mode, the former consisting of the tenor Gandhi chanting the scale in its purest form (E to E) upward in ten groups of 3,

over and over, as he ascends to grace, and the latter a descending octave scale with a chordal arpeggio in the treble and an overlay of a Hopi chorus as the screen depicts slowed-down NASA footage of a dreamily turning, burning fragment of an exploded Saturn rocket as its falls inexorably back to earth—Reggio's final metaphor for the futility of technological progress.

Akhnaten was the last and the most complicated artifact of Glass's early music. Its opening captured in orchestral form the arpeggiated basis of the ensemble style (itself an instrumentation of those figures that lay easily under the composer's hand at the keyboard). The prevalent mood throughout the opera is a pining regret for something ancient and, for us, unreachable. And yet many of the hallmarks of Glass's music in the '80s and '90s can be heard here, too, sometimes disadvantageously: in particular, there is his habit—he still hasn't shaken it—of pounding out basic chordal figures in the brass, bluntly and crudely. (Just as *Akhnaten* did without violins, *Satyagraha* has done quite well without brass.) Yet *Akhnaten* also offered pungent percussion, piquant instrumental touches, and fascinating timbral experiments with the vocal writing. (The pharaoh has a mother, a wife, and six daughters, and Glass makes him a countertenor, with several keening, all-high-voice ensembles and the conventional male singing confined to the villains.) Its apogee appears in Akhnaten's hymn to his new sun god, with its polytonally clashing descending solo trumpet line, E–D–C–B, which sticks in the mind like the very best kind of pop hook.

What happened thereafter? Well, to be precise, it wasn't quite such a clean break in 1983. One of the most noteworthy moments in Glass's musical career came, or should have come, on March 23 and 24, 1984. Few composers, and certainly few American composers, have had back-to-back premieres of major operas in major European opera houses. March 23 was the scheduled premiere by the Rome Opera of the evening-long, self-contained fifth act of Wilson's mammoth *Civil Wars* (a project intended for its daylong completion at the 1984 Olympic Arts Festival in Los Angeles, but never realized). A wickedly typical Italian strike forced the transformation of the "premiere" into a private dress rehearsal for the assembled army of journalists. The official premiere came several days later. Then, on March 24, there was the premiere of *Akhnaten* in Stuttgart.

The fifth act of *Civil Wars* has recently been released on Nonesuch. Composed at nearly the same time as *Akhnaten*, it provokes a fascinat-

ing and discouraging comparison. The main interest of the new recording is the eloquent voice-overs by Wilson and Laurie Anderson. The vocal writing is stentorian—Jessye Norman was supposed to sing in Los Angeles—but unevocative, and the instrumental writing alternates between the bluntly hectoring (as in the music for the Italian tenor who plays Garibaldi) and the self-effacingly formulaic echoes from his earlier work, which called more attention to themselves than to whatever it was Glass was trying to convey.

Since then, little of his music has seized one's attention with quite the same degree of intensity or enthusiasm. What seems to have changed most profoundly is the composer's own faith, or interest, in his great aesthetic experiment in unadorned, protracted repetition. The repeated materials have become too plain; the periodization of the repeats—how often and how long they are repeated—seems now too restless, too willing to accommodate conventional taste; and the variations to which the material is subjected sound likewise more simplistic than involving. Glass once defied his audience to be bored. Now he panders nervously to his audience in the fear they may be bored. And his pandering undercuts the radical, hypnotic aura of his early music.

The expansion of Glass's ambitions into orchestral music compounded the problem. It is true that he was deluged by commissions occasioned by his earlier successes, but the industry that was suddenly required of him seems to have taken a toll on his powers and his standards. The need to write for busy bands of professional musicians, with little rehearsal time and an often ingrained resistance to trying anything new, may have encouraged a simplification of the tricky variations of his ensemble repetitive style. Even when working with smaller groups, Glass's musicians are now often professional freelancers rather than (or in addition to) his core ensemble, and his expansion into popular and ethnic music and film scoring has likewise encouraged a devolution of his music into smaller atmospheric chunks closer in length to pop singles.

This is not to say that Glass has become complacent. He is still broadening his harmonic language, extending his instrumental combinations, and exploring new ways of recording. (The overdubbing of separate orchestral and vocal elements in the 1985 recording of *Satyagraha* was an early example of his technological restlessness.) He has also undertaken new kinds of collaborations, in particular his trilogy of music for or inspired by classic French films. All this is evidence of an

active musical imagination. The problem lies in the quality of all this activity.

His two orchestral reformulations of the music of David Bowie and Brian Eno, the "Low" Symphony and the "Heroes" Symphony, are interesting as ideas, reaching out to the music of two of the most inventive figures of British art rock, but the symphonies combine the worst of both worlds, reducing the distinctiveness of their pop models into old-fashioned-sounding orchestral gestures. Nearly all of Glass's music from the '80s and '90s sounds similarly second-rate, from the unrecorded operas such as *The Voyage* and *The Making of the Representative for Planet 8*, to dance works such as *In the Upper Room* (1986), to orchestral works such as the Symphony No. 2 and the Violin Concerto, to *Itaipu* and *The Canyon* (two grandiose scores for chorus and ethnically flavored orchestra and orchestra, respectively) and even most of the more recent string quartets, to the overt world-music experiments and scrappy underscoring such as the Reggio *Powaqqatsi* and the film scores for *Anima Mundi, Mishima, Screens, The Thin Blue Line, Kundun, Monsters of Grace*, and the Bela Lugosi *Dracula*, to the unselfconscious reductions of his own style in *Glassworks* (which preceded 1983; these demarcations are not exact) and the popsy *Songs from Liquid Days*, to the scenically brilliant, musically undernourished David Henry Hwang and Allen Ginsberg settings of 1000 *Airplanes on the Roof* and *Hydrogen Jukebox*. Precious little of all this stands up.

The trouble with Glass's recent formal and coloristic innovations is that they have not been accompanied by a coherent and still convincing expansion of his idiom. A repetitive music based on pure repetition has become a compromised, crude reduction. In attempting to expand his harmonic idiom and to increase the responsiveness of his music to texts in familiar modern languages, he has approached neoromantic conventionality and demagoguery in a way that both exposes the weaknesses of his style to accomplish those ends and subverts the stark abstraction of that style. What once was meditatively stimulating has become truly primitive.

Consider two orchestral works, the Violin Concerto (1987) and the Symphony No. 2 (1994). Both were born in prestigious circumstances—commissioned by Dennis Russell Davies, for the American Composers Orchestra and the Brooklyn Philharmonic, respectively—and both have enjoyed authoritative recordings, the concerto with Gidon Kremer as soloist and Christoph von Dohnányi conducting the Vienna Philhar-

monic, and the symphony with Davies conducting the Vienna Radio Symphony. Yet both reveal similar failings.

The very opening of the concerto is dispiriting. Its first thirty seconds offers only a recycling of overfamiliar devices, compressed into too short a time frame to allow them to register: phases repeated and then bluntly juxtaposed with other material, a low pedal note and then, too quickly, the entrance of the solo violinist, arpeggiating as if his life depended on it. Similarly, one minute and fifteen seconds into the third movement (I take the timing from the compact disc) comes one of Glass's patented bass figures, intoned by the brass, A–A–A–A–B-flat–B-flat–A–G, with the final A implied, which recurs throughout the movement, louder and louder, blunter and blunter. The best thing about this concerto is the solo violin writing, and Kremer plays beautifully, especially in the haunting slow movement. But Kremer has also recorded John Adams's Violin Concerto, a fat more imaginative score that makes Glass's look stale. And the Second Symphony is likewise constructed of crushingly familiar devices: a short-breathed tune that snakes through the first movement without compelling variation; syncopated figures in the second; a choppy, hiccupy alternation of melodic and rhythmic material in the third, particularly one of Glass's core patterns, da-da, da-DA-da, hammering itself into a listener's brain.

Struggling and stumbling along the path of career growth is hardly unique to Glass. Artists who enjoy an early success face the dilemma of altering their style at the risk of alienating their early fans, or maintaining it and losing creative momentum. Glass, having invented a language, chooses not to abandon its basic grammar. He seems to have no faith that his own compositional personality will shine through any idiom in which he chooses to work. Stravinsky constantly reinvented himself; Copland's sweet personality and bedrock Americanism permeate even his twelve-tone scores; Adams, starting as a Reichian, has pushed his idiom in both the American-symphonic and pop-pastiche directions. But Glass is stuck in his Glassisms. "Style is a very dangerous concept," the architect Renzo Piano warned recently. "It's a narcissistic attitude. Style is like a rubber stamp, a designer label; it becomes quite commercial."

Glass has long asserted that he is a born dramatist, but I am not sure that he is right. True, he wrote yards of incidental music early on for the theater troupe Mabou Mines. But his best works for the stage have been occult rituals in languages (Urdu, Hindu, ancient Egyptian, Sanskrit,

even the numbers and solfège syllables of *Einstein*) that mean nothing to contemporary audiences. The mood was heightened by exotic incomprehension, and in his case, the clarity afforded by supertitles did him a disservice. Setting understandable modern languages in a more conventional way exposes the rigid limitations of his self-imposed, doggedly sustained style; his text settings, unless he falls back on the device of spoken narration over music, sound clunky. He is not a narrator of any skill; he is, rather, a painter of moods, and for this reason his music works better with images (films, stage spectacles) than with texts, and maybe better still as concert music.

It is no accident that two of his most striking works of the '90s are the String Quartet No. 4 (1990) and the Piano Etudes, which are unrecorded, with more etudes apparently still coming. The "Buczak" Quartet, as No. 4 is titled in memory of a friend who died of AIDS, has the meditative grief of his best works of the past. (It may be heard on the Kronos Quartet's recording of four of his string quartets, also on Nonesuch.) And the Piano Etudes, far more complex and interesting than the simplistic compositions assembled on the CBS CD from 1989 called *Solo Piano*, represent what may be a genuinely new direction for Glass. They retain most of his signature stylistic elements; and yet they manage, without descending into pastiche, to summon all manner of ghosts of keyboards past: one hears visitations by Bach (whose spirit is also lovingly evoked in the late Donald Joyce's stirring Point CD of Glass music played on the pipe organ), Chopin, Debussy, Ravel, and Bartók.

At the height of the modernist/postmodernist, uptown/downtown musical polemics of the '70s and '80s, modernists dismissed Glass as a mere populist; but that was never correct, even when he (and Reich) courted rock audiences during the punk-progressive moment in the late '70s. At this discouraging moment in our musical culture, when we are awash in cheap, demagogic, faceless neoromanticism, we can look back on the older polemics from a new perspective. Obviously there were airheads downtown and pedants uptown (or vice versa), but the best in both neighborhoods were genuine experimentalists, and in that sense they were modernists, pushing the language and the expressive power of music into new realms, breathing the air of new planets.

Glass, the early Glass especially, was just such an experimenter. His achievement of those years is likely to endure when the airheads and the pedants have long faded from memory. Of course, there were those who

complained at every step along the way—especially after *Music in Twelve Parts, Einstein,* and *Satyagraha*—that Glass had betrayed his art. And so it is worth remembering, when considering Glass's decline, or lull, that artists have a way of surprising, and defeating, their critics. At least he is still working. He did not quit while he was ahead, or retire early like Rossini or Sibelius, or come to some abrupt rock-and-roll termination. And there are those powerful Piano Etudes—which Glass, no keyboard virtuoso, will play in April at the Metropolitan Museum of Art. They may still point a way toward a wise and self-aware maturity, less a sin of his old age than a harbinger of his future.

ANNA HALPRIN

The New York Times, June 11, 2000

San Francisco—For an artist so influential, Anna Halprin is barely known outside her worlds, of dance and, more recently, ritual healing. Yet those who do know her are drawn to her, as proven by the large and enthusiastic audience at her "Eightieth Year Retrospective"—she doesn't turn eighty until July 13—last weekend at the Cowell Theater here.

Many of them, of us, were bearded and/or muumuu-wearing, turquoise-laden, white-haired veterans of the '60s, and hence turned the opening concert on June 2 into a kind of nostalgic reunion. What transformed the evening into something more than nostalgia was the unexpected power and charm of the dancing, much of it by Ms. Halprin herself. She proved that a life devoted to a kind of mystic religion of the body, to social healing and confrontations with the Big Questions of life and death, need hardly preclude communicable artistry. And it was her artistry, to which she has newly rededicated herself, that explains the extent of her influence.

After an Illinois upbringing and a stint of study and performance in New York, Ms. Halprin and her husband, Lawrence, a landscape architect, moved to San Francisco in 1944. They settled on a hillside in Marin County looking over to Mount Tamalpais, across the Golden Gate

Bridge from the city, and by the late '50s Ms. Halprin began to break openly with modern-dance orthodoxies.

Alternating between a San Francisco studio and a redwood deck attached to her home, she offered workshops, classes, performances, and communal events that attracted attention far beyond the Bay Area. Merce Cunningham and John Cage, Luciano Berio and Terry Riley and LaMonte Young, Robert Morris and Richard Brautigan and Michael McClure, Yvonne Rainer and Meredith Monk and Trisha Brown and, later, Eiko and Koma all passed through her doors and took away some of her sensuous physicality, restless imagination, and openness to ideas. The Judson Church movement and the whole course of experimental dance in New York over the last four decades would not have evolved as they did without her.

Her most active period of performance and renown in the greater dance world came in the 1960s, with national and international tours of performance pieces like *Parades and Changes* (1965) and *Ceremony of Us* (1969). They became notorious, at least in prudish America, for their nudity and overt sensuality, but their imagistic boldness is less clearly remembered.

Even before a desperate battle with cancer in 1972, Ms. Halprin was moving away from performance in the conventional sense. From the '70s to the mid-'90s, she concentrated on "healing," as she called it: communal dances of togetherness, dances for AIDS patients, dances to exorcise demons (in one case, a serial killer near her home, who was caught soon after).

But in the last five years, she has started dancing and choreographing again, and it was the bridge between past and present, between the '60s and the late '90s and into a new millennium, that made up her retrospective—along with a lobby display of historical photos and a more recent color series by Eeo Stubblefield of a nude Ms. Halprin caked with mud, strewn with leaves.

The program began with a half-hour excerpt from *Parades and Changes*, the most famous part of this originally evening-long work, which she had first revived at the American Dance Festival in North Carolina in 1997. Here it consisted of eleven young performers dressed in black slacks and white shirts who first ritualistically dress and undress and dress again in slow motion, in different configurations and poses. But the dance takes life when the dancers, now nude, begin rolling and stretching and twisting among strips of brown wrapping paper. The

rustling of the paper becomes an amplified roar (the score is by Morton Subotnick), and the dancers and the paper, sometimes torn and hurled into the air, are lighted from the sides in orange or blue; the orange makes the whole writhing array look like fire. It remains as striking a stage image as I have seen, at one with the best of the Living Theater, the Open Theater, and early Robert Wilson.

The rest was all recent. First was a solo piece with Ms. Halprin, short vignettes of narrated recollection and reflection titled *Memories from My Closet: Four Dance Stories*, offering evocations of her dance ambitions from age 5 to age 110: a Venetian courtesan, her grandfather from Odessa, and her gratitude for the richness of human life.

And finally came *Intensive Care: Reflections on Death and Dying*, for Ms. Halprin and three other dancers, all to a droning, shimmering score by Miguel Frasconi for electronics, glass harmonica, and wordless female voice. This was an artistic refraction of Ms. Halprin's quarter-century of work with healing. The dancers, shrouded as in a morgue, grimaced and screamed with fear and agony, then walked acceptingly toward the audience as the curtain fell.

Like all her work, and the work of many of the artists with whom she has collaborated, these dances could easily be dismissed as New Age California dippiness. "I'm accused of being touchy-feely," she once said. "Well, I am."

But what made these retrospective performances so moving was her ability, enriched by a lifetime of desire and human drama, to refocus her experience back into art. And the power of her choreography was conveyed by the remarkable agility and expressivity of her movements. Like so many older dancers, and like the Asian artists who have exerted such a spell over California, Ms. Halprin achieved many of her effects through the suppleness of her upper body. But she could be as spry as a goat, too, as in her evocation of joyous Odissi dancing.

At the end, it was cheers and flowers and emotion, which might have been expected had Ms. Halprin merely been gazing back self-indulgently on her past. But she turned out to be very much of the present, as well. So much so that her aspiration still to be dancing at 110 seemed hardly far-fetched at all.

THE NATIONAL ENDOWMENT FOR THE ARTS

The New York Times, July 23, 2000

Command Performance: An Actress in the Theater of Politics. By Jane Alexander. Illustrated. 335 pp. New York: PublicAffairs. $25.00.

Jane Alexander, the actress who was chairwoman of the National Endowment for the Arts from 1993 to 1997, has written a memoir of her term there, and an earnest, naive, and dispiriting document it is. Not dispiriting because Alexander failed to fight a good fight; by her own lights, the simple fact that the endowment was not eliminated under her watch, just further crippled, constitutes a triumph. The true cause for despair is her picture of the blind and deaf philistinism of American politicians.

Alexander, a warmhearted liberal from the 1960s, was tapped by the Clinton administration early on. The first working artist to assume the position, she was bright, personable, famous, and well-groomed enough (or so it was hoped) to disarm her opponents. Beaming with idealism, an amusingly self-styled "Jane of Art," she wooed her way to a triumphant Senate confirmation that nearly everyone, on all sides of the culture wars, applauded.

At first, while she had her troubles with Republican and conservative Democratic opponents, she seemed to be making headway. After the Republican sweep of Congress in 1994, her job became a war of attrition. She won in that the agency survived, but her hair turned white and she chose to leave at the expiration of her first four-year term.

The interest in *Command Performance* lies in its anecdotal descriptions of friends and foes: of Strom Thurmond and her hero, Teddy Kennedy, and Jesse Helms and Orrin Hatch and Nancy Kassebaum and a West Texas congressman named Charles Stenholm, leader of the twenty-five "blue dog" Democrats, described as moderate Westerners who were so inundated with hate mail from the Christian Right, and so reflexively antigay, that they could not see the endowment as anything but a nest of homosexuals.

For the salvation of her soul, or at least her conscience, Alexander gradually lets her anger break through her veil of well-mannered deference and tactical discretion. She admits to despising the crude, not to say

nakedly hostile, disdain for the arts in our nation's capital. The charming but elusive President Clinton essentially ignored the issue, concerned about keeping the endowment out of the news and delegating arts matters to his wife. Alexander rightly complains that Newt Gingrich would not make an appointment to meet with her, but neither would Clinton, for months on end. Yet the president never entirely deserted her, because for him the endowment was as potent a symbol as it was for the Right.

Alexander's principal animus is toward the generally debased level of discourse in Congress and the Gingrich Republicans, stubbornly intent on subverting the best interests of their constituents and their own beloved local arts institutions in favor of ideological purity and party loyalty. Tom DeLay's "brain could fit in an eggcup as far as I could tell." "I was extremely angry with Congress. I felt contempt for many of the members and despair over the level to which our federal government had sunk."

Peter Hoekstra, a Republican representative from Michigan who chaired a key subcommittee, practiced "harassment pure and simple," Alexander writes. "His tactics were scurrilous and his aide Derrick Max was rude and underhanded."

"It is hard to know what a politician believes anymore because he is so beholden to the special interests of those who elected him," she adds. "The system is so corrupt that it may not ever be fixed." No wonder she's happy to be back on stage.

The title, subtitle, and chapter headings of Alexander's memoir suggest that she never quite left. Other than a proper Massachusetts upbringing, what seems to have enabled her to maintain her ladylike equanimity was her ability to distance herself from her role, to see the chairmanship as another part in a play that unfortunately lacked the comforting grounding of a good script. But one could argue that such distancing limited her effectiveness as an infighter.

She could enjoy her own modest initiatives and small victories. She traveled to all fifty states and enjoyed what she saw there. She treasured her few friendships on Capitol Hill. She rested content in her simple belief that art is good and the more people it reaches, the better. She assayed some controversial reorganizations of the agency, which she does not explain very well. And she did manage to sustain the endowment's very existence in the teeth of conservative hostility and in the absence of much overt support from Clinton.

All of this is recounted in workaday prose flecked with odd errors: Mario Botta, not Robert Venturi, designed the San Francisco Museum of Modern Art; Americans abroad are not "ex-patriots"; and it was Gertrude Stein who famously said of Oakland, not Dorothy Parker of Los Angeles, that "there is no there there."

Politically, what is curious about the National Endowment for the Arts is how tiny its budget actually is compared with, say, a missile, yet how symbolically important it remains in a kind of backhanded tribute to the power of art. For the Right, it is a fund-raising tool; apart from grisly photos of dead fetuses, nothing apparently scores more money than a lurid newsletter portraying the agency as a tool to spread artistic, moral, and sexual subversion through the republic. And since the Right places such weight on this issue, the center Left has to defend it, at least nominally.

In the end, it is hard not to sympathize with Alexander's despair. One wonders what might have happened—in the arts as in so many other areas of policy—had the Clinton administration mounted a more vigorous, impassioned advocacy for its putative beliefs. To be sure, her own decision never to comment positively or negatively on any artwork contributed to this politic distancing. "I rose weakly to the challenge," she writes of her first encounter with Strom Thurmond. A cynic would say the same for her entire tenure, but then one must remember the dire circumstances.

The endowment, founded in 1965 with bipartisan support, seemingly cannot win now. The Right hates it as a subversive symbol. Multiculturalists undercut its support of high-art institutions. Neoconservatives suggest that since federal financing is so low anyway (a reduction they advocated in the first place), one might as well eliminate it. And centrists, however sympathetic they may be about the supposed moral uplift and economic advantages of culture, let the Right define the debate and do not believe enough in the arts themselves to make them a priority.

The only hope an arts lover might feel is a faith in the ultimate common sense of the American people in the long run—common sense, because even on pragmatic terms, the endowment is clearly a benefit to society, and most Americans know it. Even with its present meager budget, it is positively positioned in the tumult of the culture wars to make a comeback when political circumstances permit: still supportive of the big institutions and European traditions that define the high arts

but properly cognizant of the diversity and vitality of immigrant, folk, and regional arts as well.

An arts lover can cling to faith for the long run, because one can cling to the hope that the economic buoyancy that has revitalized our cities and our education budgets may eventually percolate down into sophisticated arts education and a general refinement of the national aesthetic sensibility, wherein the arts are valued as such, not just as symbols or stimuli for urban renewal. "Congress had no interest in the worthiness of the art itself," Alexander notes in passing, which might seem obvious and almost universal until one realizes what a sad comment it makes about our country. Only when the people and their politicians care about art will they start caring about its proper and legitimate support. And if eventually the endowment is reinvigorated and properly budgeted, at least Jane of Art can take some credit for helping it survive its darkest days.

A ROBERT WILSON INSTALLATION

The New York Times, October 5, 2000

Note: This article helped call attention to Wilson's installation. It was displayed for nearly two years at MassMoca in North Adams, Massachusetts, and talks continue about further sites for its display, perhaps permanently.

Oberammergau, Germany—The Passion Play here, depicting the last hours and resurrection of Jesus, has been delighting Christian believers and incurring increasing controversy over its anti-Semitism, however grudgingly modified in recent decades, for nearly four hundred years. But this year's installment, which began on May 21 and ends October 8, has a curious pendant, which in its own understated way makes a comment on that anti-Semitism that has passed largely if not entirely unnoticed in Germany.

The pendant is an installation by Robert Wilson, the American artist best known for his original plays and operas and for his highly stylized

direction and design for stage works by others, old and new. But Mr. Wilson started as a painter, and has kept up his work in the visual arts throughout his career. He has specialized (apart from his idiosyncratic chair designs) in installations, tableaus charged with implied theatricality. He won the Golden Lion sculpture award for one of those installations at the 1993 Venice Biennale.

Mr. Wilson's Oberammergau installation is called *Fourteen Stations* and is located directly behind the Passion Play Theater. Its subject is, of course, entirely suitable and was indeed commissioned by the organizers of the Passion Play. It depicts the fourteen Stations of the Cross, the stages through which Jesus passed on the way to his crucifixion.

The work is entered through a long, warehouselike building, from the center of which extends a walkway. On either side of the walkway are six gray cottages, and at the end is a final sculpture depicting the Resurrection. The entrance building has a dark floor and walls and a clinical-looking bright ceiling. Bright bulbs hang on wires in neat rows, and in the center is a metal cistern, at the bottom of which is a vortex of liquid that looks like blood.

The far end offers a Wilsonesque vision of the Resurrection: a cut-away teepeelike structure with a grass floor, a thatched interior, a blue bed, and, suspended above the bed, an upside down white mannequin.

The twelve cottages, six on either side of the Via Crucis, or axis, have small windows on the walkway side, through which only one person at a time can comfortably peer. As you stick your head inside each cottage, you become the sole observer of a tableau—a Ludwig II–like observer at your own private opera—with eerie sound effects adding to the effect of a frozen Wagnerian music drama.

Each tableau depicts an incident in Jesus' passage toward death: shouldering the cross, falling beneath it, Veronica wiping his face, six charitable women, being stripped of his garments.

The tableaus are in a style familiar to those who know Mr. Wilson's work. Each has a chilly mystical power, with disembodied hands, hanging boulders, white mannequins dressed and undressed, suspended furniture, beds. They are moving but also disturbing, nightmares for the faithful.

The most striking tableaus are the twelfth and thirteenth, the last before the Resurrection. The twelfth, entitled "Jesus Dies on the Cross," shows a pack of five raging red wolves, snarling, teeth glistening, ready to lunge. They are set against a painted rendering of craggy Alps, of the

sort in which Oberammergau itself is nestled, part of a recurrent motif of German romanticism that pervades the installation.

The thirteenth, "Jesus Is Taken Down from the Cross and Laid in Mary's Arms," has a blue ceiling and walls, with what looks like a heap of hundreds of glass medical-sample bottles piled up on the floor. Above them soar eleven stuffed birds, depicted with precise realism. In the background is a hanging fabric, rippling lightly, with what looks like a red-lipsticked fashion model from an issue of *Vogue* magazine from the 1950s, with literally bejeweled tears on her face and an enigmatic smile. The model turns out to be Madonna, the pop singer.

In discussing his ideas for the installation in interviews, Mr. Wilson has laid emphasis on the shape of a Christian cathedral and on Quaker imagery, which has long influenced his work. The cottages and much of the furniture look Quaker, and especially in the sixth and eighth stations, with threatening female mannequins dressed in Quaker costumes, the connection is marked. But that's not all there is to it.

Nearly everyone who visits *Fourteen Stations* is disturbed by it, and some, including one recent visitor, a Jewish woman from Beverly Hills who is a longtime Wilson admirer, say they are terrified, even though they may feel no particular involvement with the Passion story itself. There may be a covert reason for this disquietude.

Whether for a stage production or an installation, Mr. Wilson draws from piles of pictures and picture-books heaped on a worktable. While he was preparing his version of *Four Saints in Three Acts* at the Houston Grand Opera, the table had everything from Javanese and African jewelry to Quaker houses to Spanish Renaissance paintings.

From the form *Fourteen Stations* has taken, it appears Mr. Wilson drew his pictorial inspiration not just from representations of Christian cathedrals, Quaker villages, and craggy Alps, but also from photos of nearby Dachau, Auschwitz, and the ultimate Nazi killing machine, Birkenau, near Auschwitz.

There is a long transverse brick entry building at Birkenau, through which the train tracks ran directly toward the crematories (now replaced with an anti-Fascist memorial). The tracks (they're still there) ran up the central spine of the camp, flanked by low wooden bunkers that look rather like Mr. Wilson's Quaker cottages. The Resurrection teepee recalls death-camp crematories. The medical bottles in the thirteenth station look like the piles of eyeglasses at Auschwitz. Hitler's nickname was Wolf. The central walkway here is made of railroad ties.

When asked about this connection, Mr. Wilson allowed that people had suggested the parallel to him as the work took shape, and that he had conceded, "You could see it that way."

But Mr. Wilson has a history of discretion about owning up fully to controversial inspirations for his pieces; he would rather they be appreciated on their own terms, not clouded by controversy. His first-ever production commissioned and created in Europe was for the West Berlin Schaubühne in 1979 and was called *Death, Destruction and Detroit*. (There have since been two more in that series.)

The central image that inspired Mr. Wilson for that piece was a photo of Rudolf Hess raking leaves in a walled courtyard of Spandau Prison in Berlin. In other words, a reference back to the Nazis was the centerpiece of the entire production, yet Mr. Wilson never once 'fessed up to that image in interviews.

In this instance, perhaps he can be taken fully at his word that death-camp imagery played no role in his initial conception. Perhaps. But sometimes those who perceive an artwork find insights in it of which even the artist was unaware, or chose to mask.

Whether consciously or subconsciously intended, the connection with the Holocaust adds a powerful resonance to this already moving and important work. Mr. Wilson is apparently trying to find a permanent home for *Fourteen Stations*, most likely in the United States, once it is dismantled after October 8. If that happened, more people would have a chance to experience its beauty, and its disturbing undercurrents, for themselves.

LARS VON TRIER

The New York Times, April 8, 2001

Note: This article led to an expansion of it in Opera *magazine, to my book on* The Idiots *for the British Film Institute, and, said von Trier, however puckishly, to Wolfgang's Wagner's invitation for him to stage* Der Ring des Nibelungen *in Bayreuth, a project that most unfortunately collapsed for technical reasons.*

Lars von Trier, the subject of a retrospective continuing through this week at the BAM Rose Cinemas in Brooklyn, is surely the most controversial filmmaker on the planet. His movies—particularly the trilogy of *Breaking the Waves* (1996), *The Idiots* (1998), and *Dancer in the Dark* (2000)—routinely make critics' best- and worst-film lists. Film enthusiasts have reportedly come to blows over his work. *Dancer in the Dark* won the Golden Palm at Cannes. Yet A. O. Scott, in two thoughtful reviews in *The New York Times*, saw the "real struggle" of that film as between Björk's "artistic conviction" and Mr. von Trier's "aestheticized cynicism," and wrote that the final scene of *The Idiots*, which I found among the most moving artistic experiences I've encountered, "descends to truly contemptible emotional brutality."

Mr. von Trier, an avowed provocateur, is clearly on to something. Describing what that something might be, however, is not my goal here. No attempt to penetrate the balance of sincerity and diabolical artifice, spirituality and sadism, half-baked experimentation and crafted elegance, that make up the von Trier oeuvre. Ditto any effort to probe his complex biography and manifold phobias. Or to explore the dizzying blend of film styles and references that have made up his work over the last fifteen years. Or to brood about the smartness and silliness embedded in the cinematic "vow of chastity" he undertook with three fellow Danish filmmakers in the Dogma 95 manifesto. Or to speculate on what role a conversion to Catholicism and a new marriage might have played in the deepening humanism of his work in the last decade.

I wish, instead, to focus on what might seem an idiosyncratic angle. Recently Mr. von Trier said in an interview: "I have just decided that to film Wagner, that would be the ultimate goal of my life. The *Ring* cycle. I could die happy." What are we to make of this aspiration, from a man who has said that his interviews are lies and that he is a closet troll?

One might think Mr. von Trier is speaking of the music, and the charged aura of evil that hangs over Wagner since the Holocaust. This is a director who was brought up thinking his father was Jewish (he was, in all but the biological sense). Who used the Pilgrims' Chorus music from the *Tannhäuser* Overture to accompany the spread of pestilence in *Epidemic* (1988), and who contributed a particularly horrific vision of the Holocaust in *Europa* (1991; released as *Zentropa* in the United States).

Yet heretofore his use of music has seemed pretty patchy, and in recent films has been more pop than classical, as in Björk's songs in *Dancer in the Dark* and in the news that he is seeking a "major song-

writer" (*Variety*) for *Dogville*, to be shot later this year with Nicole Kidman. One presumes that if Ms. Kidman could take both Tom Cruise and Stanley Kubrick, she can take the sadistic manipulations of Lars von Trier.

Music aside, the fervent emotions of *Breaking the Waves*, not to say its kitschy melodrama (he's so described it), have been called operatic. But the deeper connection to Wagner is Mr. von Trier's ability, throughout this trilogy, to mine the emotion of film as a replacement for the emotion of music, and his uses and abuses of women.

Film, it has been argued, was the opera of the twentieth century—the fullest realization of the human desire to combine the arts into a whole that would surpass the sum of its parts. Wagner believed that his "total work of art" brought together the individual arts, which had been once united in Greek tragedy and then forced for thousands of years to suffer a half-life on their own.

Words, theater, and music were the key elements in the Wagnerian synthesis. Yet theater in the nineteenth century, broad-gestured and seen from afar, could not approach the naturalistic intensity of film. Wagner saw words as a masculine principle and music as feminine. Replace Wagner's music with the overwhelming intensity of feeling Mr. von Trier draws from actresses like Emily Watson, Bodil Jørgensen, and Björk, and you have a new kind of hyperemotional artistic experience. And that "feminine" emotion is focused (though not always with the surest of hands) by "masculine" Eurointellectual conceits and multilayered film techniques and references.

But Mr. von Trier also contributes the scenarios of the three films under discussion here. They involve pure, childlike women subjected to cruel suffering and, yes, "manipulated" into a raw emotion that some reasonable people find revolting.

The three films form what Mr. von Trier calls his "good woman" or "Golden Heart" trilogy. The second reference is to "a children's book called *Golden Heart* (a Danish fairy tale) which I have a very strong and fond memory of," he said in an interview at the time of *Breaking the Waves*. "It was a picture book about a little girl who went out into the woods with pieces of bread and other things in her pocket. But at the end of the book, after she's passed through the woods, she stands naked and without anything. And the last sentence of the book was, "'I'll be fine anyway,' said Golden Heart.' It expressed the role of the martyr in its most extreme form."

Fairy tales, the sort collected by the Brothers Grimm, formed the heart of German romanticism, and hence of Wagner: the *Edda* and the *Nibelungenlied* are adult folk tales. In *Faust*, Goethe's Margarethe expresses in archetypal form the ideal of the yearning woman who suffers yet redeems the hero.

Feminist critics of romantic opera, not just Wagner, have railed against this notion of the sacrificial woman. Wagner based all but one of his canonical ten operas on that ideal (*Die Meistersinger* being a comedy, Eva is a person, not an archetype). Otherwise, from Senta to Elisabeth to Elsa to Sieglinde and Brünnhilde to Isolde to Kundry, women suffering and saving are what Wagner is all about.

The issue for Mr. von Trier's critics is not that his films center on women; he did that in his *Medea* (1987), too, and owes much in that regard to Carl Theodor Dreyer, his great Danish predecessor. But with Mr. von Trier, the women serve a specific, hyperromantic role, and from film to film within the trilogy the notion of female redemption is considered and reconsidered.

Bess in *Breaking the Waves* is the closest to Elisabeth in *Tannhaüser*; her redemption is also explicitly, not to say blatantly, Christian, just like Elisabeth's. Karen, the central figure in *The Idiots*, is the strongest of the three women; the person she redeems is herself. And Selma, in *Dancer in the Dark*, suffers the most bleakly, her goodness unredeemed and unredeeming.

For me, *The Idiots*, far less known than the other two, is the least perfect yet most powerful of the trilogy. And fortunately, BAM will show it both Thursday and Friday, three screenings each day, in its uncensored version. (There are also videos, but of often dubious quality.) *The Idiots* has provoked the most anger, but for its emotional, not its physical, nakedness: the black boxes covering genitalia and a brief "penetration shot" are not really relevant to the film's impact.

The plot involves a group of attractive young folk who form a commune (not unlike those Mr. von Trier experienced with his parents as a boy, or the Dogma "brotherhood") to shock the bourgeoisie by finding their own "inner idiot." This means pretending to be mentally retarded in public, all of it arresting but nearly all of it tasteless, especially when real retarded people enter the picture.

The offensiveness may well be intentional, but like a lot of Mr. von Trier's movies, much of the film seems like a protracted setup for the ending. Without revealing the crucial plot turn, Karen, the quiet out-

sider of the group, finds her own "inner idiot" in heartbreaking fashion.

The scenes here between Ms. Jørgensen as Karen and Anne Louise Hassing as her friend Susanne are what occasioned Mr. Scott's charge of "contemptible emotional brutality." They are terrifying and terribly moving, laid all the more bare by the extreme close-ups and, true to Dogma principles, the absence of music.

The means by which Mr. von Trier induced this emotion could be questioned (see *The Humiliated*, a documentary about the film's making), though they were arguably no more extreme than those practiced by any good psychoanalyst or charismatic director. Wagner was accused of manipulating his audience through the power of his music. Mr. von Trier, in his madly idealistic effort to break through the barriers of acting to the primal humanity beneath, gives us a latter-day Wagnerian transcendence, using not music but the barely mediated human emotion of film.

GERARD MORTIER'S SALZBURG FAREWELL
The New York Times, August 29, 2001

Salzburg—After ten tumultuous, transformative years as artistic director of the Salzburg Festival, Gerard Mortier has delivered his last two new opera productions, which will be playing in repertory until his last festival ends on August 31.

Scandal was anticipated, and arrived on schedule, albeit not quite in the doses one might have variously feared or hoped. Both of the chosen operas were by a Strauss. First came *Die Fledermaus*, that most beloved of Viennese operettas, by Johann Strauss Jr. The trouble here is that Mr. Mortier, who has never shown much interest in frothy pleasure, has made it increasingly, abrasively clear that he hates Vienna and every aspect of the Austrian national self-image epitomized by this operetta.

The next night—the premieres were on August 17 and 18—was *Ariadne auf Naxos* by Richard Strauss. This Strauss and his librettist, the Austrian poet and playwright Hugo von Hofmannsthal, were instrumen-

tal in founding the festival eighty years ago. Mr. Mortier dislikes Richard Strauss's music and Hofmannsthal's dramaturgy—in the introduction to a new book of festival statistics he calls the beloved Feldmarschallin in their *Rosenkavalier* "the most repulsive female character in opera literature"—and has regularly attacked the composer's heirs, whom he considers money-grubbers. He has few kind words for Hofmannsthal's festival ethos, either.

Both productions were predictably deconstructionist, in the postmodern style of contemporary German *Regietheater* (directors' theater) favored by Mr. Mortier. Both elicited a healthy share of angry booing, that at *Die Fledermaus* at times almost scary in its ugliness. Both received negative reviews, *Die Fledermaus* almost universally so: the august *Frankfurter Allgemeine Zeitung* wrote that the operetta has been "massacred"; the Associated Press said the staging was "torn to pieces by reviewers"; the *Financial Times*, speaking of the tension between Mr. Mortier and the Austrian public, wrote of "a boil that had been festering too long" that burst with "fetid nastiness." Some farewell, and Mr. Mortier is rumored to be planning a double final provocation on August 31, appearing onstage in both productions, *Ariadne* in the afternoon and *Die Fledermaus* at night, the latter possibly in drag.

There was only one problem with this image of *Götterdämmerung*-like self-destruction: Hans Neuenfels's *Fledermaus*, while in poor taste and undoubtedly a failure, was at least in part seriously intended, while Jossi Wieler's *Ariadne* was a brilliantly insightful, gorgeously sung and played rethinking of a masterpiece, and greeted as such by the majority of the German-language press. ("A worthy conclusion to the Mortier era," wrote the same Frankfurt paper.) Together, they taught that a simple dismissal of all modern productions too easily absolves the opera lover of the obligation to make distinctions among them.

In the eighteenth and nineteenth centuries, stage directors were rarely even mentioned on opera cast lists. Their job was to tell Herr X to stand there and Frau Y to stand over there. In the course of the twentieth century, in seemingly direct relation to the decline of popularity of contemporary operas, the stage director (and his cohorts, the set designer and the dramaturge) rose in the operatic firmament. Postmodernist stage directors seek to reinterpret operas in the act of performance, allowing the opera sophisticate to witness in real time not only a dialogue between musical composition and its realization, but also one between dramatic intentions and their critical reinterpretation.

Mr. Neuenfels (no doubt egged on by Mr. Mortier) sees the Vienna that gave birth to *Die Fledermaus* as modernists see it in the wake of all that came after. Not for him a joyous, sexually titillating romp with a dark undercurrent. Here the darkness is right out front, a seething nest of hypocrisy, cruelty, sexual perversion, and incipient Nazism.

In his production Eisenstein and Rosalinde have children who commit suicide, Dr. Blind is assaulted by Nazi thugs, and Prince Orlofsky, that amusingly bored and decadent Russian aristocrat, becomes—as personified by an amplified American performance artist and vocal gymnast named David Moss, dressed in full *Beetlejuice* regalia—a cocaine-snorting study in antic dementia. Mr. Moss, who was just doing what he was told, however hideously, was the recipient of the ugliest boos of the night. Crowds of choristers and dancers struggle to fill the gigantic Felsenreitschule stage (there is also a crashed carriage, a dead horse, and much more clutter), miming sexual acts in *Cabaret* attire. Frosch, the besotted comic jailer of act 3, is here a woman who wanders about throughout, offering helpful interpolations, like modernist Austrian poems and the information that Arnold Schoenberg, "a very popular Austrian composer," made a chamber arrangement of Strauss's *Emperor Waltzes*, which is then played in a recording. And on and on.

As a study in grotesquerie, and a true expression of loathing of Viennese self-delusion then and now, the production had a certain integrity. But it was terribly rude and more than a little bratty. During the premiere, Mr. Mortier reportedly kept anticipating that the performance would have to be cut short; it was hard to tell if he was fearing or hoping. In the event, the booers almost seemed to have exhausted themselves by the intermission, or many of them left, because by the end, the reception seemed almost like a typical Salzburg Mortier-era premiere, with the mostly appealing singers and the vivacious conductor, Marc Minkowski, cheered and the directorial team lustily booed.

After the *Ariadne* Mr. Wieler and his team got a wave of boos, too, but also lots of deserved cheers. Mr. Wieler shares directing and dramaturgical credit with Sergio Morabito, but the former does the directing and the latter, the dramaturgy. Yet the shared credit makes sense, since clearly the thought behind their conceptions is equally important to the wonderfully intense, exact acting Mr. Wieler elicits.

The production was set in one of the designer Anna Viebrock's typical fluorescent-lighted waiting rooms. (She had done a similar set for Christoph Marthaler's *Nozze di Figaro* earlier in the festival, a produc-

tion seen by the press mostly as a collection of gags, but which to others seemed a wonderful blend of visceral humor, dangerous anger, and overt sexuality, all of which are right there in the score.)

The characters were attired in costumes of the interwar period. The central complicity is between the Prima Donna/Ariadne and the soubrette Zerbinetta. Supposed opposites, they here share a history of abuse by men. (Harlequin is a pimp, pedaling Zerbinetta to Scaramuccio and the rest.)

Yet all of this seeming outrage was accomplished with enormous sensitivity to Hofmannsthal and Strauss's intentions. This was not a perversion; it was a true reinterpretation, accomplished with always evident intelligence and theatrical flair. And what Mr. Wieler elicited from his cast of busy international opera singers was what festivals in general, and this festival in particular, are supposed to be all about.

And oh yes, by the way, those busy singers delivered a radiant account of the score. There were superb performers—for instance, Alice Coote and Franz-Josef Selig—in lesser roles. But principally there were Susan Graham as the yearningly heartfelt young Composer; Deborah Polaski as the agonized, stentorian Ariadne; Jon Villars as the trumpeting Bacchus; Russell Braun as a bullying Harlequin; and above all Natalie Dessay, who suffered much groping and got her panties pulled off in mid-song and still delivered as breathtaking an account of Zerbinetta's showpiece aria as one could dream of. In the pit, Christoph von Dohnányi and the Vienna Philharmonic caressed the music; whatever tensions may have festered between Mr. Mortier and both conductor and orchestra over the last decade were nowhere in evidence. They all did Vienna proud.

9/11

The New York Times, **September 23, 2001**

Note: I was the editor of Arts and Leisure. Another writer was unable to produce our cover story. We had a layout and an extraordinary photograph of billowing, angry clouds. So I wrote this on deadline.

The clouds came boiling up the street and obliterated every thing and every body. Inside, said those who were there, the world looked dark, murky, ghostly. People were disoriented; they lost their bearings.

We have all lost our bearings. Artists, especially, whom we presume to be particularly sensitive to our dilemmas and our dreams, are peering apprehensively into the abyss of the future. What do they, and we who love the arts and believe they are important, see there? What is the role of the arts in the present crisis, and how will the arts change in response to the new circumstances in which we live?

To judge from the nine creative artists we have asked in this issue to share their thoughts on the future of their different fields, a common feeling is one of helplessness, in that what we love and what they do seems so marginal to the crisis. To create or perform or enjoy cheerful Broadway shows and peppy contemporary novels and lines drawn on paper and movies big or small and even the soul-stirring depths of music seems irrelevant, even offensive.

Normal life, we're told, must go on, so soon enough the Broadway shows were up and running, Lincoln Center and New York's museums had opened for business, book and record stores and movie complexes were teeming with customers. Grief and bellicosity were muted by the lights and chatter of artistic business as usual, and perhaps rightly so.

But we have changed; we all feel it. Not only has the United States been attacked, horribly so, leaving us wounded and vulnerable. Our relation to the world has changed, too. Maybe those changes will ultimately be positive. Maybe not; what persists is the murky uncertainty.

To understand how the arts might evolve, and what role they might play in our national crisis, we can look to the past. Our wired world makes everything quicker and more accessible, and technological prophets like to predict that the latest innovations have, once again, transformed the rules of the game we live. Yet in most respects, human behavior seems remarkably constant throughout recorded history.

Public art—what's shown in museums, performed in theaters and concert halls, seen on screens—seems to range from trivial distractions to propagandistic fervor to romantic humanism. It's only underneath the surface, far from public censure like the Dadaists in Zurich in World War I, that our dissidents operate, questioning and doubting. Sometimes their doubts become the canon of tomorrow. But the diversions, the ones that strike some as frivolous, are as necessary as the private broodings and the public exhortations.

In reading the responses here and in talking with artists in recent days, one theme seems to be an almost dogged sense of duty, of stubborn process. Artists will keep doing what they do because that is what they know how to do and it gives them a kind of animal comfort to do it. And yet, things have changed: short-term cancellations and long-term apprehensions prove it.

Rightly, artists don't want to feel that they react like stimulated rats to the slightest shift in our circumstances. But we all change, deeper down. How we change, and what we do then, is what individuates us.

One disturbing tendency in the recent commentary is an insistence on conformity with the perceived national mood. That's what tyrants and fanatics do; that's what our enemies do. But it's also what some of us do, from the Reverend Jerry Falwell most egregiously to neoconservative pundits to well-meaning liberals, when we seize on the present crisis to admonish what we despise. Whether it's nonstandard social behavior or secular spiritual beliefs or academic styles of discourse or the racket of corporate pop culture, none of these caused the events of September 11, or are invalidated by them.

Some may indeed prove inappropriate for our new age; so may some self-righteous censoriousness. Several of the artists writing here do suggest that the new climate may temper our popular culture's obsession with violence. But one should never forget two things: our culture owes its strength to its mongrel diversity, and art counts.

Whatever changes may come in our artistic climate—how we make art, how we consume it, which decisions are made about what to present—will not come at once. The arts have historically both lagged behind and anticipated the present.

They have lagged behind in that after a surprise assault like the one on September 11, artists—especially those who require a more elaborate apparatus, like film directors—need time to find their bearings and gear up into commentary on the tragedy. They risk irrelevance if they do so too immediately or overtly. In World War II, those at home knew of war from newsreels and Hollywood; for us, reality threatened to trump artistic representation, and that was truer the closer we were to Ground Zero.

But the arts have also seemed to anticipate—witness the disquiet in European arts in the generation before World War I. One can always retrospectively interpret artistic unease as a harbinger of coming disaster, yet at times in the past the signs have seemed inescapable. Perhaps they are inescapable right now, and we just don't know them yet.

What will happen to our arts now will depend largely, of course, on what happens to our country. If we become a militarized state, obsessed—rightly or wrongly—with security and combat, only the most mindless escapism may seem a permissible alternative to patriotic fervor. This country has a history of linking the arts with moral uplift, and the pressure to do so now may prove debilitating.

Yet in a time of trouble, most of us still have faith. My own faith, as one who has been shaped by my love for the arts, is that we as a cultured nation will find a way to draw on and extend our artistic diversity. Not all art needs to be devoted directly to the glories of democracy or the deviltry of our enemies, or good versus evil. Some art can be lighthearted or dark or complex or even subversive.

Diversity is important. So is art itself. In any crisis there is a risk that the arts will be scorned or dismissed as an irrelevant distraction. Now that the real news, of terror and death and war, has arrived, attention to art with a different agenda might seem out of place.

But art has its own importance; it stakes its own claim. We are told that in times of crisis, we need to rely on faith. Art can be a faith, too, from which some of us draw the deepest solace. A terrible consequence of this new climate of fear and revenge would be for our enemies, blind and intolerant, to turn us into them. We must retain our values, and those values very much embrace the sometimes messy creativity of the arts.

Art is life itself. If we can sustain our arts in a diversity as rich as our social and political and religious diversity, then our artists can indeed play a most valuable role. They can sustain and inspire us, but they can also lead us—directly or, more likely, indirectly—from darkness to light.

DORIS LESSING

The New York Times, February 10, 2002

Note: I love Doris Lessings's writing, especially the "space fiction" books that others disparage. Although I'd never met her, I arranged through Robert Gottlieb, then her American publisher and the editor and pub-

lisher of my first book, All American Music, *for her to meet Philip Glass. Two operas resulted, unfortunately not the greatest from a compositional standpoint. When I got the chance to write about this novel, I turned my review into my homage to her.*

The Sweetest Dream. By Doris Lessing. 479 pp. New York: HarperCollins Publishers. $26.95.

What dream, and why the sweetest? The answer is, narrowly, Communism, and, broadly, 1960s London, with its self-image of pioneering personal liberation, and with Westerners' guilty desire to help others, to "do good." It's a dream because it's not real, and it's sweet because it reflects the best human instinct, to make things better, person by person.

At eighty-two, with one hopes not quite a lifetime of work behind her (there's her long-delayed Nobel Prize, for one thing), Doris Lessing has thoughts on all this. She also has an avid cult of readers who seek in her every work of fiction scraps of autobiographical insight. She is fully aware of this, and properly defensive about it. She has written two long and thoughtful volumes of actual autobiography, which ostensibly carry us to 1962, the year of *The Golden Notebook,* but with many insights that extend beyond that time. Now she has announced her disinclination to publish any more, "because of possible hurt to vulnerable people," as she puts it in an author's note to this novel. But, she hastens to add, this "does not mean I have novelized autobiography."

This might seem to protest overmuch, but also seems patently true. Characters and events in *The Sweetest Dream* are clearly drawn from her own life and experiences, especially the earth mother, Frances, and her big rambling house in the '60s full of stray youths, only a few her own. Frances is even a disillusioned former Communist. But all novelists draw from their experience, and so much of Doris Lessing's life is left out here—chiefly her fascination with R. D. Laing's experimental psychology and with Idries Shah and mystical Sufism, not to mention her status by this time as a world-famous novelist with friendships throughout artistic London and the world—that the first half of the book can hardly offer more than glancing autobiographical insight. The second half takes us off to "Zimlia," which means her childhood Rhodesia and is a morphing of Zimbabwe and Zambia (she called it "Zambesia" in the *Children of Violence* novels, which she was writing at the height of her own earth motherism). This section tells us something about Lessing's

current attitudes toward Africa and her embittered feelings about corrupt black politicians, but not so much about herself.

The inclination of readers to mine novels for autobiography is something Lessing has dealt with before, in the second volume of her autobiography, *Walking in the Shade*. "Extraordinary, this need for the autobiographical," she muses, adding: "Once, all our storytelling was imaginative, was myth and legend and parable and fable, for that is how we told stories to and about each other. But that capacity has atrophied under the pressure from the realistic novel."

But with this new book, according to the publisher, "Doris Lessing returns to realistic fiction." What the blurb may reflect is the lingering disappointment felt by some Lessing fans about her voyage into imaginative storytelling and about her "space fiction" in particular. Her *Children of Violence* series and above all *The Golden Notebook* made her a feminist icon, a role she has always resisted. For her early, not-so-loyal readers, the true Lessing is the Communist who lost her faith but still strove to do good, the strong woman who found her own destiny in a world of men. For them, her extended foray into science fiction was a betrayal, and they blame her questionable involvement with Eastern mysticism and, worse yet, an ostensibly Muslim form of Eastern mysticism.

For more recent admirers, myself among them, the *Canopus in Argos* series is where Lessing really took flight. It seemed that she had abruptly abandoned quasi-autobiographical realism for something thrilling or alienating, depending on your point of view. Allegorically depicting interplanetary civilizations and cosmic evolutionary events, these five novels, starting with the grandiose *Re: Colonised Planet 5, Shikasta*, seemed to those who loved them to have freed Lessing from the prosaic constraints of ordinary life. But these novels did not come as a complete shock to followers of her work; they were preceded by *Briefing for a Descent into Hell* (1971), still the best evocation of the terrors and ecstasies of drug-induced visions I know, and the haunting *Memoirs of a Survivor* (1974), in which the protagonist, realistically drawn, matter-of-factly passes through walls to the realms behind them, and followed by *Mara and Dann* (1999), another cosmic allegory set in a far distant ice age.

The fact is, Lessing's work has always swung between realism and imagination, as if the two could ever be separated. Dreams and madness can be found in the early realistic novels, and by *The Fifth Child* (1988),

about the birth of a monstrous anomaly, the lines have been totally, and fruitfully, blurred. Her "space fiction" is not alien; it is, as she says, full of "myth and legend and parable and fable," all as insightful into the human condition as any realism could be, full of apocalyptic images and barn-burning good stories besides. For admirers of this aspect of her writerly personality, even her stern lectures on the mismanagement of the environment or the failure of politicians read fresh.

So where does *The Sweetest Dream* fit into the canon? It is definitely "realistic"; the publisher did not lie, and trollers for autobiographical minutiae will no doubt seek out here juicy details about Lessing's own life. Which lover fits the withering profile of duplicity and deceit in Comrade Johnny, Frances's first husband and a lifelong revolutionary (until he discovers yoga)? Who is Sylvia, the angelic fanatic who tries to do good in Zimlia? Who is Franklin, the innocent boy turned corrupt Zimlian minister? Who is Rose Trimble, the implacably evil journalist? Who is Rupert, the lover with whom Frances finds contentment? Clues abound in *Walking in the Shade*.

But for more innocent readers of *The Sweetest Dream*, who cares? The book does not quite hold up to the very best of Lessing's realistic fiction, which doesn't mean it's not an engaging read or not shot through with wonderful descriptive phrases ("the two faces were like ashes spilled on the dark" can stand for many). By now, she's pretty bitter about a lot of things in her past, and characters abound who skewer every aspect of that past. Bad things happen, and Lessing dwells on them, skating over the good. We hear less about Frances's happy relationship in later life than about her day-to-day frustrations; Sylvia is driven out of Zimlia, and almost as an afterthought we read of a group of lower-mid-level do-gooders who are actually doing good.

The book is oddly organized and vague about chronology, with three women as protagonists. Frances and her teeming house are interestingly interwoven in the first half with the perspective of Julia, Frances's austere German mother-in-law, who has her own dream of a pre–World War I paradise near Stuttgart. But then Julia dies, and we follow Sylvia to Zimlia, where Frances is pretty much forgotten, except for a cameo toward the end. At the very end, there's Celia, Frances's granddaughter, a "faery child" who spins and sings about "poor little Johnny."

Celia's magical benediction suggests that *The Sweetest Dream* is a fable, with the impossibly good Sylvia, on the one hand, and the impossibly mean-spirited Rose, on the other, and with Frances as a kind of

bedrock, always present even when seemingly absent. In that sense, *The Sweetest Dream* is yet another amalgam of realism and imagination, like *Memoirs of a Survivor* or *Shikasta* or *Mara and Dann* or even *The Golden Notebook*.

Seekers after autobiographical "truth" will still be left wanting, to be sure. One wonders where Lessing stands now with her Sufism, especially after the death of Idries Shah in 1996. Has she grown embittered about searching for inner truth, too? No doubt volume 3 (and 4?) of her autobiography will be, or is being, written for posthumous publication. Someday someone will write a more serious and comprehensive study than Carole Klein managed two years ago in her *Doris Lessing: A Biography*. In the meantime we can glean some answers from Lessing's own work, including the autobiography that supposedly stops in 1962. In *Walking in the Shade*, published in 1997, she still refers to Sufism as "the main current in my life, deeper than any other, my real preoccupation." And then there's *Mara and Dann*, a fable, a story told by one of our most incantatory storytellers, about two children who traverse the continent of Ifrik toward the icy mountains of Yerrup. Imaginative, to be sure, but as full of realistic insight into how human beings work as any sweet dream.

MERCE CUNNINGHAM: A DELAYED SURRENDER

The New York Times, August 11, 2002

Note: The bookend to my first piece on Cunningham, back in 1968.

Merce Cunningham is feeling nostalgic (or at least his historians and fund-raisers are), so I might as well, too, about him. His company is celebrating its fifty years of existence with programs in this country and abroad, including two late last month at the Lincoln Center Festival. I have been watching that company dance for some thirty-five years. In the course of those years my reactions have changed, and are no doubt changing still. How much of that has been me, and my slow but growing appreciation of what it is that Merce (everyone calls him Merce)

does, and how much subtler changes in his own style, I'm not quite sure.

I first encountered the Cunningham company in the mid-1960s. At that time I was living in Berkeley, California, doing the things young people did there then. One of the things I did was dance with Ann (now Anna) Halprin and serve, for a couple of years, as a kind of ghostwriter for her.

Mrs. Halprin believed and believes in creativity welling up from within each presumably liberated dancer's soul. Back then, we called it freedom. Yes, she sets the parameters, although I think she's always been a little embarrassed 'fessing up to that controlling role. But in the '60s, from the Halprin perspective, Merce's dances and dancers looked impossibly rigid and repressed. I know I thought that, because I wrote it all down in a review for the *San Francisco Express-Times*, a hippie weekly, in 1968. Later on, when I had become friendly with the company and had presented it in 1996 as director of the Lincoln Center Festival, I gave a copy of that review to David Vaughan, Merce's unflappably English archivist. He professed to be amused.

What I saw in Merce then was a kind of modernist Rothbart, with his dancers as robotic swans. Grudgingly, I paid heed to how the "almost purely abstract" dance patterns might "sometimes . . . give hint of a winsomely emotional communicativeness." But mostly I saw his style as a deliberately quirky extension of ballet technique. In *Walkaround Time*, when the dancers seem to be casually standing about as if before class, all I could see, in "pained annoyance," was "a bunch of uptight New York dancers pretending to relax!"

Ah, the impetuousness of youth. Tastes change, and mine began to shift when I came to New York in 1972 and rekindled my long friendship with Dale Harris, a polymath critic, friend of David Vaughan, and passionate Cunningham admirer. What Dale loved was the ingenuity of Merce's choreography and the coherence of the whole in the patterns of the larger dances. Whether Dale dwelled secretly on poetic subtexts, I don't know. He certainly didn't care much for the music of John Cage or the *I Ching* or the chance intersections of silently conceived formal dancing and Cage's own controlled musical happenings. Like several of his friends, all Cunningham fans, Dale would go to Cunningham performances wearing earphones and listening to Ravel and thus avoiding all aural contact with Cage's squawks and squeaks, figuring he was being just as faithful to the Cage-Cunningham aesthetic of random dance-music conjunctions as were its founders.

What I began to like about Merce's dances was the abstraction, but I took him at his word when he said, in interviews, that the impetus behind them—and hence the preferred mode of contemplating them—was purely formal. One looked at a Cunningham dance like one looked at a Pollock painting, or maybe more appropriately a Rauschenberg painting or collage. I enjoyed doing this, and I loved some of his dancers (the ineffable Carolyn Brown above all, but everybody loved her).

But then things shifted again, and for me—not for others, who got there long before—the shift began when I saw *Ocean* in the Netherlands in 1994. A fishy dance, performed in the round with a blue-green ambience and 112 musicians surrounding the audience and making mournful tones (a Cageian concept realized by Andrew Culver), with electronic sounds by David Tudor that could sound like the putt-putt of an outboard motor, it seemed as abstract as ever but underlaid with irrefutable ichthyic and human subtexts.

I loved it so much that I presented it in Damrosch Park two years later. I had begun now to see Merce's work as implicitly (never explicitly) humanist, a kind of fleeting drama of ever-evolving, ever-newly intersecting characters and combinations. Not that all of the dances could be so interpreted; Merce has always engaged in more strictly formal or virtuosic experiments, like the new *Loose Time* that was on both Lincoln Center programs this summer. Or they still seem strictly formal to me; perhaps one day I'll perceive their humanist subtext, too.

The high point of the Lincoln Center program I saw this summer was the revival of *Fabrications* from 1987. Part of the pleasure was the wonderful restaging by Patricia Lent, simultaneously faithful and free. It made one hope that Merce can avoid the posthumous fates of both George Balanchine and Martha Graham and see his dances freshly preserved by dancers who know them in their bones.

Fabrications was created in just the controlling atmosphere that I so lamented in 1968. The dancers told an interviewer at the time that they had no clue as to what the overall shape of the piece would be as they worked on it, bit by bit, following Merce's meticulous instructions. Catherine Kerr, then a thirteen-year company veteran, said that sometimes the dancers felt insecure and uncomfortable. "If you say, 'this is about this,' immediately you limit it," she worried. "We all have our own little stories, and there's a place for them. . . . There are times when you want to rebel because you have no idea what the dance is. I try to get over that. . . . We should do any and every thing he wants."

So maybe I've abandoned the Halprinesque freedom of my youth. Maybe my feelings about *Fabrications*, seeing it with its 1940s dresses and quick couplings and departures as a kind of Altman film or Chekhov play, as a breathtaking emotional journey without predictable beginning or end but constantly alive in the present, are my own way of limiting Merce. Maybe this is all a middlebrow reading-in on my part, a projection of my own cowardly humanism onto a formalism that needs no such crutch.

But maybe not. In her 1987 *New York Times* review of *Fabrications*, Anna Kisselgoff wrote of Merce's "ability, when he desires, to create drama out of movement." For her, *Fabrications* had a "highly emotional resonance—surprisingly close to Antony Tudor's ballets about young love, or more precisely, love recalled through the haze of memory."

Whether Merce meant the Tudor connection, I know not. But surely the intimations of poetic drama were deliberate. You can maybe achieve pure abstraction with paint. Choreographers use that most humanistic of mediums, the human body. However pure the formal problems he sets out to solve, Merce has always intended the poetic subtext, or so I for one now believe. We'll see how I feel after another thirty-five years.

BEAUTY AND THE BOB

Don't Stop 'til You Can't Get Enough: Essays in Honor of Robert Christgau, 2002

Note: Part of a running conversation, carried on in print mostly on my side, between me and Bob Christgau about the place of beauty in the proper perception and judgment of the arts. See also my essays on Linda Ronstadt and "The Foggy, Foggy Dew."

This is one of those articles where I thought of the title and subject simultaneously, but found (so it's my sense of humor, not yours) the title so amusing that I was swept along with it. Of course I don't really think of Bob as a Beast and certainly don't think of myself as a Beauty. But as you will see, this article is not about me and Bob and our physical

charms, but about our differing ideas of the nature, function, and higher purpose (if any purpose can be said to be higher in the anti-elitist mindset that is Pazz and Jop criticism) of Art.

This sentence also proves that if you start to think about Bob, you start to write like Bob, insofar as convoluted sentence structure, density of ideas per square inch, and afterthoughts claiming equal turf with thoughts are concerned.

Bob, like nearly every intellectual of the mid-late twentieth century, is a Marxist, or some kind of Marxist, or at least accepts the importance of Marx, however modified, at the base of his thought structures. This means that he shares a faith (all right, a firmly grounded intellectual confidence; can't have faith) that the material world conditions the spiritual. Strike that: Bob is deeply suspicious of anything smacking of the spiritual, or maybe it's the Spiritual. He also, in a way I don't think he's quite worked out (but who of us has?), gives some credence to the notion that art (which for him means rock, mostly) carries with it some sort of meaning *an und für sich*, as we say in German—in and of itself. But whatever the complexities of the relationship between the material (the social, economic, political, psychosexual, etc. context) and the spiritual (the art itself, conforming to its own laws and claiming its own importance), for Bob the material is a notch or two more important than it is for me. It's not Manichaean, but it's clearly a staking out of different positions along the spectrum.

In other words, I'm not sure Bob would be capable of truly loving, giving himself over to, a rock song that seemed politically incorrect, i.e., morally wrong. For me, though I think of myself as politically aware and on the side of the Good Guys, wherever they may be, great music can exert its own gravitational pull, sucking me into its vortex even if it's politically or morally dubious. And by music, I mean music: Even the lyrics recede into the backdrop if the music is great. Interesting, compelling lyrics can add to a song's pleasure, but so can an impassioned vocal delivery, an appealing vocal quality, an attractive persona, clever hooks, or a cool arrangement.

At the root of this variance is my attraction to German idealism and Bob's deep suspicion of it. For Bob, German idealism is what Marx in the past and rock and roll closer to the present blew away: Self-deluding rationalizations of an outmoded political and intellectual order cleansed by the pure energy of materialist dialectics and blues-based, three-chord rock. For me, clinging to my doctorate in German cultural

history, idealist thought from, say, Kant to Hegel to yes, the early Marx himself (with Plato bubbling under, so to speak), is a Gothic cathedral of intellectual achievement, a (barely) postreligious edifice that inspired and explains some of the greatest works of art. For me, Bob's rejection of German idealism is curiously underscored by a subtle contagion of Puritanical moralism. American cultural history is shot through with judgments of art on moral grounds: whether it's supposed (just like Plato warned) to undermine the Republic or encourage licentious behavior among the young or betray our national superiority, art in general and rock in particular have scared our moralists. As a rock moralist, Bob *is* eager for rock to be subversive, as long as it's subversive of those things he wants to subvert.

Me, I trust more in the power of music itself. Even though bad people have made great music, great music is great, nonetheless. I have a faith (an idealistic faith) that the greatness of music will itself lead the way toward a better world—a more just, more moral society. But I don't insist on it explicitly conforming to any such agenda. This basic gulf between our world views has expressed itself most flamboyantly in our disagreements about music that was not only powerful (if morally suspect), but "beautiful." By beauty I mean aspiring to, or achieving, a condition of near-classical balance and perfection. Bob is ever on guard against the gentrification of rock, against any backsliding to the (for him) dreaded standards of classical music, and all the bourgeois baggage attached thereto.

This disagreement has reached a special intensity in our varying opinions of what we politically correct male critics like to call chick singers. For him, Bonnie Raitt (whom I too like, especially in the last fifteen years or so); for me, Linda Ronstadt, who I don't think was perfect on any level but whose music and voice and stylistic courage and charm moved me. For Bob, Ronstadt's beauty of voice and person was a flat-out liability (and, of course, that she was of half-German descent—a joke, given Bob's own cultural heritage). So I blew my rock-crit credibility in the late '70s for liking her music. But I did like it, and do.

But Ronstadt is just an example, however piquant. I just listened to the Giuseppe Sinopoli recording of the opera *Ariadne auf Naxos* with Anne Sophie von Otter (who recently released a duets album with Elvis Costello) singing the role of the Composer. The Composer is an idealistic young man who is appalled by philistinism and believes in a pure, noble art that will redeem the world. Yet Richard Strauss, the composer,

and Hugo von Hofmannsthal, the librettist, saw him as both noble and silly, so extreme in his naiveté that he misses the point, which is that idealism and reality (maybe also known as materialism) can coexist, must coexist, for the world to be made whole.

Ariadne is an opera, born out of the context of Austria and southern Catholic Germany just before and during World War I; if Bob knows of it, he must dismiss it not as worthless but as irrelevant. Yet his world and that world are not so far apart. And the passion and humorous subtlety and ecstasy of the Composer's music is as intense and convincing (to me, at least, who can accept the aesthetic of the operatic voice as something beyond silly and class bound) as rock and roll. Which doesn't invalidate rock, or mean that I don't genuinely, passionately love it, but which places it in a continuum of music and thought and idealistic passion broader than, I would contend, Bob's parameters. Everyone has limits, and I suppose everyone has an ideology to justify those limits, to oneself and others. It's just that Bob has a particularly complex, passionately articulated ideology.

So there. What's nice about disagreements between people who like and respect each other is that they become not sources of estrangement but kindling for crackling conversation. Our conversations have fueled our friendship—dialectically, ya might say. We agree about a lot—politics, sports, family, and a lot of music. But our opinions about the nature of art, about the continuing validity of classical music, about the role of beauty in art (and life), have become over the years a source of genuine intellectual interest and lively discussion. And that richness of discussion is framed, supported—spiritually infused, perhaps, though Bob wouldn't quite put it that way—by genuine affection. Thank God manly men don't say love.

LAND ARTISTS

The New York Times, November 3, 2002

For all the legendary machismo of the abstract expressionists, the true Promethean demigods, shaping the earth and entire cities with their

craggy hands, are the land artists. But in the myth, things don't turn out well for Prometheus, who, for giving fire to mankind, was bound to a rock and had his liver nibbled by an eagle. So the hubris of the land artists becomes a cause for mild concern.

Lots of people have assayed land art. But the landmarks, if one may use that term, are Robert Smithson's *Spiral Jetty*, which juts into the Great Salt Lake in Utah and has just reemerged from years under water; Walter De Maria's *Lightning Field* in New Mexico; Donald Judd's transformation of the small city of Marfa, Texas, into his own personal art shrine; and Michael Heizer's monumental *City* in Nevada, which hardly any outsider but Michael Kimmelman, chief art critic for *The New York Times*, has laid eyes on. Mr. Kimmelman said the first part of this six-part urban sprawl "has got to be one of the most massive modern sculptures ever built."

But maybe the most legendary of all these works of land art is James Turrell's *Roden Crater* near Flagstaff, Arizona. Its long-delayed first phase is now nearly completed but is still closed to the public.

Land art, sometimes known as earth or site art, is a quintessential product of the 1960s. Some artists of that era, repelled by the commercialism of galleries and collectors, fled to the wilderness of the West, where they dreamed of artworks that no one could collect, let alone hang in their living rooms.

I visited *Roden Crater* in 1998 (with Mr. Kimmelman; our trip also included *Lightning Field*). Dating as a concept to 1974, Mr. Turrell's crater project was still unrealized. Last summer I went back and saw what had been wrought. It's just as spectacular as Mr. Turrell always said it would be and as those of us sympathetic to the Promethean chutzpah of land artists had hoped. But the entire process of its construction, and similar concerns about Judd and Mr. De Maria and Mr. Heizer, keep nibbling away at my mind, not my liver.

Mr. Turrell's idea was to cut a tunnel from the center of a dormant volcano's crater, angling down to a point on its side, which, every few years, would line up with the sun and moon, like Stonehenge. There are also his "sky spaces," rooms for meditation with ovals in the ceiling that bathe the space in shifting light throughout the day. Later phases include another tunnel, an outdoor theater, and the completion of guest lodges at three of the cardinal points of the compass (one is already finished).

Some people view this as environmental despoliation, which seems

misplaced given Mr. Turrell's scrupulous care for his volcano (similar nearby mountains are routinely quarried into oblivion) and the surrounding land.

But the elements of obsessiveness, elitism, and what might be called territorial greed remain. They involve issues like the tiny number of people who will be able to see the solar and lunar events when they occur. Then there is the money issue. The more grandiose the land art vision, the more desperate the need for money. Mr. Turrell must constantly struggle for funds, yet he insists on using a particular kind of highly polished marble (needless to say, about the most expensive kind) to reflect the sun and moon and a specially constructed metal ladder that had to be helicoptered in through the sky space just beneath the center of the volcano's crater.

In addition, Mr. Turrell is determined to preserve the isolated, noncommercial aspect of his life's dream and hopes that it and its surroundings will one day become a public park. To that end he is trying to buy as many parcels of land as he can within sight of his private mountain and frets about those he's blocked from buying. As he fights for money, what goes to the *Roden Crater* itself (and at what cost for which details?) and what gets diverted into land acquisition?

It all recalls Judd, who died in 1994. His installations in Texas, of his own work and others', are truly wonderful, rightly called the Lourdes of minimalism, especially his one hundred milled-aluminum boxes and Dan Flavin's fluorescent installation *Untitled (Marfa Project)* (the Flavin was installed after my visit). But Judd's need to buy as many buildings in downtown Marfa as he could—and to personalize them with the precise placement of single, ordinary tables or chairs—strikes some as arrogantly compulsive. These artists may have escaped commercialism, in making works that can't sell, but they hardly escaped egotism.

The history of art—all the arts—is littered with oddballs and villains who created timeless masterpieces. Sometimes circumstances conspire to encourage a continued concern for their human flaws, as with the apparently undying interest in Richard Wagner's anti-Semitism. But usually the dross burns off and the masterwork remains, shining and pure.

Mr. Turrell is no villain, and it's way too early to tell if he has made a masterpiece, but the signs are promising. Judd's premature death prevented any sort of fulfillment of Marfa as a transformed art town,

although, for me, what he accomplished justifies the egomania. With Mr. Heizer's Xanadu, who can say? But the photographs look amazing. *Lightning Field* and *Spiral Jetty* seem modest by comparison, and effectively so.

But how amazing are any of these works of man compared with the godly wonders all around them? It was Zeus who became offended at the presumption of Prometheus and bound him to the rock. In a comparable sense, visitors to these lonely outposts in the vastness of the American Southwest are forced to compare them with the canyons and rocks and whistling emptiness of the natural world. Still, even in comparison—and when one is reminded that they are the work of something as small and proud as man—most of these examples of human artistic aspiration are extraordinary. One just worries that their creators will get caught up in their own divine delusions and overreach.

SOLARIS

The New York Times, November 24, 2002

Can a mystery about the impossibility of alien contact become a great human love story? Steven Soderbergh thinks so.

On Wednesday *Solaris*, a major new film by the director of hits like *Erin Brockovich* and *Traffic*, will open nationwide. Mr. Soderbergh not only directed it but also wrote it (and, without credit, oversaw the cinematography and the editing). So this film represents a considerable artistic investment for him—not to speak of the financial investment by Fox International and James Cameron's Lightstorm Entertainment. They put up $47 million, which doesn't include the marketing costs.

Solaris is being positioned as a love story. "The theme of *Solaris* is having a second chance at love," said one of its producers. Said another, "This film has at its core one of the most spectacular romances you can imagine." From a television commercial for the movie, you would hardly know that the action is set on a space station.

Mr. Soderbergh's approach certainly works on its own terms. Still, the source material—the Polish science fiction writer Stanislaw Lem's

novel of 1961 and the Russian director Andrei Tarkovsky's film of 1972, both also called *Solaris*—makes for a fascinating subtext to Mr. Soderbergh's film. All three versions share basic plot points. But the endings are very different and the ultimate, elusive meanings of the tale are even more divergent.

A cautionary note: two often annoying things that critics do is castigate a film by comparing it to its source (often a novel) and give away important plot twists and the ending. I propose here both to compare and to give away, so anyone who might want to see the film fresh should consider themselves fairly warned.

Mr. Lem was born in 1921 and still lives and writes in Krakow, Poland; Tarkovsky died in 1986. *Solaris*, in all three accounts, is the story of a psychologist-astronaut named Kris Kelvin who travels to the space station orbiting the ocean-planet Solaris because ominous things seem to be going on there. He arrives to find that the crew leader has committed suicide and that the two surviving members are acting mighty strange.

It turns out that each crew member has a "visitor" who somehow embodies a key wish, dream, or fear. Kelvin gets his own visitor soon enough, in the form of his dead wife, Rheya. On Earth, Rheya had fallen into depression and killed herself. Realizing that she is not quite real, the "visitor" Rheya grows desperate and confused in a way that mirrors her prototype's behavior on earth. Eventually she does away with herself.

In the novel, the now lonely Kelvin takes a scout ship from the station, lands on an island, sits by the shore, and watches bemusedly as an extension of an ocean wave curls tentatively around his hand, hovering but not touching, and then recedes. The last line of the book is: "I knew nothing, and I persisted in the faith that the time of cruel miracles was not past." Mr. Lem reportedly took a year to figure out how his last chapter should go.

Tarkovsky opens his film with scenes on Earth, as Kelvin mopes about his father's dacha. At the end, after some delirious hallucinations by Kelvin, the film returns there, rain pouring down. He kneels before his father, and the camera pulls back—rather like the shot with the mid-ocean oil rig and the heavenly bells at the end of Lars von Trier's *Breaking the Waves*—to reveal the house on an island in the middle of an endless ocean, a creation of the alien planet.

Mr. Soderbergh keeps Tarkovsky's rainy imagery on Earth, but focuses there on Kelvin and Rheya's relationship. In his ending, the only

surviving crew member other than Kelvin is determined to flee Solaris, but Kelvin chooses at the last moment to hold back. The station tilts and sinks into the Solaris sea. Then Kelvin seems to be back on Earth, but we soon realize he now has the same self-regenerative powers as all the other "visitors." Rheya reappears, strong and knowing, and they embark on the perfect love forever that they could never enjoy on earth.

Do these differences matter? Is one version "better" than another? In separate telephone conversations, Mr. Cameron and Mr. Soderbergh were eager to portray Mr. Lem's novel as a kind of Rorschach blot, open to a hundred equally valid interpretations.

Mr. Soderbergh, who said he came to the material as a teenager through the Tarkovsky film and then went on to read the novel, always saw his film as a love story. His treatment of Mr. Lem's intricate, satiric bibliography of a century of futile Solarian scholarship is to ignore it altogether, as did Tarkovsky.

Both the novel and the original film, drenched with Eastern European intellectualism, filter the story through literature and mythology: Orpheus in search of his Eurydice, Martin Luther (the devil and the ink pot), Goethe (Faust), Cervantes (Don Quixote), Swift (Gulliver), Tolstoy, surrealism, Kafka, Bach, and Breughel are all evoked. A self-described all-American "optimistic atheist," Mr. Soderbergh has an entirely different sensibility.

Novelistic description translated into film imagery became another issue. For Mr. Lem, the Solaris ocean throws up awesomely ornate shapes and structures that rise and recede from its surface like solar flares. Page after page is devoted to fantastical descriptions of these forms, biblically apocalyptic in tone.

"In the sky, blinding flames and showers of green sparks clashed with the dull purple glow," reads one such description. "Even the ocean participated in the battle between the two stars, here glittering with mercurial flashes, there with crimson reflections. The blue sun had barely set when, at the meeting of ocean and sky, indistinct and drowned in blood-red mist, a symmetriad blossomed like a gigantic crystal flower." A symmetriad is a category of wave forms on Solaris. "After fifteen minutes the colossal ruby throbbing with dying gleams was once again hidden beneath the horizon. Some minutes later, a thin column spouted thousands of yards upward into the atmosphere, its base obscured from view by the curvature of the planet. This fantastic tree, which went on growing and gushing blood and quicksilver, marked the end of the symmetriad."

Mosfilm studios, where Tarkovsky had to work, could not come close to visualizing any of that, especially after his budget was severely cut just as he began shooting. Mr. Soderbergh doesn't replicate the Lem descriptions, either, but he does come up with simpler, more abstract, and very beautiful planetary imagery of his own. For his part, Mr. Cameron seems intrigued by the possibility of modern technology creating pictures to match Mr. Lem's prose.

Best known for the original *Terminator*, with its awesome and ominous alien imagery, and, of course, *Titanic*, Mr. Cameron said he came to the Solaris story in college, first through Mr. Lem's novel, interestingly, followed by the Tarkovsky film, which he said he has cooled on. When he secured the remake rights to both novel and film and was contemplating writing a script and possibly directing it himself, he was going to go "back to the roots of the novel," he said.

"I liked the idea of the sentient ocean," he added. "My own take was very different from what Steven saw in it."

But Mr. Cameron's interest in the project languished, and when Mr. Soderbergh approached him in 1999, Mr. Cameron gave Mr. Soderbergh his head to develop the material as he wished. In his role as producer, Mr. Cameron was content to serve as Mr. Soderbergh's sounding board through endless conversations and many script revisions.

He added that he had no plans to make his own version of *Solaris*, but that's not quite the end of it. "You may yet see my ideas," he said cheerfully. "My version would probably have been much, much further afield. I had so many ideas that they may reappear through the cracks of other projects."

Tarkovsky's *Solaris* was called the Russian answer to Stanley Kubrick's *2001*. Mr. Soderbergh's may be a more plausible modern-day candidate. "I always thought of the planet as the equivalent of the monolith," he said. "I happen to think that *2001* is one of the most important pieces of art created by an American filmmaker. No one who has seen it and makes films can escape its influence."

Yet despite the convincing look of Mr. Soderbergh's space station and the beauty of his Solaris, Mr. Cameron said that the director "was not really interested in all that."

"For him, it's like a five-character play, and he's interested in exploring the psychological and spiritual issues," Mr. Cameron said.

For Mr. Soderbergh, those issues have to do with self-knowledge and love. "Both the book and the Tarkovsky film played into things that I've

also dealt with in all the films that I've made," he said. "Guilt, loss, connection, and lack of connection, the impossibility of knowing another person the way you know yourself. It's about issues of mortality and what it means to love somebody. After the movie comes out, I can say it's about accepting death."

Both the novel and the first film can be criticized for their inherently romantic view of the sacrificial woman: the wife dies to save the husband; her value, like a Wagner soprano, is to "redeem" the hero. Natascha McElhone makes a more powerful foil to George Clooney's Kelvin. She seems sacrificial at first, but her muscular arms (a serendipitous accident of casting, Mr. Soderbergh said) and knowing control at the end suggest a far more active force.

Tarkovsky had already begun shifting the emphasis from ideas to love and human relationships. Love exists in Lem, but his real concern is with man's doomed aspiration for alien contact. "We don't want to conquer the cosmos," a Lem character says. "We are only seeking Man. We have no need of other worlds. We need mirrors."

Mr. Soderbergh keeps one line about mirrors, and seems at first to accept the idea that Solaris defies human understanding. On videotape, the dead crew commander says, "If you keep thinking there's a solution, you'll die here." Kelvin does indeed "die" on Solaris, but before he does, Mr. Soderbergh has bowed to the need to make a human (more precisely, a humanoid projection of Kelvin's subconscious) his metaphor for the unknowable alien. "By choosing to become one with Solaris, Kelvin is surrendering to the idea of the unknown," Mr. Soderbergh argued. "It just happens to take the form of his dead wife. Love gives him the strength to surrender."

The issue of how to handle untouchable abstraction recalls the Judeo-Christian disputes over the place of religious images, graven or otherwise. Mr. Lem created Rheya, but then got rid of her and left Kelvin alone with the ocean. Tarkovsky got rid of her, too, but then reconnected Kelvin with a (projected) Earth. Mr. Soderbergh makes her the image of the unknowable.

But he seems to have few illusions that Mr. Lem, who fought with Tarkovsky on the set about tiny plot changes and the anthropomorphization of his ideas, and who all his life has polemicized against the corruptions of Hollywood, will have much use for his version. "He knows it's coming," Mr. Soderbergh said. "I hope he's in good health when he sees it."

SALOME

The New York Times, December 3, 2002

The Reading, as it is subtitled, of Oscar Wilde's play *Salome*, at the St. Ann's Warehouse under the Brooklyn Bridge in Brooklyn through December 22, is not to be reviewed, according to its producers' wishes. I would not be the person to review it in any case, because it's hard to see a play and hear operatic music. The one sort of gets in the way of the other.

Most librettos, of whatever literary worth, are intended specifically for music. But Wilde's play is another story, perhaps heard more often today as an opera, but the competition is close. Strauss's opera sets Wilde's play (in German, naturally) with complete fidelity, except for minor cuts for length. All the exotic virtues and ludicrous excesses and dramaturgical difficulties of the opera can be found in the source material, and for the audience member the parallels are even closer now that we're in the age of supertitles.

For those who came in late, Salome is the Judean princess whose stepfather Herod lusted after her. She, in turn, becomes erotically obsessed with John the Baptist. Herod promises her anything if she will do her striptease (the "Dance of the Seven Veils"). She dances, and then demands John's head. She comes to some sort of necrophiliac climax with the head, and is ordered killed by a horrified Herod.

Most of the exoticism and ludicrousness can be found in the purple prose of Salome and Herod: the former lusting with love or hatred over the saint's body, the latter piling on the adjectives to try to dissuade the princess from her demands for the saint's head. Al Pacino—who allowed himself one day's rest between the last performance of *The Resistible Rise of Arturo Ui* and the first performance of this *Salome*—clearly loves the part of Herod, and why not? His mannerisms suit the role perfectly, and he savors the part charmingly. He played Herod in a version of the play on Broadway a decade ago, and here he is again in *The Reading*, which may wind up on Broadway itself.

The Reading was developed at the Actors Studio and has been directed by Estelle Parsons with blocking and lighting and original music and all the trappings of a show. But it also has scripts from which the actors read, and no costumes or sets to speak of (although Ms. Parsons creates dramatic effects through the simplest of placements and means).

But for all the wit and eccentricity that Mr. Pacino quite properly brings to Herod, and for all the stentorian utterances of David Strathairn as Jokannan (as John is known here), and for all of Dianne Wiest's nice underplaying of Salome's mother, Herodius, none of them is that different from the characters as they appear in a good production of Strauss's opera.

The title role—that's another matter. It's really an impossible part, in the opera but especially in the play. To do it right, an actress would have to convey not just the bored petulance of a spoiled princess, but also her casually indifferent cruelty and her growing obsession with the saint. Besides all that, in the end there has to be a hint of helpless sexual capitulation, albeit to a severed head.

Marisa Tomei looks great and dances a sinuous dance and works very intelligently to project all these complex, contradictory facets of her character. In a staged production it's hard to imagine that a "perfect" Salome could be anything but pornographic, naked and bloody and orgasmic. Ms. Tomei was pretty effective in that regard, but to this taste she needs to work on her helpless vulnerability.

For me, though, she had another, even more impossible problem: I kept hearing Strauss's ecstatic climaxes in my ear, soaring over the orchestra and achieving by musical means the abandon and ecstasy that a mere actress of the spoken word must struggle so hard to match.

Of course most sopranos with the voice to ride those musical climaxes lack the figure even to hint at a plausible teenage princess. Those opera lovers for whom voice and music are everything can presumably suspend disbelief at the sight of a three-hundred-pound soprano snuggling up to a decapitated head. For the rest of us, it's hard.

So how do you perform this opera? Or play? The most effective sung *Salome* I've heard was by Maria Ewing, who had enough voice in her heyday and enough looks to do a pretty alluring dance, at the end of which she actually did get naked. That version, in Peter Hall's rather flat production, can be seen on video.

The most ingenious solution, albeit not very erotic, was Robert Wilson's at La Scala in Milan fifteen years ago. Mr. Wilson had a good cast, conducted by Kent Nagano, but his Salome, the Spanish soprano Montserrat Caballé, combined breathtaking vocal beauty (listen to her recording) with unseductive girth.

Mr. Wilson's solution, which didn't sit all that well with the singers, was to costume them in all-black dress of the sort high society might

have worn at the time of the opera's composition in 1905, and then pen them onto a platform extending over the orchestra pit on the audience's left.

Onstage, students from New York University, with whom Mr. Wilson had just completed a wonderful production of Heiner Müller's *Hamletmachine* in New York, acted out the drama. Mr. Wilson's conceits included splitting the characters among several actors and morphing the Salome tale with that of Alice in Wonderland. When the bored princess makes her entrance, wandering out onto the palace veranda, Mr. Wilson had her spinning, in an Alicelike dress designed by Gianni Versace. As embodied by the young and beautiful Jennifer Rohn, this image of Salome falling down the rabbit hole was a vision to remember lifelong.

One might think that the ultimate realization of Wilde's play might come on film, but it hasn't happened yet. Rita Hayworth's version from 1953 had its campy charms, but Ken Russell's *Salome's Last Dance* of 1988 was a typical mélange of brilliance, eccentricity, and silly excess, a *Salome* as it might have been staged by Herod himself.

So one day maybe we'll have an ideal *Salome*, although if we do, it will horrify both the Puritans and the politically correct. Maybe, if the St. Ann's *Salome* makes it to Broadway in a full dress (or undress) staging, it will be the one. But maybe Wilde's words (if not Strauss's music) will always live most vividly in the imagination.

SHANIA TWAIN

The New York Times, December 22, 2002

In the world of highbrow rock criticism, Shania Twain is right up there, or down there, with the least-respected pop puppets. Like many pop singers, she is scorned by those who prefer tougher, edgier, more aggressive urban rock or hip-hop or dance music. Like many pretty people, she awakens suspicion among those who aren't. Like many "chick singers," as Frank Sinatra used to call them (and as Linda Ronstadt still, with a wink, sometimes calls herself and her pals now), Ms. Twain is widely

regarded as manipulated by a Svengali. In her case, the presumed Svengali is her co-songwriter and producer (and husband), Robert John (Mutt) Lange, whom the tabloids invariably refer to as "reclusive."

Who knows what her personal contribution to her new two-CD album, *Up!*, was. (Curious, by the way, that the morose Peter Gabriel, about as down a guy as one could imagine, also has an excellently depressing new album out called *Up*, although it significantly lacks the exclamation point, not to speak of the smiley-button dots that adorn Ms. Twain's album. But, unlike hers, his hasn't topped the sales charts internationally for weeks on end.) What we do know is that conceptually, Ms. Twain's *Up!* is mighty interesting. And musically, it has an honorably bubbly tradition behind it.

What's interesting about the thing conceptually is that each CD has the same nineteen vocals, and that they've been released in three versions. A red CD is sort of power pop, a green CD is sort of country, and a blue CD is sort of Bollywood. Depending on where one lives in the world, the buyer gets two versions: in this country, the red and green CDs; in the rest of the world, the red and blue. But the third version is alluded to by a photo of Ms. Twain dressed up in the style of the missing music in question (so we in the United States get her in full bindi and multiple bracelets and a sort-of sari), and visitors to her Web site can download a couple of cuts from the version they haven't been able to buy.

Ms. Twain and the reclusive Mr. Lange are apparently aiming to make *Up!* the top-selling release ever by a female artist. And so the multiple-arrangement strategy has been presumed by some to be a ploy for more international sales and radio play. Which it no doubt is.

But as a longtime sucker for chick singers, I would like to suggest an alternative explanation. Maybe they did it for fun. Because the music on all three versions certainly is fun, and comparing the arrangements is fun too.

Ms. Twain is Canadian and came to the public's attention as a country singer. But all those sort ofs mean something, and in the case of her country stylings, they mean that she was never a true country artist—like, say, Dolly Parton, whose ventures in the direction of Las Vegas were always unsure and who has now blessedly returned to her roots and is making some of the best records of her career.

Ms. Twain has been a representative of the pop-oriented side of modern country music. She wore her country-ish gear and appealed to fans

who felt more comfortable in a country ambience but who had urbanized themselves (or at least suburbanized themselves) and who wanted cheerful, bright, upbeat, clever music, dobros be damned.

Mr. Lange, in turn, was an anthem-rock, arena-rock producer (AC/DC, Foreigner). To my taste the country (green) disc is least convincing, throwing the odd, fleet banjo or fiddle track into songs that are so tightly structured that there is no real room for country instrumental expansion. The blue, Bollywood disc is at least a complete rethinking, produced by separate Indian specialists, Simon and Diamond Duggal, and recorded in Bombay with an entire Indian orchestra; you can hear the tablas and shenais and unison violins burbling away in the background pretty much throughout. It's kooky and cute, a real party disc (if you can get ahold of it).

But it's the red CD that reflects what Ms. Twain and Mr. Lange are up to and where they're heading artistically. (And domestically, since they and their toddler son, Eja, now live in a forty-six-room chateau on Lake Geneva.) This is a bouncy pop record, with a strong whiff of the Europop that still appeals to that benighted continent. Just kidding. As one who harbored a once-unfashionable enthusiasm for Abba (whose music as used in the current Broadway musical *Mamma Mia!*—note the exclamation point—has still drawn sniffy dismissals in some quarters), I share a similar enthusiasm for this disc.

True, the song "C'est la Vie" is a shameless Abba rip-off, with a hook that sounds just like "Dancing Queen." But hey, pop is born not to run but to be recycled. Ms. Twain's green disc tells us a lot about contemporary country music, and her blue disc gives a strong hint of the endearing silliness of Bollywood musicals, although she is no more Indian than I am.

But it is her red disc that chirps and purls with the soul of the true Europopster she is. Ms. Twain and her husband may not have made a record that speaks to the deepest fears and concerns of today's youth. But they have made a record that a lot of people, all over the world, will buy, and they'll do so because they genuinely and honorably enjoy it.

MARTHA GRAHAM AND FANG-YI SHEU

The New York Times, February 16, 2003

At the first intermission of a recent program by the Martha Graham Dance Company, after a performance of *Phaedra*, I was asked what I thought. I must have looked pained. "Dated," said I.

And so it seemed, with those earnest, faintly silly mythological costumes, and dancers hopping stiffly about in emulation of Greek vases or friezes, and Christine Dakin playing the title role to the diva hilt, looking just as embarrassing, as she lusted for her stepson, as Graham herself used to look.

I was pained because I have loving memories of my first encounter with Graham, a performance of *Seraphic Dialogue* that I saw decades ago in San Francisco. It mesmerized me. I suspect it would mesmerize me again except that it is the one dance that Ronald Protas, Graham's heir, held onto in a recent legal settlement. That settlement pried Graham's dances away from Mr. Protas and awarded nearly all of them to the company or the public domain. Now it may be possible, at long last, to contemplate a renewal of both the company and the Graham legacy.

It might seem easy to see Graham's technique—with its contractions and releases and odd bodily twistings, and her dances, with their mythological themes and devouring, agonizing women in a world of strong, dopey men—as irredeemably time bound. And so some of the reviews of the company's two-week season at the Joyce Theater in Manhattan have suggested. The most extreme was Laura Shapiro's in *New York* magazine, which pretty much dismissed the viability of Graham today, and then compared her invidiously to Balanchine, that favored stick so many dance critics use to beat down any other choreographer, old or new. "I really think it's over," Ms. Shapiro wrote, with seeming satisfaction.

There can be no question that some of Graham's work—more the later Graham than the earlier—looks dated. But even something as creaky as *Phaedra* (1962) could be transformed by good dancing. And later in that same program at which I, too, had worried that it might be over, it turned out not to be over at all.

Graham's roots lay in American modern dance and its German expressionist cousin. This was a tradition that for all kinds of reasons, both good (Balanchine's genius) and accidental (the wave of European

ballet immigrants who came here in the 1930s and '40s), was sidetracked by ballet.

In the polemics of the '30s, ballet was dismissed by extreme modern-dance partisans as hopelessly old-world European and effete. But the balletomanes got their revenge, some dismissing modern dance as ama-teurish and, yes, dated. Of course, today, the two "sides" have pretty much merged.

There can be no question that the Graham performances seen at the Joyce are just the beginning of the revitalization of the Graham per-formance tradition, not its fulfillment. The company has been in limbo of late, and the veterans are getting on. The men looked weak.

But some of the younger women, very much including the corps, offered real promise for the future. And a couple of the leading dancers who counted as neither old nor young stood out.

The best example could be seen in a Graham rarity called *Sketches from "Chronicle"* (1936), which ended the program that had begun with *Phaedra*. This is a piece about war—World War I and maybe the Span-ish Civil War, too. It harks back to the kind of German expressionist pacifism best known in this country through the Joffrey Ballet's version of Kurt Jooss's *Green Table*.

In the performance I saw, the cyc was instantly arrested when the cur-tain went up to reveal Fang-Yi Sheu seated imperiously on a construc-tion of conjoined boxes, which were entirely draped by one of the most remarkable of the many remarkable costumes Graham herself designed.

In fairness to the dance-critic community, nearly everyone, including Ms. Shapiro, singled out Ms. Sheu as the finest present-day embodi-ment of the Graham technique and tradition. She was thrilling and electric to watch, not least for the utterly confident way she manipulated the huge amount of fabric that hung from her body, never making a mis-step and allowing the black skirt and blood-red undercoat to spin and swirl and flare.

A word about Graham's costumes. A condition of implied nudity pre-vails in much modern dance, the body encased in and revealed by flesh-colored tights and leotard. Graham came from an older tradition of costumed modern dance. She loved the drama of fabric, and she created costumes that conveyed metaphorical meaning and called attention to themselves yet also accented the sexuality of the body. See, for example, the split skirts and tautly gathered crotches in *Diversion of Angels*, which was on this same program.

The implication of Ms. Sheu's performances in the first and third

sketches from *Chronicle* was that the Graham legacy ain't over yet. There are other strong dancers in the company—one thinks of Katherine Crockett, who also knows how to handle those ballooning Graham skirts. But Ms. Sheu seems to be the critically and publicly anointed star.

Ms. Sheu studied Graham technique in her native Taiwan and for a year at the Graham School in New York, joining the company in 1995. But being a Graham dancer has hardly meant steady work, so she's also been active back home, most prominently with the Cloud Gate Dance Theater.

Her success was Graham's success (and that of Ms. Dakin and Terese Capucilli, the company's two artistic directors). Ms. Sheu proved that all it takes to transform Graham from a relic to a classic is—aside from picking the right repertory for revival—superb performers. By superb one means dancers who can master and convey the essence of the Graham technique. But also dancers who can use that technique to new, personal ends, transforming the past into a vivid, intense present. The company has such a performer in Ms. Sheu. Now all it has to do is cultivate a bouquet of them.

HITLER AND THE ARTS

The New York Times, February 24, 2003

Note: Had I remained an academic cultural historian, my initial field of specialization would have been domestic life in Germany between 1933 and 1945.

Hitler and the Power of Aesthetics. By Frederic Spotts. Illustrated. 456 pages. Overlook Press. $37.50.

Frederic Spotts's new book, *Hitler and the Power of Aesthetics*, has a wonderful beginning, and typically it comes with just the right photo: Hitler lost for hours in contemplation of a model of his native city, Linz, Austria, which he planned to turn into an unparalleled cultural center.

Eerily reminiscent of Wotan brooding in Valhalla or the "mad" King

Ludwig II of Bavaria, this dream world took place in February 1945 deep in the Führer's Berlin bunker, his thousand-year Reich collapsing in flames above him and the Russians at the Oder, only fifty miles to the east. At the end, and maybe a long time before, the arts had become an unreal refuge from a chaos he created.

When most people bother to think of Hitler and the arts, they see bad watercolors of *alt*-German cityscapes, architectural gigantism, and Richard Wagner. The watercolors are adduced as proof that Hitler had no taste, Nuremberg party rallies and their settings as the embodiment of his brutality, and Wagner as the evil genius behind it all.

The recent film *Max* posits the fantasy that if Hitler had only been able to peddle his initial designs for Nazi regalia to Max, a rich Jewish art dealer, he would not have embarked on his political career. Mr. Spotts provides a more nuanced picture, detailing Hitler's expert knowledge of opera and architecture especially. Still, this may not be a book for every taste: reading more than four hundred pages of dense prose about Hitler and the Nazis makes for a dispiriting slog, for all of Mr. Spotts's intelligence and hard work.

But it is the very conjunction of the most cultured nation on earth and a cultured, barbarous dictator; of Nazi ideas and their sometimes genuine, sometimes spurious antecedents in German cultural history; and of the synapses within Hitler's psyche linking murderous racial annihilation and a genuine love of culture that makes this study so grimly fascinating.

After three introductory sections (two or three chapters each) speculating on the larger issues involved in Hitler's devotion to and use of the arts, and preceding a brief, almost hasty conclusion, this book is devoted to sections on Hitler's painting, his policies on the visual arts, his relation to Wagner and Bayreuth (some but not all of this material echoing Mr. Spotts's previous study of the Bayreuth Festival), his musical program, and his fascination with architecture.

Mr. Spotts is at his considerable best when it comes to sorting out the truth behind the myths, rumors, forgeries, and blatant propaganda that have formed our view of Hitler's interest in the arts. Not just the many forgeries of Hitler's paintings and sketches, but also the sometimes mistaken notions of Hitler biographers and the anti-Fascist reputations of some modernist artists, Jewish or not, driven from Germany. Mr. Spotts traces Hindemith's efforts to ingratiate himself with the Nazi Party, for instance, and the craven efforts of the Bauhaus leaders Walter Gropius

and Ludwig Mies van der Rohe to find Nazi patronage; Mies actually designed an autobahn gas station.

Hitler's personal passions were not often shared by the party hierarchy, a fractious assortment of thugs and hacks whom Hitler kept squabbling, the better to ensure his own power. The party and much of the public, for instance, found Wagner heavy sledding and thought Hitler's urban renewal plans impossibly extravagant (insofar as they knew of them; he kept them largely secret). Hitler was occasionally willing to overlook political or even racial issues if he liked or disliked an artist. He lamented the hounding of the conductor Fritz Busch from Germany and detested the conducting of Hans Knappertsbusch, an impeccably Aryan Nazi enthusiast.

Hitler had more complex ideas about visual style than stereotypes would suggest. He found nearly all the contemporary German art and music fostered in party exhibitions meretricious. He mocked the old Teutonic imagery espoused by party ideologues like Alfred Rosenberg. For central urban and party structures he preferred a severe, brutalist neoclassicism, but for projects closer to the modern spirit he countenanced modernist architecture, as in the autobahns and their sometimes gorgeous bridges and the Volkswagen. Mr. Spotts ends with these, as if, curiously, to conclude his book on an upbeat.

In his actorly, overwrought denunciations of modern art and music (corrosively linked with his racial theories), Hitler sometimes echoed Plato's *Republic* and anticipated middlebrow, conservative taste to this day. He favored high art over kitsch, though he wanted it formally and economically accessible to all. Modernist painting and music were ugly and destructive. A review of this book in the British magazine *Opera* notes Hitler's "not wholly implausible view of the decline of Western civilization."

The book's relatively minor faults include such a sharp focus on Hitler and the arts that it reads like an airless bunker, cut off from context. If something didn't interest Hitler artistically, it's not in this book: film (despite plans for gigantic movie theaters), theater, dance, some individual artists (a curious lack of attention to Carl Orff and *Carmina Burana*, for instance). There are also a few of the usual errors and inconsistencies: did Hitler see his first opera at the age of twelve or thirteen?

In the sections on the different arts, there can be a numbing amount of detail, like Mr. Spotts's dogged enumeration of what art from what countries and collections was looted/confiscated/purchased. But in the

more general overview sections he resorts to padding and repetition and falls short of the kind of essayistic exploration that would have lifted his book to an even higher level.

For example, during World War II the West was convinced of the links between German romantic irrationalism and Nazism, and such concerns linger to this day. Anti-Wagnerians will not accept unchallenged Mr. Spotts's conclusion about Hitler and Wagner, however well argued: "Wagner's Hitler does not exist. Hitler's Wagner was an opera composer, not a political mentor."

Whether one agrees or disagrees with any particular point, however, this is still a book that will rightly find its place among the central studies of Nazism. It may be a depressing read, but it's invaluable.

CREMASTER

The New York Times, March 23, 2003

Some of us are blessed (or cursed) with attention spans attuned to the glacial and the hard bottoms to sustain us through long artistic experiences. Sitting through all five of Matthew Barney's *Cremaster* films in sequence—as can be done on Fridays at the Guggenheim Museum from 10:15 A.M. to 7:40 P.M. (with short breaks)—offers a different experience from seeing these films in bits at the upstairs exhibition or individually.

Whether Mr. Barney ever intended to have his films seen sequentially, in close order, is an open question. The films were created out of order, from 1994 to 2002, but Mr. Barney has countenanced the museum's marathon screenings. "I myself think even Matthew has not seen them straight through *One* to *Five*," mused Michael Kimmelman, the chief art critic of *The New York Times*, when I announced my intention to subject myself to them all in one day.

Mr. Barney emerged from the art world, and by and large, art critics have been ecstatic about his work (Mr. Kimmelman has been an outspoken champion), although there have been naysayers. Film critics, too, have been basically admiring, not least Stephen Holden of the *Times*.

But then there was the recent review by J. Hoberman, film critic of *The Village Voice* (counterbalancing the rave by that paper's art critic, Jerry Saltz). Mr. Hoberman systematically blasted each film, although he had grudging praise for *Three*. Passing phrases in his diatribe included "glib homage," "narcotized self-satisfaction," "migraine-inducing," "lugubrious," "gives ridiculous a bad name," and "never afraid to distend his ideas beyond ostentation."

Well. Other than that he liked it. And so, it seems, do the hordes of mostly young people coursing around the Guggenheim, although how many of them sit through the films is another matter.

But they should. Mr. Barney's cycle, with themes enunciated and developed and overlaid with other themes, can now be perceived as one megafilm. And so for the right kind of person with the right kind of bottom, it's worth the effort. (*Two* and *Three*, which are the most recently made, are the easiest to enjoy on their own.)

For those who came in late, the cremaster is a muscle that controls the rising and lowering of the scrotum. This odd anatomical detail becomes the controlling metaphor for Mr. Barney's entire meditation on gender and manhood and art.

As with all art, Mr. Barney's work can be approached intellectually or intuitively, not that the two necessarily contradict each other. You can struggle to discern meanings through Mr. Barney's signposts and images. Or you can just sit there and let all that extraordinary imagery wash by.

Art critics have taken endless delight in parsing out Mr. Barney's meanings. We have undescended testicles, which, in the course of fetal growth, eventually drop, but not before the fetus swims in a presumably blissful sea of gender ambivalence. We have Celtic legends and chorines and tests of physical strength (mostly for Mr. Barney himself, as his own star) and Harry Houdini and Gary Gilmore and Mormon and Masonic signs and rituals. Art critics have a special familiarity with some of Mr. Barney's references (for example, Richard Serra, playing Hirma Biff or the evil Architect in *Three* as an Oedipal father figure). Imagery and ideas can be traced over the cycle, and can cumulatively make some kind of sense of the whole sprawling mess—if you dutifully follow Nancy Spector's synopsis (which the Guggenheim provides) and add a healthy dollop of good will.

But you can only summon that good will if you have first been viscerally gripped by Mr. Barney's imagery. For those of us devoted to art on

an epic scale, be it onstage or in film or in huge artistic installations and land art, the *Cremaster* experience has its compelling charms along with the longueurs. It's rather like watching Wagner or Robert Wilson or Tarkovsky's *Andrei Rublev* and letting the imagery captivate you on its own, preverbal terms. There's time for reflection later, as the images cling stubbornly in your brain.

Committing to a prolonged experience over a set time focuses the attention in a way that a more casual perambulation through a museum cannot. Watching Mr. Barney's imagery evolve on two axes—the axis of its conception and the axis of its creation—quickens the mind even as it overloads the senses.

For Mr. Barney's pictures are often really brilliant, so brilliant as to be disorienting; of course, the pervasive ickiness, to use the technical term, helps in the disorientation process. This is utterly original stuff: the sleek elegance of the dirigible stewardesses in *One*; the dazzling desert and ice landscapes and bizarre Gary Gilmore enactments (although as an actor Norman Mailer is no Richard Serra) in *Two*; the Houdini zombie and demolition derby, the racetrack of rotting horses, the Chrysler Building and the Guggenheim itself, the dueling Celtic giants and the extraordinary Aimee Mullins as the Cheetah Woman, all in *Three*; the tap-dancing man-beast and androgynous "Faeries" and motorcycle racers with what Ms. Spector calls "gelatinous gonadal forms" oozing from their pockets in *Four*; the Budapest Opera House and dappled Asian water sprites and the amazing image of Mr. Barney's descended testicles attached to ribbons borne by fluttering doves, from *Five*.

Not everyone is ready for the all-day experience. People came and went when I saw the films. Of course the mind sometimes wanders; it does in Wilson and Wagner, too. But there is something about Mr. Barney's imagistic overload that evokes a comparable response in a willing viewer, making the linked themes seem even more vivid and fantastically coherent.

MARK ADAMO'S *LITTLE WOMEN*

The New York Times, March 26, 2003

One could say that every artistic genre has its occasional masterpieces, even the more improbable genres. Like carefully conservative new operas in period settings, tunelessly modernist to retain the composers' "serious" credentials yet seemingly designed to appeal to timid middle-class audiences unwilling to accept the harder stuff. But even if cravenly hedged by these qualifications, Mark Adamo's *Little Women* is some sort of masterpiece.

Right up there with Tobias Picker's *Emmeline*, another new work that has managed to extend the tired American folk opera idiom into a sub-tler contemporary climate. *Little Women* received its heartily cheered first New York performance on Sunday afternoon by the New York City Opera, which also gave us *Emmeline*.

Modest expectations are always the best setup for unexpected pleas-ure. This is an opera that has been around for a good while, having had a workshop at the Houston Grand Opera in 1998. It was first performed there in its full form in 2000, has been recorded and nationally televised, has received thirteen productions by twenty companies, including Glimmerglass last summer on its way to the State Theater. Some people I know liked it; others found it calculating and emotionally manipula-tive. Yet I had managed to insulate myself from it, so what I heard on Sunday surprised and pleased me all the more.

Mr. Adamo, who is now composer in residence at the City Opera and is working on a new opera to be performed by that company, has explained the curious genesis of his *Little Women*. First came an offer to adapt Louisa May Alcott's beloved if structurally diffuse novel of a fam-ily of four sisters in Concord, Massachusetts, around the time of the Civil War. Then doubts, followed by his discovery of how he could adapt the material for operatic purposes. This process of discovery involved several increasingly detailed synopses, including notes as to what kind of music was needed for each scene. Then, after the produc-tion had shifted to Houston, came the writing of the libretto and finally the composing of the music itself. It sounded like a recipe for just the sort of dry calculation that has sunk so many outwardly similar modern operas.

And yet: let us start with Mr. Adamo's libretto, built in rhymed cou-

plets of seemingly effortless naturalness. Mr. Adamo's way into the novel was to see the opera as the story of the dominant sister Jo's gradual coming to terms with change: her sometimes painful (to herself and others) realization that the sweet bubble of family happiness, of childhood, of pre–Civil War American innocence, had to burst. But that change could mean life, not death.

The libretto proceeds with amazing sureness for a first opera. We come to love the complexity of Jo's character but can still be appalled by her selfish cruelty. Her sisters are all limned surely, as are the three men who come as agents of inevitable change.

Mr. Adamo's music is no letdown. As with other, less successful operas in this bourgeois genre, he mixes modernism (actual twelve-tone rows) with tonal lyricism, the former usually to advance the action or for humor, the latter for the big effusions. And yet the two styles blend effectively, the modernism not rigorously alienating and the lyricism genuine and heartfelt. Nearly all the big moments in the opera work: Jo's arias, those for her sisters and for the older German teacher (who eventually, maybe, melts Jo's heart), and his recitation of Goethe in both German and English.

A friend left at intermission to go across the plaza for Richard Strauss's *Four Last Songs*. Had she stayed, she could have heard a latter-day homage to other late Strauss: the autumnal musings of the Countess at the end of *Capriccio*, which Mr. Adamo's final scene honorably recalls.

Sunday's success owed a lot to the quality of the performance. Rhoda Levine's production, with Peter Harrison's fluid set designs and Paul Tazewell's lovely period costumes and Amy Appleyard's delicate lighting, advanced the action flawlessly.

The cast was superb. Jennifer Dudley's Jo commanded the stage: a warm, authoritative mezzo and a handsome, haughty appearance, like the proud filly the libretto metaphorically evokes. Jennifer Rivera's Meg and Julianne Borg's Beth were also touching, and among the men Charles Robert Stephens (a baritone of smooth distinction) as the German teacher and Daniel Belcher as Meg's beloved stood out. George Manahan conducted the orchestra and the small offstage female chorus with real sensitivity.

The opera is scheduled for four more performances, starting tomorrow and continuing until April 8. If you have any interest in new opera, or just want to enjoy yourself, you should make every effort to go.

MARK MORRIS AND ASIA

The New York Times, April 20, 2003

Like many of Mark Morris's newer dances, *Serenade*, a solo he performed at his recent Brooklyn Academy of Music season, was received with impatient respect by critics who have long admired his work but who are now waiting for something grander and bolder. *Serenade* was pleasant but little more.

Its seemingly unimaginative title was an allusion to its music, Lou Harrison's *Serenade for Guitar*, but it also recalled Balanchine's *Serenade*. Since Morrisians are invariably Balanchinians, the parallel may have encouraged a certain restiveness in the ranks.

With all that in mind, it was worth reading a longtime Morris admirer, Robert Gottlieb, in the *New York Observer*. "The section I found most effective was the first," Mr. Gottlieb wrote of *Serenade*, "in which he's seated on his box and moves only from the waist up." Indeed, the interest in the dance lay largely in his use of his upper body and his rippling horizontal arm movements.

There are several explanations for that, ranging from the at least initially unflattering (he's older and bulkier than he once was, curtailing his capacity for faunlike leaps) to the biographical. As documented in Joan Acocella's first-rate critical study from 1993, *Mark Morris*, he grew up in Seattle immersed in folk dance, Serbian dance especially. Part of his distinctiveness as a choreographer is his recurrent use of the communal, nonvirtuosic steps and partnerings of folk dance.

In recent years, however, Mr. Morris has grown increasingly enamored of Asian dance, partly through his admiration for Harrison's Asian-inspired music. Another new dance on the same academy program, *Kolam*, was overtly influenced by Indian dance.

A telling aspect of Asian dance, if one dares lump a goodly part of the planet under a single rubric, is this very emphasis on the upper body: on the arm movements of the Bharata Natyam style from southern India or the fantastically sinuous and subtle hand gestures of Kunqu operatic dance from the Shanghai region or the theatricalized movement of so much Japanese movement, both old (Kabuki) and new (Butoh).

Often, the lower body remains relatively immobile in such dance, actually or perceptually (from the audience's point of view) constrained

by fabric. The "dress," as Mr. Morris called it, that Isaac Mizrahi designed for *Serenade* looked very much like a Southeast Asian sarong.

As much as we might love ballet and physically challenging modern dance, we can also regret their overemphasis on youthful athleticism and hence welcome a corrective influence from the East.

Ballet started at the seventeenth-century French court as elevated social dance. There is something both charming and comforting in seeing re-creations of early ballet, with their absence of point shoes and tutus and lifts. Men and women look more equal, and for all their courtly formality, the experience of dancing and watching seems less daunting than welcoming.

If ever there was a Western culture that seemed Asian, Chinese especially, it was that of the French baroque. China and France shared a love for learning and art; ornate, immobilizing costumes; and complex social and artistic rituals.

But if one accepts that shared premise, Western and Asian dance subsequently diverged. Western dance became bold and overtly sexual and obsessed with youthful feats of physical skill. A ballet dancer struggles after forty; an Asian master is just coming into his or her own.

That disparity is one reason Netherlands Dance Theater III, founded by Jiri Kylian and devoted to dancers over forty, is so heartening. The company allows dancers to extend their careers without a fruitless effort to replicate their youthful physicality, which in any case may well have been eroded by injuries brought on by excessive athleticism. Instead, its dancers are offered choreography that emphasizes upper-body movement and actorly subtleties.

Similarly with Mikhail Baryshnikov's noble forays into American experimental dance and choreography, which also deemphasize physicality in favor of conceptualism and natural movement. Such work offers one way for a great dancer, now in his fifties and with a lifetime of injuries, to convey his accrued artistry without trying to levitate like some Bolshoi Spartacus.

Not that all modern ballet is in thrall to the athletic. The partnership a few decades back of the Italian ballerina Carla Fracci and the Dane Erik Bruhn blossomed because of their histrionic skills and especially with Ms. Fracci, her sinuous arms and hands. She was never a fabulous technician in the approved Russian sense. But she was a great artist.

By the time critics notice something in art, artists have almost always long since led the way. So it is with Asian dance and its impact on the

West, which has by now insinuated itself into our dance vocabulary. Ballet remains popular, and rightly so: there is something thrilling about artistically inflected athletic accomplishment, and we'll always respond to that. But feats of studly skill are not all there is to dance, and Asians know it.

Mr. Morris knows it, too. *Serenade* may not have been the deepest dance in his canon. But perhaps it will help point us toward an aesthetic climate in which age and girth are secondary, even integral, to the wisdom and beauty of maturity.

THE DEATH OF KLINGHOFFER

The New York Times, May 4, 2003

Modern operas are not usually on the cutting edge of controversy, even with the recent rush of "CNN operas," dealing with up-to-the-minute events. But *The Death of Klinghoffer*, created by John Adams (music), Alice Goodman (libretto), and Peter Sellars (direction and all-purpose conceptualization), has become a subject of heated, sometimes superheated, debate.

At its premiere in 1991 in Brussels, which I covered for *The New York Times*, the debate revolved mostly around the quality of the work and its staging. But in the United States the controversy was reduced to a single question: to what extent might *The Death of Klinghoffer* be considered anti-Semitic? (It was also called a Zionist plot, but Arab opinion doesn't make much of an impact here.)

Now a film of the opera, sharply different in tone and approach from the coolly abstract Sellars staging, will receive its New York premiere on May 13 at the Walter Reade Theater, part of the celebration of Mr. Adams's music this spring by Great Performers at Lincoln Center.

At screenings in Europe, at the Sundance Festival, and in San Francisco, response has been enthusiastic about the film ("brilliant, morally courageous and overwhelmingly moving," Mark Swed wrote in the *Los Angeles Times*) and generally positive about its handling of the contentious issues. But New York was the epicenter of the sometimes stri-

dent opposition to the opera twelve years ago, and some of its most vocal adversaries attended a recent screening, busily taking notes.

Those who denounced the opera disputed the claims to balance in this oratoriolike depiction of the hijacking of the Italian cruise liner *Achille Lauro* in 1985, in which an elderly, crippled American, Leon Klinghoffer, was murdered and thrown into the sea.

The opera, wrote Manuela Hoelterhoff in *The Wall Street Journal* after the Brussels premiere, "turns the sport-killing of a frail old Jew in a wheelchair into a cool meditation on meaning and myth, life and death."

"And without a penny of subsidy from the P.L.O.," she added. She called Mr. Sellars's foreword in the program "repulsively amoral and culturally pretentious" and saw nothing in the real incident but "another example of the small-minded viciousness festering among Muslim thugs."

In a review of the work's New York premiere later in 1991 at the Brooklyn Academy of Music, Edward Rothstein, then the chief music critic of *The New York Times*, implicitly questioned the rectitude of the very idea that "the Palestinians and the Jews would be shown as symmetrical victims of each other's hatreds."

In a follow-up essay, Mr. Rothstein explicitly asserted that the depiction of the Jewish characters slighted their claim to an age-old mythic resonance comparable to that of the Palestinians, reducing them to petty triviality. "This ideological posing is morally tawdry," he argued.

As often happens to an artwork with a few highly placed, highly impassioned opponents, *Klinghoffer* has found its way onto the world's operatic stages much more slowly than did its acclaimed predecessor, *Nixon in China*. The new film isn't doing much better: it has no scheduled theatrical or television distribution in the United States. Still, the opera's champions are undaunted. The film is to be released on DVD late this year, and the Brooklyn Academy is planning a new "staged concert version" of the opera, directed by Bob McGrath and conducted by Robert Spano, for December.

Middle East tensions seem at a constant crisis level, and *The Death of Klinghoffer* has hardly been unaffected. Its premiere came just after the 1991 Persian Gulf War. The September 11 attacks took place while Mr. Adams was conducting the film soundtrack recording in London. Now, after the war in Iraq, Abu Abbas, the Palestinian who masterminded the hijacking of the Achille Lauro, is in American custody.

The film was directed by the British filmmaker Penny Woolcock, whose earlier work dealt with the underside of the British welfare state and its restless youth. She is no opera expert, she said recently from London, but she proposed making a *Klinghoffer* film simply because she found the work so beautiful and moving at a concert performance. "It's done in such a compassionate way," she said, "and lifted to another level by the music."

On the stage, Mr. Sellars sought to abstract the passions and the action to evoke a timeless, featureless world in which tourists, victims, and hijackers wore the same bland clothing, and smaller roles were shared by a few singers. He did use rock concert–style projection screens, thus moving his staging a little way toward film. But his cool, almost scientific distancing infuriated the opera's opponents, further blurring, for them, the line between the victims' pain and the murderers' cruelty.

Ms. Woolcock takes the opposite tack. She has made a painfully realistic film, largely shot on an actual liner at sea. She individuates the singing actors and conveys their fury and their victims' fear in the most brutally direct way possible. One wonders whether her approach will mollify or inflame the opera's opponents.

The film begins with a scene not in the libretto: Klinghoffer's wife, Marilyn, confronts the hijackers in an Italian jail and spits at them, an incident that is said to have actually happened. The opening chorus, a meditation of bitter regret by Palestinians recalling their eviction from their homes in 1948, is accompanied by historical and recreated footage of Jewish settlers clubbing grandmothers and children. The succeeding chorus of Jewish exiles has Holocaust footage of emaciated corpses being flung into open pits and boatloads of European Jews arriving in the Promised Land.

In her quest for naturalistic immediacy, Ms. Woolcock, with Mr. Adams's complicity, cut two particularly contemplative choruses and shortened several arias. (A gently comic scene, depicting fictitious friends of the Klinghoffers at home in New Jersey, had for better or worse been cut by the time of the 1993 Nonesuch recording.) She also devised an ingenious system allowing the characters to sing their music live during filming, accompanied by orchestral and choral music that had been recorded by Mr. Adams in the Abbey Road studios in London.

The film is full of added imagery that casts the hijackers in a less than favorable light: it shows them driving around in a Mercedes in the Gaza

Strip after their release, for example, and there is a horrific scene in which a secularized Palestinian woman is stoned and has acid thrown in her face, a victim of heightened fundamentalism. Ms. Woolcock feels a bit nervous about that scene. "Such things have happened," she said, "but very rarely."

Close-ups, made more intense by the use of handheld cameras, allow the victims' personal pain to register all the more strongly. What the film, even more than the opera, really does is posit a truly balanced mythic background to Palestinian and Jewish suffering. But it also unshrinkingly shows the viciousness of terrorism and the three-dimensional reality of victims who might otherwise recede into facelessness.

There may be a bit of tweaking of American (not Jewish) material comforts. But in the end *Klinghoffer* is not anti-American or anti-bourgeois or anti-Semitic but pro-human. It shows unequivocally that murder is nothing more than that, vicious and unconscionable. To see the opera or the film otherwise, it seems to me, is to be swept up in the very tribal hatreds the opera so eloquently deplores.

Ms. Woolcock reports that hardly anyone at Sundance or in San Francisco, where many in the audience pointedly identified themselves as Jewish, objected to her film on the ground of anti-Semitism.

"I find it kind of astounding that anyone would interpret it like that," she said. "And I would never have filmed it if I thought it was anti-Semitic. If the opera is about anything, it's that we have to forgive the unforgivable. Otherwise, we're lost as a species."

BRUCKNER AND THE ORGAN

The New York Times, May 25, 2003

This is a stealth review. It is ostensibly about a new Hyperion CD, with Keith John playing his own organ transcription of Elgar's "Enigma" Variations, which is of interest on several counts, to Elgar lovers, organists, and collectors of musical curiosities. But it's really about an older, parallel CD, Lionel Rogg's organ version of Bruckner's Eighth Symphony, which is flat-out great.

In those distant days before the synthesizer, the mighty pipe organ, with its multiple manuals and pedals and stops for changing tone colors, was considered the most orchestral of instruments. The late-nineteenth-century French "symphonic" organ composers—Widor and Vierne, above all, but also Franck (born in Belgium) and Messiaen (a latter-day extension)—attested to that affinity. So did transcriptions of orchestral works for organ, which in the time before recordings provided the grandest way to hear orchestral music without an orchestra.

Both of these CDs involve transcriptions by contemporary organists of well-known late-romantic orchestral scores by humble organists. Elgar was in fact a multi-instrumentalist who mostly played organ for a living when he was young. His Organ Sonata in G, his sole venture in the genre (also on Mr. John's disc, Hyperion CDA67363), dates from 1895 and sounds earnest but uninspiring in the worst English way. Yet curiously, the obvious connection between the broad palette of the orchestra and that of the organ encouraged an orchestration of this sonata as late as 1947; it came to be called Elgar's Symphony No. 0.

In no way was Elgar's most famous work, the "Enigma" Variations, composed with the organ in mind—even, one suspects, subconsciously. But Mr. John has transcribed it anyway. The results are not convincing. Too often the music recedes into the churchy distance, lacking in vigor and articulation. Time and again one misses the pungency and coloristic detail of the orchestral version.

Mr. Rogg's Bruckner Eighth, which appeared five years ago (Bis CD-946), is another matter altogether: a revelation that may not supplant the orchestral score but that casts exciting new light on it. Bruckner was an organist in his soul all his life, one might say. It's easy to hear each of his symphonies (from his No. 0 on), with their big blocks of sound, as having been first heard by him organistically, if such a word exists. The Eighth, especially, the noblest and grandest of them all, sounds like organ music even when heard in orchestral guise.

The Rogg transcription captures all of that. The buildups to the cataclysmic climaxes in the outer movements have all the brawny, brassy power of the concert hall; in some ways, they're even more overwhelming. And Mr. Rogg is such a deft and rhythmically alert player that the music never loses its spring and momentum. This is a really thrilling performance, one that justifies modern-day organ transcriptions in a way that Mr. John's Elgar CD unfortunately does not.

PANSORI

Lincoln Center Festival program book, July 2003

Note: Trimmed of the recounting of the plots of each Pansori piece in the festival schedule.

There is a telling scene towards the end of Im Kwon-Taek's film *Chunhyang*, a wide-screen, brightly colored historical epic dramatizing the same Pansori folk legend that will conclude Lincoln Center Festival 2003's cycle of five Pansori evenings at the John Jay College Theater.

The director intersperses his reenactment of the legend with a filmed performance by the noted Pansori artist Cho Sang-Hyon before an audience of mostly older Koreans sitting formally in a theater. As the film approaches its climax, all those properly dressed middle-class Koreans have tears streaming down their faces.

But what about the rest of us, those who are not Korean or steeped in Korean arts and traditions? What hope is there for us? For the average American arts lover, even one who had been beguiled by something that seemed at first impossibly exotic, like *The Peony Pavilion*, Korean Pansori may seem heavy sledding indeed. Not to speak of five straight nights of it, each marathon performance uninterrupted.

After all, the idea of listening to some leather-voiced man or woman in highly formal Korean garb singing and chanting and chatting unintelligibly for hours on end, accompanied only by the whacks and rimshots on a barrel drum played by a seated gentleman on the side, does not seem promising.

As one who has never sat through such a performance, let alone five of them, I cannot guarantee a peppy night out in the theater. But there is hope: The performances, of the entire core classic Pansori repertory by some of Korea's most gifted and popular Pansori performers, will be supertitled, allowing one to be drawn into what are in fact engaging and diverse tales. The same sequence of Pansori performances appealed hugely to French audiences at the 2002 Festival d'Automne à Paris. (Yes, yes, I know, Jerry Lewis and Mickey Rourke. But still. . . .)

What I can say from personal experience is that Pansori, however initially strange, can quickly and powerfully captivate the most ignorant outsider. And not just captivate, but elevate, convincing one that a Pansori performance can reach heights of drama and profundities of emo-

tion known only to the greatest of world performing arts. This is music and performance that can consume a performer (and hence an audience), making this one art, this one evening, seem supremely important. I know this not yet from live experience but from the films of Im Kwon-Taek.

What is Pansori? It is categorized in music encyclopedias as a folk art, but that's a little like saying that Homer was a folk bard. Pansori performances stem from an oral tradition in which a troubadour (think Benjamin Bagby in *Beowulf*—seen at Lincoln Center Festival 1997—or Walther von der Vogelweide) regaled audiences with sagas from the communal past with minimal accompaniment (a small lute, a drum). Later on such performances were set down in written language, although the music of the more ancient tales (*The Odyssey, Beowulf*) must be reimagined. It has since then become literature, and the process of its scholarly refinement and pedantic codification has begun.

Pansori was born in medieval times in the Cholla province of southwestern Korea. *Pan* means a public place of performance, like a market square; *sori* means singing or song. Emerging out of shamanistic religions, Pansori was folk storytelling, orally transmitted and hence constantly mutating. It was also a subversive way for the Korean people, subjected to an endless round of feudal oppression and alien occupiers (Japanese, Chinese), to retain their sense of self and, while they were at it, to exalt the common man and woman and to mock and vilify their rulers.

The first literary account of Pansori stems from 1754, written in Chinese by a scholar from a neighboring province. The key figure in its evolution was Shin Chae-hyo (1817–1884), a Cholla province aristocrat who set about to codify and reform the art and who first wrote down twelve canonical epics (helpfully "improving" them as he did so). He was also, interestingly, the first to train women as Pansori singers. Women now make up two thirds of the some five hundred professional Pansori artists in South Korea, and three of the five Lincoln Center Festival singers are women, including the most famous and popular of the five, Ahn Suk-sun, who will tackle the epic *Chunhyangga* on July 20.

Shin also experimented with diversifying Pansori performance into something resembling Chinese opera, with different singers for each part and fuller staging. That form didn't catch on, however.

In the twentieth century, Pansori declined. Its audiences grew increasingly elderly, and the problem was even more severe in Korea

than in Western opera. Under the Japanese occupation (1910–45), all things nationalistically Korean were discouraged, and the aftermath of the Korean War (1950–53) ushered in the age of modern mass Western culture to seduce the youth away from traditional arts.

Of the twelve legends Shin identified, five have survived as the classic canon of the genre, the other seven fading into literary texts. It is those five that Paris presented and that will be repeated in New York. But that is not all there is to Pansori repertory. There are modern texts, including a life of Jesus. One Pansori master, Park Tong-sil, became so disillusioned with the impact of Western commercial culture that he fled to North Korea, which he hoped would protect things traditionally Korean. North Korea seemed more interested in Pansori variations of the Chinese Gang of Four revolutionary operas.

Today, South Korean Pansori offers a fascinating blend of rigorous formalism and vigorous individual spontaneity. The traditional dress remains common, with a fan in the right hand and a handkerchief in the left. So does the use of prescribed melodic modes and seven accepted rhythms. Often preceding the actual legend is a *danga*, or short warm-up song. The singer alternates among chanted singsong (the dominant form), spoken passages, and asides to the drummer, who reciprocates and punctuates the narrative with guttural exclamations. The drumbeats alternate with sharp tappings on the rim of the drum. The vocal tone quality is deliberately grainy, the result of long years of training (daily hours of singing beside a roaring waterfall, or so the legend goes) to build up endurance but also to cultivate the characteristic roughness, which is perhaps the result of cultivated nodes on the vocal cords.

Beneath the guttural surface lies an enormous range of vocal sounds, as the performer impersonates dozens of characters, with dramatic gestures and acting to boot. This is a vocal style that grows not just in interpretive maturity but in physical character as a performer ages; all the Lincoln Center artists are in their late fifties to mid-sixties. In the voices of its most seasoned and wisest artists, it is this rough but nuanced intensity of singing and chanting that has drawn comparisons to Indian mantras, rap, and, most often, the blues. Blues singers lack the cultivated tonal roundness of opera singers or the smooth naturalness of many folk singers. But their devotees prefer the roughness, as a mark of sincerity, disdaining vocal mellowness as blandness and vocal cultivation as artificiality. What cannot be denied is that as a Pansori perform-

ance reaches a climax of emotional intensity, the vocal quality mirrors and exalts that intensity.

Im's most recent film, *Chunhyang*, won him a place at the Cannes Festival and more international attention than he had received for his huge previous body of work. But his first film devoted to Pansori, *Sopyonje* (1993), is the one that sparked a revival of interest in Pansori among a younger generation in Korea—tellingly, youth was inspired to return to national tradition through the international and modern medium of film—and that convinced me of the transcendent power of Pansori.

The title alludes to one of two dominant moods of Pansori perform-ance: the more assertive, energetic, masculine *dongpyeonji* style (though both modes can be performed by men and women) from south-eastern Korea, and the more lyrical, contemplative, soulful, feminine *seopyeonje* style from the southwest. The film won twenty-seven domes-tic and three international prizes, although Im was disappointed that it was not accepted at Cannes and that it failed to achieve more wide-spread international attention. It can be rented at a few specialty video stores in Manhattan. It became, however, far and away the most popular film in Korean film history.

The film is set in the 1950s after the Japanese occupation and the Korean War, when Pansori seemed to be fading away. An idealistic, not to say fanatical, Pansori master refuses to put up with the hypocrisy of big-city promoters and seeks to restore the wandering rural tradition of Pansori artists, crisscrossing the countryside (gorgeously shot; if Im's films are to be believed, South Korea is about the most beautiful place on the planet) with two orphan apprentices in tow.

The master, Youbong (played by Kim Myung-Bon, who cowrote the script), wants to mold his young charges, a girl and her brother, into his successors. The boy grows rebellious and flees. The girl remains, and in his passion to focus her solely on her art, the master blinds her. After his death the blind woman plies her art humbly in anonymous pubs and inns, trading a performance for food and rest. The brother eventually finds her, but she is content with her life, ever striving to purify her art.

This is a romantic film with a capital R. Wagner's *Meistersinger* builds over five hours to Walther's "Prize Song," which had better be beautiful because the entire logic of the opera demands it. *Sopyonje* builds to the final performances of the daughter, Songhwa, played by Oh Jung-Hae. If her singing by the end is not profoundly moving, is not great art, then the whole story collapses into one madman's obsession.

Alain Corneau's beautiful film from 1991, *Tous les matins du monde*, tells a similar story, although here the wounds are emotional, not physical. Some of Monsieur de Sainte-Colombe's music survives, but little is known about his life. In the film he is a great seventeenth-century viol player who, appalled by the vulgarity and luxury of the French court, withdraws to his country estate to perfect his art in monklike solitude. Like Youbong, he wants his two daughters to follow him, and the three make positively gorgeous music together (played by Jordi Savall and his viol consort). But one of the daughters is seduced, then abandoned, by the young Marin Marais (Depardieu, first Guillaume, the son, later Gérard, the father), who seeks out Sainte-Colombe for instruction but who is eventually drawn to the very decadent court that his teacher has forsworn. The film wants you to believe that at least Marais feels guilty about his lapse into courtly superficiality.

To understand Youbong and Sainte-Colombe and, especially, the blinded Songhwa, you have to believe that music can be so important, more important than anything else, that the men's seeming cruelty and the women's sacrifice have been worthwhile. *Sopyonje*, and hence the initially alien art of Pansori, succeeded in convincing me of just that. To my knowledge, no one among Lincoln Center's five Pansori artists went so far as self-mutilation. But one can hope they aspire to similar great heights.

THE METROPOLITAN OPERA BROADCASTS
The New York Times, June 1, 2003

Despite the news that ChevronTexaco is pulling the plug on its sponsorship after next season, the Saturday afternoon radio broadcasts of the Metropolitan Opera are not likely to go off the air anytime soon.

Joseph Volpe, the Met's general manager, says that a search for new sponsorship is under way and that, if necessary, the Met or its listeners will support the broadcasts, which cost $7 million per season. Mr. Volpe is a determined man, so I suspect that loyalists will be able to tune in to their beloved broadcasts for years to come.

But the end of such a long tradition of corporate patronage—since 1940, Texaco has been the sole sponsor of the broadcasts, which began in 1931—prompts a consideration of what the Met broadcasts have meant to people and to opera in America. Partly, this is a story of the erosion of corporate philanthropy and loyalty. But the greater story involves American perceptions of opera itself, and the role—negative as well as positive—that the Met broadcasts may have played in those perceptions.

For a long time, even as they may have whetted an interest in the art of opera, the Met broadcasts arguably dampened the growth of local opera in cities around the country. And listening to opera on the radio may also have helped create a false image of opera as a voice-driven aural art form and hence cultivated an operatic sensibility resistant to opera as live theater, especially innovative theater.

Corporate sponsorship first. A ChevronTexaco spokeswoman said in a statement, "We believe it is important to focus more of our resources directly with the countries and markets where we do business." Since the Met broadcasts are heard by ten million people in forty-two countries, one wonders what countries she means. Still, it's the company's call, one that in the absence of personal passion for opera at the top must presumably be made on strictly business criteria.

But the Met is right to sound so determined, not to say optimistic, about preserving the broadcasts, even in this recessionary period, when live broadcasts and telecasts of symphonies and especially operas are withering away. The Met may seem elitist, but it remains a potent brand name, and surely companies with luxury images to promote will find Met sponsorship attractive—on strictly business criteria.

One cannot deny the reality or the sincerity of the many expressions of pleasure and gratitude voiced by generations of opera lovers. The Met on the radio is often what first brought them to opera, kindling a lifelong devotion and sometimes an important operatic career (those of Betty Allen and Susan Graham, to name just two). Tuning in on Saturdays from December to April remains a ritual in many households.

The strength of the Met brand owes much to those broadcasts. People think of the Met as the premier provider of operatic goods. The broadcasts certify the importance of the company and of New York as cultural meccas. And that can make them problematic—in the same way as the once-annual Met spring tours, which were abandoned after more than a century in 1986. Proponents of both broadcasts and tours see

them as having planted seeds that eventually sprang into the regional opera movement, beyond the New York–Chicago–San Francisco axis.

Yet it could be just as persuasively argued that local initiative was blunted by the Met's overbearing presence. High society in one city or another would gear up for the annual Met whistle-stop, with its attendant parties and hoopla. But those same local bigwigs would lag in the sponsorship of less glamorous, less star-strewn local operatic offerings. In that sense, the end of the tours liberated local philanthropy. But the broadcasts still held out the distant beacon of "real" opera, with name singers and name conductors, and listeners would save up for annual trips to New York and to the Met.

But there is another worry, more insidious. From the earliest days of recording, the human voice has been preserved and, eventually, transmitted more easily and accurately than the orchestra, with its sonic complexities. Even today, with the Met broadcasts heard on FM, the voice is front and center.

As a result, one might suggest, millions of American opera lovers have been tilted toward a perception of opera as a voice-driven auditory experience. For them, the best stage production is imaginary: it doesn't so much adhere to the intentions of the composer as remain neutrally compatible with a listener's own made-up stage pictures. And in the comfortable confines of the home or the car, the music is usually heard without libretto or titles, as a sensual experience in melody, harmony, and a foreign tongue.

To judge from endemic protests at even slightly outré productions, and incessant online and in-lobby grousings, too many Americans are convinced that opera should be just a sensuous bath in vocal timbre and the emotional urgency a great voice and great phrasing can convey; for them, theatrical meaning or vibrancy, let alone modern-day reinterpretation, is an alien intrusion. And for that sadly limited perception, the Met broadcasts must bear considerable responsibility.

So let us lament the passing of the great American tradition of the Texaco Saturday afternoons at the Met. Let us hope that Mr. Volpe finds a way to pay for the broadcasts' continuance. But let us also realize that opera in the theater (and even on subtitled DVDs) is a more complete experience than any radio broadcast can ever provide.

KATE AND ANNA MCGARRIGLE

The New York Times, October 17, 2003

The English mezzo-soprano Monica Sinclair once told a friend of mine that more than fifty years ago, after she had finished her duties as a Flower Maiden, she had watched from the wings of the Royal Opera House as the great German bass Ludwig Weber sang the part of Gurnemanz in the third act of Wagner's *Parsifal*. At every performance, he had tears rolling down his cheeks during the "Good Friday Spell." You can hear those tears, or imagine you do, in Weber's singing in the live recording of *Parsifal* from the 1951 Bayreuth Festival.

Whether Kate and Anna McGarrigle weep as they sing, I know not. But it's that kind of emotion you hear in their music, too.

The McGarrigles, who will appear with their posse of Montreal friends and relatives on Tuesday night at Zankel Hall, are a beloved fixture of my musical and emotional life. I say that not to claim them exclusively; they lead their own lives, and others love them besides me. I personalize my reaction because their music is so personal and speaks to me so directly. They're important to me for their music and for what they symbolize—even if I can make no sure claim that my image of them corresponds exactly to reality. Who cares, since the illusion of art is so strong and satisfying.

What they symbolize is emotion and family. Anna is now fifty-eight, and Kate fifty-seven; they were born fourteen months apart. Although they have made occasional quests in the big world outside, they have spent most of their lives in and around Montreal. They are folk singers and songwriters of an especially moving, dare I say feminine, sort. Kate has a husky, confiding, yet emotionally fragile voice; Anna's sounds even more fragile in a sweet, childlike way, with a particularly haunting upper register for high harmonies.

Their songs revolve around family and friends and love and children and aging. So, it seems, do their lives. The music is rooted in the English-Scottish-Irish-Appalachian tradition, but sometimes goes beyond that to reinterpretations of popular songs they've grown up with. And they sing every song with an unaffected simplicity and an emotional honesty that show up more image-dominated, commercially driven popular music.

The McGarrigles are not friends of mine; I know them only casually,

from backstage or telephone interviews. I say all this about them based on the many shows of theirs that I have seen over the last nearly thirty years, and on their eight CDs. (They're finishing a ninth, another French Canadian effort, right now.) The most recently released, *The McGarrigle Hour* (Hannibal, 1998), epitomizes my image of them.

The CD evokes a family sitting around a parlor, perhaps listening to the antique radio pictured on the cover, but more likely just making music together on their own, as the McGarrigles' parents did. Their Anglophone father was born in 1899 and their Francophone mother five years later. Hence the musical influences in the McGarrigles' childhood home were popular songs of the day, Stephen Foster, Broadway, chansons, the whole potpourri of turn-of-the-last-century Americana. Or Canadiana.

The McGarrigle sisters were always amateur musicians—in an important sense they still are—and fell into the folk movement in the 1960s. They started composing music and playing concerts together in the '70s, and their first and still best-known album, *Kate and Anna McGarrigle*, came out only in 1976. It includes their versions of Anna's "Heart Like a Wheel" and Kate's "(Talk to Me of) Mendocino," both famously covered by Linda Ronstadt.

For all the ambitions for stardom that their producer and record company may have had for them, the McGarrigles have resisted the star-making machinery. They begged off a tour to support the first album because Kate was pregnant, and most of their concerts since have been almost stealthy run-outs from Montreal—a few days here, a few there, and then scurry on home.

The concerts are sometimes amateurish to the point of sloppiness, with embarrassed jokes and technical mishaps and friends wandering on- and offstage. There is a core band, consisting of the sisters, along with Joel Zifkin and Michel Pepin; everyone sings and plays various instruments, with the music suffused with fiddle and guitars and banjo and mandolin and piano and accordion.

But the nucleus is likely to attract orbiting electrons. Sometimes their sister, Jane, crops up, and often their daughters, Lily Lanken (Anna's) and Martha Wainwright (Kate's). Martha's brother, Rufus, rather a star in his own right now, pops in sometimes, too. And Emmylou Harris may well join them on Tuesday night, since their appearance is the inaugural event in a five-concert series she organized. On October 25 Ms. Harris herself will take the stage, where the McGarrigles may join her.

The McGarrigle Hour brings these all together, along with Loudon Wainwright III, father of Martha and Rufus; Dane Lanken, father of Lily and her brother, Sylvan; Ms. Ronstadt; and still others, including favorite songwriters and former band members and the sisters' original producer, Joe Boyd, and recording engineer, John Wood.

The result is not guest-star overkill but an altogether cherishable image of a real, interconnected family, warts (the odd divorce and estrangement) and all. These are not pop stars; they give the lie to the idea of a pop industry cranking out nubile young things and then tossing them aside. Like the blues and folk singers of old, the McGarrigles are in it for life, and for the music. Yes, that music makes them a modicum of money, enough to keep them going in affordable Montreal, which Kate last Friday cheerfully called "the communist-socialist society which I adore."

I can't say that I share my every musical taste with my wife and teenage daughter. But the McGarrigles have become a beloved institution within our family, too. My wife and I, before our daughter was born, made an audiocassette for the car of our own McGarrigles' greatest hits. Now our daughter has joined the circle: hardly a week goes by without a McGarrigle song floating through our living room, mixed in with classical music and hip-hop. We'll all three be there on Tuesday, part of a continuous tradition on both sides of the footlights, in the McGarrigles' family and in our own.

GIANLUCA CASCIOLI, HÉLÈNE GRIMAUD, AND THE PERSONAL VOICE

The New York Times, **November 7, 2003**

Last week, defying the consensus of the connoisseurs, I went to a concert in the New York Philharmonic's series of all the Beethoven symphonies and concertos. Critics may complain about such supposedly unimaginative programming, but Avery Fisher Hall was fuller than I've seen at a Philharmonic concert in a long while.

But what caught my attention was the piano soloist in Beethoven's

Concerto No. 3, Gianluca Cascioli, who was making his New York debut. This is a young man — he's twenty-four — who has been extravagantly praised for his recitals, concerto appearances, and recordings, although still not reviewed by *The New York Times*. He is prized in the standard repertory (Mozart, Beethoven, Schumann) and in twentieth-century music, having the imprimatur of appearing on Pierre Boulez's second set of the complete works of Anton Webern. Richard Dyer, the respected critic of *The Boston Globe*, named him a highlight of the year 1999 after his debut with the Boston Symphony in Mozart's Concerto No. 21.

Guess what: I hated his playing, and I hated it the only previous time I heard him, too, with the Pittsburgh Symphony in Mozart's Concerto No. 26, for the same reasons. I found it mannered and stylistically eccentric. But then I got to thinking. I don't usually hate performing artists; my reactions normally range between boredom and extravagant enthusiasm. I took such a strong dislike to Mr. Cascioli's playing because it wasn't at all normal. It violated norms, norms being codifications of current fashion. So, I began to think, maybe my visceral reaction is some kind of tribute to Mr. Cascioli's individuality.

Let us be clear: this is not a Dyer versus me column. I often agree with him and always respect him. It's about pianistic individuality, and how it should perhaps be prized even when disliked.

Mr. Dyer realized full well that Mr. Cascioli's style violated norms; it's just that he liked it and I don't. In that 1999 review he called the young Italian "unsettling but brilliant," pointing out all the stylistic traits that drive me to distraction. Mr. Cascioli plays almost impressionistically, clouding over the contrapuntal rhythmic energy. He damps down the volume to near-inaudibility (when an orchestra is chugging along behind him) and then flails out with bangy, to my ears barely controlled fortissimos. "Aural peekaboo — now you hear me, now you don't," as Mr. Dyer described the soft side of his playing. By 2001 Mr. Dyer seemed to have fewer doubts, writing that Mr. Cascioli's "extraordinary" recordings showed "how deeply he sees into the heart of great music."

What are today's performance norms? I would argue that they epitomize a kind of self-effacing plainness: wan classicism. Three obvious antecedents are Arturo Toscanini, Artur Schnabel, and the early-music movement, which has made many performers seemingly afraid of romantic excess. Toscanini was full of a passion that overrode the blunt directness of his phrasing. But his epigones (starting with the much-

admired George Szell and devolving from there) came to espouse the blunt plainness without the passion.

Schnabel's Beethoven was plain but soulfully considered; sometimes later pianists, in eschewing romantic vulgarisms, reduced classicism to anonymity. Sometimes the sober approach can still dig deep, letting the music speak seemingly without an intermediary. Richard Goode's playing is often like that.

Then I thought of another, very different pianist, but one who likewise strikes out boldly, some would say eccentrically, on her own. If Mr. Cascioli's playing is stereotypically feminine, Hélène Grimaud's is defiantly masculine. She never seems to play the same passage quite the same, responding to the inspiration of the moment (in that regard she might make a nice pianistic partner for Valery Gergiev, if the two didn't charge off in utterly opposite directions). Her playing—reviewed over the years by *Times* critics in consistently friendly and usually enthusiastic fashion—is to my ears bold, commanding, and rhythmically defined. It is full of a Germanic mysticism (though she's French living near New York) that escapes Mr. Cascioli.

Mostly she plays romantic works—Beethoven, Schumann, Brahms, Rachmaninoff—although of late she's branched back to Mozart and forward to contemporary music (John Corigliano, Arvo Pärt); in other words, she overlaps Mr. Cascioli in her core repertory. To my ears, her playing of this wide range of music speaks with the same pianistic voice. Yet there is no question she tones down her romanticism some for Mozart.

But in 2000, that's not quite the way Mr. Dyer responded. I've heard Ms. Grimaud play Mozart's Piano Concerto No. 20 in D Minor, one of his two in minor keys and hence most susceptible to romantic treatment, and liked her performance just fine. In 2000 Mr. Dyer found her appearance with the Boston Symphony in that same concerto "dainty, feeble, scared-and-scrambled sounding, and entirely without pianistic or emotional projection." He specifically adduced Mr. Cascioli as a "natural Mozart pianist," whereas Ms. Grimaud to him "hardly sounded like a professional pianist at all." He followed up his review with an aside: "Most pianists play with tight shoulders, like Hélène Grimaud last week, and they produce sawdust, not sound." Me, I love what I hear as the vivid colors of Ms. Grimaud's tone.

To sum up: Mr. Dyer hated her (Ms. Grimaud) to precisely the same degree that I hated him (Mr. Cascioli).

In his new book *Human Accomplishment: The Pursuit of Excellence in the Arts and Sciences, 800 B.C. to 1950*, Charles Murray calculates (using his rather peculiar and questionable methodology) that Wagner was the fourth most important composer in world history, after Beethoven and Mozart—a tie—and Bach. Mr. Murray then reiterates that he personally doesn't like Wagner's music, but that he must bow before the objective truth of the consensus.

Maybe that's what a social scientist must do, but not critics. I trust my own subjective taste. Probably neither Ms. Grimaud nor Mr. Cascioli would rank in the Top 10 consensus of the great pianists of today. But a consensus is like a prize awarded by an uneasy consortium of critics: quirky brilliance, in Mr. Dyer's terms, is weeded out in favor of a film or a recording that everyone can feel comfortable with.

So more power to Ms. Grimaud and Mr. Cascioli, even if he isn't my pianistic cup of tea. Better a personal voice than an earnest student of convention. And if you make some people mad, and you will, all the better.

ART FOR ART'S SAKE

The New York Times, November 28, 2003

Following the trails of friendship, either for young performers or their parents, I found myself recently at two events stocked with aspiring musicians and actors. One was a program of Spanish music by Spanish students at the Manhattan School of Music; the other was an evening of three one-act plays by Horton Foote by second-year students at the Atlantic Theater Company Acting School.

Both programs gave considerable pleasure; young talents abounded. What struck me, however, beyond all the gifted individuals, was their sheer numbers. All the time, all over Manhattan and the country and the world, there are similar performances of well-trained, gifted, and ambitious young people, all making art. What will become of them?

Well, some will make it, meaning they will become the famous violinists or pianists or actors of tomorrow. Others will bide their time, hop-

ing and dreaming and painting in their studios or practicing their instruments or traipsing off to auditions. (In the meantime they may well be serving your meals, with whatever degree of skill and grace, at restaurants all over town.) Some of the musicians and dancers will forgo their soloistic dreams and join orchestras or corps de ballet. Others will grow discouraged, trailing off into teaching or marriage or some profession far removed from their youthful artistic dreams. Who knows? They may be happier later in life, as part of the educated audience, than they are now, restless and striving.

In three-plus decades in the arts, I have known artists of every age and level of success. The famous ones are those most people know, at least from afar. To be famous doesn't mean to be frivolous: most of our finest dancers and singers and painters work punishingly hard at their craft, constantly trying to sustain and reinvent their creativity.

But the ones who fascinate me almost more are those who haven't made it and yet still make art every day. Most of them do not enjoy inherited wealth; sometimes, wealth can sap the will. They have side jobs or they teach or they let their partner earn the family income.

I think of a painter who makes beautiful work and shows regularly at a decent SoHo gallery and sells a few pieces here and there. He lives a nice life but is rarely reviewed and not likely to get a show at a major museum. Or a choreographer who puts on honorable programs at which she makes no money and her dancers are barely paid. Or struggling indie rock bands whose best shot at getting heard is at scruffy clubs or over the Internet, neither likely to keep them in Dom Pérignon. Or authors who write every day and are not published, or are published but whose books are not reviewed and don't sell. Or classical soloists who carve out marginal careers in marginal repertory.

In our day, artists—writers especially—have found new outlets in the magical world of Web sites and Internet blogs, or e-mail messages to their friends detailing their travels and thoughts. The sheer outpouring of words on the Internet, words that are sometimes thoughtful and artful and even sometimes read, gives evidence of an enormous need on the part of vast numbers of people to pour themselves out creatively, whether the results are paid for or even seen or heard by others.

I also thought of a man named Jonathan Williams, who runs an outfit called the Jargon Society (www.jargonbooks.com), devoted to various forms of outsider art. That term is often invoked for artists who make eccentric work that falls beyond conventional critical categories, like

Simon Rodia and his Watts Towers. His towers were eventually recognized and preserved. But down to eccentric roadside attractions on the western plains, people feel an overpowering need to make strange and wondrous curiosities, and never mind whether they're nationally appreciated or even recognized as art.

Mr. Williams recently came forth with a lovely book of short texts and photographs of artists, known and little known and unknown, whom he has met along the way. The book is called A *Palpable Elysium: Portraits of Genius and Solitude*. Its subjects range from Ezra Pound and Henry Miller and Buckminster Fuller to some known only to Mr. Williams.

What struck me was how, deep down, fame and success had so little impact on the way these artists led their lives. Of course, success has its rewards: most everyone likes to be liked, and in some cases there's big money involved. But success also has its travails: fear of sudden failure, the need to sustain creativity or its illusion, the dangers of being trapped in a persona or style the public has accepted. And failure can of course lead to depression and anger.

Artists make art; that's what they do. They need to play music or paint or write or dance. And they find ways to keep doing it, however unsuccessful they may be. Sheer talent alone is not always what makes one artist successful and another not. Of course, luck is involved. But it also takes a special set of extra-artistic skills — the ability to charm or manipulate people, the willpower to stay out on the road, the fortitude to overcome adversity. Those who are not successful in this public sense are not necessarily lesser artists.

All those young musicians at the Manhattan School and all those young actors at the Atlantic Theater Company will variously succeed, persevere, or fail, meaning opt out of art altogether. I saw and heard at least one person at each performance whom I might confidently predict will be vastly successful, factors of luck and personality permitting. But others will find honorable careers on every floor of the temple of art. Including, maybe, the basement or out the door altogether.

And if it is out the door, maybe that's not all bad. The last play in the Foote trilogy was called *The Land of the Astronauts*. It's about a loving wife and a man who dreams obsessively and unrealistically of becoming an astronaut. As he describes over and over to his wife and daughter, being an astronaut is very much like being in paradise.

One day he snaps, out of disappointment and disorientation. His wife

brings him back into the family, into reality. And as he again tells his story of the heavenly joys of the land of the astronauts, we realize that what he's describing is his own family and his own home.

For astronaut, read artist. Sometimes, maybe, artistic dreams are best fulfilled in our everyday existence, by making art out of life.

THE COSMIC B-FLAT

The New York Times, January 30, 2004

Note: Given the general upward drift of pitch over the last 250 years, Bach's C was probably closer to our B-flat, making his C the fundamental tone of the universe, after all. This was still a fun article to write, and it was fun talking about it with Dennis Overbye, the Times Science section's master of cosmic mysteries.

Who knew? All those philosophers and scientists and theoreticians and composers who believed in the ancient notion of a Music of the Spheres were onto something. There is such a music, and it's the note of B-flat.

Or so scientists told us a few months ago when they announced that the Perseus galaxy cluster, 250 million light years from our little planet, was emitting that note, or a series of those notes, which "appear as pressure waves roiling and spreading as a result of outbursts from a supermassive black hole," in the words of Dennis Overbye, a science reporter for *The New York Times*.

The notes have a period of oscillation of 10 million years, which makes them "the lowest note in the universe." So said Dr. Andrew Fabian, an X-ray astronomer at Cambridge University in England and the leader of the team that discovered the note.

Most of the commentary since has been about the implications of this discovery for the study of black holes and hence of the physical properties of the universe. My interest is, to put it mildly, less scientifically informed and more aesthetically speculative.

These B-flats may be the oldest and the longest notes in the universe, but just how universal are they? My eye was caught by another recent

article in the *Times*, this one about a mysterious low hum that bedevils some people, a kind of basso variant of tinnitus, which is a high pitch likewise heard in the ears of sufferers. Are those sounds, I wondered, also in B-flat, suggesting an even more cosmic implication for this once-humble pitch?

Courtesy of Mindy Sink, who wrote the article, I entered into e-mail correspondence with Dr. James Kelly of the University of New Mexico, who undertook studies of hum sufferers in Taos. Dr. Kelly first clarified for me the difference between frequency and pitch. "Frequency is a physical measure," he wrote. "Pitch is what you perceive." Since the black-hole B-flat is fifty-seven octaves lower than middle C, it cannot be heard, thus only questionably qualifying as a pitch.

As for the hum, Dr. Kelly reported that it was close to 66 Hertz, two octaves below middle C. But he suggested that other patients heard hums as low as the lowest E on a piano. No specific correspondence with B-flat, but one can always hope.

Back to the macro picture, the black hole B-flat. If that frequency (or pitch) is now the acoustical bedrock of the universe, perhaps our entire tuning system, centered on middle C, needs revision. The Western harmonic system involves keys with increasing numbers of sharps and flats exfoliating out from middle C, or from C major, all white keys on the piano. Now, perhaps, we have to exfoliate from B-flat. Maybe this is as big a shift in human thinking as that from a flat earth–centered universe to the solar system. Or maybe not.

As a digression, I thought of the California composer Terry Riley. Mr. Riley, always something of a cosmic mystic, won his first fame in 1964 with his composition *In C*, which has been endlessly recorded and played, in part because it's so beautiful and in part because it's so ingenious: a series of simple melodic figures that any group of any kind of instrumentalists may play according to certain simple rules, setting up a dappled tapestry of sound.

Mr. Riley's most recent piece attests to his fascination with the cosmos. It's called *Sun Rings*, and although lavishly praised on the West Coast (the Kronos Quartet performs it), it hasn't yet made it to our benighted eastern outback. *Sun Rings* is based on "space sounds" recorded by Dr. Don Gurnett of the University of Iowa. One wonders idly if B-flat plays any special role. To judge from *In C*, Mr. Riley is a C man.

According to the music encyclopedias, the Internet, and Jamie

James's chatty book *Music of the Spheres: Music, Science, and the Natural Order of the Universe*, thinkers and artists have been less interested in what might be designated a universal fundamental tone than in the relations between the tones: scales and modes and keys.

Tables ascribing emotional characteristics to keys have poured out over the centuries, back to the ancient Greeks. The most complete compendium of these descriptions was compiled by Dr. Rita Steblin in a book published by the University of Rochester Press and titled *A History of Key Characteristics in the Eighteenth and Early Nineteenth Centuries*, although she ranges far earlier and later than that. Check it out for $95 plus shipping on Amazon.com.

The descriptions were always highly subjective, but those in Dr. Steblin's book for B-flat major (let's try to keep this reasonably simple, avoiding B-flat minor) generally call it a happy key. "Magnificent and joyful," as per one early French source. "Noble," thought another Frenchman. "Condescending greatness mixed with venerable seriousness," said a late-eighteenth-century German. "Cheerful love, clear conscience, hope, aspirations for a better world," wrote another. "Tender, soft, sweet, love, charm, grace," according to an Italian.

If we listen to these sages, a B-flat universe is not such a bad place to be. And if we buy into August Gathy, a Frenchman who wrote in 1835, the key relates to "noble womanliness," too. Maybe there's something to Erda or Gaia, after all. Check out www.gaiaconsort.com, a site devoted to "music for freethinking pagans, humanists, psychedelics, visionaries, wiccans, mystics." Perhaps Mr. Riley already has.

Before we reluctantly leave the concept of keys, here is a highly selective list of well-known compositions in B-flat major; make of them what you will: Beethoven's "Hammerklavier" Piano Sonata and Symphony No. 4, Brahms's Piano Concerto No. 2, Haydn's Symphonies Nos. 98 and 102, Prokofiev's Symphony No. 5, Schubert's Symphony No. 5, Schumann's Symphony No. 1.

But perhaps we're getting ahead of ourselves, besides managing to annoy any serious acoustician or physicist or musical theorist. The universe has not yet been detected as emitting music in any key or mode. It is just steadily (and very slowly) singing the note of B-flat, over and over. What song did the sirens sing? What note? What key? We await further word from our intrepid scientists, ears cocked to the cosmos.

THE KIROV OPERA *RING*

The New York Times, February 2, 2004

Baden-Baden—Aside from being mostly a real pleasure to sit through during four evenings, the Wagner *Ring des Nibelungen* cycles presented by Valery Gergiev and his Kirov Opera at the Festspielhaus here were historically significant. Epochal, even. They confirmed the strength of the Kirov company outside Russian repertory, opened up a sudden new reservoir of Wagner singers and helped establish the five-year-old Festspielhaus as a real player on the German opera scene.

In July 2001 Mr. Gergiev and the Kirov Opera presented six Verdi operas and the Requiem in London. By all accounts the performances were underprepared, undercast, and unidiomatic. Then one heard tales of the Kirov's stumbling efforts to stage the *Ring*: productions by German directors of *Das Rheingold* and *Die Walküre* scrapped and exploratory discussions with still other stage directors.

Mr. Gergiev has proved himself a sure Wagnerian at the Metropolitan Opera, where he is principal guest conductor, and elsewhere. But even with some positive reports from the cycle's inauguration in June in St. Petersburg, who knew quite what to expect?

The performances from January 22 to 27, which involved some cast changes from those in December and some tweaking of the stage direction, were not to every taste. One dyspeptic British critic would concede only that at its best the cycle rose to something "almost like a performance." But for me, and I was not alone, this was a *Ring* to match the four or five most important stagings since the middle of the last century.

Not least, it established Mr. Gergiev as not just a competent but a masterly Wagner conductor, and his Kirov Orchestra as the equal of any other in this music. The pacing and phrasing were deeply satisfying but always original (sometimes a little too original, as in the breakneck speeds for the hero's impetuousness in *Siegfried*). Mr. Gergiev rose to the heights—all of *Die Walküre* and "Siegfried's Funeral March" and the "Immolation Scene" from *Götterdämmerung* especially—with rare nobility. And the orchestra's rich sweet strings, dark-hued brass, and dazzling solos (the horn calls in *Siegfried*) gave rare pleasure.

Remarkably the singers were all Russian, and every one was heretofore unheard (outside of the two previous cycles) in this music. Most were first-rate, ready to leap into any top-level cast in the world. And an

amazing number were under the age of thirty. Their German was generally excellent, trained by the diction coach of the Bayreuth Festival.

For singers and orchestra, there was a continuous sense of the music being discovered fresh. Sometimes, for all the coaching, this led to heavily accented German and uncomfortable phrasing. But more often it suggested the thrill of the new.

No one was downright bad, but there were standouts. The Sieglinde of Mlada Khudolei; the Siegmund of Oleg Balashov; the three Brünnhildes of Olga Savova (also the eloquent Waltraute in *Götterdämmerung*), Larissa Gogolevskaya, and Olga Sergeeva; the young Siegfried of Leonid Zakhozheev and the older Siegfried of Sergei Liadov; the Fasolt and Wanderer of Yevgeny Nikitin; the Fafner and Hagen of Mikhail Petrenko; and the sixteen full-throated Valkyries deserve special mention. It was as if a whole new world of Wagner singing had suddenly opened up.

And then there was the look of this *Ring*. After his experience with German directors, Mr. Gergiev changed course. Instead of proving that the Kirov could do yet another modern-day German *Ring*, he decided to make something unique to his company and country: an archaic Russian *Ring*.

His collaborator was the stage designer George Tsypin, who was born in Kazakhstan, trained in Moscow, and has been long resident in the United States. Together they created primordial, magical stage pictures, reminiscent of the look of the Diaghilev-era stagings still in the Kirov repertory. They drew on Russian, Caucasian, and especially Scythian folk mythology; Mr. Gergiev himself comes from Ossetia in the Caucasus.

Central to the imagery are four giant figures, like gods, overlooking the action of the puny mortals and the puny Wagnerian gods. But there are also little figures like African mud men, with sticks and roots sprouting from their heads; Americans of a certain age might think of shmoos. All of these creatures, large and small, were made of translucent fiberglass and had hearts that glowed red or white from within.

There were dancers in Day-Glo hair (orange for fire, green for water) and glow-from-within rocks, all lighted with fantastical purples and greens and yellows by Gleb Filschtinsky. It was wild, delirious, with even a whiff of Matthew Barney's weirdness. Yet the cross-cultural archetypes worked freshly with Wagner's Germano-Icelandic inspirations.

But—there's always a but—the stage direction wasn't very inventive, or even consistent, or even sometimes existent. Siegmund's sword wasn't broken, then appeared later in pieces, then was reforged into something shaped entirely differently. The Tarnhelm in *Das Rheingold* was not the same Tarnhelm as later on. Tatiana Noginova's costumes were usually striking but sometimes peculiar and wildly heterogeneous. And some of the staging, as when dancers clumsily enacted Siegfried's sword-forging scene while he stood there flexing his muscles, looked downright silly.

"Directors are not so important," Mr. Gergiev said backstage, and for him, they are clearly not. Two were credited, Julia Pevzner for the first two operas and Vladimir Mirzoev for the second two, but this was a visual *Ring*, not a directed one. Sometimes—as in *Die Walküre*—the singers interacted intensely. Sometimes they seemed left to their own devices. Nowhere, for better or worse, was there any kind of German *Konzept* to be seen.

As such the Kirov *Ring* amounted to a rejection of the entire Germanic postwar operatic scene, in which stage directors have seized control. This was not an old-fashioned stand-and-sing *Ring*, but it did not concern itself overmuch with directorial niceties, either. Yet most of the important German newspaper critics seemed to enjoy themselves; perhaps directorial excesses have provoked their own reaction, even in Germany.

For the Baden-Baden Festspielhaus, privately supported and often mocked for its supposed commerciality, the Kirov *Ring* has put it on the map. And there is more Wagner to come this season, with two nights of excerpts conducted by Christian Thielemann, a staged *Parsifal* with Kent Nagano, and an original-instruments *Rheingold* conducted by Simon Rattle.

For the Kirov company the *Ring* is a continuing proposition, to be seen again at home and in Tokyo and, who knows, in the United States and still other countries. It has won its German imprimatur, which is as important as had Mr. Gergiev taken his Verdi festival to Italy and triumphed. Yes, more tweaking is necessary; directors aren't so unimportant after all. But this was already a pretty extraordinary experience.

OPERA AND ROCK

The New York Times, **February 6, 2004**

"It's better to burn out than fade away," once proclaimed Neil Young, who is still pretty unfaded at fifty-eight. "Hope I die before I get old," wrote Pete Townshend, also fifty-eight.

Of course, lots of rock stars did die young, and their short, intense lives are the stuff of legend. Without suggesting a lemminglike mass suicide of today's opera stars, maybe a little rock-and-roll abandon is just what they need.

I thought of all this, improbably enough, during the Kirov Opera's *Ring des Nibelungen* last week in Baden-Baden, Germany. Whatever you thought of the staging and design, the performances revealed a wealth of new Wagner singers, all Russians.

Many were young and audibly excited to be singing this music for the first time (or nearly so, since they had sung in two previous cycles). The way Mlada Khudolei, for instance, threw herself into Sieglinde's ecstasy and terror in *Die Walküre* made her about the most exciting exponent of the role since Leonie Rysanek.

Or the way the *Götterdämmerung* Brünnhilde, Olga Sergeeva, tore into the "Immolation Scene" really put a cap on the whole *Ring*, abetted, to be sure, by Valery Gergiev and his wonderful orchestra. Too often, for me, the end of the *Ring* is anticlimactic, a stolid soprano standing there pouring out notes, the orchestra cranking through its leitmotifs, and the director and designer ladling on whatever special effects they can muster. Here, Ms. Sergeeva sang as if the fate of the world really were at stake.

Mr. Gergiev has a reputation for driving his singers into vocal crisis through miscasting and overwork. Galina Gorchakova, so lovely a decade ago and rarely heard from now, is often mentioned as a case in point. To be fair, other singers have managed to sustain healthy careers under Mr. Gergiev's ministrations: Olga Borodina, for one.

Still, Mr. Gergiev has left himself open to charges of vocal exploitation in his *Ring* casting. Olga Savova, the *Walküre* Brünnhilde, seems to have previously sung only mezzo and alto roles, although she nailed her high notes; she also reappeared as an eloquent Waltraute (a mezzo part) in *Götterdämmerung*.

Leonid Zakhozheev, who looked handsome and sang handsomely as

the young Siegfried, with plenty of range and endurance for the punishing final duet with Brünnhilde, has until now specialized in light tenor roles like Almaviva in *Il barbiere di Siviglia*, although he's done Lohengrin, too. A goodly number of the singers of heavy parts in this *Ring* were still in their twenties.

Such casting would horrify most American vocal coaches. Steven Blier, a singing teacher at the Juilliard School and codirector of the New York Festival of Song, wrote an interesting article for *Opera News* last year in which he lamented a climate of caution in the recent training of American singers. Starting with the vocal crises that struck a number of singers, primarily exponents of Italian verismo, at the Metropolitan Opera in the 1960s and early '70s, he documented a subsequent retreat into prudence.

Voice teachers became extremely conservative, he wrote: "The most successful ones were imparting a philosophy of vocal safety and longevity. . . . Chest resonance was eschewed as 'dangerous.' . . . There was a sense that full-voiced high notes were somewhat vulgar, and that floated pianissimos were a sign of class and control. Students were kept on the light side of their potential sound and generally funneled into lyric roles."

The "tenet of the times," Mr. Blier concluded, was "'the big stuff will kill you.'"

Of course, there were reasons for this change in style other than fears of vocal burnout. Tastes shifted toward Handel and Mozart, and singers like Renée Fleming, who excelled in both, also brought a cool, controlled sound to Richard Strauss.

But when Ms. Fleming lets 'er rip, as she has recently in Verdi, she's downright thrilling. Whether she secretly fears that in so ripping, she is endangering her voice, I know not. I hope not.

Common sense would tell us that singers (and their teachers and conductors and advisers) need to preach some limits. But they can't be too timid. A climate of excessive caution has robbed opera of the animal excitement it needs to thrill a large audience. Luciano Pavarotti knew his limits, even when he pushed into roles not really suited to his light spinto tenor: Radames in *Aida*, and finally Otello. But the sheer passion of his attack in those parts brought its own considerable reward. And for all his recent troubles, vocal and otherwise, Mr. Pavarotti has certainly enjoyed an extended career.

The archetype for vocal excess was, of course, Maria Callas. She lost

all that weight, she took on all those parts (even, in her misguided youth, Isolde and Kundry). Sure, her soprano gave way at a relatively early age. But she had a good fifteen years of fame. And, by the by, she was the most exciting, beloved singing actress of her century.

The history of opera is replete with youthful debuts: Conchita Supervia at fourteen, Maria Malibran at seventeen, and on it goes: Callas sang Tosca in Athens at eighteen. Some of these (Anja Silja doing the Queen of the Night at nineteen and Isolde and Brünnhilde in her early twenties) ran into difficulties. Some recovered from their crises (Ms. Silja is singing still, at sixty-eight); others did not. But German singers routinely took on Wagner in their twenties a century ago, and had notable careers. American voice teachers still fret that their tender young charges will be chewed up in the German repertory system.

But there's a counterargument. Mr. Blier goes so far as to suggest that technical deficiencies contributed to some singers' popular appeal. "These very 'flaws' may have been precisely the elements that made their sound so magnetic," he wrote. In other words, smooth out the edges, and you smooth out the appeal.

"They sang from their gut," Mr. Blier quotes the mezzo Rosalind Elias as saying about the singers of the Met's vocal golden age of the 1950s. "They didn't hold back." Cautious singers appeal only to a cautious public.

Far be it for me to suggest the deliberate, self-imposed ruination of any singer's voice. Singers nervously (neurotically) struggle to preserve "their instrument"; it's their self-image and their income. But opera would prosper with more reckless abandon. The prima donnas of yore were larger than life not in their girth, the bane of so many placid Wagner sopranos today, but in their appetites for life and willingness to sing with passion. Taking vocal risks was a big part of that passion.

People fret about opera's increasing irrelevance, and there are a lot of reasons for that and a lot of exaggerations in the death laments as well. That said, the Gergiev *Ring* was thrilling partly because we heard singers throwing caution to the winds and singing as if their lives depended on it. They sang as if Wagner still mattered, desperately. And for those few hours, he did.

RODDY DOYLE AND JAMES JOYCE

The New York Times, February 20, 2004

Earlier this month British and even American newspapers (including *The New York Times*) were abuzz with the news that Roddy Doyle, whom many count as Ireland's greatest living novelist, had attacked James Joyce, whom most count as Ireland's, and maybe modernism's, greatest novelist.

"People are always putting *Ulysses* in the top ten books ever written, but I doubt that any of those people were really moved by it," Mr. Doyle was quoted as saying at a symposium on Joyce and Irish writing at Ireland House at New York University. The symposium was intended to celebrate Joyce's 122nd birthday, no less. Mr. Doyle reportedly added that *Ulysses* "could have done with a good editor" and that he had "read three pages of *Finnegans Wake* and it was a tragic waste of time."

All of this caused great glee in Britain, especially among the tabloids, which love likening Irish literary spats to bar brawls. For me, though, as an admirer of both Joyce and Mr. Doyle, it caused some pain.

I finished "Ulysses" at 1:43 A.M. on January 16, 1963; I know because I noted the date and time at the end, and how moved I was. For years I would intone Stephen Dedalus's peroration at the end of *A Portrait of the Artist as a Young Man*: "Welcome, O life! I go to encounter for the millionth time the reality of experience and to forge in the smithy of my soul the uncreated conscience of my race." I thought it Emersonian, but soon realized it was Wagnerian, too, Joyce having been a fervent Wagnerian.

As it happens, I own an original three-volume set of the complete *Revue Wagnerienne*, a symbolist journal that appeared in Paris from 1885 to 1887 by Édouard Dujardin. In 1888 Dujardin published a stream-of-consciousness novel called *Les lauriers sont coupées* (*The Laurel Trees Have Been Cut Down*) in direct emulation of Wagner's leitmotif technique as he understood it, transposed into prose. Joyce later claimed that *Ulysses* had been partly inspired by *Les lauriers sont coupées*, which gave Dujardin, who had long since lapsed into obscurity, a late life as a lecturer all over Britain and the United States, telling how he had influenced Joyce.

More recently I intoned that uncreated conscience bit to a young Irish novelist friend to urge him on. Of course he knew it already, but he graciously professed to share my enthusiasm.

Not everyone leaped on Mr. Doyle, however, or leaped to Joyce's defense. A number of writers in more serious papers defended Mr. Doyle's right to bash an icon, and some Irish newspaper writers even conceded that they had always found Joyce rather a hard slog.

Never mind that Mr. Doyle's remarks seem to have been ripped out of context. The novelist Colum McCann, who along with Frank McCourt was part of the NYU symposium with Mr. Doyle, wrote in *The Irish Times* that Mr. Doyle had heaped praise on Joyce and *Ulysses* before making what those at the symposium perceived as lighthearted cracks about overworship.

According to Mr. McCann, Mr. Doyle also made a compelling, provocative argument linking the Jewishness of the novel's prosaic hero, Leopold Bloom, to contemporary Irish controversies about immigration. Ten years ago I interviewed Mr. Doyle at his Dublin home and found him forthright but nervous about the journalistic propensity to distort his opinions. I wonder what he thinks now. Mr. McCann cited a Seamus Heaney poem: "Whatever you say, say nothing."

Some of what Mr. Doyle said, even in the tabloid reports, seemed less controversial. He made fun of the latter-day Joyce industry, which is gearing up to a promotional frenzy before June 16, 2004, which will be the centenary of the day on which Leopold Bloom took his memorable journey through the streets of Dublin. For the anniversary, ten thousand people are expected on O'Connell Street for a meal of fried offal and mutton kidneys, all washed down with Guinness. "They'll be serving Joyce Happy Meals next," Mr. Doyle joked at NYU. "ReJoyce 2004," as the centenary festival calls itself, also promises a music-and-light spectacular along the River Liffey.

We know, more or less, through the journalistic prism, what Mr. Doyle thinks. But what might Joyce have thought about all this? He wrote *Ulysses* in self-imposed exile in Trieste and Paris; Paris was also the home of Samuel Beckett, who wrote in French and English (not Irish; few Irish novelists have gone that far). Now, in the new Europe, Dublin bills itself, not without merit, as a mecca for hip young people. At least some Irish novelists, like Mr. Doyle, actually live there. Would Joyce be proud of his ten-thousand-person Happy Meal, or ashamed, or amused?

"The name Shakespeare in Britain is rather like the names Ford, Disney, and Rockefeller in the United States," the literary critic Terry Eagleton wrote in *The Nation*. "He is less an individual than an institu-

tion, less an artist than an apparatus. Shakespeare is a precious national treasure akin to Stonehenge or North Sea oil."

A writer in *The Independent* of Ireland accused "ReJoyce 2004" of turning Joyce into "just another brand—along with Guinness, Kerrygold, freckled redheads, the Chieftains and U2."

All of which leaves Mr. Doyle and Joyce on the sidelines of a larger squabble about the elitist and populist approaches to honoring a national cultural heritage. Mr. Doyle is a wonderful writer, and he shows few signs of slowing down. He writes novels and children's books and screenplays and television scripts. His latest trilogy, still in the making, promises to expand the Irish experience onto an epic, magical canvas far grander in scale than his earlier trilogy, which made his reputation with its quirky, charming evocations of the fictional Dublin working-class neighborhood of Barrytown. That first trilogy was turned into three fine films: *The Commitments, The Snapper,* and *The Van.* If Joyce was Wagner, Mr. Doyle is rock and roll.

In its report of the NYU teapot-tempest, *The Guardian* of London duly noted that amazon.co.uk has sold 97,107 copies of Mr. Doyle's *Paddy Clarke Ha Ha Ha,* which won the Booker Prize in 1993, compared with 2,374 copies of *Ulysses.* To be sure, *Ulysses* sold a few copies in bookstores before online ordering existed. Like the one I devoured back in 1963.

Joyce has earned his place in the literary firmament: a star called James, one might say, to echo Mr. Doyle's most recently published novel, *A Star Called Henry.* Joyce can suffer attacks now, even jocular and admiring ones as Mr. Doyle's apparently was. After all, there have been major writers (Tolstoy, Shaw) who had little use for Shakespeare. If Joyce created the conscience of his race, Mr. Doyle is honorably expanding it. He makes us consider it anew with his every book and every utterance.

STRINDBERG AND HELIUM

The New York Times, May 28, 2004

Strindberg looks rather like photos of that morose, visionary late-nine-teenth-century Swedish playwright and novelist, as rendered by some-body paying homage to the campily creepy cartoons of Edward Gorey. Helium is a little pink round floating balloon, with eyes and eyebrows and a red mouth with little teeth when she smiles and flipperlike wings and tiny feet tucked away like those of a bird in flight.

They are the protagonists of four miniature animated films viewable on the Internet under the title *Strindberg and Helium*. In "Absinthe and Women," Strindberg tries to pick up a woman in an opera box; she flees. In "The Park" Strindberg wanders among dead leaves, Helium floating helpfully nearby. In the third, "At Home with the Kids," Strindberg finds the cheerful cries and intrusions of children upsetting. In the last, "Sul-phur and Iron," he tries to make alchemical gold of those elements, fails, and is rewarded by Helium drifting down with a cupcake on her head.

Each film begins with little Helium floating up to Strindberg's cheek and planting a kiss on it, accompanied by the sucking pop sound famil-iar from all cartoon kisses. Thereafter, Strindberg intones funereal pro-nouncements like "the fallen leaves are rotting" or "the whole of nature stinks of decomposition and decay" or "we are already in hell" or "the agony becomes intolerable." Cheerful Helium echoes the ends of his sentences, several squeaky octaves up: "rotting," "hell," "decay, decay."

I find these films, which can be seen and heard free on www.strind-bergandhelium.com, funny and sweet and adorable. They were con-ceived by two members of a San Francisco comedy troupe called Killing My Lobster, most of whom went to Brown University in the mid-'90s. Erin Bradley, who wrote the text, is the voice of Helium, and James Bewley is Strindberg. The films were animated by Eun-ha Paek, who is part of a computer graphics collective called Milky Elephant, then in San Francisco, now in Brooklyn. Strindberg's words are drawn from his novel *Inferno* and his *Occult Diary*.

Some reasonable (if humorless) people might find *Strindberg and Helium* trivial. For me, these films represent a delicious skewering, affectionate and satirical, of European dead-white-male pretensions by American pop culture by way of Japanese anime (it's not far from

Helium to Kitty, as in Hello, Kitty), with no slight, and all due deference, to Europe, Japan, or the United States.

They also seem to encapsulate a lovely image of male-female characteristics and relationships (no matter that Helium might be interpreted in some scholarly quarters as Strindberg's own basso voice jacked up to stratospheric levels by that very gas). It's probably no accident that Ms. Bradley and Mr. Bewley have a comedy act called "The Man/Woman Show." These films contrast male moroseness with chirpy female supportiveness from a decidedly female perspective.

I also love them because they represent something rather wonderful among the youth of America. This country has a penchant for sweet silliness, like the new sport of extreme ironing. People tend to cling most closely to the art and entertainment of their generation. It's nice to be reminded occasionally, and forcefully, that young creativity is bubbling up all over the map, and not just in San Francisco—in indie films, in garage rock, in dance, in comedy, in video, in animation.

A lot of this new art is abetted by the Internet, which is both a curse and a blessing, mostly a blessing. It's a curse because people create lovely things like *Strindberg and Helium*, post them on a Web site, and then—what? They could get lost.

Except insofar as they may serve as calling cards for commercial work, be it in film or television or rock videos, they don't make much, or any, money. Ms. Paek said on the telephone the other day that while the three creators have vague plans for *Strindberg and Helium* sequels, they're too busy with other, presumably more remunerative projects. At least their site has links to a merchandising arm: you can purchase T-shirts and thong underwear and baby bibs and mugs and mouse pads and lunchboxes and Frisbees, all with Strindberg or the cuter Helium or both emblazoned upon them.

In terms of mainstream media attention, these films have been pretty much ignored. There have been short mentions in *USA Today* and *Entertainment Weekly*, and that seems to be about it, along with appearances, among many other entries, in a couple of film festivals and museum shows.

But the Internet is a blessing because this kind of work can reach a whole new constituency, on its own terms and its own timetable. It is passed from hand to hand, like a prized secret. Secret sharing. These films came out two years ago but are still percolating through the Web. Google lists almost a thousand sites, thirty-three pages' worth, nearly all

blogs and personal online exchanges. People love these little films and want their friends to know about them. And if newcomers respond to them as I have done, they think kindly of the friends who called the films to their attention.

The Internet (like radio and television before it) has been lamented as a force encouraging the grim atomization of society. Before, legend has it, we happily congregated in cafés and theaters, building communal solidarity. Now, we sit forlornly in front of our monitors, logging on to nastiness. For me, it's just the opposite. Reading books is a solitary activity, and few lament that. The Internet reinforces community; it builds new communities. Just as e-mail has led to a rebirth of the epistolary impulse, the Internet creates new bonds between people who share their passions. Of course, those passions may include darker impulses as well as the utterly innocent *Strindberg and Helium*. But that's democracy, the kind we're trying to build worldwide.

So one more thing: It's been sometimes difficult in recent months to feel good about America. One needn't recite the litany of pride, arrogance, stupidity, and cruelty. But while wallowing in our well-justified gloom, it's salutary to come across something as sunny and sweet as *Strindberg and Helium*. It doesn't hurt anything (including Strindberg's august reputation; it may even lead some to *Miss Julie* and *A Dream Play* and all the rest). It's creative and nurturing, and we need all of that we can get.

GEEZER ROCK

The New York Times, August 6, 2004

Over here at the Sunshine retirement home in South Florida we got all excited the other day when we read that Jimmy Buffett had placed his new album, *License to Chill*, at the top of the Billboard magazine album chart—exactly thirty years after first appearing there with *Living and Dying in 3/4 Time*, which peaked, as they say at *Billboard*, at number 176.

What a triumph for us geezers, and for geezer rock! Pop music is rou-

tinely perceived or dismissed as youth music, and barely pubescent youth music at that. Here today and gone tomorrow, or at least gone into the file of potential "where are they now" television shows. But here's Mr. Buffett, plugging away in Margaritaville, and darned if he doesn't top the charts.

Keeping with Mr. Buffett's preferred Key West imagery, it may be that he lucked out a little, catching the chart in a trough between the cresting waves of bigger-selling CDs. He sold 234,000 copies in the United States of his album, but that's hundreds of thousands less than some artists sell in their first week out. And Mr. Buffett lasted only a week at the top, bumped by Jessica Simpson's kid sister Ashlee, who sold 398,000 copies of her *Autobiography*. The younger Ms. Simpson is nineteen; Mr. Buffett is fifty-seven. Still, number 1 is number 1.

The idea that pop music is only for the young is simply wrong, meaning at odds with the facts both past and present. Yes, from Rudy Vallee and Frank Sinatra and Elvis Presley on, youth has had its idols, and some of those idols fade just as rapidly as the youth of their fans.

But music then and now is made as much by professionals as by eager quasi-amateurs. Blues and country musicians grew honored with wizened age. They toured and they made records, some of them selling out big theaters and even arenas, others trudging along the club or roadhouse circuit, but always making music and giving people pleasure. Just like Mr. Buffett.

The last time I encountered him was five summers ago at, of all places, the Bohemian Grove, that secretive hideout for the WASPy rich and famous in its own towering stand of redwoods up by the Russian River, north of San Francisco. Mr. Buffett sang his songs, and the assembled men (no women at the Grove, except now as waitresses) sat there in their arboreal amphitheater and enjoyed him, even though for half the audience he was a memory from their youth and for the other half an unknown young pup.

Pop artists who last into old age, still playing before the public, tend to settle into a groove. Or a rut, if you're feeling pessimistic. Chuck Berry is famously cynical about his art and his audiences, coming into town alone, cursorily rehearsing with whatever pickup band is on hand, demanding his cash in advance, cranking out his oldies, and getting out of town as fast as he can. But his oldies are still great and he cranks them out pretty well.

To last, an artist has to love to tour, or at least accept it as a job that

must be done. James Taylor, who made it to number 4 on the chart with his last album, gets genuine pleasure from performing. You can see it from his shows, but I also know this because I know him and because his wife and his fellow singers tell me so.

The phenomenon of old singers reaching new heights (for them) of popularity is not simply a question of baby-boomer singers and audiences growing up together, getting used to each other, but it's partly that. The willingness of aging audiences to turn out for older artists, in concerts and at record stores, gives the lie to the wisdom that youth must always be served.

But older artists can have young fans, too; witness the seemingly eternal popularity of the Beatles. And youth artists can age into lifelong artistic maturity, singing very differently from their youth-idol days; witness Sinatra.

License to Chill represents no such maturation. It is a pleasant Buffett CD, ideal for summertime listening, the novelty being an overt attestation to his kind of Floridian folk rock with country music, including duets with several country singers. Both musically and tactically, this makes a lot of sense, since country music has long proved resistant to youth fads and has honored its mature performers.

There is an entire tradition of American popular music, stretching back to the dawn of the recorded era more than a century ago and before that, as transmitted by oral tradition, that has nothing to do with youth. If you wish, this is "folk" music, meaning music for the folk, although modern electrified pop is just as much for the folk as the Carter Family ever was.

Folk music progresses, or evolves, in incremental jumps, punctuated by major leaps, as in the advent of someone like Bob Dylan (not that anyone is quite like Bob Dylan). An old song, dating back to the mists of anonymity, is picked up by someone new and given new verses and melodic twists and a new infusion of personality. It becomes part of a quilt, stretched over time.

The problem today, one that Mr. Buffett has not quite escaped, is the numbing demand of mass audiences to hear the songs they love sung just the way they're used to hearing them. How Mr. Taylor manages to invest his umpteen-millionth rendition of "Sweet Baby James" with the same innocence and earnestness and lingering sadness, time and time again, is a mystery to me.

Mr. Dylan, as he's been all his long life, is an exception. By refusing

to sing his oldies the old way, by torturing them into new shapes and sounds, he keeps himself fresh even if he alienates some nostalgist fans. He's still a quintessential touring pro, although his incessant performing sometimes looks more like a hamster in a wheel than a singer who just loves to tour.

Mr. Buffett travels a lower road but a still honorable one. He sticks to his comfortable, laid-back image and style, a sleepy Dean Martin for a new generation. But he makes good, listenable music, and he makes it for everyone, young and old. So more power to him, now and for decades to come. If Billboard gives him something for having made it to number 1, I hope it takes pride of place on his mantelpiece. If they have mantelpieces down in Margaritaville.

ANN HAMILTON: ART AS THEATER
The New York Times, September 24, 2004

Stepping through a small, cluttered room that is part of another exhibition, you enter out onto a platform overlooking a vast space. What you see is the huge, long, rectangular structure, a converted factory, that is the heart of Mass MoCA, the rambling contemporary art museum in North Adams, Massachusetts.

That space has been filled with other art before now. This time you see first a field of white, which turns out to be pieces of blank writing paper through which museumgoers are blissfully kicking their way, as if it were the first snow of the season. One girl was happily cartwheeling.

There is lots more at work here: forty strange machines that slide back and forth on the ceiling, sucking ("inhaling" is the artist's word) sheets of paper off stacks and then releasing them, to swoop and dart downward toward their fellows on the floor. Loudspeakers rise and fall mechanically, whispering hypnotic words that shift as the speakers move and you move in relation to the speakers. Brilliant sunshine illuminates the room, filtered by reddish silk.

There is a smaller middle room at the far end, dark and a little threatening, in which loudspeakers spin furiously on tethers over your head,

and from which emerges music by Meredith Monk. Upstairs from there is a kind of austere church, with thirty wooden benches, and another breathtaking shot, a reverse shot, from the balcony back over the big room.

I have gone on in such detail about Ann Hamilton's *Corpus*, which will remain on view until October 16, because it is so striking and because it moved me in ways I am still trying to figure out. It helped to have made a pilgrimage up into the Berkshires to see it; pilgrimages sharpen anticipation and focus the mind. Ask Wagner, with his festival in the little town of Bayreuth, far away from everywhere.

Ms. Hamilton's work, encountered in person or evoked through the photos and text in Joan Simon's beautiful book about the artist, has long fascinated me. I think one reason, beyond the sheer, ineluctable imagination and beauty so evidently on display, is what it tells us about the state of edgy arts today, and about the latent theatricality of all installation art.

The twentieth century brought a breaking down of the fetishism of technique, and a subsequent rebuilding of new traditions and new techniques, now freshly individual. Ms. Hamilton's work is based on an evident tradition of art installations, which Ms. Simon (who is a friend of mine) calls "the dominant strain of art making in international events," like biennales. Ms. Hamilton's work is incontestably original. But it shares with other installation art—by the likes of Robert Gober, Robert Wilson, Olafur Elliason, and, extending the art into video, Bill Viola—a painstaking determination to articulate ideas pristinely and exactly.

But before they reconstructed their own techniques, artists were encouraged in the interim to explore. The breaking down of technique left artists free to venture beyond their old boundaries. Dancers could sing and make films (Ms. Monk) or dance in art installations (Pina Bausch). Filmmakers could compose and make music-theater pieces (Hal Hartley). Painters could design for the stage (too many to mention) or perform themselves (Laurie Anderson). Poets could rock (Patti Smith).

For Ms. Hamilton and her fellow installation artists, art can embrace everything, from poetry to music to video and film to recorded and live performance. But for me, the most profound extension of the traditional notion of art, as something contemplated in tranquility, is to theater. Installation art like *Corpus* is a new kind of theater, which may (as in Ms.

Hamilton's collaborations with the dancer Meg Stuart and with Ms. Monk, in their *Mercy*) or may not involve live performers.

The sheer spectacle of that first encounter with the huge white room at Mass MoCA is inherently theatrical, even operatic. Narratives are implied without being spelled out, but that's true of a lot of contemporary theater, too. Charged drama quivers in the air, powerful but elusive.

Ms. Hamilton and Mr. Wilson respect each other, and well they should. Mr. Wilson has done art installations, too, and spectacular ones. Ms. Hamilton has not extended herself so overtly into theater as Mr. Wilson has done, but the aura of theatricality, the promise of unpredictable events that could flash by in a heartbeat, is present in all her work. Mr. Wilson slows down time in his theater; Ms. Hamilton speeds it up in her art, in comparison with the stasis of a painting or a sculpture.

Back in the 1960s, Mr. Wilson emerged from painting—and from therapy for brain-damaged children. For him, conventional theater was way too busy, a disorientating onslaught of information, pushing and shoving its way into the brain, blunting his own responses. He wanted to slow things down, and slow them down he did.

Ms. Hamilton's *Corpus* represents another way to freeze time. Things happen on the micro level, within the vast macro grandeur of the space: the paper suction machines glide eerily along their tracks, loudspeakers rise and fall and spin, voices whisper, music bounces off the walls. But the overall effect is contemplative, like more conventional art. You stand there, mesmerized, but you can take everything in at your own pace.

A lot of this work owes a debt to John Cage and other conduits into Western culture of a meditative Asian sensibility. Staring at Ryoanji, the famous Buddhist rock garden in Kyoto, provides a pleasure much like installation art. Even when violent events are intimated, as with the culvert pipe driven through the body of the Virgin Mary in Mr. Gober's untitled installation from 1997 at the Geffen Contemporary museum in Los Angeles, the atmosphere remains hushed, as in a crypt.

If you're prone to perceiving drama, you can perceive anything anywhere as theatrically charged, or as art. In the fraught interrelations of two figures in a Vermeer painting, or in the casual clashes of real people in real life, on the streets. But installation art seems to invite such responses.

In *Corpus* Ms. Hamilton points to a world of echoing, chilly spaces, but with warm light filtered through her silk, of happy children

(because they're as much a part of the piece as how the artist lured them there), of hushed intimations, of whirling danger, of churchy contemplation. Passing through this huge piece is like a twenty-first-century pilgrim's progress, a book of the hours in which we move from awe to disorientation to fear to sovereign observation from on high.

Work like this challenges the stale conventions of dividing the arts into neat little categorical boxes like classical music, pop music, dance, film, television, and art. Artists have broken out of their categorical cells, sloughed off their categorical chains. They make art that crosses all boundaries, bursts out of all boxes. All we art lovers have to do is put aside our old expectations and hang on for the ride.

THE WOMAN IN WHITE
Opera, December 2004

Feelings about Andrew Lloyd Webber run toward the overheated, especially on the negative side. Tune thief, cynical pasticheur, British exploiter of an American art form, vulgarian, social climber, burnout—and those are the kinder ones. His new musical, The Woman in White, having settled in for a long run at the Palace Theatre in London, has evoked a few friendly, even enthusiastic notices, but has also provoked more vituperation, from both sides of the Atlantic.

Me, with judicious qualifications, I admire the good Lord Lloyd Webber. The qualifications have mostly to do with his seemingly unstoppable need (born of an insecurity that his shows won't work otherwise?) to reach back every fifteen minutes or so and court/milk an ovation by having his orchestra pump up the volume and the drums thump wildly, by modulating upward with a crude lurch, and by inducing his poor singers to rear back and bray. These are the bad bits, and they crop up regularly in The Woman in White. Lloyd Webber protests unpersuasively that he is forced into such excess by his stage directors. I want to compose intimate chamber operas, he argues, but then he turns around and goes again for the lowest-common-denominator climax.

Yes, yes, all true. But he *does* want to be taken seriously, and he

should be, very much so in his latest work. For long stretches the score is intimate and conversational, and yet it might seem to have a real shot at attaining the commercial success of his earlier Golden Hits—such as *The Phantom of the Opera*, which it most closely resembles.

The Woman in White is a musical and an opera, but it will not readily be accepted by opera lovers. The editor seemed reluctant to consider it in these pages until I twisted his arm. I don't propose here to rehash the hoary controversies about what distinguishes the two forms—whether *Sweeney Todd* belongs in the operatic repertory (it clearly does). Reasonable people may still disdain Lloyd Webber's work, but its hybrid categorical place is clear.

The source of *The Woman in White*, as everyone, or at least everyone British, knows, is Wilkie Collins's beloved Victorian potboiler of the same name. The subject of all manner of previous treatments for the stage, big screen, and small screen, the novel is ideally suited to Lloyd Webber, who has been an impassioned collector of Victorian art and other Victorian appurtenances for decades. The adaptation by Charlotte Jones (with Lloyd Webber peering anxiously over her shoulder, to be sure) seems smart to me, and is abetted by David Zippel's unusually clever lyrics. One should never judge an adapted work of art by its slavishness to its source. Jones's fidelities and infidelities to Collins are less important than her retention of his spirit and her crafting of an effective book (in musicals' terminology). Collins characters have been jettisoned or compressed or altered, the crucial plot twist (the Woman's dire secret) has been tweaked, and above all the character of the intrepid girl detective Marian Halcombe has been modernized and, perhaps, enriched.

For those whose immersion in Victoriana is less than complete, the plot deals with a young drawing teacher engaged to instruct two half sisters on a Cumberland estate. At the outset he encounters a mysterious Woman in White and gradually finds himself drawn into the dark tale of a heel who marries Laura, the sister he comes to love, for her inheritance, and of his and the other sister Marian's efforts to unmask the plot, save the victimized sister, and, while they're at it, discover the Woman's secret. The heel has an accomplice in the amusingly devilish Count Fosco (in the novel he has a vivid wife, here missing).

The principal changes of emphasis are to make the Count, with his Sullivanesque patter songs, even more charming than in the book (so much so that it's sometimes a little hard to dislike him at all), and to

make Marian more attractive than the spirited but mannishly "ugly" (Collins's ungracious description) woman depicted in the novel. This was done in part to accommodate Michael Crawford (the original Phantom) and his sly charm as Fosco, and Maria Friedman's verve as Marian. The reworking courts the problem that one winds up rooting for Marian at the end. But our hero pairs off with Laura, after all.

When I was the director of the Lincoln Center Festival in New York a decade ago, I approached Lloyd Webber and asked him for an opera. "You complain that you are forced to write these big, crowd-pleasing musicals, so here's your chance to prove your seriousness," or words to that effect. In fairness to him, it might have seemed he had been plenty serious with such bold choices as the life of Eva Perón and T. S. Eliot's poems about cats, to name just two of his many fascinating subjects.

But he warmed to the challenge, at least initially. He said he had always wanted to write a small-scale opera based on Dickens's short story *The Signalman (No. 1 Branch Line)*. (*The Signalman*, from the Mugby Junction series, to be precise.) Nothing came of our talks, so I was amused to see that he has in fact written his Signalman chamber opera, and that it ingeniously serves as the prologue and grand climax of *The Woman in White*. The ghostly parallels fit perfectly, and the synchronicity of tone is abetted by the fact that Dickens and Collins were close friends. *The Woman in White* first appeared in Dickens's weekly magazine *All the Year Round* (previous serialization: *A Tale of Two Cities*).

Musically, Lloyd Webber's score offers his typically wide range of idioms, but quite properly concentrates on eerie atmospherics, hushed conversation, and lush romanticism. The harmonic idiom is richer than even his more venturesome earlier work, and the rackety climaxes aside (they could easily be toned down when and if the score ever reaches opera houses), the orchestrations, credited to David Cullen but with Lloyd Webber as "orchestrations supervisor," are appropriate.

Of course, none of this will mollify those who think of Lloyd Webber as hopelessly derivative, if not an outright plagiarist. In his oddly organized but periodically insightful new study of the composer, *Andrew Lloyd Webber* (in the Yale Broadway Masters series), John Snelson twists himself in knots trying to break down categories in the Lloyd Webber oeuvre of "pastiche," "allusion," "modeling," and "borrowing." However much Lloyd Webber actually lifts phrases and motives from Puccini to *Brigadoon*, the theft is not blatant or, for me, intrusive. But Snelson takes a curiously dismissive view of what he regards as our modern-day

fetish for originality. The problem with Lloyd Webber's musical idiom is that it rarely succeeds in establishing a voice, a distinct musical personality that might bind the pastiche and allusions and borrowings into something new and individual. But he shows ample flair and energy working within his received idioms, and his music serves the drama, at least as well as the off-puttingly abrasive or tunelessly faceless scores of so many modern operas with all the proper classical credentials. And the drama here is a good one, haunting and compelling.

This is all helped by a strong cast, albeit one miked to the gills. Besides Crawford (whose games with a live white mouse and rat are worth the ticket price, unless you're squeamish) and Friedman, there are Martin Crewes as a properly boyish Walter, the drawing teacher; Jill Paice as a lovely Laura; Oliver Darley as the snakily seductive fortune hunter (Collins endearingly named him Sir Percival Glyde); and Angela Christian as the waiflike Woman.

Trevor Nunn—one of those whom Lloyd Webber once excoriated for tempting him into overblown excess—directs sensibly. But there is a genuine innovation to mention, one that has occasioned its own share of carping. William Dudley's settings are almost entirely projected, so that it sometimes looks as if the characters are trapped in a video game. This is all the rage these days in film, as in the computerized backdrops of *Sky Captain and the World of Tomorrow* or *The Polar Express*, in which, more radically than in *Sky Captain*, the characters are digitized into the entirely computer-generated settings. To my taste, the rear projections in *The Woman in White* work very well, providing shifting settings (as characters walk through a village or climb stairs) and a spectacular climax, way better than that silly falling chandelier in *Phantom*.

The Woman in White will not salvage Lloyd Webber's reputation among his many enemies, especially since precious few of them will bother to see it in the first place. But it's an effective, appealing piece of work, and it fits handily into—if not the muddled category of new opera—the rather more lively world of new musical theater. Especially in the United States, composers like Michael John LaChiusa, Stephen Flaherty, Jason Robert Brown, Adam Guettel, and Jeanine Tesori, all swimming in Sondheim's inspirational wake, are reshaping the musical. So, like it or not, is Andrew Lloyd Webber.

"THE FOGGY, FOGGY DEW"
The Rose and the Briar, 2004

Note: My entry in a book on the American folk ballad edited by Sean Wilentz and Greil Marcus.

I was born in 1940, which means that my life knits into this story. When I was still young, my parents got a long-playing record machine when they first came out in 1948. We had several prized discs, all of which helped shape my musical tastes. The ones that come to mind were the Beethoven and Brahms violin concertos with Jascha Heifetz (my father had played violin as a boy), Broadway musicals such as *Oklahoma!* and *South Pacific*, and albums by Paul Robeson, Mahalia Jackson, and Burl Ives. In retrospect, my love for black music came from Robeson and, even more, Jackson, and my love for operatic singing came from Robeson and Ives.

The Ives record we had was a ten-inch Stinson LP (SLP 1) called *The Wayfaring Stranger*, released in 1949. It was Ives's first long-playing record, although it contained 78-rpm takes from as far back as 1940. Now my parents are dead, but I still have their LPs; I'm looking at the Ives right now. The songs, all Anglo-Scottish-Irish as filtered through Appalachia and the Midwest and latter-day compilers like Cecil Sharp and Carl Sandburg, were edited by Alan Lomax.

They include atmospheric mood pieces like the title song and the haunting "Black Is the Color"; narrative ballads like "Henry Martin," "Brennan on the Moor," and "The Bold Soldier"; gentle, humorous, and children's ditties like "The Sow Took the Measles," "Buckeye Jim," "Jimmy Crack Corn," and "The Fox"; and an eerie, distinctly erotic ballad called "The Foggy, Foggy Dew." These are all charming or better. But "Black Is the Color" and, most important for the purposes at hand, "The Foggy, Foggy Dew" did much to define my notions of music and of romantic love, and I hold those notions especially dear.

I want to write here about that ballad and its variant versions, about Burl Ives's performance of it, and about the social and musical context that made it beloved—by me and by millions. That context is sometimes described as genteel, as opposed to vulgar (the musicologist H. Wiley Hitchcock uses the more genteel terms *cultivated* and *vernacular*). More often than not in these rock-and-roll days, the genteel is exco-

riated as everything stultifying that the ruder energies of Appalachian folk music, Delta and Chicago blues, and rock and roll blew away. I love the manly rough stuff but want to defend our softer feminine side. Or white. Or old. All of these being the softer halves of dualities the critic Robert Christgau, who writes of "the great war between the genteel and the vulgar" and who sides passionately with the vulgar, has deployed to describe this schism.

The folk tradition led by Ives and Lomax—and also including, in the middle of the twentieth century, John Jacob Niles and Richard Dyer-Bennett—was a cultivated effort to reclaim and preserve the folk past. This was not true folk music, unmediated from oral tradition. These were educated men who researched their sources. Their predecessors dated back to early-nineteenth-century German efforts to reclaim folk traditions for nationalistic ends, an effort replicated all over Europe and one that similarly gentrified peasant roughness into bourgeois respectability.

The American movement was born of assiduous study of printed editions, field and commercial recordings, and sought-after encounters with real folk singers in the back country. "I'm not a folk singer," Ives once said. "I am a singer who just happens to like to sing folk songs." Dyer-Bennett made a similar distinction between true folk music and what he did, which he called minstrelsy, in a sense that would not earn much currency today. What followed in the folk-music movement of the 1960s wasn't any more authentic, not that folk authenticity is an absolute virtue; the best of it was an authentic expression of self. Either in their popsier folk-rock manifestations or in the tougher kind, replete with newly composed songs in a folkish idiom, the folkies had created their own idiom, had become their own folk.

Burl Icle Ivanhoe Ives did have rural roots. He was born in 1909 into a tenant farming family in the Bible Belt of southern Illinois, and learned his first songs from his family, which had been in the United States for nearly three centuries, and especially from his tobacco-chewing grandmother, Katie White. He rode the rails in the 1930s, picking up songs where he could. All that could count as authenticist credentials. But later, drawn to the American cultural capital to better himself both vocally and professionally, he trained his tenor classically at New York University.

What emerged, with genteel tenors like Ives and Dyer-Bennett (who was so genteel he was actually born English, and who sang in white tie

and tails), was a kind of folkish music that harked back to the parlor of late-nineteenth-century America. I can still remember my beloved grandfather, who was born in 1879, singing Charles K. Harris's weeper "After the Ball." This was the first great Tin Pan Alley hit, from 1892, and it launched the commercial pop-music bandwagon of the century to come. The way Ives and Dyer-Bennett sang folk ballads came as close to my grandfather's parlor sentimentality as to Appalachian keening.

The motivations for these early folk revivalists were both noncommercial, reflecting the leftist idealism of the 1930s, and commercial. Ives sang in New York clubs and on Broadway, had his own radio show, and eventually sold records and made films. Of his later career—he died in 1995—I have little to say here, liberated as I am from suffering under direct correlations between artistic worth and political correctness.

Ives became fat and at least outwardly jolly, although his imposing Big Daddy in *Cat on a Hot Tin Roof*, on Broadway and in the film, hinted at a darker side. Some of his early fans shunned him after he named names before the House Committee on Un-American Activities. The chief name he named was that of Pete Seeger, with whom he had once appeared as part of a group called the Union Boys '44. For thirty years after that, he hardly performed in New York. But a concert in 1993 at the Ninety-Second Street Y in Manhattan reunited Seeger and the by-then-wheelchair-bound Ives, presumably signaling a healing of long-past rifts in the folk community.

The young Ives was thin and muscular (he played football professionally) and had a wonderfully pretty voice. It was highly, even painfully sensitive, yet never effete, and it was masterfully deployed, with expressive shadings of pitch, lively rhythm, and a magical ability to shade the modern tenorial chest voice into various gradations of so-called head tone and falsetto. It was singing that gave immense pleasure in itself, but also made an expressive point. It sounded mid-American, full of the sturdy optimism and poetic undercurrents that defined the heartland.

And it was still close enough to operatic style to allow people to make a smooth transition from Enrico Caruso's Neapolitan folk songs and the Irish tenor John McCormack's Irish ballads to a more direct, more American voice. In the course of the nineteenth century, operatic singing in general and tenor singing in particular had grown louder and more assertive, better to make a proper sonic impact in ever-larger halls with ever-larger orchestras. Those changes in turn reflected a shift of

patronage from the aristocracy in palaces to the newly ascendant bour-
geoisie in concert halls.

Before, despite the pyrotechnics of the castrati and star sopranos,
much operatic singing, with its soft high notes and almost conversa-
tional declamation, was closer to Ives's cultivated folk singing than to
Caruso. "Head tone" defines a light, gently nasal tone that can easily
shift upward into falsetto. Tenors started taking their high notes "from
the chest"—belting them out athletically—by the middle of the nine-
teenth century. Late-century verismo opera in Italy and Wagnerian
opera in Germany placed a new premium on manly vocal strength and
ringing high notes.

Henry Pleasants, the vocal critic and Foreign Service agent, argued
that modern electronics permitted a restoration of the conversational
ease of seventeenth-century bel canto singing, and he used Frank Sina-
tra as his poster boy for that theory. Light tenor singing of the Ives sort
could only enjoy a comeback with the advent of recordings and concert
amplification. As halls grew ever larger, no natural voice, however
pumped up (Rudy Vallee used a megaphone), could hope to fill them.
But three scrawny kids with guitars and a big amplifier and monster
loudspeakers could eventually do so with ease.

During the twentieth century, however, people grew tired of operatic
belting; they didn't need it anymore. They turned instead to the
renewed conversational naturalness that the microphone permitted.
Operatic outbursts began to sound mannered and strange, a home-
grown version of what we hear as the swooping screeches of Chinese
opera. Ives's voice was in that sense transitional: it had the sheen and
finesse of opera without its latter-day Puccinian vulgarities and without
the pretensions of operatic ritual. It was genteel in expressive impact
without being genteel in social conformity. And it moved people. As
Ives's youthful singing shaped my images of romance, millions of others
felt a similar longing for an emotion that conformed to gentility but sub-
verted it at the same time. But amplification and recording also made
untutored folk singing commercially viable, and hence led directly to
our era of putatively vulgar popular entertainment.

It was not just crooners and arena-rock musicians who benefited from
the electronic revolution. The enormous impact of radio in the 1930s
and '40s—Ives had a popular radio show early on—helped to build indi-
vidual careers but also to disseminate entire genres, like folk music. Peo-
ple like my grandfather sang "After the Ball," which as a megahit had

quickly become a part of folk music, from sheet music and from memory. Radio and recordings, offering the option of hearing performances and unfamiliar music passively, may have blunted personal music making. But they led to a huge expansion of available repertory, and hence helped transform our musical experience.

John McCormack recorded "The Foggy Dew" in 1913, but here's where the story of this song, or these songs, gets complicated—as it does with so many folk songs whose attribution is undocumented in oral tradition. Originally there were two "Foggy Dews," both love songs but with different words and melodies, one from Suffolk in England and the other from Ireland (McCormack's version, of course). During the struggle for Irish independence, new, political words were overlaid onto the McCormack song, recalling the 1916 Easter Rebellion, and that version is still often heard (Sinéad O'Connor recorded it with the Chieftains on their *Long Black Veil* album). There is even a time-honored pub in Dublin called The Foggy Dew. It has a Web site.

Ives sang the English song, called "The Foggy, Foggy Dew," and it too exists in many versions, although always recognizably with the same roots. Originally it was pretty racy—so much so that Ives spent a night in jail in Mona, Utah, in the '30s for singing a song so unsuitable for Mormon ears. But the version Ives sang by the time he made recordings is less sexually explicit and more elusively poetic.

Ives's recorded version—as collected by Sandburg and included by Lomax in his *Folksongs of North America* (with only one "Foggy" in the title) and by Ives himself in his *Burl Ives Song Book*—is in three verses, each ending with the refrain "Was / Just to keep her from the foggy, foggy dew." It tells the tale of a young weaver who woos a "fair young maid" but makes the mistake of keeping her from the aforementioned dew. One night, she comes to his "bedside," weeps, cries, and is held by the weaver "just to keep her from the foggy, foggy dew." In the third verse, he is again alone, but now with his son (presumably from the fair young maid), and every time he looks into his son's eyes, they remind him of her—and of winter, and part of the summer, "And of the many, many times I held her in my arms / Just to keep her from the foggy, foggy dew."

Aside from its evocation of a common English climatic occurrence, the foggy dew is a metaphor for whatever you want it to be. For me, it clearly implies mystery of the sort beloved of romantic painters, with their ghostly churchyards and ruined buildings. Dew means ghosts and

spirits, the romantic wilis of the ballet *Giselle*, will-o'-the-wisps, trolls, and faeries. For humans, it means unfulfillable romance but also death, an English version of Wagner's love death, a state attained in his opera *Tristan and Isolde*. Isolde's love death takes place in Tristan's home in Cornwall, just across England from the birthplace of "The Foggy, Foggy Dew."

The music, especially in Ives's singing, is particularly haunting, because while it is firmly in a major key (G major, in his recordings and his songbook), his bardlike tone and phrasing and the tune itself evoke the modal plaintiveness of an older time, before the codification of modern Western harmonic practice. The tune achieves this illusion in part through the suggestions inherent in its foggy romantic aura and lamenting lyrics ("Ah me! what could I do?"). In more specific musical terms, there is its chantlike eighth-note reiterations of the same pitch ("only, only thing that I did," on four rapid Gs and four Bs in the same bar) and quasi-modal emphasis on the subdominant, a third above the tonic of G, rather than the more comfortably common dominant, up a fifth. Ives's singing on the Stinson LP—oddly, *Poor Wayfaring Stranger*, an otherwise wonderful CD on the British Flapper label, which collects a great amount of early Ives material, including my Stinson LP, includes a faster, feebler take of this one song—is controlled yet vulnerable, with a superb use of *voix mixte*, the typically French eighteenth- and early-nineteenth-century blend of head tone and falsetto. It breaks your heart, even in a supposedly cheerful major key.

The reason Ives was arrested in Utah was that two earlier, longer versions of this same song are more explicit. Here, with only slight variants in the first three verses: "Many's the night she rolled in my arms / All over the foggy dew." After she weeps and cries, she announces, "Tonight I'm determined to sleep with you / For fear of the foggy dew." The next verse goes on: 'All through the first part of that night / How we did sport and play."

In one version, included in Lomax's *Folksongs*, the final verse pictures the happy couple later in life. "I never told her of her faults"—presumably meaning her unashamed expression of sexuality—"and never intend to do / Yet many a time as she winks and smiles / I think of the foggy dew." The other version, sadder and closer to the Ives, finds them after their passion is spent regretting the prospect of children. She marries another. The last verse is the same one Ives sings, full of regret.

Around the time of Ives's first recordings in the early 1940s, Carl

Sandburg called Ives "the mightiest ballad singer born in any century." But does that make "The Foggy, Foggy Dew" a ballad and, more precisely, an American ballad? The music dictionaries disagree as to how recently the term *ballad* in folk music came to imply narration. Some suggest that until the late seventeenth century, the difference between ballad and song was slight to nonexistent. The German *Musik in Geschichte and Gegenwart* identifies the first reference to ballad as a narrative song from 1761. The English *Grove Dictionary of Music and Musicians* argues that "ballad tunes are a part of the general body of folk music, only hypothetically separable from the mass of lyric folksong."

Still, however far back into the Middle Ages its roots may lie, "The Foggy, Foggy Dew" does indeed tell a story, however short—and many ballads dealing with love are indeed short, as opposed to long historical narratives or Bob Dylan's tale telling. And I would argue that its very Americanization, which could be interpreted as a blunting of the song's initial suggestiveness, is actually poetically superior. I like the supposedly bowdlerized version; the romanticism, the fear and excitement aroused by that mysterious foggy dew, is purer. But then, I'm genteel.

The "genteel tradition" as defined by George Santayana represented a secularization of Puritan rigor into middle-class propriety. Its polite presumptions—its "cool abstract piety," as Santayana called it—became every American's "tyrant from the cradle to the grave." There was, to be sure, more to this denaturing of Calvinism than mere philosophical entropy. As Charles Hamm argues in *Yesterdays: Popular Song in America*, the Civil War had exhausted America, and the troubles of the conquered South were best kept far away.

"Nostalgia had run its course elsewhere in the Western world by 1865," Hamm writes. But in America popular song was turned into escapism. The parlor was the domain of women, who have retained a disproportionate power on cultural boards of trustees to this day. Scorn for gentility can easily slip into scorn for women. Men deal with war and money and politics; women deal with children, the kitchen, and culture. Soft-grained tenors have had a long appeal in the parlor; they're the olden-day equivalent of the romance novel. Leslie Howard, not Clark Gable.

The latter part of the nineteenth century was the lull before the twentieth-century storm, musical and otherwise. Eventually, even the parlor grew weary of such sentimentality, the popular mood having shifted to ragtime and vaudeville, and the piano to the player piano to the phono-

graph and radio. After the golden age of Tin Pan Alley songwriting and the treacle of Hit Parade pop, the folkies—or at least some folkies, those who weren't determined to become one with the working man—appropriated the genteel tradition. But gentility had mutated by then. With two wars and the Holocaust, it became ever harder to cling to the old pieties, however secularized. In that sense, the late '40s and early '50s—Pleasantville—were the last ebb of gentility before the hellhounds of rock and roll were unleashed.

Lomax collected a lot of rougher music, and so did Harry Smith. I love that music. But there seems no reason, insisting upon your love, to scorn everything else. If the purist folkies booed Dylan at Newport in 1965, rock critics repaid the favor by mercilessly attacking such genteel latter-day folkies as Joan Baez and James Taylor, not to speak of our sappier country-pop balladeers (Ives made a couple of country albums himself late in life). Softness, and hence gentility, has never died. Most obviously, in Britain, are the postoperatic soprano warblers like Sarah Brightman, Charlotte Church, and now Hayley Westenra. Add to them an ongoing undercurrent of female confessional rock—recently, Tori Amos, Sarah McLachlan, Liz Phair before she went pop, Jewel, Dido—and you have a persistent gentility, bubbling under in the age-old war with ruddy vulgarity. Female politesse versus crude, manly vigor.

Thus, Taylor and a few other confessional males aside, it is no accident that gentility has survived in the persons of women singer-songwriters. Christgau's "dustbin of gentility" is a lovely phrase, but it lines him up all unconsciously with men and manly women. Rock, the true successor to folk, was always a boy's game, with "chick singers" looked at askance. The prejudices of capitalists and soldiers and other regular guys have been absorbed by rock and roll. The only real folk music is the kind that slides into punk rock. The only good chick singers are the tough ones, preferably lesbian.

The manly bias of rock-and-roll intellectuals masks their indebtedness to the long philosophical tradition, extending back to Plato, of rationalist moralism. The beautiful is wantonly open to unregulated feeling; the good and the true must claim precedence over roiling passion and mere surface allure. But in the nineteenth century, American gentility was infected by German romantic idealism through the agency of Emersonian transcendentalism. Feminine equality became less a weak reduction of art to manners than a threatening challenge to rational

righteousness: a conduit for feeling, suppressed by extramusical ideology, as a virtue in itself.

These are of course sweeping generalizations, just like Christgau's notion of a Manichaean struggle between the genteel and the vulgar. Real life is more complex than that: things overlap; tendrils entwine. Burl Ives appealed to the genteel but thought of himself as a friend of the working man. He was a manly football player with a sweet, some might say effeminate voice. His music drew from many sources and appealed to many audiences.

His "Foggy, Foggy Dew" started out as an English folk ballad, became American in words and music and cultural ownership, attained gentility in versions by Ives and Dyer-Bennett, and even—rather unsuccessfully—in an artsy folk arrangement by the higher-than-highbrow English composer Benjamin Britten. It is as much a part of our folk culture, our genteel culture, our culture, as any ballad ever born.

For me, as a boy with my beloved ten-inch LP, this ballad in this performance helped define vocal beauty, shaping my taste forever. And it embedded deep within me an ideal of romantic beauty and romantic love that has colored my entire life. Not determined it, but colored it. It may be a genteel song, but genteel people suffer passions and pain, too. Who knows what tensions and longings seethed in the parlor? In our age, which prizes the authenticity of roughness, gentility reinforces my lifelong conviction that beauty, even when seemingly contained within the strictures of form and tradition and gentility itself, can have haunting power. Beauty can be strength; the genteel can be real.

2005-2006

I became chief dance critic of the Times *on January 10, 2005. To the dance community, I seemed to come out of the blue, although I think this book suggests that I had had some history as a dance writer. As of this writing, I'm still at it.*

JEROME ROBBINS'S
GOLDBERG VARIATIONS

The New York Times, January 20, 2005

When Jerome Robbins's *Goldberg Variations* had its first performance in May 1971, it was greeted as an enchantment (by a majority) and a bore (a minority). In and out of the New York City Ballet repertory ever since, it hadn't been seen for a long five years before its reappearance last night. Those of us who loved it then can feel free to love it again now.

Of all Robbins's Bach ballets, this, like its score, is the grandest. Confidently played last night by the pianist Cameron Grant, Bach's "Goldberg" Variations offers a dizzying range of moods and forms, encompassing a whole world. It was Robbins's genius to capture that whole world in dance.

The ballet lasts eighty minutes, with nearly every musical repeat taken. What seemed to strike most observers thirty-four years ago, pro or con, was its comprehensive repertory of classroom steps and attitudes. Yes, they evoked human relationships, but it was the way Robbins showed the City Ballet as a family that seemed paramount.

What seems striking now is the range of emotions and historical mores embedded in what at first looks like dispassionate modernist abstraction. This is a ballet rich with history. Joe Eula's costumes, set against a bare stage and a blank backdrop, shift deliciously from eighteenth-century dress to softened modern-day practice attire. The opening theme is danced as a duet in period costume; at the end, everyone else is in period dress and the duo returns in contemporary garb. Nearly every dance is graced with complicit bows and curtsies.

The pianist Charles Rosen wrote that Bach's score "absorbs and transforms the popular styles of his time." That was Robbins's specialty, too. Besides the running allusions to courtly manners, one finds references to social dancing, from Bach's time right up to 1971, with hip shakes and hand claps. In that sense this ballet recalls Mark Morris and *L'Allegro, il Penseroso ed il Moderato*. Both Mr. Morris and Robbins prized the contemporary yet managed to enlist it to enliven a bygone age.

Again like Mr. Morris, Robbins was an intensely musical choreographer. That did not mean much direct mirroring of the music, structurally or decoratively. Sometimes Robbins goes deliberately against the grain, with a dreamy adagio for speedy musical buoyancy. But it all flows together, and the choreography is never relegated to the background.

The dancing is infused with fluid, sensuous calm; even allegros look like adagios. Sometimes the dancers simply walk about, though the patterning is always breathtaking, using asymmetry and numerical mismatches to enliven the formality. One influence on that calm, that hypnotic sense that nothing much is happening when really everything is happening, was surely Robert Wilson. Robbins was fascinated with Mr. Wilson's hypnotic stage imagery: he choreographed a homage to him in *Watermill* and acted in Wilson works.

Last night's performance, full of dancers making role debuts, took a while to relax: the first few variations looked tight and tense. But with a Janie Taylor solo, things settled into place. And even when the cast shifts with the sixteenth variation, and the virtuosic big guns (Wendy Whelan, Maria Kowroski, and—despite her pristine control, at a lesser level of charismatic intensity—Miranda Weese) sustained the courtly aura.

The final variation, before the restatement of the theme, offers a communal round, like an elaborate court ritual but glowing with good will, followed by a loving "group photo." It is a tribute to the current incarnation of the City Ballet that from solos to duets to trios to mass configurations, that sense of embracing oneness was so lovingly sustained.

DV8 PHYSICAL THEATER
The New York Times, January 25, 2005

This is a piece about something, and someone, who is great, about what a profound pleasure it is to encounter greatness, and about what a persistent concern it is that we live in a culture, more specifically a dance culture, that resists such greatness.

The greatness is that of a film, *The Cost of Living*, and of a choreographer—or is it theater director, or now film director?—named Lloyd Newson, and his ever-mutating London-based company, DV8 Physical Theater.

I first encountered their work in San Francisco in 1997, when they managed to undertake an American tour. Their piece was called *Enter Achilles*. It was thrilling and shocking, a theater work based on physical movement, dance if you wish, that violated dance norms in a way that renewed dance vitality. Subsequently made into a film of the same name, it disturbs to this day: a depiction of the underside of British male bonding in a pub, gay undercurrents churning away beneath the surface.

Mr. Newson was ballet trained and a dancer in his native Australia before moving to Britain. He founded DV8 in London in 1986, and much of his early work involved homosexuality. (Officially, DV8 refers to dance and video 8, a then-popular technology, but "deviate" is the obvious reference point.) As in the film version of his *Dead Dreams of Monochrome Men* (1990), about four men, including himself, enacting a ritual of dominance and desire, never explicit but always overt.

His newest work is the *Cost of Living* film, although stage versions date back to 2000, when it was prepared for the arts festival of the Sydney Olympics. Mr. Newson directed the film (the company's previous films were directed by others), and it's extraordinary. It has already won several awards at dance-film festivals, and on Saturday it won the top prize at the Dance on Camera Festival at the Walter Reade Theater.

The thirty-four-minute film is set in Norfolk, England, mostly on a Brightonlike entertainment pier thrust out over the ocean, in and around drab apartment buildings and along the beach. Company members play marginal circus performers: clowns, dancers, a hula-hoop virtuosa, a legless man. Each character is vividly portrayed, through dance and dialogue. The narrative thread centers on an abrasive, obsessively

outspoken man who lives with the legless man, and a tall and skinny man who falls in love with the tattooed hula-hoop girl. Outsiders all, finding companionship and love.

The most striking character, played by David Toole, cantilevers himself around on his muscled arms or is driven or carried by his roommate, Eddie Kay, or the skinny man, Rowan Thorpe. (The characters use their own first names in the film.) Nearly every scene strikes the heart: Eddie's disruption of a brilliantly choreographed six-clown routine; his caustic hostility to gays; Eddie and Dave looking down on a lawn at two women prancing on the green; Dave giving a sexual come-on to an imaginary woman in a pub; Dave verbally harassed by a man with a video camera, followed by a swaying fantasy dance, echoed by the other dancers; Rowan's first encounters with the hula hooper (Kareena Oates), and their growing romance, all done with silence and hoops; Dave's fluid floor dance with a woman in a dance studio; and the astonishing final scene, with Eddie and Dave on the beach, speculating about moving to New York and making it on the club circuit.

Mr. Newson founded his company, which now changes personnel from project to project, as a protest against traditional dance, ballet or modern. "For a lot of people who go and see dance it is not about anything and DV8 is about something," he has said. Dance "may be very pretty, but it just goes on and on, it's pretty nice, pretty much the same, and pretty dull really, a lot of it."

Fighting words, especially to a dance culture like that in the United States that still prizes dance abstraction, be it from Balanchine or Merce Cunningham or the Judson Church minimalists. Keith Watson, a dance critic from *The Guardian* in London, once called DV8 "a gale force wind across the becalmed sea of dance abstraction that dance was paddling in." Hardly comforting for those for whom dance abstraction is dance.

Perhaps that critical divide helps explain why DV8 has appeared so rarely in this country. A Brooklyn Academy of Music date in late 1988 and the 1997 tour seem to be it.

Mr. Newson has his own problems with British provinciality, looking longingly to what he regards as a healthier dance atmosphere on the continent of Europe: DV8 is a regular on the European festival circuit. Certainly there are other striking choreographers there still shamefully unknown to America: Alain Platel from Ghent, Belgium, for one. But much of the European work strikes me as inferior to Mr. Newson's.

Still, maybe now things are changing; they are if Mr. Watson is right. Everything moves in pendulum swings, reacting against what is fashionable. Modernist ballet evolved as a reaction against the perfumed theatricality of the ballet before it, as well as the heavy-breathing psychologizing of pioneering modern dance. (Mr. Newson studied psychology at the University of Melbourne.) Now maybe it's time for a swing back to raw, movement-based theatricality. Anna Kisselgoff once called DV8 "the Sex Pistols of dance." Punk rock was an attempt to blow away not just the fustian pomposity and hypocrisy of conventional mores ("God Save the Queen") but of both bloated and coolly minimalist English art rock.

By now, Mr. Newson's work and that of like-minded collaborators are all around us. Clara van Gool, a Dutch filmmaker who directed DV8's *Enter Achilles*, had two terrific short films in this year's Dance on Camera Festival. Stan Won't Dance, a DV8 spinoff, is in residence at London's South Bank Center and presented an admired showcase here during this month's annual convention of the Association of Performing Arts Presenters.

So hold on to your knickers, American dance devotees. You may think you hate "Eurotrash," but you ain't seen nothing yet. In the meantime, for the broader cultural public not in thrall to dance orthodoxies, *The Cost of Living* will be cropping up around the country in screenings arranged by or booked through the Dance Films Association, which presented Dance on Camera with the Film Society of Lincoln Center. It almost demands to be seen. But for all of Mr. Newson's provocative rhetoric and newfound brilliance as a film director, his work would never have credibility, would never move people so much, without his genius as a choreographer.

STARS AND BEAUTY IN BALLET

The New York Times, February 6, 2005

Note: This article got me in trouble in some quarters, my wife and daughter being among those who hated it. I feel a little bad about my lack of gra-

*ciousness toward the current crop of City Ballet women—which was
hardly the feminist objection. But otherwise, I stand by every word.*

I've been thinking about stars lately, seeing a large swath of New York
City Ballet repertory, noting young dancers being promoted up through
the ranks, perusing the photo display of City Ballet history at the New
York State Theater, reading Robert Gottlieb's and Terry Teachout's short
biographies of Balanchine, even watching a rare screening of *The Red
Shoes* at the Dance on Camera series last month at Lincoln Center.

What makes, or made, a star? Not in the heavens, but in the grand old
Hollywood-style, diva-ballerina sense? Is it *All in the Dances*, as Mr.
Teachout entitles his Balanchine book, implying that if someone dances
well, that's enough?

Dance artistry of some sort is the given behind the success of any
dancer. But Mr. Teachout contravenes his premise by writing a biogra-
phy that is at least as much about Balanchine the man as about Balan-
chine the artist. The two are inseparable, and to deny the impact of
life—and of looks and an abundant personality, which aren't the same
but are often linked—is to dilute the dance experience.

In fact, our greatest dancers possessed more than "just" great artistry.
They often had grandiose charisma. They were often physically beauti-
ful: not just their bodies but their faces, too. Think of Rudolph Nureyev.
Think of Mikhail Baryshnikov. Think of a whole harem of Balanchine
ballerinas, many of them wives or lovers or passionately pursued "elusive
muses," as a film about Suzanne Farrell called her.

"Woman is the goddess, the poetess, the muse," Balanchine once
said. "That is why I have a company of beautiful girl dancers."

Would he have been happy, in that regard, with the current com-
pany? There are some very attractive women (and men, but Balanchine
cared less about them) in today's City Ballet. Yes, when he came to the
United States he sought to make a company of all-American dancers,
fresh-faced and perky. But some of the company's biggest female stars
now are spectacular dancers without being spectacular beauties. Is it
merely sexist to lament that the current roster is not "a company of beau-
tiful girl dancers?"

Dancers dance, singers sing. Opera has long been a haven for over-
size or physically unimposing people of both sexes. Dancers, too, have
historically hardly all had movie-star good looks.

The soprano Deborah Voigt stirred up—reveled in?—a controversy

now much overcommented on when the Royal Opera in London canceled her contract to sing the title role in Richard Strauss's *Ariadne auf Naxos* because she was, in short, too fat. Opera purists howled; they took it to be self-evident that it's (only?) the singing that counts—and in Ms. Voigt's case, one might add, the delicious self-parodying humor she brings to her Ariadne.

Yet looks do count: for dramatic verisimilitude, for romantic illusion, for box-office excitement. Surely the beauty of so many great opera singers of the past (too numerous to list) or, to stick to the subject, so many Balanchine dancers (Vera Zorina, Tanaquil LeClercq, Diana Adams, Patricia McBride, Allegra Kent, Gelsey Kirkland, and Ms. Farrell, to name just a few) gave them an image that reached beyond their excellence as dancers and attracted the attention of the broader public as well.

In *The Red Shoes* there is Moira Shearer, a first-rate dancer who became a worldwide star through Michael Powell's film (and its *Tales of Hoffmann* follow-up). Would she have been cast if she hadn't looked radiant in close-ups? Does the very ubiquity of close-ups today, in films and television, make it more difficult for the less glamorous stage performer?

At the City Ballet, one might also take into account the company's prevalent stripped-down, post-late-modernist style. Balanchine, that lover of women, grew up in a world of prefilm, pretelevision divas and ballerinas. But as he matured he pioneered and epitomized that modernist style. Part of that involved the elevation of choreography above any individual ballerina. But Balanchine wound up cultivating all kinds of star dancers, anyhow, and not just among his romantic obsessions. For all the ingenuity or anonymity with which his epigones have emulated him, that style might seem today to flatten individual dancers' charisma, to make it harder for the vivid, idiosyncratic, even technically eccentric dancer to shine.

The best dancers at City Ballet have their impassioned fans, and they deserve them. But do those dancers reach out beyond the dance world, the critics and former dancers and subscribers, in the same way their predecessors did? In an appreciation of Peter Boal on her dance blog, the critic Tobi Tobias called him "a great dancer who is not a great star."

Maybe the time has passed, in our age of electronic mass media, for any live performer to make the impact of the stars of yesteryear. Or are today's dancers too obsessed with technical perfection, with getting it right, while losing sight of a freer, more flamboyant expression?

Enormous pleasure can be derived from appreciating the subtleties of an exact attention to technical detail. But do the frequent laments about the City Ballet's inability to preserve the essence, the spirit of Balanchine's ballets have to do with an inattention to choreographic niceties or with a failure to encourage the powerful personalities for which the ballets were created?

Perhaps the City Ballet, and ballet in general, has closed in on itself, content with tracking the in-house progress of its young dancers, bending them to a company school and system, puritanically rejecting as unworthy the pizzazz of great personalities, all in the name of a misguided fidelity to Balanchine's ideals. Perhaps its habit—one that it shares with other companies today, like American Ballet Theater—of shuffling dancers in and out of roles, giving everyone a chance, winds up giving very few a chance to establish themselves as stars.

Dance has always been about more than getting it right. It's about passion and projection and glamour and romance, all firmly grounded in a mastery of technique. With genuine respect for its current leading dancers, and despite the genuine pleasure to be derived from their performances, the City Ballet might try cultivating a few more gorgeous hothouse flowers like those that graced its stage in decades gone by.

MATTHEW BOURNE, CHOREOGRAPHER
The New York Times, March 19, 2005

Whether Matthew Bourne's *Play without Words*, at the Brooklyn Academy of Music through April 3, is theater or dance is a matter for reasoned discussion among the aesthetically minded. I think it's dance, pure if not so simple. But my main interest is why Mr. Bourne, like several other European choreographers, seems so eager to market his dance as theater.

On the aesthetical plane, dance and theater often blend. Dance contains theatrical elements; theater can convey its messages through movement as well as words. As in the work of Robert Wilson, among

many others, and Mr. Wilson has several times over the last two decades tried his hand at choreography.

Play without Words ingeniously expands upon Joseph Losey's 1963 film *The Servant*, itself based on Robin Maugham's book. There are doublings and triplings of the characters, providing contrasting filmic points of view as well as a wonderfully creepy, horror-movie aura. Evil seems to exude from every corner.

Not everyone admires Mr. Bourne's actual movement invention, and he himself has downplayed it, perhaps as part of his self-image or to deflect criticism or as a marketing strategy.

But the movement in *Play without Words* is at its best very compelling, particularly a scene in which three servants dress and undress our tripled feckless hero, or a leggy, doubled tabletop erotic duet between the hero and a servant girl in a tennis sweater. Layers of popular and artistic choreographic history are evoked, particularly the social dances of the early 1960s and jazz dance.

No matter. This is theater, Mr. Bourne insists. He designates himself as having "devised and directed" the piece, although elsewhere in the program he grudgingly credits himself as "director/choreographer." *Play without Words* was commissioned by Nicholas Hytner and first seen at his National Theater in London.

This is all part of a pattern, best evidenced in New York by the run of *Matthew Bourne's Swan Lake* on Broadway. *Swan Lake* is a canonical dance classic subjected to the kind of updating long familiar to those who have seen contemporary European balletic and operatic stagings. That it was very good, sexy, ingenious, even choreographically noteworthy, made Mr. Bourne's decision to peddle it as theater all the more galling.

Mr. Bourne belongs to a generation of choreographers in Britain and beyond who wish to escape what they see as the strictures of abstract movement and revert to theatricalized dance. "My work isn't about movement," he told the magazine *Show People*. "It's about storytelling through movement, which is different."

But storytelling in dance has a long history, against which the abstractionists (George Balanchine, Merce Cunningham, the Judson Church minimalists) sought to rebel. Martha Graham told stories in her dances. The very name of American Ballet Theater incorporates that aesthetic.

But Mr. Bourne and his allies insist on a distinction between abstract dance and narrative dance, which they barely see as dance at all. For

Mr. Bourne, as quoted in *The New York Times*, "I've always been excited by the strangeness of ballet, but I can't bear it when people just come forward and do a turn in the air for no reason."

In a *Guardian* of London interview, the Irish choreographer Michael Keegan-Dolan echoed all the angry young men in today's British art, film, literature, music, and theater: "Dead sheep are real. The wind cutting into you half-way up a ladder, that's real. Getting into the rehearsal room for the first time, that's real." All the rest, he added, using a vulgarity, is irrelevant.

In France, the choreographer Jérôme Bel, who will be at the Dance Theater Workshop starting Thursday, takes pains to separate himself from mere dance. "I'm not producing dance," he said in an interview in the *Times*. "I'm working at the borderline of dance."

In Britain, this movement comes coupled with a rejection of the elitist, upper-class associations of the word dance. It is no accident that *The Servant*, and hence *Play without Words*, are imbued with punishing class distinctions felt less acutely in American society.

Many of them, choreographers and other angry artists, come from lower-class backgrounds—Mr. Bourne is a cockney and resents the snobbishness of the "toffs." They perceive dance audiences as limited and dance critics as sniffily disapproving of their rejection of dance orthodoxies. They want to reach out, to younger, poorer, and larger audiences.

Of those adjectives, however, "larger" looms largest. There is nothing wrong with popularity or even with commerciality, which is simply a mechanism to answer popular demand. The commercial theater, and even a subsidized institution like the National Theater, offers the possibility of long runs that aren't easily accommodated in dance. Perhaps the theater audience, if it can be conned into thinking *Swan Lake* is theater, is bigger than the dance audience. Hence the West End and Broadway hold out the chance for real financial reward.

And maybe, since everyone in dance already knows he's really a choreographer, Mr. Bourne figures he can get the dance audience and the dance critics anyhow, so he might as well reach out. Movies are surely his ultimate target. Remember, his original company (now called, after a reorganization, New Adventures) was Adventures in Motion Pictures.

None of which counts as a stern indictment. Of him, at least. Mr. Bourne makes his dances, and to this taste they're good ones. Perhaps the problem, if it is a problem, lies with the dance world. If its audience

could only loosen up a little, and come to appreciate the breadth and variety, abstract and narrative, classical and modern, that dance already embraces, then maybe Mr. Bourne could reach his mass audience without having to deny the true nature of his art.

PITTSBURGH BALLET THEATER, STING, AND SPRINGSTEEN

The New York Times, **March 31, 2005**

Long known as a Balanchine company, Pittsburgh Ballet Theater still offers his work as well as the classics. But for its belated Manhattan debut Tuesday at the Joyce Theater, something very different was on display.

The most conventional of the three ballets, at least in terms of its music, was the last, Dwight Rhoden's *Seventh Heaven*, set to a slightly edited account of Beethoven's Seventh Symphony interspersed with bits from solo violin and cello music by Bach.

Forget Massine, forget Twyla Tharp, both of whom tackled the Beethoven. Mr. Rhoden's effort looked respectful but cluttered; the dancers dressed in trendy costumes by Miho K. Morinoue. They were constantly in motion, only rarely at rest; their stamina impressed. But the ballet did not.

Terrence S. Orr, the company's artistic director, who succeeded the former New York City Ballet dancer Patricia Wilde in 1997, seems to be making an effort to appeal to young audiences. He had to cut his staff by a third and lose six dancers two years ago, so no doubt he's trying to build audiences. He already has an active educational program. He is also trying to honor Pittsburgh's working-class heritage.

A result has been a raft of ballets set to popular music: Pittsburgh jazz musicians, Pete Seeger, Sting, and two to Bruce Springsteen. This week's Joyce program offers the Sting, choreographed by Kevin O'Day and called *Sting/ING Situations* and Derek Deane's *Hungry Heart "we all have one"*!!

One wishes to be polite to first-time visitors, but these ballets were

bad—not because the pop music was bad but because the choreography was bad. The too-cute title of the Sting revealed its essence: lightweight, mildly aggressive, with generic ballet moves in odd see-through costumes to Sting's clean-lined, beautifully sung pop.

The Springsteen was worse, since the songs—"Hungry Heart," of course, along with "Darkness on the Edge of Town," "The River," "Dancing in the Dark," and four more—are so dark, so personal, so complex, so intense. The ballet takes place in a 1950s-style bar populated with stock characters, some from Hollywood youth musicals, some straight from the Village People. But that band, a parade of gay archetypes, was self-parodistic. Mr. Deane presumably is not, yet he persistently trivializes the music, and loads on ballet spins and leaps to no expressive purpose whatsoever.

Two examples: "The River" as a peppy pas de deux, like Olivia Newton-John and John Travolta in *Grease*, or "Dancing in the Dark" as a finale with everyone doing his or her stereotypical thing, with all the lights brought up to full wattage. Any youth attracted by the names Sting and Springsteen would rightly be turned off ballet forever.

Oh, well. The dancers were good, a little raggedness in the Sting ballet aside. Among the men, Daisuke Takeuchi looked particularly confident, and Kalle Paavola from the corps did a lovely solo turn in the Springsteen, the only segment of that ballet with a smidgen of soul.

INDIAN DANCE
The New York Times, April 4, 2005

This month and next New York is enjoying a grouping of events called Celebrating India, jointly presented by the Asia Society and the World Music Institute and often involving nationwide tours of the artists involved. There is music and some theater, but above all there is dance.

Friday night at Symphony Space, under institute auspices, there was a production called "Masters of Kathakali," followed on Saturday by Priyadarsini Govind as the sole dancer in a Bharata Natyam performance.

Bharata Natyam and Kathakali claim an ancient lineage, but were codified in the mid-late second millennium. Both fell into decline by the late nineteenth century and enjoyed a renaissance in the twentieth. Today, young performers are trained through a network of schools based in the southeastern Indian state of Tamil Nadu for Bharata Natyam and the southwestern Indian state of Kerala for Kathakali.

Bharata Natyam, traditionally for a solo female, is more purely dance. Kathakali, for an all-male ensemble playing both male and female parts, is dance drama: the performers do not speak, leaving the narration to the singers; instead they act and mime and move, with the interest concentrated on the upper body, hand gestures, and facial expressions.

Bharata Natyam dancers are dressed relatively simply, in silk pantsuits with pleated aprons and modest jewelry. Their subjects, derived from Hindu temple dances, are almost exclusively devoted to Hindu deities. Kathakali performers wear elaborate makeup and head-dresses and costumes consisting of bell-like skirts with dangling doo-dads. Their stories are drawn largely from the epics *Mahabharata* and *Ramayana*.

Of the two generous Symphony Space programs, the Kathakali evening seemed the more authentic. The main compromise was the reduced scale a touring ensemble enforces. The performance was of a three-hundred-year-old drama called *Nala Charitham*, based on a por-tion of the *Mahabharata*. Complete Kathakali performances go on all night. The six scenes offered on Friday told of a poetic king who befriends a golden swan who acts as his go-between with the lovely Damayanthi. In the end, four gods disguised as the king are supposed to show up, confronting our heroine with five identical bell-skirted, green-faced, headdress-wearing heroes. On Friday, there was only one god.

Still, the performers were terrific, particularly Sadanam Krishnan Kutty as Hamsam, the swan. We first meet him mating (though there is no mate in sight), which demands athletic leaping and prancing. His initial encounter with the king involved much aggressive pecking. Eventually the two develop a warm friendship, warmly conveyed by the performers, the other being Chandrasekhara Warrier as the king.

The Kathakali musicians were good, but Bharata Natyam music is less raw and direct, closer to the sensuous subtleties of North Indian music. Ms. Govind's musicians were top-notch: a beguiling singer and an emphatically rhythmic chanter, a lovely violinist, and a drummer.

Ms. Govind herself won cheers from the audience, but was not to this taste. According to her program biography, she is "particularly noted for her adherence to tradition." It didn't look that way on Saturday, compared with the Bharata Natyam performances I have enjoyed in the United States, Europe, and India. Those focused on the upper body and subtle, sensuous, even spiritual facial expressions and astonishingly refined arm and hand movements.

Ms. Govind has a brightly energetic style and an earnest manner in her little lecture-demonstrations before each dance. Yet as she leapt tirelessly about the stage—miming her stories with extreme naturalism, assuming the poses but rarely communicating the sinuousness between them, flashing her dazzling Bollywood smile—she seemed more an entertainer than an artist.

ROBERT WEISS'S *SWAN LAKE*
The New York Times, May 24, 2005

Raleigh, N.C.—Radical reinterpretations of ballet classics have not gone so far in this country as have operatic rethinkings in Europe. Yes, there was Matthew Bourne's mostly male *Swan Lake*. But by and large, American ballet audiences often seem to want to take their classics straight. Even dowdy.

Enter Robert Weiss. A former New York City Ballet dancer and director of the Pennsylvania Ballet, Mr. Weiss founded the Carolina Ballet seven years ago. It began modestly, with an annual budget of $2 million, and even with steady growth is now at only $4.3 million. It's a mid-sized regional company.

Yet Mr. Weiss finally took it upon himself over the weekend—the last of five sold-out performances at the 2,200-seat Raleigh Memorial Auditorium was Sunday afternoon—to create a new *Swan Lake*. It looked conventional, on the surface: dreamy, attractive set designs and costumes; Tchaikovsky's music; classic ballet choreography; a swan maiden who seems to go over to the dark side; a handsome prince; an evil sorcerer; a white-clad lady swan corps; happy happy courtiers and peasants. Many

in the audience seemed content that they were seeing a familiar *Swan Lake*, and in some ways rightly so.

But right underneath the surface this was a downright radical undertaking. For better and for worse, it amounted to a bolder rethinking of this classic than ones with Petipa and Ivanov's choreography stuck onto some shocking modern setting.

In his comments both in the program and in conversation, Mr. Weiss placed emphasis on his need to scale down the traditional staging to something manageable for a small company like his own—and, he hopes, others of a similar size. Odette had eight swan girlfriends, not twenty-four or more. The orchestra of thirty-four (which played well under Alfred E. Sturgis's baton) was amplified more loudly than a full band twice its size would sound on its own. Jeff A. R. Jones's sets were handsome but painted on two-dimensional flats. The ballet was some forty-five minutes shorter than usual.

Mr. Weiss said he began to believe he could do *Swan Lake* when he came upon a children's-book version by an Austrian writer and illustrator, Lisbeth Zwerger. Mr. Jones's sets don't replicate Ms. Zwerger's designs, but they echo their feeling of wistful intimacy, with a nice use of blue silk to evoke the flood at the end and lovely, soft lighting by Ross Kolman throughout. David Heuvel's costumes suggest romantic ballet, not the later short tutus seen in most productions today.

So far, so unradical. But Mr. Weiss had more ideas than just rescaling the story. He builds up Rothbart's part into a real antithesis to the prince. The national dances in the ballroom scene are redistributed to the crowd. Music—a lot of the music—is shuffled from act to act. Petipa reshaped Tchaikovsky's score himself, but not to this extreme. It was like *Swan Lake* on random play.

More crucial still, some 90 percent of the choreography, by Mr. Weiss's estimate, is by Mr. Weiss himself. Most *Swan Lake* choreographers build on Petipa and Ivanov and Ashton and Balanchine and everyone else who has contributed to *Swan Lake* tradition in sedimentary layers over the last 125 years. However much those influences have seeped into Mr. Weiss's subconscious, he struggles perhaps excessively to make this his *Swan Lake*. Even going so far as to jettison some particularly beloved bits, like the four cygnets and Odile's thirty-two fouettés. Along with their accompanying music, including what Tchaikovsky wrote for the famous pas de deux.

Sometimes Mr. Weiss's musical cuts and reshufflings sound bizarre,

familiar passages unaccountably missing in action or stuck into the sequence in odd places, the key sequences rattled and expectations flustered. Sometimes the music he uses instead does not quite fit, as in the sweeping swan waltz for the evil Rothbart or the Russian dance for the Prince-Odile pas de deux.

The choreography, on its own terms, is sometimes bland but often striking and rarely anachronistic, a couple of twisty, contemporary-European-looking interactions (which I liked) in the ballroom pas de deux being about the outer limit of experimentation. Mostly it's classic and appropriate, even when the accompanying music isn't.

And the dancing was very good, blossoming in the choreography Mr. Weiss has tailored to his company's strengths. Lilyan Vigo was lovely and scary as Odette/Odile (here, the Swan Princess and the Sorcerer's Daughter). Timour Bourtasenkov preened a little but looked like a plausible, stalwart Prince. Cyrille de la Barre made the most of his expanded opportunities as Rothbart.

In the end, one was left impressed with the effectiveness of Mr. Weiss's vision if disoriented by the aggressiveness of his revisions. It might seem plausible to retain the intimacy and focus of this version while still sticking more humbly to the conventional sequence and not deliberately rejecting time-tested dances. Mr. Weiss would be an even more commanding auteur if, instead of fearing competition from the master choreographers of the past, he welcomed them into his own, overarching vision of this classic.

BORIS EIFMAN

The New York Times, May 26, 2005

Boris Eifman is an acquired taste, at least for non-Russian audiences, and it seems fair to say that a lot of New York dance connoisseurs have not yet acquired it. They express their disdain by boycotting performances of the Eifman Ballet of St. Petersburg or by complaining about them if they do attend.

As a frequent lover of things Russian and of performances (those of

the conductor Valery Gergiev come to mind) that strike more sober-minded sorts as sensationalist, I bring no bias to Mr. Eifman's work. Yes, an Eifman Ballet show I saw a couple of years ago seemed maudlin, and his *Musagète* for the New York City Ballet, a supposed homage to Balanchine (who was Russian in his training and upbringing), looked downright crude.

Still, I went on Tuesday night to see Mr. Eifman's latest work, *Anna Karenina*, which plays with alternating casts at City Center for the rest of the week, with an open mind. Although Tolstoy's massive novel, with its plots and subplots and finely shaded characters, might seem a stretch for a two-hour ballet with intermission—other Russians, including Maya Plisetskaya and Alexei Ratmansky, have taken a crack at it, too—its central grand passions are not unsuited to Mr. Eifman's insistently impassioned sensibility.

For him, above all, there is no Levin, with his tortured introspection about the meaning of life. No Oblonsky. Kitty (here, Kiti) is reduced to a supernumerary to fill out a quartet in the opening ball scene. It's all about the triangle of Anna, her tortured husband, Karenin, and her sexy lover, Vronsky.

That's it, except for several stiff, effortful ball scenes, one a Venetian number right out of *The Phantom of the Opera* but without the curving staircase. Anna's little son is seen playing with a locomotive at the outset and hurling himself into her arms when she's feeling guilty. The locomotive returns at the end of the first act, with falling snow, and again at the very end, with the entire corps playing out a constructivist ballet version of a steam engine, all clanking and hissing and machinelike movement. Anna throws herself into the melee, not quite between the wheels of a train car as in the novel, but close enough.

Otherwise, though, it's all grand passion, all the time. Anna and Vronsky are instantly smitten and have several steamy sex duets. There are a lot of tricky lifts with extreme extensions. Anna and Karenin are anguished. She has some sort of hellish drug trip.

The recorded music consists of stitched-together bits from Tchaikovsky, fairly cleverly done. It starts with the Serenade for Strings; concentrates on the big symphonies and tone poems, the louder the better; passes through some creepy electronic music (Mr. Eifman reportedly had a hand in it); and ends, inevitably, with *Romeo and Juliet*.

Mr. Eifman's choreography is not without interest, if too soon repetitive and predictable. (You just know at the end of a gloomy ball scene,

in which Society rejects the lovers, that Anna will crumple to the floor.) The dancers are long and leggy, and Anna is costumed (when she isn't metaphorically naked in a unitard) in a series of gorgeous long dresses, which seemed designed to reveal her legs in the lifts all the more. (Slava Okunev did the costumes.)

Tuesday's cast was first-rate, and indefatigable. The dancers may not all have the technique to master Petipa at the highest level, but they master Mr. Eifman just fine, and they'd be good for Maurice Béjart and any number of modern European choreographers as well. Tuesday's principals were Albert Galichanin as Karenin, Yuri Smekalov as Vronsky, and the awesomely tireless Maria Abashova as Anna, all commanding and handsome.

But the insistent, unvariegated proclamations of emotion, in the dancing and the music, ultimately drag down Mr. Eifman's good intentions. All that overbearing intensity just becomes wearing after a short while, even if you accept Mr. Eifman's right to transform the novel into a lurid soap opera.

As a Russian defender of Mr. Eifman wrote recently in *Dance Magazine*, "Good taste is just that, a matter of taste." Not much you can say to that, except that I have not fully managed to wrap my good taste around Mr. Eifman's.

AUGUST BOURNONVILLE

The New York Times, June 9, 2005

Note: The follow-up article to my first on the Bournonville Festival, which reported in greater detail what had happened there.

Copenhagen—Why has the popularity of August Bournonville, born two hundred years ago this August, swelled in the last few decades, after seventy-five years of provincial neglect? What is it about this once-obscure Danish ballet master that appeals so much to us today? And apart from him, what does his appeal say about us?

Such thoughts came to mind after a few days at the third

Bournonville Festival here. The performances by the Royal Danish Ballet were predictably lovely, and their appeal on one level fairly transparent: consummately elegant yet seemingly simple dancing, a complex technique enlisted to produce an illusion of naturalness, a charming young company proving that the Bournonville tradition is in good hands in the person of Frank Andersen, its once and current artistic director. (He was forced out in 1995 and rehired in 2002.)

One reason for the current good state of Bournonville performance in Denmark is the encouragement the company and its dancers feel when they are admired by foreigners. "I think we have gotten much more into the details because of all the interest from the outside," said Thomas Lund in the festival's daily journal; on the basis of his festival performances, Mr. Lund counts as today's premier exponent of Bournonville style.

For contemporary viewers, Bournonville's appeal seems the antithesis of so much of what came after him. No preening technical or sexual display here, no quasi-gymnastic stunts, no purging of spectacle and emotion to the level of cold abstraction, no puritanical rejection of mime, no practice clothes and blankly lighted cycloramas for decor, no vulgar latter-day straining for effect.

The first Bournonville Festival in 1979 is widely credited with establishing Bournonville among balletomanes worldwide. (The festivals have come every thirteen years since, although the fourth may break that pattern, Mr. Andersen says.) Yes, George Balanchine stopped off in Copenhagen for a year in 1930–31, and dancers like Erik Bruhn and Peter Martins and ballet masters like Stanley Williams have spread the Bournonville style, and even some of the Bournonville ballets, to North America. But to this day, *La sylphide* is about the only Bournonville ballet widely performed outside Denmark. It took the 1979 festival for critics to descend en masse on Copenhagen and spread the gospel.

In fact, however, there had been periodic Royal Danish Ballet festivals from the early 1950s, if not comprehensive and exclusive Bournonville festivals. British critics like Clive Barnes, Mary Clarke, and Clement Crisp—all on hand in Copenhagen this year—had started coming to Denmark to worship at the Bournonville shrine.

It's interesting to speculate why it was the English who first "discovered" Bournonville. There has been a Danish–English connection back to *Beowulf*. But the more immediate link is surely one of sensibility. The English never quite accepted stormy Wagnerian passions in their own art

(despite the popularity of Wagner's own operas), nor the flashiness of French post–World War I modernism. For them, ballet was epitomized by Frederick Ashton, whose *Fille mal gardée* seems closer to Bournonville than almost any other non-Danish ballet, and whose *Sylvia* sustained the French tradition in a manner not far from Bournonville's own inspirations.

It was in the 1950s that the English love for Mozart and for Mozart performances at Glyndebourne, inaugurated in the 1930s but disrupted by war, took root. The discovery of Bournonville in a more or less authentic, sustained Danish performance style can be seen as part of a shared predilection for graciousness, restraint, and humanistic feeling. Perhaps all of us, now, reacting against the wars of the first half of the last century and our travails since, prize a retreat to a gentler, almost classical romanticism.

Bournonville was a romantic, but partly by temperament and partly by a mere, but crucial, eight-year age difference, he was a very different kind of romantic from Wagner, born in 1813. In his capacity as director of the Royal Theater, Bournonville actually staged *Tannhäuser*, *Lohengrin*, and *Die Meistersinger*, but his own tastes in music ran toward the innocently tepid, watered-down Rossini and bel canto; his composers actually appropriated familiar bits of Rossini into their music. (Bournonville had been befriended by Rossini during his youthful days in Paris, and came rather to resemble him in his later years.)

Bournonville was suspicious of *Die Meistersinger* when he heard it in Munch in the late 1860s, before his own staging. He doubted that Wagner's music would last; then again, he doubted his own ballets would last, either, and fortunately in both cases he was wrong. Despite his own forays into Nordic mythology, it's lucky he never heard Wagner's *Ring*; it would have scared him half to death.

Coincidentally, the Royal Opera presented Wagner's *Siegfried* at the flashy new Copenhagen Opera House on Sunday, the off day in the Bournonville Festival. Wagner finished the second act of that opera in 1857, then put it aside as unperformable to write surefire commercial bagatelles like *Tristan und Isolde* and *Die Meistersinger*. There the music of *Siegfried* sat, in manuscript, as Bournonville was contenting himself with Joseph Glaeser, Hans Christian Lumbye, and A. F. Lincke, the composers of *Far from Denmark* of 1861.

Still, Bournonville is incontestably great on his own terms, and I for one would be thrilled if any further efforts at the reconstruction of his

ballets could salvage more of the fifty-plus works he created—along the lines of his *Abdallah*, first done in modern times at Ballet West in Utah in 1985, brought to Copenhagen in 1986, and included in the second and third Bournonville Festivals.

His aesthetic is his own, yet he provides the same kind of profound pleasure that so many great artists, no matter what their ostensible aesthetic, seem to convey. The second act of Mozart's *Nozze di Figaro* and the third act of Wagner's *Meistersinger*, to Bournonville's ears so dangerously cacophonous, both flow seraphically, catching up the willing audience member in a timeless spell. Bournonville does that, too, as in long stretches of his *Napoli* at the Royal Theater Saturday night. If the Danes deserve credit for cultivating and sustaining Bournonville, and the English for initiating his international discovery, he is now the world's. And because of that, the world, for all its horrors, is a better place.

SUZANNE FARRELL'S *DON QUIXOTE*
The New York Times, June 24, 2005

Washington—It was probably all to the good that we had to wait so long to see Balanchine's *Don Quixote* again. Forty years after its creation, twenty-seven years after it was last seen at the New York City Ballet, it was finally revived—recreated, reborn—on Wednesday night at the Kennedy Center.

The agent of its return was Suzanne Farrell, for whom the role of Dulcinea, and indeed the whole ballet, was created, and to whom Balanchine left it in his will. The Suzanne Farrell Ballet, a modestly budgeted company supported by the Kennedy Center, has joined forces with the National Ballet of Canada to produce this grandly scaled epic.

The distance from now to then helps us purge memories of Ms. Farrell and Balanchine himself in the principal roles, and discourages us from using those yardsticks to belabor anyone who might subsequently assume those parts. We can also begin to forget the intensely romantic back story of the ballet's creation, how the sixty-one-year-old choreogra-

pher yearned for his nineteen-year-old elusive muse and made this public declaration of adoration for her. We can even overlook some of the bad feelings that apparently remain between Ms. Farrell and her former company, which might have seemed the logical home for a revival of *Don Quixote*.

Letting that sort of crippling nostalgia and backstage gossip fade into the background permits us to see the ballet itself more clearly. It was highly controversial during its thirteen years of life at City Ballet. Although some admired it from the start, others questioned its coherence, its excess of mime, and Nicolas Nabokov's pallid and unattractive music. On Wednesday it looked and sounded very good indeed, well worthy of a revival, even beyond the notion that anything Balanchine touched should be preserved.

Don Quixote is not to be confused with Petipa's ever-popular virtuoso showpiece that opened the American Ballet Theater's season at the Metropolitan Opera House this year and will open the Bolshoi Ballet's stand there in July. This is a highly atypical late Balanchine ballet. Instead of leotards and tights and a blank cyclorama, there are mime and acting and lavish sets and costumes and a complex series of narrative images, not unworthy of Cervantes.

From 1965 to 1978 Balanchine restlessly tinkered with the variations and the score. Ms. Farrell, now fifty-nine and hence almost Balanchine's age in 1965, has made her own edition, sticking largely to the 1965 original and rebuilt from memory, some faded videos, and her own choreographic filler. The sets have been slightly reconceived and simplified by Zack Brown, since the Kennedy Center plans to tour the ballet (perhaps to the New York area?), and the National Ballet of Canada intends to give it in its 2006–7 season. Holly Hynes more or less recreates the Karinska costumes, and Brad Fields's lighting is sure.

The dancers come more from the Farrell company than from Canada (forty-one versus eighteen, as well as some local children), but the Canadians provide nearly all the principals and soloists; the ballet was rehearsed in Toronto; and the decor was built there. Sonia Rodriguez (who alternates Dulcinea with Heather Ogden) does not have Ms. Farrell's build or presence (how could she?), but she danced and acted very affectingly on her own terms. Momchil Mladenov made a properly spectral, haunted Don, although Eric Ragan looked a little too much like a cartoonish pro sports team mascot as Sancho Panza. By and large the solo opportunities were handled with winning aplomb.

The ballet is oddly constructed because it begins and ends with mime but offers all manner of seemingly abstract set pieces and variations in the second and third acts. Yet with Ms. Farrell summoning Balanchine's steps and spirit, the ballet looked more of a piece than might have been expected.

That means the pure dance sections are so brilliant and ingeniously choreographed and recreated that they refuse to become mere divertissements. Often they shade into phantasmagorical dramatic action, reflections of the Don's nobly addled mind. Dulcinea's shift from dance joy to dramatic terror in her third-act variation was a particularly telling case in point. And the use of Dulcinea as a choreographic leitmotif, threaded through the story, is really lovely.

The music, decently rendered by an orchestra conducted by Ormsby Wilkins, sounded far better than most reviewers from forty years ago heard it. This can be acerbic music, but it matches the drama, captures the varied moods, and is sometimes downright gorgeous.

Don Quixote must still come fraught with the most intense of emotions for Ms. Farrell. Her triumph here is that she has been able, even with dancers inevitably less stellar than herself and the rest of the 1965 City Ballet troupe, to reveal Balanchine's work as he must have intended it. That's her gift to him, and to us as well.

DIANA VISHNEVA'S *GISELLE*

The New York Times, July 14, 2005

What is there to say about American Ballet Theater's revival, for an eight-performance run to end its Metropolitan Opera House season, of its eighteen-year-old production of *Giselle*? Same old, same old?

Not likely. Monday's opening night was very good. Tuesday's performance was one that will go down in Ballet Theater annals, something so incontestably great that all whining about past golden ages can happily be laid to rest.

That greatness was shared by all three principals, but above all there was Diana Vishneva's Giselle, her first assumption of the part for Ballet

Theater (and most unfortunately, her only Giselle of this run). Ms. Vishneva delivered a performance that surely surpassed anything else she has done here. She had it all: impeccable, inspiring technique; personal charm; and heartbreaking dramatic prowess. She was equally at home as a lovesick young girl, a young woman fatally tormented by madness, and, finally, an ethereal, unearthly spirit, still deeply in love with the man who betrayed her.

She was to have been partnered by Vladimir Malakhov, who was sidelined with an appendectomy. But it would be hard to imagine a better present-day Albrecht than Angel Corella. Albrecht is not a showy role, but Mr. Corella was up to every challenge: his feathery beats as he traversed the stage toward the end were lovely, but as usual with him, so surely dovetailed into the character that they never called undue attention to themselves. Mr. Corella is the ultimate poetic dancer, and in the long adagios of the second act, he matched Ms. Vishneva step for step, emotion for emotion.

The third, inevitably lesser but still crucial member of the trio was Veronika Part as Myrta, queen of the wilis. Kirov-trained, like Ms. Vishneva, Ms. Part has the height and the grandeur to make an imperious queen. She danced with effortless command, but all she had to do was stand there to rule the stage.

Giselle, almost no matter who performs it, is a perfectly beautiful ballet, rich with history and charged with life. Continuously in the worldwide repertory for 164 years, it epitomizes romantic art and has been gracefully preserved and updated over the decades. From the German poetic inspiration of Heinrich Heine to the French balletic intellectualism of Théophile Gautier, from the choreography of Jean Coralli and Jules Perrot to Marius Petipa to a host of sensitive twentieth-century restagers, from the delightful music of Adolphe Adam to the unobtrusive orchestration of John Lanchbery, *Giselle* has evolved without losing its heart. It has bucolic charm and heavy-breathing drama, but above all, along with *La sylphide*, this is where romantic ballet myths were born: all those wispy ladies in white tulle and toe shoes and their desperate, hopeless lovers.

Ballet Theater's venerable physical production is traditional in the best sense. The performances on Monday and Tuesday, not counting the magic of the Vishneva-Corella-Part trio, were fairly evenly matched. Sascha Radetsky on Tuesday made an even more intense Hilarion than had Gennadi Saveliev on Monday, but both were fine.

Herman Cornejo on Monday dazzled in his second variation in the peasant pas de deux, but Mr. Saveliev was sturdy enough on Tuesday, and their partners, Xiomara Reyes and Anna Liceica, were both pleasantly competent. On Monday, Michele Wiles and Ms. Part made for luxury casting as Myrta's sidekicks, Moyna and Zulma. But they towered over a small-scaled Gillian Murphy as Myrta, and on Tuesday, Melissa Thomas and Carmen Corella looked perfectly fine next to Ms. Part.

The Ballet Theater orchestra, which can sound thin in lusher scores, is more suited to the Adam-Lanchbery music. On Monday, Ormsby Wilkins elicited smoother playing and reveled in sinuous, dance-friendly rubatos. Charles Barker on Tuesday was more straightforward, but by the second act, everyone's attention was focused on the stage.

That left Monday's Albrecht and Giselle. Julio Bocca is a wonderful dancer-actor, and his Albrecht was first-rate in every respect. He's a bolder, more aggressive dancer than Mr. Corella, which worked perfectly well, and he nobly partnered his Giselle, Julie Kent.

Ms. Kent, who was replacing the originally announced Alessandra Ferri, suffering from an ankle injury, is a superb technician, too, and that counts for a lot. She managed the girlishness and madness of the first act very persuasively. Her spidery arms and lovely extensions worked well as a wili, too, and if she has sometimes seemed cold to me, coldness is acceptable here. By this point Giselle is, after all, dead.

But in the end, what remains in the memory is Ms. Vishneva's artistry, and the hypnotic pleasure of her weightless second-act adagios with Mr. Corella. Ballet history doesn't come along every day, but Tuesday was one such day. It was humbling to have been there.

SPARTACUS

The New York Times, July 25, 2005

We had *Astarte*; they had *Spartacus*. American grooviness, however crudely manipulated, versus Soviet triumphalism. The Soviet Union was riding high in 1968. There were those scary displays of bellicose

hardware in Red Square, and the Soviets were still holding their own in the space race (Neil Armstrong hadn't yet stepped on the moon).

Spartacus was the perfect Soviet allegory. Based on an actual slave rebellion in Italy in the first century B.C., it mirrored the Marxist vision of a virtuous underclass fighting to free itself from decadent rulers. Yuri Grigorovich's definitive ballet version was seen in Moscow in 1968 and widely praised, a praise echoed in its first Western appearances in London the following year. By then there had already been Bolshoi Ballet versions, to the same scenario and the same Khatchaturian music, by Leonid Jacobson (seen disastrously in New York in 1962) and Igor Moiseyev. Not to speak of Stanley Kubrick's film version from 1960.

It took until 1975 for the Bolshoi to bring the Grigorovich staging to New York, and shortly thereafter it was immortalized in a widely seen film. For a ballet so iconic, and still regularly in the Bolshoi repertory, it comes as shock to realize that the company hadn't done *Spartacus* in New York for thirty years.

That was rectified on Friday and twice on Saturday at the Metropolitan Opera House, part of the Bolshoi's two-week Met engagement (and forthcoming two-week American tour).

Thirty years is a long time. One wondered how Mr. Grigorovich's choreography would hold up. And how today's Bolshoi dancers, so different from their Soviet predecessors, would dance it. The answers are OK and OK.

Mr. Grigorovich's *Spartacus* is a grand cinematic spectacle, full of leaps and loves and betrayals and brilliant tableaus and lots and lots of macho stomping about by soldiers and slaves and shepherds. Khachaturian's score, cut and revised for Mr. Grigorovich, is similarly cinematic; in other words, it sounds like movie music. At its best, it's Shostakovich without the genius. But Lord knows it's vigorous.

All this offended more refined sensibilities in 1975 and continues to offend them now. For more populist types, *Spartacus* can be enjoyed for what it is. Mr. Grigorovich steers largely clear of conventional ballet mime; his *Spartacus* is full of actual choreography, however martial. The odd thing is how readily he falls back on standard ballet steps and moves.

But whatever impression the ballet can make today is inseparable from how it's danced. Bolshoi dancers back then were more full-blooded (and full-bodied) than they are today. Strong, muscular men leaping to impossible heights; willowy yet assertive women capable of amazing contortions.

That stereotype seems true in general but in need of modification for *Spartacus*. Yes, the Bolshoi corps back then stuck out their chests with more manly self-assurance than today's prancy successors. Although the Three Shepherds, common to all three performances, were terrific, Spartaci in training.

Vladimir Vasiliev, the incontestably supreme Spartacus of yore, was not an unusually muscled man. He leapt high, but what he really did was project a thrilling intensity. Similarly, Maris Liepa as the evil Crassus achieved his effects as much through his sneering hauteur as his strutting dancing.

There are only four main characters in this ballet, and they are sharply, not to say cartoonishly, delineated. Spartacus is noble, strong, and loving. Crassus is pure evil. Spartacus's wife, Phrygia, is femme yet brave. And Crassus's courtesan, Aegina, is a showy vamp.

I never saw Ekaterina Maximova, the 1968 Phrygia, but Natalia Bessmertnova in 1975 and in the film was near ideal, and Nina Timofeyeva slithered about with as much personality as the character of Aegina allows.

Today's Bolshoi dancers are slimmer, sometimes downright skinny. Most of them don't fill out Simon Virsaladze's sexy late-'60s Roman costumes (everyone wears miniskirts). His now-faded sets are still being used, too. Yet many of the dancers this weekend conveyed the ballet well enough to let us see what Mr. Grigorovich had in mind.

Dmitri Belogolovtsev was to have danced the title role on Friday night, but in the shufflings common to ballet-company casting, he dropped out. The result was that the veteran Yury Klevtsov did Spartacus both Friday and Saturday nights, and he was just fine. He can jump and twist with authority, he has a ripped torso, and he handled the spectacular one-handed lifts with aplomb (as did his liftees). Like Mr. Vasiliev, he projects manly strength; he articulated Mr. Grigorovich's insistent stentorian gestures with enough conviction to purge their inherent risibility.

Alexander Vorobiev on Saturday afternoon never convinced me that his posing was more than that. He may well be superb in classical repertory, but here he was a ballet dancer, not a heroic slave.

All three Phrygias were good. Anna Antonicheva danced elegantly on Friday, but lacked glamour. On Saturday night, Svetlana Lunkina danced even better, and had grand ballerina pathos. Nina Kaptsova at the Saturday matinee best conveyed classic line, glamour, and sexiness.

The two exponents of Crassus—Saturday evening's principals were

the same as Friday's except Ms. Lunkina—fell decisively short of Mr. Liepa's model, although Alexander Volchkov seemed more confident and evilly oily than Vladimir Neporozny managed at the matinee. Conversely, Ekaterina Shipulina at the matinee did more with the improbable part of Aegina than did Maria Allash.

Khachaturian's music may be tacky, but Pavel Sorokin drew forceful, confident playing from the Bolshoi Orchestra. Their contributions did as much as the dancing to make Mr. Grigorovich's *Spartacus*, a true child of its time, sustain its viability for audiences today.

THE PHARAOH'S DAUGHTER
The New York Times, July 30, 2005

How much you enjoy *The Pharaoh's Daughter*, the Bolshoi Ballet's grand nineteenth-century Orientalist fantasy that opened a four-performance run at the Metropolitan Opera House on Thursday night, depends on what expectations you bring to it.

For most people, it can be enjoyed as a slight, amusing, rather mindless pastiche, full of nice lyrical dancing with gracious music. Don't demand too much of it—historical accuracy or, heaven forfend, spiritual profundity—and you're likely to have a nice time.

This is not meant to be patronizing. There is nothing wrong with simple pleasure, and with *The Pharaoh's Daughter* the Bolshoi has a vehicle in which the company's prima ballerina, Svetlana Zakharova, can shine to greater advantage then she did in *Don Quixote*.

That ballet was originally by Marius Petipa, and so was *The Pharaoh's Daughter*. It was a lavish extravaganza, born of renewed European fascination with Egypt when construction of the Suez Canal began in 1859, an enthusiasm that culminated with Verdi's *Aida* in 1871.

The Pharaoh's Daughter dates from 1862 and counts as Petipa's first original full-length ballet and first big St. Petersburg success. It was a huge production and a huge hit, lasting more than four hours, with four hundred people onstage.

Another Frenchman, Pierre Lacotte, went to Russia in 2000 and

restaged the ballet. The word reconstruction has been bandied about, but *The Pharaoh's Daughter* is really no such thing. The program, saying the choreography is "based on motifs from the ballet of the same name by Marius Petipa," is accurate.

Mr. Lacotte has made a career reconstructing or recreating nineteenth-century dances. There are some fragmentary notated records of this ballet, plus postcards and memories of a few ballerinas who danced it. But the Soviet Union dismissed it as trivial, and Mr. Lacotte didn't have all that much to work with.

What he had, he often ignored. Amusingly, the Bolshoi was refused access by the Kirov Ballet to the only extant full score of Cesare Pugni's music—the St. Petersburg–Moscow rivalry lives!—and so the Bolshoi had to piece together a score from fragments and reorchestrate them.

The plot involves a British archaeologist, Lord Wilson, and his cartoonish servant, John Bull. Lord Wilson falls into an opium dream and finds himself and Mr. Bull transformed into ancient Egyptians. Now Ta-Hor, he falls in love with Aspicia, the titular daughter. They flee her intended, the king of Nubia, who forces her to jump into the Nile. There she finds a school of fishy creatures who dance variations representing great rivers of the world. Restored to dry land, Aspicia arrives at court in time to save Ta-Hor, who is about to be bitten by the sacred snake of Isis in punishment for abducting her. All ends happily, except that Lord Wilson wakes up.

Mr. Lacotte simplified the scenario and cut well more than an hour of music (which means a lot of plot is squeezed into a constricted time frame). The Bolshoi cast is less than a quarter of the original four hundred.

Mr. Lacotte has suggested that a true reconstruction, to the extent it might be possible, would look dated. So he pretty much choreographed it from scratch, stripping the dancing of most flashy virtuosic moves and, he argued, reintroducing some lighter, fleeter footwork. He also designed the sets and costumes.

The result was still grand enough, in a deliberately hokey way, and the lyrical dancing suited the current Bolshoi troupe. While Mr. Lacotte beefed up some of the male variations—mid-nineteenth-century ballet was woman's work—this is still a ballet in which women take center stage, and on Thursday they shined.

Ms. Zakharova looked airy and elegant, no longer forcing for effect as she had in *Don Quixote*. Nikolai Tsiskaridze, filling in for the injured

Sergei Filin, partnered Ms. Zakharova deferentially. Maria Alexandrova as Aspicia's servant and Denis Medvedev as Bull, both underutilized, still danced well. Dmitry Gudanov and Anastasia Yatsenko stood out as a fisherman and his wife; Ekaterina Shipulina was especially fluent as the Congo; and Natalia Osipova, Nina Kaptsova, and Andrey Bolotin sparkled in a pas d'action. Pavel Klinichev deftly conducted Pugni's sweetly un-Egyptian score.

That all said, Mr. Lacotte, while reflecting current Russian and perhaps international taste, could be wrong about reconstructions. Opera may be decades ahead of ballet in this regard. In olden days, people assumed that for Handel, say, to be credible, he had to be romantically reorchestrated. The early-music movement started out with the same presumptions: Raymond Leppard's versions of baroque operas, which now sound bloated, were honestly intended to make those works accessible.

The critic Richard Taruskin, writing about music, has argued that all reconstructions are mere reflections of modern taste. But the Kirov Ballet has tried more historically accurate Petipa than this. One of these days, we may get the chance to explore the dance technique and mime and decor and mass spectacle and even body types of these ballets of yore. *The Pharaoh's Daughter* is, after all, a ballet about archaeology.

L'ALLEGRO, IL PENSEROSO ED IL MODERATO

The New York Times, August 20, 2005

When it was born at the Théâtre Royal de la Monnaie in Brussels in 1988, *L'Allegro, il Penseroso ed il Moderato* was recognized, at least by his admirers, as Mark Morris's masterpiece. Seventeen years later, it still is, by pretty much everybody.

It has also become something of a staple in New York, a *Nutcracker* for adults or a *Messiah* for the secular. It was performed at the Brooklyn Academy of Music in 1990 and 2001 and at the New York State Theater in 1995 and 2002. Now it's back there again, courtesy of the Mostly

Mozart Festival and as part of the Mark Morris Dance Group's twenty-fifth anniversary.

Not everyone loves Mr. Morris, but enough smart people do, especially this work, that reams of paper and buckets of ink have been spent describing its manifest wonders. There is even a lavish coffee-table book, with essays by Joan Acocella (who wrote the basic Morris biography), Wendy Lesser, and Alastair Macaulay. Anyone who cares about dance, or wants to see one of the cornerstones of late-twentieth-century choreography, or just wants to be wafted on a wave of musical and terpsichorean beauty, should try to get a ticket for tonight's performance.

No doubt connoisseurs will prefer different incarnations of Mr. Morris's company, or different dancers in the featured parts, from one year to the next. Suffice it to say that Thursday's performance, rapturously greeted by what looked like a full house, was as good as any I have seen.

The twenty-four barefoot dancers, twelve men and twelve women, were commanding and impeccably rehearsed; Adrianne Lobel's sets (wings, flats, and scrims, rising and falling into different configurations) and James F. Ingalls's lighting were as evocative as ever; and Nicholas McGegan and his vocal soloists and the Orchestra of St. Luke's and the Riverside Choral Society Chamber Singers delivered a silvery, sure account of Handel's glorious oratorio.

Which leaves me in the awkward position of trying to add a few words of my own to the vast bibliography of critical description that has been lavished on this piece. One thing that makes it so beguiling is its range of images and emotions, the way it captures all of human feeling and an entire social order in a pastoral setting. Mr. Morris's work can be too cute. Here it's cute when it needs to be cute, as when hunting dogs (dancers) pretend to urinate on bushes (more dancers). Or when the men, in a circle of couples, alternately slap one another and paddle one another and prance and kiss and slap and paddle.

But there are also intimations of love and loss and death and transcendence. Il Penseroso's final meditation invokes, in Milton's words, "the full voic'd choir" and the "anthem clear" to "let their sweetness, through mine ear, dissolve me into ecstasies / And bring all Heav'n before mine eyes!"

Handel sets this to music of Bachlike choral intensity, and Mr. Morris responds in kind, with four couples—two of men and women, one both men, the last both women—in loving embrace, while a lone woman, at the rear of the stage, points upward.

Mr. Morris's choreography is mimetic without falling into the clichés of nineteenth-century ballet mime. He echoes his dancers onstage, sometimes in ghostly apparitions behind a scrim. He mimics the musical gestures and the verbal images and even his own choreography, with recurrent groupings and steps and lifts. In other dances, Mr. Morris can seem too literal. Here, he makes magic.

So does Paul Taylor in his own work to a Handel score, *Aureole* (1962). In a nice coincidence, the Taylor company will perform *Aureole* tonight, concurrently with Mr. Morris's final performance, in the last of its three free programs at the Damrosch Park Bandshell, part of the Lincoln Center Out of Doors festival.

Mr. Taylor and Mr. Morris both allude to ballet but do so in extensions of natural movement and folk dance. In Christine van Loon's flowing costumes for *L'Allegro*, all supple skirts and flashing petticoats and, for the men, calf-high tights, loose shirts, and sashes, the dancers dart through the choreography like birds (sometimes overtly so, in the extended ornithological sections).

My last thought (for now) on this piece has to do with patterns. Mr. Morris came from folk dance, Serbian folk dance especially, in which he immersed himself in his native Seattle. The placement of bodies on the stage, whether in small numbers or large, best seen from above, is a major part of the Morris magic. There is often symmetry, but also what might be called asymmetrical symmetry: unevenly configured groups that look so perfectly right that classical ideals of balance are reborn.

Whatever. Words fail. Go see for yourself. If you can get in. If you can't, go around to the west side of the State Theater and check out *Aureole*.

FRED AND GINGER

The New York Times, September 2, 2005

Fred Astaire and Ginger Rogers made ten musicals together, from *Flying Down to Rio* in 1933, when they didn't yet get star billing, to *The Barkleys of Broadway* in 1949, a full decade after the ninth and a kind of coda to the rest.

At their peak, between 1935 and 1937, they were America's beloved couple. Their musicals offered the purest form of escape from the woes of the depression, a fantasy of the 1920s seen through the darker prism of the '30s. They provided the opportunity to commission and inspire the country's great songwriters—Berlin, Kern, Gershwin. These films, these actors/singers/dancers, have since also inspired a small library of critical commentary, of which Arlene Croce's *Fred Astaire and Ginger Rogers Book*, now lamentably out of print, remains the classiest.

Still, any excuse to write about Astaire and Rogers is always welcome, and Warner Home Video has provided a dandy excuse. In volume 1 of the *Astaire & Rogers Collection*, we have five DVDs of five Astaire-Rogers movies. Since there are five more, and this is billed as volume 1, we can safely assume a volume 2 is in the works, though Warner Brothers coyly won't confirm that.

These first five DVDs, in their crisp, vivid transfers with sometimes illuminating, sometimes tedious extras, include three of the films generally considered to be the best of their best: *Top Hat* (1935), *Swing Time* (1936), and *Shall We Dance* (1937), along with *Follow the Fleet* (1936). *Fleet* has its improbabilities (Astaire as a gum-chewing swab), but also "Let's Face the Music and Dance," which floats blissfully free of the plot and may count as their greatest self-contained dance drama. The Warner set is rounded out by *The Barkleys of Broadway*, their only one in color and their only one not for RKO, in which the magic is pretty much gone but which is still full of craft and nostalgia and a plausibly witty mirroring of the popular image of their collaboration (onstage harmony, backstage dissonance).

What made the Astaire-Rogers team great was talent, synergy, and context. Rogers was already a budding movie star when Astaire did his first film in 1933. But he was long established in vaudeville and on Broadway. When the Astaire-Rogers collaboration took off, Astaire and his dance master, Hermes Pan, laboriously worked out the dance numbers for the next film while Rogers was off making something else. Then Pan taught Rogers the moves, Astaire and Rogers danced, and America swooned.

Astaire's sister, Adele, was widely considered his "best" partner, before her retirement into marriage, but Rogers clicked with the broader public through film, a simultaneously intimate and populist medium. It has been widely, endlessly repeated that, in terms of their images, Astaire brought her class and she brought him sex. She also

brought him emotion and romance. Astaire was never an actor with a wide range; he looked like the Joker in *Batman* and always played the dapper sophisticate, nervously skimming the surface of feeling.

Rogers, in turn, was never a classic screen beauty. But she glowed in the best of these Astaire-Rogers films. Partly that has to do with a seemingly unstoppable parade of gorgeous costumes, like those (ostrich? chicken?) feathers in *Cheek to Cheek*. But her glow had even more to do with their chemistry.

She could act; some of her reaction shots are really moving. But together, in their dancing (and his singing, thin voiced but consummately stylish), they made a new kind of acting—dancing that was acting all by itself. Their dancing (meaning his choreography and their execution of it) was formal and reserved, like him. It was ballroom dancing mixed with swing and jazz and tap. But though some of the virtuosity remains remarkable, it was never vulgar and flashy like ballroom dancing today, at least as epitomized by reality TV shows like *Dancing with the Stars*.

The mid-'30s was the era, after all, in which the Motion Picture Production Code had cracked down, to the point of prudery, on the more salacious excesses of Hollywood in the '20s and early '30s. There was never anything covert in the sexual play of Astaire and Rogers. Their dancing together was sex; it was romance. "Of course, Ginger was able to accomplish sex through dance," Astaire once said. "We told more through our movements instead of the big clinch. We did it all in dance."

For me, the magic in their relationship had as much or more to do with the lead-ins as with the dance itself; more with foreplay than consummation. Often the song itself, sung by one or the other or both, precedes the dance, as in "Cheek to Cheek" from *Top Hat*. In "Let's Face the Music and Dance," there is a risible yet moving mime scene in which both are about to commit suicide before they find each other. It is the slow, rocking synchronicity of their initial dance movements, swaying and walking before the actual ballroom steps kick in, that seems particularly moving.

For an American, it is the Americanness of Astaire (from Omaha, Nebraska) and Rogers (from Independence, Missouri) that shines through. Most of these films have formulaic plots straight out of nineteenth-century French farce and aspire to a faux-European, Hollywoodized idea of elegance (Ms. Croce described the Venice of *Top Hat* as a

"celestial powder room"). Astaire, especially, is prized as a last bastion of elegance by those who resent rock and roll and the seemingly anarchic social eruptions in American life since the 1960s. But he helped presage that rebellion.

The relation to black dance and dancers in these films looks awkward today, especially the happy blacks in the steamship boiler room of "Slap That Bass" from *Shall We Dance* or the blackface "Bojangles of Harlem" number in *Swing Time*, a supposed homage to the great black tap dancer Bill Robinson. Astaire and Rogers were Caucasians in a society still dominated by Caucasian mores; whites assumed they *were* Americans.

Yet these musicals did much to democratize dance (high culture is presumed to be pompous, as in the clumsy ballet parodies in *Shall We Dance*), and to help crack open the bland gentility of white America with the livelier energies of black America. Astaire and Rogers took that racial and social fermentation and made it into art.

Social and historical contextualization is all well and good, but these movies are not just of their time; they're timeless. That is because the tension and release, the hostility and amorous ecstasy of their dance resist aging.

Some of the musical shorts these DVDs offer as extras look appallingly quaint. When Astaire and Rogers sing and dance together, their feature films escape time. They are popular art as elevated as any high art ever made.

DANCE AND THEATER

The New York Times, October 5, 2005

The Wooster Group's characteristically brilliant, ingenious play *Poor Theater* is built on the concept of "simulacrum," wherein the company inhabits the souls and the work of Jerzy Grotowski and William Forsythe, with a nod to Max Ernst.

Anyone in search of insights into Mr. Forsythe and his famously ingenious, nervously intense choreography needn't feel compelled to

attend. The actor Scott Shepherd's impersonation of Mr. Forsythe seems eerily accurate. But his text is taken largely verbatim from a documentary film and a CD-ROM and public conversations the choreographer has given, notably one with Roslyn Sulcas at the Brooklyn Academy of Music a couple of years ago.

Ms. Sulcas, who now writes about dance for *The New York Times*, is thanked in the program, and there is a character onstage named Roslyn questioning Mr. Forsythe. If your goal is to work your way inside Mr. Forsythe's head, better you should have gone to Brooklyn.

Partly that is because the *Poor Theater* version, which plays at the Performing Garage in SoHo through October 15, has aroused a level of controversy in Forsythe circles, reports Ms. Sulcas, who is writing a book about the choreographer. Some Forsythians worry that the portrayal of him smacks of condescension or parody, and that his nervous speech patterns, flitting like a bug from thought to thought, suggest that he is less articulate than he would like to be perceived. To me, the Wooster Group simulacrum is affectionate, even adorational. Linking him with Grotowski, for a theater troupe, is a pretty serious attestation of admiration.

In the end, though, *Poor Theater* is about the Wooster Group more than its putative subjects. Which is fine: the Wooster Group is right up there with them, and who better to provide insights into the group than the group? The relationship between thought and emotion, between layers of ironic meaning and primal passion, between originality and indebtedness to other artists, along with crisscrossing onslaughts from different mediums (sound, film or video, live action)—all are on dazzling display at the Performing Garage.

The Wooster Group actors are actors, not dancers. Despite Mr. Shepherd's skill at capturing Mr. Forsythe's manner of thought and speech, he looks workaday dancing his dances, as do Kate Valk and Ari Fliakos and Sheena See. Mr. Fliakos is extraordinary as an earnest, befuddled Polish translator and a howling actor in the company's re-creation—bellowed simultaneously with a film of a Polish Laboratory Theater performance—of Grotowski's *Akropolis*. In Polish, no less. But he's no Forsythe dancer.

What *Poor Theater* does reveal about dance is its closeness today to theater, even at its most abstract, and few choreographers have been more abstract than Mr. Forsythe.

In theater, there has been a movement in recent decades away from

word-driven narrative. Grotowski was a pioneer of a theater that digs deep into subconsciousness. In their vastly different ways, Lee Strasberg, Robert Wilson, Peter Sellars, and Julie Taymor also transcend overt narrative. Theater today—interesting theater, not formulaic Broadway commerciality—is as much about movement and image and multimedia and even song as the actorly articulation of text. Not that words still aren't central to the art, but they've lost their arrogant monopoly.

In dance, we live in a time of worldwide reaction against the excesses of pure abstraction. From George Balanchine's leotard-and-cyclorama ballets to the Judson Church minimalists, abstractionists created emblematic works of the mid-twentieth century. But everything is a reaction against what preceded it; abstraction certainly was. Today, variations of "physical theater" are everywhere, using movement for itself but also to tell stories, or at least to intimate emotional subtexts.

In that sense an exploration of Mr. Forsythe's way of dancing is a kind of therapeutic exercise for the Wooster Group actors. They may not dance like Forsythe dancers. But in working hard to do so, they have made themselves more complete mover-actors.

Mr. Forsythe, in his own words and seen through the enriching veil of the Wooster Group's vision of him, is so full of ideas that they jostle and crowd one another as they pour forth. He believes in physicality, but he thinks restlessly and constantly. He is a choreographer with firm ideas of what he wants, yet he prizes the individuality and improvisatory spontaneity of his dancers.

And he is, by the way, still very much at it: the program notes make him sound like a figure of the past, given the demise last year of his Frankfurt Ballet. There is no reference to his constantly touring new troupe, the Forsythe Company, which is stocked with Frankfurt dancers.

His blend of seemingly opposing attributes makes him akin to Elizabeth LeCompte and the Wooster Group. For all their own intellectuality, the Woosterians tap into dark, primal emotions, too.

Grotowski thought; Mr. Forsythe feels. The turbulent, over-the-top emotionality of Grotowski is just as much a tributary into the Wooster Group's turbulent artistic stream as Mr. Forsythe's idea-driven movement. Which is why *Poor Theater*, in the end, is not about primal theater nor about postmodernist dance but all about one of the finest, richest, most fascinating theater companies of our time.

OHAD NAHARIN

The New York Times, November 17, 2005

Ohad Naharin is fifty-three now, and long since established as Israel's leading choreographer. But he's been through a lot lately, and his new piece, *Mamootot*, in its spare, reserved, sexual, and literally touching way, reflects all that.

Mamootot (pronounced mah-MOO-tote) means mammoth in Hebrew, but Mr. Naharin has said he just likes the sound of the word. The 2003 piece is the first he did after his wife died in 2001; he thanks her in the program. After that he took a year and a half off from his post as artistic director of the Batsheva Dance Company, Israel's finest. Now he's back, apparently rejuvenated, and showing us this hourlong work. It's pretty thrilling.

Mr. Naharin's pieces have often involved large-scale spectacle. *Mamootot*, presented by the Brooklyn Academy of Music's Next Wave Festival in the top-floor studio of the nearby Mark Morris Dance Center, is for nine dancers in a small space with the audience of about a hundred seated on all four sides. The light is overhead, unchanging, and bright. (After a power failure as the audience was seating itself on Tuesday, it became more muted, but the fixed idea remained.)

So what, one might wonder. In New York we're used to spare abstraction and intimate surroundings. But for Mr. Naharin, this way of working was apparently a revelation in its restrictiveness. And it's not quite so abstract as you might first think.

Some choreographers have a way of winning your complicity right away: you're gripped, drawn in, and then most anything takes on a charge of added meaning. So it is, or at least so it was for me, with *Mamootot*.

What's unchanged about Mr. Naharin's way of working is his fascination with ritual, sensuality, repetition, and mystery. His Batsheva dancers, mostly in their mid-twenties but looking almost brazenly young, are all superb, and what Mr. Naharin asks of them brings out their inner, individual gifts. But those gifts remain focused by a seductive overall vision.

A lone woman emerges at the outset in a pastel jump suit, cut off at the knees and elbows, with white trim along the bottoms of the legs and arms and around the neck. They're all dressed like that. Along with pale

body makeup on the lower legs and arms and neck, the costuming (Rakefet Levy) makes them look like they're lost in a fairy tale, Pierrots or puppets, with arched backs and splayed fingers and twisting falls.

For the first three-quarters of an hour they dance in their own spaces, in strict patterns or solo. When that spell is broken, when they appear in duos and actually touch, the contrast is shocking. One man zips off his jump suit and, naked, performs a lascivious nontouching duet with a woman who suddenly leaps onto his side as he turns, leering. Two women do a sensuous slow dance, their contact seeming to trigger sparky electronic sounds.

What's fascinating—actually, it's all pretty fascinating—is the blend of childlike wonder and eroticism (a writhing traversal of the diagonal by one woman on her back, stretching and arching, for instance), formality, and quirky personality. At the end, all nine walk around the perimeter of the space, right next to the audience, holding strangers' hands and staring into their eyes with an inexplicable cocktail of emotions.

This is all augmented by the peculiar, and quite wonderful, soundtrack, consisting of hushed ambient sounds and cheesy loud punk-pop, all from records purchased almost at random by Mr. Naharin on shopping sprees in Japan; he chose them, he says, because he liked their covers.

Go if you can, though you probably can't. All thirteen performances were sold out before the run began. But you can always hope for returns.

THE NUTCRACKER

The New York Times, November 25, 2005

Many years ago, when I was young and Rumpelmayer's, that fabled pink ice cream parlor in the St. Moritz Hotel, was already middle-aged, I went there one day with a friend and her young daughter. It was coming on Christmastime, the air outside was crisp, and the girl and all the other little girls were dressed delectably, with their festive coats and scarves and hats.

A trip to Rumpelmayer's was a New York holiday ritual for those girls

and their attendant relatives. The place ceased to exist more than a dozen years ago, but another ritual of the holiday season, *The Nutcracker*, is still handsomely sustained by the New York City Ballet. Its annual forty-five-performance, five-plus-week run at the New York State Theater begins tonight.

Going to *The Nutcracker* is like a less fattening version of going to Rumpelmayer's: the same little girls (or their children or maybe even grandchildren) are there, dressed up and bright-eyed and eagerly expectant. A few years ago one of those little girls was mine.

There are beautiful children on the stage, too, part of the horde of youngsters that George Balanchine—recalling his own childhood in St. Petersburg in the late nineteenth century—choreographed into the production. The second act of *The Nutcracker* is even set in "Confiturembourg," which replicates the dazzling sweets of Rumpelmayer's, albeit without the stuffed animals.

The Nutcracker is ballet's *Messiah,* a surefire holiday staple so beloved as to be almost entirely critic proof, no matter how amateurish or outré a production may be. Balanchine made his own version based on his memories of Lev Ivanov's original choreography. The City Ballet production, which dates to 1954, has become the standard against which all other American *Nutcrackers* are judged, both the imitative ones and those that try to extend or flout tradition.

Year after year, in town after town, that twinkling Christmas tree rising to gigantic heights, or the dizzying onslaught of snow at the end of the first act, or the elegance of the Sugar Plum Fairy and her Cavalier and the Dewdrop—and all the charming dancers of the delicious treats (hot chocolate, coffee, tea, candy cane, marzipan, ginger)—awaken wonder in children and their parents alike.

And in the hardworking dancers, too, be they principals, soloists, corps members, or School of American Ballet students. Toni Bentley, in her classic diary of a corps dancer's life, *Winter Season* (1982), complained about the slippery snow and the sheer, injury-prone hard work of all those endless City Ballet *Nutcracker* performances: "Ah, to be rid of sugar and spice and dance to Stravinsky in leotards," she groaned. But she also remained open to the ballet's magic: "*The Nutcracker* is still wonderful. I still get chills when the tree grows and the little bed floats around the stage. 'The Nutcracker' can still excite."

It can also still balance the books. The reason so many American ballet companies consecrate weeks on end to this classic is because it's

beloved, but being beloved translates, in a country largely bereft of public subsidy, into tickets purchased. Stravinsky in leotards is a deficit operation; *The Nutcracker* can make actual money.

The Nutcracker is probably the most popular of all ballets, and there are reasons for that. Not much of the original 1892 Ivanov choreography for the Maryinsky Theater has survived, but the grand line of tradition, so carefully sustained and extended by Balanchine, most definitely has. Every famous choreographer has had a stab at it, among innumerable others: Nicholas Sergeyev in the first London staging in 1934; Willam Christensen (the first American production for San Francisco in 1944); Vassily Vainonen and Yuri Grigorovich for the Kirov and Bolshoi Ballets in the Soviet era; John Cranko, Rudolf Nureyev, Fleming Flindt, and John Neumeier in Europe; and Mikhail Baryshnikov for American Ballet Theater in 1976.

And there have been more iconoclastic efforts, like those of Mark Morris in 1991 and Matthew Bourne in 1992. But one way or another, the spirit remains, a dream vision of ballet loveliness that has inspired ballet careers in as many young dancers as there are paper snowflakes at the end of act 1.

That spirit is not all sugar and spice. Like most classic fairy tales, *The Nutcracker* is a triumph of good over evil, as befits the Germanic brooding of E. T. A. Hoffmann (as in *Tales of*), as translated through Alexandre Dumas *père*. The idyllic world of Marie and her parents and their friends is troubled by mean little boys (her brother breaks the wooden nutcracker) and her spooky godfather, Drosselmeier, and, of course, those malevolent scurrying mice and their fearsome, seven-headed king. (In some German versions he's the Rat King.) Passing through darkness makes the airy lightness of the end of the first act and all of the second brighter; joy has not just been granted; it's been earned.

Most canonic ballets boast great scores, and Tchaikovsky's for *The Nutcracker* is one of his most effervescent. It is usually less fussed with and reshuffled than those of *Swan Lake* and *The Sleeping Beauty*, however much choreographers may tinker with details of the scenario. Just listening to a recording can reawaken images of beautiful dancing.

Are there signs of *Nutcracker* exhaustion, hints out there in the heartland that this classic is losing its hold on audiences? The Colorado Ballet just announced the cancellation of six of its scheduled thirty *Nutcracker* performances, citing poor ticket sales. But chances are this is a sign of that company's larger financial and organizational problems;

when a company has to curtail or cancel *The Nutcracker*, it's surely in trouble.

There is also the question of how long the Balanchine choreography can remain sacrosanct, whether it provides a template or a straitjacket. In my own triumphant, if little-remembered, appearances as the Mouse King in Danbury, Connecticut, in 1991, I questioned the ethics of Marie's throwing her slipper and distracting me, thus allowing the callow Nutcracker to stab me in the back. What kind of hero is that, I asked the choreographer. Could I at least turn and face my nemesis and then be defeated in a fair fight? "Oh, no," she cried, truly shocked. "That's how *Balanchine* did it."

But not to worry. *The Nutcracker* is too good to go away anytime soon. For all its darkness, it appeals to parents and their children because it's like one of those glowing glass globes that you can shake and see the snow swirl. It's a dream bubble, a vision of middle-class happiness and fantasy that precedes the Russian Revolution and all the horrors of the last century and this one. That world may have faded, like Rumpelmayer's, but it is still our sweetest dream.

ALICIA J. GRAF

The New York Times, December 19, 2005

The third number of Judith Jamison's *Reminiscin'*, which had its premiere on the opening night of Alvin Ailey American Dance Theater's City Center season, on November 30, is a steamy, emotionally intense duet set to Diana Krall's throaty version of Joni Mitchell's "Case of You." (Refrain: "I could drink a case of you and I'd still be on my feet.")

On Friday night it was danced by Alicia J. Graf and Jamar Roberts, and it stopped the show—or it might have if Ms. Graf had not beguiled in an upbeat featured part in the very next section. The Friday program, the first of five the Ailey company is offering of its novelties this season, was supposed to be of interest as a showcase for repertory renewal, always a worthy goal. It was that, but Ms. Graf was so good that she became the news of the night all by herself.

She earned enthusiastic attention a few years ago at Dance Theater

of Harlem when she was still a teenager. But then she was injured, then earned a bachelor's degree from Columbia, and Dance Theater of Harlem collapsed. Now she's in Ailey, and she is one of the finest dancers I have seen this year. It was one of those instant star turns, like those unleashed of late by Diana Vishneva as Giselle last summer or Fang-Yi Sheu in Martha Graham repertory.

Ms. Graf is tall: five feet, ten inches. She has a face that can register joy and pain. Her body is lissome, almost lanky, though always in exquisite control. She has remarkable arms and hands, effortless extensions, and wonderful feet. In short, she's a ballet dancer; it was almost as if she were going on toe, even barefoot. Her body reminded me of Svetlana Zakharova, the Bolshoi Ballet star, but with more, dare I say it, soul.

Whether that makes her an ideal Ailey dancer for all the company's repertory we shall see. She was pretty much perfect in *Reminiscin'*. It would be wonderful to see her in classical ballet, too. But that's another story.

Ms. Graf's moment came at the end of a five-dance program of revivals, company premieres, and new work. The choreography made a mixed impression, but as usual with Ailey, the dancing did not: it was thrilling throughout.

Ulysses Dove's *Urban Folk Dance* (1990) has two couples in side-by-side rooms; sometimes one person or another sneaks into the others' room. The couples love and fight and flirt; some of the lifts are terrific, even if the overall impression is a little pat. The dancers Friday were Hope Boykin, Rosalyn Deshauteurs, Vernard J. Gilmore, and Willy Laury.

Acceptance in Surrender (2005) garnered some advance attention because it was a collaborative work by three of the company's dancers, Ms. Boykin, Abdur-Rahim Jackson, and Matthew Rushing, working together, not on separate sections. In it a lone woman relates to three men, usually in consort. The opening section was first-rate: the men leaping out of the darkness, the woman subtly and briefly sliding along the rear of the stage. After that, things became more conventional. The dancers were Dwana Adiaha Smallwood, Glenn Allen Sims, Clifton Brown, and Kirven J. Boyd.

Ailey's own *Witness* (1986) is a short, powerful solo, the woman (Renee Robinson) in a white gown initially seated on the middle of three benches, the stage lighted by candles everywhere. It is set to complexly arranged spirituals sung by Jessye Norman, the first one beginning "My soul is a witness."

Hans van Manen's *Solo* (1997), which is actually a trio for three men

mostly acting on their own and engaging in games of one-upmanship, provides a fine platform for three of the company's contrasting men (tall, muscular, cute) to shine, and shine they do. It was danced by Mr. Brown, Mr. Sims, and Mr. Rushing.

Reminiscin' is a chain of turns for young people hanging out in a handsome bar, set to a series of songs by female singers (aside from Ms. Krall, Sarah Vaughan, Ella Fitzgerald, Regina Carter, Roberta Flack, and Nina Simone). Whether it has much depth is open to question. That it provides brilliant opportunities for dancers, there can be no doubt. Just ask Ms. Graf.

THE '60S

The New York Times, January 4, 2006

So maybe everything old *is* new again. Or maybe everything old is just getting older but hanging around, annoyingly, like a panhandling hippie. Whichever it is, I spent the latter part of 2005 encountering echoes of the 1960s in various dances and wondering what to make of them. I'm still wondering.

My major déjà vu moment came in early December with John Jasperse's *Prone* at the Kitchen. I spent the '60s in Berkeley, California, and the last thirty-five years in Lower Manhattan. The '60s—a decade that extended well into the '70s in downtown New York performing arts—was the time of the happening and the be-in and multiple forms of trippy vanguard experimentation. Much of it involved the mixture of media and the enhancement of perception (although, as a priggish critic, I have always taken a disapproving view of perception enhancement on the job).

Mr. Jasperse brought it all home, albeit with updated materials, like air mattresses made of a clear plastic that no doubt hadn't been invented forty years ago. But as in earlier events at earlier physical incarnations of the Kitchen (Mercer Street, Broome Street), this was a deliberately participatory experience. The audience was invited to lie on the mattresses (deployed in precisely ordered rows, an '00s touch) and contemplate the

dance and the scenic effects from that position. Those effects were disorienting and fun, much enhanced by the sensuous, sleep-inducing horizontality of perspective.

Just a few days later, I came upon Pascal Rambert's Side One Posthume Théâtre at Dance Theater Workshop. This is a French theater troupe, although it is really a dance-theater company, as Mr. Rambert readily acknowledged in the postperformance discussion. His *Paradis (Unfolding Time)*—the very title recalled the Living Theater's *Paradise Now*—was an uneven affair, but its young, eager cast and ample nudity were enough to provide flashbacks for me.

Then came Movement Research's annual Improvisation Festival at St. Mark's Church. The night I went was more musical than dansical, so I didn't review it. Half the program consisted of a duet for the composer Pauline Oliveros and the dancer Simone Forti. Here was the real deal, '6os-wise: two honored veterans from that very decade, pioneers in just the kind of performance piece we're talking about. I found Ms. Forti a little inconclusive; I have always found her work a little inconclusive, however genial and well intended. But Ms. Oliveros's ability to wring magic out of simple electronic devices and a squeezebox and a few sound-making toys was as enticing as ever.

So what are we to conclude? A lot of veterans of New York dance date to the '6os. Most of them have evolved beyond their rude, conceptual, earnestly experimental youths, though they often (Merce Cunningham, Trisha Brown) retain clear traces of their roots. Organizations like the Howl! arts festival cling to their East Village origins in their very names but have evolved with the times in their art. St. Mark's and the Judson Church are still very much with us.

The old masters of today grew up in the '6os and played a major role in defining that decade and our image of it. Look at the Robert Rauschenberg retrospective at the august Metropolitan Museum of Art. When those old masters aren't around anymore to remind us personally of their presence, their decade will more formally recede into history.

Part of what makes dance so seductive is its inevitable celebration of youth and youthful bodies. People often look back on their first flush of adulthood as a time of happy memories: first real loves, first realizations of self through work, health, and energy. The eternal youth of dance reminds us of what we once were.

An even more important aspect of dance's power is its veiled allusiveness. Dance is the art of nonverbal transcendence, as the mystic Gurd-

jieff, still popular in the '60s, knew full well. Other performing arts can browbeat us with explicit verbal meaning. Dance—even if words are involved, as in Mr. Rambert's *Paradis*—conveys its meanings more mysteriously.

The '60s was a decade of sex, drugs, and rock and roll—more so on the West Coast, where I was, than on the politically driven East Coast. But it was also a decade of mystery, of strange Eastern religions offering higher states of consciousness and an almost painfully naive hope, or so it seems today, that mankind could be transformed.

Ultimately, the political side of that transformative ethos and its inner consciousness fused; the two coasts weren't so different, after all. Back then, we believed in a better tomorrow, however innocently. Some sought that tomorrow through demonstrations and protests, others through individual and communal experience.

It didn't quite work, of course. Individuals may have changed, for better or worse, and certain givens of today—meditation, environmental concern—had their origins back then. But mankind as a species was not transformed; bad things continued to happen.

Still, the '60s never died. The decade's self-indulgence and excitement and self-betrayal and visionary optimism remain. Right now, we are mired in a political climate that still seems a direct reaction against the '60s, a recoiling from the very liberation so many of us sought. Just the other day I, of all people, received a right-wing fund-raising pitch from Edwin Meese III, playing on my presumed horror of the very decade I recall so fondly.

Art has a way of playing by its own rules, out of synch with society. Sometimes, as history has proved, it can predict the future. Right now, the time is not yet quite right for a rebirth of the '60s; works like Mr. Jasperse's *Prone* look sweetly ironic. But maybe the artists know something the politicians do not.

It was forty years from the 1920s, the previous great liberating decade, to the '60s, and forty years from the '60s to now. Maybe the societal shifts that provided so fertile a climate for the '60s are about to burst forth again; you can't repress youthful energy and optimism forever. If they do, Mr. Jasperse could look like a prophet.

INDEX OF NAMES